GRAPHIC DESIGN solutions

GRAPHIC DESIGN solutions

4TH ED.

Robin LANDA

DISTINGUISHED PROFESSOR
ROBERT BUSCH SCHOOL *of* DESIGN
Kean University

WADSWORTH
CENGAGE Learning

Australia • Brazil • Japan • Korea • Mexico • Singapore • Spain • United Kingdom • United States

Graphic Design Solutions, Fourth Edition
Robin Landa

Publisher: Clark Baxter

Senior Development Editor: Sharon Adams Poore

Assistant Editor: Kimberly Apfelbaum

Editorial Assistant: Ashley Bargende

Senior Media Editor: Wendy Constantine

Senior Marketing Manager: Diane Wenckebach

Marketing Coordinator: Loreen Pelletier

Marketing Communications Manager: Heather Baxley

Senior Content Project Manager: Lianne Ames

Senior Art Director: Cate Rickard Barr

Print Buyer: Julio Esperas

Permissions Editor: Katie Huha

Production Service: Lachina Publishing Services

Text Designer: Chen Design Associates

Photo Manager: John Hill

Cover Designer: Chen Design Associates

Compositor: Lachina Publishing Services

The concept for this cover design, from the award-winning Chen Design Associates studio, is to make the design process visual, to reveal the function behind the form, and to make the cover a living example of the material covered within this book's pages.

For product information and technology assistance, contact us at
Cengage Learning Customer & Sales Support, 1-800-354-9706
For permission to use material from this text or product, submit all requests online at **www.cengage.com/permissions**. Further permissions questions can be emailed to **permissionrequest@cengage.com**.

Library of Congress Control Number: 2009941972

ISBN-13: 978-0-495-57281-7

ISBN-10: 0-495-57281-0

Wadsworth
20 Channel Center Street
Boston, MA 02210
USA

Cengage Learning is a leading provider of customized learning solutions with office locations around the globe, including Singapore, the United Kingdom, Australia, Mexico, Brazil and Japan. Locate your local office at **international.cengage.com/region**

Cengage Learning products are represented in Canada by Nelson Education, Ltd.

For your course and learning solutions, visit **www.cengage.com**.

Purchase any of our products at your local college store or at our preferred online store **www.CengageBrain.com**.

Planet Friendly Publishing
✓ Made in the United States
✓ Printed on Recycled Paper
Text: 30% Cover: 10%
Learn more: www.greenedition.org

Manufacturing books in the United States ensures compliance with strict environmental laws and eliminates the need for international freight shipping, a major contributor to global air pollution. Printing on recycled paper helps minimize our consumption of trees, water and fossil fuels.

Trees Saved: 267 • Air Emissions Eliminated: 25,404 pounds

Water Saved: 122,352 gallons • Solid Waste Eliminated: 7,429 pounds

Printed in the United States of America
1 2 3 4 5 6 7 14 13 12 11 10

TABLE OF **Contents**

PART 01: FUNDAMENTALS OF GRAPHIC DESIGN

CH /06: Composition*131*

PART 02: APPLICATIONS

CH /07: Posters*165*

PART 03: THE PROFESSION AND CAREERS GD/s

CH/**15:** The Portfolio and Job Search GD/s

Preface

Graphic Design Solutions remains the most comprehensive how-to reference on graphic design and advertising for print and interactive media, intended to serve as a foundation for a graphic design and advertising design education. Theory and applications are stressed with an instructive approach. Known for its thorough treatment of theory and major graphic design applications, this text provides hundreds of significant design solutions, which are models of excellence. The more fine examples students see, the better students can understand what constitutes effective, creative solutions; outstanding work should imprint on students.

A NOTE FROM THE AUTHOR

Every semester, I want to hand over—all at once—everything I know about graphic design and advertising to my students so they can immediately start creating effective solutions. That desire has propelled me to present the information in this book as clearly, fully, and succinctly as possible—to offer a complete graphic design foundation.

I have written *Graphic Design Solutions* to serve as a guide for my students, to support my own teaching, and hopefully you will find it helpful, as well. Teaching graphic design and advertising is very challenging. Much is taught simultaneously—critical and creative thinking, principles, theory, strategy, conceptual design, design development, technique, visualization, composition, social responsibility, and applications. In order to design, students must be critical and creative thinkers, learning to express and represent their creative ideas; that is why this book addresses conceptual and creative thinking as fully as it addresses visualization, composition, and the requirements of specific applications, such as posters or websites. (For competencies expected from designers, see the AIGA survey entitled "Designer of 2015 Competencies," http://www.aiga.org/content.cfm/designer-of-2015-competencies.)

ORGANIZATION

We begin this study with an historical perspective, in order to view contemporary thinking in perspective; an instructor can start there, or use the history as a reference throughout the course of study. *Part I: Fundamentals of Graphic Design* provides a very substantial foundation for discussion of specific applications. For some readers, these chapters may be the only introduction to visual communication they receive; therefore, I tried to make it as full of vital information as possible including: an introduction examining the visual communication profession; comprehensive coverage of two-dimensional design concepts; typography; creativity and concept development; the design process; visualization; and composition. *Part II: Applications* is an in-depth examination of major graphic design and advertising applications. The chapters are easily used in any order that is appropriate for the reader or best suits the educator. Each chapter provides substantial background information about how the application is used and how to create an application, including exercises and projects. Also included are sidebars with suggestions, tips, and important design considerations. Some chapters are much longer than others due to the role they play in most curricula.

As some educators have mentioned to me, this book covers an enormous amount of information. What I have done is allow for at least three scenarios:

> Instructors may pick and choose what to teach, whether it is content areas, applications, or the number of projects.

> Instructors may choose to use this book in several courses (there is plenty of information to carry over for several courses or semesters).

> This book is a keeper—most students and designers use this book as a *reference and resource* owing to the abundance of information, historic time line, great examples by venerated designers, and brainstorming techniques.

The last chapter (now available online with links to resources including video advice from many top designers) describes putting together a portfolio and the job search. At the end of the book are the glossary to help with terminology, a selected bibliography to encourage further reading, and two extensive indexes—one regarding all subject matter and another referencing all the agencies, clients, creative professionals, and studios mentioned in this book.

Additional material and resources (including many exercises and projects) appear online at no extra cost. This material is noted throughout the book by an icon **GD⁄**.

LOOKING AT THE ILLUSTRATIONS

Unlike a design periodical that showcases the most recent work, the illustrations in this book were chosen as classic examples that would

endure. The illustrations also were chosen to represent different approaches and schools of thought. Every illustration in this book is excellent and was selected with great thought to providing the best possible examples of effective and creative work.

Anyone can learn an enormous amount by analyzing graphic design solutions. Whether you dissect the work of peers, examine the examples of work in this text, closely observe an instructor's demonstrations, or analyze professional work, you will enhance your learning by asking *how* and *why* others did what they did. The examples provided in this text are just that—examples. There are innumerable solutions to any exercise or project. Any visual communication is measured in terms of the degree of success demonstrated in problem solving, communicating, applying visual skills, and creativity within those constraints.

NEW TO THIS EDITION

The majority of the illustrative examples in *Graphic Design Solutions* are new to this edition, providing numerous and varied examples for study. The Fourth Edition contains a new chapter, Creativity and the Graphic Design Process (Chapter 4), providing the tools to stimulate creative thinking and for brainstorming, as well as creativity exercises to prompt and support conceptualization. The Fourth Edition also provides increased coverage in a new chapter on visualization (Chapter 5) including: understanding images, approaches, methods, and media for visualizing design concepts. Discussions have been expanded on composition (Chapter 6) to offer a wide range of theories and points of view, publication design (Chapter 8), corporate communication: brochures, annual reports, and more (Chapter 12), and web design, motion and screened-based media (Chapter 14). This edition also has a more in-depth coverage of the five steps of the design process, a thorough guide to key graphic design and advertising applications for print and interactive media, pointers on information gathering, methods for concept generation, an overview of the visual communication profession, and new exercises and projects at the end of each chapter and on the web.

Also in this new edition:

› More on creative thinking
› Numerous brainstorming techniques
› Conceptual thinking and concept development
› Many new diagrams
› Brochure design coverage
› Publication design: covers and interiors
› New essays, showcases, and case studies
› Preliminary sketches of designers' works
› Alternative solutions to the printed piece
› Integrated ad campaigns
› Storytelling
› More on interactive design
› Expanded coverage of time and motion
› More information on the grid, including diagrams
› New contemporary and additional historical illustrations

FROM THE FIELD

The most highly regarded design professionals today provide insights and examples in high-interest boxes, including Essays and Before & After (showing before and after images such as Ocean Spray Juices/ Wallace Church, Chapter 11). An essay "From Start to Finish" by Dave Mason, SamataMason, walks the reader through the step-by-step process of a project (Chapter 4). Case Studies throughout the book examine the design process including Seed Media Group/Sagmeister Inc. (Chapter 4), Nickelodeon/AdamsMorioka (Chapter 9), Saks Fifth Avenue/Michael Bierut/Pentagram (Chapter 10), and Nokia Urbanista Diaries/R/GA (Chapter 14).

RESOURCES FOR INSTRUCTORS

› *Online ebank and Instructor materials* for each chapter include an instructor's manual, PowerPoint® slides designed for use with lecture, reflective chapter questions for students, and additional exercises.
› *WebTutor™ Toolbox for WebCT® and Blackboard®* offers a full array of online study tools that are text-specific, including learning objectives, glossary flashcards, practice quizzes, Web links, and a daily news feed from NewsEdge, an authoritative source for late-breaking news to keep you and your students on the cutting edge.

RESOURCES FOR INSTRUCTORS AND STUDENTS

New to this edition, *Graphic Design Studio* is an application that supports instructor and peer review of assignments submitted online with gradebook tracking. Projects can be uploaded to this site rather than sending through e-mail. Students can see the work of others.

New to this edition, *the Premium website* delivers content referred to within the text with an icon, chapter-based exercises and projects, topics related to building a portfolio, the interview and career search process, and an innovative video series, Designers Speak, offering video interviews with working designers about how they entered the field of design. The multimedia ebook links to relevant materials in the premium site.

About the Author

Robin Landa holds the title of Distinguished Professor in the Robert Busch School of Design at Kean University of New Jersey. She is included among the teachers that the Carnegie Foundation for the Advancement of Teaching calls the "great teachers of our time." Most recently, Landa was a finalist in the *Wall Street Journal's* Creative Leaders competition.

Landa has won many awards for design, writing, teaching, and creative leadership, including: National Society of Arts and Letters, The National League of Pen Women, New Jersey Authors Award, Creativity, Graphic Design USA, Art Directors Club of New Jersey, The Presidential Excellence Award in Scholarship from Kean University, and the Rowan University Award for Contribution to Design Education.

Landa is the author of twelve published books about graphic design, branding, advertising, and creativity including *Advertising by Design* (John Wiley & Sons) and *Designing Brand Experiences* (Cengage Learning). Her books have been translated into Chinese and Spanish.

Co-authoring with her colleague Professor Rose Gonnella, she wrote *Visual Workout Creativity Workbook* (Cengage Learning); and co-authored *2D: Visual Basics for Designers* with Gonnella and award-winning designer Steven Brower. Known for her expertise in creativity, Landa penned *Thinking Creatively* (HOW), and co-authored *Creative Jolt* and *Creative Jolt Inspirations* (North Light Books) with Rose Gonnella and Denise M. Anderson. Landa's article on ethics in design, "No Exit for Designers," was featured in *Print* magazine's European Design Annual/Cold Eye column; other articles have been featured in *HOW* magazine, *Step Inside Design*, *Critique*, and *Icograda*. Landa's Amazon Shorts—"Advertising: 11 Insights from Creative Directors" and "Branding: 10 Truths Behind Successful Brands"—both reached the #1 spot on the Shorts best-seller list.

Landa has lectured across the country at the *HOW* International Design Conferences, Graphic Artists Guild conference, College Art

ROBIN LANDA

· MIKE TESI PHOTOGRAPHY

Association, Thinking Creatively conference, Art Directors Club of New Jersey, and the One Club Education Summit. She has been interviewed on radio, television, in print, and the World Wide Web on the subjects of design, creativity, and art.

In addition, working with Mike Sickinger at Lava Dome Creative (http://www.lavadomecreative.com) in New Jersey, Landa is a brand strategist, designer, copywriter, and storyteller; and she is the creative director of her own firm, robinlanda.com. She has worked closely with marketing executives and their companies and organizations to develop brand strategy, enhance corporate creativity through seminars, and develop brand stories. With the keen ability to connect the seeming unconnected, Landa uses her research and writing to support her professional practice.

Acknowledgments

Without the brilliantly creative graphic design and advertising solutions that inhabit these pages, my book would be an entirely different study. Humbly and gratefully, I thank all the creative professionals who granted permission to include their work in this Fourth Edition of *Graphic Design Solutions*. Great thanks to the clients, companies, and organizations that granted permission, and to all the generous people whose help was so valuable.

New to this edition are wonderful case studies, essays, interviews, showcases, and online videos. With admiration and respect, I thank all the wonderful people who contributed to these outstanding features.

Over the years, my esteemed colleague Professor Martin Holloway, Robert Busch School of Design at Kean University, has shared his vast knowledge on the subjects of designing with type and type history. The chapter on typography depends upon his expertise and brilliant diagrams. I anxiously await Martin's own book on type and I am deeply indebted to him.

Humbly I thank Alice Drueding, Professor, Graphic and Interactive Design, and Joe Scorsone, Professor, Graphic and Interactive Design, Tyler School of Art, Temple University; Ed Sobel, Owner, CG+M Advertising + Design; Bob Aufuldish, Aufuldish & Warinner; Fritz Klaetke, Visual Dialogue; Steven Brower, Steven Brower Design; Rose Gonnella, Professor and Executive Director of the Robert Busch School of Design at Kean University; Hayley Gruenspan for her marvelous illustration; John C. Luttropp, Professor of Art and Design, Montclair University; Henry Martin, American cartoonist; Doug McGrath, writer and film director; Alan Robbins, the Janet Estabrook Rogers Professor of Visual and Performing Arts at Kean University, and Toni Toland, Professor, Syracuse University for engaging in discussion about visualization, composition, design, and storytelling—for their valuable help in shaping some new content.

New to this edition are wonderful case studies, essays, interviews, and showcases by Sean Adams, AdamsMorioka; Gail Anderson, Spotco; Christina Arbini, Hornall Anderson; Michael Bierut, Pentagram; Gui Borchert, Syrup; John Butler, Butler, Shine, Stern & Partners; Bart Crosby, Crosby Associates; Ned Drew, Associate Professor, Rutgers University; Alice Drueding and Joe Scorsone, Scorsone/Drueding Posters; Joe Duffy, Duffy & Partners; Shane Farrell, Second Story; Ellyn Fisher, The Advertising Council; Mish Fletcher and Reva Bottles, Ogilvy; Carla Frank and Gayle King at *O, The Oprah Magazine*; John Gall, Vintage and Anchor Books; Jonathan Herman, WAX; Alexander Isley, Alexander Isley Inc.; Arto Joensuu,

Nokia; Liz Kingslien, Lizart; Fritz Klaetke, Visual Dialogue; Nick Law, R/GA; Dave Mason, SamataMason; Brenda McManus, assistant instructor of graphic design, Rutgers University; Jay Miller, Imagehaus, Inc.; Drew Neisser, Renegade; Roy Poh, Kinetic; Debra Rizzi, Rizco Design; Alan Robbins, Janet Estabrook Rogers Professor of Visual and Performing Arts at Kean University; Roberta Ronsivalle, Mucca Design; Will Staehle, Lone Sheep Black Wolf; Daniel Stein, EVB; Tracy Turner, Tracy Turner Design Inc.; Jurek Wajdowicz and Lisa LaRochelle, Emerson, Wajdowicz Studios; and Rob Wallace, Wallace Church. Also new is the exciting video series, "Designers Speak" created by: Gail Anderson, Spotco; Bob Aufuldish, Aufuldish & Warinner; Steven Brower, Steven Brower Design; Carla Frank, Carla Frank Creative; Jonathan Herman, WAX; Fritz Klaetke, Visual Dialogue; Stefan Mrechko, Ogilvy; Mike Perry, Mike Perry Studio; Max Spector, Chen Design Associates; Michael Strassburger, Modern Dog; and Armin Vit, Under Consideration LLC. With admiration and respect, I thank you all.

My thanks to the following people for their valuable input: Professor Robert D. Austin, Technology and Operations Management unit at Harvard Business School; Carolina de Bartolo, Instructor, Academy of Art University; Nils Bunde, President, Brainforest, Inc.; Sheree Clark, Sayles Graphic Design; Beth M. Cleveland, Elm Publicity Inc.; Bart Crosby, President, Crosby Associates; Laura Des Enfants, Partner, DesenfantsAldrich; Richard Grefé, Executive Director of AIGA; Steven Heller, co-founder and co-chair of the MFA Design Department at the School of Visual Arts, New York; Chris Herron, Chris Herron Design, Chicago; Brockett Horne, Professor/Co-chair, Maryland Institute College of Art, Baltimore; Luba Lukova, Luba Lukova Studio; Jennifer McKnight, Assistant Professor, Department of Art and Art History, University of Missouri—St. Louis; Jay Miller, Principal, Imagehaus; Christopher Navetta; Charlie Nix, Scott & Nix; Michael O'Keefe, web designer; Debra Rizzi, Rizco; John Sayles, Sayles Graphic Design; Terry Lee Stone, Design Writer, Strategist, Educator, Los Angeles; Elizabeth Tunstall, Associate Professor, Design, Anthropology and Planning, University of Illinois at Chicago; and Armin Vit, UnderConsideration.

I am thankful for the thoughtful comments from reviewers: Eric Chimenti, Chapman University; Shelly DeForge, Southwest Florida College; Paula DiMarco, California State University Northridge; Richard B. Doubleday, Boston University; Deborah Greh, St. John's University; Merrick Henry, Savannah College of Art and Design;

Andrea Robinson Hinsey, Ivy Tech Community College; Erica Honeyman, Lehigh Valley College; Jan Jancourt, Minneapolis College of Art & Design; Gloria Lee, University of Texas at Austin; Jerrold Maddox, The Pennsylvania State University; Paul J. Nini, The Ohio State University; John C. Smith, Spokane Falls Community College; Larry M. Stultz, The Art Institute of Atlanta; Jacqueline Tessmer, Baker College; and Richard Rex Thomas, St. John's University.

As is my way, I cross-train my thinking and research. To my illustrious dance teachers not only for the gift of movement, for helping me better understand how much "design happens between the steps"—Ryan Daniel Beck, Caroline Kohles, Shannon Denise Evans, Winter Gabriel, Julia Kulakova, and Manuel Rojas—my sincere thanks.

I am grateful to President Dawood Farahi, Kean University, who provided time for research in support of this book, and to Dr. Mark E. Lender, Professor of History and Vice President for Academic Affairs, and Holly R. Logue, Professor of Theatre and Dean of the College of Visual and Performing Arts, for their great support. At the Robert Busch School of Design at Kean University, I am highly fortunate to work alongside such consummate educators, experts, and the kindest of friends: Steven Brower, Tom Clark, Ray Cruz, Janet DeAugustine, Rose Gonnella, Martin Holloway, Michele Kalthoff, Dawn Marie McDermid, Christopher Navetta, Rich Palatini, Alan Robbins, Michael Sickinger, and Janet Slowik. Thank you to Dr. Paula S. Avioli, Professor and Assistant Chair, Department of Psychology, Kean University, and Dr. Jonathan Springer, Professor of Psychology at Kean University, for their sharing their expertise.

Rewriting a book is a huge undertaking. Great thanks to the Wadsworth dream team: Clark Baxter, publisher; Sharon Adams Poore, senior development editor; Cate Barr, senior art director; Lianne Ames, senior content project manager; Wendy Constantine, senior media editor; Diane Wenckebach, senior marketing manager; Kimberly Apfelbaum, assistant editor; Ashley Bargende, editorial assistant; and, special thanks to Annie Beck, project manager with Lachina Publishing Services.

Warm thanks to former students, now highly creative professionals, who have made me proud, and great thanks to my current students. Thanks for allowing me to bask in your cumulative creative glow and glory.

Loving thanks to my family, friends, and Kean University alumni—Jason Alejandro, Denise M. Anderson, Rich Arnold, Jill Bellinson, the Benten/Itkin family, Paula Bosco, Claudia Brown, Sherri Loren Cumberbatch, Alex D'Angelo, Donald Fishbein, Lillian Fishbein, Rose Gonnella and the Gonnella family, Anna Hestler, Frank Holahan, Andrew Lowe, Jane Martin McGrath, Robert Skwiat, Mike Sickinger, Karen Sonet Rosenthal, Keith Testa, Fariida Yasin, and Iee Ling Yee. And finally, my heart and thanks to my handsome husband/tango partner, Dr. Harry Gruenspan. To my darling daughter Hayley, who is the most patient, caring, creative, bright, and adorable person I know—thanks for putting up with me, my love.

DEDICATION

For my darling daughter Hayley.

Robin Landa
2010

The study of graphic design and art history helps us better understand how we arrived at the present, how we came to be as we are. Peter N. Stearns, Professor of History at George Mason University, says: "The past causes the present, and so the future."[1]

A comprehensive study of graphic design history is a requirement for any aspiring designer or anyone interested in understanding images; *Meggs' History of Graphic Design* by Philip B. Meggs and Alston W. Purvis is standard reading; *Graphic Style: From Victorian to Digital* by Steven Heller and Seymour Chwast and *Graphic Design Time Line: A Century of Design Milestones* by Steven Heller and Elinor Pettit offer time line format support. A full study of fine art history and modern art is critical, too; *Gardner's Art through the Ages* is a comprehensive study.

Any serious study also includes design theory, criticism, understanding images, persuasion, world history, and related topics. As with anything temporal, the history of graphic design and advertising is a product of its time—of the economy, politics, the arts, philosophy, culture, and society. Graphic design is always affected by small and large human events and factors, such as war, culture, sub-culture, cultural unrest, economic turbulence, music, media, and more. Graphic design and advertising, in turn, affect culture, music, media, and more.

NOTE

1. Peter N. Stearns. "Why Study History?" American Historical Association, July 11, 2008. http://www.historians.org/pubs/free/Why StudyHistory.htm.

ESSAY

S.B.

STEVEN BROWER

Now in his own design studio, most recently Steven Brower was the creative director for Print *magazine. He has been an art director for* The New York Times, The Nation *magazine, and Citadel Press. He is the recipient of numerous national and international awards, and his work is in the permanent collection of Cooper-Hewitt National Design Museum, Smithsonian Institute. He is on the faculty of the School of Visual Arts, New York, and Marywood University's Masters with the Masters program in Scranton, Pennsylvania, and Kean University of New Jersey. He resides in New Jersey with his wife and daughter and their six cats.*

The history of design, like any history, is completely malleable. With no hard start date, we have to make choices. Should we begin with the cave paintings of Lascaux, Chinese moveable type, the Trajan column, or Gutenberg? Our history is the history of human communication, so where to begin?

For our purposes, we begin in the modern era, in the late nineteenth century. The advent of improved travel to Asia brought sailors onto the streets of Paris and London, weighted down with Japanese prints in their knapsacks. The influence of these Japanese artists on their European counterparts was profound. An organic sense of form based on nature, refined ornamental borders, and elegant composition became the rage. Combined with refined printing processes, Art Nouveau was indeed the new art.

This style spread quickly. The Arts & Crafts movement in England, Jugendstil (Youth Style) in Germany, and Glasgow Style with versions in Belgium and the United States—the basic elements were reinvented by each culture, which added their own twist. In Austria it was taken a step further with the Vienna Succession, a group dedicated to creating a new visual language.

In the early 1900s, the shot heard round the world would be in Germany. Lucian Bernhard was fifteen years old when he visited the Munich Flaspalast Exhibition of Interior Design. So moved by the forms and colors he had witnessed, he returned to his parents' house while his father was away on a business trip, and painted every wall and piece of furniture in these bold new colors. When his father returned, he was so outraged that Lucian left home, permanently.

Stranded in Berlin, he entered a contest sponsored by Priester Match to create a poster advertising their wares. He painted a composition that included matches on a tablecloth, along with an ashtray containing a lit cigar, and dancing girls in the background. Dissatisfied, he painted out the dancing girls. Feeling it was still not working, he deleted the ashtray. The tablecloth was next to go. There remained the singular word "Priester" and two matches, on a brown background, along with a discrete signature. The birth of the object poster

was born, prefiguring the Ludwig Mies van der Rohe "less is more" philosophy.

Soon the Russian Revolution was under way, resulting in an extraordinary (albeit short-lived) amount of creative freedom for artists such as El Lissitzky, Rodchenko, and Malevich. The Futurists' typographic experimentation with typography in Italy resulted in an influence that would outlast their movement, halted by World War I. After the war, De Stijl in the Netherlands and The Bauhaus in Germany would further refine the clean modernist esthetic. Artists such as A. M. Cassandre in France would synthesize entire art movements such as Cubism, Surrealism, and Art Deco.

With the advent of War World II, many of these artists would be forced to emigrate to the United States. Their influence was profound. Just as Japan had influenced the Europeans fifty years earlier, thus America was impacted by Europe. Lester Beall was one of the first American designers whose work showed strong evidence of this inspiration. Paul Rand and Alvin Lustig's designs, in part, explored the amorphous forms of European painters Paul Klee and Joan Miró.

In 1954, a group of Cooper Union graduates banded together to form Push Pin Studios. Well-versed in design and illustration history, they drew upon existing forms, such as Art Nouveau and Art Deco, to create new ones. By combining illustration and design seamlessly, they ushered in a new era, in contrast to the stark Modernist movement that had gone before. Their reexamination of the Art Nouveau style moved west in the late 1960s, combined with the cultural and musical changes at the time, and reappeared in the form of Psychedelic posters by the likes of Rick Griffin and Victor Moscoso.

In the mid 1970s and early 1980s, the retro approach reached its zenith. The European type styling of Louis Fili, Jennifer Morla, and Carin Goldberg, and Constructivist type design of Neville Brody revisited and reinvigorated existing forms.

In 1984, Apple Computers released the first Macintosh, and the relationship between

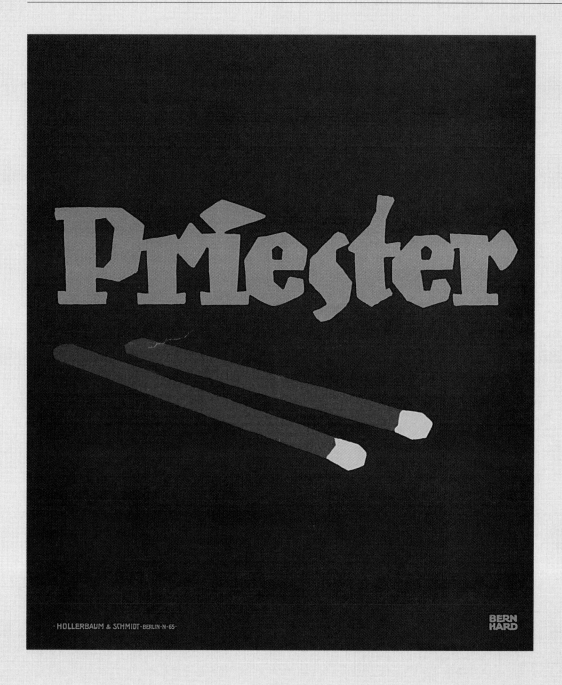

PRIESTER MATCH

- DEUTSCHES PLAKAT MUSEUM IM MUSEUM FOLKWANG, ESSEN (FOTOGRAFIE: JENS NOBER)
- LUCIAN BERMHARD (EMIL KAHN, 1883–1972)
- PRIESTER [HÖLZER]
- DEUTSCHLAND (DEUTSCHES REICH), 1915
- HOLLERBAUM & SCHMIDT, BERLIN
- FARBLITHOGRAFIE
- 59,5 X 48,5 CM
- DPM 1128

technology and design moved forward yet another step. Designers such as April Greiman and later David Carson took up the call. A myriad of new typefaces were displayed in *Emigre* magazine. Design, type setting, and production were fused for the first time. In reaction, hand-lettered typography was suddenly manifest.

Today, we are still reeling from the effects of the personal computer. Designers, perhaps more than ever before, can be the complete masters of their domain, responsible for every aspect of what winds up on the page or digital display. The time line continues. Where are we headed? Only the future will tell.

Historical Image Time Line (1893–Present)

THIS BRIEF HISTORICAL OVERVIEW of visual communication in the twentieth century is in no way meant to be a substitute for a full study; my offering does not include, as any full history would, the influences of current events, social climate and issues, inventions, politics, music, and art on the topic of visual communication; for example, the social and political climate of World War II had a profound influence on European and American artists' and designers' lives and work.

The goal of this brief time line is to put the information in this book into a broader context. As Brower asks: Should we begin with the human and animal representations and signs in the Cave of Lascaux some 16,000 years ago? Does the history of visual communication begin in the eleventh century with the invention of moveable type by a man named Bi Sheng in China? Or does graphic design begin with its roots in Johannes Gutenberg's method of printing from movable type in the mid-fifteenth century? Did graphic design begin with graphics that identified? Instructed? Promoted? Did graphic design begin with the combination of words and images in the first poster? For our purposes, we begin in the modern era, in late nineteenth century Europe.

THE PROPONENTS of the Arts & Crafts movement continued to disseminate information about design. Moving toward the twentieth century, European art was deeply affected by an influx of Japanese prints. In turn, European trends and movements influenced American artists and designers. The Art Nouveau movement, with its flowing organic-like forms, was felt in all the visual arts, from design through architecture. In both Europe and America, there were advances in printing technology by the late nineteenth century; in France, color lithography significantly advanced by Jules Chéret allowed for great color and nuance in poster reproduction. Advances in lithography helped give rise to the poster as a visual communication vehicle. Toulouse-Lautrec embraced the poster. Companies hired Art Nouveau artists, such as Alphonse Mucha, to create posters to advertise their products. In England, controversy erupted over the use of Sir John Millais's painting *Bubbles* in a poster advertising Pears Soap by Thomas Barratt, who built Pears Soap into one of the world's great brands in the nineteenth

1890s

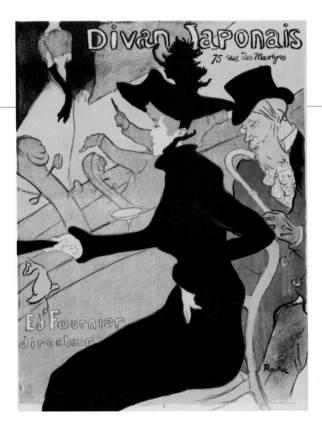

POSTER: HENRI DE TOULOUSE-LAUTREC (1864–1901), *DIVAN JAPONAIS (JAPANESE SETTEE)*, 1893.

LITHOGRAPH, PRINTED IN COLOR, COMPOSITION: 31 ⅝" × 23 ⅞". ABBY ALDRICH ROCKEFELLER FUND (97.1949).
COLLECTION: THE MUSEUM OF MODERN ART, NEW YORK, NY, U.S.A.
DIGITAL IMAGE © THE MUSEUM OF MODERN ART/LICENSED BY SCALA/ART RESOURCE, NY

Although primarily a painter (and printmaker), French artist Toulouse-Lautrec's embrace of the poster would drive the medium into popularity; he created a total of thirty-two posters.

The Japanese influence is applied to Parisian nightlife.
—Steven Brower

century. Many people objected to the use of fine art for commercial purpose. Barratt's intention was to borrow cachet from "high art"—from fine art—for his Pears Soap brand.

In 1898, an American advertising agency, N. W. Ayer & Son, opened a design department to design their own ads. An American woman, Ethel Reed, became a noted graphic designer and illustrator. William H. Bradley, an important American designer influenced by the British Arts & Crafts movement and Art Nouveau, designed a series of covers for *The Chap Book*, which became an important disseminator of style.

1870s through the 1890s/ Arts & Crafts movement
1887/ Sir John Millais's painting Bubbles *used in a poster advertising Pears Soap*
1890/ Art Nouveau movement begins
1891/ La Goulue, *Toulouse-Lautrec's first poster*

1893/ Coca-Cola is registered as a trademark
1895/ The Beggarstaffs, a pseudonym for William Nicholson and James Pryde, use an original collage influenced by Japanese art for a poster advertising the play Don Quixote at The Lyceum Theatre, London
1897/ Vienna Secession is formed
1898/ Advertising agency N. W. Ayer created the slogan, "Lest you forget, we say it yet, Uneeda Biscuit," to launch the first prepackaged biscuit, Uneeda, produced by the National Biscuit Co. (today, a company called Nabisco).

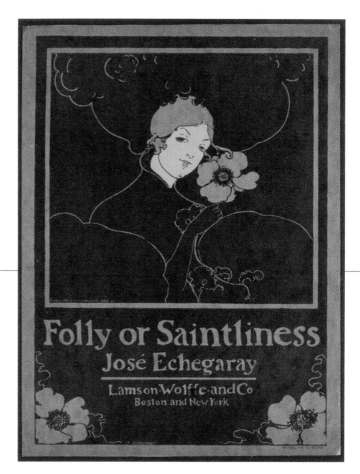

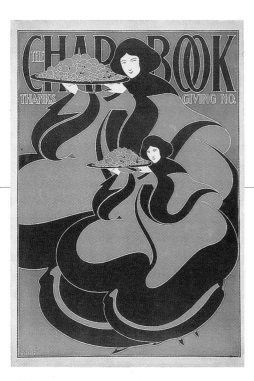

LITERARY PERIODICAL: WILLIAM H. BRADLEY (1868–1962), PUBLISHED BY STONE & KIMBALL (CHICAGO), *THE CHAP BOOK* (THANKSGIVING), 1895.

COLOR LITHOGRAPH, 528 × 352 MM.
THE BALTIMORE MUSEUM OF ART: GIFT OF ALFRED AND DANA HIMMELRICH, BALTIMORE (BMA 1993.89).

Bradley, influenced by the Art Nouveau style, introduced an American audience to a new vocabulary of forms.

POSTER: ETHEL REED (1876–CA.1910), *FOLLY OR SAINTLINESS*, 1895. HELIOTYPE ON PAPER, 20 ¼" × 14 ⅞".

COLLECTION: SMITHSONIAN AMERICAN ART MUSEUM, WASHINGTON, D.C., U.S.A.
PHOTO CREDIT: SMITHSONIAN AMERICAN ART MUSEUM, WASHINGTON, D.C./ART RESOURCE, NY

Working in the 1890s, Ethel Reed was one of few women illustrators and designers who gained recognition in her lifetime. Reed designed and illustrated posters, illustrated books, and designed covers and endpapers.

AT THE BEGINNING of the twentieth century, milestones in graphic design history occurred. Principles of grid composition were taught in Germany, and we saw the birth of pictorial modernism.

In graphic design, the watershed work of architect/designer Peter Behrens exemplifies the relationship between design and industry. Behrens sought a "modern" visual language to express the age of mass production. In 1907, Peter Behrens designed what might be thought of as the first corporate identity for A.E.G., a German electrical manufacturing corporation.

Milestone: in 1919, Walter Gropius founded the Weimar Bauhaus in Germany. This highly influential design school, whose philosophy laid the foundation for much of modern thinking about architecture and design, attempted to bridge art and industry—the machine age—with an emphasis on rationality. Students at the Bauhaus school studied with luminaries including Wassily Kandinsky, Paul Klee, and Lyonel Feininger. In 1919, Johannes Itten started teaching the *vorkurs*—the preparatory course, which would become an integral part of the curriculum, developed and expanded by other luminaries such as László Moholy-Nagy and Josef Albers.

In fine art, this time period was enormously creative. Two groups of German painters formed art philosophies: *Die Brücke* (The Bridge) with Ernst Ludwig Kirchner as a leading proponent, and *Der Blaue Reiter* (The Blue Rider) with Russian artist Wassily Kandinsky as a leading member. Kandinsky is credited with the first nonobjective painting and was a great influence on modern art. In France, major artists Henri Matisse and Pablo Picasso (born in Spain) created rippling, everlasting effects in all the visual arts.

A very noteworthy influence (still to this day) on typography was the Italian Futurists' challenge to grammatical and typographic conventions; they saw typography as a way to "redouble the force of expressive words." Similarly, Dadaists used type and image as

1900s

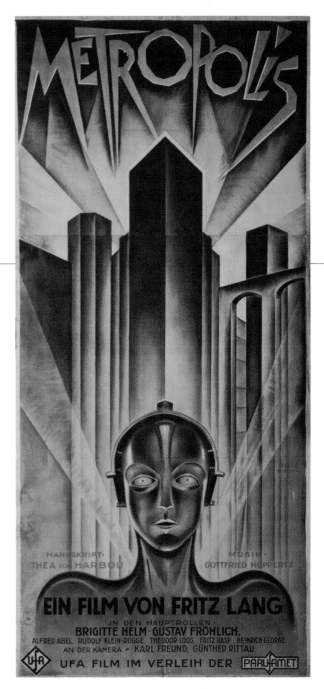

FILM POSTER: HEINZ SCHULZ-NEUDAMM (20TH CENTURY), *METROPOLIS*, 1926. LITHOGRAPH, PRINTED IN COLOR, 83" × 36 ½"

GIFT OF UNIVERSUM-FILM AKTIENGESELLSCHAFT (80.1961)
THE MUSEUM OF MODERN ART, NEW YORK, NY, U.S.A.
DIGITAL IMAGE © THE MUSEUM OF MODERN ART, LICENSED BY SCALA/ART
 RESOURCE, NY

Art Deco meets Cubism and the sci-fi film poster is invented.
—Steven Brower

expressive visual elements. Concerned with neither legibility nor function, but only with expressive form, artists such as Kurt Schwitters in his *Merz* magazine used the idea of "randomness" as a guiding principle.

1901–1905/ Picasso's "Blue" period
1905/ Lucian Bernhard designs the Priester Match poster
1905/ Salon d'Automne, Paris, is an important French art exhibit
1907/ Peter Behrens's corporate identity for A.E.G.
1909–1914/ Pablo Picasso and George Braque and the period of "Analytical Cubism"
1909/ Futurist Manifesto proclaims enthusiasm for speed, war, and the machine age
1910–1912/ Die Brücke (The Bridge) flourishes in Berlin
1910/ Kandinsky and Der Blaue Reiter (The Blue Rider)
1912/ Ludwig Hohlwein's poster for the Munich Zoo
1912/ Synthetic Cubism
1913/ Armory Show introduced European avant-garde art to America

1913/ The Xiling Society of Seal Carving and Calligraphy is founded in Hangzhou, China, with Wu Changshi as its first president
1914/ AIGA (American Institute of Graphic Arts), professional organization for design, founded
1916/ The Dada movement is founded
1916/ The first animated film is made in Japan, beginning an art form that will grow throughout the century to gain worldwide fame. Ofuji Noboro (1900–1961), who created animated movies using cutout silhouettes, is the first Japanese filmmaker in this field to gain global recognition.
1919/ Russian artist El Lissitzky coins the term "Proun"—an abbreviation for the Russian "Project for the Affirmation of the New Art" to describe his personal project to represent "the interchange station between painting and architecture"
1919–1933/ Bauhaus, founded in Weimar in 1919, under the direction of architect Walter Gropius; staff included Paul Klee, Johannes Itten, Wassily Kandinsky, László Moholy-Nagy

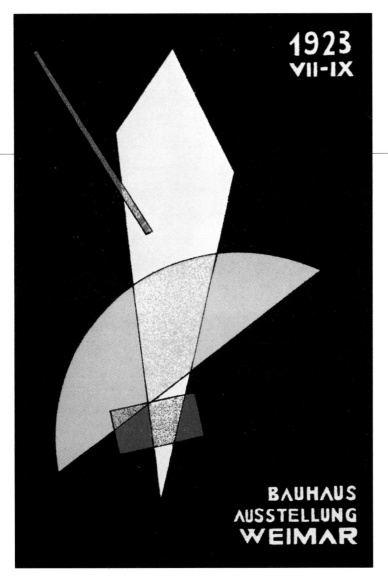

POSTER FOR THE BAUHAUS AUSSTELLUNG WEIMAR
MANIFESTO BY LÁSZLÓ MOHOLY-NAGY
ALINARI ARCHIVES/CORBIS

László Moholy-Nagy joined the *Bauhaus* from 1923–1928.

FINE ART MOVEMENTS—Cubism, Futurism, De Stijl, Constructivism, Dadaism, Surrealism—greatly affected design and advertising. Picasso's work continued to have a powerful effect on the visual arts. Art Deco, the popular geometric style of the 1920s, was significantly manifested in all the visual arts.

Many graphic designers absorbed these artistic movements, creating a popular visual aesthetic. For example, A. M. Cassandre, a renowned poster designer, created a visual language clearly influenced by Cubism and brought it to the greater public via poster design. His success in both typeface design and poster design established him as a purveyor of style.

In 1921, a group of Russian artists led by Constructivists Vladimir Tatlin and Alexander Rodchenko rejected "art for art's sake," to pursue the duty of artist as citizen. They viewed visual communication, industrial design, and the applied arts as mediums that could best serve their ideals and ideas for society.

In 1924, Surrealism, with the publication of the *Manifesto of Surrealism* by critic and poet André Breton, becomes an intellectual force.

Also greatly influenced by the Cubism, Futurism, and Art Deco movements, American graphic designer E. McKnight Kauffer created a body of work, including 141 posters for the London Underground as well as others for major corporations, that would carry fine art forms to the general viewing public. American advertising reflected designers' great interest in Modernism and European art ideas, as well; for example, the work of Charles Coiner for the

N. W. Ayer agency reflected an avant-garde influence. In an attempt to visually express their dynamic modern age, both artists and designers are highly concerned with the relationship between form and function.

1921/ *Alexander Rodchenko, painter, sculptor, designer, and photographer became an exponent of Productivism as evidenced by his poster design*
1922–1924/ *The discovery and excavation of the tomb of Tutankhamun*
1922/ *Aleksei Gan's* Konstruktivizm, *brochure on Constructivist ideology*
1922/ *E. McKnight Kauffer's poster for the London Underground*
1922/ *Piet Mondrian's* Tableau 2
1923/ *Herbert Bayer's cover design for Bauhaus catalog*
1923/ *Charles Dawson opens his studio in Chicago*
1923–1933/ *Vladimir and Georgii Stenberg produce film posters in a Russian avant-garde framework*
1924/ *El Lissitzky's photomontage,* The Constructor, *promoting his belief of "artist as engineer"*
1924/ *André Breton's* Manifesto of Surrealism
1924/ *Charles Coiner joins N. W. Ayer's art department*
1926/ *Fritz Lang's film* Metropolis
1927/ *Paul Renner designs Futura typeface*
1927/ *A. M. Cassandre's railway poster*
1928/ *Jan Tschichold advocates new ideas about typography in his book* Die Neue Typographie
1929/ *Dr. Mehemed Fehmy Agha comes to the U.S. to become art director for Condé Nast*

1920s

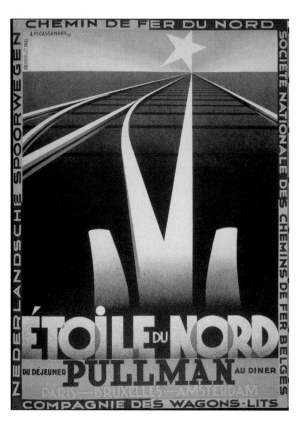

POSTER: CASSANDRE (ADOLPHE MOURON, 1901–1968)
ETOILE DU NORD 1927 REF 200007
© MOURON. CASSANDRE. LIC. CASSANDRE-LCM 28-10-09. WWW.CASSANDRE.FR

Cassandre was a founding partner of a Parisian advertising agency, the Alliance Graphique. The work produced by Cassandre and the Alliance Graphique established a French urbane modern visual vocabulary, utilizing Cassandre's typeface design.

The romanticism of travel was about the journey, not the arrival.
—Steven Brower

AT THE END OF THE 1920s, the modern movement hit America. By the 1930s, designers such as Lester Beall, William Golden, Alvin Lustig, Paul Rand, Bradbury Thompson, and émigrés Mehemed Fehmy Agha (born in the Ukraine, immigrated to the United States in 1929), Alexey Brodovitch (Russian-born, immigrated in 1930), Will Burtin (German-born, immigrated in 1938), Leo Lionni (Dutch-born, immigrated in 1939), Herbert Matter (Swiss-born, moved to New York in 1936), Ladislav Sutnar (Czech-born, traveled to United States in 1939 and stayed), and one woman—Cipe Pineles (born in Austria)—were pioneering visual ideas in the United States. Boldly testing the limits of contemporary editorial design, experimental page layout, shape relationships, color, and photographic reproduction, these designers created visual masterpieces.

The 1930s was a tragic and turbulent time for artists and designers in Europe. Many fled the Nazis and immigrated to America, including esteemed Bauhaus members Mies van der Rohe, Josef Albers, László Moholy-Nagy, and Walter Gropius. Their subsequent presence in America would have a profound influence on design, architecture, and art. Many American-born designers also became important design pioneers, including Lester Beall. Beall's convincing posters for America's Rural Electrification Administration have his distinctive imprint, and yet are influenced by European modernism.

A seminal American designer, Paul Rand, started his distinguished career in 1935 as the art director of *Esquire* and *Apparel Arts* magazines; he also designed covers for *Direction*, a cultural journal,

from 1938 until 1945. Rand's influence holds to this day. What should be noted is that although Rand was greatly influenced by the European avant-garde thinkers and designers, he established his own indelible point of view and visual vocabulary.

1930/ *237 of John Heartfield's photomontages were printed in* Arbeiter Illustrierte Zeitung *(AIZ) [renamed* Volks Illustriete *in 1936], between 1930 and 1938*
1934/ *Herbert Matter designs Swiss travel posters*
1934/ *Alexey Brodovitch is art director at* Harper's Bazaar
1935/ *WPA hires designers to work for the project*
1937/ *Lester Beall designs Rural Electrification Administration poster*
1937/ *Picasso's* Guernica *painting about the devastation of the Spanish Civil War*
1937/ *László Moholy-Nagy led the New Bauhaus in Chicago*
1939/ *Leo Lionni becomes art director at N. W. Ayer*
1939/ *Alex Steinweiss, art director at Columbia Records, invents the illustrated album cover*
1930s/ *Cipe Pineles, through the early 1940s, became the first autonomous woman art director of a mass-market American publication at* Glamour *magazine*

MAGAZINE SPREAD: *HARPER'S BAZAAR*, MARCH 15, 1938
ART DIRECTOR: ALEXEY BRODOVITCH
PHOTOGRAPHER: HOYINGEN-HUENE, COURTESY OF *HARPER'S BAZAAR*, NEW YORK, NY
PHOTOGRAPH COURTESY OF THE WALKER ART CENTER, MINNEAPOLIS, MN

Form follows form.
—Steven Brower

1
9
3
0
s

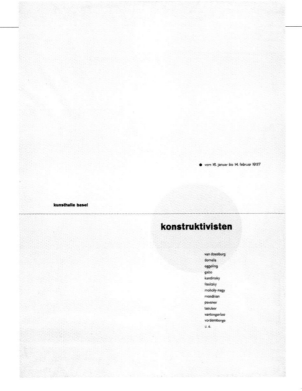

POSTER: JAN TSCHICHOLD, *KONSTRUKTIVISTEN* (*CONSTRUCTIVISTS*), 1937
POSTER: THE MUSEUM OF MODERN ART, NEW YORK, NY. ABBY ALDRICH ROCKEFELLER FUND, JAN TSCHICHOLD COLLECTION, THE MUSEUM OF MODERN ART, NEW YORK, NY
DIGITAL IMAGE © THE MUSEUM OF MODERN ART/LICENSED BY SCALA/ART RESOURCE, NY

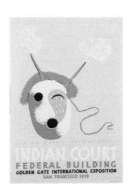

POSTER: SIEGRIEST, LOUIS (1899–1990), *ESKIMO MASK, WESTERN ALASKA.* 1939
SERIGRAPH ON PAPER, 36 ⅛" × 25 ¼".
GIFT OF RALPH H. HINES.
COLLECTION: SMITHSONIAN AMERICAN ART MUSEUM, WASHINGTON, D.C.
PHOTO CREDIT: SMITHSONIAN AMERICAN ART MUSEUM, WASHINGTON, D.C., ART RESOURCE, NY

This poster is part of the eight-piece series "Indian Court" by Siegriest, part of the Works Projects Administration (WPA) posters for the Golden Gate International Exposition held in San Francisco in 1939. Using materials provided by the Bureau of Indian Affairs, Siegriest chose visuals to represent various tribal nations.

**1
9
4
0
s**

IN 1939, World War II began. Many artists and designers were called into active duty; others, including Ben Shahn, E. McKnight Kauffer, Joseph Binder, and Abram Games, used their great talents to create posters to disseminate public information, support the war effort, pump up morale, and create anti-Nazi vehicles. In England, The British Ministry of Information recruited available preeminent designers to this cause.

At this time, many designers were embracing Surrealism and making it their own visual language, using photomontage and bold typography to create stirring war posters. One such designer was German graphic artist John Heartfield, whose strong antiwar work satirized the Nazi party.

What would eventually become The Advertising Council, a public service advertising organization, began in 1942 as the War Advertising Council; it was organized to help prepare voluntary advertising campaigns for wartime efforts.

In Italy, the Olivetti Corporation hired Giovanni Pintori, who contributed enormously to Italian design. Pintori's vision, drawing on Futurist visual forms, manifested itself in corporate identity design and advertising.

In the United States during the 1940s and 1950s, Abstract Expressionism was the primary artistic movement (overshadowing any representational artists), with leading artists such as Jackson Pollack, Willem de Kooning, Franz Kline, and Mark Rothko. In the post–World War II years, New York City became the art capital of the world.

1940s/ Paul Rand designs Directions *covers*
1940/ Robert Savon Pious designs event poster for the Chicago Coliseum
1941/ Walter Landor established Walter Landor & Associates in his San Francisco apartment
1945/ Alvin Lustig, from 1945 to 1952, designs the New Classics series by New Directions
1945/ LeRoy Winbush founds his own firm, Winbush Associates (later Winbush Design)
1946/ Lou Dorfsman joins CBS
1947/ Armin Hofmann begins teaching graphic design at the Basel School of Design
1947/ Giovanni Pintori is hired by Olivetti
1949/ Doyle Dane Bernbach opens
1949/ Cipe Pineles's cover for Seventeen
1949/ Hermann Zapf designs Palatino typeface

![We Can Do It! poster]

ADVERTISEMENT: WOMEN IN WAR JOBS—*ROSIE THE RIVETER* (1942–1945)

SPONSORS: OFFICE OF WAR INFORMATION, WAR MANPOWER COMMISSION
VOLUNTEER AGENCY: J. WALTER THOMPSON

The most successful advertising recruitment campaign in American history, this powerful symbol recruited two million women into the workforce to support the war economy. The underlying theme was that the social change required to bring women into the workforce was a patriotic responsibility for women and employers. Those ads made a tremendous change in the relationship between women and the workplace. Employment outside of the home became socially acceptable and even desirable.
—The Advertising Council

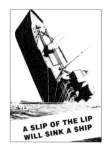

ADVERTISEMENT: SECURITY OF WAR INFORMATION, *LOOSE LIPS SINK SHIPS* (1942–1945)

SPONSORS: THE OFFICE OF WAR INFORMATION, U.S. ARMY, U.S. NAVY, AND THE FEDERAL BUREAU OF INVESTIGATION

The campaign encouraged Americans to be discreet in their communication to prevent information from being leaked to the enemy during World War II.
—The Advertising Council

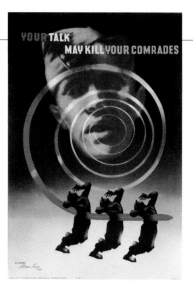

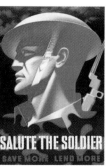

POSTER: ABRAM GAMES, *YOUR TALK MAY KILL YOUR COMRADES*, 1942 © ESTATE OF ABRAM GAMES

POSTER: ABRAM GAMES, *SALUTE THE SOLDIER (SAVE MORE, LEND MORE)* 1944 © ESTATE OF ABRAM GAMES

Abram Games, known for his powerful wartime posters, used the potential of the poster-as-vehicle to visually communicate public information fully and quickly in a boldly poetic way. Games's personal conceptual design viewpoint was "maximum meaning, minimum means."

THE INTERNATIONAL TYPOGRAPHIC STYLE, or Swiss design, played a pivotal role in design with an emphasis on clear communication and grid construction, with Max Bill and Ernst Keller as major proponents. In 1959, the movement became a unified international one, disseminating ideas in a journal, *New Graphic Design*; the editors included Josef Müller-Brockmann, Richard P. Lohse, Carlo L. Vivarelli, and Hans Neuburg.

In America, seminal designers such as Paul Rand, William Golden, Lou Dorfsman, Saul Bass, Bradbury Thompson, George Tscherny, Ivan Chermayeff, Tom Geismar, Cipe Pineles, Otto Storch, and Henry Wolf created watershed work. Saul Bass's movie titles and film promotions set new standards for motion graphics and promotional design.

Doyle Dane Bernbach (DDB) rocked the advertising world with their Volkswagen campaign and began a creative revolution in advertising, with art directors such as Bob Gage, Bill Taupin, and Helmut Krone. Bill Bernbach teamed art directors and copywriters to generate creative ideas to drive their advertising. DDB didn't use a hard sell—it set a new creative standard that winked at the consumer with greater respect.

Visual identity became gospel at corporations with in-house designers such as William Golden and Lou Dorfsman at CBS, and Giovanni Pintori at Olivetti. Corporations began to rely on designers to create visual identities that would differentiate them within a competitive marketplace. Designers such as Paul Rand created visual identities for IBM, Westinghouse, and ABC.

1950/ *Jackson Pollack's* Autumn Rhythm
1950/ *William Golden designs the CBS symbol*
1951/ *Roy Kuhlman designs Grove Press paperback covers*
1952/ *Rudy de Harak opens his New York studio*
1953/ *James K. Fogleman defines "corporate identity"*
1954/ *Adrian Frutiger creates Univers, a classic face within the Swiss International Style*
1954/ *Push Pin Studios is formed*
1955/ *Saul Bass designs the first comprehensive design program unifying film and print for the* Man with the Golden Arm
1957/ *Ivan Chermayeff and Thomas Geismar open their own practice in New York*
1950s/ *Henryk Tomaszewski creates CYRK*

1950s

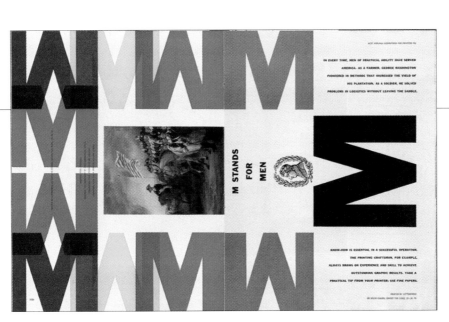

MAGAZINE SPREAD: WESTVACO *INSPIRATIONS 192*, 1953
DESIGNER: BRADBURY THOMPSON, COPYRIGHT BY WESTVACO CORPORATION, NEW YORK, NY

Seldom is there logic in using two different styles of typesetting in a design. But here, to provide symmetrical relationships to symmetrical graphics, the type is set in centered style on the left page, while on the right page the text type is set flush right and ragged left to accompany asymmetrical graphics.
—Karen M. Elder, Manager, Public Relations, Westvaco Corporation

Bradbury Thompson is one of the great pioneers of American design who fully integrated European ideas of abstraction and modernity into American design, establishing his own voice while communicating effectively.

LOGO: IBM, 1956
DESIGNER: PAUL RAND
CLIENT: IBM CORPORATION

Paul Rand was among the first wave of American modernists who created iconic visual identities as well as many other famous solutions—from posters to children's books.

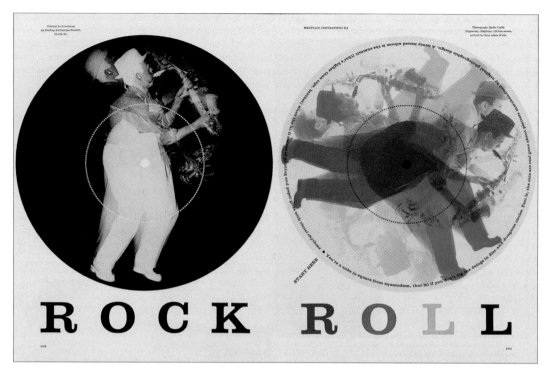

DESIGNER: BRADBURY THOMPSON
COPYRIGHT BY WESTVACO CORPORATION,
 NEW YORK, NY

*This graphic design puts forth
the illusion of color in motion as
the saxophonist comes alive on the
whirling record. Process printing
plates were not employed, as just one
halftone plate was printed in three
process inks and on three different
angles to avoid a moiré pattern.*
—Karen M. Elder, Manager, Public
Relations, Westvaco Corporation

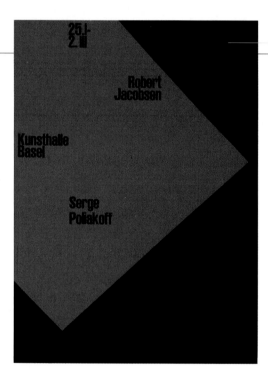

EXHIBITION POSTER: ARMIN HOFMANN, *ROBERT JACOBSEN & SERGE
POLIAKOFF,* 1958

COLLECTION: THE MUSEUM OF MODERN ART, NEW YORK, NY, GIFT OF THE DESIGNER. DIGITAL IMAGE
 © THE MUSEUM OF MODERN ART, LICENSED BY SCALA/ART RESOURCE, NY

Hofmann's modernist viewpoint and aesthetic was infused with a profound
understanding of form and elements. Hofmann's book *Graphic Design Manual,*
which explained his graphic design aesthetic and philosophy, was first
published in 1965.

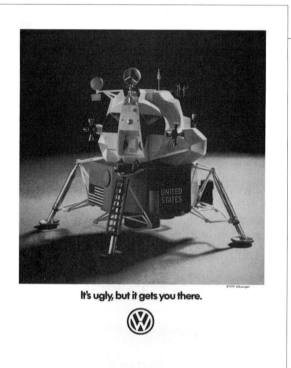

ADVERTISEMENT: "UGLY"

DOYLE DANE BERNBACH, NY
CLIENT: VOLKSWAGEN

This gutsy ad winks at its audience, as did most of DDB's advertising. Doyle
Dane Bernbach and its legendary founder Bill Bernbach are credited with the
creative revolution in advertising.

CORPORATE IDENTITY DESIGN grows in importance with work by Lester Beall for International Paper Company, and design firms such as Chermayeff & Geismar creating programs for Mobil and the Chase Manhattan Bank; Saul Bass for AT&T, Continental Airlines, and the Girl Scouts; and Massimo Vignelli and the Unimark office for Knoll.

In advertising, Doyle Dane Bernbach (DDB) continued to be the force behind creative advertising. Employed at DDB were some of the most brilliantly creative art directors and writers of the twentieth century, such as Bob Gage, Helmut Krone, George Lois, Mary Wells Lawrence, Phyllis K. Robinson, and Julian Koenig. Some of these creatives, such as Lois, Koenig, and Wells Lawrence, left DDB to open their own creative agencies.

American graphic designers, including the Push Pin Studios, Saul Bass, and Herb Lubalin, redefined American graphic design—especially typography and the relationship of type with image—thereby influencing generations.

The poster was an extremely popular application in the 1960s, with great work from Gunter Rambow in Germany, Wes Wilson in California, and Victor Moscoso in California. George Lois's covers for *Esquire* magazine raised the bar of cover design, provoking and jarring readers to stop and think.

Representational art made a comeback with the Pop Art movement—a movement drawing upon imagery from popular culture—with leading artists Andy Warhol, Roy Lichtenstein, and Robert Indiana. The Pop movement (influenced by commercial art), ironically, was clearly felt in graphic design and challenged the conventions of Modernist thinking. Push Pin Studios in New York and the Haight-Ashbury music scene designers in San Francisco rocked Modernism's structural boat. Wolfgang Weingart was at the forefront of those slowly challenging Modernism's core.

1960/ *John Berg becomes art director at CBS records*
1960/ *Lester Beall designs International Paper logo*
1961/ *Bob Gill cofounds Fletcher / Forbes / Gill (a forerunner of Pentagram) with Alan Fletcher and Colin Forbes*
1961/ *Edouard Hoffman and Max Miedinger design Helvetica typeface*
1962/ *Herb Lubalin designs* Eros *magazine*
1962/ *Carl Ally opens Ally & Gargano*
1963/ *Icograda (the International Council of Graphic Design Associations), the world body for professional communication design, founded*
1963/ *"The Pepsi Generation" ad*
1964/ *Pablo Ferro designs main title sequence for* Dr. Strangelove or: How I Learned to Stop Worrying and Love the Bomb
1964/ *First Things First manifesto signed by twenty-two signatories*
1965/ *Andy Warhol's* Campbell's Soup

1960s

POSTER: MÜLLER-BROCKMANN, JOSEF (1914–1996). *WENIGER LÄRM (LESS NOISE)*, 1960

OFFSET LITHOGRAPH, PRINTED IN COLOR, 50 ¼' × 35 ½'. ACQUIRED BY EXCHANGE (513.1983).
THE MUSEUM OF MODERN ART, NEW YORK, NY
THE MUSEUM OF MODERN ART, NEW YORK, NY, U.S.A.
DIGITAL IMAGE © THE MUSEUM OF MODERN ART/LICENSED BY SCALA/ART RESOURCE, NY

Müller-Brockmann, in Zurich, was a leading designer in the International Typographic Style. He sought to communicate to the audience without the interference of the designer's subjectivity.
This solution reminds us to never underestimate the power of a great visual mime to communicate a message.

MAGAZINE COVER: 1960

CREDIT: MILTON GLASER, PUSH PIN STUDIOS

Push Pin Studios, cofounded by Milton Glaser, Seymour Chwast, Reynold Ruffins, and Edward Sorel, ushered in a new era. The studio's influence radiated. Any lines of distinction among design, illustration, and art became blurred—these designers and illustrators were *auteurs*.

1965/ *Massimo Vignelli becomes cofounder and design director of Uni-mark International Corporation*

1965/ *Tadanori Yokoo's poster at the Persona group's 1965 joint exhibition shocks many*

1967/ *Jay Chiat opens Chiat/Day*

1967/ *Graphic Artists Guild (GAG) founded*

1967/ *Shigeo Fukuda creates posters for Montreal's Expo '67*

1968/ *Herb Lubalin designs Avante Garde magazine*

1969/ *George Lois's composited Esquire cover of Andy Warhol drowning in an oversized can of Campbell's soup*

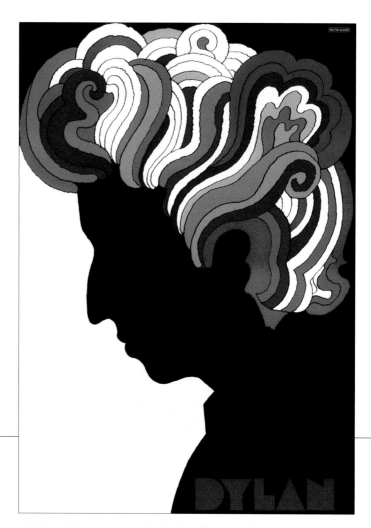

POSTER (ENCLOSED IN A BOB DYLAN RECORD ALBUM): *DYLAN*, MILTON GLASER, 1967

CREDIT: MILTON GLASER

Islamic art meets Marcel Duchamp at the dawn of the psychedelic era.
—Steven Brower

POSTER: *BETWEEN THE WARS* (NO DATE)

CHERMAYEFF & GEISMAR, INC., NY
CLIENT: MOBIL CORPORATION

This poster was designed to promote a television series on events during the period 1918–1940, with emphasis on the successes and failures of diplomacy. The hats symbolize the two wars, and the diplomacy between them.
—Tom Geismar, Chermayeff & Geismar, Inc.

A complex theme is communicated effortlessly through headgear.
—Steven Brower

LOGO: MOTHER & CHILD, 1967

DESIGNER: HERB LUBALIN, THE DESIGN COLLECTION AT THE HERB LUBALIN STUDY CENTER, THE COOPER UNION, NEW YORK, NY COURTESY OF THE LUBALIN FAMILY

In the 1960s, Lubalin's unique ability to creatively combine type and image influenced a wide audience, from the United States to Western and Eastern Europe. This is a quintessential example of Lubalin's thinking: finding the solution inside the problem.

SOME CRITICS SEE THE 1970s as the end of Modernism and the beginning of Postmodernist thinking, especially with the typographic directions taken by designers such as Wolfgang Weingart, April Greiman, Willi Kunz, and Dan Friedman leading the way.

In the 1970s, it became perfectly clear to clients and corporations that it was design and advertising that was going to distinguish their goods and services in a highly competitive international marketplace.

At MIT's Media Lab, Muriel Cooper ventured into new territory, exploring the relationships between computer technology and graphic design. The subversive posters emanating from the French design collective Grapus created an independent design point of

1970s

SYMBOL SIGNS: AIGA, 1973

A COMPLETE SET OF FIFTY PASSENGER/PEDESTRIAN SYMBOLS DEVELOPED BY AIGA.
AIGA SIGNS AND SYMBOLS COMMITTEE MEMBERS: THOMAS GEISMAR, SEYMOUR CHWAST, RUDOLPH DE HARAK, JOHN LEES, MASSIMO VIGNELLI
PRODUCTION DESIGNERS: ROGER COOK, DON SHANOSKY; PAGE, ARBITRIO AND RESEN, LTD.
PROJECT COORDINATORS: DON MOYER, KAREN MOYER, MARK ACKLEY, JUANITA DUGDALE

In 1973, the United States Department of Transportation (DOT) commissioned the American Institute of Graphic Arts (AIGA), which formed a committee of five outstanding designers, to create a set of passenger and pedestrian symbol/signs for use in DOT public spaces.

These symbol signs represent a consistent use of visual language that defies language barriers. The final set of symbol/signs was designed and created by Cook and Shanosky.

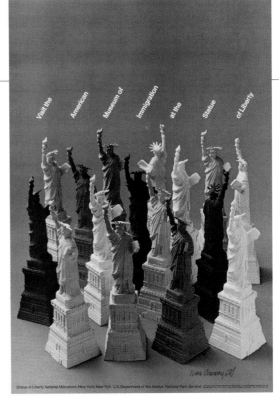

POSTER: CHERMAYEFF, IVAN (1932). *VISIT THE AMERICAN MUSEUM OF IMMIGRATION AT THE STATUE OF LIBERTY*, 1974

OFFSET LITHOGRAPH ON PAPER, 42 ⅛' × 28'.
SMITHSONIAN AMERICAN ART MUSEUM, WASHINGTON, D.C., U.S.A.
PHOTO CREDIT: SMITHSONIAN AMERICAN ART MUSEUM, WASHINGTON, D.C./ART RESOURCE, NY

Ivan Chermayeff (Chermayeff and Geismar) multiplies the Statue of Liberty to creatively express the idea of immigration. Chermayeff and Geismar set a standard for corporate communications.

view. In California, April Greiman was experimenting with type, hybrid imagery, and mixing media to create a whole new visual vocabulary.

Clearly, there was a growing response to the perceived "objectivity" of Modernism, with highly individual, personal aesthetics growing around the world.

1970/ *Grapus Studio, a French design collective, is formed by Pierre Bernard, François Miehe, and Gérard Paris-Clavel*
1970/ *Raymond Loewy designs the U.S. Mail eagle symbol*
1970/ *Shigeo Fukuda designs graphics for Expo '70*
1971/ *Massimo Vignelli and Lella Vignelli establish the offices of Vignelli Associates*
1971/ *Saul Bass designs the United Way logo*
1971/ *Tom Burrell and Emmett McBain open Burrell McBain Advertising in Chicago*
1971/ *Archie Boston founds Archie Boston Graphic Design*
1972/ *Pentagram opens in London*
1973/ *Graphic Artists Guild Handbook first published*
1974/ *Paula Scher designs covers for CBS records*
1975/ *Milton Glaser designs the "I LOVE NY" symbol*
1975/ *The One Club for Art & Copy, organization for the recognition and promotion of excellence in advertising, founded*
1978/ *Louise Fili becomes art director of Pantheon Books*
1978/ *Pentagram opens their New York office*
1979/ *M&Co founded by Tibor Kalman with Carol Bokuniewicz and Liz Trovato*

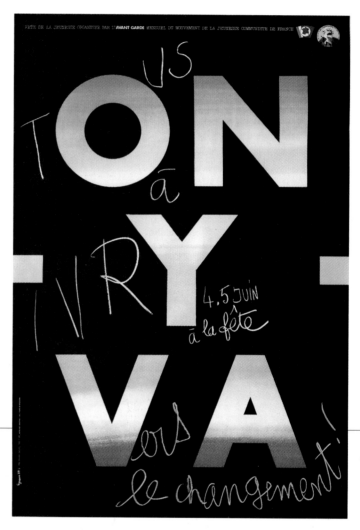

POSTER: GRAPUS, *ON Y VA (LET'S GO)*, 1977
THE MUSEUM OF MODERN ART, NEW YORK, NY GIFT OF THE DESIGNER.
THE MUSEUM OF MODERN ART, NEW YORK, NY, U.S.A.
DIGITAL IMAGE © THE MUSEUM OF MODERN ART/LICENSED BY SCALA/
ART RESOURCE, NY

The French design collective Grapus and their distinctive combinations of type and image—part of the European New Wave—made a significant and lasting contribution to modern design.

LOGO: MR. AND MRS. AUBREY HAIR, 1975
DESIGNER: WOODY PIRTLE

Pirtle originally worked for The Richards Group in Dallas and took his Texan sensibility and conceptual sharpness to the New York office of Pentagram.

Wit, in this case a pun, combines with an American Postmodern sensibility in Pirtle's trademark for Aubrey Hair.

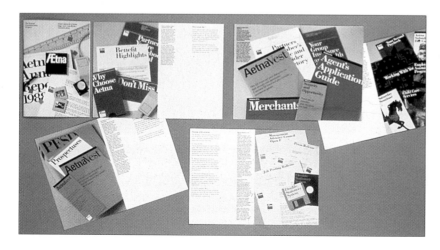

CORPORATE IDENTITY (NO DATE)
VIGNELLI ASSOCIATES, NY
DESIGNERS: MASSIMO VIGNELLI, MICHAEL BIERUT
CLIENT: AETNA LIFE AND CASUALTY, HARTFORD, CT

In 1971, Massimo and Lella Vignelli founded Vignelli Associates in New York and had a profound voice in corporate communications with an emphasis on rationality and clear communication.

IN 1984, APPLE COMPUTER introduced the Macintosh computer, which provided graphic designers with the most significant tool since the pencil.

The digital revolution enabled designers to have more creative control. Visual communicators could design and generate and lay out their own type (thus becoming their own typesetters), more easily manipulate imagery (as opposed to using handcrafted photomontage), imitate visual effects such as airbrushing, very easily make changes to layout and color, and substitute hand-lettered comps with digitally produced "finished-looking" comps, among other things.

Termed the Postmodern (or Late Modernist) period, the 1980s and 1990s was an eclectic and diverse time as designers experimented with new technology, trying to capture an ever-growing audience with breakthrough concepts and graphics. The political and social climate of the 1980s provided a fertile environment for provocatively creative designers and thinkers such as Tibor Kalman, founder of M&Co.

In California, Rudy VanderLans (trained in the Netherlands) and Zuzana Licko (born in Czechoslovakia) collaborated to create experimental typography in *Emigre*, a progressive periodical that contributed to disrupting typographic conventions. David Carson designed *Beach Culture* magazine, and his typographic methodology would eventually divide designers into "camp" divisions about typographic design philosophy. Similarly, in England, Neville Brody was challenging both editorial design and conventional typographic design with his own typeface designs and in his capacity as art director of *Face* magazine.

Also in England, advertising agency Bartle Bogle Hegarty (BBH) created sexy campaigns for Levi's and Häagen-Dazs using erotic imagery. In New York, George Lois's ad campaign concept "I want my MTV" transformed entertainment. Chiat/Day created one of the great moments in TV advertising with its "1984" spot for Apple's Macintosh. Advertising agencies outside of the usual ad hubs made indelible marks, making cities such as Minneapolis and Dallas the homes of creative advertising.

1981/ *MTV logo (art director: Fred Seibert; designers: Frank Olinsky, Pat Gorman, and Patti Rogof, Manhattan Design)*
1981/ *Ikko Tanaka's poster featuring an abstracted geisha for the dance troupe Nihon Buyo Performance*
1982/ *George Lois's "I want my MTV"*
1983/ *R/Greenberg Associates film title sequence for* The Dead Zone
1983/ *Philip B. Meggs'* History of Graphic Design *is published*

1980s

PRINT ADVERTISEMENT: *OR BUY A VOLKSWAGEN*, 1980

DOYLE DANE BERNBACH, NY
ART DIRECTOR/ARTIST: CHARLES PICCIRILLO
WRITER: ROBERT LEVENSON
CLIENT: VOLKSWAGEN

Doyle Dane Bernbach continued to set standards for creative advertising well after the 1960s.

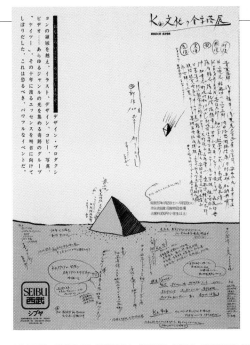

POSTER: SEITARO KURODA, *SEIBU*, 1981. POSTER FOR AN EXHIBITION AT A DEPARTMENT STORE.

THE MUSEUM OF MODERN ART, NEW YORK, NY, U.S.A. GIFT OF THE DESIGNER.
DIGITAL IMAGE © THE MUSEUM OF MODERN ART/LICENSED BY SCALA/ART RESOURCE, NY

An influential Japanese graphic designer and illustrator, Kuroda's posters are held in museum collections. Kuroda's distinctive sensibility has influenced generations of Japanese, European, and American designers.

1984/ Apple's Macintosh TV spot "1984" by Chiat/Day Agency; directed by Ridley Scott

1984/ Rolling Stone "Perception/Reality" campaign by Fallon McElligott and Rice, Minneapolis, MN

1984/ Joe Duffy starts Duffy Design in Minneapolis

1984/ Sussman/Prejza & Company, Inc. creates the graphic identity and environment for the 1984 Los Angeles Olympics

1985/ Bartle Bogle Hegarty (BBH), London, revitalizes the Levi's brand

1986/ Neville Brody designs Typeface Six for Face magazine

1986/ Chip Kidd starts in the art department at Alfred A. Knopf

1987/ Fred Woodward becomes art director of Rolling Stone magazine

1987/ Modern Dog Design Co. co-founded by Robynne Raye and Michael Strassburger

1987/ Shigeo Fukuda is the first Japanese designer inducted into the Art Directors Hall of Fame in the United States

1988/ Motel 6 "We'll Leave a Light on for You," The Richards Group, Dallas

1988/ David Carson designs Beach Culture magazine

1989/ Charles S. Anderson opens the Charles S. Anderson Design Company

1989/ Jonathan Hoefler and Tobias Frere-Jones create The Hoefler Type Foundry

EXHIBITION POSTER: *THE MODERN POSTER*, 1988

DESIGNER: APRIL GREIMAN, LOS ANGELES, CA
CLIENT: THE MUSEUM OF MODERN ART, NEW YORK, NY

This was an invited competition to design the poster for an exhibition on "The Modern Poster." We won!

The poster is a true "hybrid image." It utilizes state-of-the-art technology and is a composition of still video, live video, Macintosh computer art, traditional hand skills, typography, and airbrush.

The rectangular gradation represents time and evolution as graphic media have evolved from photomechanical means to the dynamic moving poster of TV (the video rectangles that are seen in perspective).

—April Greiman

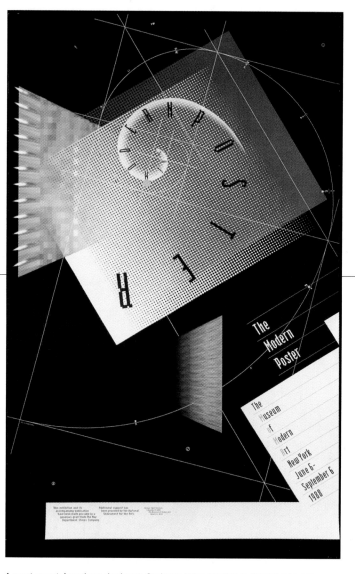

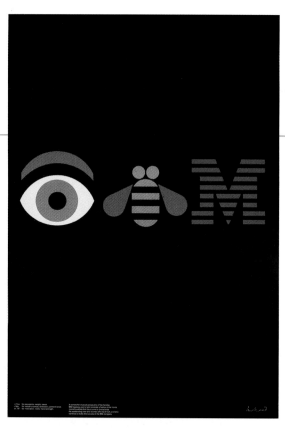

POSTER: PAUL RAND, *IBM*, 1982

THE MUSEUM OF MODERN ART, NEW YORK, NY. GIFT OF THE DESIGNER.
THE MUSEUM OF MODERN ART, NEW YORK, NY, U.S.A.
DIGITAL IMAGE © THE MUSEUM OF MODERN ART/LICENSED BY SCALA/ART RESOURCE, NY

Utilizing his own logo design for IBM, Rand made the famous logo even more elastic, using visual replacements for two of IBM's initials for this poster design. As it states on the poster, "An eye for perception, insight, vision; a bee for industriousness, dedication, perseverance; and an 'M' for motivation, merit, moral strength," represent the spirit of the corporation.

A west coast American designer, Greiman (who studied in Basel) was one of the first designers to use the Macintosh computer and Apple software to her distinct advantage, creating hybrid imagery. Her unique way of utilizing technology, handling type, creating the illusion of space, and playing with it makes her work watershed.

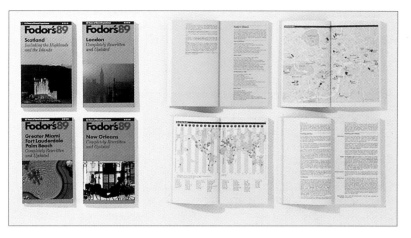

BOOKS: TRAVEL GUIDES, 1989

VIGNELLI ASSOCIATES, NY
DESIGNER: MASSIMO VIGNELLI
CLIENT: FODOR'S TRAVEL GUIDES

Vignelli Associates became synonymous with classical typefaces, the grid, and articulate design.

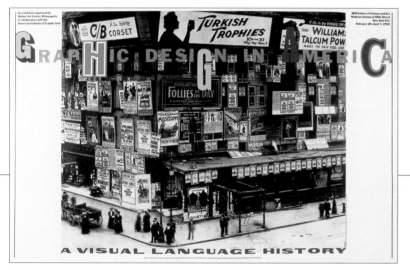

EXHIBITION POSTER: *GRAPHIC DESIGN IN AMERICA* (NO DATE)

DESIGNER: SEYMOUR CHWAST
THE PUSH PIN STUDIOS, NY
CLIENT: IBM GALLERY, NY

This poster, for an exhibit of all aspects of American graphic design, had to be developed without my expressing any specific design idiom. The image also had to be neutral. My design has a little bit of everything and no style in particular.
—Seymour Chwast, The Push Pin Studios

Chwast, cofounder of Push Pin Studios, is a designer/illustrator/ sculptor/artist who is able to imprint his visual communication solutions with a personal vision. His style, always identifiable, enhances each solution's communication.

MAGAZINE SPREAD: *EMIGRE NO.19,* "STARTING FROM ZERO," 1991

DESIGNER/PUBLISHER: RUDY VANDERLANS
TYPEFACE DESIGNER: BARRY DECK

Ever since I started conducting my own interviews, I have been intrigued with the idea of how to re-create the actual atmosphere or mood of a conversation. Usually, as a graphic designer, you receive a generic-looking, typewritten transcript, written by someone else, that you lay out and give shape to. Before I start the layout of an interview, I have spent hours transcribing the tape, listening to the nuances of the conversation, the excitement in someone's voice, etc. Much of the expressive/illustrative type solutions that I use in Emigre are a direct result of trying to somehow visualize the experience of having a conversation with someone. Although this approach is not always successful (some readers are put off by the often "complex-looking" texts), when it does work, and the reader gets engaged in deciphering and decoding the typographic nuances, the interview inevitably becomes more memorable.
—Rudy VanderLans, *Emigre*

VanderLans and Zuzana Licko launched their graphic magazine *Emigre* in 1982. In *Emigre,* they established an experimental approach to combining new technology with typographic design that rocked the design world.

AS THE CENTURY CAME TO A CLOSE, the technological boom continued to deeply affect all the visual arts. In 1990, Adobe released its Photoshop digital imaging software, providing a tool that enabled individual designers to manipulate imagery effectively, inexpensively, and rapidly. The Web became a home to every brand worldwide, as well as set new design challenges. Designers worked closely with IT professionals to launch their online visual solutions. Design and technology were at aesthetic crossroads that were reconciled in various ways with interesting effects on popular visual culture.

Not only did technology become a star, design itself now received new respect in museums and in media coverage. Hot debates on consumerism, typographic design form/function questions, and green design were arguments that became known even outside the design community. Besides creating design to earn a living, some designers were tackling social and political issues with their independently conceived, created, and produced posters.

Irony became king in advertising and in much of graphic design—a truly pervasive postmodern approach to all visual communication. Unusual combinations of form and color juxtapositions marked the work of many. Historical stylistic references allowed visual communicators to hold fast to the end of the century.

Corporations continued to count on branding and visual communication to distinguish their brands across borders. No longer belonging to the marginalized artist, Postmodernism was co-opted by major brands seeking to align themselves with hipsters and to be perceived as trendsetters.

1990/ Tibor Kalman becomes editor-in-chief of a Benetton magazine, Colors
1990/ Fabien Baron redesigns Interview magazine
1991/ Paula Scher joins Pentagram, New York
1991/ Carlos Segura founds Segura Inc. in Chicago
1993/ David Carson designs Ray Gun magazine
1993/ Sagmeister Inc. founded by Stefan Sagmeister in New York
1993/ @ Radical Media is founded
1994/ "Got Milk?" ad campaign by Goodby, Silverstein & Partners, San Francisco, for the California Fluid Milk Processor Advisory Board
1995/ Razorfish web design studio is founded
1996/ "Mixing Messages: Graphic Design in Contemporary Culture" at the Cooper-Hewitt National Design Museum
1997/ Saki Mafundikwa opens the Zimbabwe Institute of Vigital Arts, or ZIVA
1998/ PC Magazine reports Google® as the search engine of choice

1990s

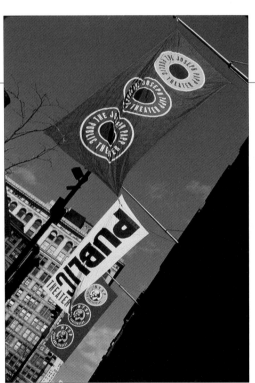

VISUAL IDENTITY: PUBLIC THEATER, 1994–1996

DESIGNER: PAULA SCHER
PENTAGRAM, NY

Starting out by designing album covers at CBS records, Scher moved onward and upward to become a highly esteemed designer and partner at Pentagram, whose work is revered and often imitated. In her recent book, *Make It Bigger*, Scher describes her brilliant career and talks about working with clients and her design philosophy.

The energy of the city is reflected in the graphics for the theatre.
—Steven Brower

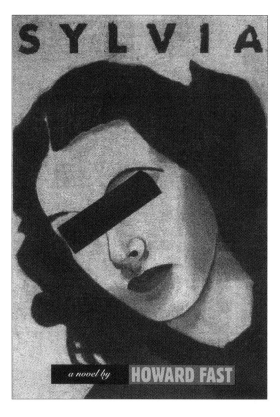

BOOK JACKET: *SYLVIA* BY HOWARD FAST, 1992

DESIGNER: STEVEN BROWER

The themes of hidden identity and censorship are combined in a single image, conveying not only the content of the book, but its history as well: the author, blacklisted during the McCarthy era, was forced to publish under a pseudonym. Here it appears under his name for the first time. The painting style is based on Mexican posters.
—Steven Brower

Brower is able to give visual life to a creative idea and his work's spirit exemplifies American wit, reminiscent of writers such as Mark Twain.

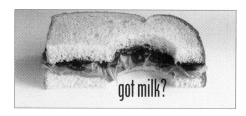

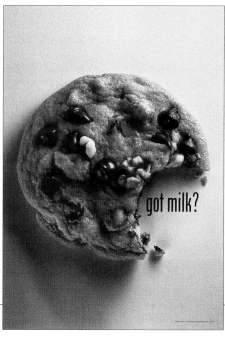

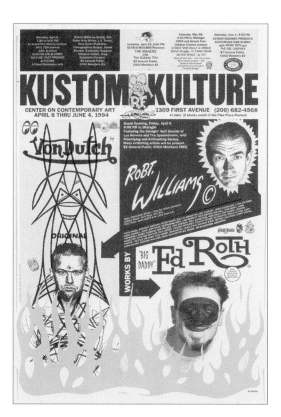

CHANTRY, ART (1954). *KUSTOM KULTURE*, 1994 SERIGRAPH ON PAPER, 33 ½" × 22 ⅜"

PHOTO CREDIT: SMITHSONIAN AMERICAN ART MUSEUM, WASHINGTON, D.C./ART RESOURCE, NY

Art Chantry, a seminal designer in the American Postmodernist movement, continues to create work that disarms and provokes. The power of Chantry's early punk flyers and work for *The Rocket* music magazine emanated from his immersion in the Seattle culture scene, his low-tech method of creating design, and his attitude about the nature of design. Working on low budgets, and utilizing and integrating found imagery and type, Chantry's two-dimensional graphic designs conjure the feeling of real time and full-sensory experiences.

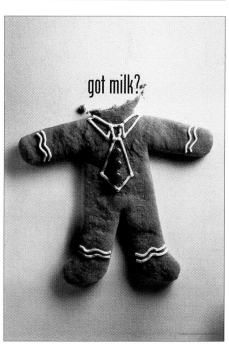

ADVERTISING CAMPAIGN: "GOT MILK?" 1990S

GOODBY, SILVERSTEIN & PARTNERS, SAN FRANCISCO, CA
CLIENT: CALIFORNIA FLUID MILK PROCESSOR ADVISORY BOARD

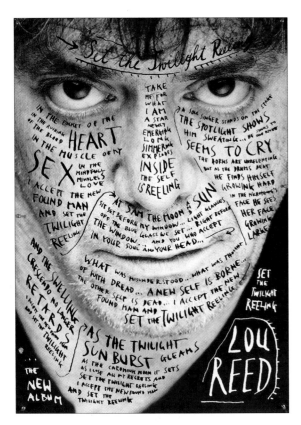

POSTER: *LOU REED*, 1996

SAGMEISTER INC., NY
ART DIRECTOR/DESIGNER: STEFAN SAGMEISTER
PHOTOGRAPHY: TIMOTHY GREENFIELD SANDERS
CLIENT: WARNER BROS. RECORDS, INC.

I went to a show in Soho given by Middle Eastern artist Shirin Neshat. She used Arabic type written on her hands and feet. It was very personal. When I came back, I read Lou's lyrics for "Trade In," a very special song about his need to change.
—Stefan Sagmeister

Sagmeister emigrated from Austria, first working with Tibor Kalman, then going on to become a highly respected member of the New York and international design world.

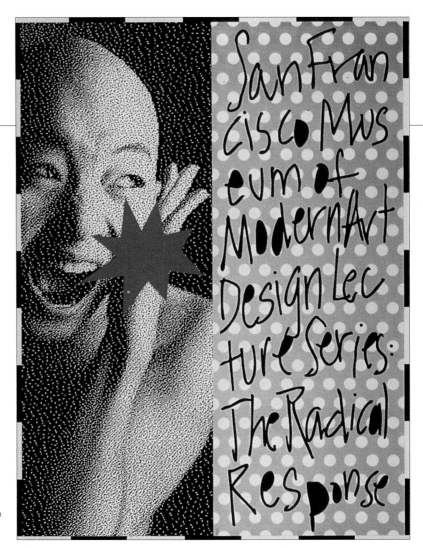

POSTER: *THE RADICAL RESPONSE*

MORLA DESIGN, SAN FRANCISCO, CA
ART DIRECTOR: JENNIFER MORLA
DESIGNERS: JENNIFER MORLA, SHARRIE BROOKS
CLIENT: THE MUSEUM OF MODERN ART, SAN FRANCISCO, CA

The Radical Response was the focus of a lecture series given at the San Francisco Museum of Modern Art. The series investigated the qualities that make design radical, featuring four individuals whose approaches to design have transformed the context of the ordinary into the realm of the extraordinary. We created an image for the Design Lecture Series that aggressively portrays the title of the series.
—Morla Design

PACKAGING: CALIFORNIA GRAPESEED OIL

LOUISE FILI LTD., NY
ART DIRECTOR/DESIGNER: LOUISE FILI
CLIENT: CALIFORNIA GRAPESEED CO.

Early in her career, Fili worked for Lubalin, then
as art director at Pantheon Books before she
opened Louise Fili Ltd. Greatly influenced by
French and Italian graphics and typography,
Fili's work is unique and her sensibility her own.

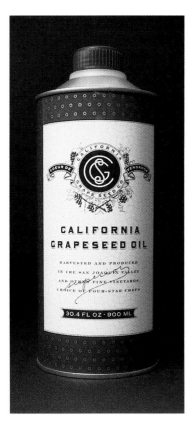

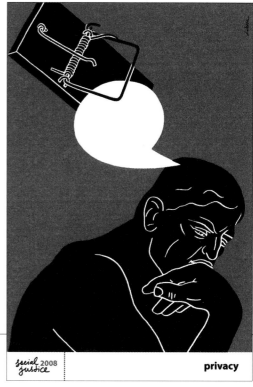

PORTFOLIO OF WORKS: JENNIFER STERLING DESIGN

JENNIFER STERLING DESIGN, SAN FRANCISCO
ART DIRECTOR/DESIGNER: JENNIFER STERLING

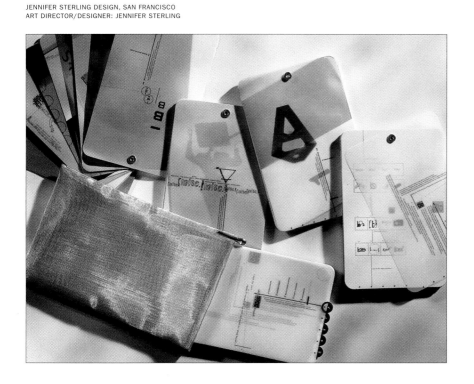

POSTER: *PRIVACY* FROM THE SOCIAL JUSTICE 2008
POSTER PORTFOLIO SERIES

LUBA LUKOVA STUDIO, NY
DESIGNER/ILLUSTRATOR: LUBA LUKOVA

Born in Bulgaria, Lukova immigrated to the United States
and gave the visual communication world a fresh style
with her seamless combination of design, illustration, and
lettering. Lukova's consistently luminous design solutions
are a testimony to design as art.

NEW AND EMERGING MEDIA in the visual communication profession has helped reshape graphic design. We continue to design for print as well as fixed, dynamic, and interactive solutions for small, medium and large screens. Visual communication is an ever-evolving discipline that can solve innumerable communication problems.

In a post-9/11 world, visual communicators are finding more and more often that design does matter. Whether it is to disseminate information to the public, enhance understanding of editorial content through editorial design, design better election ballots or posters to "get out and vote," or create public service campaigns to raise awareness, there are creative professionals who are constantly challenging us to think and reevaluate.

2000/ *First Sappi Ideas That Matter grants*
2000/ *Emigre magazine (and other magazines) publishes* First Things First *manifesto*
2001/ *Apple Computer unveils the iPod, a digital music player*
2001/ *Archie Boston writes* Fly in the Buttermilk: Memoirs of an African American in Advertising, Design & Design Education
2002/ *Gail Anderson becomes creative director of design at Spotco*

2002/ *Bryony Gomez-Palacio and Armin Vit found Under-Consideration*
2004/ *Janet Froelich is creative director of* The New York Times Magazine *publications*
2004/ *Takashi Murakami's retrospective, ©Murakami, opens at the Museum of Contemporary Art, Los Angeles*
2004/ *Rafael Esquer establishes Alfalfa Studio in New York*
2005/ *Rick Valicenti, 3ST/Thirst, publishes* Emotion as Promotion: A Book of Thirst—*a manifesto about contemporary design*
2007/ *Apple's iPhone® launched*
2007/ *Rizco Design converted its office to a 50% hydro/ 50% wind platform*
2008/ *Min Wang, design director for the Beijing 2008 Olympic Games*
2009/ *R/GA lead digital agency for* Nike+ Human Race

2 0 0 0 TO PRESENT

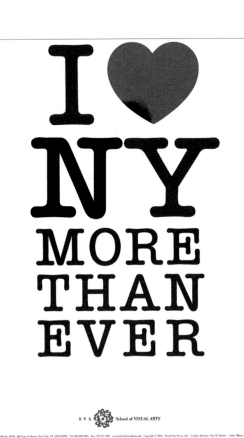

POSTER: *I LOVE NY MORE THAN EVER*

CREDIT: MILTON GLASER
CLIENT: SCHOOL OF VISUAL ARTS (SVA)

A poignant post-9/11 commentary, with Glaser utilizing his own original logo for New York State.

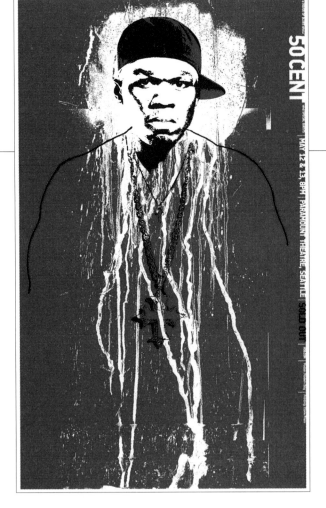

POSTER: *50 CENT*

© MODERN DOG DESIGN CO., SEATTLE

Robynne Raye and Michael Strassburger cofounded Modern Dog in 1987 and together have created an identifiable and provocative visual vocabulary.

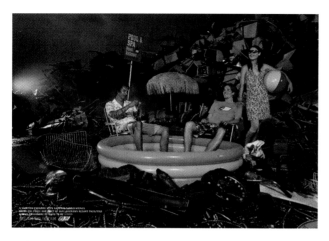

"MOUNT TRASHMORE"

KESSELSKRAMER, AMSTERDAM
STRATEGY: CHRIS BARRETT
CREATIVE DIRECTOR: DAVE BELL
ART DIRECTOR: KRISTA ROZEMA
COPYWRITER: TYLER WHISNAND
PHOTOGRAPHY: BISSE
CLIENT: 55DSL; CRISTINA CLERICI, ANDREA ROSSO, AND JEAN-LUC BATTAGLIA

WEBSITE: NIKE LAB, SPRING 2004

WWW.NIKELAB.COM
R/GA , NEW YORK

In 1977, Robert and Richard Greenberg founded R/Greenberg Associates as a motion–design graphics company specializing in film. Over the course of 30 years, R/GA has evolved into an integrated digital studio.

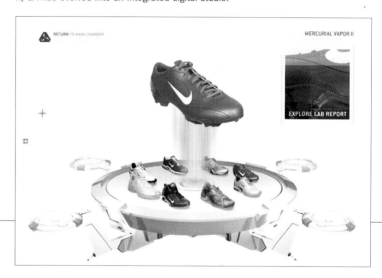

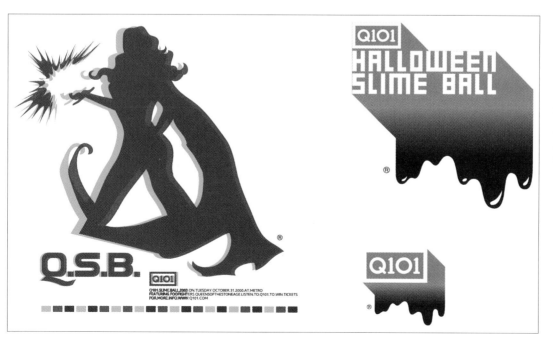

LOGOS: Q101 HALLOWEEN SLIME BALL, MTV CAMPUS INVASION TOUR

DESIGNER: CARLOS SEGURA
SEGURA INC., CHICAGO

Segura, born in Cuba, moved to Miami in 1965 and then to Chicago. He worked in advertising before founding Segura Inc. in Chicago in 1991. One year later he founded T26 Digital Type Foundry. In 2001, Segura launched 5inch.com. Forever experimenting and pushing the limits, Segura's work resonates.

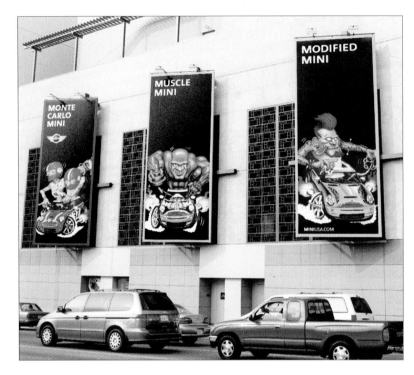

OUTDOOR ADVERTISING: MINI "MAVERICKS"

CRISPIN PORTER + BOGUSKY, MIAMI
EXECUTIVE CREATIVE DIRECTOR: ALEX BOGUSKY
CREATIVE DIRECTOR: ANDREW KELLER
ART DIRECTOR: KAT MORRIS
COPYWRITER: RONNY NORTHROP

Crispin Porter + Bogusky's MINI campaign set a new standard for unconventional advertising that gets to the consumer in unexpected ways.
 Photo courtesy of MINI division of BMW of North America, LLC.

CAMPAIGN: "SUPER TIGER TAKE-AWAY"

STRAWBERRYFROG

Amsterdam—a creative hotbed for visual communication in the early twenty-first century—is home to the creatives of Strawberryfrog, whose work is so innovative, people collect it.

PRINT MAGAZINE: HENNA COVER, 2000

ART DIRECTOR/DESIGNER: STEVEN BROWER
PHOTOGRAPHER: BARNABY HALL
HENNA ARTIST: MAKIKO YOSHIMURA

Many people mistake this for a Photoshop effort, but the type I created was actually transferred to a model's back by henna artist Makiko Yoshimura.
—Steven Brower

BOOK COVER: *PRAGMATISM: A READER* BY LOUIS MENAND
ART DIRECTOR/DESIGNER: JOHN GALL
PHOTOGRAPHER: KATHERINE MCGLYNN
PUBLISHER: VINTAGE BOOKS

John Gall is the vice president and art director for Vintage Books and another august imprint, Anchor Books. Steven Brower writes about Gall: "Gall's stylish sensibility, simple but elegant use of typography, and quiet rebellious spirit infuse these literate works with an added dimension. Subtle and compelling, his covers play with the perceptions of the viewer in unexpected ways, and to satisfying effect."

PAGE FROM *100% EVIL*, 2004
CHRISTOPH NIEMANN & NICHOLAS BLECHMAN
PUBLISHER: PRINCETON ARCHITECTURAL PRESS

Christoph Niemann, illustrator, animator and graphic designer, has produced numerous covers and illustrations for the *New York Times Magazine*, *The New Yorker*, *Rolling Stone*, and *BusinessWeek*. With collaborator Nicholas Blechman, he created the book series *100%*. The latest issue, *100% EVIL*, was published by Princeton Architectural Press.

Niemann is the author of two children's books, including *The Pet Dragon*, which teaches Chinese characters to young readers.

COVER, *THE NEW YORKER*, "T-DAY" 2007
CHRISTOPH NIEMANN

PEACE: 100 IDEAS
CHEN DESIGN ASSOCIATES, SF
CREATIVE DIRECTOR: JOSHUA C. CHEN
ART DIRECTORS: JOSHUA C. CHEN, MAX SPECTOR
DESIGNERS: MAX SPECTOR, JENNIFER TOLO, JOSHUA C. CHEN, LEON YU, GARY EDWARD BLUM,
 BRIAN SINGER
COPYWRITERS: DAVID KRIEGER, JOSHUA C. CHEN; CHEN DESIGN ASSOCIATES
PHOTOGRAPHERS: MAX SPECTOR, GARY EDWARD BLUM, LEON YU, JENNIFER TOLO, JOSHUA C. CHEN,
 DAVID L. CHEN. ADDITIONAL PHOTOGRAPHY FROM BLUM, CHEN AND TOLO FAMILY ARCHIVES,
 PHOTODISC/GETTY IMAGES
ILLUSTRATORS: MAX SPECTOR, JENNIFER TOLO, JOSHUA C. CHEN, GARY EDWARD BLUM, LEON YU,
 BRIAN SINGER, ZACHARIAH O'HORA
CLIENT: CHEN DESIGN ASSOCIATES

Peace: 100 Ideas illustrates and expands upon practical thoughts for
promoting a more peaceful world. Through design, illustration, painting,
collage, and photography, our intention was to layer the ideas with further
meaning, challenge viewers' preconceptions of peace, and inspire action.

ALBUM PACKAGING AND DVD: BJÖRK "COCOON," 2002

CLIENT: BJÖRK, ONE LITTLE INDIAN RECORDS
MEDIUM: PRINT, 5.5 × 5 INCHES
ALFALFA, EIKO DESIGN INC.
CREATIVE DIRECTOR: EIKO ISHIOKA
DESIGNER: RAFAEL ESQUER
COMPUTER GRAPHIC ARTIST: TIM WILDER

Rafael Esquer, a native of the Sonora desert of Mexico, has made New York City his home for more than a decade. He established Alfalfa Studio in 2004. In 2007, Taschen included Esquer among the world's 115 most progressive graphic designers working today.

This trio of CD and DVD designs for the single "Cocoon," from Björk's Vespertine *album was inspired by the sensuality of the music video, directed by Eiko Ishioka. In the video, Björk gradually becomes wrapped in a cocoon of red threads. We digitally manipulated video stills and enhanced them with custom typography. Originally, Björk and her record company intended to select one cover, but in the end, they thought using all three proposed designs would be more effective. The collection works as a series and individually, and is an intriguing example of Björk's image as a groundbreaking, avant-garde artist.*
—Alfalfa

LIBRARY MURAL

ALFALFA STUDIO, NY
ARCHITECT: RICHARD H. LEWIS
ART DIRECTOR/DESIGNER: RAFAEL ESQUER
DESIGN ASSISTANTS: JESSICA COVI, DAEIL KIM, WES KULL, NIKHIL MITTER, MINAL NAIRI
CHILDREN'S WORKSHOP ASSISTANTS: LAURA ANDERSON BARBATA, NIKHIL MITTER AND JENNY TRAN
COMMISSIONED BY MICHAEL BIERUT, PENTAGRAM

The mission of the L!brary Initiative is to enlist the talent of leading designers, architects, illustrators, and photographers in transforming every school library within New York City's vast public school system into inspiring places for learning. It is part of a larger effort to improve student literacy rates, especially in some of the poorest neighborhoods.

Esquer was invited by the L!brary Initiative to design a 7-foot-high, multi-panel mural running along 3 quarters of the library interior at Public School 195–197 in the Bronx. Esquer hoped to achieve twin goals with his mural:

to represent the library as a sanctuary for language and the entire world of ideas; and to give the students a sense of ownership in their library.

To meet both goals, Esquer began by gathering 30 students from Grades 1 through 6 for a morning workshop designed to generate content for the mural. Armed with reams of paper, poster paint, and artist's brushes, Esquer asked the students to have fun painting their answers to dozens of questions about words. For example, Esquer's questionnaire asked, "Imagine that you could eat words. Which one do you think would taste really good?" At the end of the workshop, Esquer collected nearly 1,000 painted words.

Esquer incorporated the students' words prominently into his mural of a child's universe. Superimposed on silhouettes arranged in thematic groups, the children's words give voice and attitude to this visual universe, bouncing playfully from homelife to nature, from foods to media and books, and from animals to people and professions.

—Alfalfa

OI /

INTRODUCTION

<<< / *facing page*

T-MOBILE 2007 NBA ALL-STAR WEEK EXHIBIT

- HORNALL ANDERSON, SEATTLE
- ART DIRECTORS: JAMES TEE, MARK POPICH
- DESIGNERS: THAD DONAT, ANDREW WELL, JON GRAEFF, ETHAN KELLER, JAVAS LEHN, KALANI GREGOIRE, BRENNA PIERCE
- PRODUCERS: RACHEL LANCASTER, PEG JOHNSON, JUDY DIXON, CHRIS NIELSON, RYAN HICKNER, JORDAN LEE
- CLIENT: T-MOBILE

WE DON'T HAVE TO GO TO A MUSEUM OR

GALLERY TO SEE GRAPHIC DESIGN—IT SURROUNDS US. EVERYTHING FROM A WEBSITE TO A POSTER TO THE COVER OF A BOOK IS VISUAL COMMUNICA-TION—IDEAS, MESSAGES, AND INFORMATION CONVEYED THROUGH VISUAL FORM AIMED AT A MASS AUDIENCE. GRAPHIC DESIGN AND ADVERTISING ARE BOTH DISCIPLINES UNDER THE UMBRELLA OF VISUAL COMMUNICATION AND ARE INTEGRAL PARTS OF CONTEMPORARY POPULAR VISUAL CULTURE.

Since visual communication plays a key role in the appearance of almost all print, film, and screen-based media, graphic designers and advertising art directors are the primary makers of the visual artifacts of our environment and popular culture. Imagine a world with no provocative posters or no thought-provoking CD covers. Imagine no choking poster or cities without wayfinding or signage systems. And imagine the chaos of a newspaper or website that wasn't designed by a professional graphic designer. That would be a world without graphic design.

WHAT IS GRAPHIC DESIGN?

Graphic design is a form of visual communication used to convey a message or information to an audience; it is a visual representation of an idea relying on the creation, selection, and organization of visual elements. Powerful graphic design imbues a message with greater meaning. "Graphic design is therefore one of the ways in which creativity takes on a visual reality," according to Professor Alan Robbins.

A graphic design solution can persuade, inform, identify, motivate, enhance, organize, brand, rouse, locate, engage, and carry or convey many levels of meaning. A design solution can be so effective that it influences behavior: you may choose a particular brand because you are attracted to the design of its package, or you may donate blood after viewing a public service advertisement.

THE GRAPHIC DESIGN PROFESSION

Designers solve a wide range of communication problems, collaborating with a variety of clients—from a not-for-profit organization attempting to reach families in need, to a brand promoting a new product, to a corporation that wants to go green, to a revitalized city's transportation secretary who needs a wayfinding system. To best explain the goals of any visual communication, we categorize communication intention and problem solving with specific applications falling under one or more categories. Within these categories are specific applications. The following list is an attempt to be as encompassing as possible in keeping with standard thinking. However, it should be noted that some formats—including but not limited to brochures, books, posters, environments, or websites—are

FIG. **1**/**01**

TAUBMAN: BRANDING

· CARBONE SMOLAN AGENCY, NEW YORK
· CREATIVE DIRECTOR: KEN CARBONE
· DESIGNERS: ANNA CRIDER, CHANNING ROSS, AMY WANG
· PROJECT MANAGER: RACHEL CRAWFORD

Taubman, one of the nation's top retail mall developers with a growing international presence, looked to Carbone Smolan Agency to update its 50-year-old logo and identity. Appealing to Taubman's fashion-forward clientele, CSA's new designs include a refined logotype, fresh color palette and bold approach to imagery. The resulting materials, from stationery to brochures to website, debuted at the International Council of Shopping Centers convention and convey Taubman's reputation for quality, productivity and execution.
—CSA Carbone Smolan Agency

utilized for a variety of communication goals. For example, a poster can promote an event; it can explain how to save someone who is choking; or it can communicate the voice of dissent. In addition, some people categorize visual communication according to media—for instance, interactive design, which certainly can be utilized for a variety of goals, including promotion, information, editorial, entertainment, or presentation. If you keep communication goals in mind, it will aid your understanding of how applications are utilized.

Advertising involves generating and creating specific visual and verbal messages constructed to inform, persuade, promote, provoke, or motivate people on behalf of a brand or group. More than ever, advertising is conceived and executed in the form of integrated campaigns across a variety of media. *Advertising applications* include print, television commercials, radio, outdoor advertising (also called out-of-home or OOH), banner ads, guerrilla/unconventional formats, mobile advertising, videos, branded utilities, websites, webisodes (web commercials), web films, online episodic programming, e-marketing, direct mail, branded entertainment, ambient, and social media.

Branding is a comprehensive and strategic program for a brand or group ("group" refers to both commercial industries and not-for-profit organizations) and may include creating a brand, brand name, brand identity, package design, environmental design, website and other on-screen applications, promotional design, and advertising. Some primary *branding applications* include brand naming, brand conception, brand strategy, brand identity, brand revitalization (see Figure 1-01), rebranding, brand launch, brand environments, digital branding, global branding, corporate branding, social cause branding, branding for nonprofits, and political branding. Branding and identity design are similar, but branding is a broader category.

Identity design or brand identity involves the creation of a systematic visual and verbal program intended to establish a consistent visual appearance and personality—a coordinated overarching identity—for a brand or group. *Identity design* applications include logos, visual identity, corporate identity, and branding across media.

FIG. **1** / **02**

W. L. GORE: EXHIBITION

· CARBONE SMOLAN AGENCY, NEW YORK
· CREATIVE DIRECTOR: KEN CARBONE
· DESIGNERS: ERIN HALL, TIMEA DANCS, MELISSA MENARD, LYNN PAIK
· PROJECT MANAGER: SHANNON KOY

Corporate communication design involves any visual communication applications that communicate internally with employees, create materials for a sales force or other employees, as well as applications used by a corporation or organization to communicate externally with other businesses, the public and stockholders, and customers. The emphasis is on maintaining a consistent corporate voice throughout any and all applications. Corporate communication applications include annual reports (see Figure 1-12), brochures, sales kits, marketing collateral, corporate publications, business-to-business applications, corporate websites and intranet, and new product offerings applications.

Environmental design can be promotion, information, or identity design in constructed or natural environments and defining and marking interior and exterior commercial, educational, cultural, residential, and natural environments; for Figure 1-02, an exhibition, Carbone Smolan Agency (CSA) says: "W. L. Gore & Associates, Inc. has the technical superiority to make ingredient products for a wide range of industries from medical, to military to leisure. To help translate the science within the products into a visible and understandable expression of the brand, Gore assembled a creative and visionary team of designers, fabricators and architects. CSA led the design and development of Gore's new showroom to be known as the Gore Capabilities Center. The Center successfully presents complex scientific information in a way that is compelling and accessible to a wide audience."

Environmental design applications include branded environments, corporate headquarters, civic developments, architectural interiors, environmental graphics, exhibits (trade show, museum, and educational, among others), and environmental wayfinding (system of integrated signs).

Information design is a "highly specialized area of design that involves making large amounts of complex information clear and accessible to audiences of one to several hundred thousand" (definition by the American Institute of Graphic Arts [AIGA]). Whether the application is an exhibition, chart, website, pictogram, subway map, instruction booklet, or choking poster, the graphic designer's task is to clearly communicate, make information easily accessible, and clarify and enhance any type of information (from data to listings) for the user's understanding. Information design applications include charts, graphs, signs, pictograms, symbol signs, icons, websites, sign systems, and widgets.

Interactive or experience design is graphic design and advertising for screen-based media, including web, mobile, widget, kiosks, digital out-of-home, CDs, or DVDs, in which the user interacts with the application. Whether for commerce (Figure 1-03) or a nonprofit organization (Figure 1-04), most have a home on the Internet, making websites primary interactive experiences

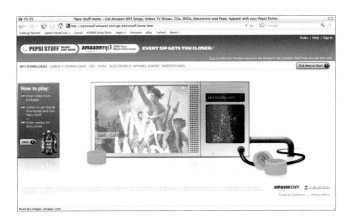

FIG. 1 / 03

AMAZON PEPSI WEBSITE

- HORNALL ANDERSON, SEATTLE
- DESIGNER: HANS KREBS
- DEVELOPERS: TREVOR HARTMAN, ADRIEN LO, MATT FRICKELTON
- PRODUCERS: ERICA GOLDSMITH, HALLI THIEL

What happens when two global heavyweights team up in a joint promotion of their products? Hornall Anderson discovered this firsthand when we were engaged in a collaborative cobranding project with Amazon, the world's largest online consumer retail destination, and PepsiCo, the world's number-two carbonated soft-drink maker, to develop a website supporting their cobranded Pepsi Stuff campaign.

We created a website that offers visitors a multi-dimensional, sensory experience and captivates users without inundating them with information. The experience gives consumers a clear, simple way to shop for digital and physical goods. Branded cues direct user behavior that is supported by key messages and succinct content, which allows for a truly immersive experience relying heavily on key visual elements to communicate the brand and inventive navigation for keeping the user engaged at every level.
—Hornall Anderson

FIG. 1 / 04

WEBSITE: THE DESIGN CENTER

- LAVA DOME CREATIVE, BOUND BROOK, NEW JERSEY
- ART DIRECTOR/DESIGNER: MICHAEL SICKINGER
- CLIENT: DESIGN CENTER; DIRECTOR: PROFESSOR ALAN ROBBINS, KEAN UNIVERSITY

The moving, overlapping layers of letters in this website design create compelling visual texture. Visit the site at www.kean.edu/~designct.

FIG. **1**/**05**

PARAISO TRAVEL

· HUSH, NEW YORK
· ANIMATION DIRECTOR: HUSH
· CREATIVE DIRECTORS: MANNY BERNARDEZ, ERIK KARASYK, DAVID SCHWARZ
· POSTPRODUCTION SUPERVISOR: J. M. LOGAN
· DESIGNERS: MANNY BERNARDEZ, ERIK KARASYK, DAVID SCHWARZ
· ANIMATORS: EMMETT DZEIZA, ERIK KARASYK, DAVID SCHWARZ, MANNY BERNARDEZ
· PHOTOGRAPHY: EMMETT DZEIZA
· PHOTO RETOUCHER: ROBBIE JOHNSTONE
· PRODUCTION COMPANY: PARAISO PICTURES
· DIRECTOR: SIMON BRAND
· EXECUTIVE PRODUCERS: JONATHAN SANGER, ED ELBERT, SARAH BLACK, JORGE PEREZ, SANTIAGO DIAZ, ALEX PEREIRA, JUAN RENDON, ISAAC LEE

For the feature film Paraiso Travel, *HUSH worked intimately with Colombian director Simon Brand to create memorable end titling that keeps viewers entertained and in their seats until the last credit rolls. At the film's thematic core is love, travel, exploration, heartache and the distorted realities of the "American Dream" for many newcomers looking to make their way in New York City. HUSH's concept revolves around several main characters and their distinct personalities at the most critical moments in the film. The highly stylized animated collages seamlessly transition one character to the next. Each character's representational journey parallels that of the film—both physically and emotionally.*
—HUSH

FIG. **1**/**06**

COOKIE TREAT PACKAGING FOR OLIVE GREEN DOG

· MODERN DOG DESIGN CO., SEATTLE
· © MODERN DOG DESIGN CO.
· CLIENT: OLIVE™

Modern Dog has worked on everything from website design to direct mail to packaging for Austin based Olive™, makers of "Green Goods for Modern Dogs." Pictured right are the organic, handmade, all natural Cookie Treats (no wheat, corn or soy—no artificial colors, no artificial flavors and no preservatives of any kind). We named the products, did all the copy writing and of course designed them as well. Scrummy for your best friend's Tummy.
—© Modern Dog Design Co.

for today's person who consumes much of his or her time on screen. Interactive design applications include websites, widgets, social networking, video sharing, photo sharing, blogs, vlogs, games and other entertainment, and mobile applications.

Motion graphics is screen-based visual communication moving (sequentially) in duration, including film title design, TV graphics design, openers, e-mail videos, mobile motion graphics, motion for video-sharing platforms, and promotional motion presentations for any screen (Figure 1-05).

Package design involves the complete strategic planning and designing of the form, structure, and appearance of a product's package, which functions as casing, promotes a brand, presents information, and becomes a brand experience. Package design includes structural packaging, packaging and visual identity systems, packaging graphics, new brand development, and self-promotion, with applications ranging from consumer packaged goods to CDs to shopping bags and more (Figure 1-06).

Promotional design is intended to introduce, promote, or sell brands (products and services), ideas, or events and to introduce or promote groups, not-for-profit organizations, and social causes. (The goals of promotional design and advertising applications can overlap.) Promotional design covers a very wide range of applications, including CD covers, book covers, posters (Figure 1-07),

FIG. **1** / 07

HONENS POSTERS

· WAX, CALGARY, ALBERTA
· CLIENT: HONENS INTERNATIONAL PIANO COMPETITION
· CREATIVE DIRECTOR: MONIQUE GAMACHE
· DESIGNER: MONIQUE GAMACHE
· WRITER: TRENT BURTON
· ILLUSTRATOR: TARA HARDY

Honens is Canada's leading presenter of music for piano. The main communication challenge was to raise the awareness of the triennial Honens International Piano Competition—one of the world's great music competitions. The Competition is subtitled "The Search for the Complete Artist."
—Jonathan Herman, art director/ designer, WAX

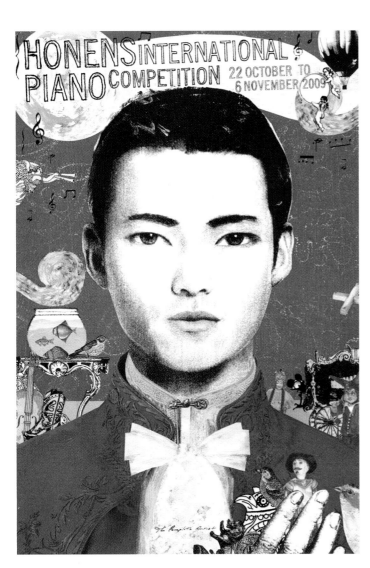

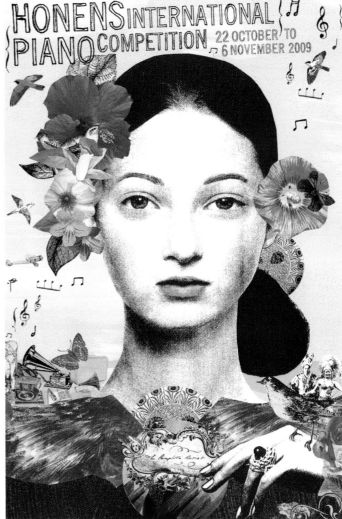

FIG. **1**/**08**

**T-MOBILE 2007 NBA ALL-STAR
WEEK EXHIBIT**

· HORNALL ANDERSON, SEATTLE
· ART DIRECTORS: JAMES TEE, MARK
 POPICH
· DESIGNERS: THAD DONAT, ANDREW WELL,
 JON GRAEFF, ETHAN KELLER, JAVAS LEHN,
 KALANI GREGOIRE, BRENNA PIERCE
· PRODUCERS: RACHEL LANCASTER, PEG
 JOHNSON, JUDY DIXON, CHRIS NIELSON,
 RYAN HICKNER, JORDAN LEE
· CLIENT: T-MOBILE

*Go big or go home. This mantra
guided our design of one of
T-Mobile's biggest and boldest
promotions yet for the 2007
NBA All-Star Weekend in Las
Vegas. As the Official Wireless
Telecommunications partner of
the NBA, T-Mobile approached
us to help them create a splash
at the All-Star weekend and launch
their latest T-Mobile Sidekick, a
Dwyane Wade Limited Edition—
on which we consulted with him.*

*The overall focus of the weekend
was to position T-Mobile in the
hearts and minds of the NBA
fans as their preferred mobile
communications provider. In
support of this strategy, we
designed opportunities for fans
to connect with the spirit of the
game on multiple levels.*

*At Jam Session, the focus of
the fan experience was a total
Sidekick brand immersion. Based
on the concept of stepping inside
the mind of Dwyane Wade, our
booth gave fans an interactive
three-dimensional experience,
allowing a peek inside his world,
both on and off the court. Elements
of the Limited Edition Sidekick
design, such as crisp white and
tan leather, transformed the space
into a representation of Wade's
personal style.*

—Hornall Anderson

packaging, exhibits (Figure 1-08), websites, web banners, motion graphics, multimedia promotions, giveaways, merchandise catalogs, direct mail, invitations, announcements, point-of-purchase displays, social networking applications, and blogs.

Publication design involves the design of editorial content for print or screen; it is also called *editorial design* and *book design*. The publication designer makes content accessible, interprets content to enhance communication, enhances the reader's experience, creates visual interest, and establishes a voice, character, and structure for a publication (Figure 1-09). Publication design applications include book design, magazine design, newspaper design, newsletters, booklets, online publications, vlogs, mologs, and blogs.

Typographic design is a highly specialized area of graphic design focusing on the creation and design of letterforms, typefaces, and type treatments (Figure 1-10). Many type designers own digital type foundries, which are firms that design, license, publish, and dispense fonts. Other typographers specialize in handmade type and typefaces. **Lettering** is the drawing of letterforms by hand (as opposed to type generated on a computer). Typographic design includes custom and proprietary font design for digital type foundries, hand lettering, handmade type, and custom typography.

Mass Media

For many of these categories, different media can be employed, such as print, screen-based, unconventional, or film. For example, one sees advertising in various media: television commercials, commercial trailers run in movie theaters, mobile ads, print advertisements in magazines and newspapers, unconventional formats such as chalk writing on a sidewalk, motion-activated graphics projected on pavement, and online ads in the form of websites, marketing that goes viral, web films, banners, social networking applications, and webisodes. One can read a magazine in the conventional print format or online; one can hold a business card in hand or view it as an e-mail attachment.

THE NATURE AND IMPACT OF VISUAL COMMUNICATION

Graphic design is created for a specific audience; a message is intentionally designed, transmitted, and then received by viewers. Whenever you read an advertisement or see a logo, you are on the receiving end of communication through design. Is the viewer's interpretation of graphic design and advertising paramount? Is graphic design an art that allows self-expression? Is it a discipline that can be tested, quantified, and scientifically evaluated?[1]

Certainly, it is reasonable that all of these viewpoints should be considered and incorporated into one's view of the nature of graphic design. We can look at the works of many designers and see personal expression. The readability and legibility of typography can be scientifically studied and measured. An advertisement is targeted at specific groups in consideration of the audience's demographic, tested in focus groups, or protested because of its possible effect on society.

Most graphic design and advertising is ephemeral by nature—people don't keep it. However, there are some applications, such as posters, book covers, CD covers, advertisements, and (beer, wine) labels that some people do keep, savor, and contemplate.

WORKING IN THE FIELD OF VISUAL COMMUNICATION

The main places of employment for a visual communication professional are design studios, branding firms, publishers, digital/interactive agencies, guerrilla/unconventional marketing firms, advertising agencies, integrated communication firms, marketing companies, and organizations with in-house design departments, as well as self-employment and freelance work.

Many designers are self-employed. However, for a novice, it is advisable to work for someone else to gain design experience and learn all the aspects of running a small business and working with printers and other vendors before going out on one's own. It is highly beneficial to secure an internship, a cooperative educational experience, or part-time work in the design field while still in school. Attend the meetings of local art directors' clubs and professional design organizations, such as the American Institute of Graphic Arts, The

One Club, the D&AD in England, The Society of Graphic Designers of Canada (GDC), and art directors' clubs around the world. Find an organization in your community. The purpose of these institutions is to educate, help set professional standards, and promote excellence and education. Attend as many professional conferences and lectures as possible.

You may begin to notice that you enjoy some areas of graphic design and advertising more than others. Which work attracts your interest? Which designers do you admire? Noticing which you like may help you decide on the direction of your graphic design career.

COLLABORATION

Whether the client is a local business owner, a large corporation, or a nonprofit organization, the graphic designer's role is to provide solutions to visual communication problems. However, from determining the needed applications to developing strategy through design implementation, graphic designers often work in partnership with their clients. More than ever before, graphic design is collaborative. From working closely with their clients to collaborating with programmers or writers, graphic designers team up with a variety of other experts, such as creative directors, design directors, associate creative directors, production experts, photographers, illustrators, copywriters, art directors and specialists (interactive experts, type and hand-lettering specialists, architects, film directors, producers, casting directors, actors, musicians, models, music houses, IT professionals, psychologists, social anthropologists, and market researchers), and with printers and their sales representatives. When working on television commercials, advertising art directors and creative directors work with directors, location scouts, and postproduction experts and may also be involved in casting talent (actors, models, spokespeople, celebrities) and suggesting locations, as well as choosing music. When working on products, exhibition design, interior graphics, or branded environments, graphic designers might collaborate with industrial designers, architects (as in Figure 1-11), or interior designers.

FIG. **1** / **11**

INTERIOR GRAPHICS: PENN STATION, NEW YORK

· PENTAGRAM DESIGN LTD., NEW YORK

Part of a comprehensive interior graphics program, this 200-foot-long prototype media wall will inhabit the main concourse at New York's busiest train station. The architectural redevelopment was led by project architects at Skidmore Owings Merrill LLP.
—Pentagram

FIG. **1** / **12**

GILDA'S CLUB CHICAGO ANNUAL REPORTS

· BRAINFOREST, INC., CHICAGO
· ART DIRECTOR: NILS BUNDE
· DESIGNERS: DREW LARSON, JONATHAN AMEN
· COPYWRITERS: MARION MORGAN, CHRISTA VELBEL
· PHOTOGRAPHERS: KARL SCHLEI, MARK JOSEPH
· CLIENT: GILDA'S CLUB, CHICAGO

The Objective: Gilda's Club is a special place where the focus is on living with cancer. But to keep itself financially healthy, the not-for-profit Gilda's Club must consistently reach out to its many benefactors for funding and tell its story to the community at large.

The Solution: For two years, Brainforest has created unique, deeply personal Annual Reports for Gilda's Club donors. One, entitled "The Thread that Joins a Community," was inspired by a hallmark of Gilda's Club—the Living Quilt. These stories of various individuals touched by cancer were sewn together graphically with humanity and a life-affirming voice.
—Brainforest

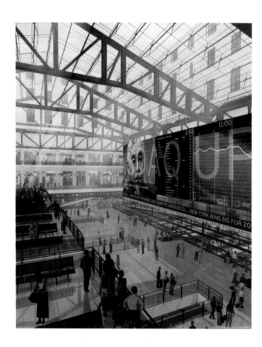

At times, collaboration begins at the ground level when different firms work together to solve a visual communication problem. For example, from the start of a large project, a branding firm and an advertising agency might work together. Or a design studio might collaborate with an interactive studio. At other times, the lead design firm or agency may hire freelancers. When a design concept is selected, graphic designers and advertising art directors might select and hire illustrators and photographers.

WHY DESIGN MATTERS

As designer Paula Scher wisely said— "Design matters."

Most people know that graphic designers have commercial clients—creating solutions for brands and corporations. The visual communication profession helps to drive the economy, provide information to the public, and promote competition (which can result in the research and development of goods and services). There is another side of graphic design that is less well known and vital to society: designers use their expertise to inform people about important social and political issues and promote good causes. For example, Brainforest created "The Thread that Joins a Community," inspired by a hallmark of Gilda's Club—the Living Quilt (Figure 1-12).

ETHICS IN VISUAL COMMUNICATION

Each designer is responsible for discovering ethical ways to practice. Any design problem can be solved in a great number of ways, and each solution has different economic and social benefits and consequences.

Graphic designers respond to social need with projects; for example, Brainforest had a great idea—Creative Pitch—a not-for-profit program. (See Figure 1-13.) Many find funding from various sources, including the Sappi Ideas That Matter initiative (www.sappi.com).

Many in the global design community are actively voicing the need for entirely ethical practice and for limiting consumer work. The important manifesto "First Things First," originally

FIG. **1** / **13**

CREATIVE PITCH/A SAPPI IDEAS THAT MATTER GRANT RECIPIENT

· BRAINFOREST, INC., CHICAGO
· DESIGNERS: DREW LARSON, JONATHAN AMEN
· PHOTOGRAPHY: JONATHAN AMEN
· PRINTING: DONATED BY DENNIS BOOTHE, LAKE COUNTY PRESS

The Objective: *Brainforest had a great idea. Why not collect unused art materials from the design community and give them to art teachers and students at some of our poorest schools? Thus, Creative Pitch was born, and we needed to get the word out.*

The Solution: *Once we had the idea nailed down, Brainforest began the fun task of translating our excitement about this program to printed and electronic materials. To date our program logo, brochure, poster, t-shirts and website have won 8 industry design awards. Not only is this a great idea for the community, but our commitment shows in the great design work it generated.*

Our Sappi Ideas That Matter Grant idea was to create a kit that would contain all the information needed to start a Creative Pitch program in other communities. Using a combination of printed and digital materials (on CD) we provide everything needed to inform and implement the program. The brochures are printed on "make ready" printer sheets and the binders and boxes are fabricated from recycled post-consumer stock. Because we will be sending the kits mostly to the design and advertising communities, the visuals need to be compelling, and the message engaging. If you want to ask an ad agency to hang up a poster in their space, it needs to be great! Our challenge was to create as little "stuff" as possible, and still provide the needed materials and information.
　　—Brainforest

FIG. **1 / 14**

"BUZZED DRIVING IS DRUNK DRIVING"

· SPONSOR ORGANIZATION: U.S. DEPARTMENT OF TRANSPORTATION/ NATIONAL HIGHWAY TRAFFIC SAFETY ADMINISTRATION

· CAMPAIGN WEBSITE: WWW. STOPIMPAIREDDRIVING.ORG

· VOLUNTEER AGENCY: MULLEN

· COURTESY OF THE AD COUNCIL (WWW.ADCOUNCIL.ORG)

The overall campaign hopes to educate people that consuming even a few drinks can impair driving and that "Buzzed Driving Is Drunk Driving."

written in 1964 and updated in 2000, is the subject of an ongoing debate. The First Things First manifesto is a call for designers to use problem-solving skills in pursuit of projects that would improve society. There are urgent concerns worldwide that would greatly benefit from the expert skills of designers, what the twenty-two original undersigned members of the manifesto would consider "cultural interventions," such as educational tools, health tools, information design, public service advertising campaigns—any design project that moves away from consumerism and toward a socially useful benefit.

Advertising matters, too. It drives the economy in a free market system and provides information and choices to the public. Ethical advertising is critical to competitive enterprise and to bringing better products and services to people. Globally,

public service advertising campaigns have helped an enormous number of people. For example, the Ad Council has endeavored to improve the lives of Americans since first creating the category of public service advertising in 1942. In 1983, the Ad Council launched one of its most successful campaigns, featuring the tagline "Friends Don't Let Friends Drive Drunk." The campaign has evolved, continuing to motivate Americans to intervene to stop a friend from driving drunk. "A recent poll revealed that 68 percent of Americans have acted to stop someone from driving drunk after being exposed to the advertising. I think that shows the impact of the strategy and the creative ability to motivate change in attitudes and behavior," says Peggy Conlon, Ad Council president, about this campaign.[2]

It seems that though the "Friends Don't Let Friends Drive Drunk" campaign was very successful, "it did not change the behavior of many potential impaired drivers. Many thought the messages to be targeted at overtly drunk drivers, and not them. When decision time came, they would consider themselves merely 'buzzed' and get behind the wheel," according to the Ad Council. New PSAs were created to address this, to motivate people to stop driving buzzed (Figure 1-14).

In the early days of advertising, there were no government regulations or watchdog groups. Concerned citizens united and government agencies formed to protect consumers from unethical manufacturers and fraudulent advertising claims. With or without watchdog groups or government regulations, every art director, copywriter, creative director, and creative professional involved in the creation of advertising must assume responsibility for ethical practices.

Visual communication professionals are among the leading architects of mass communication and its artifacts, creating images that reflect, help delineate, and describe contemporary society. With that function comes responsibility. Professional organizations such as the International Association of Business Communicators (IABC) and the American Institute of Graphic Arts (AIGA) are very helpful in creating a foundation for ethical practices. For more information, visit their respective websites. For links, go to our website. **GD/s**

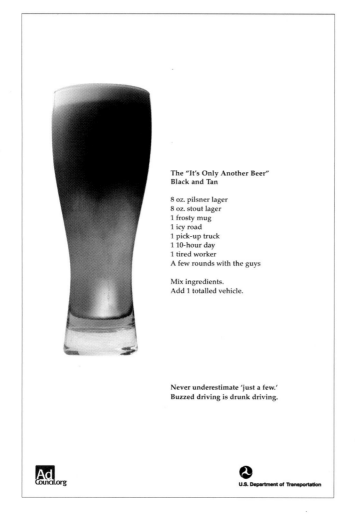

The "It's Only Another Beer"
Black and Tan

8 oz. pilsner lager
8 oz. stout lager
1 frosty mug
1 icy road
1 pick-up truck
1 10-hour day
1 tired worker
A few rounds with the guys

Mix ingredients.
Add 1 totaled vehicle.

Never underestimate 'just a few.'
Buzzed driving is drunk driving.

AdCouncil.org

U.S. Department of Transportation

The visual communication profession demands critical thinking, creative thinking, and creative and technical skills. A broad liberal arts education (literature, anthropology, psychology, sociology, economics, music, philosophy, fine art, art history, design history, theater, and dance) would best equip a graphic designer to understand the context of design assignments and propose meaningful solutions, as well as to best understand the meaning of images. Both theory and skills are necessary for practice; one must have the ability to solve visual communication problems, with a thorough knowledge of design principles, typography, visualization, composition, theories, and the ability to construct meaningful images and forms.

For competencies expected from designers, see the AIGA survey entitled "Designer of 2015 Competencies." Go to http://www.aiga.org/content.cfm/designer-of-2015-competencies, or use our link from our website. **GD/s**

A critical component to becoming more creative is developed through studying great solutions, such as the ones in this book, so that you can discern the difference between the formulaic and the creative.

The visual communication field—graphic design and advertising—is very exciting. Each and every day, visual communication professionals have the opportunity to be creative. How many professions can boast about that?

Go to our website **GD/s** for study resources including the chapter summary.

NOTES

1. Steven Heller, ed., *The Education of a Graphic Designer* (New York: Allworth Press, 1998), p. 10.

2. Peggy Conlon interview in *Advertising by Design*, Robin Landa (Hoboken, NJ: Wiley, 2004).

The New York Times Style Magazine

DESIGN FALL 2004

02/

GRAPHIC DESIGN: THE BASICS

<<< */ facing page*

**DESIGN FALL 2004
COVER: *"T," THE NEW
YORK TIMES STYLE
MAGAZINE***

· CREATIVE DIRECTOR: JANET
 FROELICH/*THE NEW YORK
 TIMES MAGAZINES*

· ART DIRECTOR: DAVID
 SEBBAH

· DESIGNERS: JANET
 FROELICH, DAVID SEBBAH

· PHOTOGRAPHER: RAYMOND
 MEIER

AS A RULE,

FROM CHILDHOOD ON, ASPIRING DESIGNERS ARE PEOPLE WHO ENJOY THE IMAGE-MAKING PROCESS AND SO, AT A MINIMUM, POSSESS A CASUAL KNOWLEDGE OF FORMAL ELEMENTS AND PRINCIPLES—THE VOCABULARY AND TOOLS FOR BUILDING VISUALS. THE GOAL OF THIS CHAPTER IS TO EXPLORE THE FORMAL ELEMENTS AND BASIC DESIGN PRINCIPLES ON A MORE SOPHISTICATED LEVEL TO KNOW EACH ELEMENT'S POTENTIAL AND HOW IT CAN BEST BE UTILIZED FOR COMMUNICATION AND EXPRESSION.

DIAGRAM [2-01]

LINES MADE WITH A VARIETY OF MEDIA AND TOOLS

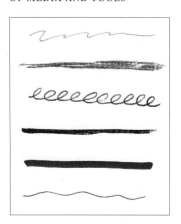

FORMAL ELEMENTS

The formal elements of two-dimensional design are line, shape, color, and texture.

LINE

A **point** or dot is the smallest unit of a line and one that is usually recognized as being circular. In a screen-based image, a point is a visible, single pixel of light (with or without hue) that is square rather than circular. In the digital realm of paint software, all elements are composed of pixels.

A **line** is an elongated point, considered the path of a moving point; it also is a mark made by a visualizing tool as it is drawn across a surface. A variety of tools can draw a line—a pencil, a pointed brush, a software tool, or any object that can make a mark (a cotton swab dipped in ink, a twig dipped in coffee; see Diagram 2-01). A line is primarily recognized by length rather than width; it is longer than it is wide.

Line is included among the formal elements of design because it has many roles to play in composition and communication.

Pick up a pencil and draw a line. That line will have direction and quality.

Lines can be straight, curving, or angular; they can guide the viewer's eyes in a direction. A line can have a specific quality—it can be delicate or bold, smooth or broken, thick or thin, regular or changing, and so on.

When you look at an exquisite linear illustration—for example, the illustration by James Grashow on the package design by Louise Fili (Figure 2-01)—you realize the potential of line as a visual element.

FIG. **2** / **01**

PACKAGE DESIGN: MARGARITA MIX

· LOUISE FILI LTD., NEW YORK
· ART DIRECTOR/DESIGNER: LOUISE FILI
· ILLUSTRATION: JAMES GRASHOW
· CLIENT: EL PASO CHILE CO.

The repetition of oval movements on these bottles of margarita mix helps to create a unified design.

Various categories of line include:

› Solid line: a mark as it is drawn across a surface

› Implied line: noncontinuous line that the viewer perceives as continuous

› Edges: meeting point or boundary line between shapes and tones

› Line of vision: the movement of a viewer's eye as it scans a composition; also called a line of movement or a directional line

The basic functions of lines include:

› Define shapes, edges, forms; create images, letters, and patterns

› Delineate boundaries and define areas within a composition

› Assist in visually organizing a composition

› Assist in creating a line of vision

› Aid in creative expression

› Can establish a linear mode of expression, a *linear style*

When line is the predominant element used to unify a composition or to describe shapes or forms in a design (or painting), the style is termed **linear.** This can be seen in the poster in the moving announcement (Figure 2-02), where lines are used to describe the objects and map and to unify the illustration.

SHAPE

The general outline of something is a **shape;** it is a configured or delineated area on a two-dimensional surface created either partially or entirely by lines (outlines, contours) *or* by color (Figure 2-03), tone, or texture. It is also defined as a closed form or closed path.

A shape is essentially flat—meaning it is actually two-dimensional and measurable by height and width. How a shape is drawn gives it a quality. All shapes may essentially be derived from three basic delineations: the square, the triangle, and the circle. Each of these basic shapes has a corresponding volumetric form or solid: the cube, the pyramid, and the sphere (Diagram 2-02).

› A **geometric shape** is created with straight edges, precise curves, and measurable angles; it is also called **rigid.**

› An **organic, biomorphic,** or **curvilinear shape** seems to have a naturalistic feel; it may be drawn precisely or loosely.

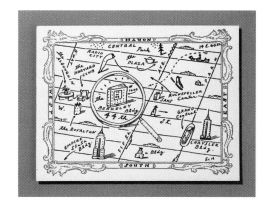

› A **rectilinear shape** is composed of straight lines or angles.

› A **curvilinear shape** is formed by curves or dominating marked flowing edges.

› An **irregular shape** is a combination of straight and curved lines.

› An **accidental shape** is the result of a material and/or specific process (a blot or rubbing) or accident (for example, by a spill of ink on paper).

› A **nonobjective** or **nonrepresentational shape** is purely invented and is not derived from anything

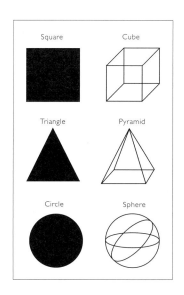

DIAGRAM [2-02]

BASIC SHAPES AND FORMS

DIAGRAM [2-03]

SHAPES

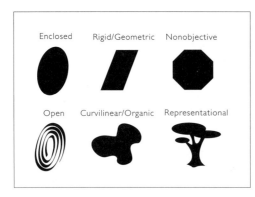

FIG. **2** /**04**

"INSPIRATION: WHERE DOES IT COME FROM?"

· *THE NEW YORK TIMES MAGAZINE,*
 NOVEMBER 30, 2003
· CREATIVE DIRECTOR: JANET FROELICH/
 THE NEW YORK TIMES MAGAZINES
· DESIGNER: JANET FROELICH
· INITIAL LETTER: PAUL ELLIMAN

FIG. **2** /**05**

STOP THE PLANT

· PENTAGRAM DESIGN
· ART DIRECTOR/DESIGNER: WOODY PIRTLE
· CLIENT: SCENIC HUDSON

visually perceived; it does not relate to any object in nature. It does not literally represent a person, place, or thing.

› An **abstract shape** refers to a simple or complex rearrangement, alteration, or distortion of the representation of natural appearance used for stylistic distinction and/or communication purposes.

› A **representational shape** is recognizable and reminds the viewer of actual objects seen in nature; it is also called a **figurative shape** (see **Diagram 2-03**).

FIGURE/GROUND

Figure/ground, also called **positive and negative** space, is a basic principle of visual perception and refers to the relationship of shapes, of figure to ground, on a two-dimensional surface. To best understand what is being depicted, the mind seeks to separate graphic elements that it perceives as the figures from the ground (or background) elements. In figure/ground relationships, the observer seeks visual cues to distinguish the shapes representing the figures from those that are the ground. The **figure** or **positive shape** is a definite shape; it is immediately discernible as a shape. The shapes or areas created between and among figures are known as the **ground** or **negative shapes.** Since the observer hunts for the figure to make sense of the visual, the ground may appear to be unoccupied and without shape to the untrained observer; however, *a designer must always consider the ground as an integral part of the composition.* Theoretically and even literally, the (back) ground actually takes shape—negative shape. Considering all space as active forces you to consider the *whole* space.

In **Figure 2-04** designed by Janet Froelich, the huge initial letter "r" by Paul Elliman creates

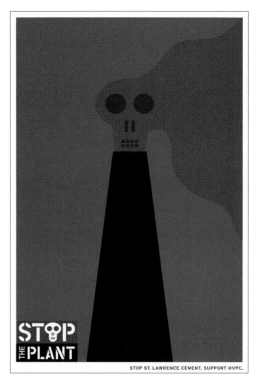

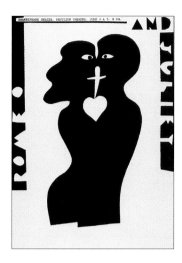

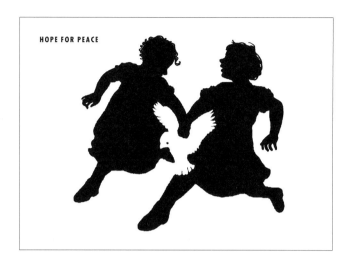

interesting negative shapes with the ground, thereby yielding a unified composition. Both figure (stack and smoke) and ground (blue) are given great consideration in the poster *Stop the Plant* (Figure 2-05). Also see Charles Nix's figure/ground handling of the images in Figure 3-03, *Dugong, Manatee and Sea Cow.*

Figure/Ground Reversal

At times, figure/ground relationships can be arranged to equally represent either the positive or negative shapes. The traditional example is the ancient Chinese symbol yin and yang (two principles that oppose one another in their actions); another example of an equal and interchangeable distribution of figure and ground is a simple checkerboard pattern. When shapes are interchangeable, an **equivocal space** or ambiguous figure/ground relationship is created, and you have **figure/ground reversal** (Diagram 2-04).

In Figure 2-06 and Figure 2-07, the respective designers create figure/ground reversal, where the negative shapes are also identifiable as positive images. Lanny Sommese positions a heart and dagger between Romeo and Juliet. Ronald J. Cala II creates a dove between the two girls.

Typographic Shapes

In graphic design, characters/letterforms, numerals, and punctuation marks are also shapes—albeit highly specialized ones that symbolize the sounds of language. And like basic shapes, type can be rectilinear, curvilinear, geometric, or organic. A letterform, numeral, or punctuation mark is the figure, and the counters or open spaces of type are the ground or negative spaces (see Chapter 3 on typography).

COLOR

The study of color deserves your attention because it is a powerful and highly provocative design element. Color is a property or description of *light energy*, and only with light do we see color. The colors we see on the surfaces of objects in our environment are perceived and known as reflected light or **reflected color**. When light strikes an object, some of the light is absorbed, whereas the remaining or unabsorbed light is reflected. The reflected light is what we see as color. For instance, a tomato absorbs all but red light; therefore, the red is reflected light. For this reason, reflected color is also known as **subtractive color**.

Pigments are the natural chemical substances within an object that interact with light to determine the characteristic color that is perceived, as in the bright yellow of bananas, the reds of flowers, and the browns of fur. Naturally occurring or artificially made pigments are added to agents to color such things as paper, ink, and plastic.

Naturally or commercially produced pigmented surfaces are seen as reflected light, but the colors on a computer screen are light energy—a wavelength—that we can refer to as *digital color.*

FIG. **2**/**06**

POSTER: *ROMEO & JULIET*

· SOMMESE DESIGN, STATE COLLEGE, PA
· ART DIRECTOR/DESIGNER/ILLUSTRATOR: LANNY SOMMESE
· CLIENT: THEATRE AT PENN STATE

The Theatre at Penn State needed a poster for the play, quickly and cheaply. I cut image and headline type out with scissors (low-tech). The concept of the play lent itself to boy/girl with the negative areas between becoming heart and dagger. It also seemed appropriate. At the time, everyone seemed to be doing high-tech, computer-generated stuff. I decided to go low-tech. The simplicity of the image also made it very easy to silkscreen.
—Lanny Sommese

FIG. **2**/**07**

POSTER: *HOPE FOR PEACE*

· CALAGRAPHIC DESIGN
· ILLUSTRATOR/DESIGNER/ART DIRECTOR: RONALD J. CALA II

DIAGRAM [**2-04**]

THE HISTORICAL CHINESE SYMBOL FOR THE INTERCONNECTION AND HARMONY OF LIFE FORCES: YIN-YANG.

Equivocal space seen in a "checkerboard" composition—the white and black shapes can be seen as either positive or negative shapes.

For example, when selecting a pure blue color in Adobe Photoshop™ (defined as Blue 255, Red 0, Green 0), the color seen is actually a blue wavelength of light itself. The digital colors seen in screen-based media are also known as **additive colors**—mixtures of light. Mixing light—adding light waves together—creates a variety of colors.

COLOR NOMENCLATURE

We can discuss color more specifically if we divide the element of color into three categories: hue, value, and saturation. **Hue** is the name of a color—that is, red or green, blue or orange. **Value** refers to the level of luminosity—lightness or darkness—of a color—for instance, light blue or dark red. Shade, tone, and tint are different aspects of value. In graphic design applications that require blocks of text, the value of the mass of the type block, paragraph, or column takes on a tonal quality, creating a block of gray tone. **Saturation** is the brightness or dullness of a color—that is, bright red or dull red, bright blue or dull blue. **Chroma** and **intensity** are synonyms for saturation. A hue also can be perceived as warm or cool in **temperature**. The temperature refers to whether the color *looks* hot or cold. Color temperature cannot actually be felt; it is perceived in the mind through association and memory. The **warm colors** are said to be reds, oranges, and yellows, and the **cool colors** are blues, greens, and violets.

PRIMARY COLORS

To further define color, it helps to understand the role of basic colors called **primary colors**. When working with light in screen-based media, the three primaries are red, green, and blue (RGB). These primaries are also called the **additive primaries** because when added together in equal amounts, red, green, and blue create white light (Diagram 2-05).

Using the RGB model:

Red + green = yellow

Red + blue = magenta

Green + blue = cyan

When working with a computer's color palette, you can mix millions of colors. However, it is very difficult, if not impossible, for the human eye to distinguish the millions of tones and values created by the additive primaries on a computer.

As mentioned earlier, subtractive color is seen as a reflection from a surface, such as ink on paper. We call this system the subtractive color system because a surface subtracts all light waves except those containing the color that the viewer sees (Diagram 2-06). In paint or pigment such as watercolors, oils, or colored pencils, the **subtractive primary colors** are red, yellow, and blue. They are called primary colors because they cannot be mixed from other colors, yet other colors can be mixed from them:

Red + yellow = orange

Yellow + blue = green

Red + blue = violet

Orange, green, and violet are the **secondary colors**. You can mix these colors and get numerous variations.

As seen in Diagram 2-07, in offset printing, the subtractive primary colors are cyan (C), magenta (M), and yellow (Y), *plus black* (K), or CMYK. Most often, black is added to increase contrast.

DIAGRAM [2-05]

DIAGRAM: ADDITIVE COLOR SYSTEM

The color system of white light is called the additive color system.

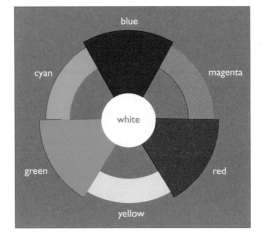

DIAGRAM [2-06]

DIAGRAM: SUBTRACTIVE COLOR SYSTEM

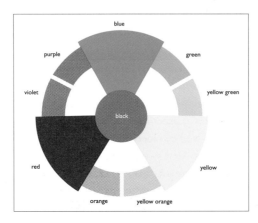

Using all four process colors—cyan, magenta, yellow, and black—to print a document is called **four-color process**, which is used to reproduce full-color photographs, art, and illustrations. The viewer perceives full color that is created by dot patterns of cyan, magenta, yellow, and/or black. There are books available that illustrate the various mixtures resulting from mixing two, three, or four process colors. Please see the bibliography for a book list.

TECHNICAL CONSIDERATIONS

The dual responsibility of wanting to select and compose colors for a particular design solution and needing to understand the technical aspects of color production is, in short, exceptionally difficult. Metallic bronze ink may possibly be a good choice for a museum exhibition brochure, but in regard to printing, a metallic ink cannot be reduced in saturation or value; it is more expensive than black ink and physically difficult to work with. Metallic ink doesn't always dry quickly (or dry at all on certain papers). Printers (printing company experts) are very helpful in educating designers about the pitfalls of color printing and the nature of ink on paper. As a designer, you must constantly interact with printers on getting colors to physically function well.

Having a knowledgeable and conscientious technician, printer, or computer programmer guide a designer through technical color production in print or on screen-based media is essential. However, the student and professional designer should also have a basic awareness of color print production, ink mixtures, and screen "safe" colors—and their problems.

Basic color knowledge should include awareness of the printer primaries of CMYK, the process of layering dots of ink to produce color, and the Pantone™ color system of ink selection. The Pantone color system is a standardized color matching set of inks used in printing processes (see Diagram 2-08). Using a color matching system ensures that the color printed from the digital file is the color intended, though it may look different when viewed on a color monitor. It is always advisable to work closely with a printer to ensure color correctness. It's also advisable to investigate the different printing inks available;

| C 0 |
| M 100 |
| Y 100 |
| K 5 |

| C 0 |
| M 10 |
| Y 100 |
| K 0 |

| C 100 |
| M 10 |
| Y 0 |
| K 0 |

DIAGRAM [2-07]

DIAGRAM: SUBTRACTIVE PRIMARY HUES WITH CMYK PERCENTAGES

In offset printing, magenta, yellow, and cyan are the colors of the process inks used for process color reproduction. A fourth color, black, is added to increase contrast.

for instance, nontoxic, nonflammable, and non-polluting inks are available.

In addition, students of design should be aware that colors on the web can be unstable; therefore a palette of 16 "web-safe" colors was standardized. The web-safe colors are listed in the Adobe Photoshop™ and Illustrator™ and other web software color selection directories.

Web-safe colors are those that are somewhat consistent and most reliable when viewed on computer monitors across platforms (Windows or Apple) and across browser software (Explorer, Netscape, Safari, Google Chrome, etc.). Some designers believe it is no longer necessary to stick to web safe colors, except when designing for mobile devices.

The myriad of technical aspects regarding color is too expansive to be discussed at this point; however, technical basics should be part of a design education. These basics can be found in specialized courses such as preparing design for printing and website production and other courses for screen-based media.

There have been many scientific studies of color, with modern theories by Albert Henry Munsell, Johannes Itten, Josef Albers, and Faber Birren. Understanding color symbolism relative to culture, country, region, and demography is crucial. Much of what you need to know about color will come from experimentation, experience, asking printers questions, getting color advice before going to print, and observation. Visit a printer. Attend paper shows. Talk to printers, paper sales representatives, and professional designers about color and paper stock (recycled, tree-free), special techniques, the ink/paper relationship, and varnishes. For an informative essay on color design basics by Rose Gonnella, go to our website. **GD**

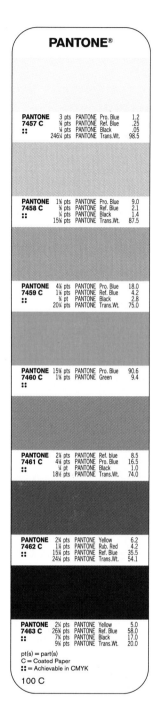

PANTONE®

PANTONE 7457 C ::	3 pts	PANTONE	Pro. Blue	1.2
	⅜ pts	PANTONE	Ref. Blue	.25
	¼ pts	PANTONE	Black	.05
	246¼ pts	PANTONE	Trans.Wt.	98.5

PANTONE 7458 C ::	1⅜ pts	PANTONE	Pro. Blue	9.0
	⅜ pts	PANTONE	Ref. Blue	2.1
	¼ pts	PANTONE	Trans.Wt.	1.4
	15¼ pts	PANTONE		87.5

PANTONE 7459 C ::	4¼ pts	PANTONE	Pro. Blue	18.0
	1¼ pts	PANTONE	Ref. Blue	4.2
	⅜ pt	PANTONE	Black	2.8
	20¼ pts	PANTONE	Trans.Wt.	75.0

| PANTONE 7460 C :: | 15¼ pts | PANTONE | Pro. Blue | 90.6 |
| | 1⅜ pts | PANTONE | Green | 9.4 |

PANTONE 7461 C ::	2⅜ pts	PANTONE	Ref. blue	8.5
	4⅜ pts	PANTONE	Pro. Blue	16.5
	¼ pt	PANTONE	Black	
	18¼ pts	PANTONE	Trans.Wt.	74.0

PANTONE 7462 C ::	2⅜ pts	PANTONE	Yellow	6.2
	1⅜ pts	PANTONE	Rub. Red	4.2
	15⅜ pts	PANTONE	Ref. Red	35.5
	24¼ pts	PANTONE	Trans.Wt.	54.1

PANTONE 7463 C ::	2¼ pts	PANTONE	Yellow	5.0
	26¼ pts	PANTONE	Ref. Red	58.0
	7⅜ pts	PANTONE	Black	17.0
	9¼ pts	PANTONE	Trans.Wt.	20.0

pt(s) = part(s)
C = Coated Paper
:: = Achievable in CMYK

100 C

DIAGRAM [2-08]

SWATCH: PANTONE® MATCHING SYSTEM

Pantone® match color can be specified by the designer for filling a color area using the PMS color number. The printer then matches the color by following the ink formula provided on the swatch. Also, "C" indicates coated paper and "U" indicates uncoated paper.

Value

Value refers to the level of luminosity—lightness or darkness—of a color, such as light blue or dark red. To adjust the value of a hue, two neutral colors are employed: pure black and white.

Black and white are colors (pigment), but they are not considered hues. The two are not found on the visible spectrum and therefore are considered *achromatic* or *neutral* (without hue).

Black and white have relative value and play an important role in mixing color. Black is the darkest value and white is the lightest. Mixed together,

black and white make gray. Grays are the interval neutral colors between black and white. Black and white are separately mixed into paint and ink colors to make them darker (**shades**) or lighter (**tints**). A black and white mixture will also dilute the intensity of the hue, as noted in the next section on saturation.

Even if black and white seem to be pure, some level of hue may still be discernible. A neutral black or white can appear "warm" (containing red, orange, or yellow) or "cool" (containing blue or green). A neutral color will also react to and be affected by its placement in a composition. Placed next to a hue or among particular hues, the pure neutral color will seem to take on the hue itself.

In composition, *value contrast* is most useful for purposes of differentiating shapes. Note the value contrast of the type (black) and substrate (white paper) of the page of words you are now reading. The value contrast most clearly differentiates the figure from the ground. Hue contrasts alone have less impact and therefore may not be as effective for differentiating between the figure and ground images or between elements of a single composition (Diagram 2-09).

Different value relationships produce different effects, both visual and emotional. When a narrow range of values, which is called **low contrast**, is used in a design, it evokes a different emotional response from the viewer than a design with a wide range of values, or **high contrast**. The high contrast in the poster for Amnesty International by Woody Pirtle easily captures one's attention (Figure 2-08). (Other types of contrast will be discussed in detail in Chapters 5 and 6.)

Saturation

Saturation refers to the brightness or dullness of a color or hue; a hue at its highest level of intensity is said to be purely saturated. A saturated color has reached its maximum chroma and does not contain a neutralizing color (pure black and white are without hue) or the mixtures of the neutral colors (gray). Mixed with black, white, and especially gray, the fully saturated hue becomes dull in various degrees. The neutral colors dull the intensity or saturation because they dilute the hue. A

DIAGRAM [2-09]

Value contrast obviously creates the greatest differentiation between the figure and ground, as seen in the grid of highly contrasting value versus the grid of similar values.

Value contrast Hue contrast

FIG. **2 / 08**

POSTER: *UNIVERSAL DECLARATION OF HUMAN RIGHTS, 1948–1998, 50TH ANNIVERSARY*

· PENTAGRAM DESIGN
· ART DIRECTOR/DESIGNER: WOODY PIRTLE
· CLIENT: AMNESTY INTERNATIONAL

color mixed with gray is called a tone or a reduction of the fully saturated hue.

Color saturation may be selected and adjusted for practical function within a composition. A saturated color will call attention to itself when placed alongside duller tones. A single saturated hue on a black-and-white page or computer screen will grab one's attention because it is most vivid. In a composition, a saturated hue has an advantage of being noticed first when surrounded by hues of lower saturation.

TEXTURE

The actual tactile quality of a surface or the simulation or representation of such a surface quality is a **texture**. In the visual arts, there are two categories of texture: tactile and visual. **Tactile textures** have actual tactile quality and can be physically touched and felt; they are also called **actual textures** (see Diagram 2-10). There are several printing techniques that can produce tactile textures on a printed design, including embossing and debossing, stamping, engraving, and letterpress.

Visual textures are those created by hand, scanned from actual textures (such as lace), or photographed; they are illusions of real textures (see Diagram 2-11). Using skills learned in drawing, painting, photography, and various other image-making media, a designer can create a great variety of textures.

Pattern

Pattern is a consistent repetition of a single visual unit or element within a given area. In all cases, there must be systematic repetition with obvious directional movement. (An interesting aspect of pattern is that the viewer anticipates a sequence.) If you examine patterns, you will notice that their structures rely on the configuration of three basic building blocks: dots, lines, and grids. In a pattern, any individual small unit, whether nonobjective (think organic) or representational (think leaf) shape, can be based on the dot or point. Any moving path is based on lines, also called **stripes**. Any two intersecting units yield a **pattern grid**.

If we refer back to the common checkerboard pattern, we see a figure/ground reversal created by an **allover** pattern; that balanced design is

COLOR AND GRAPHIC DESIGN

- Color can create a focal point (low saturation color amid a field of highly saturated colors, and vice versa).

- Color is often used symbolically.

- Color can have cultural and emotional associations.

- Color can be associated with a brand and be chosen to express a brand's personality—for example, Coca-Cola™ red or Tiffany™ blue.

- Color juxtaposition can create the illusion of space.

- Color selection should enhance the readability of type.

- Ramped color, or a gradation of color, creates the illusion of movement.

- A color should always be selected in relation to the other colors in the piece.

- There are established color schemes, such as monochromatic schemes, analogous colors, complementary colors, split complementary colors, triadic schemes, tetradic schemes, cool palettes, and warm palettes, among others. Color palettes are also associated with techniques, historical periods, and art and nature, such as batik colors, art deco, Victorian, retro palettes, ancient Chinese ceramic colors, and earth tones.

- Grays can be warm or cool.

DIAGRAM [2-10]

Actual textures can be found in the great variety of paper available for printed designs.

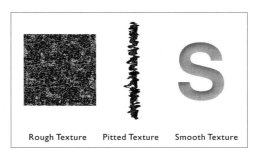

Rough Texture Pitted Texture Smooth Texture

DIAGRAM [2-11]

Textures are also characteristics of other elements: a square shape filled with a rough texture, a line with a pitted texture, and type with a smooth texture.

FIG. 2/09

OPEN YOUR HEART—GIVE BLOOD

· CEDOMIR KOSTOVIC
· SERIES OF THREE POSTERS DESIGNED
 TO PROMOTE BLOOD DRIVE BY THE
 COMMUNITY BLOOD CENTER OF THE
 OZARKS, SPRINGFIELD, MO, SAPPI IDEAS
 THAT MATTER RECIPIENT.

With project Open Your Heart—Give Blood my intentions were to raise awareness among high school and college students about blood donation. A series of intriguing images are used for the design of the educational booklet, posters, flyers, postcards, stickers, and gift bags for The Community Blood Center of The Ozarks.

My goal was to expand the Community Blood Center of The Ozarks volunteer base, encourage donations and foster social responsibility. Beyond their persuasive function these designs are meant to educate about our cultural heritage.

—Cedomir Kostivic

called **crystallographic balance**. Allover patterns can serve as graphic design solutions in and of themselves.

The unique and creative patterns in Cedomir Kostovic's poster series are an integral part of the visual message (Figure 2-09). Kostovic explains, "The tag line Open Your Heart—Give Blood is supported visually by images based on combinations of different symbols, which are juxtaposed in unexpected ways. Background images are based on patterns inspired by the rich visual heritage of diverse ethnic groups unique to American culture."

PRINCIPLES OF DESIGN

When composing with the formal elements, you utilize basic design principles. In combination with your knowledge of concept generation, type and image integration, and the formal elements as the form-building vocabulary, you apply the principles of design to every visual communication.

The basic principles are absolutely interdependent. Balance is about stability and creating equi-

librium; viewers find ease in a stable composition. Unity is about designing a whole in which elements *relate* to one another; proximity (elements that are close together are perceived as more related), similarity (similar elements are perceived as more related), and continuity (aligned elements are perceived as more related) are keys to unity. Within unity, a degree of variety adds visual interest and excitement. Emphasis through visual hierarchical organization increases the clarity of communication. Rhythm is used to help create a flow from one element to another and to add a visual pulsing excitement and flow.

Over time, through empirical studies, a working knowledge of each principle will become second nature—a conditioned consciousness—to your practice of design. As you begin, it is necessary to be mindful of the principles.

FORMAT

Before we examine the basic principles, let's understand the role of the format. Format is a term that means two related things. The **format** is the defined perimeter as well as the field it encloses—the outer edges or boundaries of a design; in actuality, it is the field or substrate (piece of paper,

SINGLE FORMATS VERSUS MULTIPLE-PAGE FORMATS

Posters, single-page advertisements, outdoor billboards, business cards, letterheads, any front cover, and unanimated web banners are single formats. The composition is on a single page. More often, designers must work with multiple-page applications, such as brochures, the interior design of books, magazines, newspapers, websites, reports, corporate communications, newsletters, catalogs, and more. A website is seen by clicking through to another page. Corporate, government, and institutional websites can have hundreds of pages; yet, at any given moment, a website can be one still image—and look like one still rectangle—viewed on a computer screen (unlike motion graphics). Any multiple-page format must be addressed as a continuous field, keeping unity, visual flow, and harmony in mind across the entire application (see Diagram 2-12).

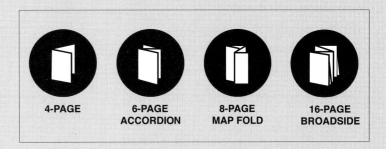

| 4-PAGE | 6-PAGE ACCORDION | 8-PAGE MAP FOLD | 16-PAGE BROADSIDE |

DIAGRAM [2-12]

FOLDING STYLES

mobile phone screen, outdoor billboard, etc.) for the graphic design.

In addition, designers often use the term *format* to describe the type of application—that is, a poster, a CD cover, and so on. Graphic designers have to work with a variety of formats.

Some examples are a CD cover is a square shape, a single-page magazine ad is a rectangular shape, and a two-page spread is a different rectangular shape. A brochure can unfold into an extended landscape-shaped rectangle; furthermore, there are a variety of brochures in different sizes and shapes, and each may open up differently (see Diagram 2-12).

There are standard sizes for some formats. CD covers, for example, are all the same size. Posters have standard sizes; however, you can print a poster in almost any size, too. Sometimes, a format shape and type are predetermined, and the designer has to work within those constraints. Any size format is available to the designer at varying costs. Shape, paper, size, and special printing techniques can greatly affect cost. Paper is roughly half the cost of any printing job. Size is determined by the needs

of the project, function and purpose, appropriateness for the solution, and cost.

No matter what shape or type of format, each component of the composition must form a significant relationship to the format's boundaries. That page, where you make your first mark, not only has all that blank space/white space, but it also has edges to which each mark and graphic element should relate when applying the principles of design. In one of the courses he taught at the Bauhaus, Wassily Kandinsky emphasized the basics of organization of a composition, the function of the center and the *edges*, and the progression from point to line to plane.

BALANCE

Balance is one of the principles that may come more intuitively to you because you utilize it in your own physical movement. If you practice yoga, martial arts, gymnastics, dance, or most sports, you understand that one action balances an opposite and equal action. **Balance** is stability or equilibrium created by an even distribution of visual weight on each side of a central axis, as well

DIAGRAM [2-13]

RECTANGLES, SQUARE, AND CIRCLE

FACTORS AFFECTING VISUAL WEIGHT

- Orientation and location of an element within the format
- Line of vision (directional pull)
- Whether the element is figure or ground
- Color: hue, value, saturation, and temperature
- Density or number of elements in a given area
- Isolation and emphasis of an element in the composition (focal point)
- Groupings (equal groups; group of several small shapes could counterbalance one large shape)
- Actual movement (time-based/screen-based media, motion graphics)

Size and shape of an element. For example, a large shape is heavier in comparison to a small shape

Black often weighs more than white

Patterns: textures or patterns have heavy visual weight compared to shapes without patterns

Dull tones are lightweight; bright tones are heavy

Cool/cold colors weigh less than warm/hot colors

For strategies on balancing a composition, please see Chapter 6 on composition.

as by an even distribution of weight among all the elements of the composition. When a design is balanced, it tends toward harmony with the viewer feeling level. The average viewer is adverse to imbalance in a composition and reacts negatively to instability. Balance is only one principle of composition and must work in conjunction with the other principles.

Interrelated Visual Factors of Balance
Understanding balance involves the study of several interrelated visual factors: visual weight, position, and arrangement.

In two-dimensional design, weight is not defined as an actual or physical gravitational force but rather as a visual force or as **visual weight**. This visual weight refers to the relative amount of visual attraction, importance, or emphasis the element carries in a composition. Every element in a composition carries energy—an impression of force, strength, or weight.

The size, shape, value, color, and texture of a mark all contribute to an element's visual weight. Where you *position* the mark on the page also affects its visual weight. The same mark positioned at different points on a page—bottom right, bottom left, center, top right, or top left—will appear to change in visual weight because of its position. In visual perception, different areas of the page seem to carry more or less visual weight. Recommended reading about this subject includes studies by gestalt theoreticians as well as books by Rudolf Arnheim, distinguished psychologist, philosopher, and critic, who wrote extensively about visual perception in relation to art and design. There are also many newer studies and experiments by psychologists and social scientists, among others.

Symmetric versus Asymmetric Balance
Symmetry is a mirroring of equivalent elements, an equal distribution of visual weights, on either side of a central axis, as in Figure 2-10 where the symbol component of the French Leave logo is symmetrical; it is also called **reflection symmetry**.

Approximate symmetry is very close to symmetry as in the poster *The Tale of the Allergist's Wife* in Figure 2-11. Imagine a vertical axis dividing

FIG. **2**/**10**

LOGO

- SOMMESE DESIGN, PORT MATILDA, PA
- ART DIRECTORS: KRISTIN SOMMESE, LANNY SOMMESE
- DESIGNERS: KRISTIN SOMMESE, LANNY SOMMESE, RYAN RUSSELL
- COPYWRITER: EDDIE LAUTH
- PHOTOGRAPHERS: EDDIE LAUTH, DAN LANINGAN
- DIGITAL EXPERT: RYAN RUSSELL
- CLIENT: FRENCH LEAVE

French Leave is an exclusive resort that is being developed on French Leave beach on the Island of Eleuthera in the Bahamas. The client asked us to create a design approach that was stylish, upbeat and clean, while at the same time capturing the island's calm, quiet grace and unspoiled natural beauty.

Logo: *We felt that the butterfly was the perfect metaphor for the unspoiled natural setting that is Eleuthera and it became the point of departure for our logo. Adding the silhouetted faces to the butterfly's wings was our way to visualize the relationship between French Leave Resort and its pristine surroundings. In order to enhance the stylish, clean, and exclusivity of the resort, the logo was silver foil stamped and embossed in most of its applications.*
—Sommese Design

FIG. **2**/**11**

POSTER: *THE TALE OF THE ALLERGIST'S WIFE*

- SPOTCO, NEW YORK
- ILLUSTRATOR: ROZ CHAST
- DESIGNER: MARK BURDETT

Theater reviewer Ronald Mangravite opined that this play had the "brittle hilarity" of a *New Yorker* cartoon, which is probably why SpotCo enlisted *New Yorker* cartoonist Roz Chast. The center alignment of the typography brings our eye to the main character, a Manhattanite, who is cowering inside a huge shopping bag, sporting her interests and obsessions. This witty poster conveys the underlying humor in the main character's midlife crisis.

FIG. **2**/**12**

DESIGN FALL 2004 COVER: "T," *THE NEW YORK TIMES STYLE MAGAZINE*

- CREATIVE DIRECTOR: JANET FROELICH/ *THE NEW YORK TIMES MAGAZINES*
- ART DIRECTOR: DAVID SEBBAH
- DESIGNERS: JANET FROELICH, DAVID SEBBAH
- PHOTOGRAPHER: RAYMOND MEIER

The green chair is the focal point in this interesting space, counterbalanced by the magazine title "T."

this poster in half; you can see an equal distribution of weight on either side of it. Symmetry and approximate symmetry can communicate harmony and stability.

Asymmetry is an equal distribution of visual weights achieved through weight and counterweight by balancing one element with the weight of a counterpointing element *without mirroring* elements on either side of a central axis (Figure 2-12). To achieve asymmetrical balance, the position, visual weight, size, value, color, shape, and texture of a mark on the page must be considered

DIAGRAM [2-14]

SYMMETRICAL ARRANGEMENT (TOP)

ASYMMETRICAL ARRANGEMENT (MIDDLE)

RADIAL ARRANGEMENT (BOTTOM)

and weighed against every other mark; every element and its position contribute to the overall balancing effect in a design solution. (See more in Chapter 6 on contrast and balance.)

Radial (allover) **balance** is symmetry achieved through a combination of horizontally and vertically oriented symmetry. Elements radiate out from a point in the center of the composition, or there is extensive repetition of an element or elements (Diagram 2-14).

VISUAL HIERARCHY

One of the primary purposes of graphic design is to communicate information, and the principle of visual hierarchy is the primary force for organizing information and clarifying communication. To *guide* the viewer, the designer uses **visual hierarchy**, the arrangement of *all* graphic elements according to emphasis. **Emphasis** is the arrangement of visual elements according to importance, stressing some elements over others, making some superordinate (dominant) elements and subordinating other elements. Basically, the designer determines which graphic elements the viewer will see first, second, third, and so on. This is what creative director John Rea calls the ABCs of emphasis:

A. Where do you want the viewer to look first?

B. Where do you want the viewer to look second?

C. Where do you want the viewer to look third?

The designer must determine what to emphasize and what to de-emphasize.

It is important to remember that if you give emphasis to all elements in a design, you have given it to none of them; you will just end up with visual chaos. Regardless of the expressive quality or style of the work, visual hierarchy aids communication.

Emphasis is directly related to establishing a point of focus. We call this point of emphasis the **focal point**—the part of a design that is most emphasized or accentuated, as in Figure 2-12, where the green chair is the focal point. Position, size, shape, direction, hue, value, saturation, and texture of a graphic element all contribute to making it a focal point. Once past the establishment of a focal point, a designer must *further guide* the viewer, as in Figure 2-13. As you will recall from the ABCs of emphasis, this rule can be extended to every component part within a composition.

Superdrug Stores asked Turner Duckworth to redesign their range of natural herbal supplements to appeal to health conscious consumers of

FIG. **2** / **13**

POSTER: *METROPOLIS*

· DESIGNER: E. MCNIGHT KAUFFER (1890–1954)

· E. MCNIGHT KAUFFER. METROPOLIS. 1926. GOUACHE, 29½" × 17" (74.9 × 43.2 CM)

· MUSEUM OF MODERN ART, GIVEN ANONYMOUSLY

In this asymmetrical composition, top left are the letters "Met. . . ." The "T" extends downward leading the eye to the next part of this single word, ". . . ropo . . . ," which is itself a diagonal pointing down and to the right to the conclusion at the bottom, ". . . lis" and then we are pulled up and the right-hand big red wheel balances the left side.

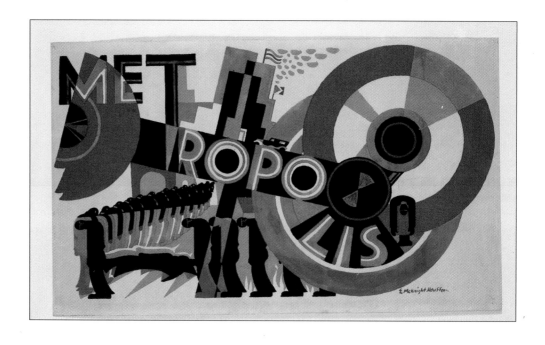

FIG. **2** / **14**

PACKAGE DESIGN, SUPERDRUG HERBAL SUPPLEMENTS

· TURNER DUCKWORTH, LONDON
· CREATIVE DIRECTORS: DAVID TURNER, BRUCE DUCKWORTH
· DESIGNER: JAMIE MCCATHIE
· CLIENT: SUPERDRUG STORES PLC
· © 2008 TURNER DUCKWORTH, LLC

Superdrug Stores briefed us to redesign their range of natural herbal supplements to appeal to health conscious consumers of either gender.

Our solution came from the herbs themselves. As these supplements are all natural, our motivation was to celebrate each individual herb with graphic, kaleidoscopic images that travel across the pack. The uplifting images clearly differentiate each supplement from the others in the range, making it easier for Superdrug consumers to select their perfect tonic.

—Turner Duckworth

either gender (Figure 2-14). The visual hierarchy is very clear. First we see the dominant visual or the herb, then the name of the supplement, next the retail brand logo, and then the number of tablets. The smaller cropped image of the herb along with the name counterbalances the dominant visual against a pure white field.

EMPHASIS

To establish a visual hierarchy, decide on the importance of the graphic elements that are the component parts (visuals and type) of your design. Create a flow of information from the most important element to the least.

There are several means to achieve emphasis:

Emphasis by Isolation

Isolating a shape focuses attention on it (focused attention = more visual weight). Please note that a focal point usually carries a great amount of visual weight and must be counterbalanced accordingly with other elements in a composition.

Emphasis by Placement

How the viewer moves visually through a spatial composition has been an ongoing topic of study. It has been shown that viewers have preferences for specific regions of a page. Placing a graphic element at specific positions in a composition, such as the foreground, the top-left corner, or the center/middle of a page attracts most viewers' gaze most easily. Read more about eye direction and placement in Chapter 6.

Emphasis through Scale

The size and scale of shapes or objects play an important role in emphasis and creating the illusion of spatial depth. Used effectively, the size of one shape or object in relation to another—what we call *scale*—can make elements appear to move forward or backward on the page. Large shapes and forms tend to attract more attention; however, a very small object can also attract attention if it is seen in contrast to many larger ones.

Emphasis through Contrast

Through contrast—light versus dark, smooth versus rough, bright versus dull—you can emphasize some graphic elements over others. For example, a dark shape amid a field of lighter shapes might become a focal point. Of course, contrast also depends on and is aided by size, scale, location, shape, and position.

Emphasis through Direction and Pointers

Elements such as arrows and diagonals use direction to point viewers' eyes to where they should go.

Emphasis through Diagrammatic Structures

Tree Structures. By positioning the main or superordinate element at the top with subordinated elements below it in descending order, hierarchical relationships are created (Diagram 2-15). Another tree structure looks similar to a tree trunk with branches; subordinate elements stem out from the main element carried by lines.

Nest Structures. This can be done either through layering (main element is the first layer and other layers move behind it) or through containment (the main element contains the lesser elements) (Diagram 2-15). Layering for the purpose of hierarchy is critical to understand in relation to websites and information design.

Stair Structures. To illustrate hierarchy, this structure stacks elements, with the main element at the top and subordinate elements descending like stair steps (Diagram 2-15).

To create emphasis, a designer must present content in a logical order as well as control how the information is conveyed. For more about emphasis, see Chapter 6 on arrangement: visual hierarchy, flow, and eye direction.

DIAGRAM [2-15]

TREES, NESTS, AND STAIRS

RHYTHM

In music and poetry, most people think of rhythm as the beat—created by a pattern of stress (and unstress). In graphic design, a strong and consistent repetition, a pattern of elements can set up a **rhythm**, similar to a beat in music, which causes the viewer's eyes to move around the page. Timing can be set by the intervals between and among the position of elements on the page. Just as in music, a pattern can be established and then interrupted, slowed, or sped up. If you've ever danced to music, you know how important a steady recognizable beat is to the success of moving to the rhythm. Similarly in design, a strong visual rhythm aids in creating stability. Rhythm—a sequence of visual elements at prescribed intervals—across multiple-page applications and motion graphics, such as book design, website design, and magazine design, is critical to developing a coherent visual flow from one page to another (think strong dance beat). Equally important is incorporating an element of variance to punctuate, accent, and create visual interest.

Many factors can contribute to establishing rhythm—color, texture, figure and ground relationships, emphasis, and balance.

Repetition and Variation

The key to establishing rhythm in design is to understand the difference between repetition and variation. In graphic design, the repetition of rhythm is interposed by variation to create visual interest. In *2D: Basics for Designers*, Steven Brower writes: "As in music, patterns are established and then broken through. By building expectations, accents can be created that enhance and inform. Once this visual rhythm is achieved through the repetition of pattern, any variation within will break the rhythm, producing the visual equivalent of a pulse or a beat. These can either create a slight pause or bring the entire piece to a halt, depending on the intent of the designer."

Repetition occurs when you repeat one or a few visual elements a number of times or with great or total consistency, as in Figure 2-15. The *Baby Wayne Ram DJ* CD cover creates rhythm through the intervals as our eyes move from head to head and with the variation in sizes of the heads

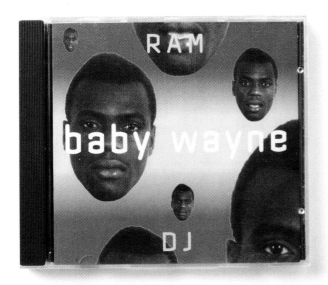

FIG. **2** / **15**

ROUNDER RECORDS CD PACKAGING,
BABY WAYNE RAM DJ

· VISUAL DIALOGUE, BOSTON
· DESIGNERS: FRITZ KLAETKE, IAN VARRASSI, CHRISTIAN PALINO
· CLIENT: ROUNDER RECORDS

Problem: *Rounder Records is an independent label specializing in music ranging from reggae to bluegrass, blues to folk, and a few genres that defy categorization. With every release it's important to have the design reflect the character of the featured artist and the music he creates.*

Solution: *Visual Dialogue looks at these CD covers as basically 4¾" square ads. Using just a few elements—photo, artist's name, and title—we create covers, which engage the desired audience while also giving a sense of the music. The end result is a visually distinctive and memorable identity that lasts for years.*
 —Fritz Klaetke

complemented by the background colors and vertical arrangement of the typography. **Variation** is established by a break or modification in the pattern or by changing elements, such as the color, size, shape, spacing, position, and visual weight. Variation creates visual interest to engage a viewer and adds an element of surprise; however, too much variation will do away with a visual beat.

UNITY

When you look at a book jacket, do you ever wonder how the graphic designer was able to get all the type and visuals to work together as a cohesive unit? There are many ways to achieve **unity** where all the graphic elements in a design are so interrelated that they form a greater whole; all the graphic elements look as though they belong together.

An ideal layout might be viewed as a composition of graphic elements so unified as a whole that it cannot be described merely as a sum of its parts. Most designers would agree viewers are able to best *take in* (understand and remember) a composition that is a unified whole. This belief relies on *gestalt*, from the German for "form," which places an emphasis on the perception of forms as organized wholes, primarily concerned with how the mind attempts to impose order on the world, to unify and order perceptions.[1]

From gestalt, we derive certain laws of perceptual organization that govern visual thinking,

profoundly affecting how you construct unity in a composition. The mind attempts to create order, make connections, and *seek a whole* by **grouping**—perceiving visual units by location, orientation, likeness, shape, and color. A fundamental principle is the law of *prägnanz* (German for "precision" or "conciseness")—which means we seek to order our experience as a whole as well as possible in a regular, simple, coherent manner.

LAWS OF PERCEPTUAL ORGANIZATION

The laws (illustrated in Diagram 2-16) are:
› **Similarity**: like elements, those that share characteristics, are perceived as belonging together.

DIAGRAM [2-16]

LAWS OF PERCEPTUAL ORGANIZATION: SIMILARITY, PROXIMITY, CONTINUITY, CLOSURE, COMMON FATE, CONTINUING LINE.

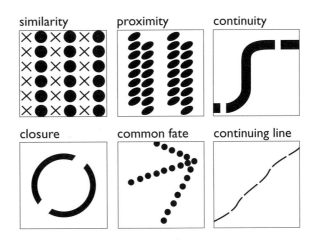

Elements can share likeness in shape, texture, color, and direction. Dissimilar elements tend to separate from like elements.

> **Proximity:** elements near each other, in spatial proximity, are perceived as belonging together.

> **Continuity:** perceived visual paths or connections (actual or implied) among parts; elements that appear as a continuation of previous elements are perceived as linked, creating an impression of movement.

> **Closure:** the mind's tendency to connect individual elements to produce a completed form, unit, or pattern.

> **Common fate:** elements are likely to be perceived as a unit if they move in the same direction.

> **Continuing line:** lines are always perceived as following the simplest path. If two lines break, the viewer sees the overall movement rather than the break; also called **implied line**.

One or more principles (or devices) may be employed to get the desired results for unity. Here are some of them.

Correspondence

When you repeat an element such as color, value, shape, texture, or parallel directions or establish a style, like a linear style, you establish a visual connection or **correspondence** among the elements.

Continuity is related to correspondence. It is the handling of design elements—like line, shape, texture, and color—to create similarities of form. In other words, continuity is used to create a family resemblance. For example, if you were designing stationery, you would want to handle the type, shapes, colors, and any graphic elements on the letterhead, envelope, and business card in a similar way to establish a family resemblance among the three pieces.

Unity is one of the primary goals of composition—composing *an integrated whole*, not unrelated component parts. In Figure 2-16, Luba Lukova creates unity through similarity (letterforms and illustrations share common characteristics) and corresponding use of red and yellow throughout, as well as through echoing the stepped staircase in the red polygon shape containing the title. In a series (related independent pieces), such as Figure 2-17, the package design system created by Louise Fili, each package design is unified on its own (through compositional movements—circular movements in the typography and graphic elements—echoing one another and sympathetic visualization). Each design is also unified as a series through corresponding (shared) characteristics and through a consistent layout (consistent positioning of elements).

In Figure 2-18, a promotional poster for the Flaming Lips, although there is a variety of different elements—small silhouetted figures atop the spaceship, the spaceship's legs and ground made

FIG. **2** / **16**

POSTER: *VISUAL METAPHORS*

· LUBA LUKOVA STUDIO, LONG ISLAND CITY, NY
· DESIGNER/ILLUSTRATOR: LUBA LUKOVA
· CLIENT: CONTEMPORARY ILLUSTRATORS GALLERY

Look closely at the images comprising the pattern of visual metaphors. Visual metaphors are valuable tools, like their verbal cousins in rhetoric, having the potential to communicate dramatically or poetically, as they do here.

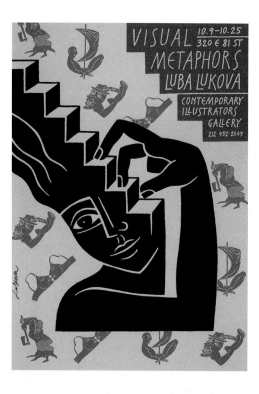

FIG. **2** / **17**

PACKAGE DESIGN: BELLA CUCINA

· LOUISE FILI LTD., NEW YORK
· ART DIRECTOR/DESIGNER: LOUISE FILI

Elements used consistently on each package are typography, illustration, position, composition, and color.

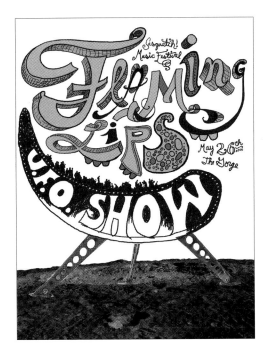

FIG. **2**/**18**

POSTER: *FLAMING LIPS*

· MODERN DOG DESIGN CO., SEATTLE
· © MODERN DOG DESIGN CO.

This is an example of continuity with variety.

from photographic collage elements, black and white type versus colored/patterned type—there is continuity through the structure of the composition, where the curve of the spaceship strongly echoes the curve of "Lips." A certain level of variety can exist and still allow for continuity.

Structure and Unity

Various structural devices can aid in unifying a static page or multiple-page applications. Modular systems, grids, and mathematical devices and alignment can aid in establishing unity; these will be examined in depth in Chapter 6.

Viewers will perceive a greater sense of unity in a composition when they see or sense visual connections through the alignment of elements, objects, or edges. Because viewers seek order, their eyes easily pick up these relationships and make connections among the forms. **Alignment** is the positioning of visual elements relative to one another so that their edges or axes line up. A

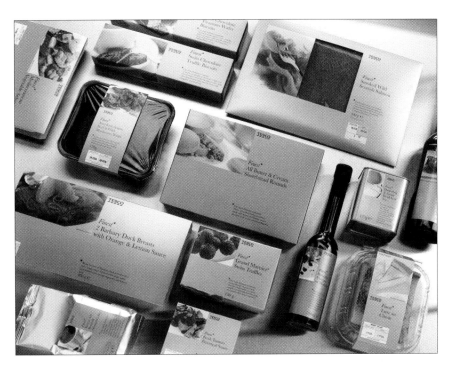

FIG. **2**/**19**

IDENTITY/PACKAGING: TESCO FINEST

· PENTAGRAM DESIGN LTD., LONDON
· DESIGNER: JOHN RUSHWORTH (PARTNER)
· DESIGN ASSISTANTS: KERRIE POWELL, CHRIS ALLEN
· PHOTOGRAPHERS: ROGER STOWELL, JAMES MURPHY
· CLIENT: TESCO

The U.K.'s leading supermarket retailer, Tesco, recently launched a new sub-brand of prepared and ready-made meals—Finest—with packaging and identity designed by Pentagram. The range was devised to target a new market for the more discerning customers who require food of exceptional quality and want a restaurant experience in the comfort of their own home.

It was important for Pentagram to design packaging that reflected an air of freshness and quality, personified professional cooking, and positioned the new line above Tesco's current range of Luxury products.

A two- and three-dimensional visual language was designed using simple geometric shapes for the structure of the packs, to which clear, elegant graphics were applied.

The packs, predominately silver and black, have an understated quality which was created by reducing the size of the pictures rather than using full-bleed images often seen on own brand products. Each pack was divided geometrically, the pictures placed in the top left corner taking up either an eighth, sixth, or quarter of the whole. The photography has an editorial style that adds to the refined appearance of the packaging.
—Pentagram

graphic structure, such as the grid, used to organize the placement of visual elements incorporates guides that naturally lend themselves to alignment. All the type on the packaging system for Tesco is aligned flush left (Figure 2-19). Besides the type alignment, other design decisions contribute to unity in this design solution—color,

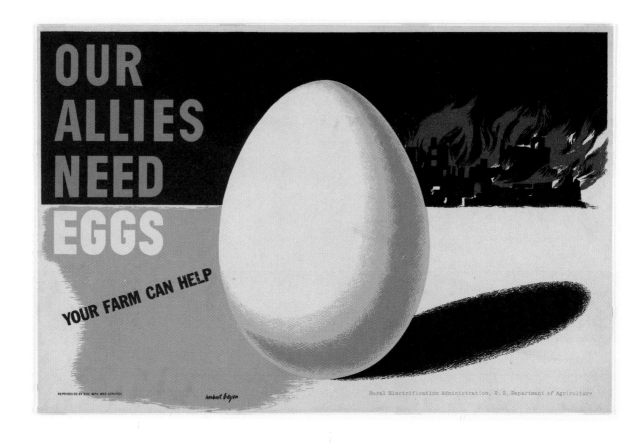

FIG. **2**/**20**

POSTER

· HERBERT BAYER (1900–1985) © ARS, NY. OUR ALLIES NEED EGGS, YOUR FARM CAN HELP. C. 1942. SILKSCREEN, 20¼ × 30" (51.4 × 76.1 CM). GIFT OF THE RURAL ELECTRIFICATION ADMINISTRATION. (110.1968)

· THE MUSEUM OF MODERN ART, NEW YORK

· DIGITAL IMAGE © THE MUSEUM OF MODERN ART / LICENSED BY SCALA /ART RESOURCE, NY

In this historic work by Bayer, monumentality is established by contrasting the size of the egg in the foreground with the burning buildings in the background. The contrast in scale, enhanced by the extreme light and dark lighting, results in dramatic communication.

typefaces, and position of photographs in relation to the flush-left alignment of type.

Elements should be arranged so that the audience is led from one element to another through the design. **Flow** is also called *movement* and is connected to the principle of rhythm. Rhythm, in part, is about a sense of movement from one element to another.

SCALE

In a design, **scale** is the size of an element or form *seen in relation* to other elements or forms within the format. Scale is based on proportional relationships between and among forms. Traditionally, architects show a person standing next to or in front of a model or illustration of a building to best give an idea about the size of the building; the person is understood in scale to the building. In general, we best understand the size of visual elements in relation to other visual elements. The

way a designer uses scale can relate to our understanding of the relative size of real objects, such as the relative size of an apple compared to a tree. Through our experience of the natural world, we expect an apple to be much smaller than a tree. If a designer plays with our expectations, distorting scale as we normally see it in nature, then the result is surreal or fantastic as in Figure 2-20.

Along with utilizing fundamental principles, one must control scale for the following reasons:

› Manipulating scale can lend visual *variety* to a composition.

› Scale adds contrast, dynamism, and positive tension to relationships between and among shapes and forms.

› Manipulation of scale can create the illusion of three-dimensional space.

PROPORTION

Proportion is the comparative size relationships of parts to one another and to the whole. Elements or parts are compared to the whole in

terms of magnitude, measure, and/or quantity. For example, the size relationship of an average-height person's head to his or her body is a proportional relationship; the viewer *expects* there to be one head and expects the head to be in a particular proportion to the (average) body. Also, if the head is *not* in a logical proportion to the body, then the viewer would expect that other elements or parts might be out of proportion as well. That expectation implies a "standard" relationship among elements, such that if one varies from the "norm" or standard, then another element-to-whole relationship should vary in the same manner. When the viewer's expectations are intentionally challenged, the designer creates a visual surprise, possibly a surreal solution, or a disjunctive appearance.

For designers and artists, there is also an additional implied meaning to proportion. It is an aesthetic arrangement—a harmonious or agreeable relationship of parts or elements within a whole, where reciprocity of balance exists lending to harmony. In design, **harmony** is agreement within a composition, where elements are constructed, arranged, and function in relation to one another to an agreeable effect. Art critic John Ruskin said: "In all perfectly beautiful objects there is found the opposition of one part to another and a reciprocal balance." Certainly, Ruskin's view bestows value on aesthetics and beauty. Today, a designer can deliberately play with expected proportion in a composition with the hope of creating a graphic impact that is not "conventionally" or "classically" beautiful or even remotely about beauty.

MATHEMATICAL RATIOS AND PROPORTIONAL SYSTEMS

Since the time of ancient Greece, at various points in Western art, artists, architects, and musicians were interested in determining ideal proportions. They looked to math for a system of creating ideal proportions that could be applied to the visual arts, music, and architecture. Most designers prefer to rely on their learned and innate sense of proportion; however, some employ graphic devices that can aid in establishing harmony, such as Fibonacci numbers and the golden section, among others.

FIBONACCI NUMBERS

Fibonacci numbers are named after the medieval Italian mathematician Leonardo of Pisa, also known as Fibonacci. The numbers constitute a numerical series which begins with 0 and 1. Each subsequent number in the sequence is the sum of the two numbers preceding it, yielding the series 1, 1, 2, 3, 5, 8, 13, 21, and so on.

Fibonacci squares (Diagram 2-17) have sides with lengths that correspond to the numbers in the Fibonacci sequence. Placing two squares with sides of 1 next to each other constructs a 1 × 2 (or 2 × 1) rectangle. That is, the short side of the rectangle is 1 unit in length and the long side is 2 units. Placing a square with a side of 2 next to the long side of the 1 × 2 rectangle creates a new, 2 × 3 rectangle. Likewise, adding a square with a side of 3 to the long side of that rectangle yields a

DIAGRAM | 2-17 |

FIBONACCI SQUARES

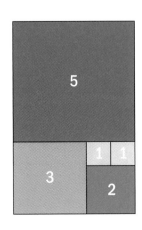
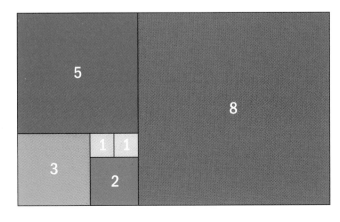

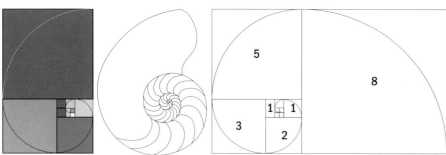
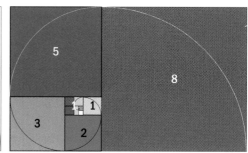

DIAGRAM [2-18]

FIBONACCI SPIRAL

new rectangle with sides of 3 and 5. The addition of a square with a side of 5 then yields a 5 × 8 rectangle, a square of 8 yields an 8 × 13 rectangle, and so on. (The ratio of the long to the short side of each rectangle constructed in this way from Fibonacci squares approximates the golden ratio, discussed below.)

A **Fibonacci spiral** (Diagram 2-18) can be created by drawing quarter circles through a set of Fibonacci squares. Connecting the opposite corners of the squares yields a spiral like many found in plants, seashells, and other forms in nature.

The ratio between adjacent numbers in the Fibonacci sequence approximates 1.6. That is, 5/3, 8/5, 13/8, and 21/13 all approximate 1.6, a value that in turn approximates the golden ratio, a mathematical constant, which is approximately 1.618.

THE GOLDEN RATIO

The **golden ratio**, commonly denoted by the Greek letter phi (φ), refers to a geometric relationship in which a longer length a is to a shorter length b as the sum of the lengths ($a + b$) is to a. Mathematically, the golden ratio can be expressed as: $(a + b)/a = a/b = 1.618$.

Conversely, $a/(a + b) = b/a = 0.618$. The golden ratio is also referred to as the golden mean, golden number, or divine proportion. A rectangle whose ratio of length to width is the golden ratio is a **golden rectangle**. (The rectangles built from Fibonacci squares approximate golden rectangles.)

A **golden section** is a line segment sectioned into two unequal parts, a and b, such that the total length ($a + b$) is to the longer section a as a is to the shorter section b:

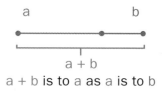

a + b is to a as a is to b

Again, stated algebraically,

$$(a + b)/a = a/b$$

In Western art, shapes or structures defined by or based on the golden section have been considered aesthetically pleasing by many artists, designers, and architects. For example, architect

DIAGRAM [2-19]

A GOLDEN SECTION
SEEN IN THE FORMAT
OF AN 8½" × 11" PAGE

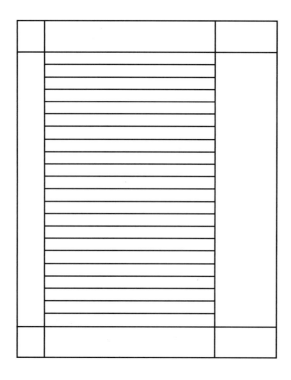

Le Corbusier used the golden ratio as the basis of his modular architectural system. The golden ratio is still used today in graphic design, fine art, and architecture. Graphic designers utilize the golden section for grid systems and page formats. Although the U.S. standard size page (8.5 × 11 inches) and the European standard size page (210 × 297 mm) are not golden section proportions, a golden section can be inscribed in each (Diagram 2-19). Likewise, a website's proportions are not golden-section based; however, a golden section can be inscribed in it.

People in the visual arts have different views on ideal proportions depending on their culture, education, and philosophy. Some think pursuing ideal proportions is an important pursuit; others find different ways of addressing scale, proportion, grids, and page formats without utilizing mathematical ratios.

ILLUSION AND THE MANIPULATION OF GRAPHIC SPACE

To understand illusion, we need to revisit point and line and see that they can build a **form**, a shape that has the illusion of existing in three-dimensional space. A form can give the illusion of having weight, mass, or solidity. We start with a point (dot), which describes a specific place or position in space; it has no length, breadth, or volume. That point can move and become a line, which is the path of a moving dot (see Diagram 2-20).

VOLUME

A line has length but no breadth. A line also has position or direction and *can form the border of a plane*. A **plane** is a two-dimensional surface bound by lines that defines the outside of a form, a volume. A plane has length and breadth but no thickness; it has position and direction. (Essentially, it is a conceptual surface.)

Volume is the representation of mass on a two-dimensional surface; it can be bound by planes and has position in space. It also is called **mass**. Form as volume creates the illusion of three-dimensional space on a two-dimensional surface.

DIAGRAM | 2-20 |

PROGRESSION FROM POINT TO VOLUME

Picture Plane

Volume on a two-dimensional surface can be defined as the illusion of a form with mass or weight (a shape with a back as well as a front). When you set out to create a design on a two-dimensional surface, like a board or a piece of paper, you begin with a blank, flat surface. That surface is called the **picture plane**. It is your point of departure; it is where you begin to create your design.

As soon as you make one mark on the surface of the page, you begin to play with the picture plane and possibly create the illusion of spatial depth. The **illusion of spatial depth** means the appearance of three-dimensional space, where some things appear closer to the viewer and some things appear farther away—just as in actual space. The illusion of spatial depth can be shallow or deep, recessive or projected.

Foreground, Middle Ground, Background

We tend to see graphic elements in terms of three main planes: the **foreground** (the part of a composition that appears nearest the viewer), the middle ground (an intermediate position between the foreground and the background), and the **background** (the part of a composition that appears in the distance or behind the most important part). Once those planes are established, the viewer begins to enter the piece by deciphering the information presented. The designer needs to give visual cues as to where to enter. Most observers look at foreground elements first.

On the cover design by Paul Rand for *Direction* magazine (Figure 2-21), the horizontal stripes behind the dancer define the picture plane. Rand has created the illusion that the picture plane is no longer on the surface of the page but has moved back behind the dancer. However, the picture plane does not seem to be too far away from us; the illusion of spatial depth seems shallow. Shallow space immediately engages our attention; our eyes cannot wander off into deep space. We tend to think of writing or lettering as flat elements drawn on a flat surface; however, in Figure 2-22,

FIG. **2/21**

MAGAZINE COVER:
***DIRECTION*, APRIL 1940**

· DESIGNER: PAUL RAND
· COURTESY OF THE
 MANUSCRIPTS AND ARCHIVES
 DIVISION, YALE UNIVERSITY,
 STERLING LIBRARY.

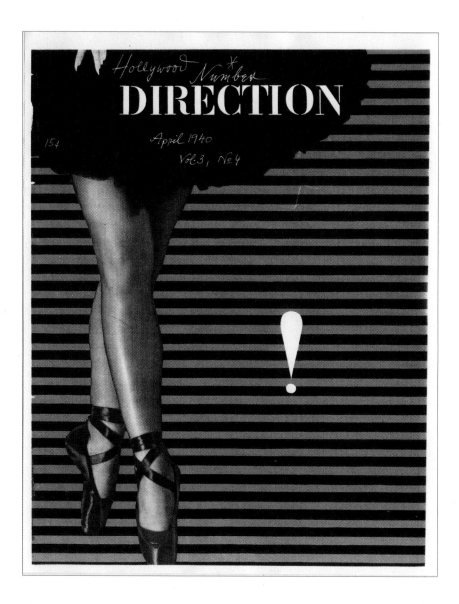

FIG. **2/22**

LOGO: LE MONDE

· LOUISE FILI LTD., NEW YORK
· ART DIRECTOR/DESIGNER:
 LOUISE FILI

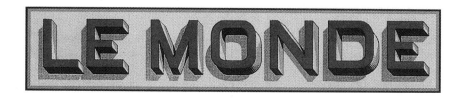

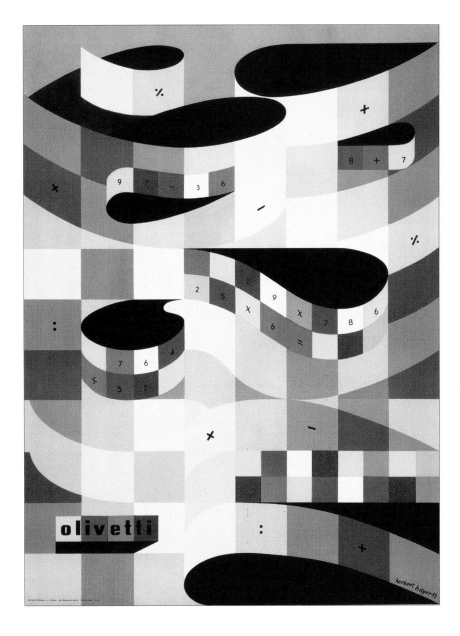

FIG. **2** / **23**

POSTER

· HERBERT BAYER (1900–1985). © ARS, NY. OLIVETTI. 1959. OFFSET LITHOGRAPH, 27½ × 19⅝" (69.8 × 49.8 CM). GIFT OF THE DESIGNER. (39.1960)
· THE MUSEUM OF MODERN ART, NEW YORK
· DIGITAL IMAGE © THE MUSEUM OF MODERN ART/LICENSED BY SCALA/ART RESOURCE, NY

FIG. **2** / **24**

COVER: *DESIGN QUARTERLY 110*
"IVAN CHERMAYEFF: A DESIGN ANATOMY"

· CHERMAYEFF & GEISMAR INC., NEW YORK
· DESIGNER: IVAN CHERMAYEFF

A collage of personal images, notes, type proofs, etc., used for the cover of a magazine special issue devoted to the work of Ivan Chermayeff.
—Tom Geismar, Chermayeff & Geismar Inc.

the Le Monde logo, the picture plane is behind the letterforms, which move forward in front of the picture plane creating an illusion of depth. In Figure 2-23, design pioneer Herbert Bayer's well-known poster for Olivetti, the orange at the top is the background, and the ribbonlike forms move forward and back creating a warping spatial illusion.

It is possible to create such impressive illusions that the viewer, at first sight, doubts whether the thing depicted is real or a representation. This effect is called **trompe l'oeil**. The use of shadows and overlapping shapes can create effects fooling the viewer into thinking the elements are actually adhered to the surface rather than an illusion, as in Figure 2-24, the cover for *Design Quarterly 110*. Overlapping shapes or forms can also increase the illusion of spatial depth. When you overlap shapes, one shape appears to be in front of the other. Layering also increases the illusion of depth.

Hornall Anderson's solution to evolving the Tommy Bahama online shopping process involved the objective of "Bringing the in-store experience

FIG. **2** / **25**

**TOMMY BAHAMA ECOMMERCE
WEBSITE (FLASH DESIGNED)**

- HORNALL ANDERSON, SEATTLE
- CREATIVE DIRECTOR: JAMIE MONBERG
- DESIGNERS: NATE YOUNG, JOSEPH KING
- PHOTOGRAPHY: CLIENT PROVIDED
- PROGRAMMERS: GORDON MUELLER,
 MATT FRICKELTON
- SENIOR PRODUCER: ERICA GOLDSMITH
- CLIENT: TOMMY BAHAMA
- HTTP://WWW.TOMMYBAHAMA.COM

*Bringing the in-store experience
online. That was the objective
of Tommy Bahama when they
approached Hornall Anderson
seeking to evolve their online
shopping process. Through a new,
richer web presence, visitors are
offered a true digital "experience"
that mirrors the Tommy Bahama
signature brand offerings. This site
redesign marries the extension
of their products, retail look &
feel, and customer service to the
creation of a new ecommerce
platform with intuitive buy-flow, all
designed to seamlessly launch their
products online.*

*The result is a deep on-brand
consumer experience backed by
a robust design and technology
solution, enabling guests to shop
and take part in the Tommy
Bahama community in a refined
and relaxed manner—the Tommy
Bahama way of life.*

—Hornall Anderson

online." In Figure 2-25, you can see how the trompe l'oeil illusion would make the online shopping experience more tactile and rich. Note how the map that is the background is the picture plane, and all the objects and images move in front of the picture plane.

Think of the common image of train tracks. If you are standing on train tracks, the tracks appear to converge in the distance. You know the tracks do not converge but actually remain parallel. Perspective is a way of mimicking this effect. **Perspective** is based on the idea that diagonals

DIAGRAM [2-21]

ILLUSION OF CONVERGENCE.

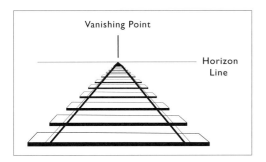

moving toward a point on the horizon, called the *vanishing point*, will imitate the recession of space into the distance and create the illusion of spatial depth. Perspective is a schematic way of translating three-dimensional space onto a two-dimensional surface (Diagram 2-21). Volumetric shapes, such as cubes, cones, and cylinders, can also create the illusion of spatial depth.

Remember, as a designer manipulating graphic space, you have many choices. You can maintain the flatness of the picture plane or create the illusion of spatial depth. You can create a shallow or deep space or create the illusion that forms are projecting forward. Understanding the illusion of spatial depth will enlarge your design vocabulary and enhance your ability to affect an audience.

The foundation of a solid graphic design education begins with the study of two-dimensional design—the formal elements, the principles of design, and the manipulation of graphic space. This study provides the basic perceptual and conceptual skills necessary to study typography, layout, and graphic design applications.

EXERCISE 2-1

EXPLORING LINES

❶ Divide a page into four units.

❷ Draw a curving line from corner to corner in each square.

❸ Draw different types of lines of varying direction and qualities in the divided areas.

PROJECT 2-1

CREATING ILLUSION WITH LINES: A WARP

❶ Using a black marker or the line tool in your computer's software, draw horizontal lines of varying thickness completely across the page.

❷ Vary the distance between the lines.

❸ Do several small sketches (thumbnails) or versions before going to the final solution.

PRESENTATION

PRESENTATION OF PRINTED DESIGN SOLUTIONS

Designs should be printed on good quality, double-sided, matte photo paper. Print the image at the largest size possible to fit on the paper (size to coordinate with your portfolio binder, if applicable), allowing for a 1" to 2" margin. Print each solution on its own page.

All images must be at high-resolution. Do not include any borders or additional graphics, as these would interfere with the composition of the presented work.

DIGITAL DESIGN SOLUTIONS

For the digital presentations, the suggestions are the same as print except that the images should be PDFs or 72 dpi resolution for embedded images on websites. Display of images on websites should load quickly and be easy to navigate through in a linear progression: forward and back.

Go to our website **GD/s** for *many* more Exercises and Projects, and presentation guidelines, as well as other study resources including the chapter summary.

NOTE

1. In 1890, Austrian philosopher Christian von Ehrenfels introduced the term *gestalt* into psychology. In 1912, the gestalt school of psychology gathered momentum from German theorists Max Wertheimer, Wolfgang Köhler, and Kurt Koffka.

AGUIRRE THE WRATH OF GOD/
LAST WORDS/PRECAUTIONS
AGAINST FANATICS/SIGNS OF
LIFE/STROSZEK/FITZCARRALDO/
LITTLE DIETER NEEDS TO FLY/
GRIZZLY MAN/NOSFERATU/THE
GREAT ECSTASY OF
WOODCARVER STEINER/
LESSONS OF DARKNESS/BELLS
FROM THE DEEP/

HERZOG/
FILM RETROSPECTIVE / NOV–JAN / SFMOMA.ORG

SFMOMA

PERU/
CRETE/
WISCONSIN/
LAOS/
ALASKA/
TRANSYLVANIA/
YUGOSLAVIA/
KUWAIT/
RUSSIA/

HERZOG/
FILM RETROSPECTIVE / NOV–JAN / SFMOMA.ORG

SFMOMA

CONQUISTADOR/
SOLDIER/
STREET MUSICIAN/
RUBBER BARON/
FLIER/
ENVIRONMENTALIST/
VAMPIRE/
SKI JUMPER/
FIRE FIGHTER/
MYSTIC/

HERZOG/
FILM RETROSPECTIVE / NOV–JAN / SFMOMA.ORG

SFMOMA

I BELIEVE THE COMMON
CHARACTER OF THE UNIVERSE
IS NOT HARMONY, BUT
HOSTILITY, CHAOS, AND
MURDER.

HERZOG/
FILM RETROSPECTIVE / NOV–JAN / SFMOMA.ORG

SFMOMA

03/

TYPOGRAPHY

<<< / *facing page*

POSTER: *WERNER HERZOG RETROSPECTIVE*

- MENDEDESIGN, SAN FRANCISCO
- ART DIRECTOR: JEREMY MENDE
- DESIGNERS: AMADEO DESOUZA, STEVEN KNODEL, JEREMY MENDE
- CLIENT: SAN FRANCISCO MUSEUM OF MODERN ART

MOST
PEOPLE WHO BECOME DESIGNERS HAVE AN

AFFINITY FOR IMAGERY. CREATING IMAGERY OR UNDERSTANDING IMAGERY COMES FAIRLY EASILY TO THEM. PEOPLE WITH AN AFFINITY FOR TYPE—WHO CONSIDER TYPE AN INTEGRAL ELEMENT OF VISUAL COMMUNICATION—TEND TO HAVE MORE FACILITY DESIGNING WITH TYPE. IF YOU VIEW TYPE MERELY AS LITERAL CONTENT, TYPOGRAPHY BECOMES A CHALLENGE. ONCE YOU EMBRACE TYPE'S CRITICAL ROLE IN GRAPHIC DESIGN, YOU CAN BEST THINK ABOUT TYPE AND DESIGN WITH TYPE.

If you are designing with type for a branded environment, that context is different from designing type for a business card. However, there are basic guiding principles. *Type is form and should be evaluated based on aesthetic criteria of shape, proportion, and balance. Type communicates on a denotative and connotative level. Type has to be thoughtfully integrated with visuals. Type should be readable. Margins present text type and need to be respected. Transitions between letters, words, and paragraphs are critical—spacing can make or break communication.*

Typography is the design of letterforms and the arrangement of them in two-dimensional space (for print and screen-based media) and in space and time (for motion and interactive media). Type is used as display or as text. Display type functions as a dominant typographic component and is usually large or bold. It functions as titles and subtitles, headlines and subheadlines, headings and subheadings. Text type is the main body of written content, usually in the form of paragraphs, columns, or captions.

NOMENCLATURE AND ANATOMY

Today, almost all type is produced digitally or is handmade; however, most type terminology is based on the earlier process, when type was cast in relief on a three-dimensional piece of metal (Diagram 3-01), which was then inked and printed. Some key terms follow; for more on nomenclature, including charts and terms, go to our website. **GD/s**

› **Letterform**: the particular style and form of each individual letter of our alphabet. Each letter of an alphabet has unique characteristics that must be preserved to retain the legibility of the symbols as representing sounds of speech.

› **Typeface**: the design of a single set of letterforms, numerals, and signs unified by consistent visual properties created by a type designer. These properties create the essential character, which remains recognizable even if the face is modified by design.

› **Type font**: a complete set of letterforms, numerals, and signs, in a particular face, size, and style, that is required for written communication (to see The Typographic Font Chart, go to our website). **GD/s**

› **Type family**: several font designs contributing a range of style variations based upon a single typeface design. Most type families include at least a light, medium, and bold weight, each with its own italic (to see The Typographic Family Chart, go to our website). **GD/s**

DIAGRAM [3-01]

CHART: METAL TYPE TERMS
CHART BY MARTIN HOLLOWAY

MARTIN HOLLOWAY GRAPHIC
DESIGN, PITTSTOWN, NJ

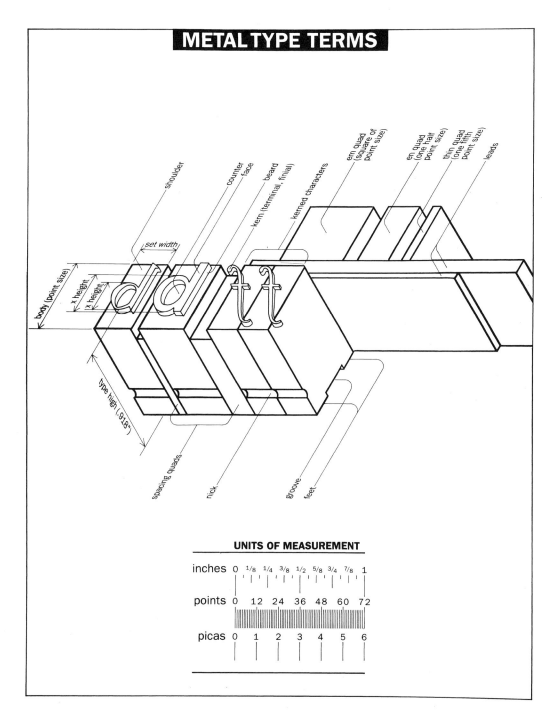

METAL TYPE TERMS

UNITS OF MEASUREMENT

> **Italics:** letterforms that slope to the right, a style variant of a typeface within a type family. Italics also refer to typefaces that suggest a cursive origin, inspired by written forms.

> **Type style:** modifications in a typeface that create design variety while retaining the essential visual character of the face. These include variations in weight (light, medium, bold), width (condensed, regular, extended), and angle (Roman or upright, and italic), as well as elaborations on the basic form (outline, shaded, decorated).

> **Stroke:** a straight or curved line forming a letter.

> **Serif:** a small element added to the upper or lower end of the main stroke of a letterform.

> **Sans serif**: a typeface with no serifs.
> **Weight**: the thickness of the strokes of a letter-form, determined by comparing the thickness of the strokes in relation to the height—for example, light, medium, and bold.

TYPOGRAPHIC MEASUREMENT

The traditional system of typographic measurement utilizes two basic units: the point and the pica. The height of type is measured in points, and the width of a letter or a line of type is measured in picas. Point size is the height of the body of a letter in a typeface; originating in metal type, it was a slug of lead the typeface was set upon. The width of a typeface is measured in characters per pica.

Most type is available in sizes ranging from 5 points to 72 points. Type that is 14 points and less is used for setting text and is called **text type** or **body copy**. Sizes above 14 points are used for **display type.**

Line length, which is the horizontal length of a line of type, is measured in picas. Approximately 6 picas = 1 inch; 12 points = 1 pica; approximately 72 points = 1 inch. Determining a suitable line length for readability depends on the design of the specific typeface, type size, line spacing, and length of the content.

DIAGRAM | 3-02 |

TYPE SIZE/LEADING CHART

Indication of type size and leading; the type size and the amount of leading you choose will enhance or detract from readability.

10/10 Gather material and inspiration from various sources and bring them together. Examine other cultures and draw inspiration from diverse styles, imagery, and compositional structures. Go to the movies, look at magazines, listen to comedians, read humorists' works, watch music videos, look at all graphic design, observe human behavior.

10/11 Gather material and inspiration from various sources and bring them together. Examine other cultures and draw inspiration from diverse styles, imagery, and compositional structures. Go to the movies, look at magazines, listen to comedians, read humorists' works, watch music videos, look at all graphic design, observe human behavior.

10/12 Gather material and inspiration from various sources and bring them together. Examine other cultures and draw inspiration from diverse styles, imagery, and compositional structures. Go to the movies, look at magazines, listen to comedians, read humorists' works, watch music videos, look at all graphic design, observe human behavior.

Spatial Measurement

A designer measures type as well as the spatial intervals between typographic elements. These intervals occur between letters, between words, and between two lines of type. The spatial interval between letters is called **letterspacing**. Adjusting the letterspacing is called **kerning**. The spatial interval between words is **word spacing**. The spatial interval between two lines of type is **line spacing**, traditionally called **leading** in metal type, where strips of lead of varying thickness (measured in points) were used to increase the space between lines of type. Many people still use the term *leading* to mean line spacing: the distance between two lines of type, measured vertically from baseline to baseline.

In metal type, letterspacing and word spacing are produced by the insertion of quads—metal blocks shorter than the type height—between pieces of metal type. Both traditionally and today, an "em" is used as a unit of measure. An em is the square of the point size of any type—a unit of type measurement based on the "M" character. One half of an em is called an "en." In digital typography, spacing is controlled using a unit system. A unit is a subdivision of the em, used in measuring and counting characters in photographic and digital typesetting systems.[1] The unit is a relative measurement determined by dividing the em into thin, equal, vertical measurements. When characters are digitally generated, each has a unit value including space on either side of the letter for the purpose of letterspacing, which can be adjusted by the designer.

BASIC TYPE SPECIFICATIONS

When a designer wants to indicate the type size and the leading, the following form is used: 10/11 indicates a type size of 10 with 1 point leading; 8/11 indicates a type size of 8 with 3 points leading. The amount of leading you choose depends on several factors, such as the type size, the x-height, the line length, and the length of the ascenders and descenders. When a designer does not want additional space between lines, type is set *solid*; that is, with no additional points between lines, such as 10/10 (Diagram 3-02).

CLASSIFICATIONS OF TYPE

Although numerous typefaces are available today, there are some major classification categories, by style and history, into which most fall (see Diagrams 3-03 and 3-04). It should be noted that these classifications are not hard and fast but vary among type historians.[2] Some classifications of type are:

› **Old Style:** Roman typeface, introduced in the late fifteenth century, most directly descended in form from letters drawn with a broad-edged pen. Characterized by angled and bracketed serifs and biased stress, some examples are Caslon, Garamond, Hoefler Text, and Times New Roman.

› **Transitional:** serif typeface, originating in the eighteenth century, represents a transition from Old Style to Modern, exhibiting design characteristics of both; for example, Baskerville, Century, and ITC Zapf International.

› **Modern:** serif typeface, developed in the late eighteenth and early nineteenth centuries, whose form is more geometric in construction, as opposed to the Old Style typefaces, which stayed close to forms created by the chisel-edged pen. Characterized by greatest thick–thin stroke contrast, vertical stress, and most symmetrical of all Roman typefaces; for example, Didot, Bodoni, and Walbaum.

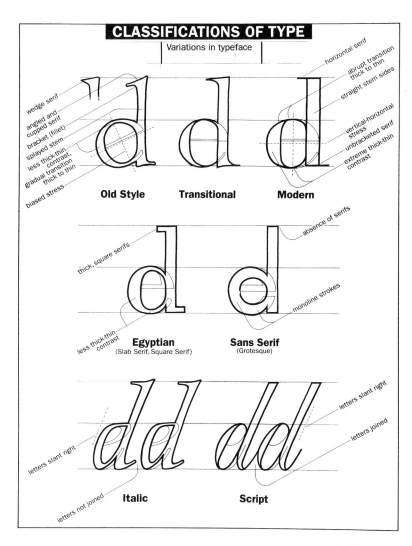

Old Style/Garamond, Palatino	San Serif/Futura, Helvetica
BAMO hamburgers	BAMO hamburgers
BAMO hamburgers	BAMO hamburgers
Transitional/New Baskerville	Italic/Bodoni, Futura
BAMO hamburgers	*BAMO hamburgers*
	BAMO hamburgers
Modern/Bodoni	
BAMO hamburgers	Script/Palace Script
	B A M O hamburgers
Egyptian/Clarendon, Egyptian	
BAMO hamburgers	
BAMO hamburgers	

DIAGRAM [3-03]

CHART: CLASSIFICATIONS OF TYPE CHART BY MARTIN HOLLOWAY

MARTIN HOLLOWAY GRAPHIC DESIGN, PITTSTOWN, NJ

DIAGRAM [3-04]

TYPEFACE EXAMPLES

> **Slab Serif:** serif typeface characterized by heavy, slablike serifs, introduced in the early nineteenth century; sub-categories are Egyptian and Clarendons. Slab serif typefaces include American Typewriter, Memphis, ITC Lubalin Graph, Bookman, and Clarendon.

> **Sans Serif:** typefaces characterized by the absence of serifs, introduced in the early nineteenth century; for example, Futura, Helvetica, and Univers. Some letterforms without serifs have thick and thin strokes, such as Grotesque, Franklin Gothic, Universal, and Frutiger. Sans serif typeface subcategories include Grotesque, Humanist, Geometric, and others.

> **Gothic:** typefaces based upon the thirteenth- to fifteenth-century medieval manuscript letterform; also called **blackletter.** Gothic characteristics include a heavy stroke weight and condensed letters with few curves. Gutenberg's first printing types were textura, a Gothic style. Examples include Textura, Rotunda, Schwabacher, and Fraktur.

> **Script:** typeface that most resembles handwriting. Letters usually slant and often are joined. Script types can emulate forms written with a chisel-edged pen, flexible pen, pointed pen, pencil, or brush; for example, Brush Script, Shelley Allegro Script, and Snell Roundhand Script.

> **Display:** typefaces that are used primarily for headlines and titles and would be more difficult to read as text type; they often are more elaborate, decorated, or handmade, and fall into any of the other classifications.

DIAGRAM [3-05]

TYPE ALIGNMENTS

justified

JACQUES DERRIDA'S theory of *deconstruction* asks how representation inhabits reality. How does the external images of things get inside their internal essence? How does the surface get under the skin? Western culture since Plato has been governed by such oppositions as *inside/outside* and *mind/body.*

centered

JACQUES DERRIDA'S theory of *deconstruction* asks how representation inhabits reality. How does the external images of things get inside their internal essence? How does the surface get under the skin? Western culture since Plato has been governed by such oppositions as *inside/outside* and *mind/body.*

flush left

JACQUES DERRIDA'S theory of *deconstruction* asks how representation inhabits reality. How does the external images of things get inside their internal essence? How does the surface get under the skin? Western culture since Plato has been governed by such oppositions as *inside/outside* and *mind/body.*

flush right

JACQUES DERRIDA'S theory of *deconstruction* asks how representation inhabits reality. How does the external images of things get inside their internal essence? How does the surface get under the skin? Western culture since Plato has been governed by such oppositions as *inside/outside* and *mind/body.*

ALIGNMENT

The style or arrangement of setting text type is called **type alignment** (Diagram 3-05). (The term *alignment* here is used more specifically than its broader definition in Chapter 2.) The primary options are as follows:

> Left-aligned: text aligned to the left margin and ragged or uneven on the right side; also called left-justification or flush left/ragged right.

> Right-aligned: text aligned to the right margin and ragged or uneven on the left margin.

> Justified: text aligned on both the left and right sides.

> Centered: lines of type centered on an imaginary central vertical axis.

> Asymmetrical: lines composed for asymmetrical balance—not conforming to a set, repetitive arrangement.

TYPE AS SHAPES

Each letterform is made up of positive and negative shapes. The strokes of the letterform are the positive shapes (sometimes just called forms), and the spatial areas created and shaped by the letterform are the negative shapes (or counterforms). The term **counterform** includes counters, the shapes defined within the forms, as well as the negative forms created *between* adjacent letterforms. The negative forms are as important as the positive forms, as demonstrated in the design of the logos in Figure 3-01 and Figure 3-02, where respectively, the "E" and "9" are formed by the negative shapes.

Each letterform has distinguishing characteristics. Some letters are closed shapes, like the "O" and "B," and some letters are open forms, like the "V" and "C." The same letterform can vary in form depending on the typeface, such as this lowercase g in the Times face and this lowercase g in the Helvetic face. Have you ever noticed the variations of the form of the letter "O" in the different typefaces? For example, the "O" in some typefaces is circular and in others it is oval (Diagram 3-06). You may want to compare letterforms in a few classic typefaces such as Bodoni, Garamond, Century Old Style, Futura, Times Roman, and Univers. (In this case, classic means a typeface

that has become a standard because of its grace, readability, and effectiveness.) It is a good idea to be so familiar with at least two classic typefaces that you know every curve and angle by heart.

TYPOGRAPHIC TEXTURE

One way to determine the graphic impact of a typographic solution is to measure the "typographic texture" of the solution. Here the term **typographic texture**, also called **typographic color**, refers to the overall density or tonal quality of a mass of type on a field—page or screen, usually referring to the mass of text type. In graphic design applications that require blocks of text, the value of the mass of the type block, paragraph, or column takes on a tonal quality, creating a block of gray tone. (See the typography in the spreads in Figure 4-11 as an example of typographic texture.) Typographic texture is established through the spacing of letters, words, and lines; by the characteristics of the typeface; by the pattern created by the letterforms; by the contrast of Roman to italic, bold to light; and by the variations in typefaces, column widths, and alignment.

Variations in typographic texture from paragraph to paragraph on a single field could contribute to the illusion of depth or could interrupt reading. For this reason, you must consider how you create typographic texture and for what purpose.

Here is a tip: Stand back and squint at typography to get a sense of its "lightness or darkness," its tonal quality, or view it in a mirror.

DESIGNING WITH TYPE

"The most important thing to keep in mind when designing with type is that its purpose is to communicate. It needs to be comprehended, usually quickly and easily.

"Type is inherently verbal in nature. That's not to say that it doesn't have a visual component as well. Every typeface has characteristics that convey meaning, however subtle or overt. Consider blackletter, wood type, and script faces. Letterforms from these categories contain an abundance of culturally informed information.

"But the visual aspects of type are meant to reinforce the verbal message. They provide context for the voice of the speaker, whether an individual or institution. As such, type choice is a critical aspect of effective communication.

"In addition, type treatment provides subtle levels of meaning to the reader. Violations of typographic norms can communicate in their own right, but they usually result from lack of care or skill on the part of the designer. Following these norms with respect to letterform proportion, letterspacing, wordspacing, leading, etc., results in messages that effectively convey the meaning of the speaker."

—Chris Herron
Chris Herron Design, Chicago

O
AVANT GARDE

O
FRANKLIN GOTHIC

O
MELIOR

O
BENGUIAT

O
FUTURA

O
OPTIMA

O
NEW CENTURY SCHOOLBOOK

O
HELVETICA

O
PALATINO

O
EGYPTIAN

O
FOOTLIGHT MT

O
PEPITA

DIAGRAM [3-06]

COMPARISON OF LETTERFORMS IN VARIOUS TYPEFACES

FIG. **3** / **03**

BOOK DESIGN: *DUGONG,*
MANATEE, SEA COW

· ART DIRECTOR/DESIGNER: CHARLES NIX
· ILLUSTRATOR: STEFANO ARCELLA
· AUTHOR: ARNOLD KLEIN
· PRODUCTION COORDINATOR: CHARLES NIX
· TRIM SIZE: 9 × 9 ¼ INCHES
· PAGES: 32
· QUANTITY PRINTED: 500
· COMPOSITOR: CHARLES NIX
· TYPEFACES: CASLON OPEN FACE,
 ENGRAVERS BOLD FACE, MONOTYPE
 GROTESQUE, USHERWOOD BOOK,
 BITSTREAM DE VINNE

*The poem refers to the geographic
locations of the dugong, manatee
and sea cow throughout, and so
the design steals aspects of late-
19th-century maps—line numbers
undulating like latitude lines, a
cordoned text block tucked low
and toward the spine like a legend,
pages lettered in circles rather
than numbered.*
—Charles Nix

Most people will
start a project with
the logo and then
try to incorporate
the type. Instead,
one should start by
selecting a type that
has characteristics
that best illustrate
the personality of the
brand, then design
the project.

—Jay Miller
Principal
IMAGEHAUS

Developing typographic skills entails *designing and
selecting for clarity and visual interest*, which means:
› *Selecting a typeface* or type family suitable for
concept, audience, context, and application
› *Facilitating reading* through determining proper
point sizes, spacing, line length, alignment, col-
umn depth, variation, and contrast
› *Orchestrating flow* of information through vis-
ual hierarchy

SELECTING A TYPEFACE

When there are thousands of typefaces readily
available, and more being designed each day, how
do you choose? For the book design of Figure
3-03, *Dugong, Manatee, Sea Cow*, Charles Nix
generated a design solution from the language
and content of the poem. Nix comments, "The

language is of a peculiar 19th-century style—
turning back on itself, using clauses to modify
clauses to modify clauses, and a vocabulary suited
to Victorian descriptions. The typography alludes
to the period: De Vinne and a host of other type-
faces are from that period."

Choosing a suitable face depends upon several
factors:

› *Visual Interest: Aesthetics and Impact*
As with any graphic design, creating visual inter-
est is paramount. Creating or selecting a typeface
for its aesthetic value and the impact it will have
on screen or in print is as important as creating a
visual. The individual characteristics of a typeface
matter greatly to communication and how well
any typeface will integrate with the characteristics
of the visuals. Each typeface should be evaluated
for its characteristics, aesthetic value based on
proportion, balance, visual weight, positive and
negative shapes of each individual letter, as well as
shape relationships between and among letters.

Realizing how display type will be *seen in con-
text*—up close, its impact from a distance, where
it is seen, lighting conditions, and more—should
be a consideration. How a typeface looks as dis-
play or text must be tested and evaluated. John
Sayles suggests doing the following exercise:

*"If there is a font I use more than others it is prob-
ably_____ because . . .*
*"—Helvetica: simple, easy to read, portrays a clear
message"*

› *Appropriateness: Concept*
Jay Miller, Principal, IMAGEHAUS, further
advises: "Before you choose a typeface, clearly
define the audience, tone, personality and attitude
of what you are trying to communicate and how
you want to say it. This will help you strategi-
cally choose the right font to ensure successful
communication."

Very often, beginning students and nondesign-
ers simply choose typefaces for their attractive-
ness and do not consider the concept or have
little understanding of what a typeface connotes,
of its history, and of its provenance. For example,
choosing a face associated with a period, such as

art deco, or associated with an era or industry carries meaning, even if you aren't aware of it.

This is where knowing type classifications and history comes strongly into play. For example, would you use American nineteenth-century wood type for a magazine article about the history of East Asia? Or would it be sound to use Tobias Frere-Jones's typeface Whitney (for the Whitney Museum in New York) for a catalog for the Prado Museum in Madrid or for a dog food brand?

For a retrospective of Werner Herzog films at San Francisco's Museum of Modern Art, Jeremy Mende, MendeDesign, wanted the poster to communicate the essence of selected Herzog films, about man's struggle against the universe, while also communicating something about Herzog himself. In an interview with Romy Ashby in *Step Inside Design* magazine, Mende said about Figure 3-04,

"We chose the horizon to represent this vast, unyielding force and selected film stills that suggested the smallness of man against this backdrop." Romy Ashby explains, *"Over those images, lists of adjectives were written—words such as conquistador, soldier, baron and mystic—meant to purposefully confuse descriptions of Herzog's main characters with descriptions of Herzog himself. At first glance the typography appears to be digitally generated, and most people will assume that it is. But up close, idiosyncrasies of hand-drawn letterforms become apparent, revealing an obsessive attempt to recreate 'the perfect' that Herzog likewise obsessively seeks to capture in his films."*[3]

> *Clarity: Readability and Legibility*

If typography is readable and legible, then content should be clearly understood. Essentially, ensuring *readability* means text is easy to read, thereby making reading enjoyable (and frustration-free) as well as interesting. How you design with a suitable typeface, with considerations of size, spacing, margins, color, and paper selection, contributes to readability. *Legibility* has to do with how easily a person can recognize the letters in a typeface—how the characteristics of each individual letterform are distinguished. Here are some pointers:

› Typefaces that are too light or too heavy may be difficult to read, especially in smaller sizes.

FIG. **3**/**04**

POSTER: *WERNER HERZOG RETROSPECTIVE*

· MENDEDESIGN, SAN FRANCISCO
· ART DIRECTOR: JEREMY MENDE
· DESIGNERS: AMADEO DESOUZA, STEVEN KNODEL, JEREMY MENDE
· CLIENT: SAN FRANCISCO MUSEUM OF MODERN ART

› Typefaces with too much thick–thin contrast may be difficult to read if they are set very small—the thin strokes may seem to disappear.

› Condensed or expanded letters are more difficult to read because the forms of the letters change, as well as appearing to merge together when condensed and dissociate when expanded.

› Text type set in all capitals is difficult to read. Opinions differ on whether all caps enhance or diminish readability for display type.

› Greater value contrast between type and background increases readability.

› Highly saturated colors may interfere with readability.

› People tend to read darker colors first.

> *Relationship: Integration with Visuals*

With literally thousands of typefaces available, selecting a typeface may seem daunting. As you will read in Chapter 5, in any design, one must be mindful of the relationship between type and visuals.

The poster in Figure 3-05 from Morla Design is a clear example of how the type and image work synergistically to communicate meaning.

When integrating type and visuals based on the design concept, answering the following questions can guide your decisions:

› Should the typeface share visual characteristics with the visuals?

› Should the typeface be neutral and allow the visual to drive the solution?

› Should the typeface dominate the solution?

› Should the typeface contrast with the characteristics of the visuals?

› Would handmade letters work best?

For *The New York Times Magazine* "White Mischief" spread, we see parallel shapes and forms on the facing pages, with each page having a central axis that repeats the other, contributing to balance and unity (Figure 3-06). Paula Scher created a now famous poster series for the Public Theater, which was often imitated, creating an integrated type/visual vocabulary that became synonymous with the Public Theater as well as with Manhattan (Figure 3-07).

INTERIOR PAGE COMPOSITION: VOLUME OF TEXT AND IMAGES

Communication requirements, content, and the nature of an application and its content—the volume of text and images—help guide your type decisions about structuring type.

Text Heavy

If an application is text heavy, such as the *running text* (text that runs from column to column often filling a page) in a history textbook, an annual

FIG. **3** / **05**

POSTER: *ENVIRONMENTAL AWARENESS, AIGA*

· MORLA DESIGN, SAN FRANCISCO
· ART DIRECTOR: JENNIFER MORLA
· DESIGNERS: JENNIFER MORLA, JEANETTE ARAMBU
· CLIENT: AIGA, SAN FRANCISCO

The visualization of the type and image in the top half of this poster contrasts with the visualization of the negative visual and sans serif caps depicted in the bottom half of the poster. Together they communicate the need for environmental awareness.

FIG. **3** / **06**

THE NEW YORK TIMES MAGAZINE, "WHITE MISCHIEF"

· CREATIVE DIRECTOR: JANET FROELICH, *THE NEW YORK TIMES MAGAZINES*
· DESIGNER: JANET FROELICH
· PHOTOGRAPHER: RAYMOND MEIER

Approaching an opening spread as an opportunity to attract a reader and inspire him or her to read further is the main objective.

report, or a government website, that prerequisite should narrow your choices to faces that are eminently readable, as well as a face from an extended type family, which offers many options while aiding unity. (Most likely, a text-heavy application also will call for a column grid.)

Text and Images

If an application has an almost equal volume of text and images, then you need to select a highly readable face based on your design concept, audience, context (print or screen and environment), a typeface that integrates in a satisfactory, appropriate, and aesthetic manner with the images. Also consider how the type will act as text, caption, and perhaps display type all in relation to the images, as in Figure 3-08. (See "Case Study: Rutgers University-Newark: A Century of Reaching Higher.")

Image Heavy

If an application primarily requires display type (title or headline), for example, a cover, poster, advertisement, splash page, or banner, then your selection is primarily governed by concept and context. Although some argue that readability of display type is not critical because there is little content to read, I submit that people become frustrated when readability is diminished. For display type, some people argue that a well-designed sans serif typeface is most legible—easiest to recognize. Others argue that serifs aid in distinguishing one letter from another. For display type, any well-designed face would likely be legible, which is certainly a concern because people tend to read titles and headlines very quickly. Judicious spacing and larger point sizes will increase the readability of display type. To encourage a reading sequence, thoughtful placement and positioning within the composition are important as well.

Caption Heavy

If the typography in an application is predominantly captions or tables—for example, a catalog, map, art book, or photo sharing website—then your selection should consider how readable the face is at a smaller point size and how well it integrates with the images.

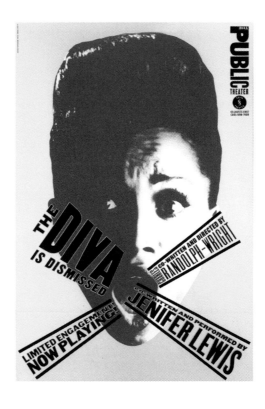

FIG. **3** / **07**

POSTER: *THE DIVA IS DISMISSED*

· PENTAGRAM DESIGN, NEW YORK
· PARTNER/DESIGNER: PAULA SCHER
· DESIGNERS: RON LOUIE, LISA MAZUR, JANE MELLA
· PHOTOGRAPHER: TERESA LIZOTTE
· CLIENT: PUBLIC THEATER, NEW YORK

When Joseph Papp was producer at the Public Theater, Paul Davis produced a memorable series of illustrated posters which set the standard for theater promotion for nearly a decade. In keeping with the expanded vision of new producer George C. Wolfe, a new identity and promotional graphics program were developed to reflect street typography: active, unconventional, and graffiti-like. These posters are based on juxtapositions of photography and type.

The Diva Is Dismissed was Jennifer Lewis's one-woman show.
—Pentagram

FIG. **3** / **08**

INTERIOR BOOK DESIGN: *2D: VISUAL BASICS FOR DESIGNERS* BY ROBIN LANDA, ROSE GONNELLA, AND STEVEN BROWER

· STEVEN BROWER DESIGN, MATAWAN, NJ
· ART DIRECTOR: STEVEN BROWER
· DESIGNERS: STEVEN BROWER, DAWNMARIE MCDERMID
· CENGAGE LEARNING
· © 2008 STEVEN BROWER

CASE STUDY

RUTGERS UNIVERSITY–NEWARK: A CENTURY OF REACHING HIGHER/BRENDA MCMANUS & NED DREW

Description: This is a publication commissioned by the university to celebrate the 100-year history of higher education in Newark, NJ.

Problem: Design a publication for the university highlighting the rich 100-year history of higher education in Newark.

Process: We were provided with a rough manuscript of the history of higher education in Newark. After reading it, we discussed revisions with the editor. We felt the manuscript lacked a necessary structure. With the editor, we reworked the manuscript from less of a narrative to more of a time-based, progressive history. At this time, we also began sorting through the images we were provided and categorizing them into decades. We collected the yearbooks throughout the decades, as well as student newspapers, miscellaneous documents, papers, and folders. This collecting and gathering of materials, categorizing, and organizing was a necessary and very important first step for us. The research we compiled started to slowly reveal the structure and visual tone of the book.

Structure: It is important to understand that a designer doesn't have to be a passive partner when it comes to establishing content. We were fortunate and took advantage of the opportunity to become active participants in establishing the content for the publication. From our interaction with the editor and our own research, we decided to divide the book into decades. We also decided we would need a system for the following information in each chapter:

1 / Headline treatment
2 / Body copy
3 / Pull quote
4 / A timeline element
5 / An illustration to give the text a visual context
6 / A snapshot image of the campus or environment of that particular decade
7 / An alumnus profile, which would consist of an image and brief text
8 / A folio (page number) system
9 / Small silhouette image of students from that particular decade

Now that we had identified our elements, we started to investigate formats. The horizontal format seemed to make the most sense because we were presenting a historical timeline. We considered a smaller format since this publication would be a gift to donors for the centennial gala celebration. The smaller format had a more personal, intimate feeling. The grid structure was determined loosely on a mathematical equation using the golden section, which would help us determine the best proportions of text to page format. Once we started playing with the elements on the page, we did make the necessary optical adjustments. After all, design is not a perfect science.

We felt, with our access to a seemingly endless library of rich historical images, it was a great opportunity to convey a sense of time through the use of images. Each chapter opens with a snapshot image of the campus during that particular decade. This helps the viewer place content in the context of the time period.

In each chapter, we decided to create illustrations/collages to help communicate the social, political, and academic pulse of that particular time period. We reinforced this notion with the suggestion and design of a small timeline highlighting the events taking place in Newark. The university's historical facts were then juxtaposed with the major events of the world at that particular time in history. We felt it would help the viewer put in context the achievements, actions, and demographics of each particular decade.

Academic collateral was used throughout the book as a foundation for the design. We gathered and scanned various papers, book spines, documents, yearbook images, student newspapers, folders, notebooks, and so on to help reinforce the tone of an academic environment. We also

introduced a small, silhouetted image of students appropriate for each decade to support the notion of an academic environment. These images also help the reader navigate through the text.

Setting a rhythm or pace for any narrative/book is always important. We took this into consideration when not only establishing the use of images but also the typographic flow of the book.

Each chapter opens with a large vertical headline, followed by a column of text set at a large point size. The use of the larger point size is more stylistic than functional. The text was originally designed using the same point size as the body copy, but the balance of the page visually seemed off. Increasing the point size for the first column gave a greater presence to the copy and felt more balanced and inviting visually. The larger text takes on a greater importance and presence, which naturally makes the text feel less overwhelming and more accessible.

The body copy is designed using a two-column grid. Again, our grid was loosely based on the golden section; our goal was to balance proportions of text to the page format. We wanted the copy to have a nice balance and inform the reader without feeling too dense and overwhelming. We did several iterations of the two-column page using various point sizes and leading. These studies were very instrumental in helping us achieve the proper balance for optimal readability.

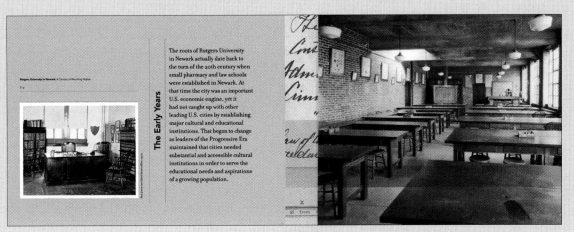

BOOK: *RUTGERS UNIVERSITY–NEWARK: A CENTURY OF REACHING HIGHER*

· DESIGNERS: BRENDA MCMANUS AND NED DREW, NEW YORK

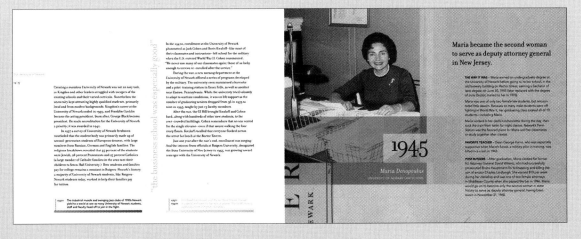

FACILITATING READING

Socrates is attributed with extolling the desirable quality of moderation—"take everything in moderation; nothing in excess." Applied to facilitating reading, this axiom would mean common sense dictates:

› Long line lengths impede readability
› Very small point sizes and extreme column depths impede reading
› Very open spacing and very tight spacing impede readability
› Left justification or justified text type alignments are most readable (depending on attention to spacing)
› When composing text type, headings, and subheadings, break text into manageable chunks
› Avoid extreme rags, widows, and orphans
 – The irregular side of a left-justified block of text type should not be extremely ragged; any ragged edge should not impede reading. Major variation in line lengths will result in negative shapes that interrupt the flow of moving from one line to the next.
 – Avoid ending a paragraph or column with a widow, a very short line length usually composed of one or two words. Widows do *not* contribute to balance. The last line length should be long enough to act as a base or platform; it should have enough "visual word weight to carry" the paragraph or column, to ensure balance.
 – Avoid starting a paragraph on the next page with an orphan, a one- or two-word line. This doesn't look balanced.

To ensure readability, for text type especially, moderation is the rule. Display type can be more extreme, though readability is always an issue for all type as literal message.

Variation and contrast complement moderation. Without variation and/or contrast in text type, any reader would become tired and perhaps bored. *Variation creates visual interest*; break up text type with a

› pull quote
› visual
› initial cap
› color
› rule
› paragraph that starts with small caps or all caps
› graphic element, such as a rule, simple graphic, or dingbat
› anything that makes sense for your concept and adds some variation, some rest stop of visual interest, for the reader

ORCHESTRATING FLOW OF INFORMATION

Just as with designing any visual hierarchy, many factors contribute to organizing type according to emphasis, from most important message to least important content.

The designer must determine what to emphasize and what to de-emphasize. (Please see Chapter 2 on two-dimensional basics for more general information on visual hierarchy.)

There are several ways to achieve emphasis within an entire composition using typography:

› Emphasis by isolation
› Emphasis by placement
› Emphasis through scale (size relationships of title to subtitle to text as well as to images)
› Emphasis through contrast
› Emphasis through direction and pointers
› Emphasis through diagrammatic structures

There are also ways to achieve emphasis in text type/body copy:

› Size
› Color
› Boldface
› Italics
› Typeface change
› Type style change—variations in weight (light, medium, bold), width (condensed, regular, extended), and angle (Roman or upright and italic), as well as elaborations on the basic form (outline, shaded, decorated)

Fundamental organizational principles also apply to typographic design. When arranging typographic elements, besides visual hierarchy, you should consider rhythm and unity. You direct the reader from one typographic element to another by using visual hierarchy and *rhythm* (a pattern created through position of components, intervals, repetition, and variation), by considering the

space between elements, and by establishing a sense of movement from one element to another, as in Figure 3-09.

To establish *unity*, limit type alignments (for a novice, employ one alignment), consider employing a type family rather than mixing faces or mix two faces at most, intentionally integrate type and visuals using a sympathetic or purposeful contrast, use color to unify, and aim for correspondence.

In the logo design by Red Flannel, between the type and image Jim Redzinak finds what is called an intuitive alignment, finding edges that seem to naturally align well together (Figure 3-10), where the word "Spirit" seems to naturally "fit" in the negative shape of the butterfly.

SPACING

The three types of spacing you have to control when designing with type are letterspacing, word spacing, and line spacing. Spacing should enhance reader comprehension or, at the very least, enrich the reader's experience (unless, of course, your concept and approach call for purposeful dissonance). If people have difficulty reading something, they probably will lose interest. *Spacing is about transitions*—from letter to letter, from word to word, from line to line, from paragraph to paragraph, from page to page, from screen to screen. Seventy percent of how you design with type depends on how well you craft transitions!

When a character is produced digitally, the software automatically advances in numbers of units before generating the next character. It is not a good idea to rely on automatic spacing when designing with display type. The designer can control the letterspacing by adding or subtracting units between letters to improve readability.

Since computers calculate spatial intervals— units—according to type metrics (preset calculations for each font), designers should consider the type as form, adjusting letter, word, and line spacing for balance and visual relationships. For example, the computer may automatically set the same distance between an "H" and an "N" as it does between an "L" followed by an "A," yet the

The Bookbinders' Guild of New York
Twenty First Annual

New York Book Show

March 6, 2007
Manhattan Center Studios : The Grand Ballroom
311 West 34th Street : New York City

FIG. **3** / **09**

POSTER: *THE NEW YORK BOOK SHOW*

· DESIGNER: RAY CRUZ, OAKLAND, NJ
· CLIENT: THE BOOKBINDERS' GUILD OF NEW YORK

The viewer can easily flow from one piece of information to another due to placement and intervals in the composition as well a clear visual hierarchy.

Spirit of a Child Foundation

FIG. **3** / **10**

LOGO: SPIRIT OF A CHILD FOUNDATION

· RED FLANNEL, FREEHOLD, NJ
· CD/DESIGNER/ILLUSTRATOR: JIM REDZINAK
· CLIENT: SPIRIT OF A CHILD FOUNDATION

This logo symbolizes the metamorphosis of the dysfunctional cycle of destructive parent-child relationships, transforming them into something more meaningful and rewarding through their experiences with nature. It represents a new beginning for the children and their parents.
—Jim Redzinak

shapes between the letters in the second pair are quite different and can be moved closer together to enhance readability and cohesiveness.

You should always judge the letterspacing optically. When designing display type, it is feasible to adjust the spacing of individual characters because the number of words in headlines is limited. This fine-tuning of negative space is a hallmark of typographic excellence.

TEXT TYPE: SPACING, PACING, CHUNKING, AND MARGINS

Spacing

When designing text, check word spacing, line length, widows, orphans, and the raggedness of a ragged edge.

Always consider the point size of the typeface in relation to the amount of spacing; for example, small point sizes set with a lot of leading will

When setting type, whether it's a big, two-word headline or a big, two-hundred-page document, one of the most overlooked aspects is the space between the letters, the words, the sentences and the paragraphs. This is as important as which typeface you choose and at what size you use it. Everyone can look at type and design with it but it takes a real craftsperson to look at the negative space and define the true relationship within the typography. Whether it's loose or tight, it has to be consistent and pleasurable, and it's right there, you just have to shift your attention.

—Armin Vit
UnderConsideration
LLC

seem "lost" and hard to read. Generally, longer line lengths should take more leading to offer some "breathing" room.

Too much space may detract from readability; conversely, too little space may make reading difficult. As stated earlier, you must not trust automatic spacing; always make adjustments. Also, in text and display type, uneven letterspacing and word spacing may cause unwanted pauses or interruptions that make something more difficult to read. John Sayles advises being aware of word breaks (widows, orphans) and suggests reading the copy as you lay it out, following the same process as the reader, to ensure a flow.

Similarly, if the line length is too long or too short, it will detract from readability. For example, some designers say that if you have open letterspacing, the word spacing should be open. Conversely, if you have tight letterspacing, the word spacing should be tight as well. Much depends on the typeface or family you are using and the point sizes, weights, and widths, since some typefaces seem to lend themselves to more open spacing because of their shapes; others lend themselves to tight spacing. Study specimens of display and text type to develop an "eye" for typefaces, weights, and widths.

Chunking and Pacing

When we read a novel or short story, we expect a full one-column page of text. Paragraphs help break up the page of a novel. In most instances—newspapers, reports, brochures, and even textbooks—written content is most appealing when broken into modules, into chunks of written content. For any screen-based message, chunks of text are the best choice. (For screens, keep line lengths a bit shorter than for print.) When you modularize content, it is broken into manageable, digestible units. Many people scan written content for specific information, which is enabled by chunking along with other devices such as rules, subheads, color, and other ways to create emphasis. Other readers find it easiest to take in information and absorb it in module doses.

How you compose modules or chunks will create a reading pace. Depending on the background color, typeface selection, and typeface color, each chunk will become a tonal unit and help or impede moving from one unit to another.

Pacing involves creating a visual sense of rhythm, syncopation, variation—creating visual interest and giving the reader's eyes a rest somewhere in the text.

Margins

Understanding margins as borders—as presenting written content—will undoubtedly aid in respectfully "framing" text, giving enough distance from the boundaries of a page, in print or on screen, to allow a reader to focus. Certainly, margins can be used creatively, but they can never be ignored or violated without purpose.

MIXING TYPEFACES

Most designers mix faces when they want *distinction between display type and text type*. Other designers mix for conceptual, creative, and/or aesthetic reasons. There are general type rules for beginners and, perhaps, for any designer. The most common rule is to restrict designing to *utilizing a type family* or to *no more than two typefaces*. Before our discussion of mixing faces, it behooves us to consider *not mixing*.

TYPE FAMILY

It's been said that a type family is like a variation on a theme. In a family, all the typefaces maintain the same basic structure with variations, differentiated by slight individual characteristics. A well-conceived, well-designed family includes variation—variations in weight from ultra light to ultra black; variations in width from condensed to extended; multiple character sets, such as small capitals, titling capitals, swash capitals; and more. *Employing a type family affords enormous flexibility as well as contributing to unity.*

MIXING TWO TYPEFACES

Being creative involves experimentation. Having guidelines or grasping standards allows you to critique your experiments. The following provides a point of departure for readable, coherent compositions.

Experiment with Type

Experiment by testing how the typefaces work in various combinations: heading plus paragraph; short and long paragraphs; headings, subheadings, captions; and so forth.

Limit Mixing and Select for Contrast

Most seasoned designers advise limiting mixing to two typefaces per solution—one for display and one for text—for example, a sans serif for display and a serif for readable text. The obvious point of mixing faces is differentiation (for example, to make captions distinct from text) and to add contrast to the visualization of a concept. The equally obvious reason to avoid selecting similar faces is that the reader would not be able to tell them apart. Therefore, select for contrast yet be mindful of similar structure, with suitability to overall concept and visualization clearly in mind.

Selecting for contrast might mean mixing typefaces based on differences in structure—selecting from different structural classifications—for example, mixing a sans serif face with a slab serif face. Do consider how one face will transition to the other and how well their proportions work to create harmony and typographic texture on the field (page or screen).

Janet Slowik, Senior Art Director, Pearson Professional & Career, advises: "In editorial design the type and image should coexist harmoniously, and one should never overpower the other. They should complement each other. Novice designers often select elaborate display typefaces that conflict with the image. A good selection of a serif and sans serif typeface that contain a corresponding italic is all that is needed . . . a proficient designer helps."

Use Decorative Faces with Great Caution

Decorative faces tend to be highly ornamental, often faddish. Some have endured, such as those based on copperplate engravings or wood type. Many decorative faces include outlines, in-lines, stencils, or faceted, shaded, and shadowed letters; because decorative faces tend to overwhelm a design (and designer), they should be left to seasoned designers. If you must use a decorative face, use it for display type in very small quantities and mix with a timeless face for text.

HANDMADE/HAND-DRAWN TYPE

Although most rely on selecting from digital faces, others go for handmade type. Try hand-drawn, collaged type (not ransom type) or found type, which includes photographed type (for example, see www.neonmuseum.org). Some designers focus on hand-drawn typography, such as Ed Fella (Figure 3-11), Martin Holloway (Figure 3-12), and Mike

FIG. **3** / **11**

POSTER: *AND YOU ATE NOTHING*

· ED FELLA

FIG. **3** / **12**

LOGO: COUNTRY THINGS

· MARTIN HOLLOWAY GRAPHIC DESIGN, PITTSTOWN, NJ
· LETTERING/DESIGNER: MARTIN HOLLOWAY

FIG. **3** / **13**

TYPOGRAPHY:
URBAN OUTFITTERS

· MIKE PERRY

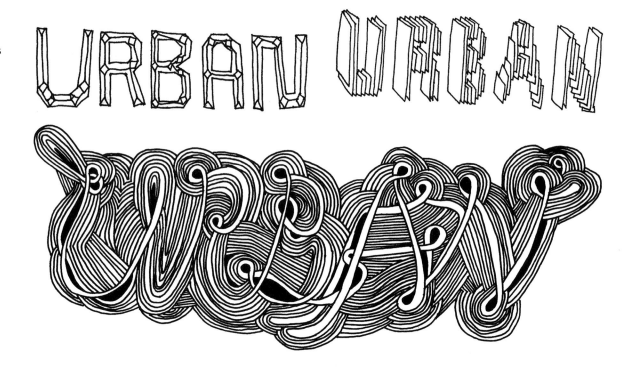

FIG. **3** / **14**

EDITORIAL ILLUSTRATION: "SO
FIVE MINUTES AGO"

· RICK VALICENTI/THIRST/3ST.COM,
 CHICAGO
· TYPOGRAPHY: RICK VALICENTI/3ST
· 3D ILLUSTRATION: RICK VALICENTI/3ST
 AND MATT DALY/LUXWORK
· CLIENT: *I4DESIGN MAGAZINE*, CHICAGO

The typographic geometry is
consciously rendered by Paul
Rand's YALE press logotype and by
looking back to this master's iconic
work, the continuum in which we
practice design is acknowledged
and respected.
—Thirst

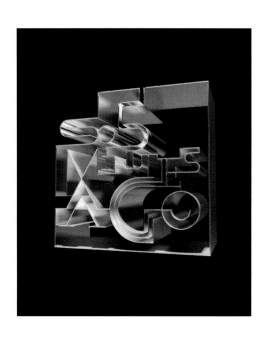

Perry (Figure 3-13). (For more about handmade type and elements, see Mike Perry's book, *Hand Job: A Catalog of Type* and *Fingerprint: The Art of Using Hand-Made Elements in Graphic Design* by Chen Design Associates; see Figure 3-25.)

Figure 3-14 is an editorial illustration for *i4Design Magazine*; "a comment on architecture's ephemeral fashionable presence is rendered in polished stainless." About Figure 3-15, a personal work made public for "5:12: China's Massive Earthquake: A Commenorative Exhibition" in Nanjing, Rick Valicenti/3st comments, "My entry was inspired by the calligraphy on display at the Chinese National Museum in Shanghai. I decided to enter my journal entries in large form and physical in expression. My marks were made with sumi ink applied with either a syringe or a foam brush on 22 × 30" Rives BFK. Gravity's influence is also a central component within the temporal nature of this making process. Since the beginning of 2008, I have made over 500 entries."

TYPE AS SOLUTION

In addition to understanding the fundamentals of design and how they relate specifically to designing with type, it is essential to understand how type is used creatively and expressively. Type becomes the solution for the following design concepts. In Figure 3-16, Jeremy Mende expresses a conference theme in unique typography. The Mesa Grill logo is a play on the word *mesa*, which means "flat-topped mountain" (Figure 3-17).

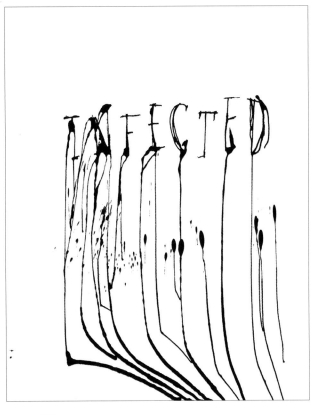

FIG. **3** /**15**

INFECTED

- STUDIO/DESIGNER/TYPOGRAPHY:
 RICK VALICENTI/THIRST/3ST.COM, CHICAGO
- CLIENT: PERSONAL WORK MADE PUBLIC FOR "5.12: CHINA'S MASSIVE
 EARTHQUAKE: A COMMEMORATIVE EXHIBITION", RCM ART MUSEUM, NANJING

FIG. **3** /**17**

LOGO: MESA GRILL

- ALEXANDER ISLEY INC., REDDING, CT
- CLIENT: MESA GRILL

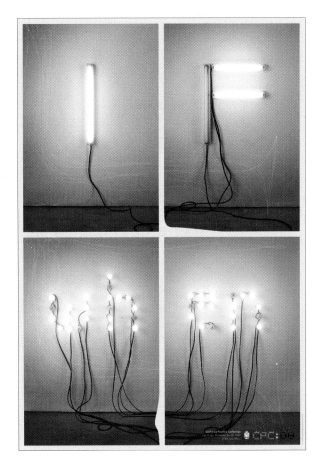

FIG. **3** /**16**

POSTER: *IF NOT NOW, WHEN?*

- MENDEDESIGN, SAN FRANCISCO
- ART DIRECTOR: JEREMY MENDE
- DESIGNERS: JENNIFER BAGHERI, AMADEO DESOUZA, JEREMY MENDE
- CLIENT: AIA CALIFORNIA COUNCIL CALIFORNIA PRACTICE CONFERENCE

Light-based letterforms illuminate the conference's theme.

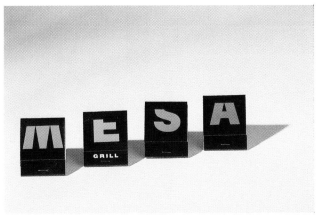

FIG. **3** / **18**

CORPORATE IDENTITY: CALGARY INTERNATIONAL FILM FESTIVAL

· WAX, CALGARY, AB
· CREATIVE DIRECTORS: MONIQUE GAMACHE, JOE HOSPODAREC
· ART DIRECTOR: JONATHAN HERMAN
· COPYWRITERS: SEBASTIEN WILCOX, SARO GHAZARIAN
· CLIENT: CALGARY INTERNATIONAL FILM FESTIVAL

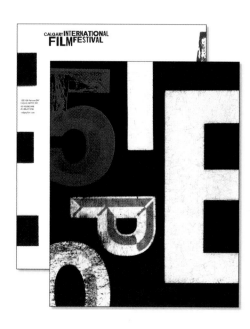

FIG. **3** / **19**

BRAND STRATEGY, BOTTLE DESIGN, PACKAGE DESIGN: BLOSSA ANNUAL EDITION

· BVD, STOCKHOLM
· CREATIVE DIRECTOR: CATRIN VAGNEMARK
· DESIGN DIRECTOR: SUSANNA NYGREN BARRETT
· CLIENT: V&S GROUP

Assignment: *Brand strategy, bottle design, packaging design, Blossa årgångsglögg (vintage mulled wine). Nordic region*

Challenge: *Blossa annual edition is an important member of the Blossa family. It is launched every year with a new flavor and design. The aim of the vintage mulled wine is to generate awareness of Blossa ahead of the mulled wine season and drive sales across the whole range. The design needs to capture the essence of the year's flavor and be unique and alluring.*

Solution: *A bottle that is shorter and rounder than other Blossa products. The shape of the bottle is kept from year to year, with the colors and typography changing to reflect that particular year's design and flavor.*
—BVD

Some view type as the verbal part of the design message, providing context and support for the imagery. However, that view is a limiting one. Type should always be an active contributor and can, in fact, be the image itself, expressing the entire message.

The identity in Figure 3-18 "borrows from the visual language of the marquee signs that hang in front of most festival venues. The letters had been gathering dust in the 80-year-old basement of Calgary's historic Plaza Theatre. It's eclectic, bold, and we feel it communicates the excitement, immediacy and energy of the Calgary International Film Festival," says Jonathan Herman of WAX.

For the Blossa Annual Edition series, the colors and typography change to reflect that particular year's design and flavor (Figure 3-19). The "O" in the Polaris logo acts as both image and letterform (Figure 3-20).

Figure 3-21, "Ametrica!" is an awareness campaign to help convert the United States to the metric system, which is typographically (and specifically) number driven.

Providing equal access to the law is expressed through the typography in Figure 3-22, an annual report for Chicago Volunteer Legal Services.

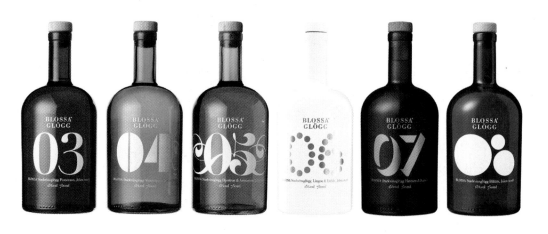

POLARIS

FIG. **3** / **20**

LOGO: POLARIS

· REGINA RUBINO / IMAGE: GLOBAL VISION, SANTA MONICA, CA
· CREATIVE DIRECTORS: ROBERT LOUEY, REGINA RUBINO

FIG. **3** / **21**

PROMOTIONAL CAMPAIGN: "AMETRICA!"

· AMY WANG

No one thinks about an act as routine as measuring, much less the impact it can have on education, economy, and health. Through bold numbers and subtle humor, viewers are initially invited to interact with the pieces and their environment such that they experience metric units directly, rather than through comparison with customary units (which perpetuates the problem of dependency on the old units). Those intrigued by the issue are then directed to visit the Ametrica! website for more information, interactive components, and motion graphics experiences.
—Amy Wang

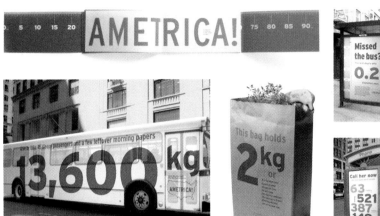

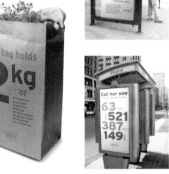

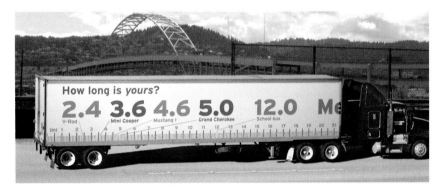

FIG. **3** / **22**

ANNUAL REPORT: CHICAGO VOLUNTEER LEGAL SERVICES

· LOWERCASE, INC., CHICAGO
· ART DIRECTOR/DESIGNER/ILLUSTRATOR: TIM BRUCE
· PHOTOGRAPHER: TONY ARMOUR
· CLIENT: CHICAGO VOLUNTEER LEGAL SERVICES

Chicago Volunteer Legal Services is one of the largest practicing law firms in the city. Through panel referral, neighborhood clinics and the foundation itself they provide legal assistance to roughly 17,000 people a year in the Chicago area. They accept no government funding, are lean and entrepreneurial. Our books help them increase awareness for their work, raise money and recruit talent. Each of the books reflects this purpose and yet captures the year and point of view uniquely.
—Tim Bruce, LOWERCASE, INC.

FIG. **3** / **23**

BOOK COVER: *THE FATE OF THE NATION STATE,* **EDITED BY MICHEL SEYMOUR**

· SALAMANDER HILL DESIGN, QUEBEC
· DESIGNER: DAVID DRUMMOND
· CLIENT: MCGILL-QUEEN'S UNIVERSITY PRESS

FIG. **3** / **24**

BOOK COVER: *CROSSING THE BLVD: STRANGERS, NEIGHBORS, ALIENS IN A NEW AMERICA*

· AUTHORS: WARREN LEHRER AND JUDITH SLOAN
· DESIGNER AND PHOTOGRAPHER: WARREN LEHRER

In this book, we use Queens BLVD—the thirteen-lane treacherously dangerous pedestrian crosswalk that cuts through the borough—as a metaphor for many of the things new immigrants have crossed coming to and navigating their way within this country: war, ethnic cleansing, economic hardship, discrimination, cultural and language divides.
—Warren Lehrer

FIG. **3** / **25**

BOOK COVER: *FINGERPRINT*

· CHEN DESIGN ASSOCIATES, SAN FRANCISCO
· CREATIVE DIRECTOR/ART DIRECTOR: JOSHUA C. CHEN
· COVER DESIGNER: JENNIFER TOLO PIERCE
· DESIGNERS: JENNIFER TOLO PIERCE, MAX SPECTOR, JOSHUA C. CHEN, JENNY JI, ASHLEY HOFMAN
· ESSAY CONTRIBUTORS/DESIGNERS: MICHAEL MABRY, DEBBIE MILLMAN, JEAN ORLEBEKE, MARTIN VENEZKY, ROSS MACDONALD, JIM SHERRADEN
· EDITORS: JOSHUA C. CHEN, JENNIFER TOLO PIERCE, KATHRYN A. HOFFMAN
· ILLUSTRATOR: JENNIFER TOLO PIERCE
· CLIENT: HOW BOOKS

Chen Design Associates authored and designed this vivid exploration as inspiration for a field parched with predictable, look-alike, hi-tech solutions. Includes a foreword by Michael Mabry, essays by industry heroes, and insights into each featured project to reconnect designers with their passion.
—Chen Design Associates

About the type design for *The Fate of the Nation State* (Figure 3-23), David Drummond says: "This book deals with the future viability of nation-states in the context of globalization. I don't often do type-only covers but when I do I try to add a twist and have type interact in some way with the created environment."

Figure 3-24, the book cover for *Crossing the BLVD*, is a cross-media project by Warren Lehrer and Judith Sloan that "documents and portrays the largely invisible lives of new immigrants and

refugees that live in the borough of Queens, New York—the most ethnically diverse locality in the United States." Lehrer uses type crossing the "BLVD" as a metaphor.

Figure 3-25, Chen Design Associates' cover design for *Fingerprint*, subtitled "The Art of Using Handmade Elements in Graphic Design," features a unique typographic treatment that simultaneously communicates "creative" and "hand-wrought." Max Spector, Art Director and Senior Designer, Chen Design Associates, comments, "The topic of this book, handmade elements in graphic design, is represented on the cover. The title type and

background are scanned from original hand work; the subtitle and author credit are printed on a label, then wrapped around the front cover. Additional tactile qualities are achieved with debossed type and textured paper."

Experimenting with type is one of the best ways to learn about it. The study of typography should be ongoing. Please see the bibliography for further reading.

EXERCISE 3-1

DESIGN YOUR NAME

1 With the notion that your "handwriting" is you, your DNA so to speak, start by writing your name. Determine if your signature has any characteristics that might characterize your personality.

2 Write ten adjectives that describe your personality.

3 Find typefaces that express your personality.

4 Design your name in three different typefaces that you believe are appropriate.

5 Now, hand make, hand draw, or hand letter the letterforms of your name, retaining any quirks or imperfections that might just be "you."

6 Give careful consideration to the spacing between the letters and words.

PROJECT 3-1

DESIGN A TYPE-DRIVEN POSTER

Choice of subject: Flu prevention or a cable television or web channel featuring old films and TV programs

Step 1

a. Choose from among: flu prevention (cdc.gov/flu/), wellness (webmd.com or prevention.com or any brand or organization), or a cable television or web channel featuring old films and TV programs (for example, TCM or hulu.com). Research your subject.

b. On an index card, in one sentence, write your objective. Define the purpose and function of the poster, the audience, and the information to be communicated.

c. For flu prevention or health and wellness, find one interesting fact and write one line of copy using this information as your headline. Or if you've chosen the other subject, choose one famous line from a classic film or TV program to use as your headline—for example, "Of all the gin joints in all the towns in all the world, she walks into mine."

Step 2

a. Find typefaces that express the spirit of the subject. Or use handmade or found type or a combination of handmade and a typeface.

b. Design a poster that is type driven—that is, type is the star of the poster. If you use any image, it should play a secondary role to the type-driven headline.

c. Produce at least twenty sketches.

Step 3

a. Choose two of your best sketches and refine them.

b. Establish emphasis through a visual hierarchy.

c. Carefully examine the spacing between letters, among words, and between lines of type.

Step 4

a. Create a finished solution.

b. The poster can be designed in a portrait or landscape orientation.

Go to our website **GD/s** for *many* more Exercises and Projects, and presentation guidelines, as well as other study resources including the chapter summary.

NOTES

1. Rob Carter, Ben Day, and Philip Meggs. *Typographic Design: Form and Communication*, 3e. Hoboken: Wiley, 2002, p. 293.

2. I am indebted to Professor Martin Holloway, designer and design and type history scholar, for information on type classifications and his brilliant type charts in this text.

3. Romy Ashby. http://www.stepinsidedesign.com/STEP/Article/28854/0/page/7

04/

CREATIVITY AND THE GRAPHIC DESIGN PROCESS

<<< / *facing page*

**QUALYS TRADESHOW
EXHIBIT**

· GEE + CHUNG DESIGN, SAN
FRANCISCO

· CREATIVE DIRECTOR/ART
DIRECTOR/DESIGNER/
ILLUSTRATOR: EARL GEE

Creativity is the power to connect the seemingly unconnected.

—William Plomer

A SUCCESSFUL GRAPHIC DESIGN SOLUTION

IS, AS THE ADAGE GOES, A RESULT OF PERSPIRATION AND INSPIRATION, REQUIRING FOCUS, CRITICAL AND CREATIVE THINKING, AND RIGOR. OF ALL THE PROFICIENCIES NECESSARY TO BE A RESPECTABLE GRAPHIC DESIGNER, CREATIVITY IS THE MOST ELUSIVE. ONE CAN WELL LEARN HOW TO PROBLEM SOLVE AND COMPOSE YET STILL PRODUCE PERFUNCTORY SOLUTIONS. BEFORE YOU EMBARK ON SOLVING DESIGN ASSIGNMENTS, ENHANCING YOUR CREATIVITY WILL ENHANCE EVERYTHING YOU DO—FROM GRAPHIC DESIGN TO HOW YOU LIVE YOUR LIFE.

CREATIVE THINKING

Creative thinking is the ability to stretch beyond the ordinary, to be original, innovative, and flexible in one's thinking. For example, creating a mnemonic device (a memory aid) is one way to think creatively, connecting unrelated things with a single visual in a design context. For TheHive.com, a new online community of musicians and music fans, Visual Dialogue determined they needed a strong logo to serve as a mnemonic device for what they were about (Figure 4-01).

Other aspects of creative thinking are:
› associative thinking (recognizing commonalities, common attributes)
› metaphorical thinking (identifying similarities between seemingly unrelated things)
› elaboration and modification (working out details and being able to propose alterations)
› imaginative thinking (forming images in one's mind and imagining the unlikely

CHARACTERISTICS OF CREATIVE THINKERS

Certain characteristics are markers of creative thinking:
› *Courage*: Fear quashes creative risk taking and supports playing it safe. Courage coupled with intellectual curiosity fuels creativity.
› *Receptiveness*: Being open to *different* ways of thinking as well as constructive criticism allows you to embrace possibilities and new ideas.
› *Flexibility*: Not only do an agile mind and flexible personality allow you to keep up with the times, they allow you to bend with the path of a blossoming idea or let go of a path that is not fruitful.
› *Being Sharp-eyed*: Paying attention to what you see every day (shadows, juxtapositions, color combinations, textures, found compositions, peeling posters, etc.) allows you to see inherent creative possibilities in any given environment, to notice what others miss or do not think noteworthy.
› *Seeking and Recognizing Connections*: Creative people are able to bring two related or unrelated things together to form a new combination; they arrange associative hierarchies in ways that allow them to make connections that might elude others.

FIG. 4 /01

LOGOS, THEHIVE.COM

· VISUAL DIALOGUE, BOSTON
· DESIGN DIRECTOR/DESIGNER:
 FRITZ KLAETKE

Problem: *TheHive.com was a new online community of musicians and music fans and they needed a strong logo which served as a mnemonic device for what they were about.*

Solution: *The logo variations presented show a typical range of exploration by Visual Dialogue—in this case with a special emphasis on references to music and beehives.*
—Fritz Klaetke

TOOLS THAT STIMULATE CREATIVE THINKING

Beyond enhancing personal creative characteristics are tools that aid creative thinking. Besides using these creativity techniques for concept generation, some designers and students use them as visualization and spontaneous compositional tools (see Chapter 5 on visualization and Chapter 6 on composition).

Brainstorming (Group or Individual Tool)

In *Your Creative Power*, published in 1945, Alex Osborn, an advertising partner at BBDO in New York, presented a technique he had been using for years at BBDO: brainstorming. The objective of Osborn's technique was to generate ideas that could be solutions to advertising problems; the notion was that an uninhibited atmosphere would cultivate the flow of creative thinking. Traditional brainstorming is conducted with a group of people so that one contributor's thought builds on or triggers another's, although it may even work better when modified for individual use, since there is no holding back. (See sidebar "How to Brainstorm in a Group.")

Osborn's Checklist (Individual Tool)

In the mid–1960s, American artist Richard Serra began experimenting with nontraditional materials, including fiberglass, neon, vulcanized rubber, and lead. He combined his examination of these

HOW TO BRAINSTORM IN A GROUP

- Clearly and succinctly define the problem. Determine criteria.

- Appoint two people: (1) a good note taker and (2) an effective facilitator responsible for running the brainstorming session. (An oversized note pad, a marker board, or an interactive whiteboard screen is useful. Or record the session. Notes should be evaluated at conclusion.)

- Including participants with a different expertise is optimum.

- Participants should openly contribute.

- Stay focused on the problem under discussion.

- During the brainstorming session, do not judge any contributed ideas. Creativity should not be stifled, no matter how harebrained the idea offered.

- A second round of brainstorming builds onto ideas suggested in round one.

Average time: 30- to 45-minute session.

At the conclusion of the session, ideas are evaluated. According to creativity expert Edward de Bono, ideas should be evaluated for usefulness, for whether they merit further exploration, and for originality.

The advantages of brainstorming include:

- It is an effective idea-generation tool

- Encourages creative thinking

- Generates many ideas

- Provides an opportunity for collaboration

materials and their properties with an interest in the physical process of making sculpture. The result was a list of action verbs Serra compiled— "to roll, to crease, to curve"—listed on paper and then enacted with the materials he had collected in his studio. *To Lift* by Serra, "made from discarded rubber recovered from a warehouse in lower Manhattan, is a result of the rubber's unique response to the artist's enacting of the action verb 'to lift.'"[1] (moma.org).

"It struck me that instead of thinking what a sculpture is going to be and how you're going to do it compositionally, what if you just enacted those verbs in relation to a material, and didn't worry about the results?"
—*Richard Serra*

Before Serra's sculptural experimentations, Alex Osborn, BBDO, created an inspired checklist technique as a tool to transform an existent idea or thing. (For example, if you magnify something, you could add height, length, or strength; or you could duplicate, multiply, or exaggerate.) Arguably, this could be the only tool you ever need to foster creative thinking. In short, Osborn's Checklist is composed of action verbs:

› Adapt
› Modify
› Magnify
› Minify
› Substitute
› Rearrange
› Reverse

Mapping (Individual Tool)

A **mind map** is a visual representation, diagram, or presentation of the various ways words, terms, images, thoughts, or ideas can be related to one another. A useful tool in understanding relationships and organizing thoughts, it leads to idea generation. Mapping is a brainstorming and visual diagramming tool that is used to develop an idea or lead to an idea; it is also called word mapping, idea mapping, mind mapping™, word clustering, and spider diagramming. It can be used to visualize, structure, and classify ideas and as an aid in study, organization, problem solving, and decision making. A resulting visual map is a diagram used to represent thoughts, words, information, tasks, or images in a specific diagrammatic arrangement. There is a central key word or thought, and all other words, thoughts, or visuals stem from and are linked to the central one in a radius around that central focal point. It has been said that mapping is an ancient visualizing technique dating as far back as ancient Greece.

Types of Mind Maps

Mapping is a useful tool for the writing process, design process, or brainstorming process, or simply for thinking something through. You can approach mapping in two basic ways.

› *Automatic mapping* relies heavily on the surrealist strategy of spontaneous free association, trying to avoid conscious choices and allowing associations to flow freely.

› *Deliberate mapping*, although not totally controlled, relies more on natural growth of associations, revealing the way your mind instinctively organizes or makes associations.

You can reorganize or revise what you have mapped based on new information, based on a deeper understanding derived from the first go-round, or based on something that occurred to you while mapping. You can articulate a range of connections or see links among items on the map. The resulting mind map is a tangible representation of associations (that may reveal thinking or lead to an idea). You can rearrange items to create a new beginning (central word or image), reordering subtopics (secondary items), sub-subtopics (tertiary items), and so on.

How to Create a Mind Map

Mapping software is available that offers templates, shuffling, notes, labels, cross-linking, and more. However, since the nature of the drawing process maximizes spontaneous mapping, doing it by hand offers better outcomes. Drawing your own map is likely to increase personalization and a natural flow of thoughts.

› Position an extra-large sheet of paper in landscape position.

› At the center of the page, your starting point, draw a primary visual or write a key word, topic, or theme.

› Starting with the central word or image, draw branches (using lines, arrows, any type of branch) out in all directions, making as many associations as possible. (Don't be judgmental; just write or draw freely.)

Each subtopic should branch out from the major central topic. Then, each sub-subtopic or image should branch out from the subtopic, branching out on and on. Seek relationships and generate branches among as many items as possible. Feel free to repeat items and/or cross-link.

Spontaneous mapping draws upon the unconscious. Write or draw as quickly as possible without deliberating or editing. This type of mapping promotes nonlinear thinking. Interestingly, it can be the most unforeseen item or possibility that becomes a key to idea generation. (You can always go back into the map to make adjustments later.)

Deliberate mapping utilizes long and careful thinking. As a complement, you could consider note taking—writing down some explanatory notes near the items or branches so that later, when you reexamine the map, you can more easily recall exactly what you were thinking. This piece in Robert Skwiat's senior portfolio was based on a mind map (Figure 4-02).

Oral Presentation Tool:
Present the Problem to Someone Else

Most people realize that writing or sketching can lead to an idea. Talking about the design problem can lead to ideas and insights as well.

This tool is based on two premises: (1) talking about your problem may reveal insights (analogous to speaking to a therapist who listens, more than speaks, so that you can *hear yourself*), and (2) having to present or explain the design problem to someone unfamiliar with it will force you to organize and articulate your thoughts, which might lead to better understanding of the problem and ultimately to an insight or idea.

Oral Presentation Tool Technique

1/ Solicit a friendly listener. This person should not attempt to help you solve the problem or make any comments. If no one is available, use a tape recorder. You do not need oratory

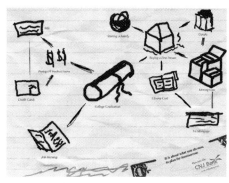

FIG. **4** /**02**

DESIGN: ROBERT SKWIAT

· WWW.ROBERTSKWIAT-DESIGNS.COM

skills; however, you will have to listen to what you say for a possible key insight.

2/ First, give an overview of the design problem. Then explain it in more detail. The listener should focus on you, nod to encourage you to keep speaking, but not comment so as not to interrupt your stream of thoughts.

3/ If this process has not yet stimulated an insight from which you can develop an idea, then go to step 4.

4/ Once you finish speaking, the listener is then free to ask questions—questions to clarify points or questions that pop into that person's head based on what you have presented. If the person has been attentive, then he or she may have some pointed questions that can aid in focusing your thinking. Or ask the person to take notes, which you could use as jump-starts.

CREATIVITY THROUGH PROBLEM FINDING

In *The Mystery of Picasso* (a 1956 documentary film by director Henri-Georges Clouzot and cinematographer Claude Renoir), Picasso is painting. As we watch Picasso paint, we realize his process is spontaneous—each form he paints brings him to another; nothing was preconceived. His free-form association continues. Five hours later, Picasso

declares that he will have to discard the canvas: "Now that I begin to see where I'm going with it, I'll take a new canvas and start again." Picasso used the process of painting to find inspiration and direction *while painting*; he *didn't plan it before he began painting*.[2]

Like Picasso, designers can employ **problem finding** or **problem seeking**, where the *process* of sketching or making marks allows visual thinking, allows for discovery, for staying open to possibilities during the visual-making process.

Brainstorming by Image Making (Individual Tool)

The act of creating art—painting, drawing, sculpture, ceramics, collage, photography, any traditional or nontraditional art—activates several parts of the brain, sharpens thinking, provokes the mind's associative network, and increases focus to a point where creative thinking can occur. When creating art for a solid period of uninterrupted time, you enter into a meditative "zone" of active experimentation. Creating fine art frees the subconscious mind from the design problem and may lead to ideas.

Spontaneous Art Improvisation: Problem Finding (Individual Tool)

One of the premises of spontaneous art is that it allows access to your subconscious and liberates you from inhibitions; you create images without concerns regarding conventions, aesthetics, composition, or intention, without concerns about content, not governed by the constraints of a design assignment. In *The Creative Vision: A Longitudinal Study of Problem Finding in Art*, a study of art students, Jacob W. Getzels and Mihaly Csikszentmihalyi found that the more creative students were more adroit at *staying open to possibilities* during the art-making process.[3]

Spontaneous Art Process
Enjoy the process without concern about an end product or finishing anything. Choose any preferred art medium—traditional or nontraditional, nonrepresentational, abstract or representational.

› Start making art
› Keep working

› Move from surface to surface or medium to medium, as you like it.

If you're not sure which subject matter or techniques to explore, choose from one of the following:

› Everyday experiences
› Environments: cities, landscapes, oceanscapes
› Emotions
› Nonrepresentational patterns, textures
› Rubbings (creating an image by rubbing, as with a soft pencil, over a textured surface placed underneath the paper)
› Collage
› Photomontage

Happy Accidents

If we go back to how Picasso painted on one canvas for five hours, only to discard the canvas, declaring he now found direction, then we can understand something about how visual artists work. According to an evolutionary model of creativity,[4] we need two processes:

› one process to generate things that we can't or don't plan and
› another process to assess what we have generated for merit

As with being successful in most disciplines, knowledge, study, and experience enable a practitioner to distinguish between what has merit and what does not. However, as Professor Robert D. Austin, Technology and Operations Management unit at Harvard Business School, stated, the key here is "being a bit skeptical of preset intentions and plans that commit you too firmly to the endpoints you can envision in advance."[5]

Professor Austin believes: "Artists think they develop a talent for causing good accidents. Equally or perhaps even more important, they believe they cultivate an ability to notice the value in interesting accidents. This is a non-trivial capability. Pasteur called it the 'prepared mind.' . . . Knowing too clearly where you are going, focusing too hard on a predefined objective, can cause you to miss value that might lie in a different direction."[6]

Exquisite Corpse (Group Tool)

"While researching my talk for the Kean University 'Thinking Creatively' conference, I began to

think about what it truly means to be creative in what is essentially a collaborative field. I recalled a game I used to play with my father, wherein one person draws the beginning of a figure, folds the paper, and the next one continues the drawing without seeing what came before. When I invited Milton Glaser to participate, he informed me that the 'game' was actually an 'Exquisite Corpse,' invented by the Dadaists and Surrealists. I also asked Mirko Ilić and Luba Lukova to participate," comments Steven Brower about Figure 4-03.

Believing in artistic collaboration while pursuing the enigma of accidental art and their belief, the surrealists played a collective word game called Exquisite Corpse (*cadavre exquis*). (See "Case Study: Kobo Abe Book Cover Series" for another example using the Exquisite Corpse tool.)

Each player contributes one word to a collective sentence, without seeing what the other players have written. Adapted to using collective images, each player is assigned a different section of the human body, though the original players did not adhere to any conventional sense of human form. Steven Brower talks about his process:

How to Play Exquisite Corpse:
Collective Images

1/ Fold a piece of paper into four parts. (Fold the paper in half from top to bottom. Fold it again from top to bottom.)

2/ On the first fold, the first player draws a head. That player extends the lines of the neck slightly below the fold and then folds the paper over so the second player cannot see what has been drawn.

3/ The second player creates the neck, shoulders, and top half of the torso with arms, extending the waist below the fold so that the third player cannot see what has been drawn.

4/ The third player creates the bottom half of the torso. The upper thighs extend below the fold so that the fourth player cannot see what has been drawn.

5/ The fourth player continues until the figure is drawn.

6/ The group unfolds the paper and discusses the resulting figure.

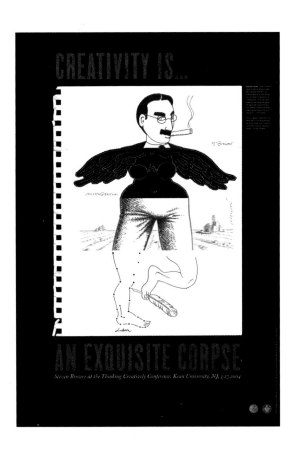

FIG. **4 / 03**

POSTER: *EXQUISITE CORPSE*

· ART DIRECTOR/DESIGNER: STEVEN BROWER
· PARTICIPANTS: STEVEN BROWER, MILTON GLASER, MIRKO ILIĆ, AND LUBA LUKOVA
· CLIENTS: ART DIRECTORS CLUB OF NEW JERSEY AND KEAN UNIVERSITY DEPARTMENT OF DESIGN

Steven Brower designed this poster for the inaugural creativity conference at Kean University. Attendees waited patiently in line to have Brower and Luba Lukova (one of the poster's illustrators/participants) autograph their posters, which have now, undoubtedly, become prized objects of contemplation.

Attribute Listing (Individual Tool)

By focusing on the attributes of an object, person, place, character, topic/theme, product, or service, you can find a characteristic that might lead to an idea. **Attribute listing**, a technique developed by Robert Platt Crawford in *Techniques of Creative Thinking*, is a method for analyzing and separating data through observing and identifying various qualities that might have otherwise been overlooked; it is a diagrammed list of attributes. The process works deconstructively, breaking down information into smaller parts that are then examined individually.

It can be useful to first break the object down into constituent parts and examine the attributes of each part. For example, if the item under examination is a laptop computer, you could break it down into the screen, keyboard, and motherboard; or if the topic in question is a tax preparation service, you could break it down into the online operation, the brick-and-mortar storefront, the name, the staff, the environment, their proprietary preparation process, and so on.

CASE STUDY

KOBO ABE BOOK COVER SERIES

· ART DIRECTOR: JOHN GALL
· DESIGNERS/ILLUSTRATORS: JOHN GALL, NED DREW
· CLIENT: VINTAGE/ANCHOR BOOKS

If the computer and the Internet allow us to connect with distant communities, then creative methods that take advantage of this power must be created. One such way is the following book covers conceived by John Gall and myself.

Taking advantage of my ability to send images across the Internet, I re-conceptualized the surrealist game Exquisite Corpse. Asking design colleagues to respond to images sent to them became the basis for these collaborations. A piece of art was sent back and forth—with each designer adding something to the collage—until they reached a mutual agreed-upon finishing point.

John Gall, Vice President and Art Director for Vintage and Anchor Books, an imprint of Alfred A. Knopf, was one of the collaborators that I had engaged in this creative process. John realized that the eclectic nature of these electronic collages might work well with a series of books that were going to be reissued for the author Kobo Abe, who is known for his surreal narratives. This collaborative method became a natural fit. The electronic collaboration allows for an "open" design process in which unexpected and oddly juxtaposed images could be created to parallel the often bizarre and dreamlike worlds created by Abe's books.

There is a sophisticated and subtle use of common elements that create a visual cohesiveness to the series. Muted, golden yellow-toned paper textures become a foundation upon which the images are built. A distinctive bold frame on each cover helps create a unity to the typographic system, while retaining its own individual characteristic within the composition. The typographic system mimics the juxtaposition of elements in their contrasting typographic style. Roman vs. Italic, Bold vs. Light, Serif vs. Sans Serif, All Caps vs. Lower Case.

Intuition, chance, and play can serve a valuable role in the problem-solving process. Collage, as a game of chance, embraces this idea and can help develop new discoveries. This methodology, when established with ample time for experimentation, often leads to innovative solutions. Challenging our perceptions about the role of the computer in the process can safeguard against our solutions becoming predictable and/or formulaic. Switching back and forth between the computer and drawing board keeps the process balanced and fresh. We need to use the tools we have to advance and explore creative ways of working, collaborating, researching, and discovering.

—Ned Drew

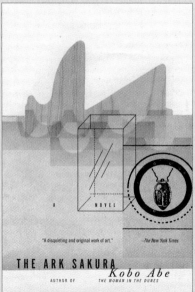

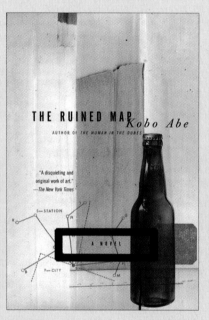

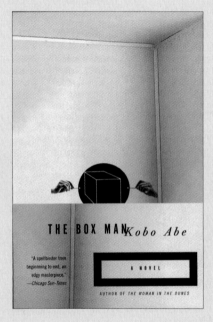

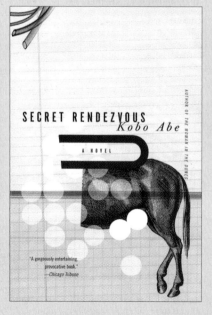

The Process of Attribute Listing

› Select an object, person, place, character, topic/theme, product, or service for examination.

› List the physical or functional attributes (parts, characteristics, properties, qualities, or design elements) of the object under examination.

› List as many attributes as you possibly can.

› Separately list unique or unusual attributes.

› List the psychological or emotional attributes, if applicable.

› Think about the "value" of each attribute. Ask: "What is the purpose? Benefit?" Consider the positive versus negative value of each attribute. (For example, a heavy glass laptop screen might prevent breakage but adds overall weight to the laptop.)

› Examine ways attributes can be *modified* to increase positive values or create new values.

› Examine for potential leads to a design concept.

Using Attribute Listing
for Creativity Enhancement

› Choose a place or thing.

› List its attributes.

› Then, choose one attribute and focus on it.

› Think of ways (from conventional, to unable to be realized, to ridiculous) to change that attribute.

Visual Metaphors (Individual Tool)

Visual metaphors can underpin a design concept and be used to create strong images in graphic design, suggesting a similarity between two non-identical things. (See Figure 2-16, *Visual Metaphors* poster by Luba Lukova, and Figure 7-26, *Help Solve Global Warming* by Fang Chen.) Additionally, a visual metaphor, a nonliteral use of an image, results in a "partial mapping of one term, image, object, concept or process onto another to reveal unsuspected similarities."[7] A visual metaphor can make connections between two worlds of meaning and reveal an insight.

The Process

1/ At the top of a page, write the subject of your design problem.

2/ Sketch or write as many objects as possible having similarities to your subject. If you're having difficulty, use attribute listing to help you or treat this as a kind of a Rorschach inkblot test, where you simply sketch the first thing that comes to mind, when asking yourself, "What might this remind me of or be similar to?"

Keep an Idea and a Collage Sourcebook

Keeping a sketchbook is a wonderful way to practice creative thinking and visualization on a daily basis. Carry a sketchbook with you for sketching, doodling (automatic drawing), and jotting down ideas. Keep another book as a collage sourcebook, adhering images and typography you find inspiring to pages of the book. Add inspiring articles or phrases. Keep an image file, which you can use to draw from or upon.

CONCEPTUAL THINKING

Concept generation—the ability to form/think up an idea, cogently state the idea, and then evaluate it—demands creativity and critical thinking skills. According to Dr. John Chaffee, Professor of Philosophy at the City University of New York, "Logic and critical thinking seek to establish rules of correct reasoning, clear understanding, and valid arguments. In addition, they identify fallacies—chronic ways in which people use illogical reasoning to reach conclusions."[8] Critical thinking also entails appraising concepts, issues, statements, and points of view. Among the many thinking skills of a critical thinker, the ones that are most applicable to designing are the ability to:

› Analyze

› Ask penetrating questions

› Identify and address key issues

› Identify patterns or connections

› Conceive concepts

› Conceive a conceptual framework

› Communicate effectively

› Evaluate relevance

› Support one's viewpoint with reasons and evidence

Solving graphic design or creative advertising assignments involves gathering or generating content, problem solving, elaboration (adding details to a main idea), working within (or possibly setting) parameters of an assignment, and forecasting—which all depend on critical thinking skills.

Good thinking uses the skills of:

- Analysis
- Association
- Classification
- Comparison
- Comprehension
- Deduction
- Evaluation

- Flexibility
- Fluency
- Forecasting
- Generalizing
- Hypothesizing
- Interpretation
- Observation

- Planning
- Predicting
- Questioning
- Sequencing
- Synthesizing
- Theorizing

Any good graphic design solution is based on a design concept—the designer's primary reasoning. The design concept sets the framework for all your design decisions—for how you are creating, selecting, and arranging imagery, writing copy for the imagery, the colors you select, for cropping an image, or choosing a particular typeface. Absolutely, this explanation does not exclude the value of any designer's intuitive choices; however, it does emphasize that design is *not* about decoration. Creative thinkers conceptualize, communicating their ideas visually, as in Figure 4-04. "Aether Apparel, a new line of adventure sportswear inspired by a life spent outdoors, aims to appeal to the outdoor enthusiast who needs the function of performance garments, but who desires a more sophisticated form. CSA designed the brand's logo, which evokes infinity and clouds circling a mountain peak, to appeal to this demographic and to reference the word itself, Aether, meaning 'the heavens.'" (Please see Figure 9-07 for the

entire Aether branding project.) For the most part, graphic designers use the term "design concept" and advertising professionals use the term "idea" or "the big idea" to mean the same thing. Design assignments begin with a need and problem.

Effective creative conceptual thinking results in:
> Discoveries
> Ideas and design concepts
> Actions and decisions
> Creative methods that lead to inventive solutions
> New questions or needs

PROBLEM SOLVING

In the second part of this chapter, you will learn about the steps involved in solving a graphic design or advertising problem. Generally, problem solving is the process of:
> Identifying and defining a given problem (part or all of a design application)
> Defining what is to be accomplished
> Brainstorming for original ideas
> Evaluating ideas
> Interpreting raw ideas into graphic design concepts or advertising ideas
> Visually expressing and communicating the concept in creative or unique ways

SIX ESSENTIAL QUESTIONS: THE KIPLING QUESTIONS

Becoming a good problem solver involves cultivating investigative thinking. Investigative journalists and law enforcement officers depend on these six questions:
> Who?
> What?
> Where?
> When?
> Why?
> How?

Rudyard Kipling immortalized these questions, referring to them as "six honest serving men" that taught him all he knew, in a short poem embedded in "The Elephant's Child." This essential set of questions can help problem solve and trigger ideas. (Interestingly, these questions are asked in most

FIG. **4** / **04**

LOGO: AETHER

· CARBONE SMOLAN AGENCY, NEW YORK
· CREATIVE DIRECTOR: KEN CARBONE
· DESIGNERS: NINA MASUDA, DAVID GOLDSTEIN
· PROJECT MANAGER: RACHEL CRAWFORD
· CLIENT: AETHER APPAREL

design briefs, though the six-question method certainly simplifies any brief.) You can tailor the six questions as in this example:

> Who is the audience?
> What is the problem?
> Where do this problem and potential solution exist?
> When does this happen?
> Why is it happening?
> How can you overcome this problem?

FIVE PHASES OF THE GRAPHIC DESIGN PROCESS

Five Phases of the Design Process:

Orientation ▶ Analysis ▶ Concepts ▶ Design ▶ Implementation

PHASE 1: ORIENTATION/ MATERIAL GATHERING

Phase 1 of the design process involves orientation: being briefed on the assignment, learning about the client's needs and requirements, product, service, organization, audience, competition, and more. It also involves active listening, gathering materials and information, and meetings, and may include conducting market research.

Although there are legendary stories of esteemed designers who, during the first client meeting, sketch their logo solutions right there and then, most designs *are not* created that way. (Paula Scher, a Pentagram partner, sketched the Citibank™ logo during the first client meeting. Woody Pirtle, former Pentagram partner, sketched his AIGA/Iowa poster on a napkin [see Figure 4-05]. For Taco Bueno, a regional restaurant chain, former Pentagram partner Lowell Williams says about the development of the wordmark, "We did the original design, the conceptual part, on a napkin. Woody Pirtle was in [our office] at the time, and I asked him to draw out the idea.") *Before* putting pencil to paper, you will need to gather and absorb a good deal of materials.

Orientation

Phase 1 is **orientation**—the process of becoming familiar with your assignment, the graphic design problem, and the client's business or organization,

product, service, or group. Usually, junior designers and junior art directors or copywriters are not involved in strategic planning or in design brief formation; more often, they are challenged by a simple design brief that has been distilled for them by their design director or art director. It is important, however, at this point in your education, to understand how the design process works at every level and stage.

Who Conducts the Orientation?

During this initial phase, you and your team learn about the assignment. Since designers and art directors work in a variety of settings, who conducts the orientation and how it is conducted will depend on the nature of your firm. Designers work in design studios (small, medium, and large), advertising agencies, publishing houses, in-house corporate and nonprofit organizations, educational institutions, and any setting where a designer's expertise may be required—an in-house design department for a retail chain, a

FIG. **4** / **05**

POSTER: *CHRYSLER/CORN*

· PENTAGRAM DESIGN LTD., NEW YORK
· DESIGNER: WOODY PIRTLE, PENTAGRAM DESIGN
· CLIENT: ART DIRECTORS ASSOCIATION OF IOWA

This design was developed from a sketch Woody Pirtle made with a fountain pen on a napkin during a lecture trip to Iowa.
—Sarah Haun, Communications Manager, Pentagram Design Ltd.

regional design studio, a global ad agency, or the design unit of a charitable organization. Therefore, an orientation might be conducted by a variety or combination of individuals: the client, the client's team, an account manager/team from your own studio or agency, your design director or creative director, an editor, an in-house executive, or any individual who is the liaison with a client in charge of the assignment.

Getting essential answers to questions happens during this phase. For any type of assignment, there are standard questions, and some will be revisited during the next phase of analysis. Additional questions are fashioned for specific types of graphic design applications, as you will see below.
> What is the nature/extent of the assignment? Is it an individual application or part of a broader assignment/strategy?
> What does your assignment entail? What is its role in a broader scheme?
> Who is the audience?
> How is this project relevant to its audience?
> Does a similar application already exist?
> What is the media plan? Budget? Deadline? Other parameters?

For a *brand or group (nonprofit organization, educational institution, company, human services, any entity that is not a branded product or service),* here are additional questions that will help obtain information:
> Is the brand or group new, established, merging, or being rethought? A start-up? Known or unknown? Regional, national, or global?
> What makes this brand or group (organization, company, any entity) unique?
> What are the functional benefits and the emotional benefits?
> How does the brand or group compare to the competition? Is the brand or group a category or industry leader? In second place? A newcomer?
> Is your client's brand or group relevant to its target audience?
> What is your client's brand or group five-year plan? Ten-year plan?

For an *information design* application, here are additional questions that will help obtain information:
> What makes this application unique?

> How should it function? What form should it take?
> What are the audience's limitations?
> How can we best display this type of information?
> What is the context? Where and how will this application be seen?

For an *editorial design* application, here are additional questions:
> Is it a new publication or an existing publication? Is it a supplemental publication?
> What is its function?
> What is the context? Where, when, and how will this application be seen and in which media?
> What is the subject of the editorial content? Who is the author? When will I have access to the content (entire publication/summary/synopsis/proposal)?
> What are the audience's limitations (vision, language, reading level)?

For an *environmental design* application, here are additional questions:
> What is its function?
> What type of space is it?
> How will the design solution work with the interior design and architecture?
> Where will it exist?
> What are the audience's limitations?
> Will I be collaborating with an interior designer? Architect?
> What is the context?

Orientation also involves reviewing and evaluating the current graphic design applications, branding, and/or advertising program created for this product, service, or group. How well did those solutions fare? How does the client consider those solutions? How does the public/audience perceive and respond to the existing solutions? What is the performance measurement, the return on investment (ROI)? This process is referred to as a **marketing audit**, a methodical examination and analysis of existing and past marketing for a brand or group. A **competitive audit** is an examination and analysis of the competitions' branding efforts with the intention of best understanding how the competitors position themselves in the marketplace, their functional and emotional advantages and disadvantages, and who their audiences are.

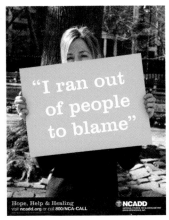

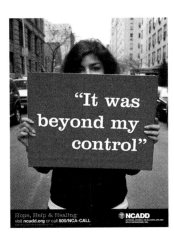

FIG. 4 / 06

POSTERS: *HOPE, HELP & HEALING*

· CAMPAIGN FOR THE NATIONAL COUNCIL ON ALCOHOL AND DRUG DEPENDENCY (NCADD)
· DESIGNER: LARA MCCORMICK

A Sappi Ideas That Matter Grant recipient

Project Background: *I attended the School of Visual Arts MFA Designer as Author Program. My thesis was a campaign targeting young addicts and alcoholics.*

The final campaign was based on some of my MFA thesis, but altered and fine-tuned to fulfill the needs of NCADD's affiliate offices across the country.

NCADD: *Founded in 1944, NCADD is the oldest advocacy organization addressing the disease of alcoholism and other drug addictions focusing on education, awareness, policy and advocacy.*

Strategy: *The goal was to create a set of brochures and posters that make the process of recovery inviting and easy to understand, and to encourage people to call the NCADD hopeline or visit their website to get more information.*

Each of the three poster/brochure sets targeted a different audience; young people (under 21), the general public, and family. Because of the anonymity factor associated with recovery, I did not want the campaign to use images of people that showed their identity. For the posters, I took photographs in which the faces of individuals could not be seen.

—Lara McCormick

Equally important during orientation is learning about the **audience**—the targeted, specified group of people at whom you are aiming your message, design, and solution; the audience is the main group who would purchase this brand or utilize this information, service, or product, or patronize this entity. Knowing about the audience is critical. For example, in Figure 4-06, *Hope, Help & Healing*, a campaign for the National Council on Alcohol and Drug Dependency (NCADD), the audience is "In recovery, the average age is 48, and only one fifth are 30 and below (*Alcoholics Anonymous, 2001 survey*). *Hope, Help & Healing* targets addicts and alcoholics between the ages of 20–35, and their family and friends. The goal is to get people into recovery at an earlier age." Designer Lara McCormick's challenge was "To provide NCADD with a set of materials that target a young demographic of addicts and alcoholics, as well as their family members."

For HBO (Figure 4-07), Visual Dialogue fully understood how to appeal to its targeted audience, and knew their audience spent a great deal of time online.

"If we go deeply enough, or far enough, we nearly always find that between every product and some consumers there is an individuality of relationship which may lead to an idea."

—*James Webb Young from* A Technique for Producing Ideas

FIG. 4 / 07

VOLUME.COM LOGOS FOR HBO

· VISUAL DIALOGUE, BOSTON
· DESIGN DIRECTOR: FRITZ KLAETKE
· DESIGNERS: FRITZ KLAETKE, IAN VARRASSI

Problem: *How do you reach an urban, cutting-edge 12- to 35-year-old demographic if you're HBO?*

Solution: *Start a new online portal, of course. (This is an audience that is always online). Give it a cool, evocative name like volume.com. And then hire Visual Dialogue to create a logo which a 15-year-old marketing cynic wouldn't mind sticking on his skateboard.*

—Fritz Klaetke

Material Gathering: Getting All the Information

To design, *first* you must learn about the sector (see sidebar on industries and sectors); the product, service, company, or organization; the company's history, values, and mission; and of course, the audience. If your assignment were to design a visual identity for a farm tractor manufacturer, you would need to learn about farm tractors, a farm tractor's purpose and utility, who purchases and uses tractors, and the marketplace for such equipment, as well as competing farm tractor brands. Unless you were an expert on farm tractors, you'd have to collect information. And even if you were an expert, you'd still have to learn about your client's farm tractors and that company's goals, objectives and mission, philosophy, points of distinction, and competition. If your assignment were to design packaging for an energy beverage, even though you might be more generally familiar with that product category than with farm tractors, you still would have to gather materials and orient yourself to your client's product and needs. Every designer must be informed about his or her sector under assignment, the client's business, and the problem under assignment.

Gathering Information through Active Listening

During this first phase of the design process, you get the lay of the land and obtain as much specific introductory information (what James Webb Young refers to as "raw materials") as you can. In most cases, the client or individual (executive, editor, creative director, other) in charge of the project provides a good deal of information. The client (or individual in charge) is the expert about his or her brand or group. That certainly does *not* qualify the client (or account executive or editor) to design, but it does mean that you should *listen carefully to the information this particular expert can offer*—to what the client says about the problem, audience, and marketplace—and thoughtfully examine the information provided by the client. Often, an active listener can identify an insight by carefully paying attention to what the client (and/or individual in charge) says about the brand or group and about the competition. Active listening entails concentrating, focusing on the content of the speaker's message, interpreting what the client says/means, and actively reflecting on what has been said.

INDUSTRIES AND SECTORS

Characteristically, designers tend to be curious. Many designers are the type of people who are interested in learning about a variety of industries and organizations, people who enjoy discovery and gathering raw materials; they become interested in their clients' sectors and spheres. Being a designer also requires a love of lifelong learning, of having the mind-set of an explorer.

Industries and sectors include:

- Agriculture
- Airlines
- Alcoholic Beverages: Beer, Wine, and Spirits
- Animal Services
- Arts Organizations
- Automotive and Transportation
- Beverages
- Business Services
- Charity Organizations
- Child Care Organizations
- Churches and Religious Organizations
- Communications
- Consumer Products
- Education
- Energy and Utilities
- Entertainment
- Environmental Groups and Organizations
- Fashion
- Financial Services
- Food
- Government
- Healthcare
- Hotel and Hospitality
- Human Services
- Industrial Institutions
- Insurance Corporations or Organizations
- Music
- Nonprofits
- Political Groups or Organizations
- Private Foundations
- Public Foundations
- Real Estate
- Restaurants
- Retail

From my own design experience, I have found "listening for insights" to be key to generating on-target design concepts. For example, by listening carefully to one of my clients, I was able to generate the name of their consultancy based on a few words the partners repeated often. Designer Mark Oldach concurs; in an interview with Bryn Mooth in *HOW* magazine, Oldach advised: "Listen. Listen to how clients speak about their business, the language they use, the concepts they focus on and the initiatives that define what they do. Everything that I've learned about business, process and strategic communications has been through and with my clients. Sure, I read books and journals and take courses, but the vast amount of learning has been by listening to clients."[9]

You may also have to gather materials to supplement those provided to you. (See sidebars: "Material Gathering" and "Information-Gathering Tools.") At times, the provided information, in part, comes from an outside market research firm; other materials might have to be gathered, found, or researched by you or your design firm or advertising agency. Develop an understanding of conducting research, of where to look for and gather information. For Internet research basics, go to our website. `GD/s`

Too many students skip material gathering, with the naive belief that it is not important. Perhaps many skip or rush this step because they find it not as engaging as the great adventure of designing. Not only does gathering information about the client's business help you solve the assignment, but it also enriches your general wealth of knowledge. With each client and assignment, you have the potential to become more informed about many subjects and industry sectors. Taking in more information, processing it, assimilating data, and putting it in its proper place contribute to original thinking.[10]

To best solve the visual communication problem, you need to complete this phase. For students working on class assignments without actual clients, your instructor becomes your client. You still need to gather materials, familiarize yourself with the brand or group under assignment, and actively listen to the instructor's orientation.

MATERIAL GATHERING

It involves:

- Becoming thoroughly acquainted with the brand or group: background, the entity's orientation/culture, values, information, data, subject matter, history

- Understanding the client's goals and objectives, current and imminent hurdles, and listening carefully to the client about the assignment, product, service, or group

- Identifying how the immediate assignment relates to the entity's greater/broader brand strategy and solutions (past, present, and future)

- Knowing the audience

- Orienting yourself (and your design team) to your client's general industry/sector and particular business/product/service/organization

- Making initial discoveries

PHASE 2: ANALYSIS/ DISCOVERY/STRATEGY

In this phase, you are examining, assessing, discovering, and planning; you are *not* conceptualizing or designing.

Analysis

Once you and your team/studio have completed phase 1, the next phase is **analysis**—examining all you have unearthed to best understand, assess, *strategize*, and move forward with the assignment. After reflective thinking, you develop the direction your solution(s) will take. When you analyze, you

› Examine each part of the problem
› Concisely and accurately define constituent elements
› Organize the information so that it is broken down into parts that are easily analyzable
› Draw conclusions based on your analysis that will allow you to move forward to the next step

Discovery and Strategy

Strategy is the core tactical underpinning of any visual communication, unifying all planning for every visual and verbal application within a

INFORMATION-GATHERING TOOLS

Conventional

- Using index cards or sticky notes, write one piece of pertinent information per card.

- Categorize them.

- Organize in a box, binder, or some other storage device.

 or

- Keep a notebook, three-ring binder, or expanding file caddy with categorical sections.

- Keep one notebook per assignment and take lots of notes when the client is speaking.

Digital

- Collect and then store gathered materials in a widget (interactive virtual tool that provides services such as showing the user desktop notes) or in desktop notes (notelike windows (short notes) on the screen).

- There is software that aids in organizing information allowing the user to save queries, save views, sort topics, select topics for modification, and more.

Online

- You can also take advantage of Web 2.0 capabilities by using online social bookmarking websites, such as http://del.icio.us.com, that allow you to store your bookmarks online and access the same bookmarks from any computer as well as add bookmarks from anywhere.

program of applications. Essentially, the strategy is how you are conceiving, creating, and positioning your brand or group and aiming your application (the type of design problem) in the marketplace to achieve differentiation, relevance, and resonance. The strategy *helps* define the brand's or group's personality and promise, differentiates it from the competition by defining positioning, and codifies the brand essence; it is a conceptual plan providing guidelines—for both client management and creative professionals—to drive all visual communication applications.

Strategic questions include:

› What's the message? What do you need to communicate?

› Who is the audience?

› Who is the competition? How have they addressed similar problems?

› What is the marketplace like right now?

› What is the client's actual problem versus what he or she perceives it to be?

› What are the impediments to getting the message out? Can you identify opportunities to communicate the message?

› Articulate the incentive—why should the audience want to act on the client's message?

› What is the call to action? Donate? Purchase? Go to the web? Make a phone call? Subscribe? Become aware? Take medication properly? Get tested?

THE DESIGN BRIEF

A **design brief** is a strategic plan—a type of map—that both the client and design firm or advertising agency agree upon, a written document outlining and strategizing a design project; it is also called a **creative brief**, brief, or creative work plan. (Strategy can be determined outside a design brief or within a brief.) Most important for designers and the creative team, strategy is a springboard for conceptual development.

Most design briefs are made up of questions and answers—a format used in an attempt to fully understand the assignment, the objectives of the project, the design context, and the audience. The answers to questions delineated in a design brief are usually based on predesign (preliminary) market research, information gathered about the product, service or group, and audience, and predicated on the budget. Finally, the design brief becomes the strategic plan for implementing objectives; it is a written standard against which creative solutions can be measured. The client and creative professionals can go back to the brief for guidance, or designers can use it to support their concepts and/or solutions. *A thoughtful, clear brief can foster focused, critical thinking and lead to creative concept formulation.*

Who Constructs the Design Brief

Newer models of strategic planning include designers and art directors in design brief construction. From the project outset, integrated

teams (client, account managers, designers, copywriters, editors, IT professionals, architects, interior designers, and industrial designers, among others) are more progressive, leading to broader strategic thinking, multiple perspectives, and *fostering greater collaboration*. With new and emerging media, an integrated team is critical to strategic planning.

In small studios and agencies, junior designers might have the opportunity to work on writing a brief; in medium-sized and larger graphic design studios and agencies, junior designers are *not* likely to be part of design brief development. *Everyone on the team, both marketing and creative professionals, should intimately understand the assignment, brand or group, and audience.*

Each type of creative studio—design studio, agency, publisher, in-house design—handles a brief differently if a brief is used at all. A brief can be written collaboratively between client and design firm or ad agency *or* given to the design firm or ad agency by the client. The design brief can be initiated by the client's marketing team or by the design firm or ad agency's account team or creative director (CD) or design director. The brief may include input from the creative team, strategic planners, research or media department in the design firm or agency, or any related media unit.

› Often, the client's account team writes the design brief (as it is called in design studios) or creative brief (as it is called in advertising agencies), which is then given to the creative team. Design briefs may take different forms.

› In a design studio, the brief might be written by the design director or by the client's team.

› In an advertising agency, most often, the account manager gives the creative brief to the creative team.

› In publishing, rather than or in conjunction with a brief, a synopsis or a manuscript will be provided to the book jacket designer.

Visual Brief Collage Board

A visual brief collage board is a visual way of determining strategy, an alternative to using written strategy. For example, Duffy & Partners first developed visual positioning collages for a brand revitalization for Fresca® with the goal of designing a "new visual brand language" to communicate the intrinsic characteristics of Fresca. After focus group research for Fresca, Duffy reports, "Two design directions clearly rose to the top and were fused to form one visual brief for the brand."

The advantage of visual briefs is their use as a tool with focus groups and clients. Directions for color palettes, kinds of imagery, photography styles, and other graphic approaches can be narrowed down to distill a strategic goal. Client involvement at this phase almost guarantees client satisfaction because the client becomes part of the process early on. For more on visual brief collage boards, please read Chapters 9 and 10.

SAMPLE DESIGN BRIEF 1

The fundamental content of a design brief:

- Project title
- Product information
- Market information
- Communication objectives
- Format and size
- Media
- Parameters
- Deadlines
- Budget
- Approval process

SAMPLE DESIGN BRIEF 2

The basic questions to answer in a design brief:

- What is the project title/assignment?
- What is the challenge?
- Who comprises the key audience?
- What is our current understanding?
- How did we arrive at this realization?
- What is the brand essence?
- What is our strategy?
- How can we best execute our solution?

Sample Detailed Design Brief Used for Branding, Visual Identity, Promotional Design, and Advertising

Question 1: What Is Our Challenge? What Is Our Goal?

Every project has a purpose and desired outcome. The project could be anything from the design of a comprehensive visual identity to a single application such as the design of a brochure or informational poster. It could be for a new or established brand or group or for a merger. Succinct answers to these questions will aid concept generation. See "Case Study: MSF" to learn about Emerson, Wajdowicz Studio's interesting design challenge.

Question 2: Who Is the Core Audience?

Identifying the people who comprise the core audience is essential in formulating design concepts that are relevant. Many factors and criteria are evaluated when defining the core audience. The final answer is usually in the form of a *demographic, psychographic,* or *behavioral profile.* The term **demographic** means selected population characteristics. Some common variables include age, gender, income, education, home ownership, marital status, race, and religion. *Psychographic* profiles are any type of attributes relating to personality, attitudes, interests, values, or lifestyles.

Behavioral variables refer to things such as brand loyalty or the frequency of a product's use. It can also include activities that these people perform either individually or as a group, such as blogging, dancing, or playing soccer.

Question 3: What Is the Audience's Perception of the Brand or Group?

You need to assess what the core audience thinks and feels about the brand or group for which you are going to design to better understand and appreciate these people's needs and desires. Keep in mind that people's perceptions of a brand, group, or entity fluctuate.

Question 4: What Would You Like the Core Audience to Think and Feel?

Determine one clear reaction you want the audience to have. The designer needs to develop a design concept that will engage the core audience and offer a positive experience. The answer to this question should reflect the goals of the assignment as well as take into account what the audience currently perceives (relates to Question 3).

For Figure 4-08, Superdrug asked Turner Duckworth "to create a new kid's hair care range of shampoos, conditioners, and detanglers that would bring a sense of fun to a sometimes stressful experience for both parent and child.

FIG. **4** /**08**

PACKAGE DESIGN: SUPERDRUG STORES PLC, LITTLE MONSTERS

· TURNER DUCKWORTH, LONDON AND SAN FRANCISCO
· CREATIVE DIRECTORS: DAVID TURNER, BRUCE DUCKWORTH
· DESIGNER: SAM LACHLAN
· ILLUSTRATOR: NATHAN JUREVICIUS
· TYPOGRAPHER: SAM LACHLAN
· CLIENT: SUPERDRUG STORES PLC

For Little Monsters—everywhere.
—Turner Duckworth

"With tongue firmly in cheek we created a range of fruity little monsters, which hint at the fragrance of each product. Other monsters that illustrate the product type include a dripping three-eyed monster for the 'After Swim 3 in 1 Conditioning Shampoo and Body Wash,' for example.

"Kids love the illustrations and the name connects on a personal level with mums. Fun continues on back of pack with copy talking directly to the little monster in every household with a 'helpful' checklist of what you should and shouldn't do when washing your own hair. Bath time transformed."

Question 5: What Specific Information and Thoughts Will Assist in This Change?

Provide facts and information that will enable people to alter their beliefs and opinions. Make a short list of the relevant information to support the message. Rank information by importance to further focus the creative development. "This is great for critique of the creative work, as well, by asking if the creative solutions address the real issues that need to be communicated so as to influence the audience," advises creative director Richard Palatini, Delia Associates.

Question 6: What Is at the Core of the Brand Personality?

The brand essence should be codified. Each brand or group should have a well-defined essence, a core brand personality. This allows for *positioning* which will help define the entity against the competition in the minds of the target audience.

Examples of well-known brand cores are:

> Volvo™ Safety
> Orbit™ gum Clean
> Apple™ Creativity
> Peace Corps™ Nobility

Question 7: What Is the Key Emotion That Will Build a Relationship with the Core Audience?

Identify one emotion that people need to feel most when connected to the brand or group. Establishing the right emotional connection with people creates deep relationships, builds brand communities, and fosters loyalty. Determining how to connect to a targeted audience also means understanding

FIG. **4** / **09**

AD

· LEO BURNETT
· CLIENT: FIAT AUTO CHINA, SHANGHAI

their culture or community. What might connect to an audience in China might not connect to an audience in Ireland (Figure 4-09).

Question 8: What Media Will Best Facilitate Our Goal?

Consider media where the people you want to reach spend the most time. When searching for answers to this question, consider media in creative ways. Determine the manner in which your viewers relate to each different medium. Consider the capabilities of each medium. Budget can also have a great effect on the selection of media.

Question 9: What Are the Most Critical Executional Elements? What Is the Budget?

Determine visual and text elements required for each application. Elements can include requisite visuals, color palette, typeface(s), logo, tagline, sign-off, tone of voice, main text or copy, features, rules or regulations, promotions, values, expiration dates, 800 numbers, website addresses, and games. Again, budget will affect many of your decisions, including media, paper selection or substrates for print, and colors for print.

The number of required elements will vary depending on the nature and scope of the project. For example, a logo and web address may be the only elements required for an outdoor billboard; for a website, there will be a long list of required components.

Determine which elements are most important in establishing visual and verbal identity and personality in a consistent and relevant manner.

CASE STUDY

MÉDECINS SANS FRONTIÈRES (MSF)®/EMERSON, WAJDOWICZ STUDIOS

Emerson, Wajdowicz Studios (EWS), New York's design firm led by Jurek Wajdowicz and Lisa LaRochelle, is one of the world's leading practitioners of socially responsible, issue-driven graphic design.

Their passion for bold, intelligent presentation almost always ensures that every message is communicated not just intelligently and effectively but with resonance.

"Creating annual reports and fundraising posters for Médecins Sans Frontières (MSF)/Doctors Without Borders is possibly one of our most interesting design challenges," says creative director Jurek Wajdowicz.

"It gives us an opportunity to combine my deep personal interest in social issues with a photojournalistic approach to design and the ability to lucidly communicate the mission of an incredible organization while helping their fundraising efforts; all without compromising design integrity."

Main design components of the MSF brand created by Emerson, Wajdowicz Studios consist of

SERIES OF FOUR FUNDRAISING POSTERS: *MÉDECINS SANS FRONTIÈRES/DOCTORS WITHOUT BORDERS USA*

· EMERSON WAJDOWICZ STUDIOS, NEW YORK

· ART DIRECTORS: LISA LAROCHELLE, JUREK WAJDOWICZ

· DESIGNERS: LISA LAROCHELLE, MANUEL MENDEZ, YOKO YOSHIDA, JUREK WAJDOWICZ

· PHOTOGRAPHERS: (TOP) HANS JURGEN BURKARD; (BOTTOM) SEBASTIÃO SALGADO; (OPPOSITE PAGE, TOP) FRANCESCO ZIZOLA; (OPPOSITE PAGE, BOTTOM) PAOLO PELLEGRIN

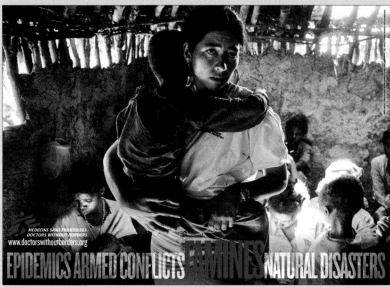

• decisive editorial choices to use strong black and white duotone photography (often converted from four-color originals) resulting from an extremely careful and painstaking search for the appropriate images

• consistent black, gray, and red color customized palette

• strong, logical, clear, and unembellished layouts

"MSF doctors and volunteers do a fantastic job of carrying out a dangerously difficult mission. In this design we wanted to powerfully convey their struggles and at the same time publicize the most underreported international humanitarian crises ignored by the media. Publications and posters designed by EWS act as a powerful informing and fundraising tool that honestly and compassionately conveys the incredible work of MSF. We strive to present in a comprehensive, organized, logical and emotional way the multifaceted relief work performed by Médecins Sans Frontières," says Jurek Wajdowicz.

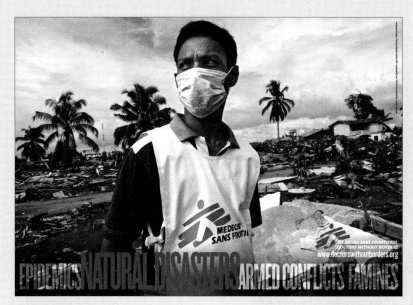

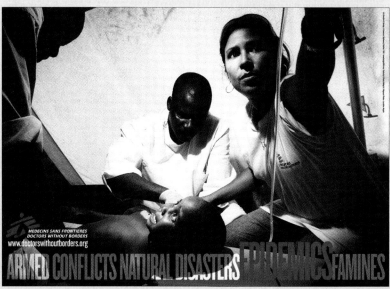

*Question 10: What Is the Single
Most Important Takeaway?*
*Establish the single most important message to con-
vey* in the form of a *single thought*. What do you
want the audience to remember, to take away with
them? Some people prefer to answer this question
first. By answering it last, the answers from the
other nine questions might provide an insight to
answer this question.

*Question 11: What Do We Want
the Audience to Do?*
Define the call to action—what you want the viewer
or visitor to do. This could include buy, subscribe,
donate, visit a place or website, call a number,
click through, complete a survey, get a medical
exam or test, share information, save a choking
victim, and more.

Figure 4-10 is a sample creative brief from The
Richards Group, Dallas.

FIG. **4** / **10**

**PRINT AD CAMPAIGN: HARLEY-
DAVIDSON OF DALLAS**

· THE RICHARDS GROUP, DALLAS
· CREATIVE DIRECTOR/WRITER: TODD TILFORD
· ART DIRECTOR: BRYAN BURLISON
· PHOTOGRAPHER: RICHARD REENS
· CLIENT: HARLEY-DAVIDSON OF DALLAS

**Warning: People don't like ads.
People don't trust ads. People don't
remember ads. How do we make sure
this one will be different?**

Why are we advertising?
To announce the introduction of a
clothing line to the Harley-Davidson
store in Dallas.

Who are we talking to?
Weekend rebels. Middle-class men who
are not hard-core bikers (they may not
even own motorcycles), but want a
piece of the mystique.

What do they currently think?
Harley-Davidson has a badass image
that appeals to me.

What would we like them to think?
Harley-Davidson now makes clothing
that reflects that wild, rebellious image.

**What is the single most persuasive
idea we can convey?**
Harley-Davidson clothing reflects the
rebellious personality of the Harley-
Davidson biker.

Why should they believe it?
Harley-Davidson bikers shop for their
clothes at Harley-Davidson.

Are there any creative guidelines?
Real and honest. Should be viewed
favorably by hard-core Harley-Davidson
bikers.
—The Richards Group

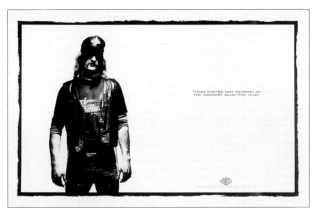

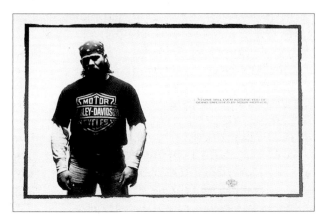

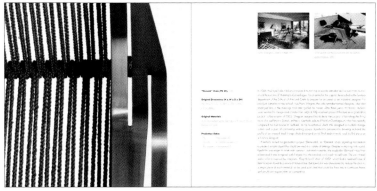

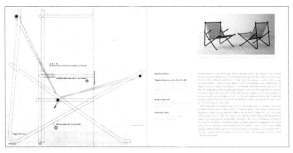

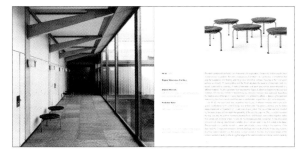

FIG. 4 / 11

CATALOG RAISONNE: *THE FURNITURE OF POUL KJAERHOLM*

· AUTHOR: MICHAEL SHERIDAN
· MATSUMOTO INCORPORATED, NEW YORK
· CREATIVE DIRECTOR: TAKAAKI MATSUMOTO
· DESIGNERS: TAKAAKI MATSUMOTO, HISAMI AOKI
· PHOTOGRAPHER: KELD HELMER-PETERSEN
· EDITOR: AMY WILKINS
· PRINTER: NISSHA PRINTING CO., KYOTO

This catalog raisonne documents the complete work of the mid-twentieth-century Danish furniture designer Poul Kjaerholm.

Client Review during Phase 2

During certain phases of the process, the client reviews and approves the direction and efforts up until that point. Asking a client to review and sign off on what has been discussed and determined can help avoid misunderstandings down the road.

PHASE 3: CONCEPTUAL DESIGN/ VISUAL CONCEPTS

An effective graphic design solution is driven by an underlying concept. A **design concept** is the creative reasoning underlying a design application, the guiding idea that determines how you design; it is the primary broad abstract idea. Essentially, the design drives the hows and whys of your design decisions—how you create or why you select imagery and typefaces or lettering, the reasoning for color palette selection. It sets the framework for all your design decisions. For example, in Figure 4-11, Matsumoto Incorporated explains how the design expresses their concept: "The square format is used because Poul Kjaerholm based many of his furniture designs on the square. The use of Futura type reinforces the mid-century look of the furniture. The pho-tographs used throughout the book were taken by Keld Helmer-Petersen, Kjaerholm's friend and sometime collaborator. The all black-and-white catalog reinforces the spareness and elegance of Kjaerholm's designs."

A concept is visually expressed through the creation, selection, combination, manipulation, and arrangement of visual and verbal (text) elements.

For Opus™, a new carpet brand (see Figure 4-12), Tricycle, Inc., wanted to communicate that the company is a bold and hip "brand in a mature industry. A visual trick is played with the same letterform used for the p and s to represent a roll of carpet."

Generating solid and creative design concepts takes intelligence, work, skill, and talent. For many students and novices, generating concepts is the most challenging stage in the design process. You realize it is not enough to simply arrange graphic elements; it is necessary to

FIG. 4 / 12

LOGO: OPUS

· TRICYCLE, INC., CHATTANOOGA, TN
· CREATIVE DIRECTOR: R. MICHAEL HENDRIX
· DESIGNER: BEN HORNER
· CLIENT: OPUS

Repeating the logo implies abstract patterns found in modern carpet design.
—Tricycle, Inc.

FIG. 4 / **13**

QUALYS TRADESHOW EXHIBIT (TOP ROW: PRELIMINARY CONCEPTS AND SKETCHES)

· GEE + CHUNG DESIGN, SAN FRANCISCO
· CREATIVE DIRECTOR/ART DIRECTOR/DESIGNER/ ILLUSTRATOR: EARL GEE

Preliminary Sketches

Qualys Tradeshow Exhibit Concepts:

Three distinctly different conceptual approaches were presented to determine the most effective approach for the client:

Concept 1: Overlapping Rings of Security

Concept 2: Transparent Towers of Security

Concept 3: Symbolic Metaphors of Security

Objective: *Qualys is the leading provider of on demand security audits to identify and protect against network vulnerabilities. The challenge was to create an effective tradeshow environment at the RSA Conference 2006, the world's largest network security technology showcase.*

Solution: *Bold, iconic security metaphors establish Qualys' "Security On Demand" theme. The reception "target wall" conveys the firm's focus on targeting vulnerabilities while inviting a clear view of the presentation stage. The giant padlock with rotating shield logo functions as a powerful symbol of network security and projects a strong corporate presence across the hall. The keyhole entryway opens to a clean, calming all-white conference room for private meetings. The plasma screen's fluorescent rings and podium's vertical lines represent Qualys' state-of-the-art scanning technology. The theater structure suggests scanning waves and provides high-key lighting and surround sound for the audience. Stools with clocks of 12 major international cities symbolize 24/7 global network security. Key-shaped workstations embedded with computer code demonstrate network security solutions.*

Results: *The iconic booth was highly successful, generating a significant increase in qualified leads and becoming the anchor for nightly RSA Conference news coverage and generating valuable exposure for Qualys.*

—Earl Gee

expressively communicate an idea and message to an audience through the visual design, to create clear and interesting communication. Formulating a concept necessitates analysis, interpretation, inference, and reflective thinking.

For any assignment, a design studio or agency must generate several viable concepts to present to their client. In Figure 4-13, we see both the preliminary concepts and finished solutions for the Qualys Tradeshow Exhibit project. Earl Gee, Gee + Chung Design, presented three distinctly different conceptual approaches "to determine the most effective approach for the client." Being able to generate several, or in fact many, concepts to solve any given problem is a design skill.

Concept-Generation Process

The generally accepted protocol for concept generation is based on the four-stage model outlined in *The Art of Thought* by Graham Wallas, English political scientist and psychologist, in 1926:

Preparation ▸ Incubation ▸ Illumination ▸ Verification

In 1965, James Webb Young, a renowned copywriter at J. Walter Thompson, wrote an indispensable book, *A Technique for Producing Ideas*, where he colorfully and articulately explains his process based on Wallas's model.

Step 1: Preparation

Software can aid in organizing the materials you've gathered, allowing you to save queries, save views, sort topics, select topics for modification, and more. Social bookmarking websites, such as http://del.icio.us.com, allow you to store your bookmarks online and add bookmarks from any computer. Such sites can keep track of source materials and commentary you find online.

1/ Thoroughly examine your materials for insights.

2/ Examine for connections; then correlate to find an insight or idea platform.

3/ Write any idea or insight on an index card, in a notebook, or in a digital file.

Developing your ability to *see relationships* among elements, facts, information, places, and objects will help you generate concepts. Any of your first thoughts or (partially formed) ideas may lead to a workable design concept. Clearly define the assignment to generate a successful design solution. Make sure you examine the materials with the specific assignment and goal in mind.

Step 2: Incubation Period

Once you have examined all the materials, it's time to allow all you learned to simmer in your mind. Taking a break from working on an assignment turns the concept generation over to your subconscious mind. Even when disengaged from concept generation, the brain is highly active. By allowing the problem to percolate in the back of your mind, your subconscious may do the job for you. Often, to take a break, designers turn to experiencing other arts, which might engage their conscious minds, stimulate emotional responses, and encourage the subconscious. Psychologists say this is especially true if the mind is turning over a problem.[11] Examples include reading award-winning fiction; seeing an art house film; attending a music or dance concert, theater performance, or fine art exhibit; or creating fine art (painting, sculpting, drawing, photography, ceramic arts). Some designers prefer semiconscious behaviors, like doodling, daydreaming, or folding paper into odd shapes, to be a kind of constructive self-entertainment.

Step 3: Illumination/Concept Generation

For many, a concept is illuminated—it pops up as if out of a magic lamp, as Athena sprung from Zeus's head in Greek mythology. Often, when we are relaxed and not working at formulation, while driving, cooking, exercising, showering, or doodling, a concept comes to us. However, if incubation has not worked for you, refer to the creativity section in this chapter. Here are other avenues to pursue.

More Points of Departure for Conceptualization

› *Words*: Legendary graphic designer and adman George Lois advises using words to generate concepts. Lois asserts that visual artists can think equally well in words as in visuals. Try making word lists, word associations, word maps, word mergers, or any method that will work for you.

CASE STUDY

SKETCHES, PRESENTATION, AND IDENTITY

- SAGMEISTER INC., NEW YORK
- CREATIVE DIRECTOR: STEFAN SAGMEISTER
- DESIGNER: MATTHIAS ERNSTBERGER
- CLIENT: SEED MEDIA GROUP

SKETCHES

Seed Media Group is a scientific publisher of magazines, books and films.

As we worked on the identity it became clear that the end result should constitute a visualization of science and media.

Science is culture, it surrounds us, it is part of everything we do. We were looking for something open ended and flexible, a vessel we could fill with new meanings as they developed.

Formally the identity is based on phyllotaxis, a form found everywhere from Seashells to Greek architecture, from pineapples to the Sydney opera house, horns of Gazelles to the optimum curve a highway turns. It plays a role in biology, zoology, botany, medicine, physics, geometry and math. It's in the golden ratio and golden curve.

Looking at the world through this scientific lens of the phyllotaxis, we developed an identity like a chameleon, it always takes on the form of the medium it is put on. On the business cards it shows a version of the portrait of the bearer, the letterhead iridescently reflects the room, etc.

—Sagmeister Inc.

PRESENTATIONS

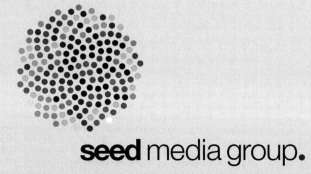

FINISHED IDENTITY

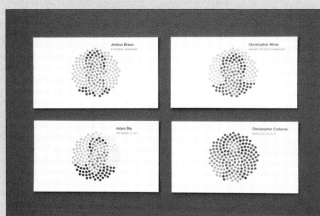

> *Theme as concept*: New media designer and filmmaker Hillman Curtis discusses themes in his book, *MTIV: Process, Inspiration and Practice for the New Media Designer*. A theme is a distinct conceptual or pictorial topic-based approach, which can be based on a thought, an emotion, society, nature, politics, or religion, among other subject areas such as "independence," "jealousy," or "democracy." Variations on a theme also can work as a platform for ideation.

> *Symbol*: Employ an object or image to represent or stand for another thing, thought, idea, or feeling.

> *Literary and rhetorical devices*: Use a metaphor, simile, onomatopoeia, personification, pleonasm, or metonymy, among others, as a concept platform.

> *Merge*: Combine two related or unrelated objects or visuals together to form a unique whole.

> *Synthesis*: Combine/synthesize more than two separate elements that form a new, more complex whole.

> *Juxtaposition*: Place two visuals side by side for contrast or comparison.

Step 4: Verification: Crystallizing the Design Concept

Once you generate a concept, you need to evaluate it, testing for both functionality and creativity. Most concepts require refinement to strengthen them and to ensure they will work in practice. This is the point in the process to keenly critique your own concepts; it involves evaluating/assessing and logically supporting your viewpoint.

Those who are able to generate concepts quickly or immediately are either seasoned designers or well informed about the subject and assignment. Experienced creative thinkers rely on a warehouse of creative thinking tools they have utilized in their repertoire, just as a seasoned winning football coach relies on his experience, range of techniques, abilities, skills, and talented instincts.

Several steps are involved in concept generation:

> Defining the design problem
> Preparation: Gathering and examining materials
> Incubation
> Generating and selecting ideas
> Assessing ideas

PHASE 4: DESIGN DEVELOPMENT

Finally, it's time to design your solution. Now your design concept takes articulate visual form. For many, this is a nonlinear process, where the steps in the design process vary markedly as a result of the nature of creative thinking and designing. Individual factors or circumstances cause designers to follow different paths with deviations from those paths. For instance, many designers create thumbnail sketches throughout the process to develop concepts, to visualize, and to compose. Some designers start with visual collages; others start with words. The following steps are a good point of departure. Soon you will find your own way of working that best suits your personality.

Step 1: Thumbnail Sketches

Thumbnail sketches are preliminary, small, quick, unrefined drawings of your ideas in black and white or color. Best practice dictates that you use traditional image-making techniques—*sketch by hand using a drawing tool*, such as a pencil, marker, or pen, and do *not* sketch using digital media. Why? Sketching with a pencil or marker fosters *exploring, problem finding, visual thinking*, and *discovering*. When starting with digital media, many students do not sketch; they surf for images from stock houses to jump-start conceptualization. Using conventional drawing tools, such as a pencil, also prevents you from refining created images too quickly, which happens to almost every novice when proceeding to the computer to "sketch."

When you sketch, the actual process of sketching allows you to think visually, to explore and make discoveries, and to stay open to possibilities during the art-making process. At first, generating many sketches may be frustrating; however, it gets easier with experience. Generate as many different sketch ideas as possible. (Unfortunately, beginners are often happy with their first few sketches, stopping after a few.) Jose Molla, founder and creative director of La Comunidad in Miami, advises: "The difference between bad and good creatives is that they both come up with the same pedestrian solutions, but the bad creative stops there and the good creative keeps working toward a more unique and interesting solution."

Tip: When you show your thumbnail sketches to your instructor or design director, it's helpful to number them for reference, especially if you are e-mailing them.

Step 2: Roughs

Roughs are larger and more refined than thumbnail sketches. The purpose of this stage is to flesh out a few of your best ideas—to work on each design concept and how it can best be expressed through the creation, selection, and manipulation of type and visuals in a composition. It is important for students and novices to work out their ideas, exploring how to best create, select, and manipulate visuals and type more fully before going to a final stage. At this point, depending on how you work, you will have begun or be in the midst of visualization. (See Chapter 5 on visualization.) This stage also is used to explore possible creative approaches to image making—collage, photomontage, printmaking, drawing, or any handmade technique that can be used to best express your design concept. Even though a rough may look final, it is *not finished* at this point. Roughs should be done to scale (in correct proportion of the final format, whether it is a website frame or a business card). Depending on your design director or creative director at work, he or she may wish to see each visual stage—from thumbnails through comps for input or approval. A client sees a more refined solution.

If a design concept does not work as a rough, it certainly will not work as a solution. If it's not working, rethink, go back over your thumbnail sketches, or generate more concepts. It is important to generate several workable design concepts at the outset so that you have backup. *Most clients prefer to select from among at least three different design concepts and executions.*

Tip: It is a good idea to wait a day or so between creating roughs and creating comps, which is the next step. Time in between will give you a fresh perspective on your work.

Step 3: Comprehensives

A **comprehensive**, referred to as a **comp**, is a detailed representation of a design concept thoughtfully visualized and composed. Comps usually look like a printed or finished piece, though they have not yet been produced. **Mock-up** or **dummy** describes a three-dimensional comp.

When a client sees a comp, he or she will see a very close representation of how the piece will look when produced. It fully represents your solution to the design problem before it goes public, before it is printed or viewed digitally or in any other media.

(Color comps generated on an office or home ink-jet printer will vary a good deal from color printed by a professional printer using printing inks.) Type, illustrations, photographs, and layout are rendered closely enough to the finished design application to convey an accurate impression of the final piece. Every line of type should be adjusted, all the letterspacing considered. A final comp must be well crafted.

Client Review during Phase 4

Rarely do clients throw up their arms in wild approval and say, "That's great! Let's produce this." More often than not, clients request changes and refinements. During this phase, the designer evaluates, refines, and secures approval from the client.

Very often, the comp is used as a visual agreement of the solution between the designer and client and as a guide or "blueprint" for the printer. If you are creating an application for print, it is important to remind the client that the paper stock will most likely change the appearance of the printed piece. Also, digital applications will look different from comps printed on laser paper.

PHASE 5: IMPLEMENTATION

For a graphic design student, execution means either printing one's solution on a home printer or showing it on-screen to one's instructor or creating a mock-up of a three-dimensional application, such as a package design. In a professional setting, implementing one's design solution takes a variety of forms depending on the type of application and whether the application is print, screen-based, or environmental. Very often, designers go on press to ensure accuracy and may work closely with the

FROM START TO FINISH

LIZART DIGITAL DESIGN/LIZ KINGSLIEN

1 / After discussing the desired "look" that the client wanted, several thumbnail sketches were produced.

2 / Artwork, such as this copyright-free pattern, was gathered from source materials.

3 / Four sketches were worked up into black and white logos.

4 / Color was applied to the chosen logo.

PROJECT: LOGO DESIGN

· LIZART DIGITAL DESIGN, CHICAGO
· DESIGNER: LIZ KINGSLIEN
· CLIENT: PAGE'S DAY SPA & SALON

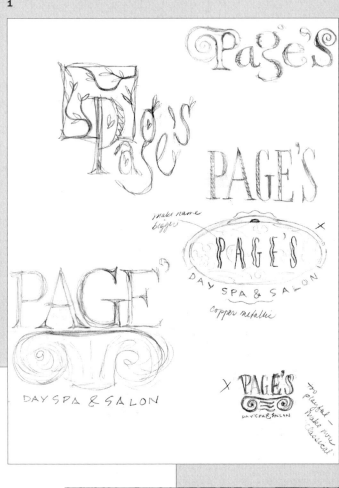

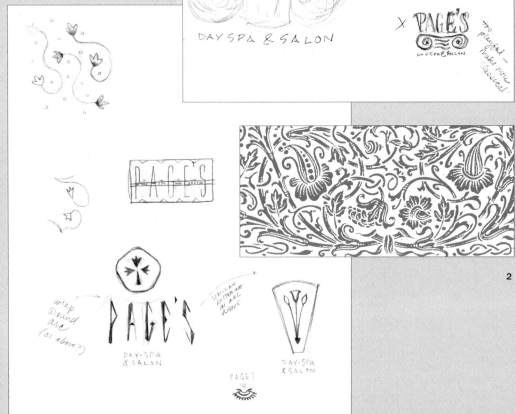

3

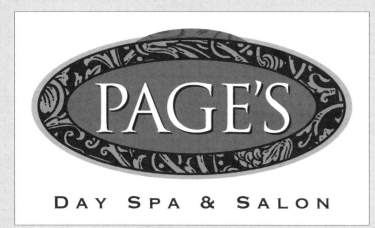

4

FIG. 4 / **14**

BOOK: *LEVI'S JEANS*

· MORLA DESIGN, SAN FRANCISCO
· ART DIRECTOR: JENNIFER MORLA
· DESIGNERS: JENNIFER MORLA, CRAIG BAILEY
· CLIENT: LEVI STRAUSS & CO.

This is a pair of Levi's jeans . . . *is the definitive history of the Levi's 501 Brand. The book lavishly illustrates the past 140 years of Levi's 501 jeans with the people, places, movements, and marketing that turned one brand into an American icon.*

Eclectic typography, historic letters, western imagery, and pull-out spreads add to its visual interest. What began as a small project turned into a 300-page book of which Morla Design handled all aspects of production, from concept inception to delivery of 40,000 books.

—Morla Design

printer. For Figure 4-14, Morla Design said they "handled all aspects of production, from concept inception to delivery of 40,000 books."

In Figure 4-15, you see some of the steps involved in producing and printing an application. Brainforest comments that their goal for pro bono client Gilda's Club Chicago was "to spread the news about this special place where the focus is on living with cancer. We applied for, and won, a prestigious Sappi Ideas That Matter grant that allowed Brainforest to develop, print and distribute 5000 *Living With Cancer Workbooks* on behalf of the Club. This piece won several design industry awards and has been used as a model for Gilda's Clubs and other cancer support foundations on the national level."

Digital prepress, also called **production**, includes preparing the digital files utilizing industry-standard software, collecting all needed photographs and/or illustrations and having them scanned, preparing font folders and image folders, proofreading (with or without the client), and following through by working with the printer. It is often required of an entry-level designer because senior-level designers prefer to design only and not be involved with production work. Entry-level graphic designers often prepare digital files for the printer and prepare digital files for upload to the web. The designer must create meticulous digital files and give explicit instructions to the printer,

select paper, check laser proofs and other prepress proofs, and deliver the job to the client.

A design solution must be prepared in the form of digital files. All visual elements—photography, illustration, and fonts—must be prepared properly to ensure successful printing or digital loading.

The technical skills one needs for creating a comp are somewhat different from the ones needed to prepare a file for the printer. Many students and designers work in imaging or drawing software to create comps. For the printer, almost all files should be prepared in layout programs or in Adobe Acrobat™. (For a fee, most printers can correct your files.) You must learn to properly prepare font and label folders. This book does not attempt to cover the intricacies of print or web production. However, the following is a list of skills most often required.

Digital Design Skills Necessary for Implementation

For print media, an entry-level graphic designer is required, at a minimum, to be fluent in industry-standard software applications, such as the Adobe Creative Suite®—PhotoShop®, Illustrator®, and InDesign®. To be a desirable entry-level candidate, you need to understand how to utilize and integrate these software programs to produce work that conforms to industry standards and your employer's expectations. You should know shortcuts and be familiar with major programs. Besides possessing knowledge of the Adobe Creative Suite, an entry-level web designer should possess an in-depth understanding of the capabilities of web browsers; website architecture (hierarchical organization structure of information specifically for navigation purposes); (front-end) design capabilities in graphics; motion (and perhaps animation); Flash® and Dreamweaver®; and knowledge of ActionScript®; CSS with HTML (back-end) is a plus.

Craftsmanship

Craftsmanship refers to the level of skill, proficiency, and dexterity of the execution. It includes the use of papers, inks, varnishes, cutting and pasting, and software programs. Well-crafted work enhances good design concepts. Many students

FIG. 4 / 15

GILDA'S CLUB CHICAGO *LIVING WITH CANCER WORKBOOK*

· BRAINFOREST, CHICAGO
· SAPPI GRANT RECIPIENT

display their portfolios on websites, on mobile or other digital devices, or on DVDs. Some employers still prefer to see hard copies—comprehensives and mock-ups in portfolios. Many design directors respond to the visceral impact of work. Design solutions should be neat, clean, accurate, functional, and ecologically mindful.

You should familiarize yourself with as many materials, tools, and processes as possible: papers, boards, inks, adhesives, cutting tools, drawing tools (markers, pens, pencils, chalks, brushes, crayons), software programs, and graphic aids. Learn about materials by visiting art supply stores and printing shops. Attend paper shows where you can examine paper samples and ask questions of sales representatives. Learning about paper is crucial. When you obtain paper samples, notice how each paper takes ink. (Many designers are

FROM START TO FINISH

DAVE MASON, SAMATAMASON

D.M.

DAVE MASON

· SAMATAMASON, WEST DUNDEE, IL

After twelve years of specializing in corporate communication design, Dave Mason and cofounders Greg and Pat Samata formed SamataMason Inc. in 1995. Dave Mason's work has been honored in numerous national and international competitions and publications, including The Mead Annual Report Show, The AR100 Annual Report Show, The American Center for Design 100 Show, Communication Arts, Graphis Annual Reports, and Print and HOW magazines.

I've been asked to write a brief article about the process designers use to move an idea from thought to execution. Since design is the result of both left and right brain activity in varying proportions, it's subject to the individual nuances of individual brains; it's highly unlikely that any two designers would solve the same problems in exactly the same way. So although there are probably universal checkpoints in the design process, the only designer I can actually speak for is me. A lot of this may be just common sense and a lot happens between and around these points, but here's my attempt to systemize an incredibly complex, nonlinear process.

1 / Have a problem. There is no more difficult design project than one which does not involve solving a problem. All of the work I consider my most successful has been built around a problem (or two). Want something to just look good? Big problem!

2 / Have an audience. If I don't know who my client wants to be talking to, how can I determine which language to use?

3 / Get the information. Design is about solving someone else's problem with someone else's money, so it has to start with someone else's information. I'm an "expert" in very few areas, but I get asked to help communicate for people who do incredibly diverse things, and they usually know their stuff. So I sell my ignorance. I ask as many dumb/smart questions as necessary to try to get to the essence of any problem.

4 / Read between the lines. I pay attention to what I'm hearing but also to what I'm *not* hearing. Sometimes there are incredible ideas hiding in there.

5 / Get the words right. A picture may paint a thousand words, but a few of the right words can help me visualize a design solution. I think in words. I design around words. There are usually lots of good ones

flying around in the meetings I have with my clients. And clients say the darnedest things!

6 / Bring yourself to the problem. Design is the product of human interpretation. I believe if a client has hired me to help solve their problem, I have to approach it in a way that makes sense to me. If I try to solve a problem the way I think someone else would, what value have I added?

7 / Recognize the solution when you see it. Buckminster Fuller summed it up perfectly: "When I am working on a problem, I never think about beauty. I only think about how to solve the problem. But when I have finished, if the solution is not beautiful, I know it is wrong."

8 / Don't sell design. When I present a design recommendation, I'm not selling "design"—I'm selling a solution to my client's problems. Colors, images, typefaces, technologies, papers—whatever. No one cares but you and your peers. Your client just wants to: *insert client problem here.*

9 / Make sure your clients can see themselves in the solution. If I've done my homework and my interpretation is correct, my clients should recognize themselves—either as they are or as they want to be—in what I design. If they don't, I missed the mark. If you don't believe in listening to your clients, try putting your money where your mouth is: give your hair stylist $500 and let him do whatever he wants to your head.

10 / Make sure you can build what you've designed. Everyone has a budget, and everyone needs/wants more for that budget than they can get. Never present anything unless you know it delivers on that. The best solution isn't a solution at all if your client can't afford it.

11 / Keep the ball in your client's court. Once a project is into development and production, never get into a situation where you are the one holding things up. Move it or lose it.

12 / See it through. How a design project is printed/programmed/fabricated/finished is critical, and attention to detail makes all the difference. I remember seeing a sign in an aircraft factory: "Build it as if you are going to fly it." When the finished design project is in your client's hands, your reputation is too.

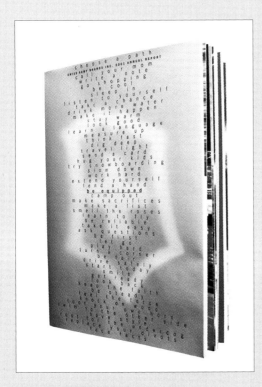

ANNUAL REPORT: SWISS ARMY BRANDS

- SAMATAMASON, WEST DUNDEE, IL
- ART DIRECTOR: DAVE MASON
- DESIGNERS: DAVE MASON, PAMELA LEE
- COPYWRITERS: SWISS ARMY BRANDS PERSONNEL, DAVE MASON
- PHOTOGRAPHERS: VICTOR JOHN PENNER, JAMES LABOUNTY
- CLIENT: SWISS ARMY BRANDS

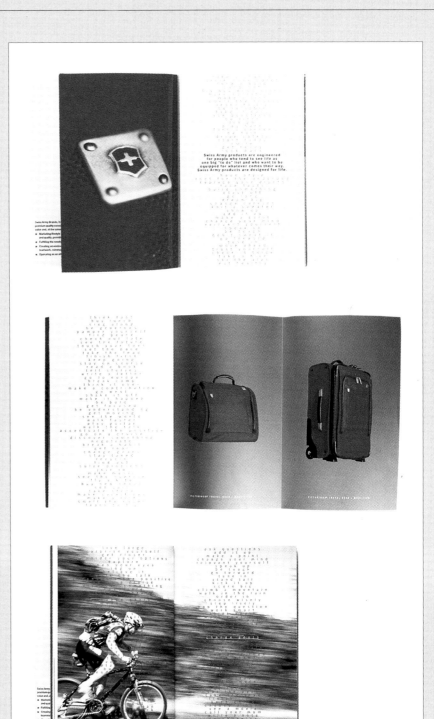

seduced by the tactile aspect of a paper and forget to check how it will take ink.) Visit a printer and see how things are done; start conversations with printers. Learn about the different types of inks, finishes, and printing techniques. In addition to the basic materials listed, there is a wealth of presentation materials available. Learning to cut, glue, mount, and mat are essential hand skills for a design student.

Presentation—the manner in which comps are presented to a client or the way work is presented in your portfolio—is important. When presenting to a client, a great presentation can truly enhance your chances of selling your solution.

Suggestions

› Make it accurate. Try to closely capture the colors, textures, type, and visuals of the concept you are presenting.

› Make it neat. You want people to notice your design, not how poorly something is cut or pasted.

› Present it professionally. A good and thoughtful presentation can enhance your design solution, and a poor presentation can only detract from it.

Paper Tips

› Consider recycled paper or tree-free papers.

› Consider all paper attributes: finish, weight, and color.

› Understand which weights of paper are best suited for various applications.

Tips from Sandy Alexander, Inc. of Clifton, New Jersey:

› Ask, "How will this paper hold up for binding, laminating, foil stamping, spot varnish, die cut, or embossing?"

› For a small quantity, the cost is insignificant for a higher-grade paper.

› When choosing paper, look at printed pieces, not just swatches.

› Go to paper shows and get paper promotionals. They will allow you to see how paper takes ink and special printing techniques. Also, there is often an explanation of how it was printed on the back of the promo.

› Paper choice usually represents 50 percent of the cost of the entire printing job.

› Never skimp on paper! Stock will determine how the paper handles the finishing process.

› Coated and uncoated papers take color very differently.

› Think of paper choice and color results together.

› Your choice of paper will affect how the color is reproduced.

› Each paper type has its own limitations.

The materials you use, whether for a comprehensive or a printed graphic design solution, are critical to the execution of the design and contribute to effective communication, expression, and impact. The skill with which you craft your solution and present it can enhance or detract from it.

Debriefing

After a design assignment has ended, some clients and designers find debriefing useful. This involves reviewing the solution and its consequences.

It is exceptionally useful to debrief—to examine your finished assignment after it has ended to figure out what went wrong and what went right.

EXERCISE 4-1

BRAINSTORMING: MOVIE POSTER

Select an independent film or classic film you've recently seen. If you have never seen an independent film or classic film, then rent one or view one online (www.ifc.com offers web series films online; www.hulu.com).

My recommendations: *Metropolis* directed by Fritz Lang; *Infamous* directed by Douglas McGrath; *Some Like It Hot* directed by Billy Wilder; *Rashomon* directed by Akira Kurosawa; *Purple Rose of Cairo* directed by Woody Allen; *Gas, Food, Lodging* directed by Allison Anders; *Lost in Translation* directed by Sofia Coppola.

Write a summary (a few paragraphs) about the film.

❶ Sketch four visuals that relate to the film. Assign emotions to each visual. Creatively name each visual.

❷ Now pair each of your sketches with a (logical or absurd) related visual (found or handmade). Using the creative tool of synthesis, merge or juxtapose the visuals. If you merge the two

visuals, you bring two things together to form a new combination.

PROJECT 4-1

ACTION VERBS + VISUAL

❶ Choose an existing photograph of yourself or take a photo of an object or person.

❷ Using a variety of methods to alter the image, digital and by hand, take the following actions:

» Modify

» Magnify

» Minify

» Substitute

» Rearrange

» Reverse

Go to our website **GD/s** for *many* more Exercises and Projects, and presentation guidelines, as well as other study resources including the chapter summary.

NOTES

1. *To Lift*, 1967, Vulcanized Rubber. http://www.moma.org/

2. R. Keith Sawyer. "Improvisation and the Creative Process: Dewey, Collingwood, and the Aesthetics of Spontaneity," *The Journal of Aesthetics and Art Criticism*, Vol. 58, No. 2, Improvisation in the Arts (Spring 2000). Boston: Blackwell Publishing, p. 149. http://www.jstor.org/pss/432094

3. Jacob W. Getzels and Mihaly Csikszentmihalyi. *The Creative Vision: A Longitudinal Study of Problem Finding in Art*. New York: Wiley, 1976, p. 126.

4. Sarah Jane Gilbert. "The Accidental Innovator: Q&A with Robert A. Austin," *Harvard Business School Working Knowledge*, July 5, 2006. http://hbswk.hbs.edu/item/5441.html

5. Gilbert, "The Accidental Innovator."

6. Gilbert, "The Accidental Innovator."

7. In *Making Truths: Metaphors in Science*, Professor Theodore L. Brown explains a *conceptual metaphor* as any nonliteral use of language that results in a partial mapping of one term, image, object, concept, or process onto another to reveal unsuspected similarities.

8. John Chaffee. *The Philosopher's Way, Teaching and Learning. Classroom Edition: Thinking Critically about Profound Ideas*. Englewood Cliffs, NJ: Prentice-Hall, 2004, p. 35.

9. Interview by Bryn Mooth. Eureka! Column, *HOW*, June 2002. http://www.zoominfo.com/Search/PersonDetail.aspx?PersonID=200486704

10. Sara Reistad-Long. "Older Brain Really May Be a Wiser Brain," *The New York Times*, May 20, 2008, p. F5. http://www.nytimes.com/2008/08/05/health/research/05mind.html

11. Benedict Carey. "You're Bored, but Your Brain Is Tuned In," *The New York Times*, August 5, 2008, p. F5.

Vasi Comunicanti
Paesaggi della grafica contemporanea
Ottobre 02 / Maggio 03

5 manifesti di Ed Fella
Palazzo Fortuny
13.10 / 8.12.02

Palazzo Fortuny
Campo San Beneto 3780
Venezia

Orario 10 / 18
Biglietteria 10 / 17
Chiuso lunedì

Per informazioni
mkt.musei@comune.venezia.it
www.vasicomunicanti.org

05/

VISUALIZATION

<<< / *facing page*

**POSTER: *LOW AND
BEHOLD***

· ED FELLA

VISUALIZATION
AND COMPOSITION ARE

DRIVEN BY A DESIGN CONCEPT—BY ITS PURPOSE, ITS AUDIENCE, AND ITS FUNCTION, AS WELL AS WHAT FORM IT WILL TAKE (FORMAT, MEDIA, SCOPE). HOW YOU VISUALIZE AND COMPOSE YOUR CONCEPT HINGES ON WHAT YOU WANT SAY, TO WHOM YOU ARE SAYING IT, AND WITH WHAT CONNOTATION. AS ALICE E. DRUEDING, PROFESSOR, GRAPHIC AND INTERACTIVE DESIGN AND AREA HEAD OF THE BFA PROGRAM AT TYLER SCHOOL OF ART, TEMPLE UNIVERSITY, POINTS OUT, STEPS IN THE DESIGN PROCESS MAY NOT PROGRESS IN AN ORDERLY FASHION: "THE ORDER I EMPHASIZE WITH STUDENTS IS (1) CONCEPT, (2) GENERAL VISUALIZATION (CONTENT, MEDIUM, STYLE), AND (3) ORGANIZATION (COMPOSITION, GRID, GOLDEN SECTION, ETC.)—WITH THE CAVEAT THAT THINGS DON'T ALWAYS WORK IN SUCH A LINEAR MANNER."

OBJECTIVES

Learn the considerations of content, medium, and mode/style

Understand how visuals are classified

Integrate type and visuals

Appreciate modes of visualization and expression

Examine the basics of visualizing form

Designers learn by doing. They can learn faster when someone gives them a way to do it. When they learn how, they can understand it.
—Paula Scher

Often, steps in the process of conceptualization, visualization, and composition can happen simultaneously or with great overlap, with back and forth, modifying a concept as you make discoveries while visualizing. Or use visualizing for concept generation. Or . . . whichever method best allows you to visually express your concept. Undoubtedly, you will find your preliminary decisions are subject to change during the course of visualization. You may find your initial impulse overridden by intuition during the process, by a critique, by practical matters related to image quality, time, budget, by a happy accident that altered your thinking, or by any number of factors.

CONSIDERATIONS OF CONTENT, MEDIUM, AND MODE

After you generate a concept, you make *preliminary* decisions about content, medium, and mode.

› *Content*: Required text + visual components
› *Media and Methods*: How the component parts will be created, rendered, and displayed on screen or in print. Some include illustration, drawing and painting, photography, graphic illustration, collage, photomontage, layering, and type as image.
› *Mode of Visualization and/or Style*: A mode of visualization is how you will render and execute the visuals and type for a project, including decisions about the qualities and characteristics of the form. Although some designers develop a unique style (distinctive, identifiable forms), such as Luba Lukova (Figure 5-01), most designers vary their modes of visualization depending on a specific project, using what is most appropriate and expressive. Many beginners fixate on style development, which should not be a concern while studying design; it is much more important to focus on experimentation with visualization

and composition. Style *also* can become a means for composing; for example, you can base your composition on the compositional, structural, stylistic conventions of the Vienna Secession, art deco, Swiss school, or any other school of thought.

ABOUT VISUALS

Graphic designers work with two main components: type and visuals. As discussed in Chapter 3, *type* can be created in a variety of ways—for example, computer generated, hand drawn, handmade, or photographed. **Visuals** is a broad term encompassing many kinds of representational, abstract, or nonobjective depictions—photographs, illustrations, drawings, paintings, prints, graphic elements and marks, and elemental images such as pictograms, signs, or symbols; visuals are also called **images**.

In *Type and Image: The Language of Graphic Design*, Philip B. Meggs explains, with great clarity, how we classify images, from the rudimentary to the complex.[1] Classifying visuals and how to depict them helps you understand the range and potential of visuals to communicate (see Diagram 5-01).

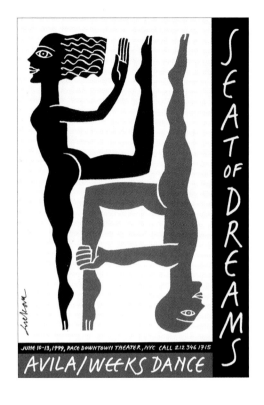

FIG. **5**/**01**

POSTER: *AVILA/WEEKS DANCE*

· LUBA LUKOVA STUDIO, NEW YORK
· DESIGNER/ILLUSTRATOR: LUBA LUKOVA
· CLIENT: PACE DOWNTOWN THEATER

› **Notation:** a linear, reductive visual that captures the essence of its subject, characterized by its minimalism.

› **Pictograph:** an elemental, universal picture *denoting* an object, activity, place, or person,

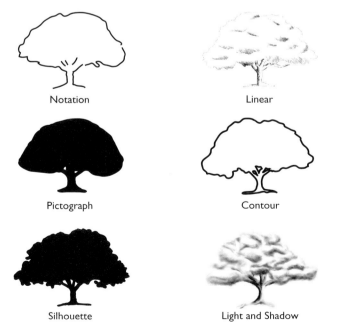

Notation

Linear

Naturalistic

Pictograph

Contour

Expressionistic

Silhouette

Light and Shadow

DIAGRAM [5-01]

CLASSIFICATION OF IMAGES

Representational

Abstraction

Nonobjective

DIAGRAM [5-02]

THREE BASIC CLASSIFICATIONS
OF DEPICTION

· ABSTRACTION ARTIST: HAYLEY GRUENSPAN

DIAGRAM [5-03]

SIGNS AND SYMBOLS

captured through shape—for example, the images denoting gender on bathroom doors.

> **Silhouette:** the articulated shape of an object or subject taking its specificity into account (as opposed to the universal visual language of a pictograph).

> **Linear:** a visual created by a predominant use of line to describe shape or form.

> **Contour:** a shape or form created through the linear outline of an object or subject's boundaries.

> **Light and Shadow:** using light and shadow to describe form most closely simulates how we perceive forms in nature. Also, a logical flow of light, as it touches and describes forms, can help unify a composition. An extreme use of light and shadow is called chiaroscuro (also called claire-obscure).

> **Naturalistic:** a visual created by full color or tone using light and shadow that attempts to replicate an object or subject as it is perceived in nature; also called *realistic*. (Please note, in modern and contemporary *fine art* theory and criticism, the terms *naturalism* and *realism* are defined differently and represent different schools of thought.)

> **Expressionistic:** an expressionistic visualization is characterized by a highly stylized or subjective interpretation, with an emphasis on the psychological or spiritual meaning; there is no strict adherence to things as they appear in nature, as opposed to naturalism.

There are three basic classifications of depiction as they directly refer to and then move away from what we see in nature (see Diagram 5-02):

> **Representational:** a rendering attempting to replicate actual objects as seen in nature; the viewer recognizes the image; also called **figurative**.

> **Abstraction:** a simple or complex rearrangement, alteration, or distortion of the representation of natural appearance, used for stylistic distinction and/or communication purposes.

> **Nonobjective:** a purely invented visual, not derived from anything visually perceived; it does not relate to any object in nature and does not literally represent a person, place, or thing; also called **nonrepresentational**.

SIGNS AND SYMBOLS

Graphic design signifies. Graphic design represents. Graphic design communicates. From the theory of semiotics, the study of signs and symbols, we get a classification of signs—what they mean and how they are used in graphic design.[2] (Please see Diagram 5-03.)

> **Sign:** a visual mark or a part of language that *denotes* another thing. For example, the word *dog* and a pictograph of a dog are both signs used to represent "dog"; the $ denotes money; the letter "H" is a sign for a spoken sound.

> **Icon:** a generally accepted (pictorial or symbol) visual to represent objects, actions, and concepts; an icon resembles the thing it represents or, at a minimum, shares a quality with it. It can be a photograph, a pictorial representation, an elemental visual (think magnifying glass desktop icon), arbitrary (think radioactive sign), or symbolic (think lightning bolt to represent electricity).

> **Index:** a visual that directs the attention of the interpreter (viewer) due to its neighboring relationship to it without describing or resembling the thing signified. There are a variety of ways this happens: whether as a cue that makes the viewer think of the reference (for example, a pacifier is an indexical sign for an infant), by its proximity to it (for example, a divers down flag means someone is under water and you must steer clear of the area), by actually pointing to the thing signified (an arrow at an intersection in a road), or by being physical evidence of it (for

Icon

Index

tree

Word
as symbol

Symbol
of tree

example, a photogram of a hand or a hoof print on the ground).

› **Symbol:** a visual that has an arbitrary or conventional relationship between the signifier and the thing signified. The interpreter decodes meaning through learned associations (for example, a dove has become accepted as a symbol of peace). Spoken or written words are symbols as well.

› Some symbols take on greater meaning than others due to their context and roles in religion, culture, history, or society; for example, the cross in Christianity, the ankh as symbol for life associated with ancient Egypt, the Star of David as symbol for Judaism, and the yin–yang as the Chinese symbol of the interplay of forces in the universe. It is hard to think of anti-war protest posters without thinking of the nuclear disarmament symbol designed by Gerald Holton in 1956. This graphic, a circle with a few lines in it, stands for something as profound as the idea of peace (Diagram 5-04).

Use of Signs and Symbols in Graphic Design

Signs and symbols serve many functions and purposes in graphic design, whether as a stand-alone image, such as in a logo or as a pictograph on a bathroom door, or most often as components of a

DIAGRAM | 5-04 |

PEACE SYMBOL

design solution, such as a sign system that is part of a visual identity program, or a symbol, such as a heart, as a visual component within a poster or brochure.

Today, so much information must be universally understood, crossing language and cultural barriers. Signs or icons in the form of pictograms serve this purpose wonderfully; they are purely visual, nonverbal communication. The Talk Chart, a communication tool for patients in hospitals, designed at Kean University's Design Center, is an example of graphic design using pictograms and the alphabet (Figure 5-02).

Wayfinding signs and systems are used internationally. Usually, these **wayfinding systems** assist and guide visitors and tourists to find what they are looking for in museums, airports, zoos, and

FIG. **5** / **02**

CHART: THE TALK CHART

· THE DESIGN CENTER AT KEAN UNIVERSITY
· DESCRIPTION OF WORK: A COMMUNICATION DEVICE UTILIZING ICONS
· CREATIVE DIRECTOR: ALAN ROBBINS, THE DESIGN CENTER, KEAN UNIVERSITY OF NEW JERSEY
· DESIGNERS: VARIOUS DEDICATED STUDENTS
· CLIENT: SELF-INITIATED

The Talk Chart is a communication device for patients in hospitals and nursing homes. Using the 8½" × 11" laminated chart, patients with aphasia, throat tubes, or other impairments to their speech can now make their needs known to family and staff by pointing to the graphic symbols or letters of the alphabet that appear on the chart. The graphic symbols represent twenty basic patient needs and figures of the human body for pinpointing problems.

The Talk Chart was created and designed by college students in The Design Studio at Kean University under the direction of Professor Alan Robbins and is donated to local hospitals. Thanks to a generous grant from Sappi Paper, the Talk Chart is currently used in 2,000 hospitals throughout the United States.

For more on this, visit: http://www.kean.edu/~designct/

FIG. **5** /**03**

ICON DESIGNS

· AARON MARCUS AND ASSOCIATES, INC., BERKELEY
· ART DIRECTOR AND PRINCIPAL DESIGNER: AARON MARCUS, PRESIDENT, AARON MARCUS AND ASSOCIATES, INC.
· DESIGNER: WOLFGANG HEIDRICH, DESIGNER/ANALYST, AND OTHER DESIGN STAFF MEMBERS OF AARON MARCUS AND ASSOCIATES, INC.

Aaron Marcus and Associates, Inc., designed these icons for a revolutionary change in the user interface for the Sabre travel reservation system for travel agents, one of the world's largest extranets, with about 40 terabytes of data at the time and used by approximately one-third of the world's travel agents.

—Aaron Marcus and Associates, Inc.

city centers. Icons are widely used today in other functions; they are also referred to as *symbol signs* or *access symbols* by some in graphic design vernacular.

Screen-based media make great use of icons, usually in the form of pictographs (Figure 5-03). The primary objective of the Disability Access Symbols Project is for organizations to use these to better serve their audiences with disabilities (Figure 5-04).

Designing a system requires a clear design concept and a consistent use of shapes, scale, and all the formal elements. The signs or icons in a system must look as if they belong to the same family. At times, more than one designer in a design firm or studio will work to produce a system. It is imperative to establish a firm design concept, style, and vocabulary of shapes for the system to look like it was created by one hand and mind, as

FIG. **5** /**04**

DISABILITY ACCESS SYMBOLS PROJECT

· X2 DESIGN, NEW YORK
· THE DISABILITY ACCESS SYMBOLS WERE PRODUCED BY THE GRAPHIC ARTISTS GUILD FOUNDATION WITH SUPPORT AND TECHNICAL ASSISTANCE FROM THE OFFICE FOR SPECIAL CONSTITUENCIES, NATIONAL ENDOWMENT FOR THE ARTS. SPECIAL THANKS TO THE NATIONAL ENDOWMENT FOR THE ARTS. GRAPHIC DESIGN ASSISTANCE BY THE SOCIETY OF ENVIRONMENTAL GRAPHIC DESIGN. CONSULTANT: JACQUELINE ANN CLIPSHAM.

The project was extremely challenging in terms of design because the client insisted on having organizations representing people with various disabilities review and comment on the proposed symbols. With the help of a disability consultant, we were able to reach consensus among all these groups and still achieve the primary objective—for organizations to use these symbols to better serve their audiences with disabilities.

Several existing symbols did not meet the standards we established and needed redesign. For example, the old symbol for Assistive Listening Systems focused on the disability (an ear with a diagonal bar through it). The new symbol focuses on the accommodation to the disability, i.e., a device that amplifies sound for people who have difficulty hearing. Other upgraded symbols include Sign Language Interpreted, Access (Other than Print or Braille) for Individuals Who Are Blind or Have Low Vision, and the International Symbol of Accessibility. A new symbol for Audio Description for TV, Video and Film was developed which, through design, proved less likely to degenerate when subjected to frequent photocopying.

—Graphic Artists Guild Foundation

in the complete set of fifty passenger and pedestrian symbols developed by the American Institute of Graphic Arts (AIGA) (Timeline, page TL-15).

TYPES OF IMAGES AND IMAGE MAKING

Imagery is either *created* by the designer, *commissioned* from an illustrator or photographer, *selected* by the designer from among stock imagery or the client's archives, or *found* by the designer (to be discussed in this chapter).

Visuals can be created using a multitude of tools and media—for example, using photography, software, assemblage, collage, photogram, photomontage, drawing, painting, printmaking, mixed media, sculpture, ceramics, and more. (Any three-dimensional image would have to be photographed to be utilized on a printed or digital two-dimensional surface.)

When you create your own image, you are in control; you decide what goes into the image or scene (point of view, colors, textures, people, room, clothing, setting, etc.). When you select an image, you either accept the image as is—as someone else conceived it, visualized, and composed it—or alter it, assuming the stock image provides rights for such alterations. This difference is critical because every component of an image contributes to communication. For example, legendary American cartoonist Henry Martin elucidates: "I get the idea first and then think how the idea would look. What props would I need? Who are the people? What are their clothes? Where are they? In a room? On a boat? In America? Then I imagine the setting and the people and then start to draw. I usually do a rough drawing and then a finished drawing."

The following list explains broad categories of producing and creating images.

› **Illustration:** a handmade unique visual that accompanies or complements printed, digital, or spoken text, which clarifies, enhances, illuminates, or demonstrates the message of the text. Illustrators work in a variety of media and most often have uniquely identifiable styles, as does Mitzie Testani in Figure 5-05. The AIGA notes, "Each illustrator brings a different perspective, vision and idea to play that, when married with great design, becomes an original art form." When you are working professionally and need to hire an illustrator, you can find them in annuals, in sourcebooks, on the Internet, and through agents/representatives. (On a historical note, prior to the invention of photography, and also when photography was in its infancy and the equipment cumbersome, illustration was the most popular form of imagery in visual communication. Visit http://societyillustrators.org.)

› **Photography:** a visual created using a camera to capture or record an image. Commercial photographers specialize in various genres, such as still life, portraiture, sports, outdoor imagery, fashion, journalist, aerial, landscape, urban, moving image, events, food, and others. When you are working professionally and need to hire a photographer,

FIG. **5** /**05**

ILLUSTRATIONS/BOOK: *THE WATER OF LIFE* (UPDATED GRIMM'S FAIRY TALE)

· DESIGNER/ILLUSTRATOR: MITZIE TESTANI (CREATED AS A SENIOR, TYLER SCHOOL OF ART, TEMPLE UNIVERSITY)

· INSTRUCTOR: ALICE E. DRUEDING, PROFESSOR, TYLER SCHOOL OF ART, TEMPLE UNIVERSITY

you can find one in annuals, in sourcebooks, and on the Internet. Fine art photography and journalist photography are also utilized in graphic design. (Today, photography is probably the most popular form of image in visual communication.)

> **Graphic interpretation:** an elemental visualization of an object or subject, almost resembling a sign, pictogram, or symbol in its reductive representation (see Diagram 5-05). Although a graphic interpretation employs economy (stripping down visuals to fundamental forms), what differentiates a graphic interpretation from a sign or pictogram is its expressive quality; it is often more descriptive. *With the same skill set used to design logos or pictograms, graphic designers can capably create graphic interpretations.*

> **Collage:** a visual created by cutting and pasting bits or pieces of paper, photographs, cloth, or any material to a two-dimensional surface, which can be combined with handmade visuals and colors. A conventional collage technique can be simulated and rethought for digital media using computer software (and its tools and capabilities) and hardware, a digital camera, and/or a scanner.

> **Photomontage:** a composite visual made up of a number of photographs or parts of photographs to form a unique image.

> **Mixed media:** a visual resulting from the use of different media—for example, photography combined with illustration.

> **Motion graphics:** time-based visual communication that integrates visuals, typography, and audio, created using film, video, and computer software, including animation, television commercials, film titles, and promotional and informational applications for broadcast media and new media.

> **Diagram:** a graphic representation of information, statistical data, or a structure, environment, or process (the workings of something). A **chart** is a specific type of diagrammatic representation of facts or data. A **graph** is a specific type of diagram used to indicate relationships between two (or more) variables, often represented on axes. A **map** is a specific type of diagrammatical representation used to depict a route or geographical area—to show location.

More on Visualization: Approach and Connotation

Designers may choose an approach—a look, manner, tone, style, or any appearance—to communicate or connote meaning. For example, utilizing a retro approach reminiscent of the 1950s for a hair gel product might endow the brand with a vintage look. Or using a historical period typeface or hand lettering for an American Civil War Memorial Museum should add to its authenticity rather than seem clichéd.

Some approaches are:
> Retro
> Psychedelic
> Funk
> Primitive
> Childlike
> Grunge
> Surreal
> High-tech
> Homemade
> New Wave
> Futuristic

DIAGRAM [**5-05**]

GRAPHIC INTERPRETATION

HISTORICAL PERIODS AND CONNOTATION

Studying the history of graphic design affords one an understanding of how style communicates a period and the spirit of an age—the zeitgeist. Without a knowledge of design history, one risks designing without understanding the provenance, heritage, and associated meanings, as well as how form communicates meaning. For example, the art nouveau letterforms carry meanings that are reminiscent of that time period. By using an art nouveau–period typeface for a logo, that logo design would share in the vested meaning of the art nouveau period. (The essential book is *A History of Graphic Design* by Philip B. Meggs [Wiley].) Go to our website for a list of the styles and periods every designer should be able to grasp and visualize. **GD/s**

Selecting Images and Image Manipulation

When a budget does not allow for commissioning an illustrator or photographer, you can turn to available archives of preexisting illustrations or photographs, referred to as *stock* (*royalty-free* and "rights' managed"), which can be licensed for a project from stock houses. *Footage* (a shot or sequence of shots on videotape or film) and music also are available from stock houses.

Some designers employ *found* imagery, utilizing existing imagery or objects in environments, public domain, or copyright-free images (woodcuts, linocuts, etchings, patterns, rules, and more), historical imagery, ephemera, old postcards, old letters, old maps, family photos, old photos, old playing cards, stamps, old greeting cards, old wrapping paper, old cigar box labels, old labels, old signs, et cetera (all involving securing necessary rights if any are required).

Image making also involves manipulation. A common decision a designer must make is whether to use a visual *as is* or change it—manipulate it. Image manipulation includes:

› Alteration: a modification or change to the appearance of a visual
› Exaggeration: a modification that embellishes, amplifies, or overstates
› Economy: a reductive visualization

IMAGERY, IMAGE APPROPRIATION, AND INTELLECTUAL PROPERTY

Many students start the visualization process by searching through stock image websites. This route stunts thinking and visualization. Also, the ease of finding high-resolution visuals on the Internet has led to some significant issues concerning image appropriation and violating intellectual property rights. Other than images that are in the public domain, which are copyright-free, photographs, illustrations, and graphic representations found on the Internet or in print publications are intellectual property (original creative work that is legally protected) belonging to other visual artists. In a professional setting, a designer or art director would have to commission images from a photographer or illustrator for a design application and/or license stock images from an archive or a stock house (a creative resource for graphic design, advertising, and media professionals that provides illustration, photography, footage, and rights services).

Most design directors and creative directors prefer to see original visuals created by students themselves in their portfolio projects, demonstrating a student's creativity, individuality, range, and initiative. With the advantage of digital cameras, students can take their own photography and work in Adobe Photoshop™. Scanners allow students to scan in their own handmade images and illustrations or illustrate using computer software. Some use of stock imagery in your portfolio allows creative directors to see that a beginner can *choose stock appropriately and well*. Choosing appropriately and well entails understanding images—their denotative and connotative meaning, classification, style, shape, orientation, lighting, point of view/angle, color palette, and composition.

› Combination: merging two or more different or related visuals into a unique whole
› Deliberated camera angle and viewpoint: the perspective from which you position your camera

Presentation

How you present a visual affects communication. Will you crop it? Bleed it? Isolate it? Juxtapose it? Frame it? How will the visual be presented on the page? Matters include:

› **Margins:** the blank space surrounding a visual on the left, right, top, or bottom edge of a page can frame a visual, almost presenting it in a formal manner. Margins also afford space for page numbers, running heads in publications, notations, captions, headings, titles, and credits.

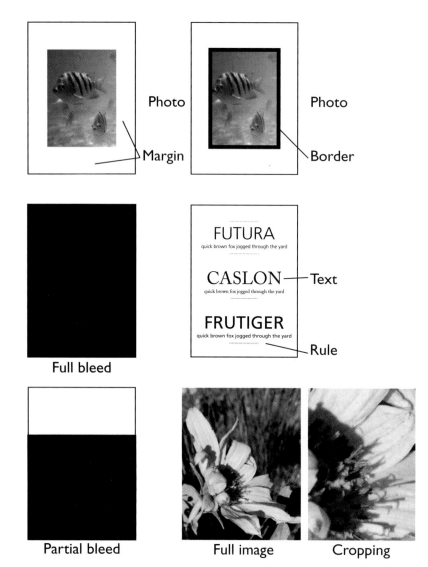

DIAGRAM [5-06]

PRESENTATION

edit it, to improve it, or to delete visual information that might distract the viewer from the communication. Cropping alters the original visual; it alters its outer shape, its internal scale, and how the inner content is framed, and can change its focus.

› **Bleed** or *full bleed*: type or a visual that extends off the edges of the page, filling the page with an image. A **partial bleed** can run off one, two, or three sides. See Diagram 5-06.

INTEGRATING TYPE AND VISUALS

When type and visuals interact, then you have to determine *how they will interact*.

› Will the type and visuals share characteristics?
› Will the type and visuals work in opposition, be contrasted in style of visualization and/or form?
› Will the type drive the composition? Will the visual drive the composition?
› Will the type and visuals be organically intertwined?
› Will they touch, overlap, be juxtaposed, fuse? Will they be words that incorporate images or be images that incorporate words?
› Will one be the star and the other the supporting player?

To best explain visual/type integration, let's break it into three categories:

› *Supporting partner*: a classic "neutral" typeface works cooperatively with the visual as the "star." (This is, by far, the biggest category.)
› *Sympathetic* type and visual relationships. (This is the next biggest category.)
› *Contrasting* type and visual relationships. (This is an under-utilized category.)

SUPPORTING PARTNER

For the sake of clarity and visual interest, the tendency is to allow either type *or* visual(s) to be the star, hero, or heavy lifter, with the other component acting in a more neutral fashion, like a supporting actor. As an analogy, when reviewing a recent revival of David Mamet's play, *Speed the Plow*, Ben Brantley, chief theater critic of *The New York Times*, described Scott Pask's "tasteful, sterile

› **Rules:** thin stripe(s) or line(s) used for borders or for separating text, columns of text, or visuals. Most often, rules function best when used to separate, as *dividers*, attracting little notice to them.
› **Borders:** a graphic band that runs along the edge of an image, acting to separate the image from the background, like a frame, by something as simple as a thin rule or as ornate as a Baroque frame. Borders also can act to emphasize the boundaries of an image. *A border should never overwhelm or distract from what it frames.*
› **Cropping:** the act of cutting a visual, a photograph, or illustration to use only part of it, not using it in its entirety. You can crop an image to

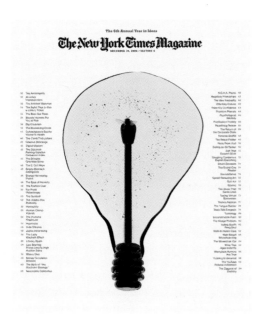

FIG. 5 / 06

THE 6TH ANNUAL YEAR IN IDEAS COVER: *THE NEW YORK TIMES MAGAZINE*

· CREATIVE DIRECTOR: JANET FROELICH, *THE NEW YORK TIMES MAGAZINES*
· ART DIRECTOR: AREM DUPLESSIS
· DESIGNER: GAIL BICHLER
· PHOTOGRAPHER: HORACIO SALINAS

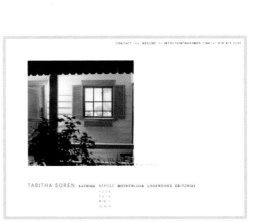

FIG. 5 / 07

BOOK COVER: *SOUTH OF THE BORDER, WEST OF THE SUN* **BY HARUKI MURAKAMI**

· ART DIRECTOR/DESIGNER: JOHN GALL
· PUBLISHER: VINTAGE BOOKS

Gall's mysterious visual juxtaposition—which makes the viewer look twice (or more)—reflects Haruki Murakami's psychological probe into obsession, unrequited love, and human frailties.

sets" for a character's office and house as "blank slates; words are what furnish these rooms."[3] Similarly, in a design, type might be the well-chosen, sterile, blank slate, and the visual "furnishes the room." For example, in Figure 5-06, the light bulb "icon" reigns supreme. If both type and visuals attract our attention due to equal prominence, then focus is diffused or lost.

For Haruki Murakami's *South of the Border, West of the Sun*, John Gall creates an image as rich and mysterious as the novel (Figure 5-07), with the type designed for clarity to complement the image. For Figure 5-08, a photographer's website, it certainly makes sense to allow the visual to be the star; as John Clifford, Think Studio, comments, "A clean design allows the photography to

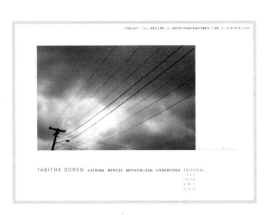

FIG. 5 / 08

WEBSITE

· THINK STUDIO, NEW YORK
· DESIGNERS: JOHN CLIFFORD, HERB THORNBY
· CLIENT: TABITHA SOREN

ESsay

USING IMAGES BY ALAN ROBBINS

A.R.

Alan Robbins is a professor of visual communications, the Janet Estabrook Rogers Professor of Visual and Performing Arts (2006-2009) at Kean University in New Jersey. He is the founding director of The Design Center, which produces exhibitions, publications, and products in the various fields of design and which has won numerous design awards.

Professor Robbins is also an award-winning writer and the author of 20 books in the areas of mystery, science fiction, puzzles, and humor. His cartoons, illustrations, graphics, and games have appeared in dozens of publications and exhibitions. His unique series of mystery jigsaw puzzles has millions of fans around the world and his featured YouTube channel has over 3.5 million hits.

His work can be seen at www.alan robbins.com

We never see images in isolation anymore but almost always in conjunction with other images— adjacent, linked, connected, overlapping.

One of the ways the field of graphic design is radically changing relates to the increasing emphasis we are placing on images for communication. The digital revolution and especially the technology of the web have pushed this steady evolution into an explosive mode. We are bombarded with images on our streets, in our homes, and in every device we use to keep in touch. Still and moving images dominate the media to the point that it is rare now to see isolated text or even isolated images. Instead, our visual surround is becoming a vast matrix of images, a virtual world we increasingly live inside.

As designers, we therefore need to understand the impact that images have and the ways we can manipulate and present them to achieve our goals. We need to understand, in other words, the kinds of information that images can convey, the way people look at images, and the impact our choices have on viewers.

One thing to keep in mind when working with images is that we understand them in many ways and on many different levels. Looking is an active process in which we very quickly build up the meaning of an image by probing it with our eyes and brain. For this reason, very few images have one single impact or meaning; most images affect us in a number of different ways.

But image creation is not accounting; there are no common rules to follow. The goal in using images, as it is in all of design, is to become sensitive to the impact of the decisions we make and to understand what our options are as we pursue our objectives. As we select and alter images, we have to remember that many parts of that image may be significant depending on its final use. That can include details that we choose to emphasize or eliminate, colors and tones that we adjust or create, and the sense of balance, hierarchy, or rhythm that we decide to manipulate or impose.

Take the first issue about which details in the image matter. Ask yourself what the focus, the main point, in the image is or should be. What do you want people to notice first, second, third? Even a simple tool like cropping can have an impact here. Or you can enhance certain parts of the image and diminish the effect of others by selectively sharpening or blurring. You can also adjust the tones of the image through contrast and brightness to create different moods.

The colors and shapes, which are thought of as two of the visual elements of an image, have a different and subtler impact. Ask yourself which colors matter and what the palette or overall color scheme communicates. Shifting the colors generally—or adjusting specific areas of color—can have a profound effect on the impact by making the image softer or harsher, warmer or cooler, more or less intense.

And along similar lines, what kinds of feelings do the shapes convey? Angles and sharp edges can be softened to make images more seductive or, on the other hand, can be hardened to give the image a blunter effect. Busy images can be simplified for more direct impact, as is often the case with logos that have to be recognized quickly, whereas images that are too simple can be enriched for more in-depth viewing, like many book covers.

Composition plays a role here too. Balanced images are seen as stable and calming; imbalanced ones are dynamic and moving. For example, images that are religious in nature tend toward the former, whereas those that relate to music tend toward the latter. And again, the rule is that there is no rule, just your awareness of the effect your decisions have. Keep your goal in mind, your sense of what you want the viewer to see or feel, your objective for the communication.

The question about whether to create our own image or use or alter an existing one is a consistent

issue for designers in a world of images. Different projects require different solutions, but in general, we always want to leave our creative stamp on everything we make. Ideally, you can create your own images that reflect your unique skills and talents, but even when that is not possible, try to make each image your own by altering, adjusting, manipulating. A poster or page that you design should work because all the elements—including the image—work together to achieve your goal, not simply because it relies on a strong image that you found online.

And then there is the relationship of images to text to consider. This too is a complex challenge with no simple rules. Words tend to provide more precise, in-depth meanings while images tend to have a broader, more immediate impact. When an image is used to support written text, it can serve many functions. If it is used to illustrate the content of the words (for a magazine article, for example), then the question is which part of the text is worth illustrating and whether you can create an image to achieve that in a compelling way. If the image is used to demonstrate an argument made through the words (like a chart, for example), then the question shifts to whether the image is clear, accurate, and precise. Images can also be used to simply support the general mood or tone created by the words, in which case the subtle impact of shape, color, balance, and hierarchy become more significant.

But of course, in many cases and increasingly, the image is the focus of the communication, and words are used to support, explain, or expand on it. Then the question becomes how to present the words in a way that clarifies rather than confuses the impact of the image—where to place them, how big to make them, how to connect them visually to the image.

And one final point about the new world of the image: We never see images in isolation anymore

IMAGES BY ALAN ROBBINS

Illustration 1 (drawing): Illustrations, like this one for a book of essays, suggests a more intimate and personal communication.

Illustration 2 (logo): Simplified images, like this logo for a TV studio, rely on bold shapes to emphasize instant recognition.

Illustration 3 (painting): Nonobjective images like this painting also communicate but on a more emotional and intuitive level than images that depict.

but almost always in conjunction with other images—adjacent, linked, connected, overlapping. So in addition to all the decisions you make about individual images for various projects, you also have to keep in mind the entire image landscape you create, how the parts interact, and what the overall effect is.

Plenty to think about and keep in mind now that we are just at the beginning of this image revolution. New developments, media, and innovations are happening all the time, leading to new types of images and new uses for them. All of this will require designers who are sensitive to the impact of every choice they make regarding each image they select or create.

Stay tuned.

stand out—does not distract." For their holiday gift (Figure 5-09), WAX "created a greeting card kit that could be used by our clients and suppliers year-round. Each kit contained illustrated stickers depicting various occasions, colorful blank cards, envelopes and sheets of word stickers, which included odd words and phrases such as 'hot dog'

and 'lawyer.' The recipient of the kit mixes and matches these elements to create unique greeting cards," says Jonathan Herman. The type plays a contributory role to the humorous illustrations' leading roles.

SYMPATHETIC

Type and visuals possess shared or similar qualities and characteristics, and the resulting harmonious agreement communicates or enhances meaning, or type and visuals share apparent thematic character and purpose. Congruence relies on agreement in shape, form, proportions, weights, widths, thin/thick strokes, lines, textures, positive and negative shapes, and historical period. For example, Corey Harris's name, image, and album title are treated similarly in Figure 5-10. In Figure 5-11, a spread for *The New York Times Magazine*, the Teutonic initials "KL" and the photograph of Karl Lagerfeld share qualities, black and white color palette, shape relationships, and central positioning.

Again, it must be understood that even though visual/verbal components share characteristics, there is the hierarchic strategy that one component—*either type or visual*—is the star, possessing

FIG. **5** / **09**

WAX GREETING CARD KIT

· WAX, CALGARY, ALBERTA
· CREATIVE DIRECTOR: MONIQUE GAMACHE
· ART DIRECTORS: JONATHAN HERMAN, JONATHAN JUNGWIRTH
· WRITER: SARO GHAZARIAN
· ILLUSTRATOR: CHRISTOPH NIEMANN

Self-promotional graphic design applications offer an opportunity to demonstrate a design studio's capabilities, wit, personality, or style.

FIG. **5** / **10**

CD PACKAGE DESIGN: COREY HARRIS,
MISSISSIPPI TO MALI

· VISUAL DIALOGUE, BOSTON
· DESIGNERS: FRITZ KLAETKE, IAN VARRASSI, CHRISTIAN PALINO
· CLIENT: ROUNDER RECORDS

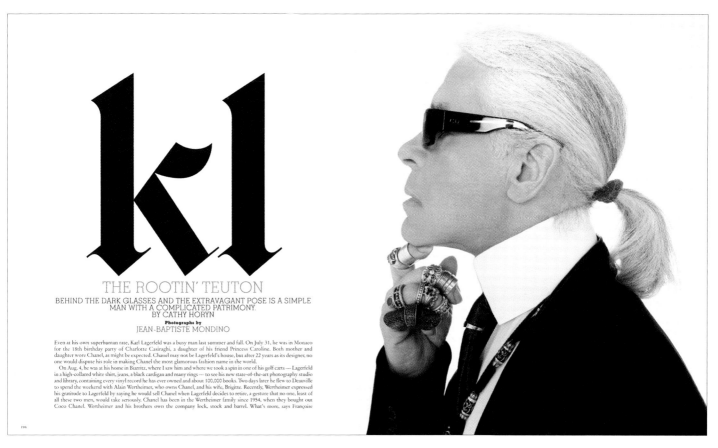

FIG. **5** / **11**

MAGAZINE SPREAD: "KL" *THE NEW YORK TIMES MAGAZINE*

· CREATIVE DIRECTOR: JANET FROELICH, *THE NEW YORK TIMES MAGAZINES*
· ART DIRECTORS: JANET FROELICH AND DAVID SEBBAH
· DESIGNER: JANET FROELICH
· PHOTOGRAPHER: JEAN-BAPTISTE MONDINO

the most visual interest, and the other is more neutral to support the one doing the heavy lifting, as in the poster for the Funk Brothers (see Figure 5-18). In Mike Perry's cover for *A Circular Universe*, although the imagery corresponds to the letterforms in many ways—shape formation, color palette, and movement—it takes a subordinate role to type as the hero (Figure 5-12). Similarly, in all of Luba Lukova's work, her hand lettering and illustrations share visual characteristics, but there is always a clear hierarchy, as in Figure 5-1.

CONTRAST

Type and visuals possess apparent differences, contrasting points of differentiation, contrasting or opposing qualities and characteristics that become interdependent to produce an effect only when present together. There are two basic ways in which type and visuals work in contrast: complementary relationship or a formal ironic relationship.

FIG. **5** / **12**

COVER: *A CIRCULAR UNIVERSE*

· MIKE PERRY

A Circular Universe is a newspaper designed and illustrated by Mike Perry for an art show of the same title in Silver Lake, L.A. The heavy hand-drawn line of the letterforms against the soft imagery/color contrast gives a sense of dimension to the image, which is otherwise flat, and separates the type out so you can read it.

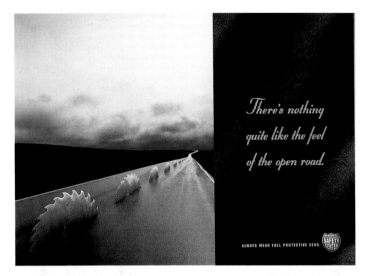

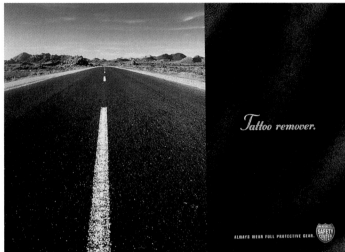

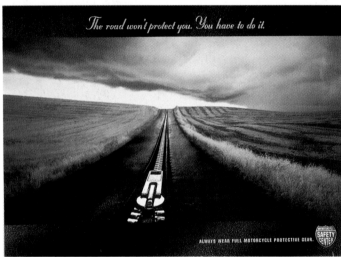

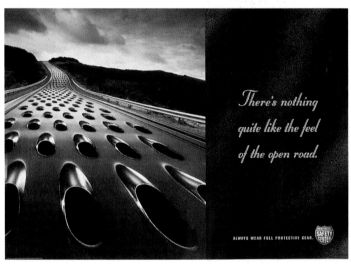

FIG. **5** / **13**

AD CAMPAIGN: "TATTOO
REMOVER," "THERE'S NOTHING
QUITE LIKE THE FEEL OF THE
OPEN ROAD," AND "THE ROAD
WON'T PROTECT YOU. YOU HAVE
TO DO IT."

· MARTIN/WILLIAMS INC., MINNEAPOLIS
· CLIENT: MINNESOTA MOTORCYCLE SAFETY
 CENTER

FIG. **5** / **14**

LOGO: GROUND

· VISUAL DIALOGUE, BOSTON
· DESIGN DIRECTOR/DESIGNER: FRITZ
 KLAETKE
· DESIGNER: JESSE HART
· CLIENT: GROUND

Complementary Relationship

Typefaces or hand-drawn type are chosen to work *in opposition to or in juxtaposition to visuals, relying on contrasts* in shape, form, proportions, weights, widths, thin/thick strokes, lines, textures, positive and negative shapes—for example, geometric versus organic, elegant versus rough, refined versus sloppy, detailed versus loosely rendered (such as a detailed linear illustration contrasted with freely-drawn type). In Figure 5-13, a public service advertising campaign to promote motorcycle safety, the display typeface is juxtaposed to startling imagery to communicate the twist on what we think about riding on the open road. In Figure 5-14, a logo for Ground, a landscape architecture firm, hard-edged, geometric type contrasts with the organic plant imagery. For the "Day without Art" symbol, by contrasting a brushstroke "X" with the regularity of the square representing a picture frame, meaning is enhanced (see Figure 5-25).

In this category, Professor Martin Holloway, Kean University, would include a type/visual relationship where the type is *purposely understated* in contrast to a strong visual statement, where, perhaps, the visual is the "big idea." This doesn't mean the type, or text for that matter, is given a diminutive role; rather it means the type simultaneously contextualizes the image and by its understatement bestows celebrity status to the image while being noble itself. Mixing styles and historical periods can also create opposition.

Formal Ironic Relationship

Typeface and visual are chosen for incongruity, for an ironic effect—for example, the typeface chosen for Figure 5-15, *Catch of the Day*, by Scorsone/ Drueding or the irony of choosing a subway map typeface to write "Lost," the twist that it reads lost when it should be mapping in Figure 5-16.

VISUALIZATION MODES

In the visual arts, there are theories on modes of visualization and their respective meanings. For example, French seventeenth-century painter Nicolas Poussin utilized ancient Greek musical

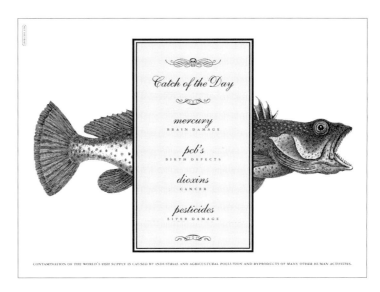

FIG. **5** / **15**

POSTER: *CATCH OF THE DAY*

· DESIGN: JOE SCORSONE/ALICE DRUEDING, JENKINTOWN, PA

modes as the basis for some of his compositions. Other visual artists and schools, such as the Bauhaus, maintained specific theories about visualization and meaning. Although many of the terms in this section are largely used to describe fine art, they also can be used to better understand how to make decisions about visualization in graphic design, as Professor Donis A. Dondis does in the essential book *A Primer of Visual Literacy* to explain the dynamics of contrast.

LINEAR AND PAINTERLY

In his seminal work *Principles of Art History: The Problem of the Development of Style in Later Art*, Swiss art historian Heinrich Wölfflin describes modes of representation, which help us understand how form and style communicate meaning and how they are shaped by culture, time period, and context. (In Chapter 6 on composition, we

FIG. **5** / **16**

ILLUSTRATION: OP-ED LETTERS PAGE, *THE NEW YORK TIMES*

· STEVEN BROWER DESIGN, MATAWAN, NJ
· ILLUSTRATOR/DESIGNER: STEVEN BROWER
· CLIENT: *THE NEW YORK TIMES*
· © STEVEN BROWER

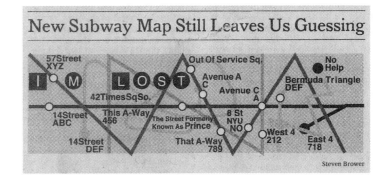

FIG. **5**/**17**

LOGO: IDLEWILD

· THE PINK PEAR DESIGN CO., KANSAS CITY, MO
· ART DIRECTOR/DESIGNER: SARAH SMITKA

This logo design is for a jewelry designer who makes most of her pieces with antique and vintage beads, clasps and charms. The name Idlewild comes from an area where the designer's great-aunt lived and built her own cabin by hand. Her great-aunt has very much been a creative inspiration in her life and in her jewelry design. We wanted to capture the antique feel of the material she uses in the logo and have a little fun with choosing a variety of flowers that could be used interchanged as the primary logo.
 —Sarah Smitka

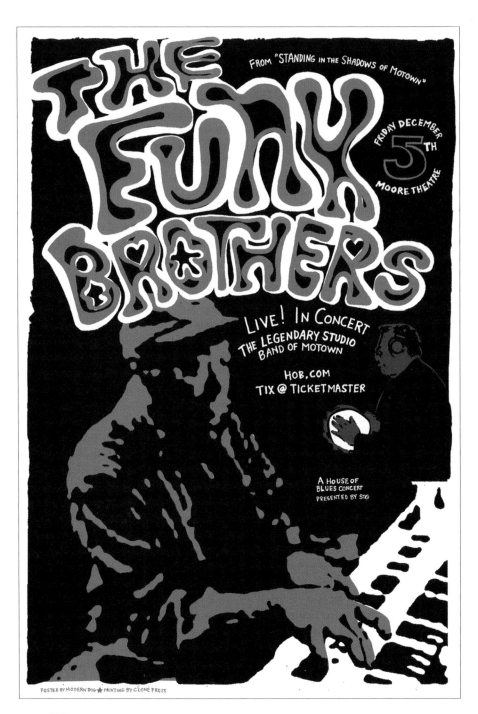

FIG. **5**/**18**

POSTER: *THE FUNK BROTHERS*

· MODERN DOG DESIGN CO., SEATTLE
· DESIGNER: ROBYNNE RAYE
· CLIENT: HOUSE OF BLUES
· © MODERN DOG DESIGN CO.

Robynne Raye routinely ignores the boundaries between illustration, design and typography.
 —Modern Dog Design Co.

will examine Wölfflin's other modes: "plane and recession" and "closed and open form.")

A linear mode is characterized by a predominant use of lines to describe forms or shapes within a composition (see Figures 2-01 and 2-02). In graphic design, painterly modes are characterized by the use of color and value to describe shapes and forms, relying on visible, broad, or sketchy description of form rather than the specificity of lines. Sarah Smitka uses a linear mode to visualize the flowers in the logo in Figure 5-17, and the logotype shares characteristics. The general sketchiness of the forms, type, and visuals make *The Funk Brothers* poster "painterly" (Figure 5-18), and the rendering of Bob Dylan on the book cover in Figure 5-19 is painterly in contrast to the typography. Both modes can also contribute to structuring compositions.

Related to this mode are the opposites of *unity* and *multiplicity*. According to Heinrich Wölfflin, in this context, unity means forms that seem to merge, where edges are blurred as in a painterly style (think Peter Paul Rubens, Diego Velázquez, Robert Motherwell). In multiplicity, individual shapes or forms maintain a certain amount of independence from one another; at times, the forms are so distinct that they could easily be cut out with scissors.

PROXIMATE VISION VERSUS DISTANT VISION

In his "must read" essay "On Point of View in the Arts," in *Dehumanization of Art and Other Essays on Art, Culture, and Literature* philosopher José Ortega y Gasset offers "proximate vision" and "distant vision" modes, accounting for the difference in how visual artists describe forms that they see. He explains the point of view of the artist in relation to the thing seen, with these changes reflecting the culture, religious beliefs, and philosophy of their time periods.

All images are rendered in focus and in detail in *proximate vision* regardless of whether they are located near or far in space. There is no evidence of the effect of the atmosphere on the thing seen. We see every form and shape with clarity and in detail no matter how far from us it is. Figure 5-20's lush "poster within a poster" sets the stage (reset

FIG. 5/19

BOOK COVER: *A SIMPLE TWIST OF FATE: BOB DYLAN AND THE MAKING OF BLOOD ON THE TRACKS* BY ANDY GILL AND KEVIN ODEGARD

· COOLEY DESIGN LAB, SOUTH PORTLAND, ME

FIG. 5/20

POSTER: *LA BOHEME*

· SPOTCO, NEW YORK
· PHOTOGRAPHER: DOUGLAS KIRKLAND
· DESIGNERS: VINNY SAINATO, MARY LITTELL

This campaign features rich, romantic photography of the beautiful young performers, capturing director Baz Luhrmann's vision of La Boheme as "the greatest love story ever sung." The goal was to make the production of Puccini's classic opera as vibrant today as it was in 1896, and even more accessible to a wide audience.
—SpotCo

from 1840 to the Bohemian Left Bank of Paris in 1957) and gives us a romantic glimpse; it communicates not only the romance but also includes us—the viewers—as an audience even before we get to the theater.

FIG. 5 / 21

POSTER: *THE PRETENDERS*

· MODERN DOG DESIGN CO., SEATTLE
· DESIGNER: ROBYNNE RAYE
· CLIENT: HOUSE OF BLUES
· © MODERN DOG DESIGN CO.

The pixilated image of Chrissie Hynde corresponds with the treatment of the type to make an imaginative and unified visual statement.

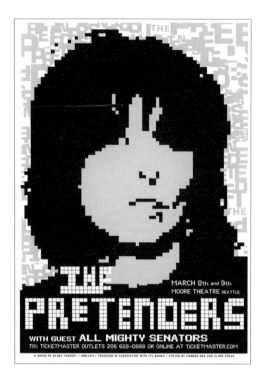

In *distant vision*, the effect of the atmosphere between the artist's (and viewer's) vision and the thing seen is in evidence. There is one point of focus (in any given moment, we can only focus on one thing at a time) with surrounding elements somewhat obscured. Distant vision is usually partnered with a painterly mode.

BASICS OF VISUALIZING FORM

Examining basic methods of describing form is important for visualization. How you describe form affects communication and expression.

SHARPNESS VERSUS DIFFUSION

Sharpness is characterized by clarity of form, detail, clean and clear edges and boundaries, saturated color, readable and legible typography,

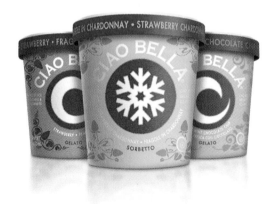

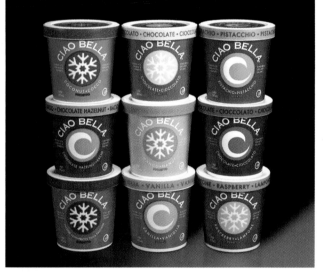

FIG. 5 / 22

PACKAGE DESIGN: CIAO BELLA

· WALLACE CHURCH, NEW YORK

If you've ever had gelato in a restaurant, it was probably Ciao Bella. This super premium, super indulgent brand was originally marketed only to the food service trade. Launching Ciao Bella at retail demanded that the brand establish a distinct personality. This young company, however, had severe budget restrictions that made photography impossible. Wallace Church's dynamic graphics solved the problem, immediately distinguishing the brand as very different from everything else in the freezer case. The simple icons change to differentiate gelatos and sorbettos; the bold colors change to highlight the exotic flavors. As a result of this new design effort, the Ciao Bella brand has established a stronghold with consumers at retail.
 —Wallace Church

proximate vision, hyperrealism, photorealism, closed compositions, and limited type alignment. Blurred forms and boundaries, transparencies, muted color palettes, layering, open compositions (think Helen Frankenthaler), and painterliness characterize **diffusion.**

ACCURACY VERSUS DISTORTION

Viewers believe an object or subject to be *accurately* depicted when it conforms with what they know or to common knowledge of that form. When an object or subject is twisted, stretched, bent, warped, buckled, or significantly altered from its normal appearance, it is *distorted.* Pixilation of the image of Chrissie Hynde and the type in the poster promoting a concert by The Pretenders distorts them for creative purpose (Figure 5-21).

ECONOMY VERSUS INTRICACY

Economy refers to stripping down visuals to fundamental forms, using as little description and as few details as possible for denotation. For the Ciao Bella package design, Wallace Church used simple icons that change to differentiate gelatos and sorbettos, with bold colors changing to highlight the exotic flavors (Figure 5-22). **Intricacy** is based on complexity, on the use of many component parts and/or details to describe and visually communicate.

SUBTLE VERSUS BOLD

Using a subtle visualizing treatment is about restraint. *Subtlety* can be created through low contrast, muted color palettes or tints, static compositions, transparencies, layering, limiting typefaces and alignment, distant vision, and atmospheric perspective. *Boldness* can be conveyed with big, brassy, aggressive movements and compositions, saturated color palettes, thick lines, high contrast, cropping, or images that are near (see Figure 7-06). Related to this is *understatement versus exaggeration.* An understated depiction is less dramatic, subtle, and restrained, whereas an exaggerated visual uses visual hyperbole and might be bigger, grander, more prominent, more dramatic, embellished, or amplified.

PREDICTABLE VERSUS SPONTANEOUS

Pattern, symmetry, absolute consistency of elements and their treatment, stable compositions, even weights, among other things would be considered *predictable.*

Sketchiness, abrupt movements, asymmetry, change in pace, staccato lines, open forms, changes in case, or blurring of edges could communicate *spontaneity.* In Figure 5-23, the spontaneous

FIG. **5 /23**

POSTER: *LOW AND BEHOLD*

· ED FELLA

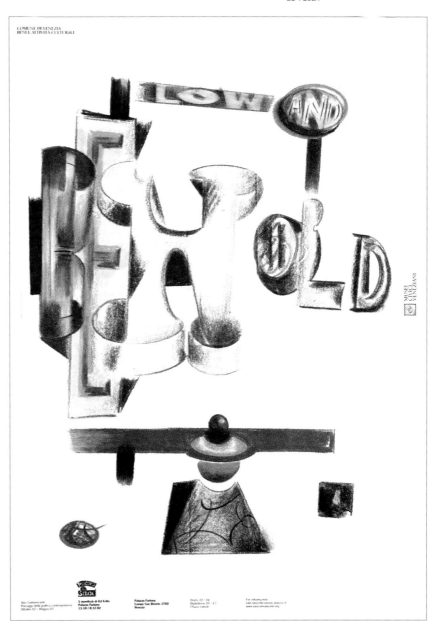

quality in Ed Fella's *Low and Behold* poster is felt through whimsical changes in the sizes of letters, hand-drawn letters, and forms, and you can see why in *Graphis*, Stuart Frolick titled his article about Fella "Design Doodler."

OPAQUE VERSUS TRANSPARENT

Opaque elements are dense, seemingly solid, and not see-through. Elements, type, and visuals can be **transparent**, which means see-through from one image to another, from one letterform to another, or from one texture to another, as in the free-form shapes constituting the visuals in Figure 5-24. Seeing through could imply space to various degrees of graphic depth. *Digital transparency* involves altering the opacity of any graphic element or image in print or motion. The contrast of an element is lowered so that it appears transparent in relation to its original opaque form. Visualization can rely on a juxtaposition of transparent and opaque components.

Patterns often employ *graphic transparency* where layers of lines, shapes, textures, forms, letterforms, or fields or bands of color overlap. Related to graphic transparency, *linear transparency* refers to transparent layering of linear forms or lines or outline type.

HARD-EDGE VERSUS BRUSHY

In fine art painting, hard-edge visualization is almost diametrically opposed to those works in a brushy, painterly style. For the unique "Day without Art" symbol, by contrasting a brushstroke "X" with the hard-edge delineation of the square representing a picture frame, meaning is enhanced (Figure 5-25).

FIG. **5** / **24**

CD COVER: *AUTHENTIC FLAVORS*

· SEGURA INC., CHICAGO
· DESIGNER: CARLOS SEGURA

Segura utilizes related visual elements (unity with variety) on the CD cover and the CD itself, as well as on promotional items such as T-shirts.

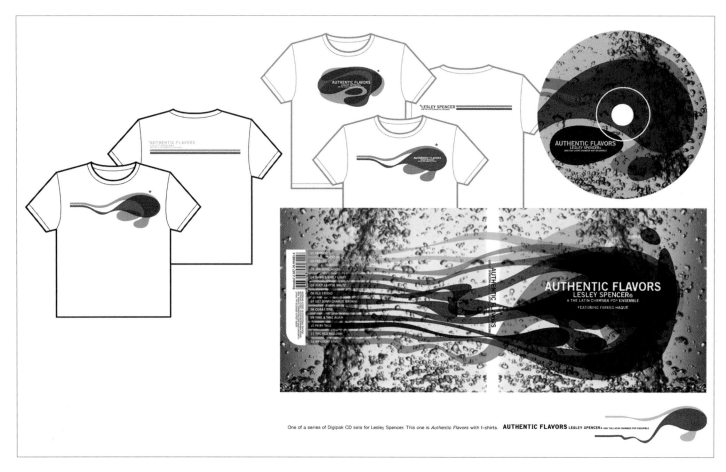

One of a series of Digipak CD sets for Lesley Spencer. This one is *Authentic Flavors* with t-shirts. **AUTHENTIC FLAVORS** LESLEY SPENCER® AND THE LATIN CHAMBER POP ENSEMBLE

A FINAL WORD ON VISUALIZATION: STORYTELLING

How can an image tell a story? How can combining text and image tell a story more fully?

Every image tells a story through its subject, visualization, and composition. And every aspect of that image—color, light and shadow, details, angle/point of view, value contrast—all contribute to the nature of the story: what you leave in an image, what you edit out—how you frame it, whether you crop it, and so on.

A still image is an artificial construct; it is a deliberately constructed visual held in time for us to contemplate, to help inform us, to help us make sense of the world. Motion—moving images whether created by a filmmaker or motion designer—are also artificial constructs that are deliberate and deliberated. All tell stories—the story the visual artist, director, or writer intends—and the story the viewer gleans from it and brings to it.

If you doubt that a single image can convey meaning, then look at the work of great photographers, illustrators, and painters. If you look at stills from great filmmakers, you will also see how each shot tells a story on its own, yet contributes to the greater story. Doug McGrath, a writer and director, shares this story about his work:

"In my film INFAMOUS, which was about the making and undoing of Truman Capote, a key scene is his arrival in Kansas. He has come with his childhood friend, Nelle Harper Lee, who lived, as he did, in New York City. Capote lives his life in that city in a glittering way: nightclubs, private clubs, events that were often underwritten by his friends whom he chose carefully from the famous and wealthy. He himself was not yet famous to a wider public; he was only known among the rarified social circles in Manhattan and to a slightly wider literary audience. But it was not his way to tiptoe in to someplace new on little cat's paws. He always announced himself.

"I wanted to cover his arrival in one shot: not several angles, just one, and with no dialogue because in this case, I felt the image would say more than words would. I preceded his arrival in Kansas with

FIG. **5**/25

SYMBOL: "DAY WITHOUT ART"

· MATSUMOTO INCORPORATED, NEW YORK
· ART DIRECTOR: TAKAAKI MATSUMOTO

This logo was for the first annual demonstration day, titled "Day without Art," sponsored by Visual AIDS, a nonprofit AIDS awareness organization.

an opening of several minutes set in Manhattan, in crowded noisy restaurants, smoky nightclubs, glamorous penthouses. But then we cut to the shot of him and Nelle, just off a dusty red train, deposited on the platform in Holcomb, Kansas.

"The train fills the shot, top to bottom, side to side. At the start of the shot, a conductor signals the driver that the passengers from New York—Truman and Nelle—are off. The train slowly pulls out and, in so doing, appears to wipe the screen clean: as it leaves to the left of screen, to the right it begins to reveal the vast emptiness of the Kansas plains, until finally there is nothing in the shot but the high sky, the endless horizon, the empty fields, and the two New Yorkers, one of whom has his very pretty luggage stacked high beside him.

"It is a quiet shot. There is some music, but gently played, so that the audience is aware of how noiseless the new world is. I held the shot for a long time, without moving the camera, to let the audience feel the change in mood. Up till then everything had been merry and bustling, bursting and jolly. It also allows the audience to notice how Truman was dressed which, without getting into it too much, was not typical for the Kansas man of 1959. By keeping it as a single shot, without close-ups, and letting it sit there for a minute, I allow the audience to discover all the things it needs to on its own, which is always more flattering and pleasing to the viewer because it says that you trust them—and you trust the image, with all its information."

—*Doug McGrath, Writer/Director*

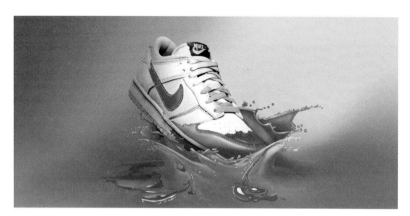

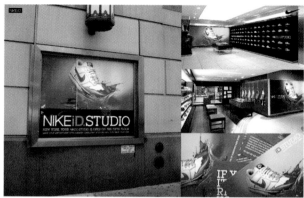

FIG. 5 / 26

ENVIRONMENTAL GRAPHIC: "SPLASH"

- HUSH, NEW YORK
- DESIGN/PRODUCTION: HUSH
- CREATIVE DIRECTORS: DAVID SCHWARZ, ERIK KARASYK
- ART DIRECTOR: HEATHER AMUNY
- DESIGN DIRECTORS: MANNY BERNARDEZ, SCOTT DENTON-CARDEW
- DESIGNERS/ILLUSTRATORS: LAURA ALEJO, DOUG LEE, JONATHAN CANNON, DAVID SCHWARZ, ERIK KARASYK
- PRODUCERS: JESS PIERIK, LORI SEVERSON
- CLIENT: NIKE, INC.

HUSH created two 10-foot-wide images, intended as wall coverings for NIKEiD and Nike Town stores to represent the NIKEiD service, which allows people to customize their Nike footwear.

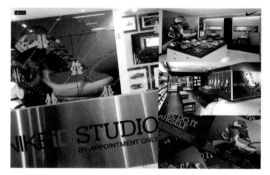

In another example, for Figure 5-26,

"Nike asked HUSH to come up with a single, definitive image that evokes the idea surrounding the NIKEiD service. NIKEiD is Nike's online service that allows anyone to customize the look of their own shoe (a 'blank') by choosing colors and material types.

"HUSH presented several different design concepts and Nike immediately gravitated towards the idea of the 'Splash.' HUSH created 'Splash'—a dynamic single frame in which a blank, gray shoe is transformed instantaneously by color and style . . . like jumping in a puddle. This image speaks directly to Nike customers where they have the ability to rapidly transform a blank shoe into the vastly more colorful, personal and unique vision in their minds.

"This image was commissioned for display in Nike Town retail stores, the unique NIKEiD Studio in New York's Nolita neighborhood, as well as used for various other NIKEiD collateral."

—In an interview with Neil Bennett for Digital Arts online magazine

"We needed to tell the story in a single image," says HUSH cofounder and director David Schwarz. "Working in motion-based media, we literally have time on our side—which allows for a story to develop. Creating a single image meant we had to be smart in our approach and figure out how to embed a lot of thinking into one frame."[4]

EXERCISE 5-1

❶ Choose one image, such as a tree, bird, house, or flower.

❷ Sketch or draw the chosen image twenty different times, trying different sketching styles. Experiment with drawing or sketching tools.

PROJECT 5-1

❶ Choose one image, such as a tree, bird, house, or flower.

❷ Depict the chosen image as a notation, pictograph, and silhouette.

❸ Depict the same image in the following modes: linear, light and shadow, naturalistic, and expressionistic. (Research fine art examples of these modes.)

❹ Create ten thumbnail sketches for each depiction.

❺ Choose the best of each and refine into comps.

Go to our website **GD/s** for *many* more Exercises and Projects, and presentation guidelines, as well as other study resources including the chapter summary.

NOTES

1. Philip B. Meggs. *Type and Image: The Language of Graphic Design.* Hoboken: Wiley, 1992, p. 18.

2. Meggs, *Type and Image.* p. 8.

3. Ben Brantley, "Do You Speak Hollywood?" *The New York Times,* October 24, 2008.

4. Neil Bennett, "Hush Makes a Splash with Nike Art," *Digital Arts,* May 14, 2008. http://www.digitalartsonline.co.uk/features/index .cfm?featureid=1716&pn=2

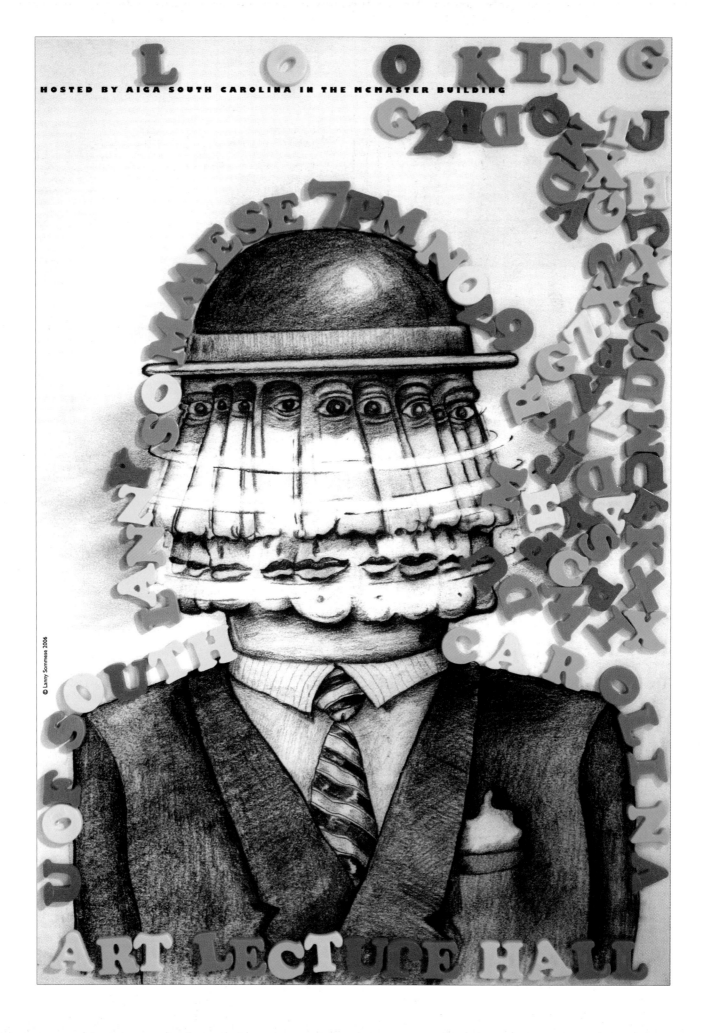

06

COMPOSITION

<<< */ facing page*

POSTER: *LOOKING*

- SOMMESE DESIGN, PORT MATILDA, PA
- ART DIRECTOR/DESIGNER/ ILLUSTRATOR: LANNY SOMMESE
- DIGITAL EXPERT: RYAN RUSSELL
- CLIENT: UNIVERSITY OF SOUTH CAROLINA

WHEN YOU LOOK AT A POSTER, YOU MOST LIKELY ASK

YOURSELF: "DO I FIND THIS INTERESTING?" AND "DO I GET IT?" "IS THE MESSAGE CLEAR?" THAT'S EXACTLY HOW ANY OBSERVER WOULD RESPOND. SINCE THE PRIMARY PURPOSE OF GRAPHIC DESIGN IS TO COMMUNICATE INFORMATION OR A MESSAGE TO AN AUDIENCE, CREATING INTEREST AND CLARITY ARE TWO MAIN GOALS. FOR CERTAIN TYPES OF APPLICATIONS AND CATEGORIES OF GRAPHIC DESIGN SUCH AS INFORMATION DESIGN (THINK CHOKING POSTER OR SUBWAY MAP), CLARITY IS ESSENTIAL AND PERHAPS ENOUGH. FOR OTHER CATEGORIES OF DESIGN WITH GREATER PROMOTIONAL INTENT (THINK WEB BANNER OR BOOK COVER), CATCHING PEOPLE'S ATTENTION IS CRITICAL SINCE SOMEONE HAS TO BE ATTRACTED ENOUGH BY THE DESIGN'S FORM TO TAKE THE TROUBLE TO INTERPRET THE MESSAGE. ALTHOUGH A FORMULAIC SOLUTION MIGHT BE CLEAR, IF IT'S BORING, NO ONE IS GOING TO BOTHER TO SPEND TIME WITH IT. OFTEN, VIEWERS WILL SPEND MORE TIME TRYING TO MAKE SENSE OF A MESSAGE IF THE FORM OF IT INTERESTS THEM. THE HIGHER THE DEGREE OF INTEREST YOU CREATE, THE MORE SATISFACTION THE VIEWER WILL FIND IN THE SOLUTION. ONCE YOU OBTAIN SOMEONE'S INTEREST, THE MESSAGE SHOULD BE CLEAR. IF SOMEONE LOOKS AT A DESIGN AND THINKS "I DON'T UNDERSTAND THIS," THEN THE SOLUTION IS INEFFECTIVE.

PURPOSE OF COMPOSITION

To create clear and interesting solutions, you need to develop keen compositional skills. You must understand the content well enough to structure it. Intelligibility of communication depends upon logic—upon how you visually order information in terms of its importance to the message. And interesting form depends upon a good concept in concert with finely honed visualization and compositional skills.

WHAT IS COMPOSITION?

A **layout** is the visual organization of type and visuals on a printed or digital page; it is also called **spatial arrangement**. A layout is about how all the parts of your design work together. Like layout, one could simply say that a composition is a group of organized component parts

or graphic elements, but it is much more. **Composition** is the form, the *whole spatial property and structure* resulting from the intentional visualization and arrangement of graphic elements—type and visuals—in relation to one another and to the format, meant to visually communicate, to be compelling and expressive. The designer's vocabulary of formal elements (line, shape, color, value, and texture) and skill set of basic principles (balance, emphasis, unity, and proportion) *and more* (which we will explore shortly) are all employed when composing.

Just like any human behavior, the entire process of conceptualizing, visualizing, and composing is complex, nonlinear, and largely unpredictable. For this reason, most designers use spontaneous composition as the primary methodology when designing single or static applications that do not require a grid structure, such as posters or web banners. (When designing multipage applications, such as magazines or newspapers, most designers employ and need grids as compositional guides.) A compelling and clear solution, whether working spontaneously or composing with a structural device such as a grid, requires iterations. Since designing is nonlinear (for most of us, anyway) and composing is an iterative process, in order to create clear, interesting communication, rethinking and revising is part of the organic process that is composing.

MEANS

How do you begin to compose your design concept? For beginners, figuring out how to compose can seem daunting since there are innumerable options and decisions to be made. Also, part of what might be overwhelming for many is that composing requires a willingness to experiment and work through problems. When I asked Ed Sobel his thoughts about composition, he responded with two extremely helpful axioms, point of view and design architectonics, to initiate our discussion of compositional means.

[T]he only thing I can think of adding is the personal problem-solving techniques I employ before I begin to layout/design. Once in the actual process of design, all those issues you mention in this chapter are tactics/tools that I think we all use to further our communication . . . but how to choose what to use? That is, type-driven or graphics-driven? Emphasize what, subordinate what? In other words, how to go about thinking about solving a problem in order to choose a methodology?

Point of View: Design is the visual organization of a communication; graphic designers are communicators . . . promulgating a point of view. As designers we need to start with the question "What are we trying to say?" Once that question is surrounded, we then need to take a stand—a point of view—that is, "A" is the main thrust and most important idea to be communicated, the rest of the alphabet becomes subordinate. From that point all other questions and methodology are answered by this question: Does it add to or detract from driving the point home?

Choice of concept, typeface, photography or illustration or graphics, color versus B&W, symmetrical versus asymmetrical composition . . . ALL choices are now determined by what makes the strongest, most compelling communication. Taking a point of view affords a place to start, an anchor point that enables and empowers the process.

Design Architectonics: Architectonics is a fancy word for building the composition by imposing an abstract, underlying structure that holds it all together, emphasizes the point, de-emphasizes secondary issues. I think of composition like a building . . . if parts don't align, lack foundation, are not physically attached with a tension that is visually palpable . . . the whole thing topples and falls apart. Conversely, if elements relate, are attached, balanced and aligned . . . the composition holds together and makes a strong statement—visually as well as conceptually.

Regardless of the composition structure designed . . . the concept of architectonics (that is, alignment, visual space vs. mass, physical/visual relationships of the elements to create a strong underlying structure) is the underpinning of all successful design compositions.

The informed use of these two maxims is often the difference between a great idea going down the tubes through bad execution, or even a so-so idea that is made powerful and compelling.

—Ed Sobel, Owner, CG+M Advertising + Design, NY

THREE BASIC ROUTES: TYPE-DRIVEN, IMAGE-DRIVEN, AND VISUAL-VERBAL SYNERGY

Most designers utilize one of the following basic routes for compositional structures.

› *Type-driven*: emphasis on type/de-emphasis on visuals, where type is the dominant force with visuals as secondary, as in Figure 6-01, or there are no visuals at all. Type can be the only component; also called *type as image*.

› *Image-driven*: emphasis on visual/de-emphasis on type, where the visual is the "hero" with little type, as in Figure 6-02, or a no-copy solution. Related to an image-driven compositional mode is a theme-driven one—visualizing and composing based on a *visual theme*. Although a thematic approach is used for concept development, it can also be employed during visualization with a distinct pictorial, abstract, or nonrepresentational topic-based visual dominating the composition. For example, if your concept for an MP3 player has to do with the benefit of authentic sound, then sound could be the thematic basis for a pictorial, abstract, or nonobjective visual theme.

› *Visual-verbal synergy*: a synergistic relationship between title (or headline) and the main visual, around which all other graphic elements are subordinate; this is a fundamental means for book jacket design, as in Figure 6-03, and advertising.

COMPOSITIONAL STRATEGIES

Composing is a process—where one achieves a desired result by repeating a sequence of steps and successively getting closer to that result. Iterations or revising (major changes/minor changes)

FIG. **6** / **01**

BOOK COVER: *THE THINKER'S WAY: 8 STEPS TO A RICHER LIFE* BY JOHN CHAFFEE, PH.D.

· DESIGNERS: MICHAEL IAN KAYE, AMY GOLDFARB
· PUBLISHER: LITTLE, BROWN AND COMPANY

For Dr. John Chaffee's book, the designers focus on the title since it conveys substantive information to the viewer.

FIG. **6** / **02**

POSTER: *PITTSBURGH AIGA*

· DESIGNER: JOHN GALL
· CLIENT: PITTSBURGH AIGA

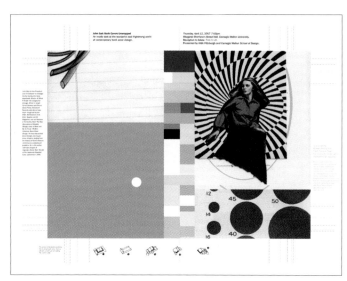

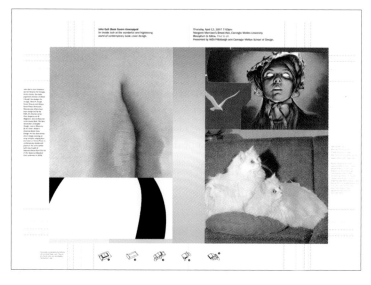

or graphic elements, but it is much more. **Composition** is the form, the *whole spatial property and structure* resulting from the intentional visualization and arrangement of graphic elements—type and visuals—in relation to one another and to the format, meant to visually communicate, to be compelling and expressive. The designer's vocabulary of formal elements (line, shape, color, value, and texture) and skill set of basic principles (balance, emphasis, unity, and proportion) *and more* (which we will explore shortly) are all employed when composing.

Just like any human behavior, the entire process of conceptualizing, visualizing, and composing is complex, nonlinear, and largely unpredictable. For this reason, most designers use spontaneous composition as the primary methodology when designing single or static applications that do not require a grid structure, such as posters or web banners. (When designing multipage applications, such as magazines or newspapers, most designers employ and need grids as compositional guides.) A compelling and clear solution, whether working spontaneously or composing with a structural device such as a grid, requires iterations. Since designing is nonlinear (for most of us, anyway) and composing is an iterative process, in order to create clear, interesting communication, rethinking and revising is part of the organic process that is composing.

MEANS

How do you begin to compose your design concept? For beginners, figuring out how to compose can seem daunting since there are innumerable options and decisions to be made. Also, part of what might be overwhelming for many is that composing requires a willingness to experiment and work through problems. When I asked Ed Sobel his thoughts about composition, he responded with two extremely helpful axioms, point of view and design architectonics, to initiate our discussion of compositional means.

[T]he only thing I can think of adding is the personal problem-solving techniques I employ before I begin to layout/design. Once in the actual process of design, all those issues you mention in this chapter are tactics/tools that I think we all use to further our communication . . . but how to choose what to use? That is, type-driven or graphics-driven? Emphasize what, subordinate what? In other words, how to go about thinking about solving a problem in order to choose a methodology?

Point of View: Design is the visual organization of a communication; graphic designers are communicators . . . promulgating a point of view. As designers we need to start with the question "What are we trying to say?" Once that question is surrounded, we then need to take a stand—a point of view—that is, "A" is the main thrust and most important idea to be communicated, the rest of the alphabet becomes subordinate. From that point all other questions and methodology are answered by this question: Does it add to or detract from driving the point home?

Choice of concept, typeface, photography or illustration or graphics, color versus B&W, symmetrical versus asymmetrical composition . . . ALL choices are now determined by what makes the strongest, most compelling communication. Taking a point of view affords a place to start, an anchor point that enables and empowers the process.

Design Architectonics: Architectonics is a fancy word for building the composition by imposing an abstract, underlying structure that holds it all together, emphasizes the point, de-emphasizes secondary issues. I think of composition like a building . . . if parts don't align, lack foundation, are not physically attached with a tension that is visually palpable . . . the whole thing topples and falls apart. Conversely, if elements relate, are attached, balanced and aligned . . . the composition holds together and makes a strong statement—visually as well as conceptually.

Regardless of the composition structure designed . . . the concept of architectonics (that is, alignment, visual space vs. mass, physical/visual relationships of the elements to create a strong underlying structure) is the underpinning of all successful design compositions.

The informed use of these two maxims is often the difference between a great idea going down the tubes through bad execution, or even a so-so idea that is made powerful and compelling.

—Ed Sobel, Owner, CG+M Advertising + Design, NY

THREE BASIC ROUTES: TYPE-DRIVEN, IMAGE-DRIVEN, AND VISUAL-VERBAL SYNERGY

Most designers utilize one of the following basic routes for compositional structures.

› *Type-driven*: emphasis on type/de-emphasis on visuals, where type is the dominant force with visuals as secondary, as in Figure 6-01, or there are no visuals at all. Type can be the only component; also called *type as image*.

› *Image-driven*: emphasis on visual/de-emphasis on type, where the visual is the "hero" with little type, as in Figure 6-02, or a no-copy solution. Related to an image-driven compositional mode is a theme-driven one—visualizing and composing based on a *visual theme*. Although a thematic approach is used for concept development, it can also be employed during visualization with a distinct pictorial, abstract, or nonrepresentational topic-based visual dominating the composition. For example, if your concept for an MP3 player has to do with the benefit of authentic sound, then sound could be the thematic basis for a pictorial, abstract, or nonobjective visual theme.

› *Visual-verbal synergy*: a synergistic relationship between title (or headline) and the main visual, around which all other graphic elements are subordinate; this is a fundamental means for book jacket design, as in Figure 6-03, and advertising.

COMPOSITIONAL STRATEGIES

Composing is a process—where one achieves a desired result by repeating a sequence of steps and successively getting closer to that result. Iterations or revising (major changes/minor changes)

FIG. **6** /**01**

BOOK COVER: *THE THINKER'S WAY: 8 STEPS TO A RICHER LIFE* BY JOHN CHAFFEE, PH.D.

· DESIGNERS: MICHAEL IAN KAYE, AMY GOLDFARB
· PUBLISHER: LITTLE, BROWN AND COMPANY

For Dr. John Chaffee's book, the designers focus on the title since it conveys substantive information to the viewer.

FIG. **6** /**02**

POSTER: *PITTSBURGH AIGA*

· DESIGNER: JOHN GALL
· CLIENT: PITTSBURGH AIGA

usually happen at the same time as creating/ producing. This editing process isn't the same as the task of a copy editor going over a manuscript for correct usage or pith—this means you are rethinking, revising as you work, which is part of the organic process of composing.

Spontaneous formative methods for composing (and visualization) include but are certainly not limited to:

› *Spontaneous/improvisational/experimental composing:* mostly unplanned visualization and structuring, with the *design concept as driver.* In the process of creating, shaping, moving, experimenting, and "playing" with graphic elements while relying on the principles of composition and a designer's intuition and insights into the creative process, you form a composition. This type of composing does not utilize formal structural devices or systems; however, it does rely on creative thinking partnered with critical thinking, creative impulses, inclinations, and intuition that result from a working knowledge of design principles and zealous experimentation. Many designers use creativity exercises to start the process, such as problem finding, free drawing, unconventional methods, or any of the creativity exercises in this book. The best way is to start sketching, to think with a pencil or marker in your hand. *Making enhances thinking.*

If spontaneous composing is too open-ended as a starting point, you can try using one of the following creative directives, which are essentially ways to visualize a concept:

› *Formally driven creative directives:* contrast; illusion of three-dimensional space, movement, or sound; exaggerated scale; exaggeration; near and far; image manipulation; synthesis; visual merge; unexpected juxtapositions; and abstraction, among others.

› *Media-driven creative directives:* collage; photograms; photomontage; experimental materials; mixed media; painting; sculpture; 3D illustrations; photography; sewing/stitching; weavings; rubbings/blottings; monotypes, and printmaking, among many others.

› *Style-driven creative directives:* primitivism; techno; homemade; flat color; period/vintage, and historical references/homage, among many others.

FIG. **6** /**03**

BOOK COVER: *CONSIDER THE EEL: A NATURAL AND GASTRONOMIC HISTORY* BY RICHARD SCHWEID

· COOLEY DESIGN LAB, SOUTH PORTLAND, ME

The book title and eel rely upon one another; they are compositionally interdependent. All other elements are subordinated to this synergistic visual-verbal relationship.

THREE A'S: ACTION, ARRANGEMENT, AND ARTICULATION

Composing is an extremely demanding, complex process. With empirical experience, compositional skills develop as you employ the basic principles more fully and deeply. More and more, design principles will become second nature; you will be able to rely more on intuition, enabling you to design with greater nuance. To help with this illusive process and to best explain composition and best practice, let's start with three tenets—action, arrangement, and articulation—the three A's. These tenets build upon the basic design principles discussed in Chapter 2.

When you compose, in addition to employing all the design principles, it is very helpful to be aware of these additional precepts. All of these involve concurrent rational decisions and intuitive impulses.

ACTION

Action involves the visual energy of a surface.

Any blank surface, whether print or screen-based, has potential energy—it is a potentially active field. If you are conscious of the interplay among the graphic elements, considering each space, shape, and interval, creating visual tension (interesting shape relationships and interstices, a tautness), then all graphic elements will seem to have connective tissue (think ligaments). Figure 6-04 illustrates this well. The designer's aim for the *Support and Resist* cover was to create "tense type compositions." Each typographic or visual component should relate to the other in a way that creates harmony, rhythm, and consensus.

FIG. **6** /**04**

BOOK COVER: *SUPPORT AND RESIST*

· THINK STUDIO, NEW YORK CITY
· DESIGN: JOHN CLIFFORD, HERB THORNBY

For a book about ways that engineering informs innovative architecture, we combined bold photography with asymmetric, tense type compositions—almost like unbalanced type structures.
—John Clifford

ACTION THROUGH DYNAMICS: CONTRAST

Bob Aufuldish, Aufuldish & Warinner, tells his students, "Contrast is your friend." We comprehend "concave" juxtaposed to "convex." "Straight" looks straighter compared to "crooked." In music, we understand "loud" in relation to "soft."

There are two overarching purposes for differentiating visual elements:
› To create visual variety and interest, and
› To enhance the uniqueness of dissimilar elements through contrast/comparison.

A viewer can see how and if visual elements are alike and how they are different as well as how they relate to one another, how they integrate to equal a new whole.

In order to show differences between elements or components in a design, you must establish a difference between two or among several. You must make distinctions. For example, when mixing typefaces, many designers select for weight contrast or by contrasting a serif with a sans serif so that people can distinguish them; after all, you're using more than one typeface so that your composition will have visual variety. Through variation and contrast, we get dynamics.

Johannes Itten, artist, professor, author, and color and design theoretician, held to a theory of structural compositional oppositions, which he referred to as "polar contrasts":
› big/small
› long/short
› straight/curved
› pointed/blunt
› much/little
› light/heavy
› hard/soft

Itten's polar contrasts certainly could establish visual drama. Contrasts also enable the viewer to better understand each graphic element through comparison (see Figure 6-05). We understand big in relation to small. We understand bright colors compared to dull colors. We understand a rough texture in contrast to smooth, and so on. Imagine if an actor delivered all his or her lines in a monotone voice—without any variation; that would be like a design without contrast.

We could add other extremes to Itten's list:

> compress/stretch
> bright color/dull color
> colorful/grey
> light/dark
> dense/sparse
> twisted/straight
> irregularity/regularity
> bold/subtle
> dynamic/static
> disharmony/harmony
> disorder/order
> sharp/dull
> night/day
> organic/geometric
> understatement/exaggeration
> whole/fragment
> transparent/opaque
> flat/deep

ACTION THROUGH CONTRAST: COUNTERPOINT

Since we deal with balance in our lives, achieving formulaic types of balance (symmetry, approximate symmetry) in a composition usually comes more naturally to beginners than all the other principles; however, *balancing opposing forces* through complex asymmetry is another matter. (This is the most difficult aspect of establishing contrast.) Two issues come strongly into play—visual weight plus the notion of weight and counterweight (counterpoint).

In asymmetric compositions where complementary graphic elements are positioned in counterpoint, visual weight deliberations are strategic, not formulaic (see Figure 6-06). To understand counterpoint, think of every visual weight you position in a composition requiring a contrasting counterbalancing force strategically placed in the composition. In music, the most rudimentary way to think of counterpoint is "note against note." In design, counterpoint is the use of contrast or the *interplay* of elements in a work simultaneously providing unity and variety, any graphic element contrasting with yet complementing another. (See Chapter 2 for more information on visual weight.)

FIG. **6** / **05**

POSTER: *WINTERFERIEN – DOPPELTE FERIEN, SCHWEIZ*

· DESIGNER: HERBERT MATTER

· THE HERBERT MATTER COLLECTION. DEPARTMENT OF SPECIAL COLLECTIONS, STANFORD UNIVERSITYY

FIG. **6** / **06**

BOOK COVER: *LOVE IN THE TIME OF CHOLERA* BY GABRIEL GARCÍA MÁRQUEZ

· ART DIRECTOR/DESIGNER: JOHN GALL

· CLIENT: VINTAGE/ANCHOR BOOKS

This asymmetrical composition is an example of a complex balancing act of opposing forces (parrot versus the human eye; positive versus negative shapes; warm versus cool hues; light versus dark values) with very careful positioning of elements for flow from one element to another.

BALANCING FORCES

Every graphic element positioned on a page contributes to a potentially balanced action, similar to how opposing physical movements operate in sports, martial arts, dance, and yoga. You can think of these *complementary balancing forces* as *simultaneous actions* building strength, stability, and harmony:

- *In and Out.* Pulling forces inward, toward the vertical midline of the page, and forces expanding outward, toward the edges of the page (see Figure 6-07).

- *Afferent/Efferent.* Inward contraction from the outer edges to the core, moving from the edges *to the focal point* (the heart of your composition) and then back from focal point to the boundaries. (Not to be confused with actual radial composition where the composition radiates outward from a central point.)

- *Up and Down.* Grounding (rooting) down while lifting up.

FIG. **6** /**07**

POSTER: *NEW MUSIC AMERICA*

- ALEXANDER ISLEY INC., REDDING, CT
- ART DIRECTOR: ALEXANDER ISLEY
- DESIGNER: ALEXANDER KNOWLTON
- CLIENT: BROOKLYN ACADEMY OF MUSIC, NEW MUSIC AMERICA FESTIVAL

FIG. **6** /**08**

POSTER: *CONQUEROR LIGHTSPECK*

- VIVA DOLAN COMMUNICATIONS AND DESIGN INC., TORONTO, ONTARIO, CANADA
- DESIGNER/ILLUSTRATOR: FRANK VIVA
- WRITER: DOUG DOLAN
- CLIENT: CONQUEROR FINE PAPERS

This poster was created to introduce Conqueror LightSpeck, a new range of pale-flecked paper, to the North American market. The chief design goal was to achieve a memorable visual impact that would carry through in the accompanying swatch book and other collateral, giving this unique product a distinctive image while clearly positioning it as part of the overall Conqueror range.

Try this little experiment. If you cover one of the oval portraits on the upper left side of the poster design in Figure 6-08, the right side becomes heavier. Each element in this poster design is dependent upon the other; each element was thoughtfully positioned. Similarly, using the spread in Figure 6-09, from a new edition of *Aesop's Fables* designed by Milton Glaser, cover the graphic element (artwork) in the lower right corner. You'll notice that the layout is no longer balanced. This demonstrates just how important the arrangement of every element is to a successful layout. (See sidebar on Balancing Forces.)

Action: Relate to the Midline

Envision an imaginary vertical line down the center of a page. As you position graphic elements, analyze how each interacts with that midline. Do graphic elements cross the midline? Approach or

FIG. **6** /**09**

BOOK SPREAD: *AESOP'S FABLES,* **NEW EDITION OF ARTWORK CREATED IN 1947**

· MILTON GLASER

· ARTWORK: JOHN HEDJUK, ARCHITECT

· PUBLISHER: RIZZOLI INTERNATIONAL PUBLICATIONS, INC.

FIG. **6** /**11**

BOOK COVER: *DECODING THE UNIVERSE* **BY CHARLES SEIFE**

· THINK DESIGN, NEW YORK

· DESIGN: JOHN CLIFFORD, HERB THORNBY

This is a visual representation of the concept of information theory.
—John Clifford

FIG. **6** /**10**

BOOK COVER: *SAYONARA HOME RUN! THE ART OF THE JAPANESE BASEBALL CARD* **BY JOHN GALL AND GARY ENGEL**

· ART DIRECTOR: JOHN GALL

· DESIGN/ILLUSTRATION: JOHN GALL, CHIN YEE LAI

· PHOTOGRAPHER: SIMON LEE

· CLIENT: CHRONICLE BOOKS

The vertical red rule, the midline dividing the baseball card images, becomes an important structural device. Notice how the baseball is directly under the red line and how the words "Sayonara" and "Home Run!" are angled in relation to the red line and the ball to create movement.

tease the midline? Touch? How do the elements interrelate in the central space of the composition? Study how Figure 6-10 makes use of a midline.

Action: Relate to the Edges of the Format

All visual elements must relate to (though not necessarily actually touch) the edges of the page. Not merely the end of the space, a page's bound-aries fully participate in the compositional struc-ture, as do the typography and graphic elements in Figure 6-11, where the numbers and arrows relate to the edges of the cover.

ACTION THROUGH MOVEMENT

Any design can appear still, imply motion, or even have intervals of stillness and movement. In print and any static digital page motion is an illusion

FIG. **6**/**12**

POSTER: *LOOKING*

- SOMMESE DESIGN, PORT MATILDA, PA
- ART DIRECTOR/DESIGNER/ILLUSTRATOR: LANNY SOMMESE
- DIGITAL EXPERT: RYAN RUSSELL
- CLIENT: UNIVERSITY OF SOUTH CAROLINA

Surprised, the angst-ridden face frantically watches the menacing letterforms as they move about to form words announcing my lecture. I used the colorful magnetic plastic letters not only because they added to the playfulness but also to enhance the meaning; they are often stuck on refrigerator doors to remind family members of upcoming events (like my lecture).

—Lanny Sommese

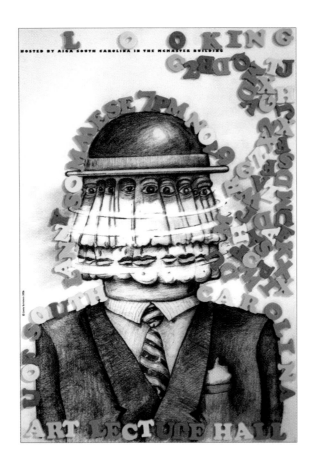

FIG. **6**/**13**

LOGO: JACKRABBIT

- DOUBLE ENTENDRE, SEATTLE
- DESIGNERS: DANIEL SMITH, RICHARD SMITH
- ILLUSTRATOR: MIKE MARSHALL

We wanted to create a logo that implied gourmet food that was good and that you could get quickly. The clientele is mostly at lunchtime, when people don't have a lot of time to spare.

—double entendre

created through skillful manipulation. The illusion of movement can be created through action-oriented relationships—diagonal counterpoints, acute shifts in scale, extreme value contrasts, and more. In Figure 6-12, motion is implied in the face and letters.

In time-based media, such as motion graphics and animation, the illusion of motion occurs over time. (See Chapter 14 on motion graphics.)

ARRANGEMENT

Arrangement involves guiding the viewer.

One adjustment to a composition affects how all other graphic elements relate to one another. When arranging, make adjustments mindfully, thinking of how each alignment affects the overall composition. Facilitate the viewer's reading of a composition through entry point, flow, and eye direction. *Keep all graphic elements in play* (just as each action in a video game affects future actions as well as the actions of other players).

ARRANGEMENT: ADJUSTMENTS

In Chapter 2, we examined how alignment contributes to unity. That bears further discussion. In a composition, every graphic element is positioned in graphic space. You determine those positions and their resulting alignments with other visual components either through purely optical means (by eye) or with the aid of a grid or some other structuring device (still requiring some optical judgments). All type is aligned. Visuals are aligned. Type and visuals are aligned. *Congruity of alignment enhances unity and creates clarity.* Designers who compose optically/spontaneously seek inherent ways to align type and visuals, by finding movements within the graphic elements that can be paralleled or echoed, prospecting for occasions of sympathetic relationships among the forms where alignments could occur and be capitalized on. Other than the several basic alignments—flush left, flush right, centered,

FIG. **6** / **14**

BOOK COVER: *STRANGE PILGRIMS* **BY GABRIEL GARCÍA MÁRQUEZ**

· ART DIRECTOR/DESIGNER: JOHN GALL
· CLIENT: VINTAGE/ANCHOR BOOKS

FIG. **6** / **15**

LOGO/STATIONERY: CONVERSĀ

· HORNALL ANDERSON, SEATTLE
· ART DIRECTOR: JACK ANDERSON
· DESIGNERS: JACK ANDERSON, KATHY SAITO, ALAN COPELAND

The main objective was to develop a proprietary wordmark for Conversā that incorporated a restylized saycon icon, a speech-enabled icon.
—HADW

justified—there are wrap-around or edge alignments, each with several options.

› *Wrap-around alignment*: Title or text wraps around, follows the contour of an image (straight, angled, or curved) or the edge of a visual (Figure 6-13).

› *Edge alignment*:
 – Center alignment on vertical or horizontal axis, as in this book cover by John Gall (Figure 6-14).
 – Internal image alignments from image to image, as in the way type (text type on letterhead and business card) is aligned with the icon, which is incorporated in the logotype (Figure 6-15).
 – Sympathetic alignments can be parallel or analogous arrangements, echoing or repeating edges, as in Figure 6-16, a book cover by Cooley Design Lab. (Also see Figure 2-20 as an example of sympathetic alignments, where the headline echoes the edge of the egg and "Your Farm Can Help" is parallel to the egg's cast shadow.)

FIG. **6** / **16**

BOOK COVER: *HOWARD HUGHES: THE UNTOLD STORY* **BY PETER HARRY BROWN AND PAT H. BROESKE**

· COOLEY DESIGN LAB, SOUTH PORTLAND, ME

Book title, authors' names, and endorsement all echo the diagonal movement of the airplane to create flow and graceful movement off the page.

– Intuitive alignments come about by finding edges that seem to naturally align well together (Figure 6-17).
– Alignment related to an historical style or school of thought (think Vienna Secession or New Wave) (Figure 6-18).

FIG. **6** / **17**

BOOK DESIGN: *LEARNING TO LOOK* **BY LESLEY D. CLEMENT**

· SALAMANDER HILL DESIGN, QUEBEC, CANADA
· DESIGNER: DAVID DRUMMOND

When I read in the catalogue copy for this book that Clement uses techniques similar to painting when she is creating her fictional world, I wanted to see if there was a way to show painting with words. The words in the paintbrush are actually from one of her works.

—David Drummond

ARRANGEMENT: ENTRY POINT, FLOW, AND EYE DIRECTION

In all two-dimensional design compositions—graphic design, painting, drawing, etching, or print advertisement—the viewer seeks a point of entry into the compositional space. This entry point can be the focal point (the largest or brightest or key positioned element, component with the greatest visual weight, etc.); it can be a path created by white space or any number of other kinds of entry points. You must structure space to facilitate the viewer's comprehension (visual reading) of the composition, his or her passage through the compositional space. In Figure 6-19, we enter the composition along the tilted floor plane, along the book's title and author's name. As we enter, we realize we are about to be crushed by a huge shoed foot.

Eye tracking studies (a method used to determine how people's eyes move, scan, and rest on a page) reveal how visitors observe print, web banners, and websites. Besides the composition, there are many variables involved with how an individual views and scans a single surface, including associative meaning, time exposed to the design, personal attention span, and distractions, among

FIG. **6** / **18**

POSTER

· CONCRETE DESIGN COMMUNICATIONS INC., TORONTO, ONTARIO, CANADA
· DESIGNERS: JOHN PYLYPCZAK, DITI KATONA
· CLIENT: AREA, TORONTO, ONTARIO, CANADA

Manufactured by Wiesner Hager in Austria, this line of furniture was inspired by the Viennese Secession. The Canadian distributor, Area, needed a vehicle to promote the line. We responded with a two-sided poster that folded down into a 10" × 10" folder. Printed economically in one color, the poster uses quotes by artists and architects of the secession.

—Diti Katona, Concrete Design Communications Inc.

others. One study found that people who are not trained artists had shorter fixations and focused on semantically important regions of the image.[1]

Guiding the Viewer

Preferred points of entry can be the focal point, the key component established through visual hierarchy, or a dominant image (people tend to prefer visuals over copy). In addition to the point of entry, *transitions* are the key to creating a smooth visual flow from one graphic element to another throughout the composition. A **transition** is the passage or progression connecting one graphic element or movement to another in

FIG. **6** / **19**

BOOK COVER: *KOCKROACH: A NOVEL* **BY TYLER KNOX**

· ART DIRECTOR: RICHARD AQUAN
· DESIGNER: WILL STAEHLE/LONEWOLFBLACKSHEEP
· ILLUSTRATOR: COLLAGE BY WILL STAEHLE
· CLIENT: WILLIAM MORROW

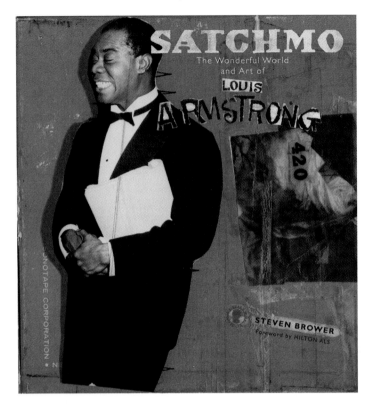

FIG. **6** / **20**

BOOK COVER: *SATCHMO: THE WONDERFUL WORLD AND ART OF LOUIS ARMSTRONG* BY STEVEN BROWER

· DIAGRAM SHOWING TRANSITIONS BY STEVEN BROWER
· ART DIRECTOR: MICHELLE ISHAY
· DESIGN: STEVEN BROWER
· ART: LOUIS ARMSTRONG
· CLIENT: HARRY N. ABRAMS

Each transition in this composition is considered.

a design; often, the transition is negative space or a subordinate element (see Figure 6-20). (Read more about transitions under "Articulation" later in this chapter.)

You can help the viewer navigate through a composition with a principle called continuity or agreement. Continuity—one element directing your eyes to the next—helps guide the viewer through a composition (see Figure 6-21). Think of agreement as design's equivalent to the body's circulation system.

Keep in mind these factors relating to agreement:

› Position and orientation of the elements can promote or inhibit visual flow.

› An unambiguous visual hierarchy with an apparent focal point will provide a point of entry; for example, a dominant title or headline or a dominant visual provides a point of entry.

› All directions must be considered: right, left, up, down.

› A *theory* holds that the top left of a page of any single surface is a preferred reading position, a point of entry (with the bottom of the page as

a less preferred reading position); also called the *primary optical area*.

› Viewers tend to be drawn to the figure as opposed to the ground.

› Unity and balance contribute to visual flow.

› Repetition, parallel movements, and counterpointing movements contribute to guiding the viewer.

You will also need to apply agreement in special situations:

› *Agreement throughout a website*: A clear sense of place or geography created by consistent position of menus will help guide the viewer (Figure 6-22).

› *Agreement across a spread*: Determine the most advantageous way to bridge the gap of the **gutter** (the blank space formed by the inner margins of two facing pages in a publication).

› *Agreement in a series*: When designing for a series of individual but related units (for example, a series of brochures; a book series; a series of covers; related package designs), establish parameters to define a typographic system (palette and usage) along with a common visualization language, compositional structure, and color palette

FIG. **6**/**21**

WEBSITE: SEMILLERO, A SCHOOL FOR CREATIVES

· GRUPO W, MEXICO
· CREATIVE DIRECTOR/ART DIRECTOR: MIGUEL CALDERÓN
· DESIGNER/ILLUSTRATOR: CESAR MORENO
· COPYWRITER: RUBEN RUIZ
· MULTIMEDIA PRODUCER: ULISES VALENCIA
· MULTIMEDIA PRODUCTION: CESAR MORENO/SEBASTIAN MARISCAL
· PROGRAMMER: RAUL URANGA
· CLIENT: SEMILLERO

Using a metaphor of a seed growing into a flowering plant to represent a school for creatives, type and illustrations are composed to create continuity and flow from one screen to another.

the DESIGNstudio
at kean university

FIG. **6**/**22**

LOGO AND WEBSITE: THE DESIGN STUDIO AT KEAN UNIVERSITY

· CO-CREATIVE DIRECTOR: STEVEN BROWER, CD, THE DESIGN STUDIO AT KEAN UNIVERSITY
· CO-CREATIVE DIRECTOR/DESIGNER: MICHAEL SICKINGER, LAVA DOME CREATIVE, BOUND BROOK, NJ (KEAN ALUMNUS)
· CLIENT: KEAN UNIVERSITY ROBERT BUSCH SCHOOL OF DESIGN, UNION, NJ
· LOGO: THE DESIGN STUDIO AT KEAN UNIVERSITY
· DESIGNER: STEVEN BROWER
· CLIENT: KEAN UNIVERSITY
· © 2008 STEVEN BROWER

The Design Studio is an internship at Kean University, where students provide work for on-campus clients and the community. In the logo, Brower finds edges that seem intuitive while also making good use of interstices.

to ensure continuity across the individual units as well as to ensure that viewers see the individual units as belonging to a series. (See Figure 8-04, Futuro Passato Series.) A designer also plans for some variation among the individual units within the series for purposes of identification of each as a unique unit and to create differentiation within the series (think differentiation of caffeinated and decaffeinated beverages through color palette) and visual interest (Figure 6-23).

Mostly, discrepancies interrupt visual flow (think road barrier). However, a discrepancy could also establish an anomaly (functioning as an interesting focal point), which might be desirable depending upon your intention. Any movement that pulls the viewer's eye from the preferred path or from important information is counterproductive; that is *disagreement*.

For text-heavy applications, such as newspapers (print and online), newsletters, government websites, and editorial websites, some designers rely on the Gutenberg Rule to help guide the viewer. This theory posits that readers follow a "Z" pattern of scanning a page, starting with the upper left-hand corner, followed by the middle, and then to bottom right. Newspaper designer and educator Edmund Arnold is credited with this theory, also known as the Gutenberg Diagram and the Z pattern of processing.

ARRANGEMENT: MANIPULATING GRAPHIC SPACE

There are as many ways to compose as there are ideas. That statement, although exciting, is not much help to a beginner; for that reason, here are some basic sets of compositional approaches to create graphic space. Please note that these sets of comparative compositional modes are *not* qualitative, they are different; each can be appropriate for particular goals.

FIG. **6 / 23**

PACKAGE DESIGN: SUPERDRUG STORES PLC., HANDY WIPES

· TURNER DUCKWORTH, LONDON AND SAN FRANCISCO
· CREATIVE DIRECTOR: DAVID TURNER, BRUCE DUCKWORTH
· DESIGNERS: SAM LACHLAN, CHRISTIAN EAGER
· PHOTOGRAPHER: ANDY GRIMSHAW
· IMAGE RETOUCHING: PETER RUANE
· CLIENT: SUPERDRUG HANDY WIPES
· © 2008 TURNER DUCKWORTH, LLC

A redesign of Superdrug's everyday wipes range. The objective of the redesign was to remind Superdrug shoppers of the myriad occasions on which they might need a wipe or two!

Each pack has a different visual prompt of accidents waiting to happen, perfectly illustrating the point that it is not only parents with small children who should have a pack of wipes to hand.

The designs show a bitten doughnut about to drip gloopy jam, an ice lolly starting to melt and create a sticky mess, a banana skin for the antiseptic wipes to sooth and clean impending cuts and grazes, and tomato ketchup because those condiment sachets are impossible to open without a mess following shortly after!

—Turner Duckworth

Flat versus Illusion of Depth

Any two-dimensional surface is flat. A designer can compose graphic space preserving the page's inherent flatness, resulting in a flat-appearing composition, *or* create the illusion of depth. Certain manipulations of elements contribute to flatness; others contribute to the illusion of depth. For example, vertical and horizontal movements tend to give the impression of a flat surface (though can certainly be manipulated to create the illusion of shallow depth). Alternatively, one diagonal line can evoke the illusion of depth. Equivocal or ambiguous figure/ground relationships *tend* to appear flat, whereas overlapping shapes lend to creating the illusion of depth.

Gradation and Illusion

A gradual or progressive change from one color to another or a progressive arrangement of an element according to size or characteristic can contribute to the illusion of depth or motion.

Regular versus Irregular (Classical versus Baroque)

This set concerns "regular" planar recessional graphic space versus "irregular" recessional graphic space. (The term *planar* comes from the word *plane* and suggests that the main elements of a composition are arranged in planes parallel to the picture plane. As explained in Chapter 2, a plane is a flat surface and the picture plane is the front plane of a print or digital single surface.) In "regular" or "Classical" (*Classical* here refers to the Italian Renaissance; think Raphael and Leonardo) compositions, none of the major elements penetrate the picture plane; nor do any move in front of the picture plane at an angle. Basically, this is a "picture window" arrangement, where, like a window pane, all that we see moves behind the front plane and does not penetrate the picture plane (Figure 6-24).

In contrast, in an "irregular" or Baroque (think Flemish Baroque/Peter Paul Rubens or a comic book superhero's fist punching in front of the picture plane) or recessional graphic space, diagonal elements and planes move in front of as well as behind the picture plane, creating the illusion of great depth and action, suggesting an aggressive spatial property (Figure 6-25).

FIG. **6**/**24**

BOOK COVER: *I NEVER HAD IT MADE* BY JACKIE ROBINSON

· ART DIRECTOR: ROBERTO DE VICQ DE CUMPTICH
· DESIGNER: WILL STAEHLE
· CLIENT: ECCO PUBLISHERS

We see the winning image of Jackie Robinson from behind his baseball card, which establishes the picture plane.

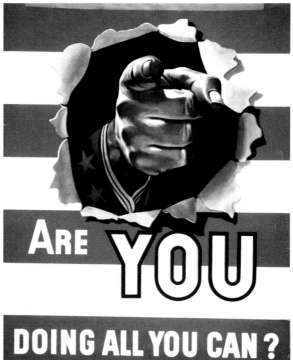

FIG. **6**/**25**

POSTER: *ARE YOU DOING ALL YOU CAN?*, 1942

· DESIGNER: UNIDENTIFIED POSTER-MAKER
· PHOTOGRAPHER: TERRY MCCREA
· PRODUCER: GENERAL CABLE CORPORATION
· PHOTOMECHANICAL LITHOGRAPH, 71.1 × 55.9 CM (28 × 22 IN.)
· LIBRARY OF CONGRESS PRINTS AND PHOTOGRAPHS DIVISION WASHINGTON, D.C. [LC-USZC4-6033]
· GIFT OF GENERAL CABLE CORPORATION

In this historical poster, the hand busts through the picture plane to confront the viewer, coming into the viewer's space for dramatic impact. The red and white stripes define the picture plane.

for example, an extended landscape-shaped rectangle (elongated poster, outdoor board, banner) requires different considerations than a more conventional rectangular format (standard magazine, book page size ratio).

This set also can be thought of as "parallels versus counterpoints," where movements parallel or echo the format's edges or are positioned in counterpoint to the edges. Generally, compositions with dominating parallel movements are deemed more consonant and counterpointing ones more active and potentially dissonant. This applies to print, digital, and motion graphics.

Shallow versus Deep

This set refers to how planes and/or forms function in graphic space.

› *Overlapping*: When an *opaque* flat plane or form is placed in front of another, that overlap creates the illusion of depth. Successive overlaps create the illusion of a recessive space, which can be manipulated to appear shallow or deep. When a transparent flat plane is placed in front of another, an ambiguous space is created, which could seem shallow.

Overlapping can function for various stylistic and visualization appearances; for example, overlapping functions well in collage, where elements are cut and pasted over others and can overlap. Collage is a technique invented and first utilized by the Cubists Pablo Picasso and Georges Braque. (You can use software to simulate collage.)

To denote associations, overlaps function to display a familial relationship among related information or visuals. Overlapping can aid emphasis, utilized with such structures as nest structures and stair structures. It can also create **fractured space,** as in the Cubist style of fine art, where multiple viewpoints are seen simultaneously.

› *Layering*: By overlapping parts of an image simultaneously or in a sequence, the illusion of shallow space is created. Layers can be opaque or transparent; aligned or purposely misaligned; typographic layers in any design application; layers of information on maps or layers of data on charts; layers of images in motion graphics; subtitles on film and in motion graphics; layers can imitate actual textures found in environments

FIG. 6 / 26

POSTER: *THE B'Z*

· MODERN DOG DESIGN CO., SEATTLE
· DESIGNER: JUNICHI TSUNEOKA
· CLIENT: HOUSE OF BLUES
· © MODERN DOG DESIGN CO.

This set is akin to "shallow versus deep" space and to the illusion of atmospheric perspective. Some designers also think of this set as *static versus active* composition. In static compositions, vertical and horizontal movements are emphasized. In active compositions, diagonal or curved movements—directions that contradict the edges of the format—are emphasized. For example, in Figure 6-26 the angles of the guitar, edges of the boom box, and figure's gesture all move at angles to the format. However, this can be qualified since you can create activity by how you manipulate vertical and horizontal lines or movements, through proximity, length, and groupings. Also, another variable to consider is the shape of the single surface;

FIG. **6 / 27**

POSTER: *TØÜRISTÁ*

· MENDEDESIGN, SAN FRANCISCO
· ART DIRECTOR: JEREMY MENDE
· DESIGNERS: AMADEO DESOUZA, STEVEN KNODEL, JEREMY MENDE
· CLIENT: TOURISM STUDIES WORKING GROUP, UNIVERSITY OF CALIFORNIA, BERKELEY

Layering conveys movement, thought, and the passage of time. When interviewed by Sean Adams for *Step Inside Design* magazine, Jeremy Mende said:

Good work, whatever the medium, is driven partly from an authentic idea and partly from a unique way of expressing it. [A concept] has to result from something more than just the idea or the expressive method. Otherwise the result is at best clever but never really satisfying. This notion of a personalized and whole gesture— one that can't be broken down into "parts"—is what I find compelling. In this sense, the concept is really how idea and expression are fused.

—http://www.stepinsidedesign .com/STEPMagazine/Article/28865

(think peeling layers of outdoor boards or layers of scrapbook elements on pages). Layering conveys movement, thought, and the passage of time. In Figure 6-27, by MendeDesign, the plasticity of the layers beckons us to travel throughout the poster to enjoy and absorb the images.

› *Diagonals/tilted plane*: A shallow or deep illusion of depth is created by planes composed of diagonals or by elements that oppose the edges of the format. A recessional space created by a titled plane moving back in perspective can create a heightened illusion of three-dimensional space.

FIG. **6** /**28**

GOLDEN GRAIN/MISSION PASTA

· WALLACE CHURCH, NEW YORK

Design Problem: Merging two regional brands into one cohesive national brand is a true challenge. The American Italian Pasta Company set out to do just that when it acquired the Golden Grain and Mission pasta brands. Wallace Church's design strategy sought to synthesize prior brand recognition equities within a new, compelling, all-American image. This new brand identity architecture had to be leveraged across more than a dozen different product forms and package configurations, visually unifying the new national brand on shelf.

Main Communications Objective: In its new design for Golden Grain Mission, Wallace Church sought to convey a wholesome, all-American image. A dynamic new logo is set against the "amber waves of grain" of an American wheat field. The design's rich colors convey the brand's quality and wholesome goodness, while greatly enhancing the brand's appetite appeal.

—Wallace Church

In Figure 6-28, for Golden Grain/Mission Pasta, Wallace Church creates a dramatic illusion of depth by defining the picture plane on the bottom half of the package and bleeding the photograph off the top edges.

FIG. **6** /**29**

POSTER: *MILTON GLASER*

· MILTON GLASER

· CLIENT: TOYOTA MOTOR CORPORATION ENDOWED LECTURE SERIES AT THE ART CENTER COLLEGE OF DESIGN

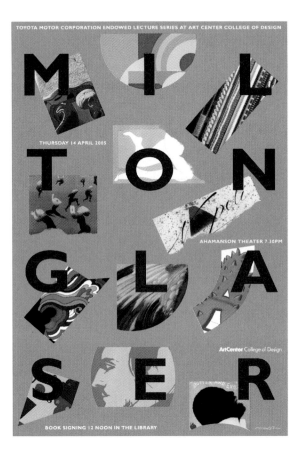

› *Atmospheric perspective*: This illusion simulates the effect the atmosphere has on color, shape, form, texture, and detail seen from a distance; also called aerial perspective.

Closed versus Open

The terms *closed* and *open* refer to the way the elements of a composition relate to the edges of a page, to the format. Basically, if the internal elements echo a page's edges to a great extent *and* the viewer's focus is kept tightly within the format, that composition is considered **closed**. If the major movements within the composition oppose the edges (think diagonals) or direct our eyes past the boundaries of the format, that composition is considered **open**. Traditionally, *regular* compositions tend to be closed, and *irregular* compositions tend to be open.

Dominant versus Multiple

You can build a composition around one dominant visual (using size, shape, color, or value contrast), where all other graphic elements form relationships with that dominant visual. A dominant composition can be based on one major movement, gesture, or compositional thrust, with all other movements as minor ones *built in relation to it through optical decisions and adjustments.*

Or, you can build a composition where there is no one overtly dominant visual; here relationships are built through sequence, pattern, grid, modular

FIG. **6** /**30**

POSTER: *VICTORY*

· DESIGNER/PHOTOGRAPHER: FANG CHEN

In my opinion, an idea is the soul of a poster and a good concept is the fruit of an analytical as well as intuitive process. My poster images not only come from my inspiration, but from my beliefs and experiences as well.

The "Victory" poster was first designed in 1997 and completed in 1998. The hand is intended to symbolize all of humankind. I felt the capitalized "V" represented by the two fingers is a universal symbol for victory and understood by viewers of all races and cultures. According to Chinese folklore, the lines in human hands are not only records of the past but also foretell the future. In my image I wanted the palm lines in the hand to show that human beings in general, no matter in the past or in the future, often go through numerous struggles and endure countless pains and sufferings in order to survive and ultimately triumph. The fact that three fingers are missing from the hand was intended to extend the feeling of victimizing in the image while, at the same time, adding to the poster's theatrical effect.

In order to convey the meaning of this image in the strongest possible way I chose the black and white color, which is based on the traditional Chinese philosophical idea of Yin and Yang. That was relevant because, in a broad sense, Yin and Yang can also be used to represent dialectic concepts such as brightness and darkness, hopefulness and hopelessness or victor and victim.

I gave an X-ray effect to the hand not only because it was dramatic, but also because it set the right tone for the viewers as to the profound inner meanings of the image.
—Fang Chen

structure, repetition, stair structures, axis alignment, edge alignment, positioning and flow, or some unifying principle. No element dominates. In a multiple composition, all movements have equal or close to equal force (Figure 6-29).

This structuring concept applies to single surfaces, multiple surfaces, and motion graphics. (Static versus sequence is related to dominant versus multiple.)

Singularity versus Juxtaposition
Whether you look at any religious icon single image, for example, any saint depicted during the Middle Ages, or at a contemporary poster using a single visual (Figure 6-30), you can see how a singular image can be employed to communicate a message or to symbolize or represent an idea. You can also juxtapose images to suggest a link or emphasize the contrast between them.

Static versus Movement
A static composition represents a fixed position; it neither moves nor implies motion. The illusion of movement can be created by a variety of means, for example, focusing on action-oriented arrangements, that is, receding diagonals (Figure 6-31); a figurative image that relates to our sense

of kinesis; capturing an archetypal movement (think Myron's *Discus Thrower*); angle or point of view; visual multiplication (see Static versus Sequence); "before and after" images implying duration; large shifts in scale; extreme value contrasts; and more.

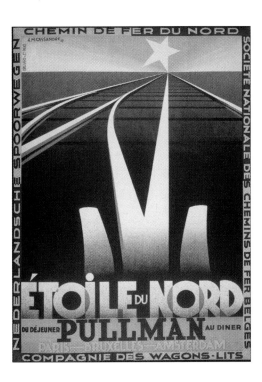

FIG. **6** /**31**

ADOLPHE MOURON CASSANDRE (1901–1968)

· ETOILE DU NORD 1927 REF 200007
· © MOURON. CASSANDRE. LIC. CASSANDRE-LCM 28-10-09. WWW.CASSANDRE.FR

Cassandre displays his optically playful use of lines to create illusion.

Static versus Sequence

As opposed to a static composition, a visual sequence is a number of things or elements or events in an order that might *imply time, interval, or motion over a period of time (duration)*; a sequence can be established on a single surface, on sequential pages, or in motion graphics. For example, a storyboard or comic graphic format

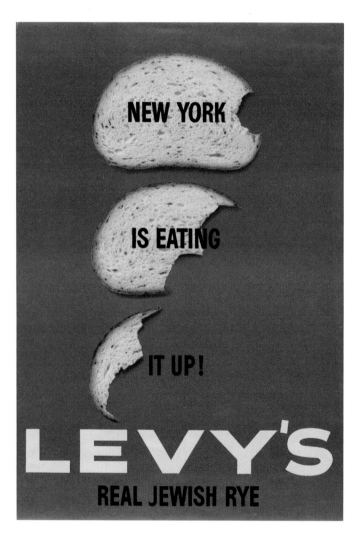

FIG. **6** / **32**

GAGE, ROBERT (B. 1921). "NEW YORK IS EATING IT UP! LEVY'S REAL JEWISH RYE." 1952.

· OFFSET LITHOGRAPH, 46 × 30¼ IN. GIFT OF DOYLE, DANE, BERNBACH AGENCY (133.1968)

· THE MUSEUM OF MODERN ART, NEW YORK, NY, USA

· DIGITAL IMAGE © THE MUSEUM OF MODERN ART / LICENSED BY SCALA / ART RESOURCE, NY 301153

Although time is suggested in this advertisement, it is a still image, unlike Flash graphics or a webfilm. The progressive bites of the rye bread would in real life happen over time.

can visualize a sequence. Or when a reader turns a page, that kinetic experience can be utilized to represent a sequence of events over a short period of time. Certainly, motion graphics and film are natural media for depicting sequence. Note how time is implied in Figure 6-32.

Sequential versus Randomness

Arrangements can *seem* ordered or random. Sequential arrangements have a discernible specific order or form a particular sequence. Also, one element or frame can seem to be the consequence or result of the previous.

The quality of randomness in composition stems from an intentional organization where elements belong *yet* no discernable pattern, uniformity, or regularity is readily apparent.

Sequential elements can also denote the illusion of motion through visual multiplication. Multiple positions (think a comic book rendering of a dog with many legs to denote running), blurred boundaries or edges, repetition, shift, and layers contribute to the illusion of motion (see Figure 6-12 for an example of multiple positions).

Near versus Far

A designer must consider *point of view*, that is, the viewer's position in relation to what he or she is looking at and from which angle. When elements or visuals are very large in relation to the size of the format, they appear to be physically closer to the viewer. Cropping also brings the viewer closer to the visual, so close that he or she cannot see the entire image. When elements are small in scale in relation to the size of the format, they seem to be farther away from the viewer. These two compositional approaches relate to human perception, to how we perceive objects in an environment. (This can be related to the visualization mode of "proximate vision versus distant vision." See Chapter 5, Visualization.)

Also, within one composition, you can contrast cropped images or big visuals with small ones to create a sense of depth.

Consistency versus Variation

Consistency helps establish unity—whether through symmetry, approximate symmetry, pat-

tern, any logical harmonious relationship of parts without discrepancy, an even level of visual weights, thicknesses of elements, or smoothness or roughness of elements. When there is no variation or minimal variation, consistency/congruence unifies and produces harmony. However, no variation could prove uninteresting; also, a flat hierarchy, where everything is treated equally, tends to be monotonous (though it can be meditative; think architectural lacework patterns).

Some variation adds visual interest. When one or more elements differ in visual characteristics (color, shape, form, texture, value, size) or in treatment or in position (isolated versus grouping), then variation is established. Besides creating difference among some graphic elements, you can employ a theme with variations. *Variation must be unified* in some way or it looks chaotic.

This set is also called "neutrality versus anomaly." Neutrality is the same as consistency; an anomaly is an obvious break from the norm in a composition.

AVOID AMBIGUITY

In visual perception, theoretically, a viewer associates psychological tension with the position of a visual element in a composition. Accordingly, viewers feel confused if the position of a visual element is ambiguous, if the positioning seems *tentative*. People prefer declarative positioning that produces stability, certainty. (This is not to be confused with figure/ground shapes that are intentionally unequivocal.)

In *Art and Visual Perception* and *The Power of the Center: A Study of Composition in the Visual Arts,* Rudolf Arnheim, distinguished psychologist, philosopher, and critic, used a diagram to illustrate this theory. **GD** If you place a dark circle slightly off center as if it had migrated from the center and should be returned to it, it might be disconcerting (psychologically frustrating) for the viewer. Therefore, if you place an element off-center, make sure it looks off-center, not out of kilter. If you want a line quality to be scratchy, make it really scratchy. If you want it to feel tall, make sure it is really tall. Rule of thumb: avoid tentativeness; make your intention clear (see sidebar "Have you M.E.N.T. It?").

"HAVE YOU M.E.N.T. IT?"

To ensure your arrangement is deliberate and each graphic component (visuals and type) is thoughtfully and deliberately positioned, consider employing these four reminders, which will aid awareness of how you position graphic elements in relation to the format. Here, the word "relate" means "having some bearing to"; it doesn't mean graphic components need to literally touch the midline or edges.

1/ M = midline
Relate all graphic components to the midline of the format.

2/ E = edges
Relate all graphic components to the format's edges.

3/ N = negative shapes/space
Consider all negative space.

4/ T = transitions
Consider all transitions among graphic components.

ARTICULATION: CREATING INTERESTING FORM

Articulation involves how well you express and how fully you craft transitions.

Creating interesting form (harmony, beauty, contrast)—creating any desired effect with impact—requires articulation and attention to clarity, coherence of expression, and how component parts are united.

HARMONY
To establish harmony, consistency, and agreement among elements and forms within a composition, you need to pay attention to several principles.

Proportions
Paying close attention to the proportions of component parts in the composition, their size relationships, how they are constructed, and how they function in relation to one another will aid harmony.

Employ Negative Spaces

Employ negative spaces to create passageways; to promote movement, unity, harmonious shapes, rhythm (Figure 6-33); and to direct the eye. If you think of negative space as a dramatic pause in the same way a pause is used between musical notes or dance movements, then you can consider an "empty" space as a purposeful break between positive shapes.

Dynamics

Know when to play it down or punch it up. Unity relies, in part, on consistency; however, if all forms are treated equally, or played down, then the composition will be lacking, whether it lacks a focal point, a dynamic quality, or any type of visual interest. Conversely, if all elements are punched up, fighting for visual attention, it might result in discord. For a dynamic quality, you punch up certain elements and play down others.

ATTENTION TO INTERSTICES AND TRANSITIONS

"Seventy-five percent of dance is about the transitions."
 —*Winter Gabriel, dancer and choreographer*

Consider each and every interstice and every transition from shape to shape, letter to letter, form to form, visual component to type component. If you focus on the interstices, those spaces that intervene between shapes and forms and type, then the entire composition will be appear organically related and taut. (Imagine choreography composed of individual dance moves with awkward or unconsidered transitions and you get the importance of efficient transitions to smooth visual moves.) Create interconnectedness among the graphic elements of the composition by paying attention to the transitions (Figure 6-34).

Create Relatedness

This goes back to unity, continuity, and flow: attention to every element as a voice in a choral piece or as an actor in an ensemble cast who works to ensure relatedness, belonging, and connections.

Focus

Your attention to the logic of your communication will allow a viewer to focus and glean the message.

FIG. **6** / **33**

BOOK COVER: *INTRODUCTION TO FINANCIAL ACCOUNTING*, 9E

· HORNGREN/SUNDEM/ELLIOT/PHILBRICK
· ART DIRECTOR: JANET SLOWIK
· COVER DESIGN: DEBBIE IVERSON
· COVER PHOTO: MOGGY/STONE/GETTY IMAGES, INC.
· CLIENT: PEARSON PROFESSIONAL & CAREER

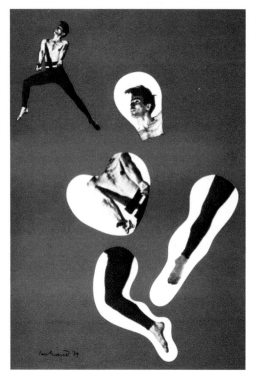

FIG. **6** / **34**

MAGAZINE: *ART DIRECTION*

· DESIGNER: PAUL RAND
· *ART DIRECTION* MAGAZINE, MARCH 1939, SILKSCREEN, 91 × 61 CM (35⅝ × 24 IN.) LIBRARY OF CONGRESS PRINTS AND PHOTOGRAPHS DIVISION, WASHINGTON, D.C., USA [LC-USZC4-5049 CONTROL # 96524953]

Work the Entire Composition at an Equal Level

Work from the general to the specific. When beginning students draw a still life, they will often draw one object at time, attempting to bring one object to finish and then move on to the next, rather than first focusing on the relationships between the objects, on where everything sits in the compositional space. Never work at 100 percent level of detail from one end of a composition to the other. Start with the most general elements of the composition and gradually work toward the more specific. Evaluate continually, making local adjustments in the context of the entire page.

Use a Fine-Toothed Comb

Evaluate your own composition by eye, transition-by-transition, part-by-part, as a whole. Judge all type by eye. Judge all interstices by eye. Do any areas of the composition appear to have been ignored? Critique your composition as if your life depended upon it, as if you were responsible for the maintenance of an aircraft where hundreds of lives depended upon how responsible you are to your duties. (See sidebar "Basic Compositional Checklist.")

MODULARITY

In graphic design, **modularity** is a structural principle employed to manage content using modules. A module is a self-contained, fixed unit that is combined with others to form a larger foundational structure composed of regular units. Modularity helps manage content as well as complexity (think of all the content on a governmental website). Modularity has three main advantages: (1) the underlying structure produces unity and continuity across a multipage application, (2) the content within each module can easily be replaced or interchanged, and (3) modules can be rearranged to create different forms yet still remain unified.

A **module** is also defined as any single fixed element within a bigger system or structure; for example, a unit on graph paper is a module, a pixel

BASIC COMPOSITIONAL CHECKLIST

Have you employed action to create visual interest, dynamics through contrast?

Have you used alignment to foster unity?

Have you arranged the composition to guide the viewer through the space?

Have you chosen a compositional approach that best enables communication?

Have you ordered the visual hierarchy for clarity?

Have you created visual interest?

Does your arrangement seem firm or tentative?

Have you "M.E.N.T." it?

Have you paid attention to the interstices?

Does your visualization of the concept enhance communication and meaning?

in a digital image is a module, a rectangular unit in a grid system is a module, and a fixed encapsulated chunk of a composition is a module.

Modularity is used to create modular alphabets, hand-lettering (see Figure 3-12, Country Things logo), typographic treatments, signage systems, symbol systems, pixel effects, or any modular-based imagery (for example, a transformation or sequence developed in modular units; figures composed of units).

CHUNKING

A technique related to modularity in graphic design, where content is split or information is grouped into chunks, is **chunking** or *encapsulating*. You do this by combining units or capsules of content or information into a limited number of units or chunks. The aim of chunking is to make information easily understood: it affords the viewer digestible amounts of content at a time. Chunking is utilized to facilitate memory and in other disciplines, such as musical composition.

In the solutions for Virgin Atlantic, a large amount of text and visuals are organized on the front and back of each piece, by grouping and

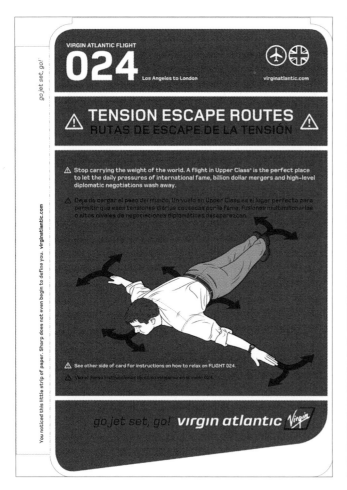

FIG. **6** / **35**

AIRLINE SEAT POCKET PLACARD: VIRGIN ATLANTIC AIRWAYS, "TENSION ESCAPE ROUTES"

· CRISPIN PORTER + BOGUSKY, MIAMI
· EXECUTIVE CREATIVE DIRECTOR: ALEX BOGUSKY
· CREATIVE DIRECTORS: BILL WRIGHT, ANDREW KELLER
· ART DIRECTOR: TONY CALCAO
· COPYWRITER: ROB STRASBERG
· ILLUSTRATOR: TIMMY KUCYNDA
· CLIENT: VIRGIN ATLANTIC AIRWAYS

Imitating the look of flight information cards, these witty pieces are unified by treatment of the layout, consistent "look and feel," and tone of voice of the copy and concept.

AIRLINE SEAT POCKET PLACARD: VIRGIN ATLANTIC AIRWAYS, "CEO CONDUCT WHILE ON BOARD"

· CRISPIN PORTER + BOGUSKY, MIAMI
· EXECUTIVE CREATIVE DIRECTOR: ALEX BOGUSKY
· CREATIVE DIRECTORS: BILL WRIGHT, ANDREW KELLER
· ART DIRECTOR: PAUL STECHSCHULTE
· COPYWRITER: FRANKLIN TIPTON
· ILLUSTRATOR: TIMMY KUCYNDA
· CLIENT: VIRGIN ATLANTIC AIRWAYS

WEB BANNER: VIRGIN ATLANTIC AIRWAYS, "BOUNCE"

· CRISPIN PORTER + BOGUSKY, MIAMI
· EXECUTIVE CREATIVE DIRECTOR: ALEX BOGUSKY
· CREATIVE DIRECTOR: ANDREW KELLER
· INTERACTIVE CREATIVE DIRECTOR: JEFF BENJAMIN
· COPYWRITER: FRANKLIN TIPTON
· PROGRAMMING/PRODUCTION: BARBARIAN GROUP
· CLIENT: VIRGIN ATLANTIC AIRWAYS

WEB BANNER: VIRGIN ATLANTIC AIRWAYS, "MASSAGE"

· CRISPIN PORTER + BOGUSKY, MIAMI
· EXECUTIVE CREATIVE DIRECTOR: ALEX BOGUSKY
· CREATIVE DIRECTOR: ANDREW KELLER
· INTERACTIVE CREATIVE DIRECTOR: JEFF BENJAMIN
· ART DIRECTOR: JUAN-CARLOS MORALES
· COPYWRITER: FRANKLIN TIPTON
· CLIENT: VIRGIN ATLANTIC AIRWAYS

encapsulating; the alignment of the visual elements and the responsiveness to the format add to visual hierarchy as well (Figure 6-35). In advertising, some campaigns use the same layout (compositional structure with designated positions for the elements) throughout a campaign, or in book cover series, such as the Design Exploration series (Figure 6-36).

RULE OF THIRDS

The rule of thirds is an asymmetrical compositional technique often used by painters, photographers, and designers to create interest, balance, and energy in visual arts by overlaying the space with a grid and positioning or aligning the focal point or primary graphic elements of the composition along these grid lines or especially on the intersections of the lines of the grid. This rule is also sometimes called the golden grid rule, since the modules created by the grid roughly relate to the ratio of the golden section (rule of thirds: 2/3 = 0.666; the golden section: 0.618). In practice, the aim of the rule is to prevent the placement of the

FIG. **6** / **36**

BOOK COVERS: DESIGN EXPLORATION SERIES

· ART DIRECTOR: BRUCE BOND
· DESIGNERS: STEVEN BROWER, LISA MARIE POMPILIO
· ILLUSTRATORS: VARIOUS
· CLIENT: CENGAGE LEARNING

subject of an image at the center of a composition or to discourage placements that divide the image in half. Theoretically, the rule of thirds produces aesthetic results.

To employ the rule, imagine an image divided into thirds both horizontally and vertically by the placement of a grid or a framework of equally spaced horizontal and vertical lines that create four intersections and nine equal squares or modules. Then place the points of interest in your composition along the lines or at their intersections. The focal point may be placed at one intersection, for example, and a counterbalancing secondary graphic element or accent placed at an opposing intersection. In a landscape, this often translates into placing the horizon line in your image along one of the horizontal lines. Although the intersections provide guidelines for the placement of primary elements, when working with asymmetry, you will still have to make judgments involving balance and counterpoint; inflexible adherence to any compositional rule is deemed undesirable and you should be able to relax such adherence after working with the rule as a guideline for a while.

THE GRID

Open up a magazine. How many columns do you see? How are the visual elements organized? All the elements, display and text type, and visuals (illustrations, graphics, and photographs) on the pages of a print or digital magazine, book, or newspaper are almost always organized on a grid. A grid is a guide—a modular, compositional structure made up of verticals and horizontals that divide a format into columns and margins.

If we go back to the original premise in this chapter, that composition should produce clarity and visual interest, then the purpose of a grid system makes good sense. Grids organize type and visuals. If you have to organize the enormous amount of content in any given newspaper, textbook, or corporate, governmental, museum, or editorial website, you would want some type of structure to ensure that readers would be able to easily access and read an abundance of information (see Figure 6-37). Imagine designing your daily newspaper using a spontaneous composition method, where you would have to intuitively design each page and then make sure each page had

FIG. **6** / **37**

BOOK COVER AND INTERIOR:
NORTON'S STAR ATLAS AND REFERENCE HANDBOOK

· EDITED BY IAN RIDPATH
· DESIGN: CHARLES NIX

FIG. **6** / **38**

POOL LANES IN A SWIM MEET

· KOHJIRO KINNO/NEWSPORT/CORBIS

FIG. **6** / **39**

TRIATHLON OCEAN OPEN SWIM

· RICK DOYLE/CORBIS

some resemblance to all the others while ensuring a sense of congruence across all the pages. Certainly you could compose spontaneously, but you would not meet a daily deadline. Not only does a grid spare you the time of having to spontaneously compose every page, it affords a skeletal structure that can provide continuity, congruence, unity, and visual flow across many print or digital pages.

A grid is about maintaining order. If you think of the pool lanes in a swim meet and how they efficiently keep the swimmers where they are supposed to be, then one goal of using a grid structure becomes clear. Compare the orderly swim meet in Figure 6-38 to the frenzied sea of bodies in a triathlon ocean open swim in Figure 6-39. A grid defines boundaries and keeps content in order.

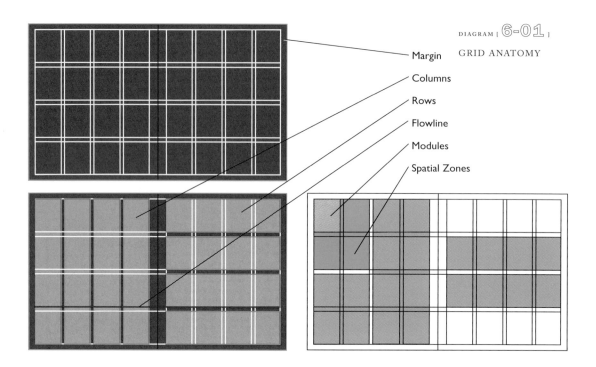

DIAGRAM [6-01]

GRID ANATOMY

Margin
Columns
Rows
Flowline
Modules
Spatial Zones

FIG. **6** / **40**

BOOK COVER AND INTERIOR: *WAITING FOR GOLEM*

· DESIGNIQ, CZECH REPUBLIC
· DESIGNER: FILIP BLAŽEK
· PHOTOS: JAROMIR KAISER
· CLIENT: XYZ PUBLISHING HOUSE, PRAGUE

This was a very interesting job. The author of the book liked my concept from the very beginning so we didn't waste time talking about the design when we met for the first time. Since then, we became good friends. I was born in downtown Prague and I wanted to put the atmosphere of old town alleys into the book. To make it a little bit dirty and gray, disturbing and friendly, beautiful and ugly. People who read the book told me, the atmosphere of Prague is there, which is a satisfaction for me.
—Filip Blažek

FIG. **6** / **41**

ONE-COLUMN GRID: *PRINT* MAGAZINE

· DESIGNER: STEVEN BROWER

TWO-COLUMN GRID: *PRINT* MAGAZINE

· DESIGNER: STEVEN BROWER

FOUR-COLUMN GRID: *PRINT* MAGAZINE

· DESIGNER: STEVEN BROWER

Sample grid designs: when you have many elements to organize—display type, text type, and visuals—you usually need to establish an underlying structure that can provide help in maintaining clarity, legibility, balance, and unity. This is especially true when you are working with a multipage format where you need to establish a flow or sense of visual consistency from one page to another.

Diagram 6-01 illustrates the anatomy of a grid. A grid's proportions and spaces provide a consistent visual appearance for an application with many pages (Figure 6-40); a grid is a structural system that holds together all the visual elements. There are even and odd number grids, ranging from one to four and sometimes even six columns.

A designer can strictly adhere to a grid or break a grid. For the sake of visual drama or surprise, you can occasionally break the grid. If you break the grid too often, however, the armature it provides will be lost (similarly, sculptural relief on a column can't go too deep or it will break the column). Often, magazines have several grid options that work together, as shown in the three sample grids used in *Print* magazine (Figure 6-41).

MARGINS

Defining boundaries starts with **margins**—the blank space on the left, right, top, or bottom edge of any printed or digital page (Diagram 6-02). Basically, in grids as well as on any single surface,

DIAGRAM | 6–02 |

MARGINS

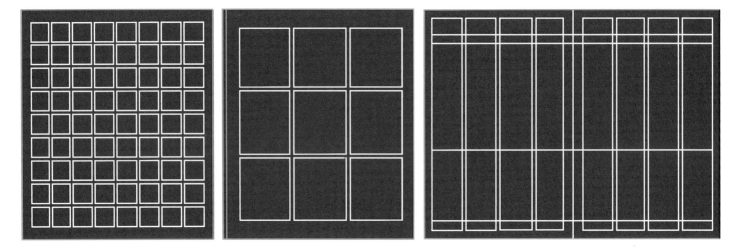

DIAGRAM [6-03]

MODULAR GRIDS

margins function as frames around visual and typographic content, concurrently defining active or live areas of the page as well as its boundaries. (When planning margins for a bound book, magazine, or annual report, allow for the space needed for binding in the gutter margin, the blank space formed by the inner margins of two facing pages of a book.)

Considerations for determining the margins include:

› How the margin can best present the content
› Legibility
› Stability
› Determining the proportions of the margins to produce harmony
› Desired visual appearance
› Symmetrical versus asymmetrical margins

COLUMNS AND COLUMN INTERVALS

Columns act similarly to the lanes of a swim meet. **Columns** are vertical alignments or arrangements used to accommodate text and images. In any grid, the number of columns depends upon several factors, mainly the concept, purpose, and how the designer wants the content to be presented. When using more than one column, columns can be the same width or vary in width. One or more columns can be dedicated to only text or only images or a combination thereof. The spaces between columns are called **column intervals**.

FLOWLINES

Flowlines establish horizontal alignments in a grid and can aid visual flow. When flowlines are established at regular intervals, a regular set of spatial units called modules are created.

GRID MODULES

Grid modules are the individual units created by the intersection of the vertical column and horizontal flowlines. A text block or image is placed in a grid module. Examples of modular grids are shown in Diagram 6–03; a text block or image can be positioned on one or more modules.

SPATIAL ZONES

Spatial zones are formed by grouping several grid modules in order to organize the placement of various graphic components. Spatial zones can be dedicated to text or image or either. When establishing spatial zones, keep proportional relationships, position of the page (point of entry), and visual weight in mind.

EXERCISE 6-1

GRAPHIC SPACE: DOMINANT VISUAL VERSUS MULTIPLE VISUALS

❶ First composition: Find or take a photograph of an object or person, which will be the dominant visual in the final composition. Then find or take

photographs of related images, for example: a person (dominant visual) and subordinate visuals: a suitcase, an umbrella, a puddle, a dog, and a fire hydrant. Convert all the photos into silhouettes.

❷ Build a composition around one dominant visual (using size, shape, color, or value contrast), where all other graphic elements form relationships with that dominant visual.

❸ Second composition: using the same silhouettes, now build a composition where there is no single overtly dominant visual; here relationships are built among several shapes or forms through some unifying principle. No element dominates. In a multiple composition, all movements have equal or close to equal force.

❹ Compare the graphic space in both of these compositions.

PROJECT 6-1

MODULAR GRID: PERSONAL OR PRESIDENTIAL HISTORY

❶ Find photographs that commemorate or represent important moments in your own life or in the life of a country's president. Scan the photos.

❷ Write text that contextualizes or complements the images.

❸ Design a basic modular grid. Grids organize content. First, design a simple three- or four-column grid. Add horizontal flowlines to create grid modules. Grid modules are the individual units created by the intersection of the vertical column and horizontal flowlines.

❹ Place type or images in a grid module. As a point of departure to learn about the purpose and aesthetic of utilizing a modular grid, do not break the grid modules.

❺ Use the grid for a three-page history.

Go to our website **GD/s** for *many* more Exercises and Projects, and presentation guidelines, as well as other study resources including the chapter summary.

NOTE

1. C. F. Nodine, P. J. Locher, and E. A. Krupinski, "The Role of Formal Art Training on Perception and Aesthetic Judgment of Art Composition," *Leonardo*, 26, pp. 219–227, 1991.

print this moment

07/

POSTERS

<<< / facing page

POSTER: *PRINT THIS MOMENT*

- THIRST/3ST.COM
- RICK VALICENTI/3ST
- ILLUSTRATORS: RICK VALICENTI/3ST, BILL VALICENTI
- TYPOGRAPHER: RICK VALICENTI/3ST
- CLIENT: GILBERT PAPER

WHETHER
A POSTER IS A PROMOTION FOR AN ART EXHIBIT, A MUSICAL GROUP, OR THE VOICE OF DISSENT, IT IS COMMON TO SEE ONE TACKED ON A WALL OR FRAMED, HANGING IN HOMES AND OFFICES ALONGSIDE PAINTINGS, PHOTOGRAPHS, AND FINE ART PRINTS. NO OTHER GRAPHIC DESIGN FORMAT HAS BEEN SO SUCCESSFUL IN CAPTURING THE ATTENTION AND HEARTS OF MUSEUM CURATORS, ART CRITICS, SOCIAL HISTORIANS, AND THE PUBLIC. SOME PEOPLE HAVE EXTENSIVE POSTER COLLECTIONS THAT CONTAIN EITHER A VARIETY OF POSTERS OR A SERIES.

OBJECTIVES

Realize why people love posters

Learn the purpose of posters

Understand the context

Appreciate a poster designed as social commentary

Become conscious of a poster as a vehicle for change

FIG. **7 / 01**

TOULOUSE-LAUTREC, HENRI DE (1864–1901). *JANE AVRIL*, **1893.**

· COLLECTION: THE MUSEUM OF MODERN ART, NEW YORK, NY

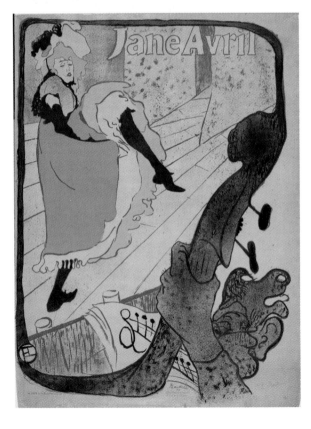

WHY WE LOVE POSTERS

It is not unusual to walk through a public space, see a poster, and think, "I would love to hang that in my home." In fact, some people find some publicly displayed posters so attractive that they go to extremes; for example, people tried to steal Gail Anderson's poster for the School of Visual Arts from subway platforms (see the Showcase of Gail Anderson's work on page 168).

One could surmise that French artist Henri de Toulouse-Lautrec's adoption of the poster medium (Figure 7-01) encouraged other fine artists' interest in this vehicle for graphic communication. The American, Japanese, Chinese, Cuban, Israeli, Russian, and European art and design communities (and governments) have embraced the poster. Innumerable visual artists have designed them, such as Eduardo Munoz Bachs (Cuba), Romare Bearden (United States) (Figure 7-02), Milton Glaser (United States), Eiko Ishioka (Japan), Oskar Kokoschka (Austria), Dan Reisinger (Israel) (see Figure 7-28), Ben Shahn (United States), and Tadanori Yokoo (Japan).

When someone chooses to hang a social protest poster or concert poster in his or her room, that individual, of course, believes in the cause or favors the musical artist. Yet, the association with the poster may be more significant—emblematic, perhaps, choosing a poster as an expression of one's individuality. Milton Glaser's poster of Bob Dylan has adorned countless walls and has become an icon (Figure 7-03). Depicting an individual as an icon communicates meaning about its subject, as does the poster for 50 Cent (see Timeline, page TL-24). Or perhaps one can identify with the designer's social or political commentary (Figure 7-04).

THE PURPOSE OF POSTERS

The purpose of any poster is to communicate a message. To do that, a poster must first grab a viewer's attention. A poster is seen while someone is on the move—driving, riding, or walking by—so it must be engaging enough to capture a person's attention amid all the other visual clutter.

BEARDEN, ROMARE, *AFRICA SPEAKS TO THE WEST*

· ART © ROMARE BEARDEN, LICENSED BY VAGA, NEW YORK, NY. AFRICA SPEAKS TO THE WEST, 1976. OFFSET LITHOGRAPH ON PAPERBOARD. 11⅛" × 28 INCHES. GIFT OF POETRY ON THE BUSES. ©1976, THREE RIVERS PRESS, CARNEGIE MELLON UNIVERSITY. PHOTO: SMITHSONIAN AMERICAN ART MUSEUM, WASHINGTON, DC/ART RESOURCE, NY

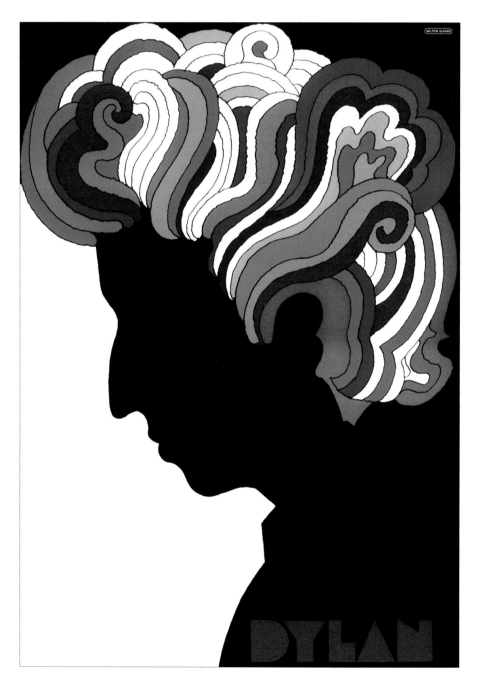

FIG. **7** /**03**

POSTER ENCLOSED IN A BOB DYLAN RECORD ALBUM: *DYLAN*

· MILTON GLASER

Designer Steven Brower comments about this iconic poster: "Islamic art meets Marcel Duchamp at the dawn of the psychedelic era."

FIG. **7** /**04**

CAPITAL OF WAR

· CALAGRAPHIC DESIGN, ELKINS PARK, PA

· ILLUSTRATOR/DESIGNER/ART DIRECTOR: RONALD J. CALA II

The black negative spaces between the white shapes greatly contribute to how the shapes interconnect.

SHOWCASE

G.A.

Gail Anderson is a creative director at SpotCo, a New York City-based ad agency and design studio that specializes in creating artwork and campaigns for Broadway theater. From 1987 to early 2002, she served as senior art director at *Rolling Stone* magazine.

Anderson's work, which has received awards from the Society of Publication Designers, the Type Directors Club, AIGA, The Art Directors Club, *Graphis*, *Communication Arts*, and *Print*, is in the permanent collections of the Cooper Hewitt Design Museum and the Library of Congress. She is coauthor, with Steven Heller, of *Graphic Wit*, *The Savage Mirror*, *American Typeplay*, *Astounding Photoshop Effects*, and *New Vintage Type*.

Anderson teaches in the School of Visual Arts' MFA Design program and currently serves on the advisory boards for Adobe Partners in Design and the Society of Publication Designers. She is the recipient of the 2008 AIGA Medal for Lifetime Achievement.

SVA Poster

"I made this super complicated and it took months of late nights in front of the TV. It's all wood type that I'd scanned from event posters over the years. When I say months, I'm not kidding. I made little type people every night after work from March till June. Someone on Facebook said it was awful and called it 'typography soup,' but people tried to steal it from the subway platforms, so someone must have liked it!"

Back, Back, Back Poster

"I worked with our two most junior designers, Kristina and Gustavo, who were with us for the summer from the School of Visual Arts MFA Design program. 'Back, Back, Back' was a play about baseball and steroids, and in the end, the client leapt at the pill as baseball idea and the simple title receding into the sky. I've included the other sketches we presented (a small show like this usually gets three or four comps, where a larger one may get a dozen or more)."

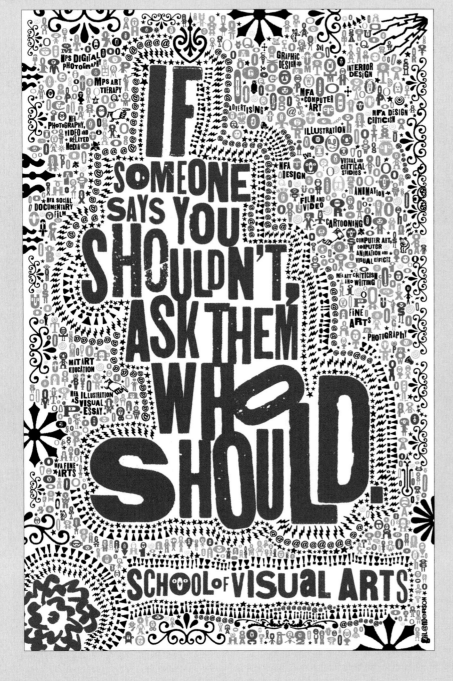

SVA POSTER

- · ART DIRECTOR: MICHAEL WALSH
- · DESIGNER: GAIL ANDERSON
- · WRITER: JIMMY MCNICHOLAS
- · CLIENT: SCHOOL OF VISUAL ARTS

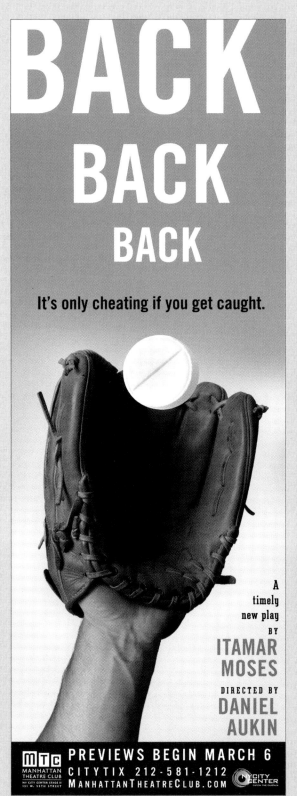

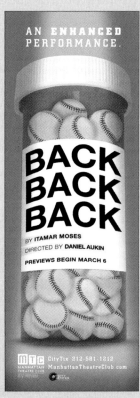

Guthrie: *Government Inspector* **Poster**

"Difficult satirical play to get through about personal greed and government corruption, but made appealing and light through the use of Ross MacDonald's illustration and woodtype. Ross has a whole letterpress setup in his barn in Connecticut, and while we don't usually give over the typography to the illustrators, Ross is an accomplished designer and has the best type library going."

Guthrie: *Gem of the Ocean*

"Bashan created this illustration himself, with the intention of handing it over to a 'real' illustrator. We were all so enamored of it that we used it as final art. The client LOVED this piece. L-O-V-E-D."

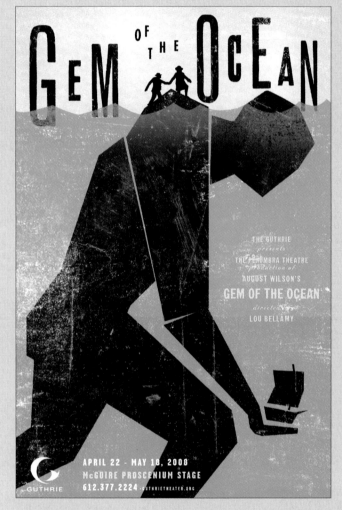

GUTHRIE: *GOVERNMENT INSPECTOR* POSTER

· SPOTCO, NEW YORK
· CREATIVE DIRECTOR: GAIL ANDERSON
· ART DIRECTOR/DESIGNER: DARREN COX
· ILLUSTRATOR: ROSS MACDONALD
· CLIENT: GUTHRIE THEATER

GUTHRIE: *GEM OF THE OCEAN* POSTER

· SPOTCO, NEW YORK
· CREATIVE DIRECTOR: GAIL ANDERSON
· DESIGNER/ILLUSTRATOR: BASHAN AQUART
· CLIENT: GUTHRIE THEATER

Roundabout: *Pal Joey*

"We sometimes end up using ourselves in art to keep the costs down. The guy is our photo producer, Mark Rheault, and the woman is the wife of Jeff Rogers, the designer."

Roundabout: *Streamers*

"The client liked a photo that was used in the Huntington Theater production of *Streamers* and wanted to use it again in theirs. The quality wasn't very good, and we wanted to make it much bolder and more graphic. We worked with an artist who'd actually interned with us while he was at SUNY Purchase. I think we were able to freshen it up a bit and the type falling back in the sky was a neat touch."

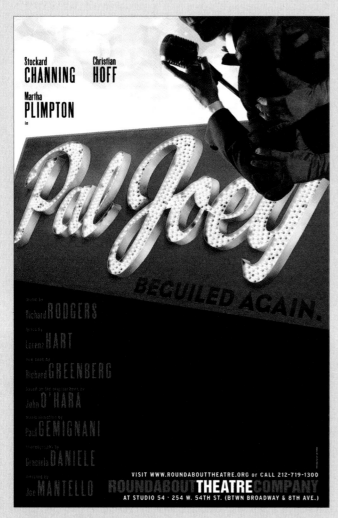

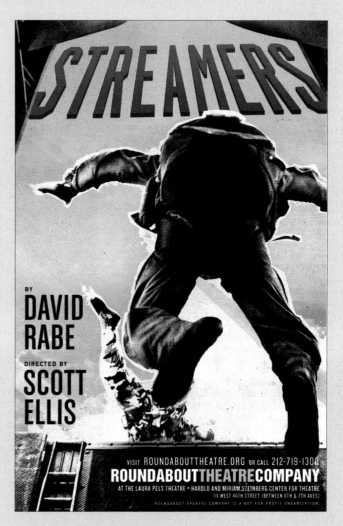

ROUNDABOUT: *PAL JOEY*

· SPOTCO, NEW YORK
· CREATIVE DIRECTOR: GAIL ANDERSON
· DESIGNER: JEFF ROGERS
· PHOTOGRAPHER: LEN PRINCE
· CLIENT: ROUNDABOUT THEATRE

ROUNDABOUT: *STREAMERS*

· SPOTCO, NEW YORK
· CREATIVE DIRECTOR: GAIL ANDERSON
· DESIGNER: GREG COLEMAN
· PHOTOGRAPHER/ILLUSTRATOR: DAN SAVAGE
· CLIENT: ROUNDABOUT THEATRE

FIG. **7** / **05**

FOR STUDENTS ONLY

- THIRST/3ST.COM
- RICK VALICENTI/3ST
- TYPOGRAPHERS: RICK VALICENTI/3ST, DANA ARNETT/ VSA PARTNERS
- ILLUSTRATORS: RICK VALICENTI/3ST, MATT DALY/ LUXWORK
- CLIENT: ALLIANCE GRAPHIQUE INTERNATIONALE/CHICAGO STUDENT DESIGN CONFERENCE 2008

This 24" × 36" poster was conceived and designed to introduce the affordable student design conference. While initially abstract and vague, the poster speaks with clarity through the obvious codes within any designer's visual language. Multiple copies were forwarded to 50 plus colleges and universities.
—Thirst/3st

FIG. **7** / **06**

FREAK

- SPOTCO, NEW YORK
- DESIGNER: KEVIN BRAINARD
- ILLUSTRATOR: WARD SUTTON

John Leguizamo's semiautobiographical one-man performance features many fascinating characters, and the energy of the performer/writer is communicated through the poster design.

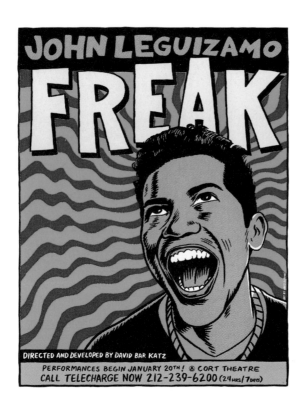

A **poster** is a two-dimensional, single-surface format used to inform (display information, data, schedules, or offerings) and to persuade or promote (people, causes, places, events, products, companies, services, groups, or organizations). Produced in multiples and (usually) widely circulated, posters are often posted in numerous locations around town and are seen more than once by the public. Ubiquity and multiple viewings reinforce messages for any single viewer. In public spaces, we see posters promoting events such as films, plays, concerts, lectures, and conferences. Figure 7-05 promotes a student design conference and multiple copies were sent to colleges and universities. Posters featuring attractive models and celebrities endorsing brands are hung in bus shelters and subway stations. Theatrical or musical events, public service advertising, sporting events, rallies, protest causes, messages of dissent, politics and politicians, propaganda, wars, museum exhibits, and brand advertising are all subjects for posters.

If a poster is not well designed or is dull, surely it will be ignored when surrounded by other visual communication or an interesting environment. An appealing poster design can capture our attention and imagination and perhaps provoke us like no other graphic design application. When words and visuals are effectively combined, a poster has the potential to communicate and become more than just a fleeting visual communication; it can become an object to return to, again and again, for contemplation, enjoyment, or provocation. It is fascinating that in this age of moving images and Flash graphics, a still form of visual communication—a poster—continues to hold our attention; as does the poster for John Leguizamo's one-man play (Figure 7-06).

A LITTLE HISTORY

Before posters became a visual communication staple, broadsides were used to communicate ephemeral information—to make announcements and publicize news and events, as well as to promote merchandise. A **broadside**, or broadsheet, is a large sheet of paper, typically printed on one side. In Europe, after the invention of moveable type, broadsides were used to make announcements. Once printers began working in

the American colonies around the mid- to late seventeenth century, broadsides had a role in colonial life.

Broadsides were relatively inexpensive to produce and served their purpose for local advertisers and information seekers. In both Europe and America, there were advances in printing technology by the late nineteenth century; in France, color lithography was significantly advanced by Jules Chéret, allowing for great color and nuance in poster reproduction. By 1900, colorful posters would eclipse broadsides as visual communication that could attract viewers.[1]

Before the end of the nineteenth century, printers composed posters primarily only with text, sometimes embellishing the poster with decorative yet conventional graphic elements, such as borders or dingbats.

Influenced by the strong graphics and ideas found in Japanese prints and the advantages of color lithography, artists such as Chéret, Toulouse-Lautrec, and Bonnard replaced type with the integration of images and hand-lettering. These new posters, by the mid-1890s, were embraced, collected by connoisseurs, and discussed in illustrated books and magazines.[2]

POSTERS IN CONTEXT

Most posters are meant to be hung in public places and to be seen from a distance. Understanding the context for any graphic design is crucial. Where will it be seen, and how will it be viewed? How close will the viewer be? In today's competitive visual landscape, a poster must catch the attention of passersby while competing for attention with surrounding posters, outdoor boards, neon signs, and any other visual material. We only need to think of the myriad of posters in the city square near a theater district to realize just how much a poster must do to capture attention.

CONCEPTUAL DEVELOPMENT

The same design development process outlined in Chapter 4 is used—

Orientation ▶ Analysis ▶ Concepts ▶ Design ▶ Implementation

Sometimes, we can almost see the designer thinking, and in these cases, the design concept is very clear. The poster by Bob Aufuldish for the lecture series at the California College of the Arts Architecture examines ideas surrounding global practice (Figure 7-07). The background is composed

FIG. **7** / **07**

CALIFORNIA COLLEGE OF THE ARTS ARCHITECTURE FALL LECTURE SERIES

· AUFULDISH & WARINNER, SAN ANSELMO, CA

· DESIGNER: BOB AUFULDISH

· CLIENT: CALIFORNIA COLLEGE OF THE ARTS ARCHITECTURE

· COURTESY OF AUFULDISH & WARINNER

FIG. **7** /**08**

THE VAGINA MONOLOGUES

· SPOTCO, NEW YORK
· DESIGNER: LIA CHEE

Ensler's provocative play is captured in this seemingly modest yet brave and emblematic conceptual treatment of type and visual. At second glance, an astute viewer might note an evocative form that both captivates and surprises.

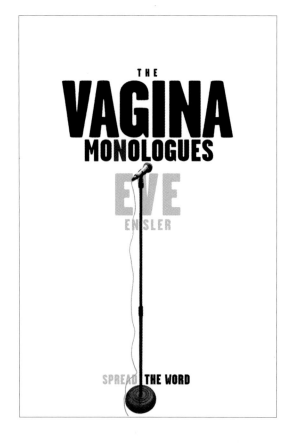

FIG. **7** /**09**

SLASH

· ART DIRECTOR: DAVID SCHIMMEL
· DESIGNER: STEVEN BROWER
· CLIENT: NEENAH PAPER
· © STEVEN BROWER

Neenah Paper commissioned and auctioned off twenty-four limited-edition punctuation "Punc't" posters and raised $14,000 for the Books for Kids Foundation. Brower's is one of the Punc't posters as part of the series of twenty-four punctuation marks.

of abstracted airline route maps, and Aufuldish designed the information to "float on top of this field." In Figure 7-08, the symmetry and vertical microphone stand evokes the title's form.

On their website, SpotCo, a leading entertainment advertising agency, presents case studies of their work stating their "big ideas," "key messages," and "real results" for each poster project (www.spotnyc.com). Several issues must be addressed simultaneously in a poster. As SpotCo's creative director Gail Anderson says, "A good deal of information has to live on each design."

Clearly identifying and then stating your three "big ideas" and three "key messages" is an extremely helpful guide for the conceptual development of a poster.

To formulate your key messages, based on Gail Anderson's assessment, ask:

› What will make the average theatergoer/moviegoer/concertgoer buy a ticket?

› What makes this poster's attraction/cause/brand different from the other choices out there?

› What are you promoting?

› Why should someone be interested in this social cause? Political view?

› How can you craft the message so the target audience believes what you're conveying?

DESIGN DEVELOPMENT

Like all other graphic design, the success of a poster depends on expressing the design concept through a cooperative combination of type and image, interesting visualization, and considered composition. The very nature of designing for one large graphic surface absolutely invites experimentation; for example, Steven Brower used hand-torn paper and a photo collage to visualize Figure 7-09.

Visualization

Any visualization should best serve the design concept. Before a major gallery renovation, Southern Exposure invited artists to respond to the gallery's tangible space exploring "the notion of home and the relationship between space and identity." For the exhibition poster *Between the Walls*, Mende-Design visualized a relationship between the walls and the artists in Figure 7-10.

The theme for a California College of the Arts Architecture lecture series was "resourcefulness." Bob Aufuldish comments about his design for Figure 7-11, "In the context of architecture, resourcefulness means both thinking nimbly and being conscious of the impact architecture has on the planet. Thinking resourcefully, we built all the text for the poster out of flowers."

Explore techniques to see which ones might work best for your concepts. As listed in Chapter 5 on visualization, experiment with collage, photomontage, and the following:

› *Printmaking techniques*: If you've studied printmaking, then further explore one of these options: woodcut, linocut, screen printing (serigraphy), etching, dry point, intaglio, and mezzotint, among others. If you haven't studied printmaking, start with a **monotype**, a one-off technique (producing one copy) in which a flat surface (Perspex, glass, cardboard, copper or zinc plate) is painted with printmaking ink or oil colors; it is then passed through an etching press or pressed by hand (rolling pin or other tool).

› *Screen printing*: Due to its popularity, screen printing deserves its own entry. Screen printing can be created at home using a porous mesh screen stretched over a wooden frame, a stencil, a squeegee, ink, and a surface, such as paper or a T-shirt.

› *Letterpress*: Letterpress is a printing method using "relief" type printing plates where the image or printing areas are raised above the nonprinting areas. (Your university or neighborhood arts center may have a letterpress that you can use.)

› *Woodblock*: Originating in China, woodblock printing is a technique for printing text, images, or patterns on textiles or paper.

› *Mixed media and experimental media*: Experiment by combining different visual art media; for example, combine paint with collage or combine photography with drawings. Try illustrating with unusual media; for example, use black coffee to paint on unprimed canvas or on paper towels, or model 3D forms out of Model Magic™ material, or create imagery with torn paper. Try a photogram; the placement of an object on light-sensitive paper creates an image of its silhouette. No camera necessary.

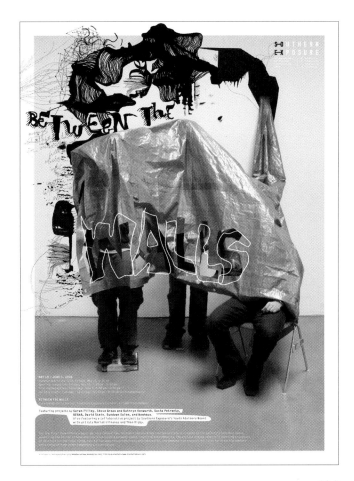

FIG. **7** / **10**

BETWEEN THE WALLS

- MENDEDESIGN, SAN FRANCISCO
- ART DIRECTOR: JEREMY MENDE
- DESIGNERS: AMADEO DESOUZA, STEVEN KNODEL, JEREMY MENDE

FIG. **7** / **11**

CALIFORNIA COLLEGE OF THE ARTS ARCHITECTURE LECTURE SERIES

- AUFULDISH & WARINNER, SAN ANSELMO, CA
- DESIGNER/PHOTOGRAPHER: BOB AUFULDISH
- CLIENT: CALIFORNIA COLLEGE OF THE ARTS ARCHITECTURE
- COURTESY OF AUFULDISH & WARINNER

Sagmeister's poster for the Adobe Achievement Awards, Figure 7-12, is an example of experimental visualization, where they had a wooden floor constructed and then arranged 2,500 filled coffee cups.

FIG. **7** /**12**

ADOBE ACHIEVEMENT AWARDS

· SAGMEISTER INC., NEW YORK
· ART DIRECTOR: STEFAN SAGMEISTER
· DESIGNER: MATTHIAS ERNSTBERGER
· ILLUSTRATOR: MATTHIAS ERNSTBERGER
· PHOTOGRAPHER: ZANE WHITE
· PRODUCER: PHILIPP HAEMMERLE
· CLIENT: ADOBE SYSTEMS

This student award poster depicts a designer creating an award-winning work out of paper coffee cups— running on pure caffeine as many design students do. Working with a modest budget, we called in many favors of friends such as producer Philipp Haemmerle and architecture firm Loading Dock 5. We needed a studio with 30ft ceilings and scaffolding to get photographer Zane White up high enough to shoot the picture (as it turned out Zane was afraid of heights). We had a wooden floor constructed and then arranged 2,500 filled coffee cups with many helpers.
—Sagmeister

FIG. **7** /**13**

POSTER: *OLIVETTI VALENTINE*

· MILTON GLASER
· CLIENT: OLIVETTI

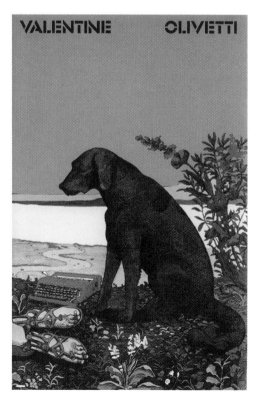

COMPOSITION BASICS

1/ *Grab attention.* A poster can persuade people to see a show, purchase a brand, donate blood, get a mammogram, protest censorship, or buy concert tickets. However, a poster can persuade only if it attracts someone's attention, if it pulls someone in. Second, it has to be interesting enough to keep a person from turning his or her head in another direction. Finally, a poster has to call you to action—persuade you to do something.

2/ *Set it apart.* To attract attention, a poster must be visually interesting as well as different from its surroundings. Just like packaging on a market shelf, a poster needs to be differentiated from others competing with it. Since there are many posters advertising films and theatrical events, why should I choose to look at one rather than another? How you visualize and compose can and should create distinction—a unique look and feel, mood, or emotional level for the subject. Your choice or creation of display type and how you visualize will contribute greatly to distinction.

3/ *Communicate key messages.* Hierarchy plays strongly into how well your composition communicates the key messages. You can use type, visuals, color, or all of them to orchestrate hierarchy. Once a focal point ushers the viewer into the composition, the composition should guide the viewer on. On a single surface, color can guide the viewer as well as establish visual connections among elements.

4/ *Single surface, one unit.* Since a poster is seen from a distance, ensuring all component parts act in concert to form a cohesive entity is paramount.

The advantage of structuring a composition for a poster is in dealing only with a single surface, similar to a painting or drawing, where you don't have to worry about continuity over several pages, as in magazine or brochure design. For a novice, it helps to decide if the composition will be dominated by a visual, by type, or by a visual/verbal amalgamation. In Figure 7-13, promoting the Olivetti Valentine, the composition is dominated by Milton Glaser's famous illustration, which is the focal point. Figure 7-14, *Hypatia Lake,* is type driven; the stars and tape add to the flow of the composition, and the arrow aids our focus.

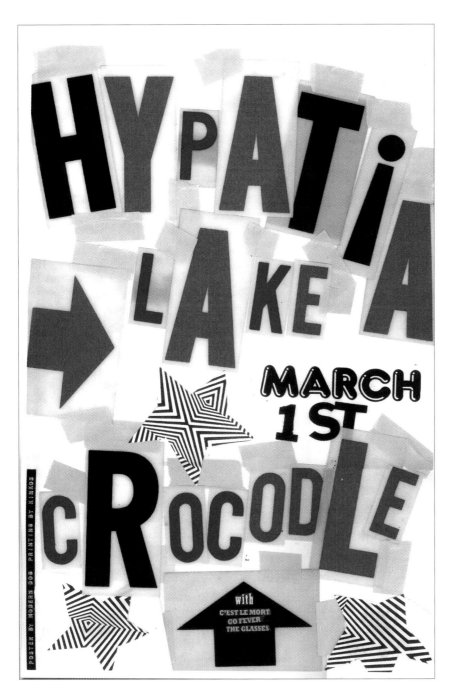

FIG. **7** / **14**

HYPATIA LAKE

· © MODERN DOG DESIGN CO., SEATTLE

In Figure 7-15 by MendeDesign, although the type and visuals possess complementary qualities, their contrast and structural amalgamation work to communicate. In the same fashion as logos that are structured as emblems, where the pictorial element and the name of the entity are inextricably related, pictorial elements and type can be fused in a poster design, as in Figure 7-16,

FIG. **7** / **15**

CALL FOR ENTRIES/DESIGN AWARDS

· MENDEDESIGN, SAN FRANCISCO
· ART DIRECTOR: JEREMY MENDE
· DESIGNERS: JENNIFER BAGHERI, AMADEO DESOUZA, JEREMY MENDE

FIG. **7** / **16**

MODERN DOG IN RALEIGH

· © MODERN DOG DESIGN CO., SEATTLE
· CLIENT: AIGA

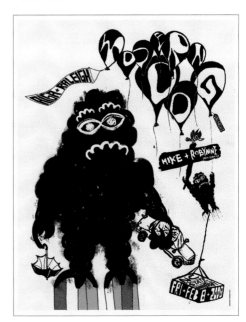

promoting the appearance of Modern Dog in Raleigh. In Figure 7-17, a theater poster for *Macbeth*, designer Cedomir Kostovic comments, "The title's typography is purposely incorporated into the image to support its communicative power."

How you visualize and structure a composition depends on what you want to communicate. In Figure 7-18, George Tscherny divides the format into a modular grid, using eight of the nine subdivisions to promote a new press capable of printing eight colors plus coating in one pass. Using a *trompe l'oeil* effect, the espresso cup in Figure 7-19 pops forward of the picture plane with the playful copy, "Now that espresso has come to Cincinnati . . ." announcing Louise Fili's appearance. *Print This Moment* for Gilbert Paper (Figure 7-20) was designed by Rick Valicenti/3st, who believes in making communication design "full of human presence."

Poster Series

Often, a poster stands alone, as a single unit. Sometimes posters, either one design or a related series, are posted in multiples (Figure 7-21). The entire Mission Mall was wallpapered with these fun and nostalgic posters to create a barricade effect. When designing a series, such as that for the 31st Cleveland International Film Festival

FIG. **7** / **17**

MACBETH

· DESIGNER: CEDOMIR KOSTOVIC

The concept for the poster for the famous Shakespeare drama is based on two strongest symbols that suggest the drama's plot.
—Cedomir Kostovic

FIG. **7** / **18**

8 + 1

· GEORGE TSCHERNY, INC., NEW YORK
· DESIGNER/ILLUSTRATOR: GEORGE TSCHERNY
· CLIENT: SANDY ALEXANDER, INC., CLIFTON, NJ

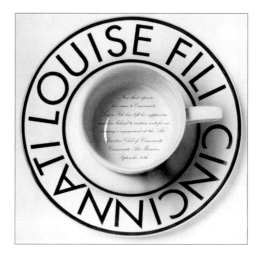

FIG. **7** / **19**

LOUISE FILI, CINCINNATI

· LOUISE FILI LTD., NEW YORK
· ART DIRECTOR/DESIGNER: LOUISE FILI

FIG. 7 / 20

PRINT THIS MOMENT

· THIRST/3ST.COM
· RICK VALICENTI/3ST
· ILLUSTRATORS: RICK VALICENTI/3ST, BILL VALICENTI
· TYPOGRAPHER: RICK VALICENTI/3ST
· CLIENT: GILBERT PAPER

With the introduction of Neutech Paper designed by Gilbert for laser printers, this two-sided poster was inserted into Wired *Magazine.*
—Thirst/3st.com

FIG. 7 / 21

MALL POSTERS

· MULLER BRESSLER BROWN, KANSAS CITY, MO
· CREATIVE DIRECTOR/DESIGNER: JOHN MULLER
· WRITER: DAVID MARKS
· PRODUCTION ART: KENT MULKEY
· CLIENT: MISSION MALL, MISSION, KS

A regional shopping mall was going to open in two weeks. The developer of the mall called me and said, "We have 150,000 square feet of blank storefront barricades and it looks desolate in here!" So, in order to get something produced and installed in two weeks and respond to a limited budget situation, I designed a series of three-color silk-screen posters. We printed 75 each of the posters on cheap billboard paper 40" × 60" and simply wallpapered the entire mall. These posters quickly became collectors' items.
—John Muller

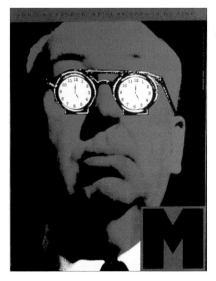

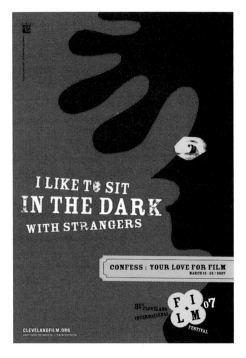
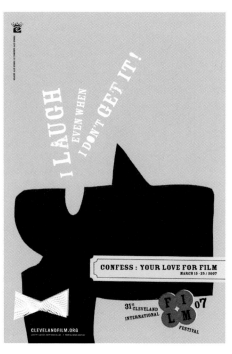
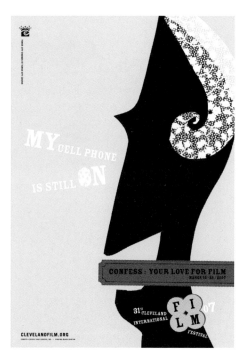

FIG. **7 /22**

POSTER SERIES

- CAMPAIGN CONCEPT + DESIGN: TWIST CREATIVE INC.—WWW.TWIST-CREATIVE .COM
- CREATIVE DIRECTOR/COPYWRITER: MICHAEL OZAN
- ART DIRECTOR: CONNIE OZAN, CHRISTOPHER OLDHAM
- ILLUSTRATOR: CONNIE OZAN
- DESIGNERS: CONNIE OZAN, JESSICA ZADNIK
- CLIENT: CLEVELAND FILM SOCIETY

FIG. **7 /23**

POSTER SERIES: *TOLERANCE*

- CEDOMIR KOSTOVIC
- SILKSCREEN PRINTS
- A. TOLERANCE TOWARD DIVERSITY
- B. TOLERANCE TOWARD PEOPLE WITH DISABILITY
- C. TOLERANCE TOWARD SEXUAL ORIENTATION

The series of three posters is based on a metaphorical visual concept that uses typographical characters and their configurations within a word TOLERANCE to make comments about tolerance in our society.
—Cedomir Kostovic

(Figure 7-22), it is important to establish elements of continuity so that the posters seem to belong to one another, like triplets or cousins. Some designers design a template so that elements are positioned similarly from poster to poster within a series, yet they create enough variety to make each individual poster distinctive. (Also see Chapter 8 about designing a cover series.)

Ideas can be expressed through a series—several posters related by strategy and conceptual thinking—as in Figure 7-23, a series promoting tolerance.

In Figure 7-24, for the Theatre Project, Baltimore's venue for avant-garde theater, David Plunkert of Spur Design established a stylistic theme to connect the series and communicate the experimental nature of the Theatre Project. Each play is represented by a large singular graphic illustration against a solid background, which allows us to focus on the creative illustration.

SOCIAL COMMENTARY

If graphic design and advertising can sell us mouthwash and movie tickets, they can also advance political ideas and social causes. As a mass communication vehicle, the poster can be used to voice dissent, to incite, to propagandize, or to inform. Whether worrisome propaganda or in the service of the public good, a poster can potentially influence many. In the interest of

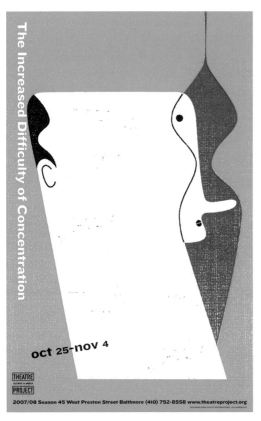

FIG. **7** / **24**

THEATRE PROJECT 07/08
POSTER SERIES: *THE INCREASED
DIFFICULTY OF CONCENTRATION,
THE MISTERO BUFFO, A SUMMER
IN SANCTUARY, BALTIMORE: THE
OPERA*

DESIGNER/ILLUSTRATOR: DAVID PLUNKERT,
 SPUR DESIGN
CLIENT: THEATRE PROJECT

The Mistero Buffo *poster, for
instance, distills the picaresque
play's iconoclastic characters (all
played by a single actor) into a
flat, bowler-hatted bottle careening
precariously across the page. To
"get something a little gritty," I
drew the original and then kicked
out individual separations and
distressed those separations from
my printer, producing an image both
easy to print and iconic. I try to get
a feeling of spontaneity that will
strike the viewer on an emotional
level if not an intellectual level.*
 —From an interview with David
Plunkert by Taylor Lowe (http://
www.stepinsidedesign.com/STEP/
Article/28854/0/page/9)

FIG. **7**/**25**

STOWAGE OF THE BRITISH SLAVE SHIP "BROOKES" UNDER THE REGULATED SLAVE TRADE ACT OF 1788.

· LIBRARY OF CONGRESS PRINTS AND PHOTOGRAPHS DIVISION WASHINGTON, D.C. [LC-USZ62-44000]

This print seemed to make an instantaneous impression of horror upon all who saw it.
—Thomas Clarkson

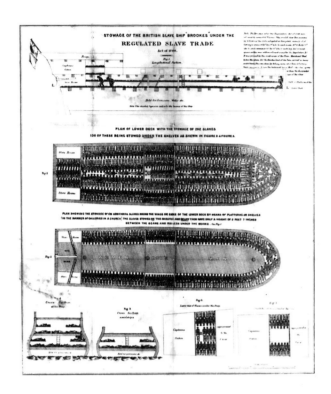

FIG. **7**/**26**

HELP SOLVE GLOBAL WARMING

· DESIGNER/PHOTOGRAPHER: FANG CHEN

We all have been taking all kinds of resources from the earth. As the globe becomes warmer and warmer, we need to protect it with our full hearts. The watermelon is the metaphor for cooling off the globe.
—Fang Chen

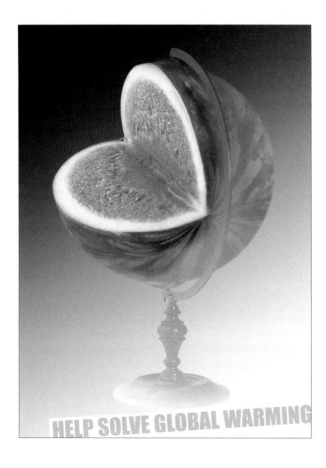

society, with each designer comes the potential for uniquely effecting change. *In a single visual, a poster can carry a message to those who see it, perhaps to people who wouldn't read extensively about a subject or listen to long political debates.*

Figure 7-25 is one of the first widely distributed "protest posters," a diagram produced by Thomas Clarkson, British abolitionist, and the Committee for the Abolition of the Slave Trade, published in 1789. About this poster, the *Independent's* art critic Tom Lubbock, writes: "The power of art has received many tributes, often from those within the profession. But if you're interested in images that have real power in the world, they're probably not going to be bona fide works of art. They're going to be cartoons, posters, documentary photos, emblems, logos, maps, and plans. Perhaps the most politically influential picture ever made is not a painting but a diagram; and it was devised not by an artist but by a campaign group. Its full title is *Stowage of the British Slave Ship 'Brookes' under the Regulated Slave Trade Act of 1788.*"[3]

In the tradition of using the poster to give voice to ideas that matter, contemporary designers create for a myriad of causes, voicing dissent or hope, protesting or urging. In Figure 7-26, Fang Chen pleads for a stop to global warming using a metaphor. Chen says, "I have always believed that a good designer should be able to express complicated and profound meanings in a simple way and a good poster should make people think." Using the violin as a metaphor in Figure 7-27, Cedomir Kostovic dismantles it, rendering it useless, to represent the division of Bosnia into three sections along ethnic lines. Dan Reisinger, born in Yugoslavia in 1934, spent the German occupation hidden by a Serbian family. In Figure 7-28, he warns against the rise of neo-fascism/neo-Nazism in the former Soviet Republic. Steff Geissbuhler comments on the meaning of the poster in Figure 7-29, "The friendship of Godzilla and King Kong makes them mightier than any other single beast. Friendship does not mean that one has to eliminate the other. It means coexistence with mutual respect and understanding. Nobody has to be the winner—nobody has to lose."

FIG. **7** / **27**

BOSNIA (DIVIDED)

· CEDOMIR KOSTOVIC
· SILKSCREEN PRINT

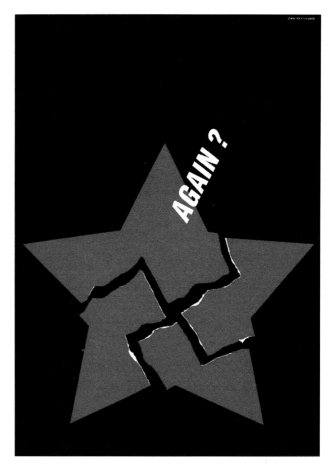

FIG. **7** / **28**

AGAIN?

· DAN REISINGER®

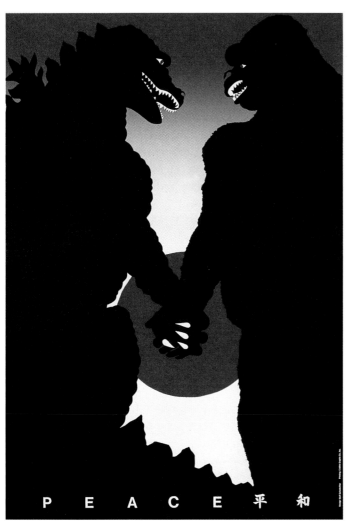

FIG. **7** / **29**

PEACE—GODZILLA AND KING KONG · COMMEMORATION OF THE 40TH ANNIVERSARY OF HIROSHIMA

· CHERMAYEFF & GEISMAR INC., NEW YORK
· DESIGNER AND ILLUSTRATOR: STEFF GEISSBUHLER

Godzilla is a modern folk hero and a symbol of Japanese superpower, called upon in times of crisis and invasion by other superpowers such as King Kong. Apparently, Godzilla emerged from the volcanic emptiness after a nuclear blast. Therefore, it is even more of a symbol relating to peace. King Kong was used as the American counterpart to Godzilla.

The centered red sun on a white background is another symbol of Japan (Japanese flag, etc.). The color palette of red, black, and white is classic, and typical in Japanese calligraphy, painting, and woodcuts. The red-to-white gradation in the background relates directly to contemporary airbrush techniques frequently used in Japanese design.

—Steff Geissbuhler, Chermayeff & Geismar Inc.

ESSAY

IMAGE-MAKING FOR POSTER DESIGN/JOE SCORSONE
AND ALICE DRUEDING

By Joe Scorsone, Professor, Graphic and Interactive Design, Tyler School of Art, Temple University and Alice Drueding, Professor and Area Head, Graphic and Interactive Design

OVER 1,000,000 SOLD

· THE QUANTO PROJECT
· DESIGNERS: JOE SCORSONE, ALICE DRUEDING

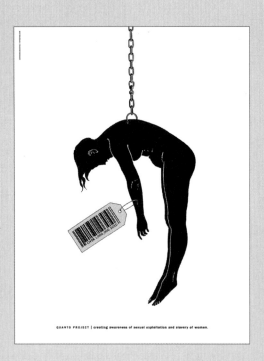

QUANTO PROJECT | creating awareness of sexual exploitation and slavery of women.

Designers communicate information and ideas to an audience. Successful images for design engage the viewer in a process of learning something not previously known or understanding a known subject in an entirely new way. The most interesting design happens in part on the printed page; the rest happens in the mind of the viewer.

To communicate effectively, a designer begins by developing a concept that will drive the image-making process. The design concept is a communication strategy that keeps the designer focused while exploring visual options. Through research and various associative techniques, such as mind-mapping, concepts achieve traction when the potential for seemingly unrelated elements to work together is identified. Visual economy is key.

A single image that captures multiple aspects of the concept, balancing simplicity and complexity in the mind of the viewer, is an experience that is unlikely to be dismissed or quickly forgotten.

The visual alchemy of transforming the familiar into imagery with an unpredictable message is the goal of poster design at Scorsone/Drueding. We aim to tap into what is known and understood by the audience and then turn it on its head. The stylistic approach for each poster is determined by what we believe will be the most effective way of visualizing a particular idea. Visual style has a powerful influence on the way images are read. Style should always support the concept.

Style is the "poetry" of visual language. The way something is said—either visually or verbally—makes it unique and enhances its meaning. Designers take their stylistic cues from the subject to maximize the expressive power of their concept. From simple vector drawings to complex, layered collages, stylistic choices bring concepts to life.

This poster [*Over 1,000,000, Sold*] is about human slavery, which is ongoing and shockingly pervasive around the world. Sexual slavery of women and children is one of the most prevalent forms of the practice. In this case, we were faced with another intangible. Slavery is not something you can see. Most people readily understand chains as a representation of slavery or imprisonment. We used the chain to represent one aspect of our subject. The other aspect of the subject is slavery as "commerce." Buying and selling human beings is making many people very wealthy. The woman, representing all victims of slavery, hangs by a chain as though she were literally a piece of meat for sale in the marketplace. Her arm is brutally pierced with a price tag. She hangs there in

a gesture of abject hopelessness. Nothing about the image is literal—this is not what slavery actually looks like. Again, we are able to capture the intangible through metaphor.

We use metaphor to express ideas that are intangible. Emotions are experienced internally. Their full implication is difficult to communicate without tapping into the power of metaphors and symbols. Common verbal metaphors often lead to interesting visual solutions. Being "consumed" by an emotion—jealousy, rage, or in this case, fear—is a readily understood figure of speech. In this poster [*Fear*], the brain is literally consumed by a relentless swarm of insects. But the viewer understands that it is really the mind—the center of human understanding, identity, and action—that is the figurative target. The insects represent the relentless cultural agents of fear (government, media, etc.) that bombard our conscious and unconscious selves daily. Visualization of the head itself, raw and exposed, enhances the horror of the image.

In this poster [*Alternatives to War*], soldiers are identified by an iconic image that was found in an old military manual. With their identical uniforms and rigid posture, these soldiers represent an abstract paradigm of the modern warrior, precise and impersonal cogs in the wheel of the military machine. What is unexpected here is their essential and even poignant humanity as they participate in familiar and wholesome peacetime activities. The faceless representatives of a national armed force are transformed into individuals engaged in living lives that resemble our own. They are clearly and disconcertingly one of us. The contraction within the imagery turns this poster into a complex question about the implications of sending soldiers—ourselves—to war.

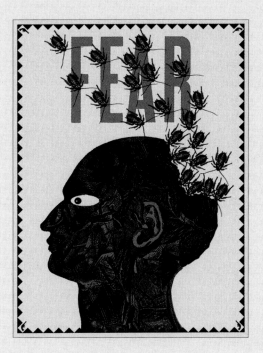

FEAR

· DESIGNERS: JOE SCORSONE, ALICE DRUEDING

ALTERNATIVES TO WAR

· DESIGNERS: JOE SCORSONE, ALICE DRUEDING

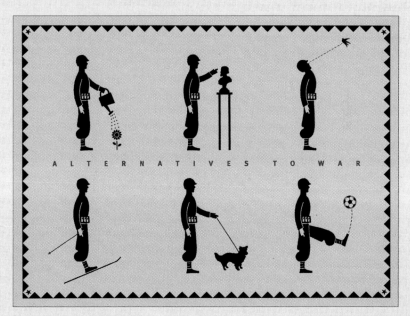

FIG. **7**/**30**

NEVER UNDERESTIMATE THE POWER OF NATURE

- 21XDESIGN, BROOMALL, PA
- DESIGNERS/ILLUSTRATORS: DERMOT MAC CORMACK, PATRICIA MCELROY
- PHOTOGRAPHER: PATRICIA MCELROY
- PRINTER: CRW PRINTING

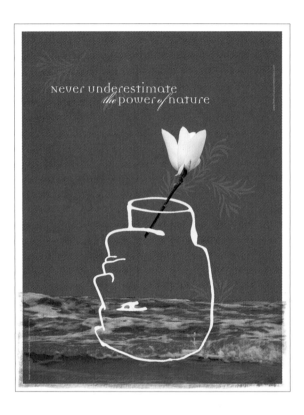

In recent times, designers have come together for causes through various organizing bodies. The Hurricane Poster Project is a collaborative effort by members of the design community to raise money for the victims of Hurricane Katrina. Examples of these posters are Figure 7-30 by Patricia McElroy and Dermot Mac Cormack and Figure 7-31 by Lanny Sommese.

For The Quanto Project, a protest against human slavery, Lanny Sommese (Figure 7-32), Alice Drueding, and Joe Scorsone (see "Essay: Image-Making for Poster Design") raise their voices in outrage.

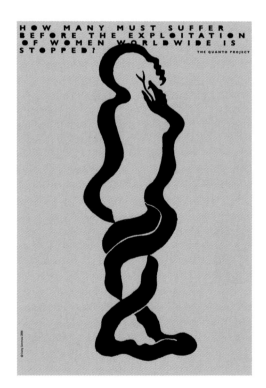

FIG. **7**/**31**

H-E-L-P

- SOMMESE DESIGN, PORT MATILDA, PA
- DESIGNER: LANNY SOMMESE
- POSTER FOR THE HURRICANE POSTER PROJECT

Designers/artists were invited to do a poster in relation to the Katrina devastation. An edition of each poster was sold to raise money to HELP the victims of hurricane Katrina in New Orleans. The image depicts (humans, animals and vegetation) trapped tenuously together—each vulnerable to the dangers that surround them.
—Lanny Sommese

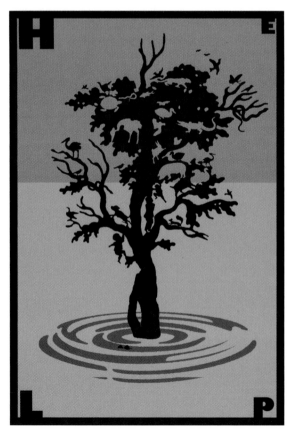

FIG. **7**/**32**

HOW MANY MUST SUFFER BEFORE . . . STOPPED?

- SOMMESE DESIGN, PORT MATILDA, PA
- DESIGNER: LANNY SOMMESE
- DESIGNED FOR THE QUANTO PROJECT

A thematic poster competition soliciting designs that focus on the increasing problem of exploitation of women worldwide. The image depicts a female trapped in the coils of a huge snake, which is intended to metaphorically represent the woman's exploitation by the human slave traders.
—Lanny Sommese

EXERCISE 7-1

A graphic design solution can be a catalyst for change. If you had a chance to raise your voice in protest through a poster, what would you protest? War? Child abuse? Pollution? What would you promote? Freedom? Clean water? To whom would you appeal?

Select one cause that you deem important.

❶ At the top of a page, write the name of the cause.

❷ Sketch or write as many objects as you can think of having similarities to your subject. If you're having difficulty, use attribute listing (see Chapter 4) to help you or treat this as a kind of a Rorschach inkblot test, where you simply sketch the first thing that comes to mind when asking yourself, "What might this remind me of or be similar to?"

❸ Sketch visual metaphors, at least two, for your cause.

PROJECT 7-1

POSTER DESIGN FOR A SOCIAL OR POLITICAL CAUSE

Step 1

a. Select a social or political cause. Gather information about it.

b. Find related visuals to use as references.

c. Write a design brief. Define the purpose and function of the poster, the audience, and the information to be communicated.

d. Generate a few design concepts. Concentrate your conceptual thinking on finding a way to prompt people to think about the cause. Select and refine one concept.

Step 2

a. Determine whether the poster should be visually driven or type driven.

b. Your poster should be able to grab the attention of people walking by.

c. The poster should include the social cause's web address and phone number so that people can take action.

d. Determine at least three different ways your concept could be visualized.

e. Produce at least twenty sketches.

Step 3

a. Produce at least two roughs before going to the comp.

b. Be sure to establish visual hierarchy.

c. The poster can be in either a vertical or a horizontal format.
Optional: Design a companion web banner.

Step 4

a. Refine the roughs. Create one comp.

b. The size, shape, and proportion should be dictated by your strategy, design concept, and where the poster will be seen (environment).

c. Use two colors.

Go to our website **GD/s** for *many* more Exercises and Projects, and presentation guidelines, as well as other study resources including the chapter summary.

NOTES

1. Digital Scriptorium website, http://scriptorium.lib.duke.edu/eaa/broadsides.html.

2. J. Stewart Johnson, *The Modern American Poster.* Kyoto: The National Museum of Modern Art and New York: The Museum of Modern Art, 1983, p. 8.

3. Tom Lubbock. "Clarkson, Thomas et al: The British Slave Ship 'Brookes' (1789)," *The Independent.* Friday, March 23, 2007. http://www.independent.co.uk/arts-entertainment/art-and-architecture/great-works/clarkson-thomas-et-al-the-british-slave-ship-brookes-1789-744401.html

BIBLIOGRAPHY

http://www.stepinsidedesign.com/STEP/Article/28854/0/page/9

http://soex.org/Exhibit/38.html

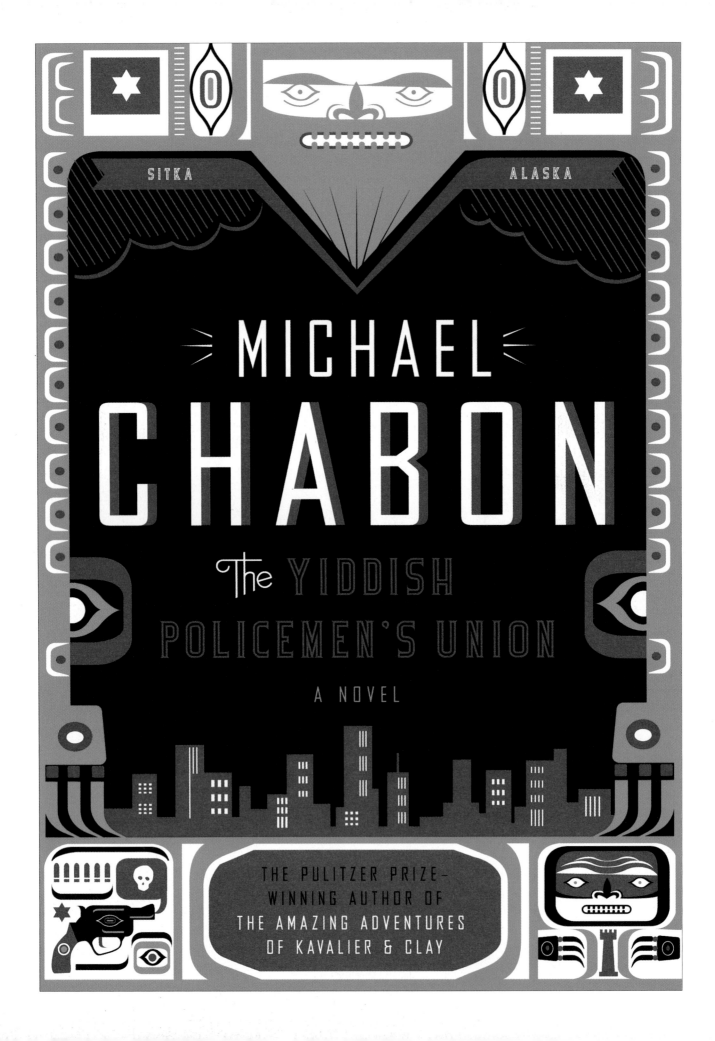

SITKA ALASKA

MICHAEL CHABON

The YIDDISH POLICEMEN'S UNION

A NOVEL

THE PULITZER PRIZE–
WINNING AUTHOR OF
THE AMAZING ADVENTURES
OF KAVALIER & CLAY

08/

<<< / *facing page*

BOOK COVER: *THE YIDDISH POLICEMEN'S UNION* BY MICHAEL CHABON

· ART DIRECTOR: ROBERTO DE VICQ DE CUMPTICH
· DESIGNER/ILLUSTRATOR: WILL STAEHLE
· CLIENT: HARPER COLLINS PUBLISHERS

PUBLICATIONS ARE MULTIPAGE FORMATS WITH A SUBSTANTIAL VOLUME OF ORGANIZED AND SEQUENCED CONTENT, INCLUDING MASS MEDIA PUBLICATIONS WITH EDITORIAL CONTENT, SUCH AS NEWSPAPERS, MAGAZINES, AND BOOKS (REFERENCE, CHILDREN'S, LITERATURE AND NONFICTION, TEXTBOOKS, LIMITED-EDITION AND FINE-PRESS, AND IMAGE-DRIVEN BOOKS). PUBLICATION DESIGN ALSO INCLUDES OTHER APPLICATIONS WITH MORE THAN TWELVE PAGES, SUCH AS BROCHURES, ANNUAL REPORTS, NEWSLETTERS, AND CATALOGS (WHICH WILL BE DISCUSSED IN CHAPTER 12). THIS CHAPTER WILL FOCUS ON THE COVERS AND INTERIOR DESIGN OF MASS MEDIA EDITORIAL PUBLICATIONS.

OBJECTIVES

Define publication design

Understand the purpose of cover design

Become acquainted with the process of designing a cover

Realize the design needs for a series of publications

Pick up the basics of how to structure the interior of a publication

FIG. 8 /01

HOW WE ARE HUNGRY BY DAVE EGGERS

· ART DIRECTOR/DESIGNER: JOHN GALL
· ILLUSTRATOR: DANIEL CHANG
· CLIENT: VINTAGE/ANCHOR BOOKS

Modules are used to organize and to contain the title, author's name, and other information.

THE PURPOSE OF COVER DESIGN

Have you ever lingered at a newsstand to look more closely because a magazine cover caught your eye? Or, when walking by a bookstore window display, has a book cover stopped you in your tracks? That's part of the purpose of a cover.

Although not every book or magazine is aimed at the same audience, in a bookstore or newsstand environment, covers are in competition, all vying for attention. At once, a cover must grab a reader's attention and, in visual shorthand, communicate the book's substance. Whether a reader views a reduced version of it online or in a catalog or sees it in its actual size displayed in a bookstore, a cover must generate intrigue and make you want to pick it up.

The design of a cover or book jacket may influence your decision to purchase a book or magazine. At the very least, it gives a clue as to what is between the covers. Book covers have a hybrid purpose—they are both promotional and editorial. Attracting someone, a cover promotes the book or magazine. Covers are also editorial, needing to communicate the publication's content. For example, for Dave Eggers's short story collection, *How We Are Hungry* (Figure 8-01), where animals (cows, an anteater, and even a talking dog) appear in almost every story, the cover conveys a sense of the creatures to come.

THE PROCESS OF DESIGNING A COVER

As with any design project, the standard process is illustrated in the following diagram:

Orientation ▶ Analysis ▶ Concepts ▶ Design ▶ Implementation

Once you have generated a design concept, visualization and composition are next. For cover design, there are required components. For a book, title (and subtitle), edition, author(s), and possibly the publisher's imprint logo and other special elements (award,

endorsement, among others) are usually required. For a magazine, the title, date, and price are part of every edition.

A cover should give the reader a sense of what the book or magazine is about. You can think of a book cover as a film trailer or preview, both informing and creating suspense or curiosity, as in *The New York Times Magazine, The Annual Design Issue* cover in Figure 8-02. A book jacket or magazine cover must communicate its message quickly and clearly, and arouse interest. How much of the book do you reveal in the cover design? Which visual would capture the book's essence? Subject? Plot? Main character?

The cover is a reader's first experience with a book. After the initial reaction to a cover in a bookstore, online, or at a newsstand, once the reader starts reading, a new relationship develops. Often a reader will turn to and contemplate the cover. Though a magazine cover is more ephemeral than a book's, it is still part of the entire reading experience. In a fashion similar to our experiences with CD covers, a reader develops a relationship with a book or magazine cover and returns to it again and again.

INTEGRATION OF TYPE AND IMAGE

Like any other graphic design application, a book jacket or magazine cover most often combines type and image. Sympathetic or contrasting elements comprising cover and spine—typeface versus image, pattern versus solid, computer-generated type versus hand-scrawled illustrations—all should support the thesis of the book or magazine's main article or theme.

Type and image should work cooperatively to communicate the subject and design concept, working in a supporting, sympathetic, or contrasting relationship (see Chapter 5, Visualization). There are four basic routes.

› *All-Type.* When budgets won't cover the cost of hiring an illustrator or photographer, or if the designer believes type is the best way to communicate the design concept, an all-type treatment should be considered. In Figure 8-03, a book where Mark J. Cherry makes a case for a means

FIG. **8** / **02**

MAGAZINE COVER: *THE NEW YORK TIMES MAGAZINE, THE ANNUAL DESIGN ISSUE,* NOVEMBER 30, 2003

· CREATIVE DIRECTOR: JANET FROELICH, THE NEW YORK TIMES MAGAZINES
· ART DIRECTOR/DESIGNER: JANET FROELICH
· PHOTOGRAPHER: MIKAKO KOYAMA

FIG. **8** / **03**

BOOK COVER: *KIDNEY FOR SALE BY OWNER: HUMAN ORGANS, TRANSPLANTATION, AND THE MARKET* BY MARK J. CHERRY

· SALAMANDER HILL DESIGN, QUEBEC, CANADA
· DESIGNER: DAVID DRUMMOND

The title for this book drove the solution. It really couldn't have been anything else.
—David Drummond

FIG. **8** / **04**

FUTURO PASSATO SERIES

· MUCCA DESIGN CORPORATION, NEW YORK
· ART DIRECTOR: MATTEO BOLOGNA
· DESIGNER: MICHAEL FIORE
· CLIENT: BUR

BUR is a division of Italian publishing giant RCS that specializes in re-editing literary classics. Mucca rebranded the BUR imprint.

is the predominant visual element, the viewer is expected to be attracted to the title's meaning or the author's reputation. When shopping for a William Trevor novel or short story collection, many people scan bookstore shelves for his name. In Figure 8-05, Paul Buckley creates a clear visual hierarchy with the author's name as the driving element. Two of Buckley's other solutions for this cover are also shown. Focusing on a provocative title, *Hand Job: A Catalog of Type*, naturally, the typography has been hand-drawn by Michael Perry, the author/designer (Figure 8-06). Although the background image works to explain the title as an astronomical reference, *Norton's Star Atlas*, this cover is also type-driven (see Figure 6-37).

› *Image-Driven.* There is no doubt that most viewers are attracted to interesting images. When a publication's cover is image-driven, it means that the image is the predominant visual element on the cover—the one doing the most work to attract the viewer. If you have any doubt about a visual's potential power to capture and move us, look at this cover published shortly after the terrorist attack on the World Trade Center on

to distribute body parts, the cover mimics a classified advertisement. For an Italian imprint, BUR, in the Futuro Passato series, the title of the book is the largest type element, which becomes the focal point (Figure 8-04). Then we see the name of the author, and then the book's contents. Color is used for differentiation.

› *Type-Driven.* When the title of the book (title-driven) or the author's name (name-driven)

FIG. **8** / **05**

SKETCHES AND FINAL BOOK COVER: *CHEATING AT CANASTA: STORIES* BY WILLIAM TREVOR

· DESIGN: PAUL BUCKLEY
· PHOTOGRAPHER: J. JOHN PRIOLA
· CLIENT: PENGUIN GROUP

FIG. **8** /**06**

HAND JOB: A CATALOG OF TYPE BY MICHAEL PERRY

· MIKE PERRY

Hand Job collects work from an international array of contemporary typographers who draw by hand. Graphic designer and hand typographer Michael Perry selected the works to represent various styles and methods. In his review, Mark Woodhouse, *Library Journal*, wrote: "Hand-drawn letterforms exhibit the kind of unique and sometimes accidental quality that sets them apart from the more precise, computer-generated graphics with which we're more familiar today."

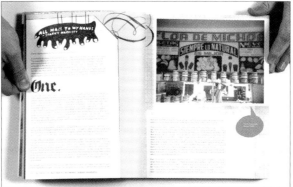

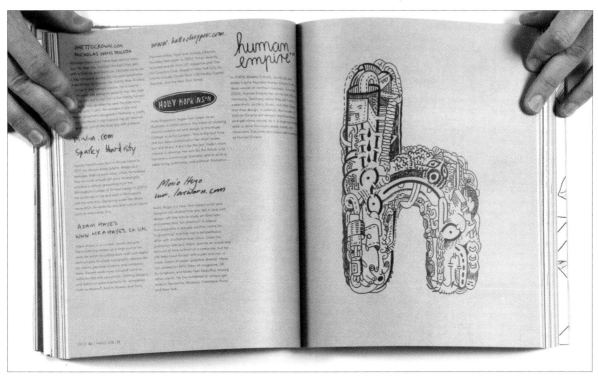

CASE STUDY

The Yiddish Policemen's Union by Michael Chabon, a classic noir with a comic twist, is an historical "What if. . ." set in an alternate reality in Sitka, Alaska. The symmetry of the composition and characteristics of the forms are references to native art from Alaska. The imagery sets the stage for murder and a fascinating world of good cops facing a hard-boiled underworld.

BOOK COVER (CENTER IMAGE) AND PROCESS (PRELIMINARY CONCEPTS): *THE YIDDISH POLICEMEN'S UNION* BY MICHAEL CHABON

· ART DIRECTOR: ROBERTO DE VICQ DE CUMPTICH
· DESIGNER/ILLUSTRATOR: WILL STAEHLE
· CLIENT: HARPER COLLINS PUBLISHERS

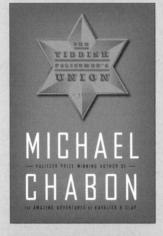
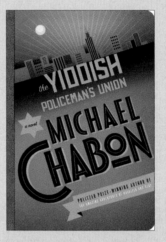
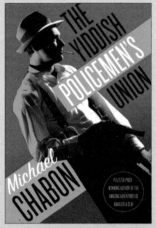
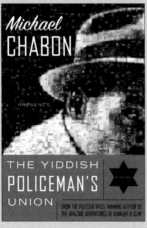
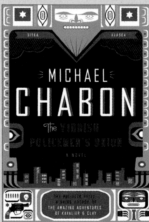
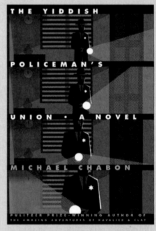
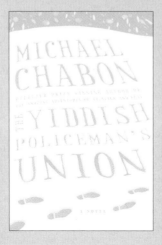
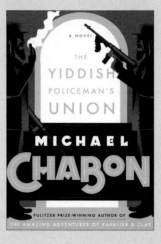
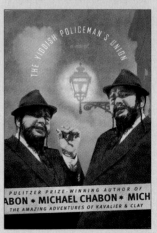

FIG. **8** /**07**

MAGAZINE COVER: REMAINS OF THE DAY, *THE NEW YORK TIMES MAGAZINE,* **SEPTEMBER 23, 2001**

· CREATIVE DIRECTOR: JANET FROELICH, THE NEW YORK TIMES MAGAZINES

· ARTISTS: PAUL MYODA, JULIAN LAVERDIERE

· PHOTOGRAPHER: FRED R. CONRAD

· ART DIRECTOR/DESIGNER: JANET FROELICH

FIG. **8** /**08**

BOOK COVER: *THE RENT COLLECTOR* **BY B. GLEN ROTCHIN**

· SALAMANDER HILL DESIGN, QUEBEC, CANADA

· DESIGNER: DAVID DRUMMOND

This is actually my wallet, which I have had for years. It was sitting beside my computer when I was working on the concept for this cover and I couldn't resist.
—David Drummond

FIG. **8** /**09**

MAGAZINE COVER: NAUGHTY AND NICE, *THE NEW YORK TIMES STYLE MAGAZINE,* **HOLIDAY 2006 (PENELOPE CRUZ)**

· CREATIVE DIRECTOR: JANET FROELICH, THE NEW YORK TIMES MAGAZINES

· ART DIRECTORS: JANET FROELICH, DAVID SEBBAH

· DESIGNER: JANET FROELICH

· PHOTOGRAPHER: RAYMOND MEIER

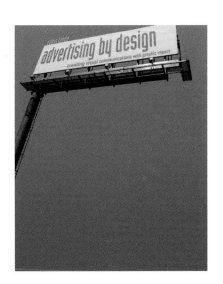

FIG. **8** /**10**

BOOK COVER: *ADVERTISING BY DESIGN™* **BY ROBIN LANDA**

· CREATIVE DIRECTOR: ROBIN LANDA

· DESIGNER: ADAM C. ROGERS

· PHOTOGRAPHY: GETTY IMAGES

· PUBLISHER: JOHN WILEY & SONS, INC.

Here Adam Rogers uses a stock photograph and color to full advantage. The massive amount of blue background space works to bring our focus to the outdoor board.

9/11 (Figure 8-07). For B. Glen Rotchin's *The Rent Collector,* the *trompe l'oeil* visualization of the wallet drives the composition, symbolizing the novel's main character's belief that we have debts to pay, both temporal and spiritual (Figure 8-08).

Since people tend to be more attracted to visuals, especially of other people, most popular magazine covers are image-driven, as in this cover for *The New York Times Style Magazine* (Figure 8-09). (Also see Figure 8-23, *Time* magazine cover.)

› *Visual-Verbal Synergy.* Every respected designer knows type and image should work cooperatively, but many beginners create interesting visuals only to "slap" type on a cover as if they were simply typing text to accompany the valued visual. The goal, always, is visual and type working synergistically, as in the cover for *Advertising by Design™,* where the type is a natural part of the visual (Figure 8-10). Mirko Ilić's cover for *The Anatomy of Design* integrates type and image to

FIG. **8** / **11**

BOOK COVER AND INTERIOR PAGES: *THE ANATOMY OF DESIGN: UNCOVERING THE INFLUENCES AND INSPIRATIONS IN MODERN GRAPHIC DESIGN* **BY STEVEN HELLER AND MIRKO ILIĆ**

The concept of the dramatic *trompe l'oeil* design is based on the book's goal—to reveal the underlying influences of design. Peel away the outer skin and the skeleton supports distinct, individual parts that function with others.

FIG. **8** / **12**

BOOK COVER: *DR. DELICIOUS: MEMOIRS IN A LIFE IN CANLIT* **BY ROBERT LECKER**

· SALAMANDER HILL DESIGN, QUEBEC, CANADA
· DESIGNER: DAVID DRUMMOND

With a title like this and the fact that the book deals with the author's lifelong love of Canadian literature, this seemed like the way to go with this one.
— David Drummond

FIG. **8** / **13**

BOOK COVER: *DEAD MAN'S FLOAT* **BY NICHOLAS MAES**

· SALAMANDER HILL DESIGN, QUEBEC, CANADA
· DESIGNER: DAVID DRUMMOND

The main character has suffered a stroke and is relegated to a hospital bed where he floats in a pool of his tragic memories. I put a silhouette of a floating person over the text of the first page of the novel.
— David Drummond

The angle of "a novel" leads to the author's name, which leads to the title and then to the image.

reveal, to visually explain the notion of "uncovering the influences and inspirations in modern graphic design" (Figure 8-11).

At times, type and image are so fully integrated, they become emblematic, as in Figure 8-12 for *Dr. Delicious*. With text type as water for *Dead Man's Float*, we immediately get a haunting feeling from the cover in Figure 8-13. Choosing a classic typeface for this cover allows the visualization and composition to reign. During visualization, it

is crucial to make decisions based on the design concept, on any component's appropriateness to the subject matter.

There are many creative approaches to visualization, as discussed in Chapter 5. Some designers begin by sketching; others start with collage; some experiment with a variety of visualizing techniques. Here are two stages in Paul Buckley's process of designing the cover for *The 351 Books of Irma Arcuri* (Figure 8-14) and Steven Brower's

FIG. **8** / **14**

SKETCHES AND FINAL BOOK COVER: *THE 351 BOOKS OF IRMA ARCURI* BY DAVID BAJO

· ART DIRECTOR/DESIGNER: PAUL BUCKLEY

· PHOTOGRAPHER: FREDRIK BRODEN

· CLIENT: PENGUIN GROUP

FIG. **8** / **15**

**MAGAZINE COVER AND SKETCH:
PRINT'S REGIONAL DESIGN
ANNUAL 2002**

· ART DIRECTOR/DESIGNER: STEVEN
 BROWER
· PHOTOGRAPHER: RICHARD FAHEY

A film noir effect lends suspense
about which design solutions
were chosen to be in this regional
design annual. Also shown is
Brower's original sketch for the
cover design.

sketch for a *Print* cover (Figure 8-15). There are
many options for creative visualization; for exam-
ple, once Brower formulated a concept for the
Print magazine cover, he spent a Sunday after-
noon chasing down knickknacks for the cover of
Print's European Design Annual (Figure 8-16).

Cover Design Checklist
› Attract and intrigue readers
› Express the essence of the editorial content
› Consider proportions of trim size when
composing

› Design the spine for graphic impact and
readability
› Treat back cover and spine as part of the
"whole" design
› Consider the relationship to the cover when
designing the interior pages

Often, people think of a book jacket as just
the front cover. The entire cover—including the
spine, which is a key player in a bookstore envi-
ronment—must be considered as a whole. Both
the front and back can be treated as a continuous
piece. Whether on a bookstore or library shelf,
it is the spine of the book that works to grab the
reader's attention (Figure 8-17).

DESIGNING FOR A SERIES

When designing for a series, corresponding visual
elements and positions will help people recognize
and identify the books as belonging together.
Among the covers or jackets, there should be
similarities; for example, method of visualization,
composition/template/placement of the elements,
type treatments, color, or use of visuals.

John Gall approaches cover design as a fine
artist manipulating collage elements, as in this
series for Gabriel García Márquez's novels (Fig-
ure 8-18). Steven Brower interviewed Gall for

FIG. **8** / **16**

**MAGAZINE COVER: *PRINT*'S
EUROPEAN DESIGN ANNUAL 2000**

· ART DIRECTOR/DESIGNER: STEVEN
 BROWER
· PHOTOGRAPHER: MELISSA HAYDEN
· HAND-LETTERING: SCOTT MENCHIN

FIG. **8** / **17**

COVER AND INTERIOR SPREADS: *BIRDS OF THE WORLD* **BY LES BELETSKY**

· DESIGNER: CHARLIE NIX

FIG. **8** / **18**

BOOK COVERS: GABRIEL GARCÍA MÁRQUEZ SERIES

· ART DIRECTOR/DESIGNER: JOHN GALL
· CLIENT: VINTAGE/ANCHOR BOOKS

Step Inside Design magazine and asked, "How did you learn to manipulate the 2D surface in such fascinating ways?" Gall replied, "I've always been kind of interested in flat 2D space vs. representational 3D space and how to create space using 2D elements as well as negating or poking holes in space within a 3D context. When designing a cover we're basically reworking the same 5 × 8 or 6 × 9 space over and over, so I'm always trying to arrange elements into interesting juxtapositions and trying to find some breathing room. It's very easy to clutter up the page."

When Helen Yentus redesigned the complete works of Albert Camus, she chose to interpret Camus' existential angst in black and white optical interplay (Figure 8-19). Interviewed by Lindsay Ballant in *Print* magazine, Yentus commented about redesigning a series of master works: "They have a voice in their own time period, their own culture," she says. "You have to find a way to give them a contemporary voice in our culture while respecting the past."

When designing a new edition for a popular, existing book, several factors must be kept in mind:

› Target the audience

› Design a cover that represents the content as an enthusiastic and intelligent approach to the book's topic

› Retain some visual equity from the previous cover (contingent on publisher's marketing objective)

› Make clear to current readers that this edition has new subject content and illustrations through an updated cover look

› Differentiate the cover from the current competition

› Make the author's name easy to see and read

For a series, often a designer will create a **template**[1]—a compositional structure with designated positions for the visual elements. The author's name, book title, and visuals are usually placed in the same position on each jacket or cover, or with only slight variations in position. A template unites each individual cover within a series so that the viewer can easily identify each cover or relate it to another in the series. Each cover is a "fraternal twin" to the next, with enough variation to distinguish the individual titles within the series. Some templates include very little variation. Others allow for greater variation, creating the look of "cousins" among the covers; there is some family resemblance, but they are not as close as fraternal twins.

DESIGNING THE INTERIORS OF EDITORIAL PUBLICATIONS

Whether online or in print, a publication design starts with orientation, analysis, and conceptual development, and involves the same design basics as any other graphic design application—organizing content, visualization, composition, integrating visuals with type, creating visual interest and clarity of communication. What separates publication design is the task of *organizing an enormous amount of content, creating a structure that organizes, unifies, and integrates across many pages*. Some editorial publications, such as newspapers and magazines, are periodicals or series-based, with a number of editions. Therefore, a structure is created for more than one issue and needs to work and be consistent across editions.

STRUCTURING A PUBLICATION

I asked Steven Brower, a designer with extensive publication design experience, what would be the five things he would stress if he were teaching a speed course in publication design. Brower replied with this surprising response, surprising because he placed "concept" last:

1/ Clarity of communication

2/ Legibility

3/ Use of type/imagery

4/ Audience

5/ Concept

What this reveals is not that Brower doesn't believe in the importance of a design concept; from experience he knows that editorial design

FIG. **8** / **19**

BOOK COVERS: CAMUS SERIES: *EXILE AND THE KINGDOM, THE FALL, THE MYTH OF SISYPHUS, THE STRANGER,* AND *THE PLAGUE*

· ART DIRECTOR: JOHN GALL
· DESIGNER: HELEN YENTUS
· CLIENT: VINTAGE/ANCHOR BOOKS

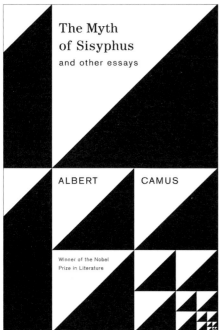

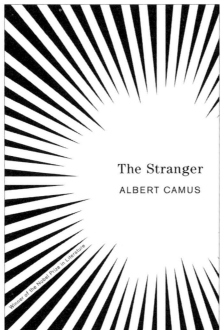

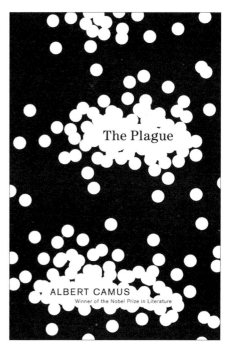

is about clear communication, making content accessible and readable. So, we still say start with content in order to first understand what needs to be communicated:

> *Identify the kinds of content.* The general nature of the content and knowing whether it is heavily illustrated or text-based and lightly illustrated will help you structure an appropriate grid. In Figure

CASE STUDY

RIZZOLI/MUCCA DESIGN CORPORATION

European publishing giant RCS manages a large portfolio of global publishing brands, which includes Rizzoli and BUR. RCS contracted Mucca to create innovative book covers for several of its imprints.

For Mucca the job required addressing a vast, twofold challenge that included extensive brand strategy, project planning, and the development of unique design solutions: first, to refine and improve the market position of the premier Rizzoli brand, and second, to reinvent and revitalize the lagging BUR brand. Beginning with the logos and uniform style guides for each imprint, Mucca implemented the new brand and art directed well over 800 books within the first year. [The result was] a marked improvement in overall sales. To further capitalize on its newfound momentum, BUR seized the opportunity to utilize Mucca's branding and art direction to introduce several new and highly successful book collections and print series.

MUCCA DESIGN CORPORATION, NY

· CLIENT: RIZZOLI

FIG. **8**/**20**

BOOK COVER AND INTERIOR PAGES: *SEVENTY-NINE SHORT ESSAYS ON DESIGN* **BY MICHAEL BIERUT**

· DESIGN: ABBOTT MILLER/PENTAGRAM
· PHOTOGRAPHER: JAMES SHANKS
· CLIENT: PRINCETON ARCHITECTURAL PRESS

8-20, for example, Michael Bierut's *Seventy-Nine Short Essays on Design* is text-based. Pentagram's blog states: "While the book has no pictures, Abbott Miller's design provides its own form of visual interest. Each essay is set in a different typeface, and readers can attempt to make real or imaginary connections between essay subject and font selection. We can guess why the essay on AT&T is set in C.H. Griffith's Bell Gothic (it was designed in 1938 for the Bell Telephone Directory) or why the essay about Stanley Kubrick is set in Paul Renner's Futura (it was reportedly the

director's favorite typeface); the rationale behind other selections may be a bit more obscure, or even completely nonexistent."

For Figure 8-21, *Building Letters*, Filip Blažek kept the layout simple to allow the images to come off the pages. Blažek comments, "The design of the magazine was inspired by *Building Letters 2* designed by Sumo Design. I used similar colors and the same size, but everything else is different. The only font used for all texts is Botanika by Czech typographer Tomáśś Brousil; the bright process colors should attract designers and

FIG. **8**/**21**

BUILDING LETTERS

· DESIGNER: FILIP BLAŽEK
· COVER ILLUSTRATION: DONALD BEEKMAN
· CLIENT: BUILDING LETTERS
· HTTP://WWW.DESIGNIQ.EU/BUILDING-LETTERS-3

The job was done for free and all the profit from the sale of the magazine goes directly to a charity organization. It was a great opportunity to work together with well-known designers.
—Filip Blažek

CASE STUDY

For this heavily illustrated book, *The Works: Anatomy of a City*, by Kate Ascher, Alexander Isley says his team "worked with Kate Ascher to organize her research material. We initially prepared a rough layout of every page and illustration (over 140 in all) so that Kate could write the text to correspond to the imagery. We then worked with our assembled team of talented designers and illustrators and, over the course of six hectic months, produced what we consider to be a once-in-a-lifetime project. (At least that's what we kept telling ourselves as we put yet another late night or weekend into the endeavor.)"

You can also see the development process for this book design in the accompanying figures.

DEVELOPMENT AND FINAL IMAGES FOR BOOK COVER AND INTERIOR PAGES: *THE WORKS: ANATOMY OF A CITY* **BY KATE ASCHER**

· ALEXANDER ISLEY, INC., REDDING, CT
· CLIENT: PENGUIN PRESS, NY

This book is a lavishly illustrated look at the infrastructure of New York City: How the subways operate, where the sewage goes, how cellular service works, why those crosswalk buttons never seem to operate, what's considered the "Avenue of Death," and what's a hump yard?
—Alexander Isley, Inc.

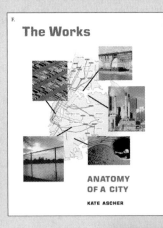
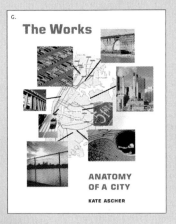
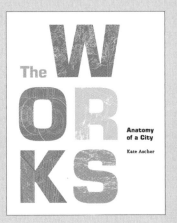

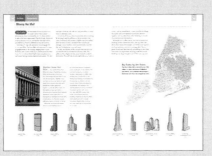

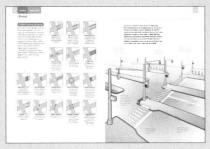

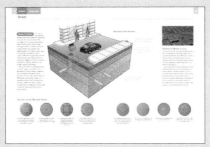

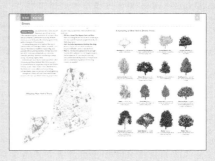

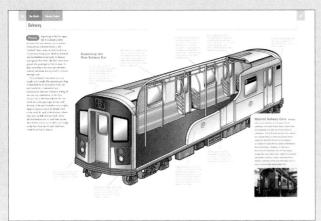

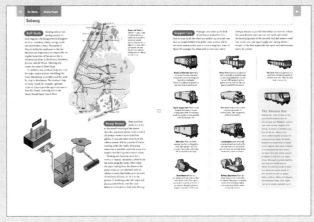

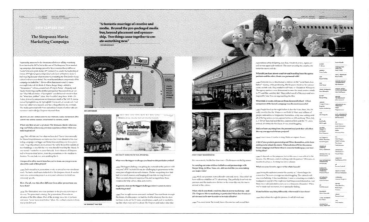

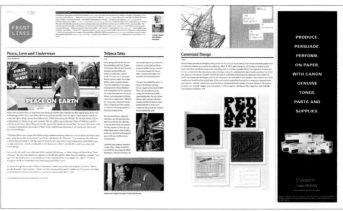

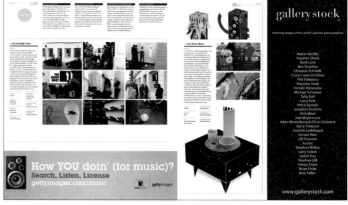

FIG. **8** / **22**

CREATIVITY MAGAZINE

· UNDERCONSIDERATION LLC, AUSTIN

· ART DIRECTION: BRYONY GOMEZ-PALACIO, ARMIN VIT

· DESIGN AND EXECUTION: JEANINE DUNN, *CREATIVITY*

· EDITOR: TERESSA IEZZI

· CLIENT: *CREATIVITY*

The redesign maintains the eclectic typographic combination of Matthew Carter's Bell Centennial, Robert Slimbach's Minion, and a customized version of John Scheppler's Orator, but has shifted the balance to feature bigger and bolder headlines in Minion and using the other two typefaces for details and emphasis. We also introduced a new format to present the detailed credits that each project requires, while allowing the visuals to appear bigger, and even meaner.

—www.Underconsideration.com

typographers, since it is a magazine written by them for them."

› *Identify serial components.* Sections or columns recur from edition to edition. For example, *The New York Times* offers a weekly Science section and a daily Sports section, as well as daily Editorial and Op-Ed pages. In Figure 8-22, you can see *Creativity* magazine's various sections and serial components that had to be considered in the redesign. Bryony Gomez-Palacio and Armin Vit comment about this on their UnderConsideration blog: "*Creativity* magazine, a monthly publication from Crain Communications, brings together information and visuals of the most relevant work in advertising and design from around the world. With their May 2008 issue the publication underwent a physical transformation, taking it from an oversized 11 × 14.5 inches to a smaller, but still commanding 10 × 12 inches and shedding its saddle-stitching in favor of perfect binding. UnderConsideration was in charge of segueing the

magazine into the new format, maintaining the basic grid structure—that Armin had previously implemented with Michael Bierut at Pentagram when they redesigned the magazine in 2006—while modifying the typographic and visual language to reflect a more sophisticated look."

To help you identify serial components, determine:

› Volume of content

› How much content will change from edition to edition

› Sections and sequence

Editor Richard Stengel's comments about the redesign of *Time* magazine, shown in Figure 8-23, offer great insight into the requirements and goals of an iconic magazine design, or any magazine for that matter:

Every issue of TIME *tells a larger story about the world we live in, and we wanted to create a design that would best present that story. . . . The magazine*

FIG. **8** /**23**

PROJECT: *TIME* MAGAZINE

· DESIGN: LUKE HAYMAN/PENTAGRAM, NY
· PHOTOGRAPHER FOR REAGAN COVER: DAVID HUME KENNERLY
· CLIENT: TIME, INC.

In 2007, *TIME* underwent a major redesign developed by Pentagram's Luke Hayman with *TIME*'s managing editor Richard Stengel and art director Arthur Hochstein. Hayman explains that "the magazine has been modernized . . . but it still has the *TIME* 'DNA.' We deliberately chose fonts and design elements that echo classic *TIME* magazine."

Paula Scher, who collaborated on the redesign prototype, provides additional insight: "We created a system that we thought would resonate with today's readers. It's full of quick bits and relevant info, but still retains the spirit of *TIME*. We used the display typeface Franklin Gothic that was part of the history of the magazine, and revisited the grid used by Walter Bernard," the legendary editorial designer.

—http://blog.pentagram.com/2007/03/new-work-time-magazine.php

FIG. **8** / **24**

BOOK: *REVERB*

- TRICYCLE, INC., CHATTANOOGA
- CREATIVE/ART DIRECTOR: R. MICHAEL HENDRIX
- DESIGNERS: BEN HORNER, NICK DU PEY, INGRID DYSINGER
- EDITOR: CALEB LUDWICK
- CONTRIBUTING WRITERS: HOLLEY HENDERSON, MK TIMME, CAMERON SINCLAIR, CARLIE BULLOCK-JONES, NADAV MARLIN, MAIRI BEAUTYMAN, KATIE WEEKS, BILL GRANT, MELISSA MIZELL, CALEB LUDWICK
- SPONSORS: AQUAFIL USA, DUSK, MOHAWK FINE PAPERS, SUMMIT GRAPHICS
- © TRICYCLE, INC.

Eleven eco-consultants, commercial designers, and editors contributed essays on topics ranging from educating clients about green choices and integrated design to this anthology of sustainability.

REVERB was printed on 100% post-consumer waste recycled paper, and produced as an FSC certified book. Thanks to the generous donations of the contributors, 50% of the sale of every book went to Architecture for Humanity raising approximately $3,000 for humanitarian relief. Because it is out of print, the book is now available online as a PDF at http://www2.tricycleinc.com/reverb/.

—Tricycle, Inc.

has been organized into four clearly defined sections—Briefing, The Well, Life and Arts—to help readers navigate the content and provide the magazine with a stronger structure. The sections are sign-posted through the use of bold headlines. (http://pentagram.com/blog/2007/03/new-work-time-magazine.php)

› *Identify the optimal format and trim size.* If the publication's format is your decision, decide on the best format and trim size for the content and audience. Books and magazine sizes have become increasingly standardized; for example, in the United States, 8" × 11" is a standard size. There are larger size formats as well as experimental formats. For economic and ecological reasons, newspapers and magazines have been moving toward smaller trim size, fewer pages, or both. For *REVERB*, a 120-page anthology of sustainability (Figure 8-24), "in response to the immediacy of the pieces, Tricycle's in-house design team created a book that is itself an experiment in form; cut to three sizes including a textbook, a flipbook, or full-size integrated design, *REVERB*'s graphics and layouts react and respond to the content of the pieces."

GRID FOR EDITORIAL DESIGN

A grid for a publication provides a system for ordering content that can lend both clarity and visual interest for the reader and can ease designing and compositing for more than one designer and production team, as in Figure 8-23. Once you've identified the content components, start with the format. The trim size (actual size of a book page after excess paper has been trimmed during production) and proportions of the format will help you best design the grid. For the anatomy and basic grid principles please see Chapter 6, Composition.

Many reference books contain sidebars, case studies, and projects, which are serial components. For each section of *Trout and Salmon of North America*, Charles Nix needed to design an overview of the species; a sidebar summarizing physical information; and a description of the fish and its biology, distribution, evaluation, classification, and conservation requirements (Figure 8-25). Specific kinds of nonfiction books require planning several components of information on a page or spread; for example, in Figure 8-26, a cookbook designed by Lowercase Inc., each recipe requires title, description, ingredients, preparation method, and image.

There are two basic grid options:

› *Modular grid*: The main functional benefit of a modular grid is how information can be chunked into individual modules or grouped together into zones. When designing heavily illustrated content, a modular grid offers the most flexibility. When designing moderately illustrated content, a modular grid can accommodate one column for running text (body of writing). Many designers believe a modular grid is most flexible, allowing for greater variety.

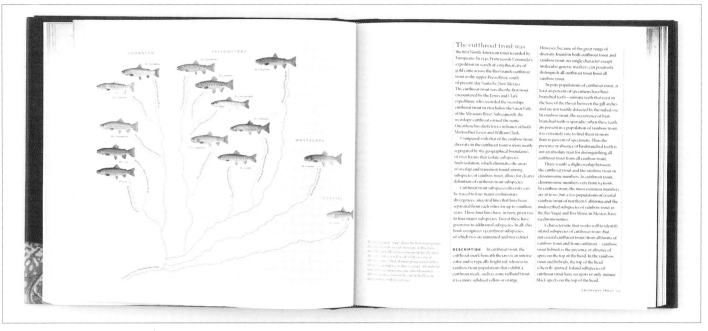

FIG. 8 /25

BOOK COVER: *TROUT AND SALMON OF NORTH AMERICA* BY ROBERT J. BEHNKE, JOE TOMELLERI, AND DONALD S. PROEBSTEL

· ART DIRECTOR/DESIGNER: CHARLIE NIX
· CLIENT: FREE PRESS

FIG. 8 /26

BOOK COVER AND INTERIOR PAGES: *WORKIN' MORE KITCHEN SESSIONS WITH CHARLIE TROTTER* BY CHARLIE TROTTER, SARI ZERNICH, JASON SMITH, AND PAUL ELLEDGE

· LOWERCASE, INC., CHICAGO
· ART DIRECTOR/DESIGNER: TIM BRUCE
· CLIENT: TEN SPEED PRESS

FIG. **8 / 27**

BOOK COVER AND INTERIOR PAGES: *AMERICAN CITY: DETROIT ARCHITECTURE 1845–2005* BY ROBERT SHAROFF AND WILLIAM ZBAREN

· LISKA + ASSOCIATES, INC., CHICAGO AND NEW YORK
· CREATIVE DIRECTOR: STEVE LISKA
· DESIGNER: VANESSA REU
· CLIENT: WAYNE STATE UNIVERSITY PRESS
· © LISKA + ASSOCIATES, INC.

American City showcases the rich architectural history of Detroit. Editorial content of the book describes the economic, social and cultural context that fueled decades of tremendous investment in fine architectural design. The heart of the book is the photography that visually communicates the grandeur of the city. Liska designed the book to include 90 full-bleed images accompanied by detailed captions. Now in its third printing, American City has also inspired a traveling photo exhibition based on the book as well as a second book, American City: Saint Louis, now being produced.
—Liska

> *Column grid*: A column grid can be very flexible and works well for running text. Depending upon the size and proportions of the format, determine the number of columns and whether columns can be combined to accommodate headers and large visuals or divided to accommodate captions and smaller visuals. A column grid can also be designed with dedicated columns for text and large visuals. Columns can be even or uneven depending upon content and function.

When making your grid determination, consider the following:

> Column width to ensure readability of running text (too long or too short line lengths inhibit readability); experiment with type sizes fitting into the column width
> Column width for illustrations
> Margins to accommodate column width, sidebars (see Figure 8-17, *Birds of the World*), callouts, folio, footnotes
> Gutter measure
> Bleeds (in Figure 8-27, to showcase the rich architectural history of Detroit, Liska + Associates included ninety full-bleed images accompanied by detailed captions)

> Whether you will break the grid and how
> Text to image relationships

As with all graphic design, spontaneous composition comes into play even when utilizing a grid. For the most part, you can adhere to the grid alignment and break the grid to allow for visual interest, the importance of the image, for a detail that needs to be seen, for example, or to bleed an illustration or run an illustration into the gutter. It is best to never break the grid arbitrarily, for example, bleed an illustration rather than ending it in the margin.

FLOW AND VARIATION

A grid is used to create a cohesive structure as well as a visual flow across pages, whether it is across a spread or throughout the publication. Just as in a popular song, where the listener hears parts of the song repeated, relying on those components for continuity and coherence, so does a reader rely on the underlying structure of a publication. However, strict adherence to a grid without some structural variation and visual cues to alert the reader to changes among parts of the publication would detract from readability. The lack of

variation would become tiresome and not create distinction among the component parts.

Cues to content change are important; they can be established through color, template, or grid variation, or color or typographically. Giving the reader distinct signals enhances communication, facilitating comprehension. Similarly, creating distinction among the publication's component parts facilitates use.

Creating Variation

Designers utilize several methods to create variation.

> *Syncopation*: Employ two or three alternating grids.

> *Section function*: Each section of the publication has its own grid or the same (flexible) grid is used but zoned differently for each section. Alternatively, each section is denoted by color cue or type of illustration or the relationship of text versus illustration.

> *Column reversal*: Same grid but the running text column and illustration change positions from spread to spread.

> *Spread reversal*: Same grid but the running text and illustration change from recto (right-hand page) to verso (left-hand page), and vice versa, in some syncopated pattern.

DESIGNING STANDARD COMPONENTS

Most publications have standard elements or component parts, such as those diagrammed at the end of this section. Once you have settled on a grid, you need to build a visual and information hierarchy to ensure clarity, readability, and rhythm. In Figure 8-28, a spread for *The New York Times Magazine*, the right-hand page is a full bleed illustration by Christoph Niemann, balanced by the left-hand page where we enter the graphic space via the title, "2011." Then we read the subtitle of the article, followed by the author's name, move to the first column, rest at Niemann's name in blue, and finally read the second column of text. The white spatial intervals between "2011" and the subtitle, between Niall Ferguson's name and the columns, and between the end of the second text column and Niemann's name all add to balancing and corresponding to the illustration on the right-hand page.

Using typography well—headers and subheads and display typefaces—you can organize and structure large amounts of content into manageable "chunked" sections, distinguishing content, to clarify and improve readability, as well as aiding visual flow and rhythm. Depending upon the nature of the content and publication, sound bite

FIG. **8**/**28**

MAGAZINE SPREAD: "2011"

· *THE NEW YORK TIMES MAGAZINE*
· CREATIVE DIRECTOR: JANET FROELICH, THE NEW YORK TIMES MAGAZINES
· DESIGNER: NANCY HARRIS ROUEMY
· ILLUSTRATOR: CHRISTOPH NIEMANN

SHOWcase

CARLA FRANK

c.f.

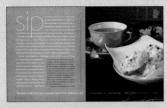

Carla Frank is a visionary creative director specializing in content development, design, branding, product positioning, management, and education.

As the founding design director of *O, The Oprah Magazine*, Frank helped create the most successful launch effort in the history of the magazine industry. Frank has worked for numerous publications during her career including *Condé Nast Traveler Magazine*, where she was the art director for more than three years. Prior to that, she freelanced for publications such as *The New York Times Magazine, Entertainment Weekly, Time*, and many more. Before moving to New York in 1994, Frank was the principal of her own design firm located in Baltimore, MD, which specialized in content and product development, publication design, packaging, corporate identity, and retail exhibitions for a variety of clients.

Carla Frank received her BA degree from Pennsylvania State University, where she was recently honored with a Distinguished Alumni Award. She has been extremely active in her profession, serving on the board of directors for the Society of Publication Designers (SPD) for four years, where, among other things, she co-authored *Solid Gold: 40 Years of Award-Winning Magazine Design*. She has been a chairperson for the SPD gala and the Art Directors Club (ADC) student portfolio show.

Frank has held a staff position at the School of Visual Arts and has been a guest lecturer at Pratt, International Center of Photography (ICP), and Fashion Institute of Technology (FIT). She has also been a key speaker and presenter for various conferences and professional gatherings. Frank's work has received numerous awards from design organizations and has been the subject of several magazine articles.

Personally, Frank travels at every opportunity, which fuels her love for shooting street and travel photography. She feels the expansiveness of travel and culture is invaluable to her general sense of interconnectivity to the world and global markets.

INTERVIEW

What made you realize you wanted to be a creative professional?

I'd always been in the arts, tapped into an honors program at an early age as a fine artist.... This may sound silly but I always loved the fact that in rather serious businesses there was often a room with a door that had a sign labeled "The Art Department." I wanted to be in there!

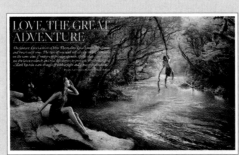

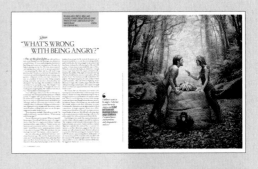

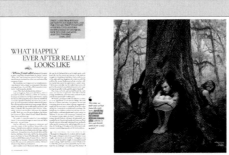

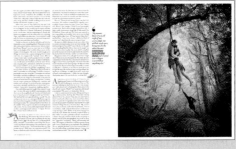

What advice would you offer an aspiring art director or graphic designer?

I think you always have to remember that you are serving a business . . . it's not enough to make something look cool. We always have to deliver in content, user-friendliness, and of course style and attitude depending on the type of business. Also, I'd advise young designers to learn as much about the business aspects of your clients or employers as it will make you better, faster, and smarter than the rest.

Further, the very best work is done when one is not self-conscious but focused on becoming better as an individual—at anything, whether it's running, singing, or design. Just work through those struggles which always seem like barriers but are really opportunities.

Where do your ideas come from?

They come from my human experiences. From being a living being on the planet right now—in our time. They come from my deepest emotions. They come from the fact that I am female, and they come from my personal beliefs. They come from my compassion, my love, my anger, my fears, my height, and my age, my hair color, and my passions.

Do you go through a specific design process, for example, conceptualization, visualization, composition?

Yes, for the most part. But sometimes I see an artist's work and wonder how I can incorporate their style and wit into my projects and keep that in the front of my brain for a while.

Why did you choose editorial design as your focus?

Well, I'd always been a magazine junkie, because of the qualities of escapism, the style, the wit, the perfection, and the authority in their voices. I learned also that when I started in advertising, there was very little room for individuality and my personal voice. In magazines I felt the opposite. There was room for my voice and everyone's who worked there. Also, I loved the idea of putting together a product the way a

theater troupe might put on a show—everyone doing their part, lines blurring here and there as to territorial rights but working for the best product possible. This kind of process enables a quick way of dealing with each other, because we are so familiar with each other's communication and creative processes. It often creates for personal breakthroughs if you push yourself.

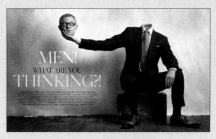

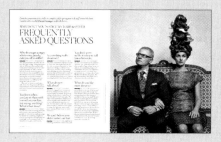

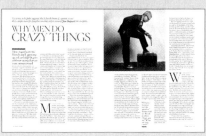

"MEN"

- DESIGN DIRECTOR: CARLA FRANK
- ART DIRECTOR: CARLA FRANK
- PHOTO DIRECTOR: JENNIFER CRANDALL
- DESIGNER: TED KELLER
- PHOTOGRAPHER: GEOF KERN
- PUBLICATION: *O, THE OPRAH MAGAZINE*

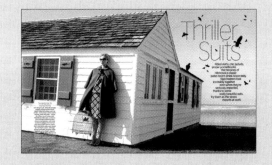

"THRILLER SUITS"

- DESIGN DIRECTOR: CARLA FRANK
- ART DIRECTOR/DESIGNER: LEE BERRESFORD
- PHOTOGRAPHER: TODD MARSHAND
- PUBLICATION: *O, THE OPRAH MAGAZINE*

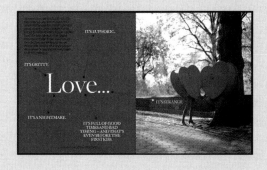

"LOVE"

- DESIGN DIRECTOR: CARLA FRANK
- PHOTO DIRECTOR: JENNIFER CRANDALL
- ART DIRECTOR: LEE BERESFORD
- DESIGNER: JANA MEIER
- PHOTOGRAPHER: GREG MILLER
- PUBLICATION: *O, THE OPRAH MAGAZINE*

DIAGRAM [8-01]

THESE ARE THE STANDARD
ELEMENTS OR COMPONENT
PARTS OF A PUBLICATION.

SIGNATURE

FOLIO

RUNNER

BODY

FOOT

HEAD

HEADER

SIDEBAR

SUBHEAD

CAPTION

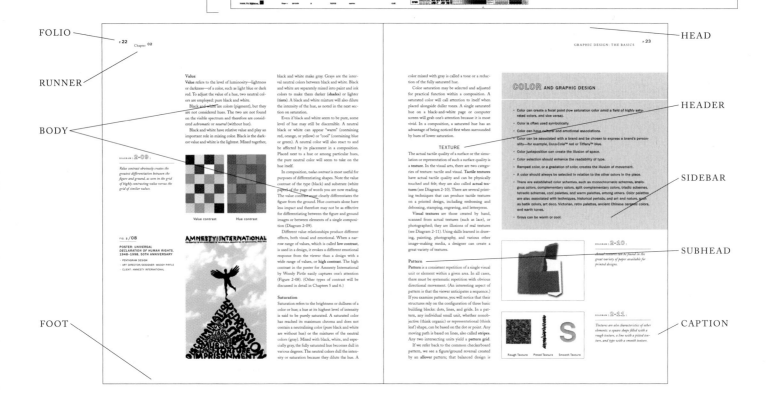

segments or chunks may be highly desirable and benefit communication.

> *Head*: the top edge of the page
> *Header*: title or head; also called headline
> *Deck*: a short paragraph or two lines of text that supports and clarifies the header
> *Subhead*: subordinate titles to mark subsections of text
> *Body*: location of the primary content; also called the block, block of text
> *Sidebar*: supplemental content often placed on the edges of the page, however can be placed anywhere
> *Captions*: supplemental text that accompanies visuals used to describe or support images
> *Runners*: running heads, feet, or sides, which are markers used to create geographic location within the publication
> *Call-outs*: excerpts from the text called out for attention; also called pull-outs
> *Folio*: page numbers; often the page number is clustered with the runners
> *Foot*: the bottom edge of the page
> *Pagination*: the sequential numbers of pages in a publication; the first right-hand page is numbered 1, and all subsequent right-hand pages take odd numbers and left-hand pages take even numbers
> *Signature*: a section of a publication consisting of a folded sheet of paper that yields four sides for printing, then bound with other signatures to form a publication

EXERCISE 8-1

ANALYZING BOOK JACKETS AND MAGAZINE COVERS

Find five examples of book jackets or magazine covers that express the spirit or personality of their contents. Justify your choices.

PROJECT 8-1

BOOK COVER DESIGN SERIES

Step 1

a. Select three short story writers. Read their works. Research them. Ask a literature professor about them.

b. Write an objectives statement. Define the purpose and function of the problem, the audience for the books, and the information to be communicated. On an index card, write adjectives that describe the work of each writer.

Step 2

a. Name the series.

b. Design a logo for the short story series (see Chapter 10).

Step 3

a. Design three book covers—one for each writer in your series. Design front covers and spines.

b. The covers must be similar in style and yet express the individuality of each writer.

c. The logo must appear on each cover in the same position.

d. Produce at least ten sketches for each jacket that could be expanded into a series format.

e. Your solution may be purely typographic, visually driven or type-driven.

f. Think about the various ways the series could be tied together:

i. Through the use of similar visuals: illustrations, graphics, photographs, typography

ii. Through the use of a technique: woodcut, mezzotint, torn paper, xerography (See Chapter 5, Visualization)

Step 4

Refine the sketches. Create one set of roughs for the series.

Remember: Book covers are very much like posters—they must attract the potential consumer. They should have initial impact. Any book cover design must compete against other books sitting next to it on a shelf.

Step 5

a. Refine the roughs and create one comp per book.

b. The covers should be 6" × 9", held vertically.

c. You may use black and white or full color.

Go to our website **GD/s** for *many* more Exercises and Projects, and presentation guidelines, as well as other study resources including the chapter summary.

NOTE

1. Here, template does *not* refer to premade templates that non-designers utilize, but rather means that a designer creates a cover layout that will work for a series or system of covers.

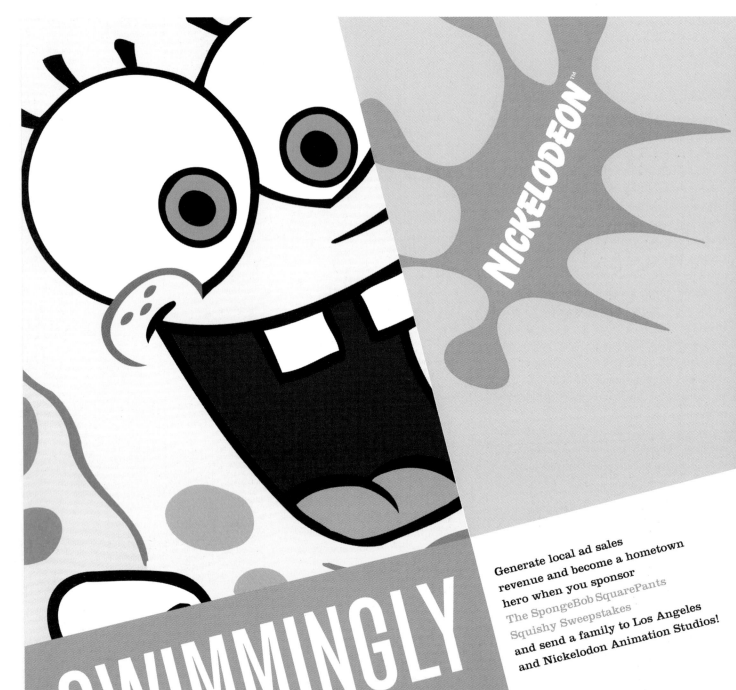

SWIMMINGLY

Nickelodeon's SpongeBob SquarePants can make your life like a day at the beach.

NICKELODEON™

Generate local ad sales revenue and become a hometown hero when you sponsor The SpongeBob SquarePants Squishy Sweepstakes and send a family to Los Angeles and Nickelodon Animation Studios!

THE SPONGEBOB SQUAREPANTS SQUISHY SWEEPSTAKES

09/

BRANDING

< < < / *facing page*

**BRANDING:
NICKELODEON**

· ADAMSMORIOKA, BEVERLY
HILLS
· DESIGNER: SEAN ADAMS,
NOREEN MORIOKA

HOW
MANY BRANDS DID YOU INTERACT WITH
TODAY? WHICH BRANDS DO YOU USE? BREAKFAST CEREAL? JEANS? CELL PHONE? COMPUTER? AUTOMOBILE? DO YOU MAKE PURCHASES BASED ON A BRAND'S REPUTATION? DO YOU DONATE TO A BRANDED ORGANIZATION? DO YOU CONSIDER YOUR FAVORITE MUSEUM A BRAND? HOW ABOUT YOUR LOCAL HOSPITAL? BASEBALL TEAM? BALLET? CHARITY? BAND? POLITICIAN?

OBJECTIVES

Define brand and branding

Understand the purpose of branding

Become familiar with the branding process

Understand the range and character of branded experiences

WHAT IS BRANDING?

Whether people like it or loathe it, almost every product, service, major city, business, and organization has been branded. Steve Liska, Liska + Associates, points out in *Designing Brand Experiences*: "When a carefully monitored and consistent experience is factored into the strategic success of a coffee company; when millions of dollars can be raised for cancer research with a simple yellow rubber wristband; and when symbols can instantly trigger a range of emotions based on our perception of what they stand for—you begin to understand the power of a brand's meaning and how it can shape our daily lives."

Understanding what a brand is and how a branding program operates lays some groundwork for understanding the roles and objectives of individual graphic design applications, such as logos and websites. Many think of a brand as a proprietary name for a product, service, or group; however, on a more multifaceted level, a *brand* is the sum total of all characteristics and assets of a brand name product, service, or group that differentiates it from the competition, as well as the perception of the brand by the public. (In this book, the term *group* is used to denote a company, organization, corporation, social cause, issue, or political group. For the sake of brevity, all branded entities—whether a product, service, or group that has benefited from any type of branding—will be referred to as a brand or group or entity.) Typically, several applications are key components of an overarching branding effort or program, beginning with a logo and visual identity through interactive experiences, package design, corporate communications, promotional design, and advertising. Although many people use the terms *visual identity*, *corporate identity*, *brand identity*, and *branding* interchangeably, branding is a broader marketing effort than visual identity since it often involves naming, advertising, and promotion. A visual identity is the visual and verbal articulation of a brand or group, including pertinent key graphic design applications, such as logo, letterhead, and business cards, and could include package design, uniforms, signage or environmental design, and corporate communications. Before learning to design a logo,

FIG. **9** /01

BRAND: MISS CHIQUITA WORLDWIDE PERSONALITY; CORPORATE WEBSITE

· SAMATAMASON, WEST DUNDEE, IL
· ART DIRECTOR: GREG SAMATA
· DESIGNERS: GREG SAMATA, JIM HARDY, LYNNE NAGEL
· ILLUSTRATOR: PAUL TURNBAUGH (MISS CHIQUITA WORLDWIDE)
· COPYWRITER: CHIQUITA
· PHOTOGRAPHY: MISCELLANEOUS
· CLIENT: CHIQUITA

the cornerstone application of any visual identity or branding program, *let's start with an overview of branding to put logo and identity design into perspective.* When you study visual identity in the next chapter, we will more closely examine how to create an identity program.

Branding is the entire development process of creating a brand, brand name, and visual identity, among other applications. Creating an integrated branding program (across media) entails weaving a common thread across all of an individual's experience with a brand or group, and integrating the common visual and verbal language into all experiences with the brand. An **integrated branding program** is the creation of a comprehensive, strategic, unified, integrated, and unique program for a brand, with an eye and mind toward how people experience—interact with and use—the brand or group. Rather than approaching individual applications as isolated brand design solutions, it is a strategic imperative to see every application—a comprehensive brand identity, every appropriate graphic design application, and an advertising campaign, including traditional, new, and emerging media—as a contributor to the entire branding effort and therefore to a person's experience with the brand.

THE PURPOSE OF BRANDING

Due to many convergent factors—new and emerging media, the economies of nations with rapid industrial growth, greater mass production, competing companies manufacturing parity products and offering parity services, rise of disposable income, desire for new products and better packaging, sustainability (green) issues, and changes in the scope and global reach of corporations—branding, including brand names, logos, visual identity design, package design, and advertising, has become indispensable to marketing. In an overcrowded, competitive marketplace, relevant and engaging branding can ensure efficacy for a quality product, service, group, individual, or commodity, for example, Chiquita Brands International, Inc.—a leading international marketer,

producer, and distributor of bananas sold under Chiquita (Figure 9-01). Not only does branding distinguish, it builds *equity*, the value of the brand or group.

If you have any doubts about how crucial effective branding is, just think of the strength of Sony, The American Red Cross, Coca-Cola, Google, Facebook, Hannah Montana, China Mobile, The Nature Conservancy, or (RED) (Figure 9-02).

FIG. **9** /**02**

(RED)

(RED)'s ambition was to harness the power of the world's greatest companies to eliminate AIDS in Africa. To do this it created both a new business model and a new brand model that would do three things: deliver a source of sustainable income for the global fund, provide consumers with a choice that makes giving effortless, and last but not least generate profits and a sense of purpose for partner companies.

The first challenge was to get the all-important founding partners on board. So we helped Bobby Shriver and his team to paint a vision of what (RED) could be. We built the brand around the idea that (RED) inspires, connects, and gives consumers power, with a visual system that unites participating businesses by literally embracing their logos to the power (RED).

We continue to work with (RED) on developing partner strategies, inspiring new partners to participate, and briefing employees and agencies. Within the first five weeks of the U.S. launch, the (RED) brand registered 30 percent unaided awareness. (RED) partners delivered $45 million to the global fund in one year, more than was received from the private sector in the last five years. This is enough money to give 290,000 people life-saving drugs for a year.

—© Wolffolins.com

Certainly, factors other than branding contribute to a brand's success, including the quality of its product or service, public perception and enthusiasm, relevance to people's lives, the time period and culture, and the communities and/or celebrities who adopt it.

DIFFERENTIATION

How many brands of coffee or toothpaste can you name? Ten? Twenty? What about automobiles? Cell phone carriers? Shoes? Cable channels? Charities? Museums? When you can easily list many brands of any consumer packaged good, service category, or nonprofit institution, the need for differentiation becomes clear. When most goods and services offer the same benefits, why do you choose one over another? When you receive requests for donations to several charities, all of which you hold in high regard, why give to one over another?

Products, services, commodities, groups (nonprofit organizations, causes, charities, companies), and individuals (musicians, celebrities, politicians, among others) *depend upon branding to differentiate* them in the minds of the public in a glutted and highly competitive market. Very few products, services, or groups offer unique benefits, usually offering similar or identical functions as their competitors, a characteristic called *parity*. Therefore, branding helps differentiate products, services, and groups in a crowded brand world.

Functional and Emotional Benefits

A brand or group is the sum total of its functional and emotional assets. Each brand has functional benefits or capabilities (tangible features) that may or may not be unique to a product or service category; for example, most toothpaste brands contain the functional benefit of fluoride, a cavity-prevention ingredient. (For many people, quality or functional benefits and a brand name are inseparable.) Due to its heritage, parent company, logo and visual brand identity, environmental design, advertising, endorsements, and associations, each brand also carries intangible assets—emotional benefits. Emotional, as well as cultural, associations arise in response to the spirit of any brand identity, the emotional content or spirit of the advertising, and the communities and celebrities who adopt the brand as part of their lives.

VERBAL AND VISUAL DIFFERENTIATORS

Two main *verbal differentiators* are the **brand name**, a proprietary name, and the *tagline*—a slogan or short distinctive phrase used to identify and promote. The main *visual identifier* is a *logo*, the cornerstone of a visual identity. Other graphic elements certainly contribute to a visual identity or branding program. When brands were first introduced, the brand name, logo, and packaging established the brand identity. Now we think of branding in more comprehensive integrated terms, where the resulting design solutions all should be in sync. As Steve Liska states, "A brand is not one thing. It is not just a logo or a package. It is a complex set of visual, verbal, and experiential cues supported by media messages."

BRANDING PROCESS

The design process for branding is

Orientation ▶ Analysis ▶ Concepts ▶ Design ▶ Implementation

The branding process is a complicated one, demanding collaboration among marketing, creative, and IT professionals. Often, a lead brand agency hires other expert firms (identity, advertising, interactive, public relations, market research, and package design, among others) to help develop the brand or execute particular applications. After what can be extensive research and footwork during orientation, strategy is the next crucial step during the Analysis phase.

STRATEGY

Brand strategy is the core tactical underpinning of branding, uniting all planning for every visual and verbal application. The brand strategy defines the brand's personality and promise, differentiates the brand from the competition by defining the brand's positioning, and codifies the brand essence; it is a conceptual plan providing

guidelines—for both client management and creative professionals—to drive all brand applications from identity and packaging to advertising. At times, the design studio outlines the marketing strategy as Alexander Isley did for BlueBolt Networks in Figure 9-03. Essentially, the brand strategy is how you are conceiving, creating, and positioning your brand in the marketplace to

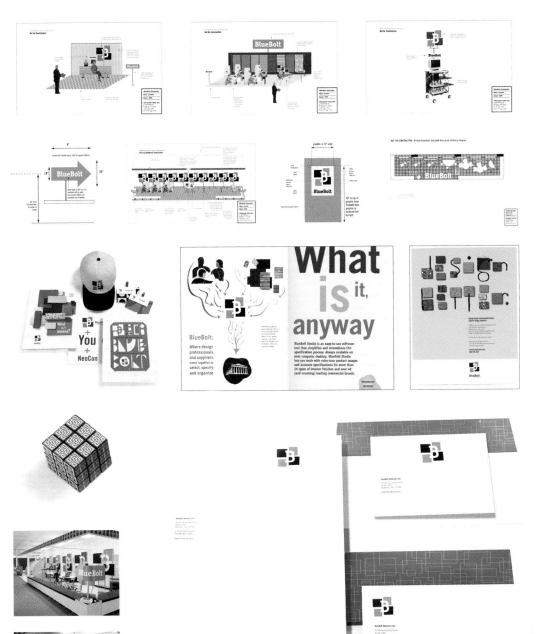

FIG. **9** / **03**

BRANDING: DEVELOPMENTAL WORK & FINAL

· ALEXANDER ISLEY INC., REDDING, CT
· CLIENT: BLUEBOLT NETWORKS

BlueBolt Studio™ is a software tool developed to help architects and interior designers review, specify, and order surface materials and fabrics. We were given the charge to introduce this new product to a skeptical and savvy audience. Our involvement included outlining a marketing strategy, establishing a brand personality, naming the products, and creating sales and promotional materials. We developed BlueBolt's logo, advertising, packaging, sales pieces, and announcements. We also created a trade show booth with a tea bar and a massage station—you could sip tea or get a ten-minute back rub while you watched a demo on a laptop. The booth was a huge hit and so was the product. Coincidence?
—Alexander Isley Design

FIG. **9** /**04**

BRAND IDENTITY: DELTA AIR LINES

· LIPPINCOTT, NY
· CREATIVE DIRECTOR: CONNIE BIRDSALL
· DESIGNERS: ADAM STRINGER, KEVIN HAMMOND, MICHAEL MILLIGAN, FABIAN DIAZ
· CLIENT: DELTA AIR LINES

The new logo was designed to convey a renewed strength and confidence and modernization of the airline to both customers and its employees. The simplified all-red symbol and all-uppercase logotype visually reinforce a more sophisticated, directed, and globally appropriate expression while being considerate of the airline's extensive heritage. The Delta symbol is further leveraged through a dynamic cropped livery treatment that speaks to momentum, growth, and optimism.

Lippincott's customer experience implementation rolled out immediately following the launch. The look and feel of the terminals is being dramatically transformed— from new outdoor signage and check-in areas to gates and baggage claim areas—to reflect the new brand identity. Elements of the in-flight experience such as monitor displays, menus, and place-settings have also been redesigned.

—Lippincott

achieve differentiation, relevance, engagement, and resonance. (When a design solution does not fit the strategy, the messaging is *off brand*; when it does work with the strategy, the messaging is *on brand*.) However, it is the design that makes the strategy corporeal, that truly gives brands their distinctive look and feel.

Delta Air Lines is the third largest U.S. carrier with more than 47,000 employees. To coincide with the airline's emergence from a Chapter 11 restructuring, Delta came to Lippincott for a strategic reposition, image revitalization, and customer experience redesign (Figure 9-04).

During the strategic analysis, some design or branding firms help determine the **brand architecture**—the structuring of brands within the company's offerings (product portfolio). Basic brand architecture models include monolithic (the company name is used on all products or services), endorsed (sub-brands are linked to the company by name), and freestanding (each product or service is individually branded). When the Nickelodeon brand saw the need to evolve, it turned to AdamsMorioka (see "Case Study: Nickelodeon").

CONCEPTUAL DESIGN AND THE BRAND CONSTRUCT

Every brand or group should possess a core value or quality that can become its **construct**, a quality or position a brand "owns" against the composition (as explained in Question 6 of the Sample Design Brief in Chapter 4). Owning a quality, even though others in your category have the same quality, establishes a brand in the audience's mind as the primary possessor of that quality; it is **positioning** of the brand in the public's mind against the competition. The tactic, then, is to "claim" ownership of a benefit or quality before anyone else does, to preempt the competition, and to express that construct through the visual and verbal identity. For example, although many luxury cars are well engineered and perform well in safety and crash tests, one brand established its construct as great engineering and another brand established its construct as safety. (Can you name them?)

A construct relies heavily on how a brand casts itself. Can you think of any brand constructs? When you think of Disney, do you think of fun? When you think of The Salvation Army, do you think of compassion? Do you associate the

Southern Poverty Law Center with tolerance? Would you purchase a Toyota for its reliability? Is there an energy drink you think is cool to carry around? Do you Bing or Google?

Constructs can be based on heritage, a unique functional or emotional benefit, authenticity, originality, earthiness, high-tech expertise, and authoritative expertise, among many qualities. Several factors must be considered when formulating branding and a brand construct:

› *Differentiation*: distinguished by a unique, consistent visual and verbal presence

› *Ownership*: the brand or group "owns" or claims an identifiable attribute, a quality, personality, or posture preempting the competition from claiming the same

› *Consistency*: construct used across media, permitting a consistent brand voice and tone in all verbal and visual communication

› *Relevance*: branding is based on an insight into the audience and an insight into the brand, making the brand relevant

How a construct can be cast:

› A brand or group symbolizes something: honesty, stability, authenticity, style, originality, safety, reliability, good health, luxury, prosperity, down-home goodness, et cetera.

› A brand or group embodies something: ethics, humanitarianism, preservation, coolness, fun, family values, respectability, excitement, energy, novelty, inventiveness, cutting-edge research, a lifestyle, et cetera.

› A group is virtuous and works toward solving a social problem or finding a cure for a disease.

NAMING A BRAND

Naming a brand involves many crucial considerations. What does the name mean? What type of spirit or personality should it convey? How will people react to it? What does the name mean in a specific language across cultures?

As stated earlier, a brand name is the verbal identity—a proprietary name—and coupled with a tagline or descriptor, it becomes the verbal signature. Without question, the brand name is the main point of reference to any brand and is the main verbal marketing tool. When a Swedish candy store chain intended to enter the U.S. market under the name "Sweetwave," Paula Scher, Pentragram partner, suggested a name that would play up the company's European origins. The word *öola* was invented (Figure 9-05).

Usually, the name is the one brand element that remains unchanged or, at least, in place for a long

FIG. **9**/**05**

IDENTITY: ÖOLA

· PENTAGRAM, NY

· PARTNER/DESIGNER: PAULA SCHER

· CLIENT: ÖOLA CORPORATION, BOSTON, PHILADELPHIA, NEW YORK, AND WASHINGTON, DC

Öola is a chain of Swedish candy stores in American shopping malls. The company intended to enter the U.S. market under the name "Sweetwave," but when Paula Scher was commissioned to design their retail identity, she expressed a concern that the name would not be interesting enough to American consumers. Scher recommended playing up the company's European origins with a new name and a bright, clean graphic look.

The word öola was invented and became the basis for the stores' entire visual identity. Öola was chosen for its Scandinavian sound, geometric letterforms, and the umlaut, which has become a central motif in graphic applications.

—Sarah Haun, Communications Manager, Pentagram

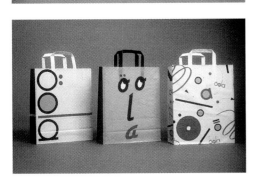

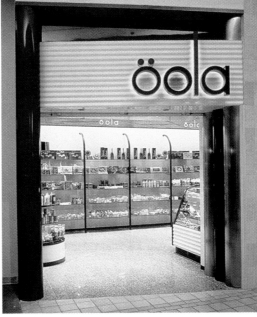

CASE STUDY

NICKELODEON/ADAMSMORIOKA

The Nickelodeon brand had grown and diversified over its history. Not atypically, the brand did not have a specific long-term overview, but had grown organically. While the success of Nickelodeon had turned it into one of the world's leading children's entertainment companies, it now faced the danger of dilution as various business ventures and divisions moved further apart in message. The audience was shifting demographically and psychographically. And, over time, employee defections to the competition had enabled others to emulate and co-opt Nickelodeon's equity. Knowing there was a potential problem in the future, Nickelodeon approached AdamsMorioka with the assignment to determine the assignment. Often, companies don't turn to a communications firm until revenue is decreasing, or audience share has shifted negatively. In this instance, Nickelodeon was exceptionally successful, seeing only increased revenue, ratings, and diversification. Rather than settling for this, waiting for a downturn, Nickelodeon saw the need to evolve.

AdamsMorioka approached the issue with a far-reaching discovery phase. Working with internal and external audiences, they mapped a process and set of deliverables to maintain and increase Nickelodeon's success, while planning for expansion. After the discovery phase, AdamsMorioka interfaced with all components of the brand and returned with new brand architecture and an execution plan. This new structure allowed each division's culture to expand, while reinforcing the primary set of promises and message of Nickelodeon.

A reface of the on- and off-air visual system followed, putting the findings and architecture into real time. The visuals are based on the idea of "kid modernism." Opposing the standard visuals in children's entertainment—complex layers, multiple typefaces, lots of purple and green—the Nickelodeon system approaches from the opposite side. The system is reductive; creating a focus on the brand and its product, with characters like SpongeBob SquarePants and other properties. There are no extraneous shapes, colors, or images. The message is simple, clear, and direct. This is not about collage, but ideas and narrative. The system is utilized in all media, print, advertising, online, and on-air. This provides a proprietary visual for Nickelodeon, separating the "voice of Nick" from other advertising, and reducing the pace of children's television.

Success for all companies is a result of multiple factors including product, distribution, programming, and human resources. Strategy and design

BRANDING: NICKELODEON

· ADAMSMORIOKA, BEVERLY HILLS

· DESIGNER: SEAN ADAMS, NOREEN MORIOKA

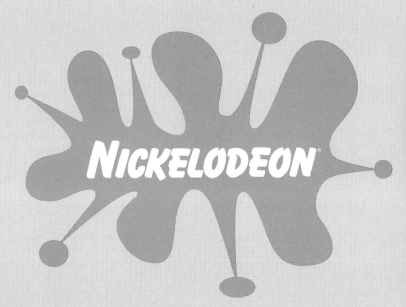

play parts of this role. It is disingenuous to portray strategy and design as the only activator of that success. Following implementation and dissemination, however, Nickelodeon had its highest profit the following year. Programming blocks were created to reach new audiences such as tweens; with new brand extensions and activities implemented, the existing product was fortified.

NICK JR.

Nick Jr. is the arm of Nickelodeon that communicates with preschool children. As Nick Jr. became more successful, both financially and critically, it became apparent that it should be treated as its own brand and given a clear proprietary look. The brand message includes the need for Nick Jr. to be a safe place for two- to five-year-olds with a priority of education and entertainment value. The visual system addresses the strategic needs of communication on two levels, talking to children and parents simultaneously. Parenting messages use iconography to explain the benefits of each television program. Children's messaging addresses the limited reading capability of this age group and show character recognition. Characters like Dora the Explorer and Blue from *Blue's Clues* are used to communicate messages from the network.

NICK AT NITE

Nick at Nite's strength was its rich programming. Comprised of sitcoms including *I Love Lucy*, *The Brady Bunch*, and *Three's Company*, the network is made of images and icons that make up our culture. AdamsMorioka designed a graphic system beginning with the idea of "less color, more content" and is designed to "get out of the way." The black and white color palette allows a wide variety of programming with different visual qualities to live together. The simplicity of the program stands in stark contrast to traditional television graphics and provides a proprietary attitude to Nick at Nite.

—AdamsMorioka

Process

FIG. **9** / **06**

IDENTITY SYSTEM, WEBSITE, AND AD PROCESS

· VISUAL DIALOGUE & RICK RAWLINS/WORK
· CREATIVE DIRECTORS: FRITZ KLAETKE, RICK RAWLINS
· ART DIRECTORS: RICK RAWLINS, FRITZ KLAETKE
· DESIGNERS: FRITZ KLAETKE, RICK RAWLINS, IAN VARRASSI
· COPYWRITER: LYNN HORSKY
· SITE PROGRAMMING: IAN VARRASSI
· MARKETING CONSULTANT: EDANA SPICKER, WWW.AGENTEDANA.COM
· CLIENT: PROCESS

Problem: Clements Horsky Creative Directions, a print production management firm, came to us with two major problems: (1) their name was confusing and didn't provide any clues to what they do, and (2) their communications materials had an amateurish and haphazard look that was inappropriate for a company that handles print production issues for designers.

Solution: Playing on the four-color process inks common in printing, and on the process of design and print production, Visual Dialogue helped rebrand the company with a new name (Process), logo, stationery, ads, and website. All of the communications materials reveal the production techniques by which they were created and serve as case studies for what Process does.
—Fritz Klaetke

period. Whereas logos, often, are periodically updated, names usually don't change unless there is a company merger, acquisition, or takeover, or the name becomes outdated. A brand name is an intangible asset, optimally adding value to a brand (think Coca-Cola, Vanguard, and Google).

Types of Names

There are several categories of name types that are more or less appropriate for any brand.

> *Founder's name*: named for the company's founder(s), such as Harrods of London named for the family name of Charles Henry Harrod; Ben & Jerry's ice cream named for Ben Cohen and Jerry Greenfield; Levi's named for founder Levi Strauss; and Martha Stewart for the brands created by Martha Stewart.

> *Explanatory*: named to best explain or describe the product or service, such as Toys "R" Us, China Mobile, Burger King, American Heart Association, Coca-Cola, Give Kids the World, and Process (see Figure 9-06).

> *Expressive or Invented*: names that are constructed to have a certain panache or sound, such as Google, Häagen-Dazs, Bing, Xerox, Def Jam recordings, Earth Share, Timex, and Intel.

> *Allegorical or Symbolic*: names that express their nature through an allusion to an allegory or a symbol to represent a brand, such as Nike (named for the Greek goddess of victory), Sirius (named

for the sky's brightest star), Nintendo, Vanguard, and Apple Computers.

› *Acronym*: a brand name formed from the initials or other parts of several names or words; for example, GE for General Electric, BMW for Bayerische Motoren Werke, KFC for Kentucky Fried Chicken, IBM for International Business Machines, and BP for Beyond Petroleum.

Name Efficacy

There are many ways to make a brand name effective.

› *Distinction*: a name that characterizes, distinguishes, and differentiates the brand among its competitors.

› *Memorable*: a name should be worth remembering and sufficiently engaging. Most say a brand name should be easy to pronounce and spell; however, one could make a case for interest over ease.

› *Purposeful*: a brand name can be meaningful, adding significance, purpose, or cachet to a product, service, or group. A brand name should communicate the personality of the brand and address its target audience.

› *Extendable*: a name should be capable of growing and changing with the company and possible brand extensions.

› *Long-lasting*: a name that endures will be viable for a long time.

› *Legally owned*: the name or domain should be available to be legally registered, owned, and trademarked. It should not legally infringe on any other trademarked name.

DESIGN DEVELOPMENT

Based on the strategy, name, and construct, visualization and composition begins during design development. You will need to consider brand differentiation, brand promise, and branding applications and media.

Differentiation through Look and Feel

As part of the design solution, a brand's unique personality is established and communicated through its "look and feel," expressed through the particulars of the visualization and composition (including color palette; characteristics and qualities of lines, shapes, and textures; typeface;

and any other visual elements). The brand look and feel is a visual "attitude" that differentiates a brand from the competition, making it unique, distinctive, memorable, and relevant to its audience. It should define its individual character, be synonymous with the brand, not be in any way generic, and definitely not look like its competitors. For example, when Keith McNally decided to open a large, classical French brasserie and bakery—in a part of east SoHo that most people simply avoided—he asked Mucca Design to collaborate in the design and development of an extensive and fully integrated identity that would define the restaurant's traditional feel with a sense of freshness, romance, and attention to period details (see "Case Study: Balthazar").

Brand Promise

The **brand promise**—essentially what the brand claims it will or can do, expressed through the identity and advertising—has always been an important part of what makes a brand desirable. Dating back to one of the first American brands, *Uneeda* biscuit, the National Biscuit Company created brand promise when it offered consumers an "inner-seal package," promising sanitary packaging and fresh, crisp crackers.

There is the actuality of a brand, and then there is the audience's perception of it. It is important to understand this component in design development. How an individual perceives a brand depends upon several factors:

› Whether a brand delivers on the brand promise

› The individual's response to the brand identity and advertising

› The experience of the brand on the website and at other touchpoints

› Brand placement and positioning in films, television programs, and sports events

› Celebrity endorsers and users (paid and unsolicited)

› Testimonials

› The public image and behavior of the company or group

› Any public relations crisis, incident, or scandal involving the brand

› Each separate experience a user has with the brand

CASE STUDY

BALTHAZAR/MUCCA DESIGN

BRANDING: BALTHAZAR

· MUCCA DESIGN CORPORATION, NY

Keith McNally, the man behind Café Luxembourg, Odeon, Nell's, Lucky Strike, Pravda, Schiller's, and Pastis, is one of New York's most successful restaurateurs; he is a truly inspired and inspiring visionary, and one of Mucca's favorite clients.

As with most of the projects we've undertaken with McNally, the process of creating Balthazar Restaurant was deeply involved and truly collaborative. It was immediately apparent to the Mucca team that the Balthazar identity had to communicate McNally's obsession with quality and detailed authenticity. From the logos and signage to menus and matchboxes to packaging and delivery vans, every part of the Balthazar brand was designed and orchestrated to give it the feel of a place that had evolved over generations to become the familiar institution that it is now.

Mucca Typo created the Decora Typeface (based on vintage Victorian examples) specifically for Balthazar packaging, and gathered dozens of other fonts and faces to support it. Elements of

the brand identity are leveraged throughout the restaurant and have become widely recognizable symbols of quality and luxury.

With the overwhelming growth of Balthazar's popularity came several extensions of the brand, including Balthazar Bakery and its wholesale division, as well as its popular gift items and famous cookbook, all of them designed by the Mucca team. Though they share defining characteristics, each new division or extension of the central Balthazar brand was given an individual identity with its own color scheme and typographical system in order to clarify the unique brand proposition.

Balthazar is now one of New York's most popular restaurants. Widely recognized as an institutional landmark and credited with sparking the revitalization of several city blocks in lower Manhattan, the McNally flagship is also highly regarded as a singularly successful and multifaceted luxury brand.

—Mucca Design

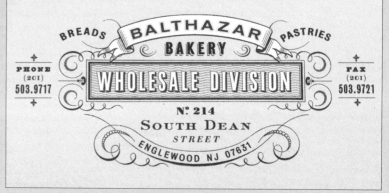

FIG. **9** / **07**

BRANDING: AETHER APPAREL

· CARBONE SMOLAN AGENCY, NY
· CREATIVE DIRECTOR: KEN CARBONE
· DESIGNERS: NINA MASUDA, DAVID GOLDSTEIN
· PROJECT MANAGER: RACHEL CRAWFORD
· CLIENT: AETHER APPAREL

Branding Applications and Media

Applications and media for any branding program can vary, depending upon factors such as project scope; budget; and type of product, service, or group. In Figure 9-07, the branding involved several applications. The Carbone Smolan Agency (CSA) comments:

Aether Apparel, a new line of adventure sportswear inspired by a life spent outdoors, aims to appeal to the outdoor enthusiast who needs the function of performance garments, but who desires a more sophisticated form. CSA designed the brand's logo to appeal to this demographic and to reference the word itself, Aether, meaning "the heavens". After creating the mark, which evokes infinity and clouds circling a mountain peak, CSA designed interior and exterior garment tags and a website featuring dramatic outdoor photography and a sleek, flash-based user interface.

Key *applications* usually include name, logo, tagline, letterhead, website, and corporate communications. *Media* includes print, screen-based media, broadcast media (television and radio), out-of-home, guerrilla advertising, product placement,

POINTS OF CONTACT:

For any brand or group, there are multiple points of contact with the public. Each is an opportunity to inform and endear.

- Logo and visual identity
- Television commercials
- Tagline
- Print advertising campaigns
- Websites (including micro-sites)
- Web banners and floater ads
- Social networking sites
- Mobile
- Motion graphics
- Corporate communications
- Radio commercials
- Out-of-home
- Viral marketing efforts
- Unconventional advertising
- Direct marketing

- Branded environments
- Environmental graphics/signage
- Broadband content
- Product placement and sponsorships
- Telemarketing
- Branded entertainment
- Promotions
- Publicity
- Buzz (word of mouth)
- E-mails
- Ephemera
- Events or happenings
- Online video sharing
- Environmental alterations
- Emerging media

and sponsorships. It is important to identify the media that will be most focused and powerful in carrying the brand message to the public and in influencing the target audience's brand perceptions. Every contact point that offers a positive experience for the audience strengthens the audience's brand perception; therefore consistency is key in how the Muzak brand, for example, is utilized across applications (Figure 9-08). For example, when Duffy & Partners designed the branding system for The Islands of the Bahamas, they created an entire brand language that is "endlessly adaptable—in signage, online communication, ads, merchandise, and iconography." (See "Case Study: The Islands of the Bahamas.")

REBRANDING

Often, designers are faced with the challenge of rebranding an existing brand identity or brand program for a variety of reasons. Duties might include reinventing a brand, repositioning, renaming, redesigning, or all of these (covered more fully in the next chapter on visual identity). For example, Landor advised Federal Express that the name FedEx conveyed a greater sense of speed,

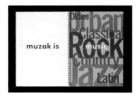

FIG. **9** /**08**

IDENTITY: MUZAK

- PENTAGRAM

Notice how the "m" is used alone and in combination with the wordmark "muzak." The use of lowercase letters establishes both a contemporary and mellow feeling.

FIG. **9** / **09**

BNSF BRANDING

· LISKA + ASSOCIATES, CHICAGO AND
 NEW YORK
· CREATIVE DIRECTOR: STEVE LISKA
· ART DIRECTOR: KIM FRY
· DESIGNER: BRIAN GRAZIANO
· CLIENT: BNSF
· © LISKA + ASSOCIATES

*We developed a nomenclature
system and created a branding
program that more accurately
reflects the values and attributes
of the unified company. To ensure
consistent application of the
branding program, including
application to thousands of
railcars, signs, and print material,
we created an online brand
manual that can be used by BNSF
associates and vendors throughout
the United States and Canada.*

*We designed the logo and
developed nomenclatures that
helped unify the company's identity
and reflect BNSF's strength and its
modern and forward-moving brand
attributes.*

—Liska + Associates

technology, and innovation than Federal Express. Landor created the FedEx identity using a specially designed typeface in FedEx's orange and purple colors.

Ten years after the company formed from the merger of the Burlington Northern and the Atchison, Topeka and Santa Fe railways, BNSF hired Liska + Associates to guide the company through a brand evolution (Figure 9-09).

CHARACTER OF
BRANDED EXPERIENCES

In today's marketplace—where, in almost all cases, there is more supply than demand *and* several, or perhaps many, brands in each product or service category—it is vital to a company's marketing strategy to establish a comprehensive, distinctive branding program for its brand. Similarly, it is vital for any group to have a distinctive branding program.

In his autobiography, *Songs My Mother Taught Me*, actor Marlon Brando wrote that he didn't ask for "power and influence"—people bestowed it upon him. Audiences decide whom they like and which brands they like as well. Ultimately, it is the public who decides which brands are stars. It is the opinion (reviews, ratings, purchases) and perception (blogs, sites, and videos that go viral) of the audience that can make or break a brand.

There are other contributing factors to brand perception, such as the communities or celebrities who "adopt" the brand, but the brand promise is the functional and emotional advantage and value pledged to the user. Due to the nature of the cumulative experiences with a brand, people may

CASE STUDY

BACKGROUND

It was late 2001, just after the travel and tourism industry had witnessed its most crippling downturn in history—9/11. The Ministry of Tourism of The Islands of the Bahamas was looking for a new partner to help it rebrand its country and present its unique tourism product to the world.

Many choices and much clutter lead to category fragmentation at best and a sea of sameness at worst. No one stood out. Nothing seemed different. The Bahamas was significantly outspent by many of its competitors.

CHALLENGE

"We want people to look at the Bahamas again and again."

—*Vincent Vanderpool-Wallace*

Former Director General, Ministry of Tourism, The Islands of the Bahamas

It was our self-described objective to "create branded desire for the Bahamas." Differentiate the nation as the preferred sun and sand vacation destination. Celebrate the many offerings of a multiplicity of islands. Provide a branding system that would be used by one and all alike—the country, many individual islands, and numerous private and public sector entities. And ultimately revitalize an economy that depends on over 60 percent of its GNP from tourism.

THE DESIGN EXPLORATION

We immersed ourselves in the culture and learned that the beautiful island nation offered myriad experiences for any travel desire. We were struck by the sights and the sounds, the shapes and colors, the flora and fauna. We started to use those elements to begin to define possible solutions in our visual brief collage board.

Duffy & Partners concluded that the Bahamas needed an entirely new brand identity, one that not only made the country stand apart, but also was flexible for many different constituencies to use.

We quickly landed upon the concept of designing a stylized map of the Bahamas—an identity system to highlight each of the fourteen major tourist destinations and their many unique offerings. This set in motion an entire brand language that is endlessly adaptable—in signage, online communication, ads, merchandise, and iconography.

RESULTS

• The new branding initiative was unanimously embraced by The Ministry of Tourism and its

IDENTITY/BRANDING/
ADVERTISING/STANDARDS/
WEBSITE: THE ISLANDS
OF THE BAHAMAS

PROCESS & SKETCHES: THE
ISLANDS OF THE BAHAMAS

· DUFFY & PARTNERS, MINNEAPOLIS

private sector partners to become the single rallying point for the country.

- Quantitative research in the United States, Europe, and the Bahamas showed double-digit increases in critical brand attributes such as communicating that the Bahamas is a chain of islands with many friendly, vibrant, and novel experiences.

- Efforts that emanated from this new brand presentation have consistently driven increased visits and increased tourism revenue in the double digits since its introduction in 2002.

- Visitor satisfaction scores have consistently increased and intent to return and recommend the Bahamas are at historic highs.
 —Duffy & Partners

perceive the brand as delivering or not delivering on its brand promise; and if they deem it to not be delivering, they will voice their opinions and move on to another brand.

BRANDING AN EXPERIENCE

At every point of contact, a person experiences a brand or group—whether it's through contact with packaging, customer relations, a branded line of merchandise, an interactive kiosk, an exhibit, a website, or an event. Every experience, whether from one point of contact or from many points of contact of an integrated campaign, should be a positive and consistent one.

"How do you leverage a landmark television series for maximum exposure so that it can be licensed to other companies for product tie-ins and promotions?" Carbone Smolan Agency was challenged to do just that (Figure 9-10). "Ken Burns' *Baseball* presented an opportunity to extend the sense of history and pride captured in this eighteen-hour miniseries. Burns' passion

for Americana inspired the branded line of merchandise, which comprised videos, soundtracks, books, and collectibles, unifying the wide number of licensees, who ranged from Bertelsmann to Elektra Records to Knopf," explains Carbone Smolan Agency.

"Overlooking Seattle's beautiful Elliott Bay, Cascade and Olympic mountain ranges, and the city's magnificent skyline is where Hornall Anderson delivered on the Space Needle's tagline of 'Live the View!' positioning, by creating a guest experience unlike those typically found at view-oriented tourist attractions." Hornall Anderson further explains their work shown in Figure 9-11: "Interactive designers and technicians built a series of intuitive, highly user-friendly kiosks that extend the 360-degree view, not just visually, but experientially, as people learn about the many treasures of the Emerald City. The branded experience is called SkyQ.

"The Experiential Branding™ system is immersive, engaging, and leaves an indelible mark

FIG. 9 / 10

BRAND IDENTITY & MERCHANDISING PROGRAM: KEN BURNS' *BASEBALL*

· CARBONE SMOLAN AGENCY, NY
· CREATIVE DIRECTOR: KEN CARBONE
· DESIGNER: JEN DOMER

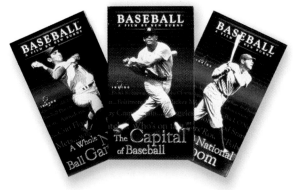

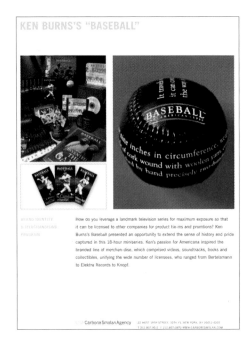

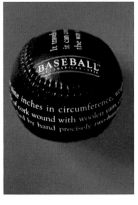

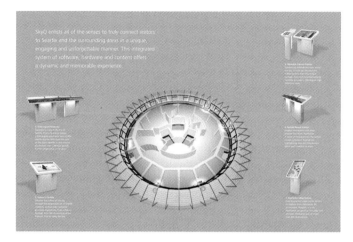

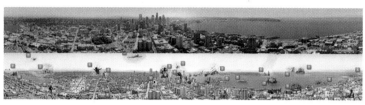

FIG. 9 / 11

EVENT BRANDING

Most branding programs are intended to endure. However, there are branding programs created for events and films that are shorter lived. Most major motion pictures are heavily branded, with websites, TV commercials, posters, and screen-based media utilized. However, once the film has left the theaters, the branding program is no longer necessary (until DVD release or for award nominations). Similarly, special events such as conferences, gala benefits, marketing events and parties, tradeshows, and award events, among others, are also branded.

The London Design Festival, the umbrella organization that promotes the annual season of design-related events in London each September, commissioned Domenic Lippa of Pentagram, with senior designer Paul Skerm and design assistant Ali Esen, to design the identity and every element of the festival's citywide graphic presence including brochures, signage, guidebooks,

on the person because they're at the center of the experience. They're not merely interested observers out on the periphery, but actual participants," states Hornall Anderson.

PROJECT: SPACE NEEDLE SKYQ INTERACTIVE INSTALLATION

· HORNALL ANDERSON, SEATTLE
· ART DIRECTOR: JAMIE MONBERG
· DESIGNERS: NATHAN YOUNG, JOSEPH KING, HANS KREBS, ADRIEN LO, COREY PAGANUCCI, RYAN HICKNER, JORDAN LEE, CHRIS MONBERG, CHRIS FREED, KEVIN ROTH, HALLI BRUNKELLA
· CLIENT: SPACE NEEDLE

At the View kiosk high-definition cameras controlled by visitors enable them to zoom in on various points of interest and learn about what they're seeing from presentations delivered in multiple media formats. Interactive maps, meanwhile, flank the View station, offering touch-screen capabilities linked to live video, produced movies, still images, and text factoids about Seattle landmarks. The viewing experience is further enhanced by aural content delivered through holophonic audio spotlight speakers.

From there, visitors might choose to move to the Vignette kiosk, where they can gather authentic local perspectives about Seattle destinations, which are delivered by local residents. The 20–40 second segments are shot in high-def, and also include still images complemented by directional audio.

Or, people can move to the Reveal kiosk and interface with motion-sensitive screens that serve up factoids and illustrated 360-degree views of the city from directly beneath the O-deck. Factoids on such popular destinations as the Pike Place Market, the Seattle Aquarium, Mount Rainier and others pop up when the user clicks on a touch-screen button mounted over five 30" LCD panels showing the Seattle skyline.

Arguably, the most dramatic visuals in the entire experience may reside at the Time-Lapse kiosk. Four 30" LCD panels display a 360-degree, digitally stitched panoramic view of the Seattle skyline shot from the roof of the Space Needle. These are taken in one-minute increments over a twenty-four-hour period. A single knob guides the experience, allowing for forward or backward travel throughout the day. The control also allows for panning the view across the assembled screens to get the full interactive effect.
—Hornall Anderson

FIG. **9** / **12**

LONDON DESIGN FESTIVAL 2007

· DESIGN: DOMENIC LIPPA/PENTAGRAM, LONDON
· PHOTOGRAPHER: NICK TURNER
· CLIENT: THE LONDON DESIGN FESTIVAL

Lippa retained the festival's established logo, designed by Frost Design for the first London Design Festival, and developed the branding with a bold typographic theme using a modified Al Fragment typeface.

—http://blog.pentagram.com

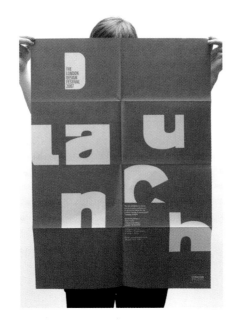

promotional material, environmental graphics, and the look and feel of the website as well as the first London Design Medal (Figure 9-12).

"As Qualcomm's BREW business introduced new technologies and moved into new markets, its popular industry conference needed to convey a sense of excitement and possibility. MiresBall anchored the conference identity around the theme Into the New. Visually, a racing-stripe motif underscores the fast pace of today's wireless market, while stylized 'action' photography showcases the 24/7 relevance of wireless technology," comments MiresBall (Figure 9-13).

For the Art Directors Club of New Jersey, Rizco, who runs a green design office, created a green solution for the awards dinner (Figure 9-14). For the "Thinking Creatively" conference cosponsored by Kean University and the

FIG. **9** / **13**

BREW CONFERENCE

· MIRESBALL, SAN DIEGO
· CREATIVE DIRECTOR: SCOTT MIRES
· PROJECT MANAGER: OLIVIA HEEREN
· DESIGNERS: LESLIE QUINN, MIGUEL PEREZ
· COPYWRITING: ERIC LABRECQUE
· PHOTOGRAPHY: EMBRY RUCKER, LOU MORA
· CLIENT: QUALCOMM

For over a decade, MiresBall has helped Qualcomm communicate its forward-looking leadership in wireless communications.

· *Named and developed identities for key components of BREW solution set*
· *Communications and design partner for annual BREW conference*

—MiresBall

Art Directors Club of New Jersey, year after year Steven Brower has made each conference a one-of-a-kind happening (Figure 9-15).

Over the next several chapters, we will examine individual applications that can be components of branding programs. For example, every brand or group has a home on the web with other supporting digital applications. Coupled with a verbal identity, a visual identity is the cornerstone of any branding initiative.

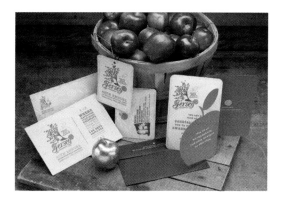

FIG. **9** / **14**

ADCNJ AWARDS BRANDING

· RIZCO DESIGN, MANASQUAN, NJ
· CREATIVE DIRECTOR: KEITH RIZZI
· DESIGNER: KEITH RIZZI
· PRINTER: CMYK PRINTING (COLLATERAL)
· ENGRAVING: PRECISE CONTINENTAL (ENVELOPES)
· CLIENT: ART DIRECTORS CLUB OF NEW JERSEY

EXERCISE 9-1

INVENTING A NAME

❶ Choose a product or service and invent a brand name for it.

❷ The name should be appropriate and communicate the brand's personality.

❸ The name should be memorable.

❹ The name could convey the brand's or group's functional benefit. Functional benefits are the practical or useful characteristics of a product or service that aid in distinguishing a brand from its competition, such as nutritional, economical, or convenient advantages.

❺ The name should have a long life span.

❻ If the company is international, the name should reflect its global status.

❼ If the brand is international, the name should work for each country in which it is sold.

PROJECT 9-1

FROZEN TREAT

❶ Invent a new frozen treat that would be sold in retail stores such as supermarkets and groceries.

❷ Using the sample design brief in Chapter 4, write a brief for your frozen treat product. Be very clear about the target audience since that will help determine the spirit of the brand.

❸ Invent a brand name.

❹ Choose a color palette.

❺ Write a very short story involving this product.

Go to our website **GD/** for *many* more Exercises and Projects, and presentation guidelines, as well as other study resources including the chapter summary.

FIG. **9** / **15**

POSTER AND ANCILLARY MATERIALS FOR "THINKING CREATIVELY" CONFERENCES

· ART DIRECTOR/DESIGNER: STEVEN BROWER
· CONFERENCE DIRECTOR: PROFESSOR ROSE GONNELLA
· SPONSORED BY THE ART DIRECTORS CLUB OF NEW JERSEY AND KEAN UNIVERSITY

苏州博物馆

SUZHOU MUSEUM

IO /

VISUAL IDENTITY

<<< / facing page

IMAGE: SUZHOU MUSEUM

· TRACY TURNER DESIGN INC.,
NEW YORK

PICTURE
AN INSURANCE COMPANY. WHAT COMES

TO MIND? YOU MIGHT THINK OF A HUGE OFFICE SPACE WITH PEOPLE IN CUBICLES WORKING ON COMPUTERS, TALKING ON PHONES, AND PARTICIPATING IN MEETINGS. NOW, LET'S TAKE IT A STEP FURTHER—WHAT IS THE DIFFERENCE IN HOW YOU IMAGINE FIVE DIFFERENT INSURANCE COMPANIES? ON THE SURFACE, MOST COMPANIES SEEM LIKE FACELESS, VAST CORPORATE ENTITIES, WITHOUT MUCH TO DISTINGUISH THEM FROM ONE ANOTHER. WITHOUT A VISUAL IDENTITY, LOGO, OR ICON, ALMOST ANY COMPANY OR ORGANIZATION WOULD SEEM A GENERIC GROUP.

VISUAL IDENTITY: WHAT IS ITS PURPOSE?

The basic purpose of visual identity is the same as a branding program—to identify, differentiate, and build a sustainable presence and position in the marketplace, as well as to engender trust in the brand or group.

DEFINITION OF VISUAL IDENTITY

In today's competitive worldwide marketplace, with so many different brands in each product and service category, it is a business imperative for each brand's identity to communicate clearly and consistently. Similarly, any organization or social cause requires an interesting and coherent visual identity. A **visual identity** is the visual and verbal articulation of a brand or group, including all pertinent design applications, such as the logo, letterhead, business card, and website, among other applications; also called **brand identity**, **branding**, and *corporate identity*. Figure 10-01 shows the straightforward visual identifier that Crosby Associates created for Edward Jones based on a simplified company name.

The keystone of any visual identity is a *logo*, a unique identifying symbol. Every time a viewer sees a logo for a brand, group, or social cause, that viewer should be able to immediately recognize and identify the entity it represents. A logo can carry enormous value for a brand, social cause, or company. Simply think of famous brands or groups and their logos should pop into your mind, such as the 3M logo (see Figure 10-05). As Milton Glaser states, "A logo is the point of entry to the brand."

Kinds of Visual Identity or Branding Projects
> New company, product, service, or group
> Name change
> Revitalization to stay relevant: redesign of an existing visual identity to have bearing in the marketplace
> Revitalization to ensure continued success (see "Case Study: Nickelodeon" in Chapter 9)
> Reposition: redesign of an existing logo to redefine an existing brand, aiming at a different audience, or to reposition the brand for a new audience

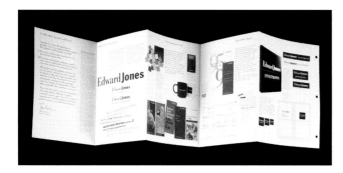
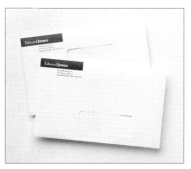

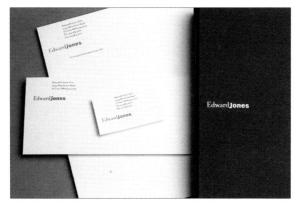

FIG. **10** / **01**

IDENTIFICATION AND BRANDING: EDWARD JONES

· CROSBY ASSOCIATES, CHICAGO
· CLIENT: EDWARD D. JONES & CO.
· *SYMBOL / STATIONERY AND PRESENTATION FOLDER / ACCOUNT SUMMARY / BUSINESS ENVELOPES*
· CREATIVE DIRECTOR/ART DIRECTOR/ DESIGNER: BART CROSBY
· *IDENTITY STANDARDS / SIGNAGE*
· CREATIVE DIRECTOR/ART DIRECTOR: BART CROSBY
· DESIGNERS: BART CROSBY, WHITNEY WATERS

Edward Jones is the leading investment resource for individuals. But a cumbersome name Edward D. Jones & Co. was confused with competing firms, a problem that was further compounded by the lack of a recognizable visual identifier.

Crosby Associates' solution was a comprehensive program built upon a simplified name Edward Jones and an equally simple visual identifier.

The signage program for Edward Jones had to be distinctive, cost-effective, and suitable across a wide range of facilities, from the firm's upscale urban office buildings to its more than 4,000 local offices, many of which are in storefronts and converted residences. The solution was a dramatically simple system of standard sign types and sizes, together with the establishment of a single, on-demand sign manufacturing and installation resource.

—Crosby Associates

› Merger of two brands or groups: newly designed logo to represent the merger and accrued equity of companies or groups who discard their previous logos

› Integrated media program to establish consistency across applications and media

GOALS OF AN IDENTITY

Ideally, a visual identity communicates meaning, adds value, is relevant to its target audience, and should be

› *Recognizable:* The shapes and forms are identifiable and decipherable.

› *Memorable:* The shapes, forms, and colors are sufficiently coherent, interesting, and unusual.

› *Distinctive:* The name, shapes, forms, and colors are uniquely characteristic to that entity and differentiate it from the competition.

› *Sustainable:* The name, shapes, forms, and colors would endure, be relevant for a period of years.

› *Flexible / Extendible:* The name, shapes, forms, and colors are flexible to work across media, to grow with the entity's new services, and to adapt to brand extensions and sub-brands.

DESIGNING VISUAL IDENTITY

As with any design project, the standard process for designing visual identity is shown here:

Orientation ▸ Analysis ▸ Concepts ▸ Design ▸ Implementation

Depending upon the nature of the firm assigned to the visual identity project, they may be involved in market research, a brand audit, a competitive audit, setting or clarifying existing strategy, and naming. After orientation and analysis, conceptual design begins and is based on the strategy set forth in the brief (for more information on design briefs, see the section on the logo design process in this chapter and Chapter 4).

CONCEPTUAL DESIGN

The design concept is conceived with a brand's or group's core value/quality and significance (as manifested in a brand construct, a quality or position a brand "owns" against the competition), visually communicated through its logo

FIG. **10** / **02**

LOGO: UNILEVER

· WOLFF OLINS, NEW YORK
· CLIENT: UNILEVER

and visual identity. A logo tells a focused visual story—meaning is distilled and then compressed into a unit—for example, Wolff Olins created a visual identity that expresses "vitality" for Unilever (Figure 10-02).

Designers and their clients *assign* meaning to logos. Today, the public "owns" brands and groups—reviewing them, blogging about them, even helping to build a logo's meaning. It is the public who interprets and accepts (or rejects) what it signifies. A visual identity system or a branding program, and other applications and efforts, support the assignment of meaning in order to build consensus. Of course, meaning evolves, sometimes naturally with age, with changes in the marketplace, or with revitalizations.

FIG. **10** / **03**

IDENTITY AND CONFERENCE MATERIALS: BIONEERS CONFERENCE

· SUBSTANCE151, BALTIMORE
· CREATIVE DIRECTOR: IDA CHEINMAN
· DESIGNERS: IDA CHEINMAN, RICK SALZMAN
· CLIENT: BALTIMORE BIONEERS (WWW .CULTIVATINGCHANGE.ORG), BALTIMORE

The Bioneers Conference is a multidisciplinary forum of practical solutions for restoring the Earth and its inhabitants. It's a thriving network of visionary innovators and thought leaders around the nation working to improve the health of our environment and human communities by bringing together nature, culture and spirit.
 —Substance151

Images:
· Baltimore Bioneers logo and letterhead
· www.cultivatingchange.org website
· "Baltimore Bioneers: Cultivating Change. Inspiring Solutions" conference brochure, spread, and cover

All points of contact with the 3M brand—advertising, literature, packaging, websites, tradeshows and even vehicles—use this identity system. The result is a recognizable design that focuses on brand messages and images to communicate value. The new 3M identity was launched globally and is used throughout the world by 3M communicators and creative suppliers adapting the message by language, culture, market and customer.
—3M

As always, you are looking for an insight that will generate a design concept and will drive your design. For example, in Figure 10-03, Substance151 developed a brand image for Baltimore Bioneers by identifying what they are chiefly about: "creating a sustainable world, being better neighbors to other species, healing human communities, and sending a message of hope to the future generations."

Designing a visual identity begins with the logo, which we will explore a bit later in this chapter. Basic key graphic elements for identity design are color, type, and imagery, which will be discussed in logo design. The font, shape, and forms of the logo, visual characteristics of the logo, and color palette will set the framework for the entire visual identity. For The Time Hotel, a hotel located in Manhattan's Times Square with small rooms each in a primary color of red, yellow, or blue, Mirko Ilić positioned the square in the "H" as a reference to Times Square, and the small red hotel room inside the "H" as the international symbol for hotel (Figure 10-04). All the other applications for the identity followed from there.

CREATING COHERENCE ACROSS A VISUAL IDENTITY OR BRANDING PROGRAM

A program of strategic, unified, and integrated solutions for a brand or group, including every graphic design and advertising application for that brand, results in harmonious brand experiences for its audience. A brand experience is an individual audience member's experience as he or she interacts with a brand—at every touchpoint. A unified brand experience was the goal of the 3M identity (Figure 10-05). "3M is a global diversified technology company operating in more than 60 countries. Historically, the 3M brand identity varied by country and market. Visually, beyond the 3M logo, there was not much to strongly connect the company's marketing efforts," the 3M design staff explains. "3M sought a way to maximize marketing resources and strengthen brand recognition by establishing one company-wide identity—providing one face and one voice to customers globally."

FIG. **10** / **06**

IDENTITY AND SIGNAGE: MICA

· PENTAGRAM, NEW YORK
· DESIGN: ABBOTT MILLER / PENTAGRAM
· PHOTOGRAPHERS: NANCY FROELICH; JAMES SHANKS
· CLIENT: MARYLAND INSTITUTE OF CONTEMPORARY ARTS

"MICA is a great art school with a rich history and an exciting future," says Miller. *"Our new identity reflects the patina of that history with solid historical letterforms that are played off against a modern linear framework. This mix of old and new is a direct reference to the school's two major buildings, the Main Building and the Brown Center—one very new and one very old—that 'talk' to each other across the main street of the campus."* In fact, it was the rhythmic lines of the Main Building's Beaux-Art facade that inspired the rules that separate the letters of the new mark, while the last, angled rule references the slanted glass prows of the contemporary Brown Center. Campus buildings also inspired the colors used in the new identity: oxidized green of the historic copper railings and architectural details, and brown and slate, the colors of the buildings' stone and brick.

—http://blog.pentagram.com/ 2007/04/new-work-mica.php

"The process was to identify existing best practices based on the thousands of communications tactics created globally and isolate a style and layout that was contemporary, effective and could be replicated across the company and around the world. The solution became a design system that began with a white background and applied a horizontal montage with a powerful message anchored to it. The montage can vary in color and structure but always contains images of people, product and pattern to bring the montage message to life."

Creating coherence entails weaving a common thread or voice—seeming like one voice, across all of an individual's experiences with a brand—to integrate the common visual and verbal language into all experiences with the brand. It includes the coordination or harmonization of all the elements of a visual identity throughout all experiences, as in Figure 10-06, identity and signage by Abbott Miller/Pentagram for MICA. "The acronym has made its way into many publications, but without a consistent expression," explains Abbott Miller. "The primary goal of the new identity was to provide a definitive graphic signature for the MICA acronym, as the institution fully embraces the moniker. And perhaps most importantly, it will provide MICA with a clear graphic expression on the national and international stage of its activities."

Considerations for establishing visual and verbal coherence are as follows.

› *Strategy*: All agencies, studios, and designers as well as other creative professionals working on brand applications should follow the same master brief and strategy in order to create solutions that are coherent and harmonious. All graphic design solutions should be consistent with the strategy and values and have a similar brand voice.

› *Look and Feel*: The brand look and feel is a visual "attitude" functioning to create unique visual interest and differentiate a brand from the competition, expressed through the particulars of the visualization and composition (including

color palette; characteristics and qualities of lines, shapes, and textures; typeface(s); images; and any other visual elements).

› *Clarity*: Since the primary purpose of graphic design is to communicate a message to an audience, creating clarity is one main goal of visual identity design. Clarity aids communication. All language—names, descriptors, taglines, headlines, titles—should be written with clarity of message in mind.

For visual/verbal coherence (see "Sidebar: Identity Coherence"), common components across brand applications are:

› Strategy
› Logo
› Tagline
› Look and feel
› Color or color palette
› Typeface(s)
› Abbreviations and titles
› Signature
› Tone of voice
› Attitude of imagery and copy
› Descriptive writing

Identity Standards

Graphic designers create standards for the use of identity design and logo on all applications to ensure consistency and logo recognition across media. Consistent use guarantees immediate recognition in a cluttered commercial environment and ensures integrity of meaning (see "Sidebar: Identity Usage Guidelines"). An **identity standards manual**, also called a **graphic standards manual**, sets up guidelines for how the logo is to be applied to numerous applications—from business cards to point-of-purchase materials to vehicles to websites. Color palette, area of isolation (the ideal amount of space surrounding the logo), brand signatures, and placement are all part of the specifications. The manual also provides a range of possibilities and guidelines for the use of typefaces in various combinations and in various applications—print, digital, and environmental—as well as guidelines on choosing weights, size, numerals, symbols, bullets, and the use of small caps—for both print and electronic applications. All designers and company employees who utilize

IDENTITY COHERENCE: FOUR KEYS TO DESIGNING CONNECTIONS

- *Color*: recognition and brand equity can be built through color.
- *Logo*: a well-designed logo identifies, unites a company's offerings, builds equity, and confers authenticity.
- *Type*: a unique and proprietary typeface builds equity with or without the logo.
- *Shape*: shape characteristics used in the logo and typeface and/or the shape of packaging build visual equity.

IDENTITY USAGE GUIDELINES

1/ Handle logo with care and consistency.

- A logo is one of the most important identity assets.
- Do not scan a logo or recreate it. Do not type the letterforms.
- Do not stretch the logo or modify it in any way.
- Do not use the logo in conjunction with any other symbol or shape or enclose it in any shape.
- Do not use the logo in a sentence or catchphrase.

2/ Use specified colors only.

3/ Position it on applications as per specifications in the identity manual. Consistent placement in and across layouts adds recognition.

4/ Separate the logo or signature from all other text and visuals using the specified area of isolation.

5/ Use specified typeface(s) and cases. Use only the typeface(s) designated by the identity manual. Usually, there are designations for primary and secondary typefaces, as well as alternative faces; follow type specifications for web text.

6/ Use specified signatures to link the logo or signature to descriptors, taglines, product name, title, or core attribute.

7/ Limit the number of times a logo appears on any one surface (to one).

8/ To protect a trademark, correctly utilize symbols: ™ and ®.

FIG. **10** / **07**

IDENTITY AND IDENTITY MANUAL: HUBBARD STREET DANCE CHICAGO

· LISKA + ASSOCIATES, CHICAGO
· CREATIVE DIRECTOR: STEVE LISKA
· ART DIRECTOR: KIM FRY
· DESIGNERS: STEVE LISKA, CAROLE MASSE
· CLIENT: HUBBARD STREET DANCE CHICAGO
· © LISKA + ASSOCIATES

For over 28 years, Liska has helped Hubbard Street Dance Chicago define and evolve their brand from their origin as a local dance troupe into an internationally acclaimed performance company with multiple business units. As Hubbard Street grew in size, scope and recognition, we've developed its identity and branding program to reflect the level of sophistication, energy, and dynamic audience experience the company delivers.

Each season, Liska designs materials that present the recognizable Hubbard brand, while also showcasing the varied highlights from the new season. Our seasonal design sets the visual and verbal brand direction for Hubbard's marketing materials that are produced by multiple international presenters.

As part of the program, we've developed online brand guidelines that are used globally to ensure that the company projects a consistent image and message, even when multiple presenters and vendors are producing marketing materials.

This design look was applied to a stationery program, corporate capabilities brochure, and marketing folder.
 —Liska + Associates

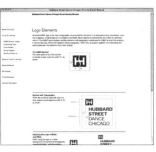

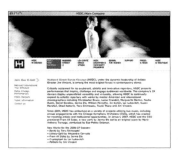

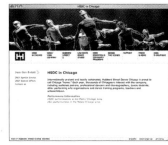

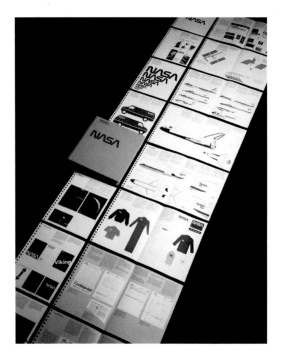

FIG. **10** / **08**

LOGO/DESIGN PROGRAM: NASA

· DANNE & BLACKBURN INC. (NOW DEFUNCT)
· DESIGN DIRECTOR: RICHARD DANNE
· CLIENT: NATIONAL AERONAUTICS AND SPACE ADMINISTRATION, WASHINGTON, DC
· MATERIAL SUPPLIED BY RICHARD DANNE, PARTNER, DANNE DESIGN, NAPA, CA
· A U.S. GOVERNMENT AGENCY DEDICATED TO AERONAUTICS RESEARCH AND SPACE EXPLORATION, NASA IS HEADQUARTERED IN WASHINGTON, DC, WITH TEN INDIVIDUAL CENTERS ACROSS THE NATION.

The firm of Danne & Blackburn Inc. was selected to develop and design a unified visual communications program for the agency. The acronym NASA was more recognizable than either the full name or its previous symbol. Building on this, the NASA logotype was developed. A system was devised that incorporates the logotype and sets standard configurations for the full agency name and the various centers. This program was honored with one of the first Presidential Awards for Design Excellence.
 —Richard Danne, Partner, Danne Design

the logo need to refer to the standards manual. Maintaining standards helps guard, maintain, and build brand equity, as Figure 10-07 and Figure 10-08 illustrate.

WHAT IS A LOGO?

A logo is the single graphic design application that will be a part of every other brand design application. It is the signifier. It is the identifier. It is the two-second "label" or alarm screaming out which brand or company or person or entity you are dealing with. It carries enormous weight and significance and is the keystone of any graphic design plan.

A **logo** is a unique identifying symbol. Stemming from the word *logotype*, "logo" is the most commonly accepted term; it is also called a symbol, mark, brandmark, identifier, logotype, or trademark. Providing immediate recognition, a logo represents and embodies everything a brand, group, or individual signifies. (See "Case Study: Saks Fifth Avenue.") Most often, a logo is part of a broader identity design project. (Again, many use the terms *visual identity*, *brand identity*, and *branding* interchangeably.)

With one glance, the average person should be able to recognize and assess a brand or group by looking at its logo. If you shop for athletic footwear, you need only see the logo to know a lot about the shoe—who manufactures it, the quality, the price range, and perhaps even which athletes endorse that brand. Many logos, such as Nike™ and Puma™, are instantly recognizable. Not only does the logo serve as a label, it also conveys a message about the brand's image and quality, one that is reinforced through marketing, packaging, advertising, the communities who adopt it, customer relations management, and product performance.

As with an entire visual identity, there are various purposes for logo projects:
› Logo for a new entity
› Redesign of an existing logo for revitalization, to stay relevant in the marketplace (Figure 10-09)
› Redesign of an existing logo to redefine an existing brand, aiming at a different audience, or to reposition the brand for a new audience

› Logo for a merger of two brands or groups when companies or groups discard existing logos in favor of a newly designed one representing the merger while retaining some equity.

LOGO CATEGORIES

A logo can take various forms and combinations; it can be a wordmark, lettermark, symbol mark, combination mark, or emblem.
› **Logotype** (also called **wordmark**): the name is spelled out in unique typography or lettering (Figures 10-10 through 10-14).
› **Lettermark**: the logo is created using the initials of the brand name (Figures 10-15 through 10-18).
› **Symbol**: a pictorial, abstract, or nonrepresentational visual.
› **Pictorial symbol**: a *representational* image, resembling or referring to an identifiable person, place, activity, or object (Figures 10-19 through 10-21).
› **Abstract symbol**: a simple or complex rearrangement, alteration, or distortion of the representation of natural appearance, used for stylistic distinction and/or communication purposes (Figures 10-22 through 10-25).
› **Nonrepresentational** or **nonobjective** symbol: purely invented and not derived from anything visually perceived; it does not relate to any object in nature. It does not literally represent a person, place, or thing (Figures 10-26 through 10-29).
› **Character icon**: a character trademark that embodies the personality of a brand, cause, or group, such as The Maytag Repairman™ (Maytag washers and dryers), Energizer Bunny™ (Eveready Energizer batteries), Aflac Duck™ (Aflac Insurance), Rosie the Riveter (recruitment of women into the workforce during WWII) (Figure 10-30), and Smokey the Bear™ (fire prevention). One of the purposes of character icons, such as Pillsbury's Doughboy™ or Miss Chiquita Worldwide Personality™ (see Figure 9-01) is to create a "face" for a product, service, or group.
› **Combination mark**: a combination of words and symbols (Figures 10-31 through 10-37).
› **Emblem**: a combination of words and visuals that are always seen together, never separated (Figures 10-38 through 10-45).

FIG. **10** /**09**

IDENTIFICATION AND BRANDING: THE AMERICAN INSTITUTE OF GRAPHIC ARTS (AIGA)

· SIGNATURE AND SYMBOL: AIGA—NATIONAL

· CROSBY ASSOCIATES, CHICAGO

· CLIENT: AMERICAN INSTITUTE OF GRAPHIC ARTS (AIGA)

· *SYMBOL AND SIGNATURE, SIGNAGE*

· CREATIVE DIRECTOR/ART DIRECTOR/DESIGNER: BART CROSBY

· *IDENTITY STANDARDS*

· CREATIVE DIRECTOR/ART DIRECTOR: BART CROSBY

· DESIGNER: MALGORZATA (GOSIA) SOBUS

The American Institute of Graphic Arts (AIGA) experienced substantial growth during the last decade. While it had historic brand equity, Crosby Associates was engaged by this association of designers and branding professionals to strengthen its logo and develop identity guidelines which would assure visual consistency when many independent designers were creating materials that personified the brand. The result was a quantum increase in awareness of AIGA without increasing products or services.

 —Crosby Associates

American Institute of Graphic Arts

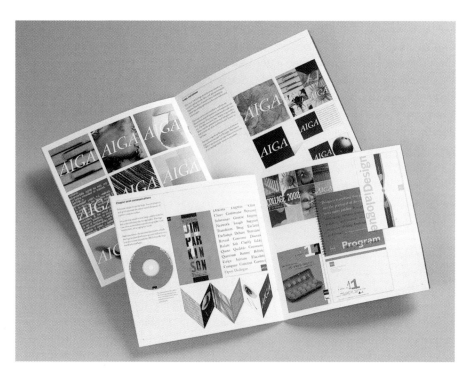

LOGO CATEGORIES: LOGOTYPE

FIG. **10**/**10**

FIG. **10**/**11**

dwell

FIG. **10**/**12**

FIG. **10**/**13**

NEXTLEVEL

FIG. **10**/**14**

FIG. **10** / **10**

LOGO: RESTAURANTE BRASIL

· DESIGN/CUSTOM TYPE: MARTIN HOLLOWAY GRAPHIC DESIGN, PITTSTOWN, NJ
· CLIENT: RESTAURANTE BRASIL, MARTINSVILLE, NJ

FIG. **10** / **11**

LOGO: SUNPARK

· GEORGE TSCHERNY, INC., NEW YORK
· CLIENT: SUNPARK

SUNPARK is a company offering parking facilities, mostly adjacent to airports. Hence the "P" in a red circle, which is the universal symbol for parking.
 —George Tscherny

FIG. **10** / **12**

LOGO: DWELL

· MIKE PERRY

FIG. **10** / **13**

LOGO: THE BEVERLY HILLS HOTEL

· REGINA RUBINO / IMAGE: GLOBAL VISION, SANTA MONICA
· CREATIVE DIRECTOR/DESIGN DIRECTOR: REGINA RUBINO
· DESIGNERS: JAVIER LEGUIZAMO, CLAUDIA PANDJI
· CLIENT: THE BEVERLY HILLS HOTEL

FIG. **10** / **14**

LOGO: NEXTLEVEL

· CROSBY ASSOCIATES, CHICAGO
· CLIENT: NEXT LEVEL SYSTEMS, INC.
· *SIGNATURE*
· CREATIVE DIRECTOR/ART DIRECTOR/DESIGNER: BART CROSBY

FIG. **10**/**15**

LOGO: *ELECTRICAL DIGEST*

- BERNHARDT FUDYMA DESIGN GROUP, NEW YORK
- DESIGNER: CRAIG BERNHARDT
- CLIENT: ELECTRICAL DIGEST

FIG. **10**/**16**

SYMBOL: APPLICATION ON METERS

- CROSBY ASSOCIATES, CHICAGO
- CREATIVE DIRECTOR/ART DIRECTOR/ DESIGNER: BART CROSBY
- CLIENT: BADGERMETER INC.

FIG. **10**/**17**

LOGO: TIHANY DESIGN

- MIRKO ILIĆ CORP, NEW YORK

FIG. **10**/**18**

LOGO: ZORAN DJINDJIC FUND

- MIRKO ILIĆ CORP, NEW YORK

FIG. **10**/**19**

LOGO: LETTER GRAFIX

- RED FLANNEL, FREEHOLD, NJ
- CD/DESIGNER/ILLUSTRATOR: JIM REDZINAK

FIG. **10**/**20**

LOGO: THE ORPHAN SOCIETY OF AMERICA

- MIRKO ILIĆ CORP, NEW YORK

FIG. **10**/**21**

LOGO: ACORN: A COMMUNITY RESOURCE NETWORK

- HARP & COMPANY GRAPHIC DESIGN, HANOVER, NH
- FOR MORE INFORMATION FROM HARP & COMPANY, PLEASE VISIT ⬛.

LOGO CATEGORIES: LETTERMARK

FIG. **10**/**15**

FIG. **10**/**16**

FIG. **10**/**17**

FIG. **10**/**18**

LOGO CATEGORIES: PICTORIAL SYMBOLS

FIG. **10**/**19**

FIG. **10**/**20**

FIG. **10**/**21**

LOGO CATEGORIES: ABSTRACT SYMBOLS

OCEAN
COUNTY COLLEGE

FIG. **10**/**22**

Firmenich
Experts in Citrus™

FIG. **10**/**23**

FIG. **10**/**24**

FIG. **10**/**25**

FIG. **10**/**22**

LOGO: OCEAN COUNTY COLLEGE

· RED FLANNEL, FREEHOLD, NJ
· CREATIVE DIRECTOR: JIM REDZINAK
· DESIGNER/ILLUSTRATOR: MICHELE KALTHOFF
· CLIENT: OCEAN COUNTY COLLEGE

FIG. **10**/**23**

IDENTITY: FIRMENICH EXPERTS IN CITRUS™

· LAVA DOME CREATIVE, BOUND BROOK, NJ
· CREATIVE DIRECTOR/DESIGNER: MICHAEL SICKINGER
· CLIENT: FIRMENICH INC.
· © FIRMENICH INC.

FIG. **10**/**24**

LOGO AND PRELIMINARY LOGOS: IASIAWORKS

· GEE + CHUNG DESIGN, SAN FRANCISCO
· CREATIVE DIRECTOR/ART DIRECTOR: EARL GEE
· DESIGNERS: EARL GEE, FANI CHUNG
· ILLUSTRATOR: EARL GEE

An Asian-focused web hosting company combines a classic Asian motif with an integrated circuit, conveying connection, integration, and the linking of cultures through technology.
—Earl Gee (Please see Chapter 12 for the entire iAsiaWorks program.)

FIG. **10**/**25**

LOGO: KHAWACHEN, PIONEERS OF TIBETAN RUGS

· HARP AND COMPANY GRAPHIC DESIGN, HANOVER, NH
· CLIENT: KHAWACHEN

Done for recently opened stores in Hanover, New Hampshire; Lhasa, Tibet; and Manchester Center, Vermont. The black mountain shape is meant to be suggestive of Tibetan calligraphy, while also symbolizing The Land of Snows (the meaning of Khawachen). The stylized clouds are reminiscent of cloud motifs that commonly appear in Tibetan rugs.
—Doug Harp

FIG. 10 / 26

LOGO: MVP ARCHITECTURE

- GARDNER DESIGN, WICHITA
- CREATIVE DIRECTOR: BILL GARDNER
- ART DIRECTOR: LUKE BOTT

FIG. 10 / 27

LOGO: ART CENTER COLLEGE OF DESIGN ALUMNI COUNCIL

- GEE + CHUNG DESIGN, SAN FRANCISCO
- CREATIVE DIRECTOR/ART DIRECTOR/ DESIGNER/ILLUSTRATOR: EARL GEE

An alumni council of a design school known for its orange dot symbol forms a circle of creative individuals linked by a common experience, sense of connection, community, support, and unity.
—Earl Gee

FIG. 10 / 28

LOGO: HUNTER CONSULTING

- RED FLANNEL, FREEHOLD, NJ
- CREATIVE DIRECTOR/DESIGNER/ ILLUSTRATOR: JIM REDZINAK
- CLIENT: HUNTER CONSULTING

FIG. 10 / 29

SYMBOL

- SEGURA INC., CHICAGO
- CLIENT: LIGHTFLOW

FIG. 10 / 30

ADVERTISEMENT: WOMEN IN WAR JOBS—*ROSIE THE RIVETER* (1942–1945)

- SPONSORS: OFFICE OF WAR INFORMATION, WAR MANPOWER COMMISSION
- VOLUNTEER AGENCY: J. WALTER THOMPSON

LOGO CATEGORIES: NONOBJECTIVE SYMBOLS

FIG. 10 / 26

FIG. 10 / 27

Hunter Consulting

FIG. 10 / 28

lightflow®

FIG. 10 / 29

LOGO CATEGORIES: CHARACTER ICON

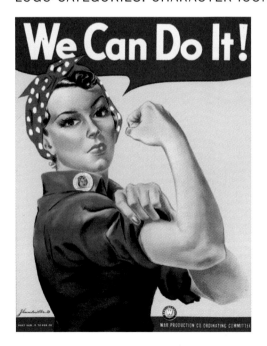

FIG. 10 / 30

LOGO CATEGORIES: COMBINATION MARK

FIG. 10 /31

Plungees™

FIG. 10 /32

PERKS
COFFEE & MORE

FIG. 10 /33

TransLink

FIG. 10 /34

FIG. 10 /35

FIG. 10 /36

South Royalton School

FIG. 10 /37

FIG. **10** /**38**

LOGO: WATCH CITY BREWING CO.

· PENTAGRAM DESIGN LTD.
· PARTNER/DESIGNER: WOODY PIRTLE
· ART DIRECTOR: JOHN KLOTNIA
· DESIGNER: SEUNG IL CHOI
· CLIENT: FRANK MCLAUGHLIN

Watch City Brewing Co. is an upscale, 180-seat restaurant microbrewery located in the Boston suburb of Waltham, MA, the so-called Watch City for its turn-of-the-century production of world-famous watches and clocks.

The logo is an engraving of an old watch filled with beer. The time reads after five, when the workday ends and people stop watching the clock, relax, and have a beer.

FIG. **10** /**39**

LOGO: AMMI

· ALEXANDER ISLEY INC., REDDING, CT
· CLIENT: AMERICAN MUSEUM OF THE MOVING IMAGE

The client is the American Museum of the Moving Image, which is a very long name, so we came up with a shorter symbol for the museum. We did not want to use a cliché film symbol. We looked at more than one hundred eyes before we settled on the one we liked best.
—Alexander Isley

FIG. **10** /**40**

LOGO

· IDEOGRAMA, MEXICO
· CLIENT: MR

FIG. **10** /**41**

LOGO: RUSK RENOVATIONS

· LOUISE FILI LTD., NEW YORK
· CREATIVE DIRECTOR/ART DIRECTOR: LOUISE FILI
· DESIGNERS: LOUISE FILI AND JESSICA HISCHE
· CLIENT: RUSK RENOVATIONS INC.

For renovation professionals, the pencil emblem, with the phone number nested into the worn-wood ruler, conjures the kind of conscientious craftsmen you want working on your home.

FIG. **10** /**42**

PACKAGING: BELAZU

· TURNER DUCKWORTH, LONDON AND SAN FRANCISCO
· CREATIVE DIRECTORS: DAVID TURNER, BRUCE DUCKWORTH
· DESIGNER: JANICE DAVISON
· CLIENT: THE FRESH OLIVE COMPANY
· © 2008 TURNER DUCKWORTH, LLC

LOGO CATEGORIES: EMBLEM

FIG. **10** /**38**

FIG. **10** /**39**

FIG. **10** /**40**

FIG. **10** /**41**

FIG. **10** /**42**

LOGO CATEGORIES: EMBLEM

FIG. 10 / 43

VIX VIX

FIG. 10 / 44

FIG. 10 / 45

FIG. 10 / 43

BESPOKE

· LOUISE FILI LTD., NEW YORK
· CREATIVE DIRECTOR/ART DIRECTOR/
 DESIGNER: LOUISE FILI

FIG. 10 / 44

LOGO: VIX RESTAURANT

· MIRKO ILIĆ CORP, NEW YORK

FIG. 10 / 45

**LOGO: MUZEJ ISTORIJE JUGOSLAVIE
(MUSEUM OF THE HISTORY OF
YUGOSLAVIA)**

· MIRKO ILIĆ CORP, NEW YORK

DESIGNING A LOGO

As with designing visual identity or any design project, the standard process for designing a logo is shown in the following diagram.

Orientation ▶ Analysis ▶ Concepts ▶ Design ▶ Implementation

CONCEPTUAL DESIGN

For branding and logo development, some clients provide a **brand brief**, a document defining the brand essence, the construct, what the brand represents. (More often, the information from the brand brief is incorporated into a design brief or creative brief, forming one document.) A brand brief is used in conjunction with a design brief; together they address strategy, used as a platform for concept generation.

Once in the conceptual design phase of the design process, generating design concepts for a logo depends, in part, on a designer's ability to compress and condense meaning and complexity into one small unit, a unit that will have to *endure* for years (if not decades), function, and be integral to every visual communication for that entity. As Gui Borchert, associate creative director at Syrup, says, "A logo is the smallest canvas for story telling." A logo must be driven by a design concept, the driving idea underpinning *what and how* you

are depicting it; *and*, that concept is based on the brief and brand strategy. It bears repeating—you must condense a great deal of meaning into one mark that will distinguish and differentiate an entity in a crowded commercial or nonprofit sphere. In Figure 10-46, Filip Blažek's design concept for D-dur, a digital radio station streaming classical music, is visualized with "a handwritten typeface standing for tradition, while the tilde with gradient symbolizes the continuous stream of music. It is a connection between the history and the future."

As you've learned, the design process is often nonlinear, relying on iterations, evaluating iterations, moving on those, and then perhaps cycling back to other ideas. During visualization and composition, through the sketching process, ideas can transform or evolve.

Figure 10-47, the logo for VisionSpring, illustrates this evolution. VisionSpring is a nonprofit enterprise that helps local entrepreneurs in poor countries provide eyeglasses in their communities, thereby stimulating the local economy and reducing poverty. Bryony Gomez-Palacio and Armin Vit of UnderConsideration worked closely with the VisionSpring team as well as their brand consultants, ?What If!, who helped them develop a brand positioning, mission, and values. Armin Vit comments, "Through the positioning of "See

FIG. **10** /**46**

LOGOTYPE AND RUNNER-UP: D-DUR

· DESIGNIQ, CZECH REPUBLIC
· DESIGNER: FILIP BLAŽEK
· CLIENT: CZECH RADIO

The colors used respect the color guideline for Czech radio. While designing the logotype, I was sure it would win. The concept of a simple form, a hidden connection to a logotype of another classical music station of Czech radio, and a surprising form of the letter 'd' (not very common in Czech hand writing), it all led to the satisfaction of the client. Although I preferred a more typographic version with classical roman typeface instead of a script.
—Filip Blažek

FIG. **10** /**47**

LOGO AND RUNNER-UPS: VISIONSPRING

· UNDERCONSIDERATION LLC, AUSTIN
· DESIGN: BRYONY GOMEZ-PALACIO, ARMIN VIT
· CLIENT: VISIONSPRING

(Figure 10-49). For the New Museum (Figure 10-50), Wolff Olins' website describes their design approach: "In a city over-saturated with cultural institutions, we faced an exciting challenge: To create a brand that would drive the museum's vision and ambition to become a world player in contemporary art and a first-choice 21st-century cultural destination.

"Based on the idea of 'New Art and New Ideas,' our first step was to simplify the name to loosen up the museum's institutional feel. More importantly, to broaden their scope from the narrow definitions of an art museum to becoming recognized as a cultural hub."

VISUAL BRIEF COLLAGE BOARD
A visual brief collage board is a visual way of determining strategy and a construct; also called a visual positioning collage. It will help you visualize the entity's essence, personality, color palette, and how all that might be compressed into a unit.

Well. Do Well." we developed an icon that would represent the economic and social ripple effect that the VisionSpring model fosters: Empowering their global network to deliver reading glasses at the local level, effecting broad changes from a central idea."

START WITH THE NAME
The brand's name is a good starting point for conceptualization. In the chapter on branding, we looked at categories of brand names. Because of their creative nature, invented and symbolic names more easily lend themselves to visualization than do founders' names. Similarly, some names point to intuitive solutions, where the name itself *could* inherently solve the logo problem—for example, Apple computer or Summit, an American brasserie designed by architect Adam D. Tihany with identity design by Mirko Ilić (Figure 10-48). For One Laptop per Child (OLPC), Michael Gericke of Pentagram chose to depict the name

FIG. **10** /**48**

IDENTITY: SUMMIT RESTAURANT

· MIRKO ILIĆ CORP., NEW YORK

FIG. **10** /**49**

LOGO: OLPC

· PROJECT: ONE LAPTOP PER CHILD IDENTITY
· MICHAEL GERICKE / PENTAGRAM
· DESIGN: MICHAEL GERICKE / PENTAGRAM
· CLIENT: ONE LAPTOP PER CHILD
 FOUNDATION

**NEW
235 BOWERY
NEW YORK NY
10002 USA
MUSEUM**

**NEW
WE STAND FOR NEW ART
AND NEW IDEAS THAT
CHALLENGE AND AWAKEN
MUSEUM**

**NEW
WE, UNLIKE ANY OTHER
MUSEUM, HAVE AN
OPPORTUNITY TO REINVENT
OURSELVES EVERYDAY
MUSEUM**

FIG. **10** /**50**

IDENTITY SYSTEM: NEW MUSEUM

· WOLFF OLINS, NEW YORK
· CLIENT: NEW MUSEUM, NEW YORK

Action: *In an exciting collaboration with the museum, we created a visual expression and identity system that features a spectrum of color and language with a logo that moves and flexes, literally, to welcome new artists and audiences, and announce new art and the new museum.*

Impact: *The identity system—instantly recognizable and constantly renewable—opens the doors to future creative collaborations and invites in new art and new ideas. Since the launch, foot traffic is up 600% and new membership is up 400%.*
—Wolff Olins

Using a visual brief collage board is a great starting point for visualization, in particular for logo design, since a collage board should encompass the general look, mood, personality, colors, imagery, and perhaps typefaces; essentially it could replace a brand brief.

Some people confuse the purpose of a visual brief collage board with a mood board. A visual brief replaces a written design brief and/or brand brief, used to determine strategy before concept generation. A mood board is created and utilized after concept generation, to help focus and indicate the visual characteristics, as well as emotional and contextual aspects of the design concept. It is also used as a guide for the design team and the client, a tool to exemplify the look, feel, and emotional tone of the concept.

LOGO DESIGN DEVELOPMENT
Two main goals during conceptualization, visualization, and composition are to meaningfully differentiate the brand and to do so in a form that has impact.

A logo should be synonymous in meaning with the entity it represents as well as be unique, memorable, and recognizable at a glance, just the way that the Nike swoosh, the Mercedes symbol, the American Red Cross's red cross, and the BP flower have become their respective brands' avatars.

While awareness of O-Cel-O™ was high compared with competitive cleaning products, consumers were having difficulty recognizing the logo mark. 3M enlisted Wallace Church to help better communicate O-Cel-O's colorful and optimistic brand essence. Lowercase letters within a soft, rounded holding shape are used to signal a younger, more playful experience (Figure 10-51). Clean, vibrant colors speak to the efficacy of the product. The addition of a "smile" below the "l" gives the logo a more proprietary shape while further expressing the brand's cheerful personality.

FIG. **10** /**51**

IDENTITY: O-CEL-O™

· WALLACE CHURCH, INC., NEW YORK
· CREATIVE DIRECTOR: STAN CHURCH
· DESIGN DIRECTOR: HEATHER ALLEN
· DESIGNER: HEATHER ALLEN
· CLIENT: O-CEL-O, 3M COMPANY

CASE STUDY

SAKS FIFTH AVENUE / MICHAEL BIERUT / PENTAGRAM

A new identity designed by Pentagram for iconic New York retailer Saks Fifth Avenue launched on January 2, 2007. Partner Michael Bierut describes the process behind the development of an identity with more variations than there are electrons in the known universe:

Saks approached us in 2004 about designing a new identity for their stores, seeking a graphic program that would encompass signage, advertising, direct mail, online and, most importantly, packaging.

We understood quickly that this was more than a logo design project. The current Saks logo . . . had been in use since the mid-nineties, but had done little to create a profile for the brand, particularly as part of a gray-on-gray packaging program that was recessive to say the least. Terron Schaefer and the leadership at Saks were looking for something that could be ubiquitous and iconic, immediately identifiable when glimpsed across a busy street. But, unlike Tiffany, the store has never had a signature color; unlike Burberry, no signature pattern. On the contrary, examining their history we found the store had used literally dozens of logos since its founding.

There was one interesting fact, however. Many of these logos were variations on the same theme: cursive writing, sometimes casual, sometimes Spencerian.

Of these, one stood out, the logo drawn in 1973 by Tom Carnese, adapted from a signature introduced almost twenty years before. In many people's minds, this still *was* the Saks logo. By coincidence, I knew it well: it was the logo that was at the heart of the identity system designed by my first boss, Massimo Vignelli, shortly before I started working for him in 1980.

But simply reinstating a 30-year-old logo wouldn't be enough. Saks was happy to emphasize its heritage, but it was even more eager to signal that it was looking to the future, a place of constant change and surprise with a consistent dedication to quality. In our early creative sessions at Saks, we'd gathered a lot of visual inspiration. The team kept coming back to the boldness of artists like Franz Kline and Barnett Newman. Was there a way to get that kind of dramatic scale and energy into the program?

We were excited when we finally hit on the solution. We took the cursive logo, redrew it with the help of font designer Joe Finocchiaro, and placed it in a black square. Then, we subdivided that square into a grid of 64 smaller squares.

The 64 tiles can then be shuffled and rotated to form an almost infinite number of variations. We say *almost* infinite, but obviously there's a fixed number of possibilities. Curious about what that might be, we consulted a friend who's a graduate student in theoretical physics at Yale. He calculated that the number of possible configurations is in fact 98,137,610,226,945,526,221,323,127, 451,938,506,431,029,735,326,490,840,972,261, 848,186,538,906,070,058,088,365,083,852,800, 000,000,000. He helpfully pointed out that this is nearly 100 googols (a googol is a 1 with 100 zeros after it), and many times the number of electrons in the known universe.

Most of the individual logo tiles are quite lovely in their own right, and within the system can be used in various combinations to form still more abstract compositions. Each of these suggests within its details the graphic character of the new logo. Enlarged, they have a kind of energy and drama that contrasts nicely with the original mark from which they were derived.

The advantage of the program, deployed in black and white like the store's holiday "snowflake" packaging, is that it creates recognizable consistency without sameness. The logo elements will be used in signage and direct mail and advertising. Most importantly, there are over forty different packages in the program, from jewelry boxes to hat boxes, and four sizes of shopping bags. In the new program, no two of these are alike, yet they all go together. Our hope is that they will all become associated in the minds of shoppers with the style and élan of Saks Fifth Avenue.

—http://pentagram.com/en/new/2006/12/ new-work-saks-fifth-avenue.php

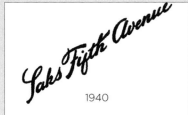

1940

1946

1955

1955

1973

SAKS
FIFTH
AVENUE

1997

2007

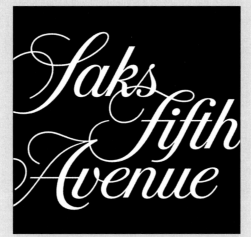

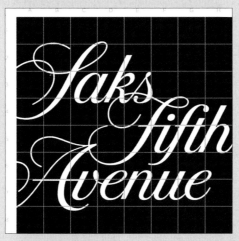

IDENTITY: SAKS FIFTH AVENUE

· MICHAEL BIERUT / PENTAGRAM, NEW YORK
· PHOTOGRAPHY: COURTESY OF SAKS FIFTH AVENUE
· CLIENT: SAKS FIFTH AVENUE

LOGO FORMAT:
A COMPOSITIONAL UNIT

As a compositional unit, a logo must be independent, able to stand on its own, since it is incorporated into many other applications, including print advertising as part of the sign-off, in television commercials (usually in the last frame), on all print applications such as corporate communications, CDs, posters, and packaging, in most digital applications (websites, mobile, kiosks), and so on.

In *2D: Visual Basics for Designers*, Professor Rose Gonnella states that logo designs are "compositional microcosms, which may be studied for their economical precision in arrangement of shapes." By nature of its application, a logo must communicate broad ideas and meanings in a very limited compositional space. Visualizing a logo as a "compositional microcosm" entails ensuring unity and a visual hierarchy that contributes to making a logo memorable and stable. At times, more information than you might think has to be embedded into a logo, as for Polly-O in Figure 10-52.

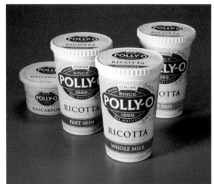

FIG. 10 / 52

IDENTITY: POLLY-O (BEFORE AND AFTER)

· AFTER CREDITS:
· WALLACE CHURCH, INC., NEW YORK
· CREATIVE DIRECTOR: STAN CHURCH
· DESIGN DIRECTOR: STAN CHURCH, NIN GLAISTER
· DESIGNER: JOHN BRUNO
· CLIENT: POLLY-O, POLLIO DAIRY PRODUCTS

Logo Format: A Self-Contained Unit versus Free-Form Unit

Self-contained unit: We can start by thinking of a logo format as a closed unit based on one of several basic shapes: circle, square, or triangle (Figures 10-53 through 10-55). Any of these three shapes can define a symbol's or logo's boundaries.

We can extend logo formats to include organic, rectilinear, curvilinear, irregular, and accidental shapes or recognizable closed shapes (flower, human form, star, tree, lotus bud) as units that can become the logo's boundaries (Figures 10-56 and 10-57).

Breaking the unit: Shapes, letterforms, or forms within a logo unit can break through the boundaries yet maintain the gestalt, the appearance of the original unit shape. Think of how a block of marble is transformed into a sculpture. A sculptor chisels away at the solid block to create forms. Some marble sculptures stay close to the original block form; others seem to break away from the original form, seeming to belong far less to the original block (Figures 10-58 through 10-61).

Free-form: Another approach to logo composition is to consider a logo unit as a free-form shape or combined free-form shapes—not contained by a rigid outer definable shape boundary (circle, square, rectangle, triangle, or trapezoid) or format, *but still* a unit that is independent, that can stand on its own and be incorporated into other applications. The design should hold together as a whole, stable unit (Figures 10-62 through 10-64).

Many logos are a formalized combination of two elements: a symbol plus brand name, which is called a **signature**. A signature may also be a combination of three unique elements: a symbol, the brand name, and the tagline or a descriptor (or a number of business lines or divisions). This prescribed juxtaposition is a composition in itself, with proscribed guidelines for an area of isolation (empty space surrounding the signature), to protect the integrity of the mark so that no other information is positioned in its zone. A signature can be designed in a vertical composition or a horizontal composition, or both. In Figure 10-65, the identity for Captive Resources by Crosby

LOGO FORMAT: SELF-CONTAINED UNIT

FIG. **10** / **53**

FIG. **10** / **54**

Alloyd Brands

FIG. **10** / **55**

FIG. **10** / **56**

FIG. **10** / **57**

FIG. **10** / **53**

LOGO: WRITER'S CIRCLE

· CREATIVE DIRECTOR/DESIGNER: CHRIS HERRON
· CLIENT: WRITERS' CIRCLE

Writers' Circle is a group created to promote creative writing.
 Sometimes, you get lucky and the very first sketched concept ends up being the final mark. This was one of those rare cases. The capital "W" has inherent shape characteristics that allow combination with graphic elements; in this case, punctuation symbols.
 —Chris Herron

FIG. **10** / **54**

LOGO: WOLFGANG PUCK BAR & GRILL

· DESIGN: REGINA RUBINO / IMAGE: GLOBAL VISION, SANTA MONICA
· CREATIVE DIRECTOR: ROBERT LOUEY
· DESIGNER: JAVIER LEGUIZAMO
· CLIENT: WOLFGANG PUCK BAR & GRILL

FIG. **10** / **55**

LOGO: ALLOYD BRANDS

· MOVÉO INTEGRATED BRANDING
· CREATIVE DIRECTOR: ANGELA COSTANZI
· DESIGNER: CHRIS HERRON

Alloyd Brands are makers of high visibility custom-engineered packaging for the retail consumer market. The former logo did not represent the fact that the company had become a dynamic and innovative market leader. This gestural monogram mark was developed to represent a sense of protection and dynamism, and to give the firm a potent, memorable symbol.
 —Chris Herron

FIG. **10** / **56**

LOGO: MERMAID INN

· LOUISE FILI LTD., NEW YORK
· CREATIVE DIRECTOR/ART DIRECTOR/DESIGNER: LOUISE FILI
· ILLUSTRATOR: ANTHONY RUSSO
· CLIENT: MERMAID INN

Although the silhouette communicates quickly, white line is used to further describe the mermaid, as well as for the lettering of the name.

FIG. **10** / **57**

LOGO: NEW YORK LIFE SALES PROGRAM

· CREATIVE DIRECTOR: BETH FAGAN
· DESIGNER: CHRIS HERRON

This mark was created as a symbol for the biannual sales conference of New York Life's Investment Management group. After considering many different metaphorical marks, the stylized lotus bud was developed as a symbol of the generation of new sales opportunities.

LOGO FORMAT: BREAKING THE UNIT

FIG. 10 /58

LOGO: SPREAD LOUNGE

· MIRKO ILIĆ CORP, NEW YORK

FIG. 10 /59

LOGO: SPIRIT AEROSYSTEMS

· GARDNER DESIGN, WICHITA
· CREATIVE DIRECTOR: BILL GARDNER
· ART DIRECTOR: LUKE BOTT
· CLIENT: SPIRIT AEROSYSTEMS

FIG. 10 /60

LOGO: CESSNA CITATION SERVICE CENTER

· GARDNER DESIGN, WICHITA
· CREATIVE DIRECTOR: BILL GARDNER
· ART DIRECTOR: LUKE BOTT
· CLIENT: CESSNA CITATION SERVICE CENTER

FIG. 10 /61

IDENTITY: INTERACCESS

· UNDERLINE STUDIO, TORONTO
· CREATIVE DIRECTORS: FIDEL PENA, CLAIRE DAWSON
· DESIGNER: FIDEL PENA
· CLIENT: INTERACCESS ELECTRONIC MEDIA ARTS CENTRE

FIG. 10 /62

LOGO: CIRCFOCUS

· STEVEN BROWER DESIGN, MATAWAN, NJ
· DESIGNER: STEVEN BROWER
· CLIENT: CIRCFOCUS
· © STEVEN BROWER

FIG. 10 /63

LOGO: HOUSING WORKS

· NUMBER 17, NEW YORK
· CLIENT: HOUSING WORKS

FIG. 10 /64

LOGO: BYADER

· BRANDCENTRAL
· CREATIVE DIRECTOR: MERALE TOURBAH
· DESIGNER: CHRIS HERRON

FIG. 10 /58

FIG. 10 /59

FIG. 10 /60

FIG. 10 /61

LOGO FORMAT: FREE-FORM

FIG. 10 /62

FIG. 10 /63

FIG. 10 /64

CAPTIVE RESOURCES

FIG. **10** / **65**

IDENTITY: CAPTIVE RESOURCES

· CROSBY ASSOCIATES, CHICAGO
· CLIENT: CAPTIVE RESOURCES, LLC
· *SIGNATURE AND SYMBOL, SIGNAGE*
· CREATIVE DIRECTOR/ART DIRECTOR: BART CROSBY
· DESIGNERS: BART CROSBY, JOANNA VODOPIVEC
· *IDENTITY STANDARDS, BROCHURES*
· CREATIVE DIRECTOR/ART DIRECTOR: BART CROSBY
· DESIGNER: JOANNA VODOPIVEC

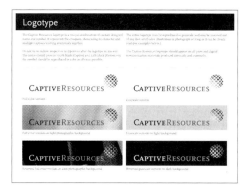

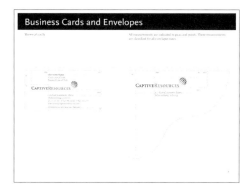

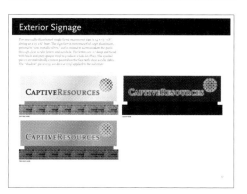

FIG. **10** / **66**

BRAND IDENTITY: SONY ERICSSON

· WOLFF OLINS, NEW YORK

Wolff Olins "developed a vibrant range of colors which stand out and allow the brand to constantly refresh itself."
—http://www.wolffolins.com/ sonyericsson.php

Associates, you can see the symbol alone, with the signature and guidelines for usage. On its website, Captive Resource's symbol is animated, where the dots come together to form the sphere.

For Sony, Wolff Olins helped Sony Ericsson talk to customers about things they love and loved doing (Figure 10-66).

Visualization

A logo has to tell a story; it must communicate meaning—clearly express a voice, communicate an essence. The characteristic manner and/or appearance of all shapes, forms, typefaces, colors,

images, and symbols you utilize contribute to the denotative and connotative meaning. Any resulting characteristic of a design has to do with every decision you make. For the Maharam identity (Figure 10-67), creative director Takaaki Matsumoto explains: "The vertical lines positioned between the letters in the logotype are an abstract suggestion of fabric threads, the core of Maharam's business. When the logotype is printed in yellow and red, the woven effect is strengthened: the red advances in space while the yellow recedes. Other color schemes are used for the logo; which one is used depends on the needs of the application. These colors do not compromise the quality and effect of the logotype.

"Letters and lines combine in the simplest manner for a highly sophisticated logotype. The woven texture effect is not only a result of the placement of lines between the letters, it also arises from the contrast and repetition of the letters within the name *maharam.* This word is structured by alternating consonants and vowels. The letter *m* begins and terminates the word; the letter *a* repeats three times, centered within the word; the *h* and *r* are linked by shared visual attributes. The patterning and grouping of these letters imbue the logotype with a pleasing symmetry. The geometric design of Futura letters contributes to the visual strength of the logotype. For example, the counterform of the *a*, which forms a dot, appears repeated three times in the logotype for an accentuated rhythm."

What might be appropriate for one entity might not be appropriate for another. Should an insurance company and amusement park be represented similarly? How about a nonprofit organization and a commercial one? A logo should express, through visualization and composition, the spirit and purpose of the entity. Every aspect of a logo communicates something about what it represents.

When Professors Rose Gonnella and Martin Holloway, my esteemed colleagues at Kean University, teach logo design, they categorize fundamental ways of depicting shapes or forms for the purpose of visualization.

› *Elemental form:* line or flat tone used to reduce an image or subject to stark simplicity, similar to a pictograph or sign.

› *High contrast*: depiction of forms based on extreme contrast of light and shadow falling on a three-dimensional form (Figure 10-68, Quaker Oats Company logo).

› *Linear*: line used as the main element to depict or describe the shape or form. This can be as simple as a notation or as complex as a full-out rendering.

› *Volumetric*: light and shadow, gradation or modeling used to suggest the illusion of three-dimensional form.

› *Texture or pattern*: line or marks used to suggest form, light, texture, pattern, or tone using hatch, cross-hatch, cross-contour, dots, smudges, and so on.

Line and texture can also conjure or depict the following looks of media or materials:
› Woodcut
› Metal engraving
› Raised metal
› Carving
› Carved ice
› Wood
› Fabric
› Animal skins
› Wire
› Distressed leather
› Handprint
› Clay impression
› Cut paper
› Torn paper
› Brush drawing

Logos can be flat shapes:
› Geometric
› Curvilinear
› Silhouettes
› Closed
› Open

Logos can imply the illusion of three-dimensional form or mass:
› Droplets
› Spirals
› Beveled
› Projections outward or canted
› Appear animated
› Shadows
› Transparent
› Photographic fragments

› Coiled-like
› Cube-like

For more on visualization, please refer to Chapter 5, Visualization.

FIG. **10** / **67**

IDENTITY: MAHARAM

· MATSUMOTO INCORPORATED
· CREATIVE DIRECTOR: TAKAAKI MATSUMOTO
· DESIGNER: TAKAAKI MATSUMOTO

FIG. **10** / **68**

LOGO: QUAKER OATS COMPANY

· USED BY PERMISSION OF THE QUAKER OATS COMPANY

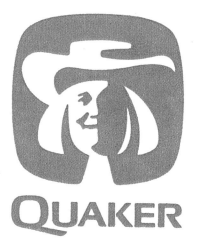

Color

Many brands are synonymous with the color or color palette of their visual identities (think BP's bright yellow/green palette, Dunkin' Donuts' orange and pink, Coca-Cola's red, or IBM's blue). Color contributes to distinction and influencing people's brand perception. Clients often

have specific color notions, as did Jacquelina Di Roberto, founder and owner of The Pink Door (Figure 10-69), who recalled the color pink from her year-long trip to Florence, Italy. People are greatly affected by color, influenced by cultural and psychological color associations. However, color is *culture specific* and should be carefully selected by culture or country. Color plays an important role and it is specified along with other visual identity guidelines. For the San Francisco Zoo, Kit Hinrichs and his team created a color palette of natural earthy and vibrant hues to aid in expressing the design concept for the identity (Figure 10-70). As another example, the Media-FLO color palette "consists of rich jewel tones that convey a sense of style and contemporary sophistication characteristic of the MediaFLO experience" (Figure 10-71).

Keep in mind these basic color considerations for logo and visual identity:

> Choose color or color palette for distinction and differentiation from the competition. Like a construct, a brand should "own" a color.

> Choose wisely for meaning, connotations, and symbolism across cultures.

> Use color to build meaning (as did Tiffany, Coca-Cola, and BP).

> Use color variations in different logos of the same company or brand to represent different operating units or brand extensions

> Ensure color consistency across media and platforms.

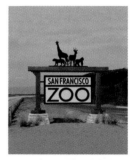

FIG. **10** / **69**

LOGO: PINK DOOR

· LOUISE FILI LTD., NEW YORK
· CREATIVE DIRECTOR/ART DIRECTOR/ DESIGNER: LOUISE FILI
· CLIENT: PINK DOOR

The color was inspired by the owner's trip to Italy, "where the hue was found on the tiles of Brunelleschi's Dome and Della Robbia's works (plus it was the color of her darling Max Mara scarf!). This pink was forever seared into her mind—and subsequently onto the front door of 1919 Post Alley."
 —http://www.thepinkdoor.net/ history.html

FIG. **10** / **70**

IDENTITY: SAN FRANCISCO ZOO

· PENTAGRAM DESIGN LTD., SAN FRANCISCO
· ART DIRECTOR/CREATIVE DIRECTOR: KIT HINRICHS
· DESIGNER: ERIK SCHMITT
· PHOTOGRAPHY: DAVID WAKELY
· CLIENT: SAN FRANCISCO ZOO

The identity communicates the zoo's role as a community organization with a park, nature center, gardens, and bird sanctuary. The new identity also reflects the zoo's commitment to wildlife education and conservation, with a strong, accessible visual language and a color palette of natural, earthy, and vibrant hues.
 —Pentagram Design Ltd.

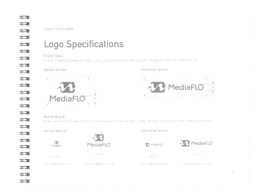

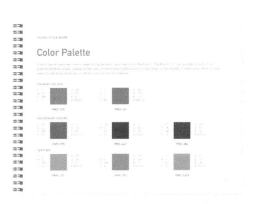

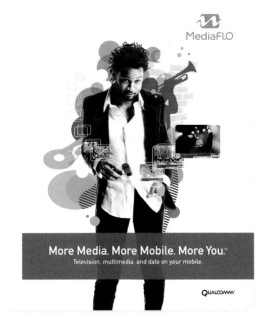

FIG. **10** / **71**

QUALCOMM / MEDIAFLO / QUALCOMM BUSINESS DIVISION

· MIRESBALL, SAN DIEGO
· CREATIVE DIRECTOR: SCOTT MIRES
· ART DIRECTOR: MIGUEL PEREZ
· PROJECT MANAGER: OLIVIA HEEREN
· DESIGNERS: JENNY GODDARD, ASHLEY KERNS
· COPYWRITING: DAVID FRIED
· PHOTOGRAPHY: BIL ZELMAN
· ILLUSTRATION: GARY BENZEL
· STRATEGY: ERIC LABRECQUE, JANELLE MCGLOTHLIN

Scope of Work: *Brand Architectures, Brand Platforms, Messaging, Copywriting, Identities, Visual Systems, Brand Guidelines, Proprietary Imagery, Corporate Communications, Product Literature, Event Environments & Campaigns, Digital Media*

Overview: *For over a decade, MiresBall has helped Qualcomm communicate its forward-looking leadership in wireless communications.*
 Highlights:

· *Shaped the brand strategy and expression of four major Qualcomm business divisions.*
· *Developed MediaFLO brand to support the launch of a $2 billion technology platform.*
· *Repositioned and renamed a core Qualcomm division, now called Qualcomm Enterprise Services.*
· *Communications and design partner for annual BREW conference (see Figure 9-13).*

MediaFLO: *To support the worldwide launch of MediaFLO, MiresBall developed a strategic platform and identity that emphasize the system's technical innovation and media savvy. These brand drivers are expressed through unique user narratives—or "auras"—that illustrate the exciting role digital media plays in everyday life.*
 —MiresBall

Type

Very often, design students choose typefaces, visuals, and graphic elements and forms without fully understanding that each and every typeface and visual element carries a heritage and connotative meaning. A novice often chooses a typeface on a purely personal basis, because he or she likes the look or shape of the face. Choosing a typeface for a logo should be done for its form, appropriateness, and expressive potential, with knowledge of both the denotative meaning and the connotative meaning (heritage, voice, expressive meaning) of the face.

Keep in mind these basic typographic considerations for logo and visual identity:

› Legibility

› Connotation: appropriateness, personality, and expression

 – Uniqueness and distinction (consider a proprietary typeface)
 – Differentiation from competition
 – Select a typeface family for range, flexibility of use, weights, widths, including numerals and bullets
 – Limit number of typefaces in one piece
 – Works in a range of sizes and across all applications (website may require its own font and standards)
 – Works well in black and white and color
 – Choose typeface to complement the logo, not necessarily replicate it

For more on typography, refer to Chapter 3.

Sound and Motion

The interplay between type and visuals in a logo in screen-based media is much the same as for print, except the bonus of sound and motion might add potential for heightened dramatic or comedic effect. To communicate the Intel Inside® in television commercials, Intel added a signature ID audio visual logo, a distinctive and memorable three-second animated jingle, displaying the logo and playing a four-tone melody. According to the Intel website, "Starting in 1995, the now-familiar tone helped cement a positive Intel image in the minds of millions of consumers."

In screen-based media, motion is king. We expect it. Many of us turn off the sound, but we are entertained by animation and motion graphics, as with the logo for Alex Coletti Productions, a TV production company that produces documentaries, television series, halftime shows, and awards programs in the music genre (Figure 10-72).

official or legal. The **letterhead** printed on a sheet of fine paper or viewed as a digital page includes specific content and is part of a broader visual identity system with consistent elements—such as the logo, color palette, and any graphic element or verbal component associated with the brand or brand signature—that allow for identification of the brand.

LETTERHEAD DESIGN PROCESS

As always, any design is based on a design concept. Before you begin the design process, determine how the letterhead will be used (letters, faxes, print or digital, invoices) and if versions (corporate only, executive, divisions, personal) are required; and obtain all required content (company's name, address, telephone and fax numbers, e-mail, and website address, and may include the executive or manager's name, among other content). While developing the design, you should explore paper samples in order to make your paper and envelope selections, as well as determine the production method so that you can guide your visualization process with production parameters in mind.

Consider the following points when selecting paper for letterhead:
› Surface quality and texture (feel the paper, fold the paper)
› Compatibility with laser printers
› Paper color in relation to ink colors and brand colors
› Stock availability
› Content: tree, tree-free, or recycled
› Cost
› How the paper takes printing ink (you must see samples)
› How the paper takes a signature or pen's ink
› How the letterhead paper coordinates (in surface quality, texture, and color) with the business card paper (business card paper stock will be heavier)

You also need to consider which printing process to use:
› Offset lithography
› Gravure
› Flexography
› Screen printing

FIG. **10** / **72**

LOGO: ALEX COLETTI
PRODUCTIONS (TV PRODUCTION
COMPANY)

· THINK DESIGN, NEW YORK
· DESIGN: JOHN CLIFFORD AND HERB
 THORNBY
· CLIENT: ALEX COLETTI PRODUCTIONS

It pops up at the end of TV shows, and the squares pop in and out and twinkle. Mr. Coletti wanted something that reflected his Brooklyn roots.
—John Clifford

LETTERHEAD

A core application of any visual identity or branding program is the letterhead. The letterhead is a formal business tool used for many purposes,

› Non-impact (which includes electronically driven ink-jet)

› Letterpress (although no longer popular)

› Specialty processes:
 – Engraving
 – Embossing
 – Watermark
 – Foil stamping

FUNDAMENTALS OF LETTERHEAD DESIGN

Every design decision counts, from the typography to the placement of the contact information. Whether you specify the paper's weight or choose the color palette, each aspect of the design is an opportunity to present a consistent identity. Usability (for example, enough space for written content) and coherent identity elements are imperatives. (See Figure 10-65.)

Function

Student designers tend to "overdesign" a letterhead, leaving little room for correspondence. Always include a sample letter on your sketches and comps to plan space for correspondence. In fact, when you present letterhead in your portfolio, a letter should be on the letterhead design solution as well, demonstrating to reviewers you understand a letterhead's function.

Keep in mind these other functional considerations:

› *Size*: The U.S. standard size is 8.5" × 11", which is also used in Mexico and Canada. Other countries use the metric system of measurement for paper sizes and envelopes.

› *Fax*: The letterhead should be legible when faxed.

› *Folds*: A letterhead is folded to fit into a standard size envelope. The composition should take the folds into account. Also, the paper selection should hold up to folding, and not crack or bulge.

› *Ink*: The letterhead paper and envelope should take printing ink, laser printer ink, and pen ink well.

› *Second sheet*: Correspondence often requires more than one sheet of paper. For letterhead design, a second sheet is designed with less content (only the brand or group name and website).

› *Template guidelines*: Along with the letterhead solution, the designer provides the client with a template for letter positioning and size, typeface and font size, and color. The template helps ensure coherence.

Layout

Very often, the pertinent information resides at the head (or top) of the page—hence the term *letterhead*. That kind of arrangement leaves ample room for correspondence. Some designers split the information and position some type at the foot, or bottom, of the page. Others break with tradition and position type, graphics, or illustrations in any number of ways—in a vertical direction at the left or right side, all over the page in light or ghosted values or colors, or around the perimeter of the page.

Any arrangement is fine, as long as it works, as long as it is a sound solution to a visual communication problem. Information should be in a logical information hierarchy, for example, the ZIP code should not be the first thing the reader notices. The logo is usually the most prominent element on the letterhead (see Figure 10-73, for example); all other type and visuals should be arranged accordingly, from the most important to the least important. A graphic element other than the logo can be the most prominent element in your design, as long as your solution stems from your strategy and is based on a design concept that has visual interest and clarity of communication.

The design—the arrangement of the elements, the creation of a visual hierarchy; the use of the logo, and the selection of colors and typefaces—is usually consistent within the parts of the stationery and visual identity. Any design system, whether it is stationery or an extensive visual identity, should have continuity—that is, similarities in form. Some designers feel it is perfectly acceptable to have slight to moderate variations in color, type, or arrangements among the letterhead, envelopes, and business cards. It is possible to design a unified stationery system that incorporates variety.

Other integral applications—package design, websites, brochures (corporate communication)—will be covered in following chapters. (See "Case Study: The Suzhou Museum.")

CASE STUDY

The new Suzhou Museum opened to critical acclaim in October 2006. This new contemporary museum is located in the historic garden city of Suzhou, about 100 kilometers northwest of Shanghai. Started in 1960, the museum was originally housed in an historic home with limited space to display its many significant collections of Chinese antiquities and cultural relics. To rectify this, the city fathers of Suzhou invited the world-renowned architect I.M. Pei, whose family was originally from Suzhou, to design the new museum.

The contemporary architectural design of the Suzhou Museum derives its inspiration from traditional Chinese courtyard and garden architecture, so notable and unique to this region of China. The museum is next to two of Suzhou's most famous garden museums: The Garden of the Humble Administrator (Zhuo Zheng Yuan) and the Lion Forest Garden (Shi Zi Lin Yuan), both UNESCO World Heritage sites.

The new museum houses over 30,000 historic works of art from Suzhou and its environs in over 5,000 square feet of exhibition space. Known as the Wu Region, this prosperous area of China was a center of artistic and literary development from the Song to Qing Dynasties. This gave rise to a highly cultivated class of scholars and literati whose devotion to the fine arts made a lasting contribution to the cultural heritage of China.

Tracy Turner (Tracy Turner Design Inc.) was engaged by I.M. Pei and the Pei Partnership Architects (PPA) to design all of the graphics and signage, as well as exhibits and other visual details, all important elements to the success of the museum. Ms. Turner had worked with Mr. Pei on previous projects in China, including his first hotel project in 1982, called Fragrant Hill Hotel (Xian Shan Fan Dian) and the Bank of China Headquarters, which opened in 2001, both in Beijing. With Mr. Pei. and the PPA team, and her experience and knowledge of the culture, she developed the following scope of work.

SCOPE OF WORK

A comprehensive environmental graphic program was created, which included:

1 / Identity Standards and Manual of Usage, for Print and Other Graphics

2 / Comprehensive Exterior and Interior Signage Program

3 / Exhibition Display Banners: seven were designed for the Opening

4 / Exhibition Labeling and Object Arrangement throughout the Museum

5 / Color Schemes for Each Gallery

6 / Museum Map Guide

7 / Two Major Exhibition Designs for the Opening:
 a. Famous Master Painters from the Ming Dynasty (loaned by the Shanghai Museum)
 b. *Prosperous Gusu* based on a famous scroll, a Chinese national treasure (loaned by the City of Liaoning)

8 / Reception Area: Permanent Exhibit

9 / Rug designs for four major public areas within the museum

10 / Various items for promotion and sale in the Museum Shop

11 / Opening program, etc.

DESIGN CHALLENGE

The first design challenge was to create a logo, as a basis of the environmental graphic design and identity program. The parameters came from several sources:

- modern and up-to-date, yet sensitive and acceptable to the Chinese and feng/shui approved
- the Architect: that the logo have some derivation of the building
- the Museum Director: that it be understood immediately as the Suzhou Museum
- the Chinese characters of artist Guo Mo Ro must be used, for "Suzhou Museum"
- use Chinese/English in designated 200/100 ratio

LOGO AND BRAND DEVELOPMENT

Inspiration for the logo came from Pei's use of geometric forms delineating the architectural features, predominantly with white stucco and gray

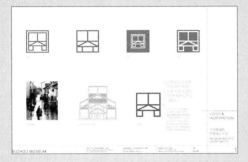
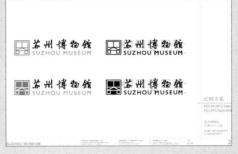

IDENTITY: SUZHOU MUSEUM

· TRACY TURNER DESIGN INC., NEW YORK

granite, all based on traditional uses of local materials. In addition, Feng Shui masters reviewed and approved the logo in the ongoing design process.

Feng Shui (the Chinese literal translation means "Wind" and "Water") is a discrete Chinese belief system involving a mix of geographical, psychological, philosophical, and aesthetic ideas with interpretative postulations to create harmonious energy. The logo was received enthusiastically by the director of the museum, and it was noted that the line work within the square creating the logo formed many auspicious Chinese characters.

EXHIBIT GALLERY SIGN CHALLENGE
At the last minute, the museum director insisted on commemorating the "Wu" culture (famous to Suzhou) on all of the signs for all of the twenty-six gallery names, with the use of four different esoteric characters for each gallery. These four characters were basically not easily intelligible to the average Chinese, and were significant only to this commemoration. Each gallery still required a description that could be readily understood in Chinese/English for the general public.

While there were limited budget constraints, the schedule was rigorous: 1 year start to finish with the designer having to spend a full 7 weeks in Suzhou with an additional staff member on site to get everything done in time for the opening date. In addition, all of the English for the major collection descriptions (28) was rewritten by the designer and the project architect.

For the signage fabrication, stainless steel and glass were used throughout. Chinese and English characters were cut out dimensionally of metal, to accommodate accessibility issues. Chinese characters always appeared in a black color and the English, always a gray color, in a 200/100 ratio.

IMAGES: SUZHOU MUSEUM

· TRACY TURNER DESIGN INC., NEW YORK

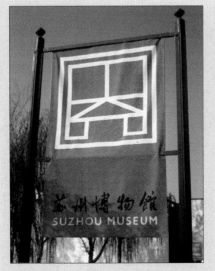
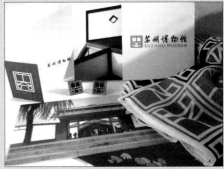

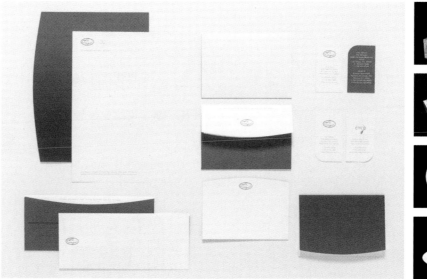

FIG. 10 / 73

IDENTITY: LE CIRQUE

· MIRKO ILIĆ CORP, NEW YORK
· CLIENT: LE CIRQUE

Mirko Ilić Corp. rebranded Le Cirque's identity and executed a comprehensive list of deliverables including logo, stationery, menus, dishes, bags, carry-out packaging, and more. The name communicates a fun circus, however, the restaurant offers an elegant dining experience and the identity combines both memorably.

FIG. 10 / 74

BUSINESS CARD

· REGINA RUBINO / IMAGE: GLOBAL VISION, SANTA MONICA
· DESIGNERS: REGINA RUBINO, ROBERT LOUEY

A creative director demonstrates the richness of her work with card variations.

These are the components of a letterhead program:

> General letterhead (short and long) and general envelope
> Executive letterhead (short and long) and executive envelope
> Digital letterhead (customized variations to meet specific needs of the company)

> Fax cover sheet
> Contracts
> Invoices
> Memos
> Large envelope
> Window envelope
> Mailing label

BUSINESS CARD

Besides television advertisements that come into your living room, a business card is, perhaps, the most intimate design application. Often passed from hand to hand, a business card quickly and directly tells its reader who you are, what you do, with whom you are affiliated, and how to contact you. Even when a business card is enclosed within correspondence, its small size begs intimacy. A **business card** is a printed or digital surface—a small rectangle—on which a person's name, business affiliation, and contact information are printed. The business card, a very portable marketing tool, is an integral part of a broader visual identity system, as in this identity for Le Cirque (Figure 10-73). A designer's own card often reflects his or her own spirit, vision, or point of view (Figure 10-74).

Most large corporations or organizations issue both general and executive business cards. Usually, there are small differences between the

7761 Waterloo Road
Jessup, Maryland 20794

tel 443 733 1234
fax 443 733 1219

STANLEY J. SERSEN
Board President

stan@greenbuildinginstitute.org
www.greenbuildinginstitute.org

FIG. **10** / **75**

BUSINESS CARD: GREEN BUILDING INSTITUTE

· SUBSTANCE151, BALTIMORE
· CREATIVE DIRECTOR: IDA CHEINMAN
· DESIGNERS: IDA CHEINMAN, RICK SALZMAN
· CLIENT: THE GREEN BUILDING INSTITUTE, JESSUP, MD

Project Objective: *The Green Building Institute is an emerging non-profit organization working to advance environmentally sustainable building practices through education and example. Substance151 was approached by GBI to create a new brand identity and a web presence that allows for growth and scalability.*
—Substance151 (Please see Figure 14-04 for entire identity program.)

general business card, used by a large percentage of employees, and the executive card, used by a small executive group; those differences may be in the paper quality, paper color, printing, or, perhaps, the brand signature. General business card paper stock is usually coordinated with the paper of the general stationery; likewise, executive cards are coordinated with the executive stationery. (See "Practical Considerations" for more information about paper.)

IDENTITY STANDARDS FOR BUSINESS CARDS

Establishing coherence entails creating identity standards and then employing them consistently. In the visual identity for Captive Resources, LLC, Crosby Associates provides standards for business cards (see Figure 10-65).

For both general and executive business cards, the standard content guidelines usually include:
> Individual's name
> Job title
> Organizational corporate unit or department name
> Address or office location
> Phone and fax numbers
> E-mail address(es)
> Web address

Either the client or the designer specifies such components as the name structure, acronyms, position of professional titles, capitalization, abbreviations, identifier formats, use of reverse side, and any other relevant information with examples.

Since business cards must include critical contact information and the brand logo on a small surface, usually no other information is included on a card. Limiting the amount of information on a business card can aid a viewer's ability to glean information.

To include more information or graphics, some design a two-sided card, utilizing the reverse side. For the Green Building Institute, Substance151 designed one side for the organization's identity and the reverse side for the individual's contact information (Figure 10-75). (To see the full identity program for the Green Building Institute, see Figure 14-04.) Although most cards do not have printed information on the reverse side, some designers find it a wonderful "canvas" for expanding the brand experience and engaging viewers, as in Figure 10-76.

There are many good reasons to employ the reverse side of a card, especially in a global marketplace. A reverse side may hold any of the following information or graphic elements:

FIG. **10** / **76**

VISUAL IDENTITY

· IDEOGRAMA, MEXICO
· CLIENT: LLUVIA DE IDEAS

This is an example of how parts of a logo can be used separately and also hold together in a very memorable way.

ESSAY

M.B.

MICHAEL BIERUT
Partner
Pentagram
New York

Prior to joining Pentagram in 1990 as a partner in the firm's New York office, Michael Bierut worked for ten years at Vignelli Associates, ultimately as vice president of graphic design.

He has won hundreds of design awards and his work is represented in the permanent collections of the Museum of Modern Art and the Metropolitan Museum of Art in New York, and the Musee des Arts Decoratifs, Montreal. He has served as president of the New York Chapter of the American Institute of Graphic Arts (AIGA) and is president emeritus of AIGA National. Michael was elected to the Alliance Graphique Internationale in 1989, to the Art Directors Club Hall of Fame in 2003, and was awarded the profession's highest honor, the AIGA Medal, in 2006. In 2008, he was named winner in the Design Mind category of the Cooper-Hewitt National Design Awards.

Michael is a Senior Critic in Graphic Design at the Yale School of Art, and a Senior Faculty Fellow at the Yale School of Management. He writes frequently about design and is the co-editor of the five-volume series Looking Closer: Critical Writings on Graphic published by Allworth Press. His commentaries about graphic design in everyday life have been heard nationally on the Public Radio International program "Studio 360" and his appearance in Helvetica: A Documentary Film is considered by many that movie's funniest moment. Michael is a co-founder of the weblog DesignObserver.com, and his book 79 Short Essays on Design was published in 2007 by Princeton Architectural Press.

A while ago, I was designing the identity for a large, fashion-oriented organization. It was time to decide which typeface we'd use for their name. Opinions were not hard to come by: this was the kind of place where people were not unused to exercising their visual connoisseurship. But a final decision was elusive.

We decided to recommend a straightforward sans serif font. Predictably, this recommendation was greeted by complaints: it was too generic, too mechanical, too unstylish, too unrefined. I had trouble responding until I added two more elements to the presentation. The first was a medium weight, completely bland, sans serif "C." "Does this look stylish to you?" I would ask. "Does it communicate anything about fashion or taste?" Naturally, the answer was no.

Then I would show the same letter as it usually appears as the first in a six-letter sequence: CHANEL. "Now what do you think?"

It worked every time. But how?

The answer, of course, is context. The lettering in the Chanel logo is neutral, blank, open-ended: what we see when we look at it is eight decades' worth of accumulated associations. In the world of identity design, very few designs mean anything when they're brand new. A good logo, according to Paul Rand, provides the "pleasure of recognition and the promise of meaning." The promise, of course, is only fulfilled over time. "It is only by association with a product, a service, a business, or a corporation that a logo takes on any real meaning," Rand wrote in 1991. "It derives its meaning and usefulness from the quality of that which it symbolizes."

Everyone seems to understand this intellectually. Yet each time I unveil a new logo proposal to a client, I sense the yearning for that some enchanted evening moment: love at first sight, getting swept off your feet by the never-before-seen stranger across the dance floor. Tell clients don't worry, you'll learn to love it and they react like an unwilling bride getting hustled into an unsuitable arranged marriage. In fact, perhaps designers should spend less time reading Paul Rand and more time reading Jane Austen: after all, it is a truth universally acknowledged that a corporation in possession of a good fortune must be in want of a logo, isn't it? Finding that one perfect logo is worth its own romantic novel.

All of this is compounded by the fact that designers themselves have very little faith in context. We too want the quick hit, the clever idea that will sell itself in the meeting and, even better, jump off the table in design competitions. More than anything, we want to proffer the promise of control: the control of communication, the control of meaning. To admit the truth—that

so much is out of our hands—marginalizes our power to the point where it seems positively self-destructive. This is especially true in graphic design, where much of our work's functional requirements are minimal on one hand and vague on the other. "The pleasure of recognition and the promise of meaning" is a nice two line performance specification, but one that's impossible to put to the test.

Yet all around us are demonstrations of how effective a blank slate can be. It's just hard to learn from them. I'd like to think, for instance, that I'd see the potential of a red dot in a red circle if I was designing a logo for a company named Target. But in truth I'd probably say, "What, that's all?" and not let it into the initial presentation. How, after all, could you guarantee that the client would invest 40 years in transforming that blank slate into a vivid three-dimensional picture?

Appreciating the power of context takes patience, humility, and, perhaps in the end, a sense of resignation. You sense it in this account of designer Carolyn Davidson's disappointing presentation for her first big ($35) freelance project:

After sifting through the stack of drawings, Knight and the other men in the room kept coming back—albeit with something less than enthusiasm—to the design that looked like a checkmark.

"It doesn't do anything," Johnson complained. "It's just a decoration. Adidas' stripes support the arch. Puma's stripe supports the ball of the foot. Tiger's does both. This doesn't do either."

"Oh, c'mon," Woodell said. "We've got to pick something. The three stripes are taken."

That was the trouble, thought Davidson. They were all in love with the three stripes. They didn't want a new logo; they wanted an old logo, the one that belonged to Adidas. Davidson liked [them] but found it disheartening to go out on her very first real job and get this kind of reception.

We all know the ending to this story: the client grudgingly accepted Carolyn Davidson's chubby checkmark, and the rest, as recounted here in *Swoosh: The Unauthorized Story of Nike and the Men Who Played There* is corporate identity history. The swoosh has proven durable enough to stand for the company's dedication to athletic achievement, its opponents' resistance to the forces of global capital, and a lot of things in between. Sometimes, the client is smarter than we think. Give Nike founder Phil Knight credit: he had the vision to admit, "I don't love it. But I think it'll grow on me."

Maybe he believed it. Or maybe he was just tired of trying to decide. Either way, context did the rest.

Reprinted with permission from Michael Bierut, www.designobserver.com/.

"It is only by association with a product, a service, a business, or a corporation that a logo takes on any real meaning,"
—Paul Rand

PRACTICAL CONSIDERATIONS

Choosing paper for your letterhead, envelope, and business card is part of a design solution. There are many paper companies and numerous qualities, styles, and colors of paper. The weight of the paper is very important because the letterhead and envelope must stand up to computer printers, pens, and markers. Letterhead must be sturdy enough to withstand being folded. Business cards are usually inserted into wallets and therefore must be a heavier weight paper than the letterhead. When choosing paper, also think about texture, how the color of the paper will work with the color of the ink, and whether the shape will fit into a standard envelope. Most paper companies provide paper samples and have shows to promote their products. They also advertise in leading graphic design periodicals.

Papers and envelopes come in standard sizes; anything other than standard size is more expensive. A business card should be of a size and shape that fits into a wallet—usually the size of a credit card. If a card must be folded to fit into a wallet, the design is being compromised (pre-folded cards are an exception). A designer must also be aware of the printing processes available, including special technical processes such as die-cuts, varnishing, and embossing. Research the printing process by visiting a good printer.

› ISO certification (the International Organization for Standardization is a network of the national standards institutes of 161 countries, which coordinates the system of standards for industrial and business organizations of all types, among other things [www.iso.org])

› Translations (international brands and social organizations, in particular, may want translations on the reverse side of cards)

› Additional phone numbers and office locations

› Brand division signature

› Other graphics that are related to the brand experience

Business Card Production Specifications

Providing the client with guidelines for production specifications will ensure that all employees using and ordering business cards will understand and communicate the proper, established brand image. Although some of these points are general and can pertain to all brand applications, it's important to list all necessary guidelines to maintain consistency throughout the brand identity.

Make sure to provide the client with the following:

› A template that delineates:

– size and color of logo

– isolation area around logo

– typeface(s), size, and color of name, title, addresses

– where the specific content should reside

› Card size for national and international use

› Paper stock for general and executive cards: content, weight, finish, color

› Printing method for front and reverse sides

EXERCISE 10-1

...

PREPARATION

VISUAL BRIEF COLLAGE BOARD

A visual brief collage board is your "visual positioning," which can be created in any way that best serves your working method. If you prefer working methodically, you might want to use a graphic aid such as a grid or a graphic organizer, or divide the page using the rule of thirds (see Chapter 6). If in doubt, use a four-column modular grid, where the two left-hand columns are narrower than the two right-hand columns. Many people start with a focal point at the board's center, almost like a visual mind map technique (see Chapter 4), holding the board either landscape or portrait.

» Determine a color palette.

» Select a limited range of shapes, textures, and patterns for your strategy.

» Find or create imagery or fine art that inspires you. Some people include industrial design images that inspire them.

» Select one or two typefaces.

Your board should establish a visual position in line with the brand strategy and provide a design direction.

PROJECT 10-1

...

VISUAL IDENTITY

This project calls for a comprehensive visual identity—from its marketing strategy to its deliverables. It demonstrates your ability to be consistent yet creative.

This is a difficult and involved assignment. It demonstrates to potential employers your ability to formulate a strategy and design concept and follow it through with a visual identity that includes several design applications. The experience and knowledge

gained here can be applied to any identity. If your solution to this project is successful, it could be one of the most important pieces in your portfolio.

Designing a visual identity is a creative activity, but do not forget the bottom line—to identify, differentiate, and inform. Create more applications, and then create another visual identity for a different type of brand or group.

» *Creating an integrated brand experience entails weaving a common thread or voice, and integrating the common language into all experiences with the brand.*

Step 1

a. Choose one of the following clients:

> » Architectural firm, *or*

> » Nut-free consumer packaged goods (snacks, baked goods, breads), *or*

> » National Crime Prevention Council (http://www.ncpc.org) *or any nonprofit organization*

b. If you choose the architectural firm or food company, invent a brand name. See Chapter 9 on naming.

c. Work on your strategy. Write the design brief (see Chapter 4). Research the competition. Determine an audience.

d. Identify key descriptive words. On an index card, write one sentence about the brand or group using two adjectives to describe it.

Step 2

a. Design a logo.

b. Be sure to use your strategy and design brief.

c. Design stationery consisting of a letterhead, envelope, and business card. Include the name, address, telephone and fax numbers, e-mail address, web address, and CEO's name.

d. Design at least two other related applications, such as a brochure or website (or add these after you've read the appropriate chapters in this book). Use visual elements consistently across applications—you are creating a visual identity.

e. Produce at least twenty sketches for each design application.

f. Use black and white or color.

Step 3

Refine the sketches and create two roughs for each design problem, the logo, stationery, and other applications.

Step 4

Refine the roughs and create one comp for each application.

Go to our website **GD/6** for *many* more Exercises and Projects, and presentation guidelines, as well as other study resources including the chapter summary.

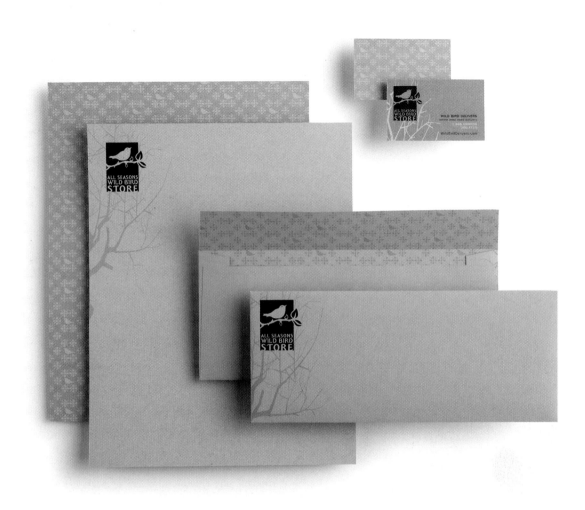

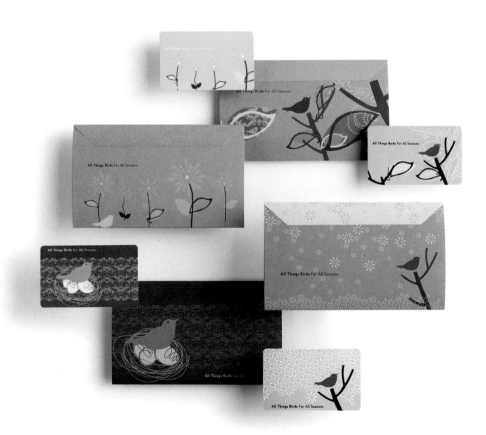

11 /

PACKAGE DESIGN

<<< / facing page

**IMAGEHAUS, INC.,
IDENTITY SYSTEM AND
STORE GIFT CARDS**

· CREATIVE DIRECTOR: JAY
MILLER
· DESIGNER: COLLEEN MEYER
· CLIENT: ALL SEASONS WILD
BIRD STORE

PACKAGE
DESIGN AFFECTS YOU MORE THAN

YOU REALIZE. IF YOU SAW AN ATTRACTIVE PACKAGE ON DISPLAY IN A STORE, WOULD YOU PICK IT UP? AN APPEALING PACKAGE DESIGN CAN SEDUCE YOU INTO PURCHASING A BRAND, AT LEAST ONCE. WELL-DESIGNED PACKAGING CAN MAKE A COMMODITY (THINK TEA, COFFEE, RICE, EGGS) LOOK SPECIAL; CONVERSELY, POORLY DESIGNED PACKAGING CAN MAKE A SUPERIOR PRODUCT LOOK INFERIOR. POORLY ENGINEERED PACKAGING CAN INFURIATE THE CUSTOMER, JUST AS WELL-ENGINEERED PACKAGING CAN FACILITATE THE USE OF A PRODUCT AND INCREASE BRAND LOYALTY.

WHAT DOES PACKAGE DESIGN ENCOMPASS?

Besides promoting a brand, packaging is functional, encasing and allowing access to a product by means of a pour spout, flap, clasp, drawstring, or another device. **Package design** involves the complete strategic planning and designing of the form, structure, and appearance of a product's package, which functions as casing, promotes a brand, presents information, and becomes a brand experience. It is a specialized area of graphic design, since package designers must be knowledgeable about a range of construction and technical factors. Familiarity with and knowledge of materials and their qualities—such as glass, plastic, paperboard, paper, and metal—and with manufacturing, safety, display, recycling, regulatory management, and quality standards, as well as printing, is necessary. Package designers work in collaboration with identity designers, marketing executives, product developers, manufacturers, industrial designers, and packaging engineers. Designers may also work as part of a group to develop the basic shape of the package, materials, and structure.

PROJECT SCOPE AND KIND: PACKAGE DESIGN, BRANDING, AND PRODUCT DEVELOPMENT

Most often, package design is one part of an integrated branding program whose marketing strategy may feature a variety of marketing initiatives, including promotions, product launches, and advertising. Think of a Pepsi, General Mills, and 3M sub-brand and you can understand how the package design is part of an entire branding program, from logo to mobile applications.

When package design is part of a brand identity program, other applications may include logo, visual identity, signage, van graphics, and more, as shown in the All Seasons Wild Bird Store case study on page 282.

In Figure 11-01, Wal-Mart wanted to "up the style-quotient" of No Boundaries, its chief youth brand. The project's scope included naming, identity, style guidelines, and packaging. MiresBall recommended graphically condensing the No Boundaries name to NoBo and designed a program to ensure implementation.

For Liz Earle Naturally Active Skincare, Figure 11-02, Turner Duckworth, London, designed an identity and several products under the brand. To communicate the meaning

FIG. **11** / **01**

NAMING, IDENTITY, STYLE GUIDELINES, PACKAGE DESIGN: NOBO

· MIRESBALL, SAN DIEGO
· CLIENT: WAL-MART

The Challenge: As part of a broad strategic effort to combat fashion-friendly retailers like Target and Kohl's, Wal-Mart wanted to up the style-quotient of its flagship youth brand, No Boundaries.

The Solution: We recommended a graphic shorthand of the No Boundaries name—NoBo—and designed a clean, high-impact identity. The NoBo nickname extends a friendly "insider" invitation to style-conscious shoppers, creating an identity with more personality and universal appeal. A playful evolution of the original brand, the new look-and-feel elevates No Boundaries' cool-factor while leveraging its existing brand equity. To accommodate the retail giant's mass production challenges, we also developed a system of packaging templates that ensure ease of implementation across a diverse range of products, media, and global manufacturers.

The Result: The NoBo brand has been rolled out successfully across Wal-Mart stores internationally and supported line extensions into lucrative new market segments from accessories to housewares.
 —MiresBall

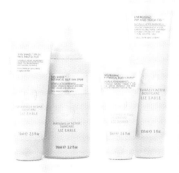
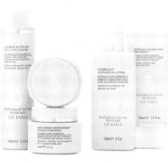

FIG. **11** / **02**

LIZ EARLE NATURALLY ACTIVE SKINCARE

· TURNER DUCKWORTH, LONDON
· CREATIVE DIRECTORS: DAVID TURNER, BRUCE DUCKWORTH
· DESIGNER: BRUCE DUCKWORTH
· PHOTOGRAPHER: AMOS CHAN
· CLIENT: BARNEYS NEW YORK

Liz Earle Naturally Active Skincare is a range of beauty products. The redesign created an umbrella identity under which the four ranges, with their naturally active ingredients, are clearly differentiated:

Daily Essentials—Facial skincare
Body—Body washes, moisturizers
Treatments—Serums, tonics, masks
Suncare—Sun shade sunscreens and after-sun balms

CASE STUDY

ALL SEASONS WILD BIRD STORE/IMAGEHAUS, INC.

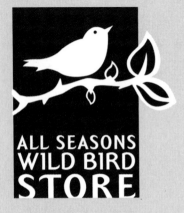

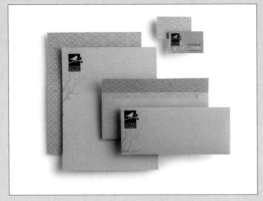

LOGO AND IDENTITY SYSTEM

The client needed a logo that would speak to its name and create a consistent, compelling brand around it. The logo is vintage modern inspired and the design reinforces the name of the brand incorporating the "All Seasons."

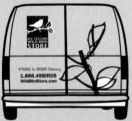

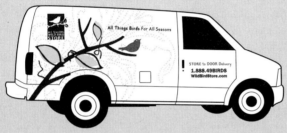

**IMAGEHAUS, INC.,
MINNEAPOLIS**

- CREATIVE DIRECTOR: JAY MILLER
- DESIGNER: COLLEEN MEYER
- CLIENT: ALL SEASONS WILD
 BIRD STORE

STORE GIFT CARDS

The objective of this project was to elevate the brand. The audience is bird lovers and those shopping for bird lovers. The challenge was to increase perceived value of the Wild Bird Store gift card program. Unique gift card designs allow customers to make a personal choice. The gift card holders also create a nice presentation and increase perceived value.

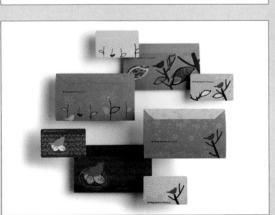

SHOPPING BAGS

The purpose of this work was to create shopping bags that reflected the Wild Bird Store's new identity. The solution is simple and fresh using the Wild Bird Store's graphic elements and vibrant colors.

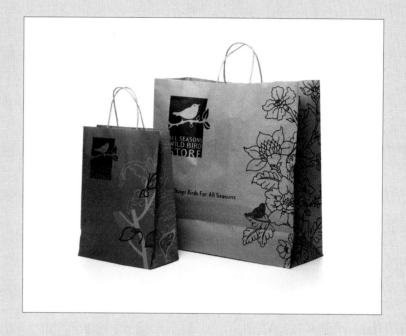

STORE BAGS

The objective was to create unique packaging for the Wild Bird Store's private label birdseed, which was unique but followed the new look and feel we had created. Bird lovers needed to be drawn in by the design and then purchase for the quality. These designs convey the Wild Bird Store brand while linking to the "seasonal" aspect of the product through a distinct color palette. These are displayed in a retail environment at All Seasons Wild Bird Store.
 —IMAGEHAUS, Inc.

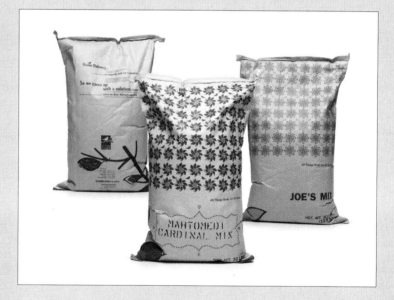

FIG. **11**/**03**

*In a culture that is at once
increasingly vigilant about
germs and the value of natural
ingredients, an herb-based
antimicrobial that is lab-proven to
kill 99.9 percent of harmful germs
would fulfill unmet user needs.
Additionally, the opportunity tied
in closely with IDEO's approach to
market validation of innovation and
disruptive brands and technologies.*

*Working with Dr. Larry Weiss,
a scientist and physician with
expertise in natural products,
chemistry, and infection control,
and a set of strategic capital
partners, IDEO helped found the
CleanWell brand of Ingenium
products. The first FDA- and EPA-
approved all-natural antimicrobial,
Ingenium is the effective ingredient
in CleanWell hand sanitizer and
hand wash, currently available
at select independent pharmacy,
grocery, and specialty retailers
across the United States as well as
many Whole Foods markets. As a
non-toxic, alcohol-free alternative
to competing hand sanitizers,
CleanWell stands out as a school-
and child-friendly solution.*

*In addition to helping to build
CleanWell's operational and
manufacturing capabilities, IDEO
designed the packaging and
graphics for the brand's line of
sprays and skin towelettes. After
going from concept to market in
less than two years, CleanWell
distribution continues to expand.*
—IDEO

of nature with science, the design concept of the identity is visualized by combining a plant that turns into a flower made up of molecular diagrams in the logo.

If package design is part of a broader branding program, the design team meets with the brand identity designers or design director to ensure everyone works from the same strategic platform. Also, a package design project may be one in a line of products (think carbonated beverages in several flavors, diet and regular, caffeinated and caffeine-free). The team needs to examine the brand architecture and identity standards. For most types of packaging, mandatory information—such as nutritional information or ingredients—must be included and considered when designing, as per industry and federal regulations. Other issues, such as printing specs, structural specs, functional data (usage, durability, tamper resistance, and more), and copy are all addressed at the outset.

Typically, a design company must leverage the brand equity of an established brand. Other times, design companies are involved with the launch of a business. IDEO describes just such an opportunity. "When IDEO was presented with a yet-to-be marketed technology for a nontoxic, alcohol-free hand sanitizer and cleaning product, the business case was undeniable. . . . To bring this patented technology—now known as Ingenium—to market, IDEO began building a business from the ground up using principles of design thinking" (see Figure 11-03).

National Brands versus Store Brands
National brands are products and services that are promoted and distributed nationally and often globally. If we examine one category—the beverage category—some national brand companies include Coca-Cola, Pepsi, and Cadbury Schweppes. Wallace Church was called on to "revitalize the Ocean Spray brand positioning, redesign its entire family of beverages, and launch an entirely new sub-brand, Juice & Tea." Not only was it tasked with retaining all of the brand's positive equities and visual cues, Ocean Spray desired to see significant changes in shelf impact, appetite appeal, and form/flavor differentiation. In the Before & After feature, you can see how the package design looked before Wallace Church's redesign.

Besides carrying national brands and boutique labels, retail store chains often offer their own branded products, called store brands, retailer brands, and private label brands. The model for store brands usually is either *a house of brands*, where each product is named and branded individually,

or *a branded house*, where all products fall under one name, such as Waitrose supermarkets in England, Scotland, and Wales. Turner Duckworth wanted its designs to reflect Waitrose's values: "Effective, with style. Sales with wit. Originality with relevance" (Figure 11-04).

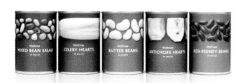

FIG. **11** / **04**

PACKAGE DESIGN

PREMIUM DRIED FRUIT RANGE

· CLIENT: WAITROSE LIMITED
· TURNER DUCKWORTH, LONDON AND SAN FRANCISCO
· CREATIVE DIRECTORS: DAVID TURNER, BRUCE DUCKWORTH
· DESIGNER: CHRISTIAN EAGER
· PHOTOGRAPHER: STEVE BAXTER
· RETOUCHER: PETER RUANE

Redesign of Waitrose's range of premium dried fruits: *Targeted at Waitrose core consumers, these packs use evocative close-up photography of individual fruits in all their perfection. Product titles further emphasize the provenance and care with which the fruits have been selected.*

WAITROSE COOKIES

· DESIGNER: SAM LACHLAN
· PHOTOGRAPHER: STEVE BAXTER
· RETOUCHER: PETER RUANE

Our brief from Waitrose was to create clarity of choice for consumers within their own brand biscuit range. The biscuit category was becoming increasingly difficult to shop, as products had been refreshed on an ad hoc basis, which, in turn, had created a fragmented range in store.

The cookie design needed a premium edge versus the everyday range of biscuits (custard creams, digestives, etc.) but not so special that consumers would feel that they were only for Sunday afternoons. Our solution uses ingredient color-coded mugs and product titles as well as close-up photography to communicate yumminess, all set off by the dark backgrounds. Just right for coffee and a chat with the girls!

WAITROSE CANNED VEGETABLES AND PULSES [CANNED CHICK PEAS, BEANS, ETC.]

· DESIGNER: SARAH MOFFAT
· PHOTOGRAPHER: ANDY GRIMSHAW
· RETOUCHER: PETER RUANE
· ARTWORK: REUBEN JAMES

Waitrose asked us to refresh their canned vegetable and pulses ranges. Store cupboard staples for most consumers, the ranges had not been looked at in entirety for a number of years resulting in a fixture that had become confused and difficult to shop.

Our solution focused on using the vegetables and pulses to create graphic panels of the products shot against complementary backgrounds that would allow consumers to not only stock up on their favorites but also find new ingredients, too. Typographic style was kept as simple as possible to further aid communication.

WAITROSE FRUIT CRUSHES

· DESIGNER: SARAH MOFFAT
· ILLUSTRATOR: JACQUES FABRE
· RETOUCHER: REUBEN JAMES

When Waitrose wanted to create a point of difference between their own range of fruit crushes and the competition, they briefed us to single-mindedly communicate "FRUIT."

We rose to the challenge by putting fruit quite literally at the heart of the design, with luscious illustrations of ripe, juicy fruit. The product titles further supported refreshment cues with provenanced fruits such as Sicilian Lemons and Alphonso Mangoes, etc. Just the drink for a hot summer's day.

BEFORE & AFTER

DESIGN PROBLEM

The exponential growth of the beverage market in recent years had expanded Ocean Spray's competitive set well beyond breakfast juice drinks to include carbonated beverages and even bottled water. Accompanying this growth were dramatic changes in the visual language used by leading brands to communicate emotional benefits and product attributes such as "taste," "refreshment," and "premium." While the Ocean Spray identity and package design remained familiar to its core audience (sophisticated moms), its emotional relevance, appetite appeal, and shopability were beginning to wane.

Wallace Church was called on to revitalize the Ocean Spray brand positioning, redesign its entire family of beverage SKUs [stock-keeping units] (Base Cranberry, Cranberry Light, 100% Premium Juice, Ruby, and White Cranberry), and launch an entirely new sub-brand, Juice & Tea. The challenge: retain all of the brand's positive equities and visual cues while significantly increasing shelf impact, appetite appeal, and form/flavor differentiation.

MAIN COMMUNICATIONS OBJECTIVE

The signature "wave" at the bottom of the labels has been retained and updated to leverage the product's refreshment cues. To this end, a soft, gradated blue sky has been added to the background as well. The top of each bottle features the familiar Ocean Spray logo while the bold, luscious fruit illustrations have been evolved significantly to better express the product's intense flavor and increase appetite appeal. A system of curved banners, consistently placed on every label, is used to segment sub-brands and flavors (the new Juice & Tea sub-brand is positioned slightly differently, with a gradated green background and green banner).

Finally, to perceptually distinguish the brand from the competition, Wallace Church sought to communicate Ocean Spray's authentic New England heritage. The addition of the lighthouse logo at the top of each banner neatly captures the spirit of Cape Cod and provides the brand with a sense of place. The new brand design gives more than 100 SKUs, of varying sizes and shapes, one cohesive identity, while clearly differentiating all sub-brands and flavors.

—Wallace Church

BEFORE

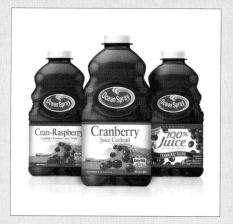

PACKAGE DESIGN: OCEAN SPRAY JUICES: AFTER

· AFTER CREDITS:
· WALLACE CHURCH, NEW YORK
· CREATIVE DIRECTOR: STAN CHURCH
· DESIGN DIRECTOR: WENDY CHURCH
· DESIGNER: WENDY CHURCH
· CLIENT: OCEAN SPRAY JUICES, OCEAN SPRAY CRANBERRIES, INC.

AFTER

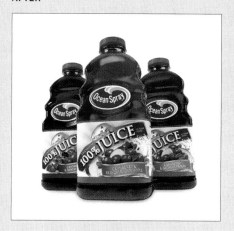

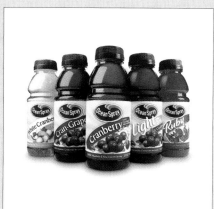

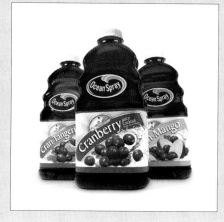

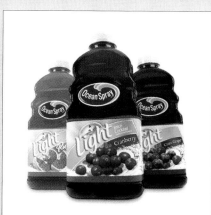

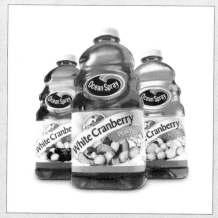

PACKAGE DESIGN PROCESS

Five Phases of the Design Process:

Orientation ▸ Analysis ▸ Concepts ▸ Design ▸ Implementation

During the first two phases of the design process, the client and design team define the problem, establish goals, determine the project scope (project may include several brand extensions or sub-brands), conduct any necessary research, including marketing and competitive audits, scrutinizing the competition, understanding the target audience (may include focus groups, interviews, in-store observations and market interceptions [speaking to consumers in stores at the shelves], or any other market research), clarifying positioning (functional and emotional benefits, brand personality, specific features), and setting strategy.

CONCEPTUAL DESIGN

The concept underlying the package design solution must be relevant to the audience, be on strategy with the broader brand identity, and, of course, have on-shelf impact. Any design concept, visualization, and composition for a package design solution must make sense for the product category as well as be appealing, be compelling to its audience, and make an emotional connection. BVD's solution for Electrolux, Figure 11-05, did all that.

The Psychology of Package Design

People are often drawn to package design for emotional rather than rational reasons, such as price or ingredients. In *The Culture Code*, Clotaire Rapaille offers startling insights into how Americans feel about products and why they buy as they do. For example, Rapaille theorizes that people equate coffee with home, where perhaps as children they awoke to the aroma of morning coffee brewing. Therefore, following this argument, one should incorporate the concept of home into coffee package design, branding, and advertising. As you will see by examples in this chapter, there are many routes for developing a solid design concept for package design.

According to Louis Cheskin, a mid-twentieth-century marketing innovator, people "transfer their perception of a package to the product it contains," which he termed "sensation transference." In other words, "The package is the product." The aesthetics of the package design can be relevant to someone; it can appeal or not, greatly affecting our perception of the product's value.

Creating a desired perception of the product requires detailed attention to not only the package's looks, but also how it feels in the hand and even the sounds it makes. The package's sensory cues are an enormously important contributor to the consumer's experience of the product. A package design is a tangible brand experience.

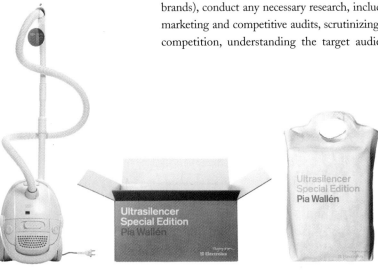

FIG. **11** / **05**

ULTRASILENCER

· BVD, STOCKHOLM
· CREATIVE DIRECTOR: SUSANNA NYGREN BARRETT
· CLIENT: ELECTROLUX FLOOR CARE AND LIGHT APPLIANCES

Assignment: *Name, logo, packaging design, PR (Public Relations) material, tote bag, and store presentation for Ultrasilencer Special Edition Pia Wallén. Scandinavia, Europe 2007.*

Challenge: *Electrolux needed a graphic identity and packaging solution for the Ultrasilencer Special Edition Pia Wallén. It needed to mirror Pia Wallén's own interpretation of the product, inspired by the quiet sound of falling snow.*

Solution: *A typographically based identity was created and applied directly onto the vacuum in a light grey tone. The packaging was turned "inside-out." The interior has a white, glossy surface, encasing the vacuum, and the exterior is brown, natural cardboard. "Ultrasilencer Special Edition Pia Wallén" was screen-printed on the outside of the package in white and orange in order to create an industrial expression in contrast with the white perfectionism of the vacuum.*

Result: *Ultrasilencer Special Edition Pia Wallén for Electrolux had its world premiere at the design store Asplunds on October 4, 2007. The product was produced in a limited edition of 5,000, 500 of which were designated for Sweden, and sold very well. There was a 20 percent increase in production costs, but because of the quality of the design, the consumer price was raised by 60 percent, increasing the overall margins for the product. An impressive PR campaign created "hype," and there is now a waiting list for this limited edition.*

—BVD

DESIGN DEVELOPMENT

Certainly, people make brand choices based on multiple factors. An individual's state of mind, familiarity with a brand, and the brand's functional or emotional benefits, quality or performance, value related to cost, and convenience all influence brand choices. In addition, exposure to advertising, promotions, brand associations, brand loyalty, and necessity, not to mention how receptive someone is to new or familiar items sitting on the store shelf at any specific moment, all play a part in influencing which item we select.

For someone to be interested in purchasing a new brand, the package design must be intriguing enough for someone to want to pick it up in the first place—or pick it out amid myriad choices online. Many design experts believe that package design is *the* make-or-break decision for a person reaching for a product on the shelf. It is estimated that about 65 to 75 percent of purchase decisions are made standing in front of the packaging in the store.

Package design has that much influence over your buying decision. The print ad, web banner, television commercial, or website you've seen or visited are in your memory bank, but the package—the most visceral, tangible brand experience—is right there in front of you, whether on the shelf or pictured on the retail web page; the packaging is the final brand experience you have before you make a purchase.

Benefits

There are both functional and emotional benefits of any package design. The functional benefits are part of the structure: how it holds the product, the materials, the weight, and how easy (or difficult) it is to use. If you think about condiment sauce packaging, you might consider packaging benefits, such as excellent valve performance and a reliable dispensing closure. Those are definitely worth considering when so many people complain about ease of squeeze or leaky dispensers. That type of functional attribute appeals to us on a rational level, whereas color, visuals, and texture appeal to us on an emotional level.

The shape of most soda bottles makes holding and pouring easier; however, for each brand or product, subtle shaping distinctions have more to do with emotional benefits than functional ones. The form of a soda bottle, shampoo bottle, box of tea, individual tea bag, box of cereal, or candy mint container contributes to its brand personality, appeal, sensuality/tactility, and the relationship to the audience.

All that a package is—visuals, form, color, typography, materials, and textures—will be absorbed as a total unit by each viewer. Most every person who looks at a package sees the whole package rather than the separate visual or tactile elements; however, each visual component has more of an effect on the individual than one realizes. Some visual components "cue" the viewer more than others.

Color plays a major role in cueing people as to flavor, scent, type, and contents of a particular product packaging. Color can also send a signal about status and quality. With only seconds (or a couple of minutes at most) to make a purchasing decision in a supermarket or drugstore, color, visuals, and type must all work together to communicate brand essence and information. Dan Olson, creative director at Duffy & Partners, Minneapolis, says: "So much of food packaging is about appetite appeal. We don't want our potatoes green or our ketchup blue, and the package shouldn't miscue the experience of the product by incorporating inappropriate colors."

Photography or illustrations on packaging play two important roles: they are cues that convey information while creating an emotional connection. Emotionally, visuals can cue the consumer to how he or she will feel after purchasing this product, which benefit will be reaped. For example, a buoyant woman depicted on a nutritional supplement or the image of a ski slope on an oral hygiene product signals the resulting sensation after use.

Package copy includes brand name, product name, pertinent and required information, and a tag line or descriptor, which communicates the emotional and functional benefit of the brand. Typography communicates on a connotative level, hopefully working with all the visual elements to establish an effective brand identity, to establish the brand as individualistic and with spirit.

FIG. **11** / **06**

**BRAND IDENTITY & PACKAGE
DESIGN**

· NUMBER 17, NEW YORK
· CLIENT: HOMEMADE BABY

The HOMEMADE BABY identity and
package design communicates
fresh, organic, and traceable (from
field to fingers), appealing to savvy
moms and the rising demand for
fresh baby food.

Clarity of Identification and Information

With so many brands on a store shelf, how will
a shopper find a particular one? First, a package
design has to be interesting enough for someone
to notice it. Sound familiar? This is true for most
graphic design. Usually when someone notices a
package, he or she is also considering other prod-
ucts in the category, on the same shelf or in the
same aisle, and giving roughly twenty seconds to
all in consideration. Then, if the package holds
the person's interest, the shopper begins to scan
the package for information.

Many eye-tracking studies have been con-
ducted on how people "read" a package. A clear
visual hierarchy with a dominant visual or typo-
graphic treatment as the entry point will draw
you into the composition. Then your eyes will go
to the next element of emphasis in hierarchical
order, and so on. Orchestrating flow and rhythm
will aid the composition and hierarchy. The
clearer the cues, the fewer elements in the com-
position, the easier it will be to read the composi-
tion. Psychologically, people tend to be attracted
most by visuals and, as mentioned earlier, often

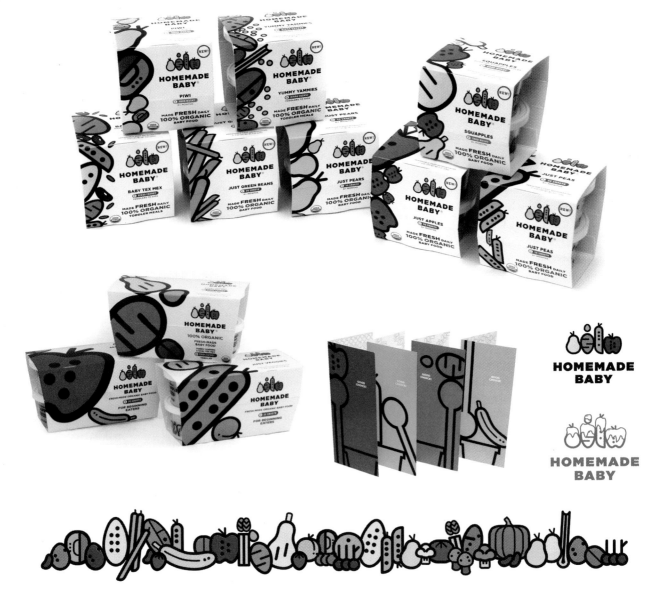

project the visual attributes of the package onto the product.

The visual hierarchy should not only ensure order, it should ensure a *logical* order. Some information is more immediately critical to a shopper in the few seconds in front of a shelf, and the designer must understand that communication hierarchy, referred to as package architecture. As a shopper yourself, you know that you "hunt" for particular information on packaging, such as flavor, scent, size, quantity, or compatibility. If someone isn't shopping for a specific brand but scanning for a product descriptor such as flavor, form, or variety, how will he or she notice that information? How will someone be able to distinguish among brand extensions, between flavors, ingredients, or choices within a category such as tea, cookies, or baby food?

Number 17 uses two main cues to identify HOMEMADE BABY's new line of organic baby food for their identity/package design shown in Figure 11-06: the dominant, bold, and playful visual denoting the food and the name of the food, such as "Just Apples," directly under the logo. As you see here, to ensure a positive brand experience, information should be clear and consistent across packages, similar to the positioning of elements on a website, so that people know where to look and can easily find information on each package. Color is an important design element in the packaging of products like food, toiletries, and beverages, often conjuring up key associations and used to designate flavor or fragrance choices. Color differentiates choices and can also unify a product line.

When the Dial Corporation needed to bring a unique experience to market, they engaged Wallace Church to "help separate the men from the boys by making a more sophisticated statement on shelf. Wallace Church's design was inspired by the elements that are critical to a young man's active lifestyle—electronics, sports, energy drinks, and first impressions" (Figure 11-07). The male body spray category had already exploded onto the scene, so to differentiate the fragrances, color is used both on the pump and below the logo as the background for the fragrance name.

FIG. **11** / **07**

PACKAGE DESIGN: RIGHT GUARD RGX

· WALLACE CHURCH, NEW YORK
· CREATIVE DIRECTOR: STAN CHURCH
· DESIGN DIRECTOR: JOHN BRUNO
· DESIGNER: AKIRA YASUDA
· CLIENT: RIGHT GUARD RGX BODY SPRAY, THE DIAL CORPORATION

The titanium skin, compelling brand mark, and vibrant, yet controlled accent colors convey a lighter smelling lineup versus the heavy scent alternatives. The RGX monogram and the X icon speak to the confident, contemporary male. When combined with a twenty-first century structure, the resulting identity is sleek, powerful, and remarkably refined.
—Wallace Church

In the store or at home, you want consumers to be able in a couple of seconds to decipher and comprehend product information. For example, Turner Duckworth's brief for Homebase "was to create a range of packaging that communicated the breadth of their range of lawn seeds (Figure 11-08). Consumer research had identified a need for single-minded benefit led communication in an area of the store where self-selection could end

FIG. **11** / **08**

PACKAGE DESIGN: HOMEBASE LTD—LAWN SEED

· TURNER DUCKWORTH, LONDON
· CREATIVE DIRECTORS: DAVID TURNER, BRUCE DUCKWORTH
· DESIGNER: MIKE HARRIS
· PHOTOGRAPHER: DAVID LIDBETTER
· RETOUCHER: PETER RUANE
· CLIENT: HOMEBASE

FIG. **11**/**09**

PACKAGE DESIGN: SESMARK

· WALLACE CHURCH, NEW YORK
· CREATIVE DIRECTOR: STAN CHURCH
· DESIGN DIRECTOR: MARCO ESCALANTE
· DESIGNER: MARITESS MANALUZ
· CLIENT: SESMARK, PANOS BRANDS

The twelve Savory Minis pictured on the box create an active frame for the brand name, product name, and flavor. For the Multigrain Chips, the photograph of a field of grain moves back creating an illusion of space, yet pushing the chips closer to the viewer, tempting us to reach for one.

Wallace Church revolutionized the Sesmark line of products from the top down. We took what was a very dated and fragmented brand, and created a sophisticated and unified design architecture, with a bold new logo. To further enhance the brand's wholesome and healthful attributes, we used beautiful duotone background illustrations to establish a sense of heritage and place. Having established the design for the existing line of crackers, we then extended the design to a new line of multigrain chips in bags.

—Wallace Church

in the wrong product being purchased." Their design solution "uses photographic imagery to highlight both the problem and solution using turf cut into shapes that consumers could identify with the needs of their lawn. For example, Lawn Revival uses a cross to indicate care; Lawn Feed, a heart."

In Figure 11-09, for Sesmark Savory Minis, Wallace Church provides two cues to the flavor—the name of the flavor placed in a distinct color band directly under the product name, and then to reinforce the name, a visual cue is strategically positioned directly under it—salt for one and garlic for the other. For the Multigrain Chips, the flavor name is reinforced by the photograph of the chips and by the bucolic photograph of a field of grain.

Imagery in Figure 11-10 is used creatively with purpose. "The Amazing Food Wine Company delivers a unique experience with a line of wines designed to pair specifically with everyday foods Americans prepare and enjoy at home.

"Lippincott was chosen to help name, design, and launch this new brand that breaks conventional perceptions of wine appreciation and usage occasions. Referencing food as the primary

FIG. **11**/**10**

NAMING & PACKAGE DESIGN: WINE THAT LOVES

· LIPPINCOTT
· CREATIVE DIRECTOR: CONNIE BIRDSALL
· DESIGNERS: PETER CHUN, ALINE KIM
· CLIENT: THE AMAZING FOOD AND WINE COMPANY

The name, "Wine that Loves," combined with contemporary packaging graphics effectively conveys the brand essence and stands out in a sea of traditional labels.

"Wine that Loves" is in high demand by consumers and has been recognized as an innovation in the wine category for its unique positioning, product quality, and strong brand presence. The packaging design has captured the attention of major retailers and has been featured in numerous publications.

—Lippincott

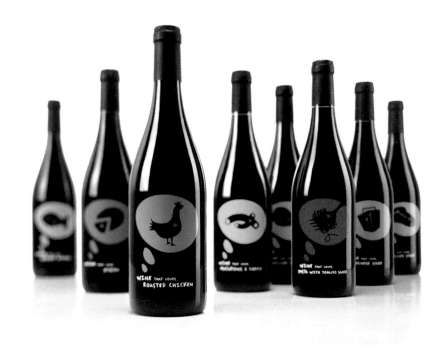

source of information rather than grape varietals and vintage, 'Wine that Loves' makes good wine accessible for everyday enjoyment."

Aesthetics are particularly important when the target audience is sophisticated, as in the target audience for The Gracious Gourmet, an identity and package design solution for a boutique condiment company (Figure 11-11). Here the type of condiment is denoted in the same color across the product line; however, the color of the flavor/ingredient name changes along with the visual background.

PACKAGE DESIGN BASICS

What makes you notice any particular packaging sitting on a store shelf amidst numerous others? Take the walk-down-the-supermarket-aisle test to see which packaging stands out among the competition. Once a package stands out, is it well identified and is the information clear?

Most packaging is displayed on shelves in multiples, where we see the cumulative effect of several packages lined up next to one another, as well as how one brand looks competitively against another. (Online shopping may change how we view and react to packaging; however, once it is delivered to our homes, we interact with it.) How will a design look stacked on the shelf? Will each individual package make any implied visual connections with the next? Will any patterns emerge? Connections?

Package design must be attractive, legible, and appropriate for its audience and marketplace. (See sidebar "Objectives for Effective Packaging.")

The 2D and 3D of Package Design

Package design is a merging of two- and three-dimensional design, promotional design, information design, and engineering. The casing aspect of package design is three-dimensional. It's the structural design; it's a form (think carton, bottle, can, jar, tin, wrapper, bag, etc.) made out of materials and substrates (glass, metal, plastic, paper, and so on) possibly involving special finishes. Your assignment may require designing a new structural form or for an existing form (think carbonated soda can). Any packaging has several surfaces to be designed for graphics, and all sides must be

FIG. **11** / **11**

IDENTITY AND PACKAGE DESIGN FOR A BOUTIQUE CONDIMENT COMPANY

· MUCCA DESIGN CORPORATION, NEW YORK
· CREATIVE DIRECTOR: MATTEO BOLOGNA
· ART DIRECTOR/DESIGNER: ANDREA BROWN
· CLIENT: THE GRACIOUS GOURMET
· © MUCCA DESIGN

A vertical rule is used as a "spine" for the type flush aligned to it on either side, contributing to a simple elegance.

OBJECTIVES FOR EFFECTIVE PACKAGING

· Design appropriately, with relevance, for the product, brand, and target audience.

· Make sure it has impact on the shelf or screen (when image is reduced).

· Differentiate from the competition; ensure identification.

· Consider how the design fits into the broader visual identity system (if applicable).

· Ensure legibility and clarity of information.

· Consider the shelf context; the packaging will be seen in multiples when on display.

· Consider appropriate color associations and coding.

· Coordinate for differentiation and unity with other flavors or choices or products in a product line.

· Realize that it may be seen on screen (reduced) for online shoppers. (When shopping online, consumers view packaging on the computer screen, and its visual appeal must somehow remain effective in that setting.)

· Research materials and construction.

· Recommend using recycled and nontoxic materials and processes.

considered in the design. On the shelf, packaging is seen from a frontal or 2D point of view; however, once taken off the shelf, the form is indeed a three-dimensional—all sides count—solution. Light falling on the form in a setting and how

FIG. **11** / **12**

GLOBAL PACKAGING AND HANG TAG SYSTEM: THE NORTH FACE

· CHEN DESIGN ASSOCIATES, SAN FRANCISCO
· CREATIVE DIRECTOR: JOSHUA C. CHEN
· ART DIRECTORS: JOSHUA C. CHEN, LAURIE CARRIGAN
· DESIGNER: KATHRIN BLATTER
· CLIENT: THE NORTH FACE

To communicate the company's technological leadership in the outdoor industry and demonstrate its efforts toward greater environmental sustainability, Chen Design Associates was brought aboard to redesign The North Face's entire global packaging system. Materials with high percentages of post-consumer content and environmentally friendly inks were used. Four languages were incorporated.
 —Chen Design Associates

CHEN DESIGN ASSOCIATES HELPED THE NORTH FACE LAUNCH A GLOBAL REDESIGN OUR PRODUCT HANG TAG AND PACKAGING SYSTEM. NOT ONLY DOES THIS NEW SYSTEM BETTER COMMUNICATE TECHNOLOGICAL LEADERSHIP, IT ALSO SOLIDIFIES THE NORTH FACE'S DESIRE TO STRIVE FOR GREATER ENVIRONMENTAL SUSTAINABILITY.

each plane of the form relates to every other must be taken into account. As with any design, it's the best practice to solve the graphics and structural form design aspects at the same time, which would make for the most organic solution. For packaging, you do need to create a prototype. If the form is new, then a prototype would be constructed. If the form exists, you could start by sketching the face panels, with 2D sketches, and position them in a photo-editing program on a form. Does information cross panels? Do planes line up when sitting next to another on the shelf? Can you create any visual connections among the panels/planes of the three-dimensional form?

As always, the design is based on a design concept. And, as with some other applications that may be a series, you may have to determine how your concept will work for a line of products, and how you can differentiate among the products (think shampoo, conditioner, and body wash), make their functions clear, create visual interest, as well make sure they are unified as a series.

SUSTAINABILITY

All visual communication professionals should make an earnest attempt to practice sustainable design—design that incorporates environmental matters, also called eco-design, green design, or design for the environment, as did Chen Design Associates for The North Face in Figure 11-12, where materials with high percentages of post-consumer content and environmentally friendly inks were used. Investigating how materials and processes impact on the environment, troubleshooting for potential hazards and wastefulness is critical. Consider how materials affect (deplete, pollute, add unnecessary refuse to) the environment. We can make choices to use environmentally friendlier materials and inks, as well as encourage clients to reduce packaging materials to essentials. (See sidebar "Eco-Friendly Design Concerns.")

Pangea Organics, a Boulder, Colorado-based organic bodycare company (Figure 11-13), was reaching the four-year mark when founder and CEO Joshua Onysko approached IDEO to

FIG. **11** / **13**

IDENTITY AND PACKAGING FOR PANGEA ORGANICS

· IDEO, PALO ALTO
· CLIENT: PANGEA ORGANICS

ECO-FRIENDLY DESIGN CONCERNS

· **Materials: utilize recyclable materials, compostable organic materials; and**

· **Pollution: manufacturing processes and materials that are nontoxic to air, water, and the earth.**

help redefine its brand expression. Small in size, with limited distribution, Pangea Organics was in need of an identity and brand language that would increase demand while embracing the sustainability and organic living philosophies upon which the company was founded. IDEO explains the approach:

> To learn more about Pangea Organics, IDEO visited the company's facilities, where the team spoke with multiple stakeholders, from an herbalist to production staff to board members. They also observed the company's sustainable process for crafting 100 percent organic soaps, lotions, and facial care products. A workshop followed the visit to promote brainstorming and idea sharing between the two companies. From the workshop, the IDEO team took inspiration from Pangea Organics' dedication to sustainability and wellness, embodied in Pangea Organics' products, practices, and emerging nonprofit—the Pangea Institute—to which 25 percent of the company's profits go to support sustainability research and education.
>
> Equipped with a deep understanding of Pangea Organics' core values, IDEO defined the company's

brand principles. These were translated into a full identity guideline and brand story, which were then used in sustainable packaging design for 35 products—including a compostable bar soap box inspired by egg cartons and made from 100 percent post-consumer content—a point of purchase display, a tradeshow booth, a product guidebook, and customer collateral.

AUDIO PACKAGE DESIGN

For many people, listening to a CD at home involves contemplating the cover, reading the inside booklet and lyrics, and looking at the photographs of a favorite recording artist such as Willie Nelson (Figure 11-14). Like a poster, audio packaging takes on greater meaning. We may glance at a superbly designed shampoo bottle with appreciation, but we study a CD cover intently! Looking at a CD cover becomes part of the listening experience. Also, audio packaging can draw in a new listener.

People feel very strongly about the music they enjoy and the recording artists they prefer. Audio package design absolutely must reflect the recording artist's or group's sensibility—no equivocations. The package design must express the unique quality of the artist or group, while inviting the browser in a music shop to pick up, consider, and purchase it. From your own musical preferences and those of other people in your life, you can understand how different people's listening choices are and how a designer must not only address the recording artist—the audience must be addressed as well. Designing for a Broadway audience, as in Figure 11-15 for the musical *Sweeney Todd*, is different than designing for David Byrne's audience as in Figure 11-16. "This round-cornered *Feelings* CD packaging features happy, angry, sad, and content David Byrne dolls. . . . The type was actually made as a model and then photographed," says Sagmeister. One of the art directors working on this CD was the recording artist himself, David Byrne.

Special manufacturing techniques can help render an imaginative concept a reality, as shown

FIG. **11**/**14**

CD PACKAGING: WILLIE NELSON, *TEATRO*

· SEGURA INC., CHICAGO

Segura creates a full experience—an environmental feel—for the viewer/listener in this CD design.

FIG. **11** / **15**

DELUXE SLIPCASE WITH 92-PAGE BOOKLET FOR DOUBLE-CD SET: *SWEENEY TODD*

· THINK STUDIO, NEW YORK

· DESIGN: JOHN CLIFFORD, HERB THORNBY

Nice and bloody for a musical.
 —John Clifford

FIG. **11** / **16**

DAVID BYRNE, *FEELINGS*

· SAGMEISTER INC., NEW YORK

· ART DIRECTORS: STEFAN SAGMEISTER, DAVID BYRNE

· DESIGNERS: STEFAN SAGMEISTER, HJALTI KARLSSON

· PHOTOGRAPHY: TOM SCHIERLITZ

· DOLL MODELS: YUJI YOSHIMOTO

· COLOR ADVICE: ANNI KUAN

· CLIENT: LUAKA BOP/WARNER BROTHERS MUSIC INC.

The packaging includes a sophisticated, color-coded "David Byrne Mood Computer" (printed on and under the CD disc) that lets you determine your current feelings.
 —Stefan Sagmeister

FIG. **11** / **17**

ROLLING STONES, *BRIDGES TO BABYLON*

· SAGMEISTER INC., NEW YORK
· ART DIRECTOR: STEFAN SAGMEISTER
· DESIGNERS: STEFAN SAGMEISTER, HJALTI KARLSSON
· PHOTOGRAPHY: MAX VADUKUL
· ILLUSTRATION: KEVIN MURPHY, GERARD HOWLAND (FLOATING COMPANY), ALAN AYERS
· CLIENT: PROMTONE B.V.

The Bridges to Babylon *cover for the Rolling Stones CD features an Assyrian lion embedded into a specially manufactured filigree slipcase. The interior reveals a long strip of desert to fit the accompanying tour/stage design.*
—Stefan Sagmeister

in the CD packaging for the Rolling Stones (Figure 11-17), which is why it is important for package designers to work collaboratively with production experts. And once again, Sagmeister expresses the nature of the recording group through his design concept, while utilizing materials to an optimum for Skeleton Key (Figure 11-18).

"All type on the *Imaginary Day* cover for the Pat Metheny Group has been replaced by code. The images connect to the songs and mood of the album and can be decoded by using the diagram printed onto the CD itself," says Stefan

Sagmeister of his innovative design solution (Figure 11-19).

Often, images of recording artists are featured on CD covers. When that solution isn't the best route, just as with any graphic design problem, you can visualize and compose a concept in a variety of compelling ways. In Figure 11-20, John Clifford notes, "The repetition of the texture of the pen line, along with the lines' endpoints as edges, make a unique CD cover for this band." For Figure 11-21, logo and CD design for New York–based Caedmon Audio Books, a vintage and classics imprint, the logo design is based on a spinning record/disc.

FIG. **11** / **18**

SKELETON KEY, *FANTASTIC SPIKES THROUGH BALLOON*

· SAGMEISTER INC., NEW YORK
· ART DIRECTOR: STEFAN SAGMEISTER
· DESIGNERS: STEFAN SAGMEISTER, HJALTI KARLSSON
· PHOTOGRAPHY: TOM SCHIERLITZ
· CLIENT: CAPITAL RECORDS

True to the album title, Fantastic Spikes Through Balloon, *we photographed all the balloon-like objects we could think of (sausage, fart cushion, blowfish, etc.), and punched a lot of holes through them. Simple.*

Since the band did not want their audience to read the lyrics while listening to the music ("this is not a poetry affair"), the words to the songs are printed flipped so they are only readable when seen reflected in the mirror of the CD.
—Stefan Sagmeister

FIG. 11 / 19

PAT METHENY GROUP,
IMAGINARY DAY

· SAGMEISTER INC., NEW YORK

· ART DIRECTOR: STEFAN SAGMEISTER

· MECHANICALS: MATHIAS KERN

· DESIGNERS: STEFAN SAGMEISTER, HJALTI KARLSSON

· PHOTOGRAPHY: TOM SCHIERLITZ/STOCK

· CLIENT: WARNER JAZZ

FIG. 11 / 20

APPLES OF DISCORD CD

· THINK STUDIO, NEW YORK

· DESIGN: JOHN CLIFFORD, HERB THORNBY

FIG. 11 / 21

CD SAMPLER DISCS, CAEDMON AUDIO

· ART DIRECTOR: LAURA KLYNSTRA

· DESIGNER: WILL STAEHLE

· CLIENT: CAEDMON AUDIO

CASE STUDY

CD PACKAGING:

- MISSISSIPPI JOHN HURT, *LEGEND*
- RIDERS IN THE SKY, *ALWAYS DRINK UPSTREAM FROM THE HERD*
- SLEEPY LABEEF, *I'LL NEVER LAY MY GUITAR DOWN*
- BOOZOO CHAVIS, *DOWN HOME ON DOG HILL*
- VISUAL DIALOGUE, BOSTON
- DESIGNERS: FRITZ KLAETKE, IAN VARRASSI, CHRISTIAN PALINO
- CLIENT: ROUNDER RECORDS

PROBLEM

Rounder Records is an independent label specializing in music ranging from reggae to bluegrass, blues to folk, and a few genres that defy categorization. With every release it's important to have the design reflect the character of the featured artist and the music they create.

SOLUTION

Visual Dialogue looks at these CD covers as basically 4³⁄₄" square ads. Using just a few elements—photo, artist's name, and title—we create covers that engage the desired audience while also giving a sense of the music. The end result is a visually distinctive and memorable identity that lasts for years.

—Fritz Klaetke

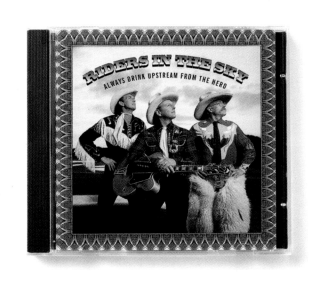

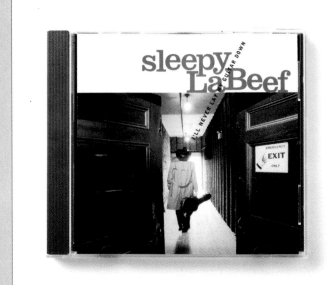

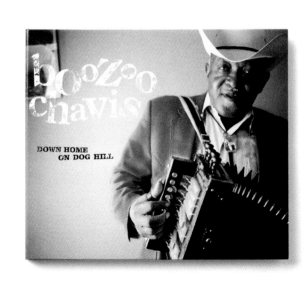

EXERCISE 11-1

COLOR

Did you know that ancient civilizations may have held the belief that chocolate has magical powers? When was sugar first added to chocolate? Does chocolate have medicinal benefits? Research the history of chocolate.

Create three different color palettes that would be appropriate for a Chocolate Café identity aimed at women ages 15–54. At least one of the palettes should not imitate the actual color of chocolate.

PROJECT 11-1

CHOCOLATE CAFÉ BRAND IDENTITY

DESIGN BRIEF

Project: Chocolate Café Brand Identity and Packaging

Product: Crème Chocolate Café *or* Coco Café & Bookstore

❶ What are we trying to accomplish?

» Create consumer awareness

» Create compelling and distinctive brand identity and packaging

❷ *Who are we trying to influence?*

» Women, ages 15–54

 » Chocolate lovers

 » People who enjoy coffee shop/café or bookstore café atmospheres

 » People willing to pay premium prices for food they enjoy

❸ *What do they think now?*

» I love chocolate and don't care about cost.

» I enjoy spending leisure time with friends in a café environment.

❹ *What do we want them to think?*

» I have to try this—it is unique.

» This is a great way to enjoy chocolate.

 » I like the idea of eating chocolate in this new setting.

❺ *Why should they think this way?*

» Because this chocolate café . . .

 » has made eating chocolate more social.

 » is bringing the same type of "coffeehouse" environment to chocolate.

 » has a sophisticated-looking brand identity.

❻ *How will this be communicated?*

» Identity design and package design

» Applications: logo, signage, package design, store environment including uniforms

Note that package design should include at least five elements: cups, bags, boxes, et cetera. Include one unusual shape and be aware of texture and color palette especially.

Optional: *Include seasonal packaging or specialty items beyond the basic group. Additionally, design the environment of the café.*

❼ *What is the tonality of the communication?*

» Sophisticated; a rich food experience

If you have your own strategy, you may expand or change any of it, but you will need to rewrite the brief.

CHOCOLATE CAFÉ BRAND IDENTITY CONCEPT

Suggested point of departure for concept and art direction provided by Rose Gonnella, Professor of Visual Communications, and Executive Director of the Robert Busch School of Design, Kean University.

What approach will you take to communicate a sense of sophistication and richness (perhaps even of the exotic)? Think in terms of comparisons, for instance, make an association to ancient cultures that developed the use of cocoa; compare with European cultures that manufacture the world's best; simply relate to gold and the color of chocolate itself.

RESEARCH

Read about chocolate. Have a chocolate tasting party. Survey people about their chocolate tastes. Talk to friends about chocolate—see what leads they might give you.

ART

a. Color—select a palette of three or five colors that will communicate the idea of sophistication, richness, and/or the exotic. The color choices should be based on research as well.

b. Texture—select a pattern/texture that will tactilely compel the viewer. Chocolate is a sensory experience, so the identity should be as well, and there is no better visual way than through texture.

c. Type—as always, the typeface should be in an appropriate and complementary "voice."

Go to our website **GD/s** for *many* more Exercises and Projects, and presentation guidelines, as well as other study resources including the chapter summary.

● Art Center College of Design

● Art Center College of Design

I2/

<<< / *facing page*

ART CENTER CATALOG

· MATSUMOTO INCORPORATED, NEW YORK
· CREATIVE DIRECTOR: TAKAAKI MATSUMOTO
· DESIGNERS: TAKAAKI MATSUMOTO, HISAMI AOKI
· PHOTOGRAPHER: STEVEN HELLER
· WRITER: VANESSA SILBERMAN

A BROCHURE JUST MIGHT BE THE MOST WIDELY USED AND VERSATILE GRAPHIC DESIGN APPLICATION, SERVING MANY PURPOSES. IN A FEW PAGES, WITH TEXT AND IMAGES, A BRAND STORY CAN BE TOLD, INFORMATION CONVEYED, INSTRUCTIONS PROVIDED, PRODUCTS DISPLAYED, OR DESIRE CREATED. OTHER SIMILAR APPLICATIONS COMMONLY USED BY A VARIETY OF COMMERCIAL AND NONPROFIT SECTORS INCLUDE PROMOTIONAL OR INFORMATIONAL BOOKLETS AND BOOKS, AS WELL AS COMMON CORPORATE COMMUNICATIONS SUCH AS ANNUAL REPORTS, OFFERING MEMORANDUMS, BOOKLETS, CATALOGS, DIRECT MAIL, AND SALES KITS. WHAT IS COMMON AMONG THESE FORMATS IS THEY HAVE MULTIPLE PAGES OR PANELS, AND THEIR PURPOSE DIFFERS FROM OTHER PUBLICATION DESIGN IN THAT THEIR STRATEGIC OBJECTIVES INVOLVE TOPICS OTHER THAN EDITORIAL CONTENT. WE WILL EXAMINE TWO OF THE MOST PREVALENT ONES—BROCHURES AND ANNUAL REPORTS—AND ALSO LOOK AT EXAMPLES OF A NEWSLETTER, OFFERING MEMORANDUM, BOOKLET AND BOOK FORMAT, CATALOG, AND DIRECT MAIL.

WHAT IS THE PURPOSE OF A BROCHURE?

When you visit a travel agency, bank, nonprofit outreach organization, or any number of businesses or organizations, you will most likely be handed a brochure or series of brochures (Figure 12-01). A brochure is a widely used tool, a multiple-page application for communicating information or for promotion (sales and marketing); it is also called a *booklet* (depending on binding and trim size) or *pamphlet*. Whether in print or PDF, whether external or internal business communication, people rely on brochures for their efficiency and content. A project may involve the design of a single brochure or a brochure system, a series of related brochures. A cohesive brochure system serves two main functions: to increase brand or group recognition and to provide comprehensible information or communication in digestible amounts, with each brochure covering a different topic, service, or product.

The subject matter of a brochure or brochure system can be any topic related to any commercial, educational, government, health, or nonprofit sector. For example, Figure 12-02 is an annual appeal for the Scojo Foundation, an organization devoted to providing affordable eyeglasses to tailors, electricians, and goldsmiths around the world who live in poverty and depend on their jobs for a livelihood. Utilized for internal communication (aimed at managers, a sales force, or employees) or for external communication (general public or a target audience), brochures run the full gamut from being information driven to almost seeming

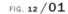

FIG. **12** / **01**

SYMBOL AND SIGNATURE, BROCHURES, STATIONERY, AND FOLDER: COLE TAYLOR BANK

· CROSBY ASSOCIATES, CHICAGO
· CREATIVE DIRECTOR/ART DIRECTOR: BART CROSBY
· DESIGNER: CARL WOHLT
· SIGNAGE: COLE TAYLOR BANK:
· CREATIVE DIRECTOR/ART DIRECTOR: BART CROSBY
· DESIGNERS: BART CROSBY, CARL WOHLT
· CLIENT: COLE TAYLOR BANK

Crosby Associates worked with Cole Taylor to develop a comprehensive repositioning strategy and a plan to accelerate growth and gain share within the bank's chosen niche. Crosby created a branding program and a new identity system featuring a simplified name, a new symbol, and fresh, new visual environments. Signs for Cole Taylor's bank locations feature the bold new corporate signature and color scheme. Large, exterior monument signs and interior wall graphics use dimensional letters to update and unify the bank's image and provide connectivity among facilities having varied architecture. Promotional, informational, and financial communications used to support the Cole Taylor brand position are driven by the company "voice," defined by qualities such as "intelligent, customer-focused, relevant, approachable, and trustworthy."
 —Crosby Associates

FIG. **12** / **02**

BROCHURE: SCOJO FOUNDATION ANNUAL APPEAL

· UNDERCONSIDERATION LLC, AUSTIN, TX
· DESIGNERS: BRYONY GOMEZ-PALACIO, ARMIN VIT
· ILLUSTRATOR: BEN WEEKS
· CLIENT: SCOJO FOUNDATION

This appeal highlights the improvements and impact of Scojo Foundation over the past year and is distributed to potential donors as well as functions as a marketing brochure.

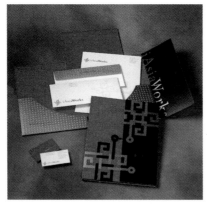

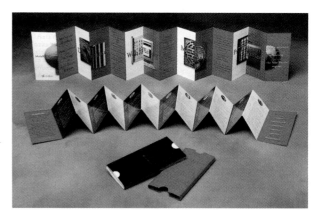

FIG. **12** / **03**

**INTEGRATED BRANDING
PROGRAM: IASIAWORKS**

· GEE + CHUNG DESIGN, SAN FRANCISCO
· CREATIVE DIRECTOR/ART DIRECTOR/
 ILLUSTRATOR: EARL GEE
· DESIGNERS: EARL GEE, FANI CHUNG
· CLIENT: IASIAWORKS

Objective: *An Asian-focused web
hosting company combines a classic
Asian motif with an integrated
circuit, conveying connection,
integration, and the linking of
cultures through technology.*

*The presentation folder uses the
logo as an Asian string-tie clasp to
provide prospective clients in Asia
with the experience of unwrapping a
gift. Folder pockets evoke a Chinese
moon-gate shape and rivets of an
Asian door, symbolic of iAsiaWorks
providing its customers with a
gateway into Asia.*

*Product data sheets combine
Asian and technology metaphors
to create a unique visual language
for the company.*

Results: *The comprehensive,
integrated branding program
successfully launched the
iAsiaWorks brand in all of their
important markets throughout
Asia, leading the company to a
successful purchase by AT&T.*
—Earl Gee

like picture view books. Each individual unit in a
brochure system (series) covers one subject in a
series of related topics—for example, the various
major areas of study at a university or the various
types of banking services.

A brochure may be one part of a larger infor-
mation program or a comprehensive, integrated
branding program for a brand or group, as you saw
in Figure 12-01. Figure 12-03 shows a branding
program for iAsiaWorks, an Asian-focused web
hosting and Internet service provider that sought
to be the dominant player for global companies
trying to do business in Asia and Asian companies
seeking world markets. This brochure is a trade-
show giveaway. Earl Gee, Gee + Chung, com-
ments, "Using a format inspired by Asian folding
screens, a pocket-sized tradeshow giveaway defines
iAsiaWorks' services on the front while providing
useful travel tips and business protocol for each
country of operations on the back."

BROCHURE DESIGN PROCESS
The design process has five phases:

Orientation ▶ Analysis ▶ Concepts ▶ Design ▶ Implementation

For any integrated media project, there may
be many deliverables such as logo, visual iden-
tity, web and online media, packaging, sales kits,
and others.

When a brochure or brochure system is part of
a broader marketing or communication program,
the design objectives strategically relate back to
the greater design brief and its core goals and val-
ues. Once you have gone through orientation and
analysis, conceptual design begins with examin-
ing the content and formulating a design concept
based on strategy, content, brand, and an insight.
Figure 12-04 was funded by Sappi Ideas That
Matter for CYCLE Kids Inc., an independent,
nonprofit organization introducing children to
the joys of cycling, the benefits of healthy eating,
and the world of physical science. According to
Sappi, this brochure "invites readers to reminisce
about the sheer joy of owning and riding a bike as
a child, how good it feels to exercise, how healthy
it is for the body and the heart. Using these
stories as a starting point, each of the collateral
pieces informs readers about how the organiza-
tion empowers children to stay fit and how much
they benefit from the program."

For Figure 12-05, Brenda McManus and Giovanni Jubert designed a newsletter on the concept of "U" for the graduate department of the Communication Design Program at Pratt Institute. McManus comments, "It was to be a piece that would explore the diversity of our GradComD program as a whole, a piece that would become a tool to encourage community, identity, and student union."

Design Development of a Brochure

Once you have generated a design concept, your visualization process may partly be dictated by brand guidelines, where type of imagery or look and feel is predetermined. A brochure's design may be based on characteristics of the visual identity; for example, when P.E.O. (Philanthropic Educational Organization) wanted to revitalize their visual identity, they turned to Sayles Graphic Design (see "Before and After: P.E.O./Sayles Graphic Design"). The flower graphic that punctuates the new logo and color palette is the same used on collateral materials.

When a brochure is less tied to the visual identity, then you determine a greater degree of the

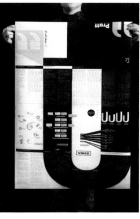
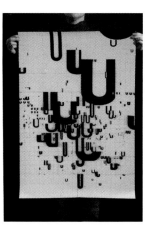

BEFORE & AFTER

P.E.O./SAYLES GRAPHIC DESIGN

**BROCHURES AND COLLATERAL:
BEFORE WORKING WITH
SAYLES GRAPHIC DESIGN**

OLD LOGO/BANNER

"As with many organizations that have been around a long time, P.E.O.'s identity elements had become somewhat tired and lacked continuity. Yet the organization did not want to lose the equity it had invested in its symbolism."

NEW LOGO/BANNER

Not wanting to abandon the past altogether, designer John Sayles chose a marguerite as part of P.E.O.'s new identity; the daisy look-alike has been the group's official symbol since its founding in 1869. Upon the new logo's introduction, members were told that it "is not meant to replace the historic 'star' emblem, but rather serves as an alternate way of identifying our sisterhood." The palette chosen for P.E.O.'s identity—PMS 584, 208, and 116—is fresh and contemporary yet retains a connection with history and tradition.

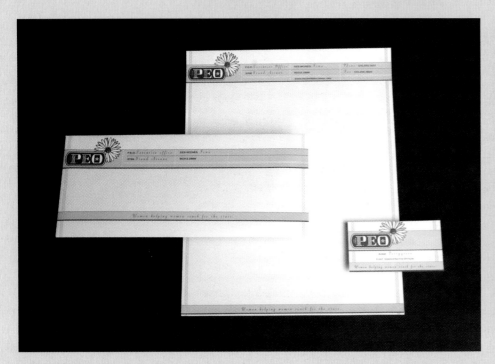

**AFTER CREATED BY SAYLES GRAPHIC DESIGN:
IDENTITY, SISTERHOOD MEMBERSHIP GUIDE,
BRANDING CAMPAIGN**

· SAYLES GRAPHIC DESIGN, DES MOINES, IA
· PRINCIPAL/ART DIRECTOR: JOHN H. SAYLES
· CLIENT: P.E.O.

FIG. **12** / **06**

SALES BROCHURE: ADAMO LONDON

· CHEN DESIGN ASSOCIATES, SAN FRANCISCO
· CREATIVE DIRECTOR/ART DIRECTOR: JOSHUA C. CHEN
· DESIGNERS: JENNIFER TOLO, MAX SPECTOR
· COPYWRITER: CHEN DESIGN ASSOCIATES
· PHOTOGRAPHERS: KARL HEDNER, JESSICA ROBINSON
· CLIENT: ADAMO LONDON

Lead-in black and white photography evokes a romantic sense of being in London while cheeky but gentlemanly copywriting accompany full color modular purchasing guides.
—Chen Design Associates

visualization, including the sort of artwork (illustration, photography, typography, etc.). For this European shoemaker's introduction to the United States, Chen Design Associates built identity, a retail brochure, and packaging inspired by Adamo's meticulously designed shoes (Figure 12-06). To announce Capital Printing Corporation's green certifications, Rizco Design developed a direct mail piece that is a trifold brochure, with an inside pocket that housed additional sheets with instructions to "make your own" origami heart, tree, and windmill (see "Case Study: Capital Printing Corporation Goes Green/Rizco Design").

Five Things to Factor into Design

There are five main issues to keep in mind when designing brochures or similar corporate communications:

1/ How the brochure system will work with the existing visual identity system: Will the brochures be largely visually related to the brand identity through color palette, look and feel, signature, typefaces, kind of imagery, and tone? Will the brochure be independent but still need to relate to identity issues? Obtain specifications and identity guidelines.

2/ What type of content: Obtain copy, required imagery, logo, signatures, taglines, and any graphic components, such as charts, graphs, or pictograms. Understanding content will guide your design decisions and help you determine how to design the grid.

3/ How you will communicate the content: Determine how to communicate with clarity, a comprehensible hierarchy, and impact. Determine whether your design will be copy driven or image driven.

4/ How the brochures *function* in context (how they are distributed, seen and used): If you think of a brochure as related sound bites of information or as an efficient workhorse, it may help you understand that its purpose is to make communication extremely easy to understand for the reader—the public, a sales force, a patient, a student, a citizen, or anyone on the receiving end.

5/ Budget will help in determining paper, visuals, printing, special printing techniques, and color (two-color, four-color, Pantone versus process

CASE STUDY

OVERVIEW

Capital Printing Corporation (CPC) was challenged to develop a marketing piece to introduce their two environmentally friendly certifications, Forest Stewardship Council (FSC) and Sustainable Forestry Initiative (SFI), and announce that

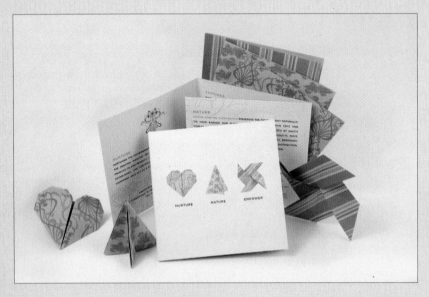

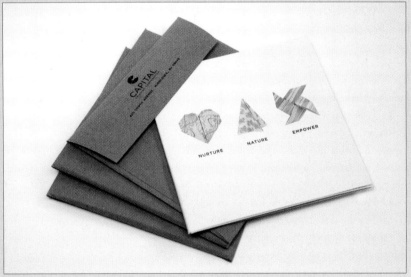

DIRECT MAIL

- RIZCO DESIGN, MANASQUAN, NJ
- CREATIVE DIRECTOR: KEITH RIZZI
- DESIGNER: JENNIFER PESCE
- CLIENT: CAPITAL PRINTING CORPORATION
- PRINTER: CAPITAL PRINTING CORPORATION

a portion of the plant had been converted over to green power. The goal was to target existing clients and attract new ones, especially agencies.

DESIGN CHALLENGE

Rizco Design, a seven-year client of CPC, was enlisted to take on the task of creating a piece that would make a "green" statement in both its design and message. Knowing that printing and paper choices have a major impact on the environment, our goal was to make sustainable design choices throughout the process: this included minimizing resources, choosing FSC-certified paper stocks and turning to vendors who utilize wind power.

DESIGN SOLUTION

A tri-fold brochure titled Nurture Nature Empower featuring an origami heart, tree, and wind mill was born. The piece tied in CPC's announcements and educational information about printing and the environment. The inside of the brochure included a pocket that housed (1) a business card and (2) patterned sheets with directions on how to make your own origami replications. This dimensional leave-behind acted as a reminder that CPC is an environmentally friendly vendor.

SUSTAINABLE SOLUTION

Though the piece was designed to minimize resources, the print production process offered many challenges.

Paper selection was a top priority, and the choice of turning to Mohawk Paper was only natural due to its extensive variety of high quality, yet sustainable, recycled, FSC-certified, wind powered, and carbon neutral paper lines. As a result, two different paper stocks were selected. First, wind powered and FSC-approved Mohawk Options Cream White Smooth #130 Cover was selected for the

exterior. Mohawk Options is backed by Inxwell technology, which dramatically improves the ink holdout on uncoated papers. Secondly, the inside of the piece was printed on Mohawk recycled and wind powered Via Kraft Vellum 70# Text for the inside. Opaque PMS colors were selected to ensure color consistency and density against both uncoated paper stocks. The result on this piece proved that a design can be environmentally responsible without sacrificing print quality.

Secondly, retouching played a critical role, since the photography of the origami needed to reproduce accurately on two different colored papers. Additionally, the investment in color correcting helped to eliminate unnecessary press time when it came to matching color on press. Last, a multiple process bindery using recyclable dyes and water-based glues ensured that the end product would be as recyclable as possible.

MEASURING THE RESULTS

The results were measured through the Beleaf report card. Rizco Design's Beleaf program is a three-tiered model that measures environmental decision making throughout the creative process in the firm—starting with how the office operates, to how the design is established, and finally, to how projects are printed. Some of the major changes include converting the office to 100 percent wind power, restructuring our vendor base to include FSC-certified printers, and specifying recycled and/or FSC-certified paper stocks from mills that are using green power. The goal for clients is to reach 70 percent sustainability on each project. After a project is completed, the end-result is rated through a web-based tool, and an electronic report card will be distributed to clients to showcase the sustainability of their job, enabling them to witness the impact first hand.

How did Capital's piece measure up? An 87!

FINAL STATEMENT

The success of this project is a testament to the benefits that agencies, paper mills, and printers reap when they work hand-in-hand in the development of green products.

—Debra Rizzi, Rizco Design

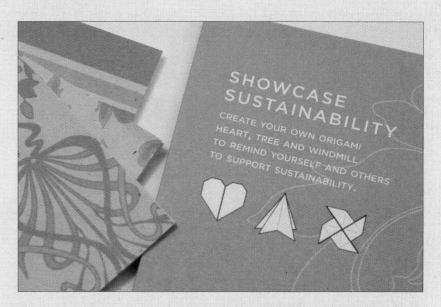

FIG. **12** / **07**

BROCHURE: BRAVE NOOD WORLD

· TRICYCLE, CHATTANOOGA, TN
· ART DIRECTOR: MICHAEL HENDRIX
· DESIGNERS: NICK DUPEY, BEN HORNER
· COPYWRITER: CALEB LUDWICK
· AGENCY COLLABORATOR: WIDGETS AND
 STONE, CHATTANOOGA, TN
· CLIENT: NOOD FASHION

*This brochure is printed on
100-percent post-consumer
waste paper, and its pages bear
perforated French folds that tear
open to reveal more detailed text.*

*Nood is not just another carpet
company that makes some green
products. They are a green company
that makes carpet.*
—Tricycle

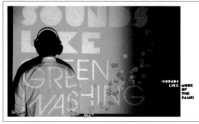

colors). Choosing paper for function, texture, quality, weight , and certifications (see "Case Study: Capital Printing Corporation Goes Green") will help you determine how to best visualize. For a brochure system, you may determine that a family of papers is warranted and optimum.

Context and Function

If you recall seeing brochures displayed in various settings—banks, physicians' offices, government agencies, schools—you realize that brochures are seen in particular contexts: on tabletops, in wall unit dispensers, on counters, or in racks. Brochures can be mailed directly to people's homes or businesses, too. Determine how the brochure system will be seen and distributed before making layout decisions. For example, there are practical considerations: if brochures are displayed in racks, only the top portion of the brochures may be seen initially, and that should be a design consideration. If a brochure is mailed, then space for the addressee needs to be taken into account.

Sometimes function gets lost while we're busy creating, but it never should be forsaken. In fact, function can and should be the springboard for creativity, as in Figure 12-07, for Brave Nood World, which "is a brand manifesto for Nood Fashion, an eco-minded carpet brand. It functions as both brochure and presentation in order to be fiscally efficient. Tearing apart the perforated creases of the book reveals detailed content about each spread—this mimics the format of the accompanying online slide show. The slide show was designed to supplement the book. Sales reps for Nood may use the slide show or booklet for presentations and then leave the book with a customer afterward. The idea is to ease a potential customer into this information. The photography consists of staged snapshots from around our office because of the low production budget. This lo-fi approach works appropriately with Nood's street-smart aesthetic."

FIG. **12** / **08**

THE 1% USER'S GUIDE

· MENDEDESIGN, SAN FRANCISCO
· CREATIVE DIRECTOR/WRITER: JEREMY MENDE
· DESIGNERS: STEVEN KNODEL, AMADEO
 DESOUSA, JEREMY MENDE
· WRITER: VINNIE CHIECO
· JUNIOR DESIGNER: DIANA MARTINEZ
· CLIENT: PUBLIC ARCHITECTURE
· SAPPI AWARD RECIPIENT

*Public Architecture identifies and solves
practical problems of human interaction
in the built environment. It acts as a catalyst for public discourse through education, advocacy,
and the design of public spaces and amenities. Believing that design is a process of making
things that build constructive values directly into the work, the team from MendeDesign of San
Francisco saw a coming together of their own values and vision with those of Public Architecture.
They identified in particular with the 1% program, an attempt to bring design sensitivity to the
non-profit sector, a sector typically woefully short of access to thoughtful space planning and
design. By pairing non-profit organizations with interested architects, the 1% program enables
those organizations to develop more healthy, dignified, efficient, user-friendly and meaningful
working environments that function to better serve their clients and overall mission.*
—Sappi

MendeDesign "came up with the 1% User's Guide, a package of related print materials that seek to forge real, project-oriented, working relationships between architects and 501(c)(3), non-profit organizations. The 1% User's Guide consists of two booklets: one written to engage principals of architecture firms, the other to engage the executive directors of non-profit organizations in need of design services (Figure 12-08). The two booklets are adjoined, sharing a single spine. In this way the architect's booklet leads into the back of the non-profit booklet, and the non-profit booklet leads into the architect's booklet, creating a physical model of the architect-non-profit relationship the project advocates."

Function along with budget should also help you determine if "more" than a brochure or booklet is warranted or useful. Perhaps a short book would better fulfill your strategic objectives. Books are less ephemeral and may be kept rather than thrown away. The page count also may provide the space needed to communicate the required content or make the appropriate impact. For a fifty-eight-page book, a type of "recruitment piece," for Depelchin Children's Center (Figure 12-09), Doug Hebert remarks, "We thought it was a great way to inspire action and provide a sense of hope by featuring successful stories of kids and families brought together through this process. To truly appreciate the 'happy endings,' we also needed to feature some of the sad stories of abuse the kids came from. So we would have a negative story and then a positive story to contrast it. We did three features of each in total. We wanted the piece to be sized smaller, to make it feel a little more personal and 'storybook-like' and we used warm, bright, happy colors to truly put a positive spin on this process."

Format

At times, you will have to work with a standard size format and specifications, or you will need to determine size based on objectives, concept, need, context, and budget. If you do have a choice, then trim size and layout should depend on your design concept. For the Depelchin Children's Center, the designers wanted the piece to size smaller to be "storybook-like." For the DCM IV Offering

FIG. **12** /**09**

FIFTY-EIGHT-PAGE BOOK:
DEPELCHIN CHILDREN'S CENTER

· SAVAGE INC., HOUSTON
· CREATIVE DIRECTORS: PAULA SAVAGE, DOUG HEBERT
· ART DIRECTOR/DESIGNER: DOUG HEBERT
· ILLUSTRATORS: JACK SLATTERY, LEIGH WELLS
· PHOTOGRAPHER: TERRY VINE
· COPYWRITER: MOLLY GLENTZER
· PRINTER: BLANCHETTE PRESS, VANCOUVER, BC
· CLIENT: DEPELCHIN CHILDREN'S CENTER
· SAPPI GRANT RECIPIENT

I choose to do this piece for Depelchin because I am adopted. And I could not imagine being 8, 12 or 16 years old and not having parents, not having a place to come home to, parents to take you to the park to play or attend your little league baseball game. That, on top of the horribly abusive situations all of the Depelchin kids come from, I just could not fathom that. So we decided that the piece would be a sort of "recruitment piece" for what Depelchin calls "forever families."

Depelchin has to actually recruit families. This is an ongoing process where they have monthly orientations and events. And they have to recruit because these are not newborn babies that are up for adoption. These are kids who come from sexual, emotional, verbal and physically abusive situations. They are not going to come into your home and immediately love you and everything is going to be great. There are going to be issues, and there's going to be counseling and acting out. It's all these kids know. But it's also a very rewarding process for these new parents.

The piece was designed to give a little background on why it's important to adopt, some background on Depelchin and the adoption process, and some discussion on different types of adoption scenarios (empty nesters adopting a child, interracial adoptions, same sex adoptions, multi-sibling adoptions, etc.). But the heart of the piece are the profiles or case studies of different Depelchin kids.
—Doug Hebert

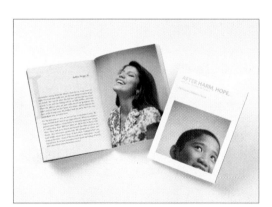

FIG. **12**/**10**

DCM IV OFFERING MEMORANDUM

· GEE + CHUNG DESIGN, SAN FRANCISCO
· CREATIVE DIRECTOR/ART DIRECTOR/ILLUSTRATOR: EARL GEE
· COPYWRITER: DAVID CHAO (DCM)
· DESIGNERS: EARL GEE, FANI CHUNG
· PHOTOGRAPHER: GEOFFREY NELSON (PORTRAITS)
· CLIENT: DCM

*Objective: DCM is a leading Silicon Valley venture
capital firm with significant technology investments in
Asia and throughout the world. Their DCM IV Offering
Memorandum sought to attract investors
in DCM's $350 million technology fund.*

Solution: *The transparent plastic cover interactively reveals the clear difference the fund offers
investors, juxtaposing physical and fiscal transparency. Familiar financial symbols identify key
sections throughout the book and function as coding devices to guide the reader. The traditional
Japanese binding combines with modern materials to represent the firm's careful due diligence
in evaluating new technology investments. Bold, conceptual chapter openers and red-bordered
case studies showcase fund strategies.*

Results: *The book's content and form successfully reflected DCM's innovative approach and
enabled the fund sellout with committed investors faster than any of the firm's previous funds.*
—Earl Gee

· INDUSTRY TRENDS: A VISION FOR THE FUTURE SPREAD
· A PALM-READING METAPHOR CONVEYS THE FORECASTING AND DIRECTION OF FUTURE TECHNOLOGIES IN A VERY
 HUMAN AND MEMORABLE MANNER.
· INVESTMENT PARTNERS SPREAD
· AS SUCCESSFUL VENTURE INVESTING IS ESSENTIALLY ABOUT PERSONAL RELATIONSHIPS, FULL-BODY PORTRAITS
 ALLOW EACH PARTNER TO EXPRESS THEIR OWN UNIQUE PERSONALITY AND CHARACTER.
· FUND DIFFERENTIATION: INTERNATIONAL BUSINESS DEVELOPMENT SPREAD
· THE FIRM'S WORLD-CLASS EXPERTISE IN INTERNATIONAL BUSINESS DEVELOPMENT IS EXEMPLIFIED BY THE OLYMPIC
 IDEALS OF COMPETITION AND ACHIEVEMENT.

Memorandum, Gee + Chung's solution was an unconventional 10" w × 13.5" oversized format, plastic cover, Japanese binding, and French-fold pages to set the book apart and position DCM as a venture firm committed to thinking differently (Figure 12-10). For this venture capital firm, the book uses a transparent plastic cover and familiar financial symbols to interactively reveal the clear difference their fund offers investors.

"This admission catalog for Art Center College of Design has an oversized format and is printed on uncoated paper to give the publication a magazine-like feel. The large type, large illustrations, and abundance of white space are used to make the book approachable and inviting to use. The structure of the book is meant to show off the school's main asset, the quality of its student body, by devoting the majority of the pages to student work," comments Matsumoto of Figure 12-11.

Figure 12-12 is a catalog created for the "Burrow" exhibit at Oakville Galleries that "shows off the featured art to best advantage, and, through production and design, communicates a feeling of depth, of hidden elements, reinforcing the exhibit's burrowing theme. The concrete, tactile elements of the catalogue—exposed stitching and tipped-in essay booklets—recall and continue the viewer's experience of 'Burrow,'" explains creative director Fidel Pena.

Grid

Once you determine the size, design the grid. Make sure it is *flexible enough* to allow for variety, to work for a system of brochures, and to accommodate the content (copy, including subtitles and captions, and visuals). The width of the columns is key to the accommodation of content. Since visuals usually need greater width, consider the ratio of text to visuals when designing the grid.

› Will you combine text and visuals on every panel?
› Will panels be dedicated to only text or visuals?
› Also consider a modular-oriented grid for flexibility. Make sure to be mindful of margins, too.

As you compose the layout, keep rhythm and pacing across panels in mind. Design panels with a sense of flow from one panel to another by minding alignments, contrasting, and repeating elements

FIG. **12** / **11**

ART CENTER CATALOG

· MATSUMOTO INCORPORATED, NEW YORK

· CREATIVE DIRECTOR: TAKAAKI MATSUMOTO

· DESIGNERS: TAKAAKI MATSUMOTO, HISAMI AOKI

· PHOTOGRAPHER: STEVEN HELLER

· WRITER: VANESSA SILBERMAN

This grid, with one wide column for text and one narrow column for photographs and captions, is an excellent structure for this type of catalog. The two columns can also be combined to accommodate one large photograph. When a piece is printed in four-color process, you can make good use of color for headers, charts, quotes, rules, etc.

to establish continuity across surfaces. Contrast provides visual interest; however, a great degree of variation in sizes of type and images might collapse the grid structure and look fragmented.

Utilizing a type family and a limited color palette helps maintain unity.

Brochure System

When designing a brochure system, there should be enough difference among the brochures to distinguish one from another. Each brochure should be able to stand alone, as a strong individual piece, as well as belong to the other brochures. Modular systems or chunking information is an interesting route for brochure systems.

Many designers utilize the same layout for a cover system, where graphic components reside in the same positions on each cover. This ensures unity among covers, but it should also allow for differentiation among the individual pieces through the use of color, image, title, or a combination thereof.

Make dummies (prototypes) to check for functionality and to see if there is flow, coherence, differentiation, and visual interest. Even when designing PDF files, prototyping on paper helps you work through any compositional issues.

FIG. **12** / **12**

BURROW CATALOG

· UNDERLINE STUDIO, TORONTO

· CREATIVE DIRECTORS: FIDEL PENA, CLAIRE DAWSON

· DESIGNER: CLAIRE DAWSON

· WRITER: SHANNON ANDERSON

· CLIENT: OAKVILLE GALLERIES

ANNUAL REPORTS

An annual report is a document of record, published yearly by a publicly held corporation, that contains information about the corporation's fiscal condition. Essentially, it is a required report to stockholders and an important corporate document. This report—distributed to employees, stockholders, and potential stockholders—contains detailed information such as the income statement, balance sheet, description of the corporation's operations, and general reports about management and operations. Given access to a corporation's information on the Internet, many investors, fund managers, securities analysts, and corporations still maintain that an annual report is the single most important document produced by a company.

During the mid-twentieth century, when corporations realized the importance of a corporate visual identity to the success of their businesses, they began to use the annual report as an opportunity to enhance their corporate identity and to "promote" their corporate message—the corporate ethos, drive, and main concerns.

WHAT IS THE PURPOSE OF AN ANNUAL REPORT

Certainly, a website and visual identity may carry more importance as visual communication tools; however, for a *single document*, an annual report still carries enormous weight in the minds of key players. Why? An annual report is not only a required corporate document, regulated in the United States by the SEC, but it is also a marketing tool—a visual communication tool that conveys a corporate image. Some think of an annual report as a strategic positioning vehicle as well. Because this document includes, very significantly, the discussion of financial results and the CEO's letter to investors, its message carries important meaning to most of its target audience.

An annual report describes the state (health) of a company as well as predictions and intentions for the future, comparable to the U.S. president's State of the Union address. One or more corporate communications executives work closely with a design firm to guide the content (and perhaps the theme) of an annual report.

Some designers specialize in corporate communications with an emphasis on annual reports. "This field is specialized to the point that most clients want you to have experience in doing an annual report before they will ever trust you with one," says Denise M. Anderson, design director of DMA. Also, some printers specialize in high-end annual reports, ones requiring high-quality printing, special techniques, binding, and folding.

Components of an Annual Report

Most annual reports are divided into two sections. The front of the report carries the editorial and promotional content and contains the most attractive marketing elements, such as photography or illustrations, the CEO's letter to shareholders, and thematic statements. The back of the report contains all the required statistics, what some call the "10K wrap." In fact, some may include the statistics as an insert on different paper, enclosed in a back pocket, or stitched to the report.

Today, a corporate website can host the required annual statistics (the 10K wrap), leaving the printed annual report to be more of a corporate image tool, although still part of a required document. Some corporations post their entire annual report online—giving a visitor the ability to download an annual report as a PDF—as well as publish a print document. Depending on the company, whether it is a Fortune 500 company, a recent initial public offering (IPO), or a smaller corporation, the annual report may take more emphasis online than in print, or the parts may supplement each other.

ANNUAL REPORT DESIGN PROCESS

Orientation ▸ Analysis ▸ Concepts ▸ Design ▸ Implementation

Orientation and analysis may involve more collaboration with the client, due to the legal nature of the project, and may even extend to using a highly collaborative team during conceptual development.

Conceptual Development for an Annual Report

The nature of a concept or a theme should appropriately reflect an entity's values, make a

FIG. **12** / **13**

ANNUAL REPORT

· LOWERCASE, INC., CHICAGO
· ART DIRECTOR/DESIGNER/ILLUSTRATOR: TIM BRUCE
· PHOTOGRAPHER: TONY ARMOUR
· CLIENT: CHICAGO VOLUNTEER LEGAL SERVICES

Chicago Volunteer Legal Services is one of the largest practicing law firms in the city. Through panel referral, neighborhood clinics, and the foundation itself, they provide legal assistance to roughly 17,000 people a year in the Chicago area. They accept no government funding and are lean and entrepreneurial. Our books help them increase awareness for their work, raise money, and recruit talent. Each of the books reflects this purpose and yet captures the year and point of view uniquely.
 —LOWERCASE, INC.

statement, enhance a corporate image, highlight achievements or strong points, or explain major corporate actions. A design concept for an annual report may hinge on a theme, a unifying quality, subject, or idea and involve a motif, a repeated shape, pattern, or image. All visual components—photography, illustration, graphs, and charts—should be related to the theme, the corporate voice, and the tone of the copy. Tim Bruce, art director, explains LOWERCASE's conceptual thinking behind the annual reports for Chicago Volunteer Legal Services (CVLS) (Figure 12-13). Bruce comments: "We design the CVLS annual reports backwards. Most organizations concept the annual, get the directions approved, and then build out the piece. We talk with CVLS about the year, the industry, the issues that are top of mind, the challenges and opportunities that have

presented themselves. From this, we build a mix of client and lawyer profiles that reflect these issues. Instead of trying to fit our concept to the people, we let the people and the year form our concept. It's organic and it relies on a high level of trust from CVLS. For CVLS it reflects the way they work and why they are so good at what they do." When I asked Bruce about how this annual report was visualized, he responded:

"This is a perfect example of the concept being driven by what is at hand. The drawing (scratch board, something all school age kids have done) was reflective of the creativity and hands-on approach the lawyers use to solve the problems at hand, the creativity that the organization shows in creating opportunities where others see only problems (they accept no government funding, for example,

CASE STUDY

ANDERSON ENERGY ANNUAL REPORTS/JONATHAN HERMAN,
ART DIRECTOR, WAX

J.H.

A graduate of Vancouver's renowned Emily Carr University's Communication Design program, Jonathan began his career at the New York office of Pentagram. Following his time abroad, he returned to Canada to join WAX, a Calgary-based design and advertising firm with a diverse group of clients. He believes that good design should be illuminating, intelligent, honest and fun, and that a shared, inclusive creative process yields the most effective work. Jonathan has been consistently recognized by every major design competition including Communication Arts, Clios, D&AD, Graphis, The Black Book AR 100, London International Awards and Applied Arts.

Annual reports become much more significant during challenging economic times. This is the time when clear communication is valued the most. If an annual report can deliver its message concisely, it can only benefit the company.

An economic downturn is an important time to stand out from the crowd. During such times, a company needs to prove that it is thinking differently from its competitors.

What do you think about the current state of today's Annual Reports (ARs)?

It is obvious that annual reports are going through a major transition. Investors are going online to download annual reports as PDFs more and more each year. It seems that annual reports are viewed on screen more frequently than they are in print. With that said, not all investors have access to online annuals, or they prefer to hold something in their hands. Printed annual reports are still critical. They are tactile. Investors can get a good sense of what a company is by how the book feels.

What changes have you noticed in annual reports?

The days of the really extravagant books are over. The creative is becoming more concise. The paper is thinner, print runs are shorter, and the MD&A [Management Discussion and Analysis] is getting longer. The standard AR format is being challenged, and books are becoming more inventive.

In which direction do you see the annual report moving?

Digital. It is only a matter of time before we see highly interactive web versions of annual reports, perhaps involving complex animations and even video clips. There's no reason why a president's letter to the shareholders couldn't be a video clip. The AR might become more of a corporate report profiling the past year's events and future objectives. Detailed financial info would be available online.

What are companies looking for when it comes to designing an annual report?

Companies are looking for designers to understand the challenges that their industry is in. They're also looking for efficiency, reliable process, someone who can quickly understand their company and how they fit into the competitive mix. And someone who can take all of that and produce an AR that is interesting and different.

Do you and the client both view the AR as part of the company's communications strategy?

Absolutely. An annual report is a great opportunity for a company to evaluate, revise, and reinforce their communications strategy. The AR is a very important part of Anderson's communications message. It is one of the only times they communicate with their complete investor base.

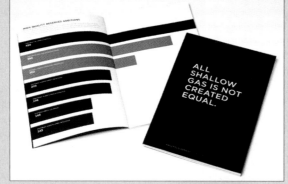

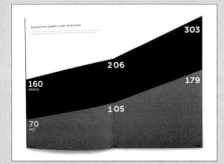

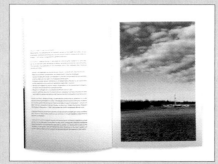

ANDERSON ENERGY ANNUAL REPORTS

· WAX, CALGARY
· CREATIVE DIRECTOR: MONIQUE GAMACHE
· ART DIRECTOR: JONATHAN HERMAN
· WRITERS: NICK ASIK, SEBASTIEN WILCOX
· PHOTOGRAPHER: JUSTEN LACOURSIERE
· CLIENT: ANDERSON ENERGY

noting that those organizations that do spend more time and money addressing the red tape that comes attached to the money than dealing with the reason they exist—to provide equal access to the law for the poor and working poor of Chicago and the surrounding regions).

"The illustrations are crude, creative and reflect the hardworking pragmatic way CLVS addresses the larger issue at hand."

When I asked how they select their compelling color palettes, Bruce replied:

"Our process is intuitive but not without reason. Color is subjective but also reflective of the industry and CVLS. We might note unusual color combinations while out on a shoot, or in a lawyer's office (on a book, a file, etc.) or in the neighborhood of a clinic or client that we might store away in our minds as interesting. But the color, like type, paper, cropping, illustration, etc. adds meaning. The pink for instance, while odd in the context of an annual report, is an exact match of typical phone message pads—something the lawyers are using all the time and reflective of the work that goes into the 17,000 cases they work on every year."

THEME

The process for generating a theme is the same as for concept generation. Some platforms for theme generation can be:

› the entity's mission
› the company's charitable undertakings
› the topic of the CEO's letter or other research or information
› the entity's accomplishments, activities, changes, or achievements of the past year as a springboard
› a brand icon, character, or product
› a general platform, such as family, giving, growth, advancement, development, cultural reference, or looking toward the future
› an intangible platform, such as responsibility, brotherhood, or fighting against tyranny
› a visual platform, for example, visual juxtapositions, structure versus fantasy, a visual merge of two objects, or a high-tech look
› a metaphor

DESIGN DEVELOPMENT OF AN ANNUAL REPORT

Juggling a large amount of content and many components—graphs, charts, lists, large blocks of text, product information, financial statistics, data, photographs, and graphic elements—is part of designing an annual report and demands the use of a flexible, well-designed grid. The grid should be able to accommodate text, images, and information graphics, such as charts and graphs. If you visualize your concept with an image-driven composition or with a text-driven design, it will influence your grid design.

To help guide your grid design, determine

› the number, sizes, and type of information graphics required at the outset
› print and online components
› how imagery relates to concept or theme
› visualization of *information* graphics as related to the concept or theme
› paper (cover stock and text stock) for visualization and quality

During visualization, determine the kind of visuals and how they will be presented—silhouetted, collaged, squared-up halftones, duotone (a halftone picture made of two printed colors), tritone (a halftone picture made of three printed colors), bleeds, or ghosting (a faint printed image). Choose imagery that will demonstrate the entity's values and attributes and that will best illustrate and exemplify the theme or design concept. If you are using a motif, think of how much variation you can incorporate while maintaining the meaning and integrity of the motif. Again, a common thread in how imagery is visualized will help unify multiple pages. All information graphics (charts, graphs, lists, diagrams) should have a similar style—a unified visual language.

Whether for an annual report or any multipage corporate communication, during visualization and composing, it is advisable to design two or three spreads and single pages that have slightly different visual/text relationships, yet share enough common characteristics to unify them, to see how pages will flow. Differing the spreads will add contrast and visual interest while varying the reading pace.

CASE STUDY

*THE ROCKEFELLER FOUNDATION/EMERSON,
WAJDOWICZ STUDIOS (EWS)*

The Rockefeller Foundation is a knowledge-based leading global foundation with a commitment to enrich and sustain the lives and livelihoods of poor and excluded people throughout the world. Emerson, Wajdowicz Studios (EWS) are creative consultants to the foundation and the designers of the foundation's outstanding annual reports.

EWS's relationship with the foundation is an example of a strong, long-term, trusted, and creative partnership between the client and the designers, which, over time has produced a remarkably high number of the outstanding printed publications seen in the nonprofit world.

Here are examples of two annual reports created by EWS from over a dozen produced to date by the Rockefeller Foundation. Every year the communications challenges and objectives may vary. What is consistent, however, is the outstanding narrative and original photography. Among the photographers working under photo direction of Jurek Wajdowicz are world-renowned

photojournalists such as Philip Jones-Griffiths, Antonin Kratochvil, Steve McCurry, and Jonas Bendiksen (whose work is shown here).

This very hands-on art direction and daily involvement in the photographic process helped achieve unusually powerful photojournalistic results which were a cornerstone contribution to the annual report.

"Our goal was to produce a multipart, comprehensive annual report integrating in a consistent and arresting way several of the foundation's universal issues. By focusing on the foundation's priorities, we were successful in designing program narratives, financials, and grants in a memorable, functional, and logical way while keeping consistent with the structure, detail and navigation involved in creating a fluid reading experience," says Jurek Wajdowicz.

The creative strategy was to begin with a strong photojournalistic design approach and to partner the narrative text of the five main program

**2003 ANNUAL REPORT COVER
AND SPREADS: THE ROCKEFELLER
FOUNDATION**

- EMERSON, WAJDOWICZ STUDIOS (EWS),
 NEW YORK
- ART DIRECTORS: JUREK WAJDOWICZ,
 LISA LAROCHELLE
- DESIGNERS: LISA LAROCHELLE,
 MANUEL MENDEZ, YOKO YOSHIDA,
 JUREK WAJDOWICZ
- PHOTOGRAPHER: JONAS BENDIKSEN

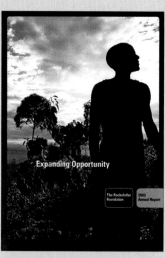
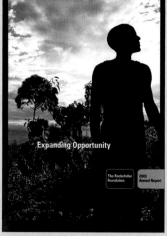
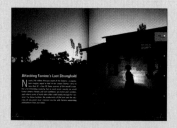
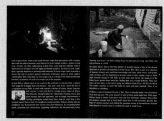
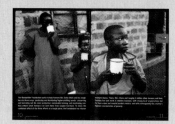

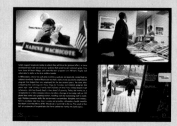

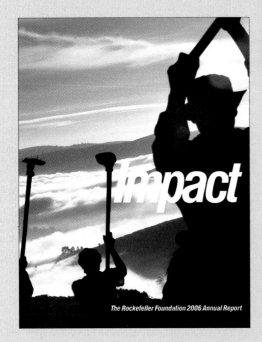

The Rockefeller Foundation 2006 Annual Report

Where We Are Today

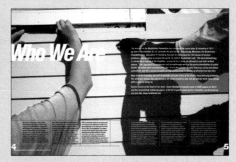

Who We Are

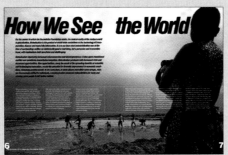

How We See the World

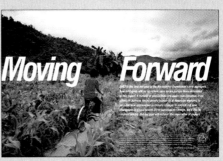

Moving Forward

2006 ANNUAL REPORT COVER AND SPREADS: THE ROCKEFELLER FOUNDATION

- ART DIRECTORS: JUREK WAJDOWICZ, LISA LAROCHELLE
- DESIGNERS: LISA LAROCHELLE, MANUEL MENDEZ, YOKO YOSHIDA, JUREK WAJDOWICZ
- PHOTOGRAPHER: JONAS BENDIKSEN

goals with arresting images. Second, throughout the piece, EWS created a lucid and appropriate book design system that incorporated the issues of priority to the Rockefeller Foundation and zoomed in on the specifics of a particular continent, country, and/or the individual challenges facing the grantees.

By structuring the book along major themes and photographing regions of the world where the foundation's programs were located (such as food security or the working communities shown here) EWS created a "zoom-in" photojournalistic approach where the focus began on global challenges and strategies and then zoomed in on regional issues, and then narrowed down even further to families and the individual.

Helping to ensure that the benefits of globalization are more widely shared, the Rockefeller Foundation is one of the most prominent organizations devoted to the well-being of the world's most poor and vulnerable. In the 2006 annual report for the foundation, the twelfth created with Emerson, Wajdowicz Studios, the report embodied the new directions and expanded initiatives that had been recently instituted. Bolder

and more streamlined, this report was structured and designed around straightforward questions (such as "Where Are We Today?"), followed by concise answers ("Moving Forward"). The powerful design elements and strong photojournalistic photography served to reinforce this structure, telling a story of transition, reflection, and continued growth.

These annual reports exemplify EWS's strong photojournalistic design approach. By using a logical and consistent design along with their editorial approach, we were able to achieve a complex yet cohesive image of the Rockefeller Foundation as one of the most extraordinary organizations dedicated on improving chances of the underprivileged of the world.

"With increasingly heated battles for dwindling donor funds, it encourages (or should encourage) the financially challenged nonprofit organizations to become more aggressive and innovative in their communications activities. In the end, I do believe that good design is making something lucid and memorable as well as meaningful and worthwhile," says Jurek Wajdowicz.

—Emerson, Wajdowicz Studios

FIG. **12** / **14**

CSPD 2008 ANNUAL REPORT

· WAX, CALGARY, ALBERTA
· CREATIVE DIRECTORS: MONIQUE GAMACHE, JOE HOSPODAREC
· ART DIRECTOR: JONATHAN HERMAN
· WRITER: SARO GHAZARIAN
· PHOTOGRAPHER: JUSTEN LACOURSIERE
· CLIENT: CALGARY SOCIETY FOR PERSONS WITH DISABILITIES

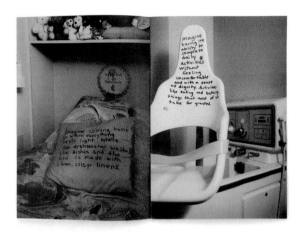

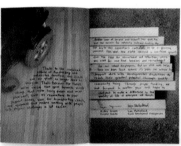

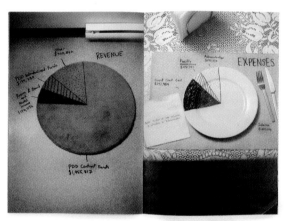

Ensure:

> the annual report's look and feel are considered in relation to the entity's established visual identity
> functionality: reporting information and promoting the entity
> information is easy to find and logically presented
> diagrams, charts, and graphs are comprehensible
> photography or illustration expresses the design concept or theme
> the theme highlights the entity's achievements

How you visualize and compose an annual report should be driven by the concept, as in Figure 12-14, for the Calgary Society for Persons with Disabilities. "To express the issue and significance of fundraising on a simple, human level, the entire annual report was written by hand on objects purchased through fundraising efforts that ultimately benefited people with disabilities," explains Jonathan Herman.

EXERCISE 12-1

BECOMING FAMILIAR WITH BROCHURE FOLDS

See Diagram 12-01 for examples

❶ *Single-Fold Brochure*: Fold an 8.5" × 11"-size paper in half.

❷ *Trifold Brochure*: Fold an 8.5" × 11"-size paper in thirds.

❸ *Gate-Fold Brochure*: Using 8.5" × 11"-size or 11" × 17"-size paper, fold the ends of the page inward so that they meet in the middle, folding in symmetrically. Then fold the folded paper in half again toward the middle.

❹ *Accordion-Fold Brochure:* Using 8.5" × 11"-size or 11" × 17"-size paper, fold the page in equal parts, like an accordion, with parallel folds that go in opposite directions, part in front and part in back, like a zigzag. (If you've ever seen con-

tinuous forms used in businesses, an accordion fold is similar to that type of fan-folding.)

Note: A bone folder or wooden craft stick is handy for creasing the edges.

PROJECT 12-1

PROMOTIONAL BROCHURE

Step 1

Choose a type of programming featured on a public broadcast channel or a cable television channel—for example, documentaries, arts, news and public affairs, or children's programming—or a commercial broadcast channel such as the Discovery Channel or CNN. During prime time, most public broadcast stations and cable stations present signature series about a wide variety of subject areas, such as nature, the arts, politics, finance, and science. Public broadcast and select commercial broadcast programming offer viewers the opportunity to learn about new ideas and new worlds through television and broadband content.

Step 2

a. Research the topic of the program you selected. Gather information that you can utilize in your brochure.

b. Write a design brief, determining the goal of the brochure and the audience. Determine your strategy.

c. Brainstorm ideas.

d. Generate a design concept.

Step 3

a. Fold several trifold brochures, which will be used for sketches.

b. Determine how you visualize the concept: Will you combine text and visuals on every panel? Will panels be dedicated to only text or only visuals?

c. Composition: If you use a grid, make sure it is *flexible enough* to accommodate the content (copy, including subtitles and captions, and visuals). The width of the columns is the key to accommodating content. Since visuals need greater width, consider the ratio of text to visuals when designing the grid. Also consider a modular-oriented grid for flexibility. Make sure you are mindful of margins, too.

d. To ensure unity and flow across the brochure, keep a checklist in front of you while sketching. As you compose the layout, keep rhythm and pacing across panels in mind. Design panels with a sense of flow from one panel to another by minding alignments and by contrasting and repeating elements to establish continuity across surfaces. Contrast provides visual interest; however, a great degree of variation in sizes of type and images might collapse the grid structure and look fragmented.

e. Utilize a type family.

Step 4

Create two roughs. Check each for flow from panel to panel and check for unity throughout the composition.

Make sure the content is readable and clear. Goals: clarity and impact.

Step 5

Create one final comp as a trifold brochure.

Optional: Design a small book of facts or trivia on the same subject as a companion piece to the brochure, as well as a direct mail postcard that will drive people to the website.

Go to our website **GD/s** for *many* more Exercises and Projects, and presentation guidelines, as well as other study resources including the chapter summary.

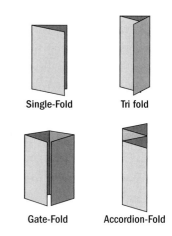

DIAGRAM [12-01]

TYPES OF BROCHURE FOLDS

Single-Fold Tri fold

Gate-Fold Accordion-Fold

13/

ADVERTISING

<<< / *facing page*

POSTER: *CONVERSE*
BRAND DEMOCRACY

· BUTLER, SHINE, STERN &
PARTNERS, SAUSALITO

ADVERTISING MATTERS.

FROM PUBLIC SERVICE TO HELPING DRIVE THE ECONOMY, CREATIVE ADVERTISING IS AN IMPORTANT CONTEMPORARY VISUAL COMMUNICATION VEHICLE. ADVERTISING IS PART OF DAILY LIFE AND INSEPARABLE FROM AMERICAN POPULAR CULTURE. IN MANY COUNTRIES, ADVERTISING IS THE ONE COMMON EXPERIENCE THAT IS SHARED BY A LARGE, DIVERSE GROUP OF PEOPLE. ADVERTISING IS A MASS MEDIA LEVELER—IT IS THE ONE POP CULTURE VEHICLE WE ALL COME INTO CONTACT WITH—FROM OUTDOOR BOARDS TO WEB BANNERS TO TELEVISION COMMERCIALS.

THE PURPOSE OF ADVERTISING

Advertising is used in a free market system to promote one brand or group over another. Whether used to launch a new brand or remind us to buy an established brand, advertising helps build the value of brands, groups, causes, and even individuals in people's minds. Advertising motivates us to act on behalf of a cause, helping to save lives and aid people in countless vital ways.

Most competing brands are on a par—parity products or services; for example, most shampoos in the same price category (or perhaps across price categories) are parity products. That said, effective advertising could persuade you that a particular brand is better or more appealing than the competition even though the brands are parity. An ad campaign for shampoo might convince you that your hair would be shinier or fuller or curlier or straighter or less frizzy or smell better or anything else that might appeal to you. In order for that shampoo advertising to affect you, it has to be relevant to you, and it has to be carried in media channels that will reach you as well as help make it relevant.

Advertising has become more ubiquitous than ever, as advertisers try to find new ways to get their message through to people. Advertising differentiates brands, groups, and causes, and ultimately sells products and calls people to action. An **advertisement (ad)** is a specific message constructed to inform, persuade, promote, provoke, or motivate people on behalf of a brand or group. (Here, "group" represents both commercial industry and social cause/not-for-profit organizations.) An advertising campaign is a series of coordinated ads, based on an overarching strategy, connected by look and feel, voice, tone, style, imagery, and tagline, where each individual ad in the campaign can also stand on its own. An integrated ad campaign involves various media, and might include broadcast, print, interactive, and other screen-based media, out-of-home, and unconventional media. Figure 13-01, "So Real You Can Feel It," is an integrated campaign for Toshiba HD DVD, which includes high-definition TV commercials, print advertisements, Internet banners, taxi toppers, and a "Times Square Extravaganza."

TYPES OF ADS

Commercial advertising promotes brands and commodities by informing consumers; it is also used to promote individuals, such as political candidates and groups, including corporations and manufacturers. Commercial advertising messages can take the form of single advertisements or campaigns in any media.

THE CLOUD OF
BLOODTHIRSTY BATS
ENCIRCLED US.
I GRINNED AT MY
MOTHER-IN-LAW

**BUT DID NOTHING
TO SAVE HER.**

TOSHIBA HD DVD
THE FEEL OF REAL

THE BEAST'S LIFELESS
EYES TRACKED OUR
EVERY MOVE. I REACHED
FOR GRANDMA

**AND HELD HER LIKE
A SHIELD.**

TOSHIBA HD DVD
THE FEEL OF REAL

THE LAVA FLOWED
TOWARD US WITH
HELLISH INTENSITY.
I GRABBED
MY BOYFRIEND

AND SHOVED HIM IN.

TOSHIBA HD DVD
THE FEEL OF REAL

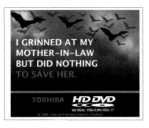

I GRINNED AT MY
MOTHER-IN-LAW
BUT DID NOTHING
TO SAVE HER.

TOSHIBA HD DVD
SO REAL YOU CAN FEEL IT

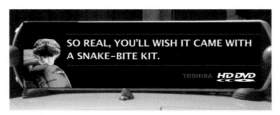

SO REAL, YOU'LL WISH IT CAME WITH
A SNAKE-BITE KIT.

TOSHIBA HD DVD

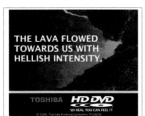

THE LAVA FLOWED
TOWARDS US WITH
HELLISH INTENSITY.

TOSHIBA HD DVD
SO REAL YOU CAN FEEL IT

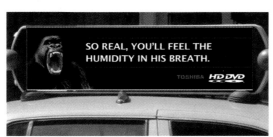

SO REAL, YOU'LL FEEL THE
HUMIDITY IN HIS BREATH.

TOSHIBA HD DVD

TOSHIBA HD DVD

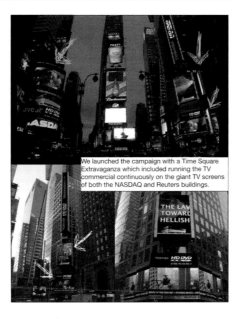

We launched the campaign with a Time Square
Extravaganza which included running the TV
commercial continuously on the giant TV screens
of both the NASDAQ and Reuters buildings.

FIG. 13 / 01

**PRINT, BANNERS, TAXI TOPPER, TV, TIMES
SQUARE EXTRAVAGANZA: TOSHIBA HD DVD,
"SO REAL YOU CAN FEEL IT."**

· DELLA FEMINA/ROTHSCHILD/JEARY & PARTNERS,
 NEW YORK
· CREATIVE DIRECTOR: MICHAEL "MAC" MCLAURIN
· CLIENT: TOSHIBA

Challenge: Toshiba HD DVD and Sony Blu-ray were
in the early stages of a "format war," competing
for the right to be the high-definition DVD player
of choice among consumers.

Solution: Capture the feeling of being totally
immersed in a movie. Focus on the shared
experience of watching movies at home—
especially on a Toshiba HD DVD player, when
the movie is "so real you can feel it."

Result: While being outspent nearly 10-to-1 by
Sony, Toshiba HD DVD sold out of its entire
inventory of early product, secured sell-through
agreements with all targeted retailers, and got
the endorsement of virtually every major movie
studio not owned or affiliated with Sony.

**MOVIE TRAILER-LIKE, HIGH-DEFINITION TV
COMMERCIAL**

*We launched the campaign with a Times Square
Extravaganza that included running the TV
commercial continuously on the giant TV screens
of both the NASDAQ and Reuters buildings.*
 —Michael "Mac" McLaurin

FIG. **13** / **02**

HIGH IMPACT DIRECT MAIL, GLOBAL TRADE SHOWS: DOUBLECLICK, "EMPOWERING ORIGINALS"

· COURTESY RENEGADE, LLC, NEW YORK
· CLIENT: DOUBLECLICK

DEFINE THE CHALLENGE

· Create an overarching brand platform for DoubleClick, a leading global provider of online advertising solutions.
· Get current clients excited about DoubleClick's new products and upgrades.
· Cut through B2B clutter of staid communications.

KNOW THY TARGET

· Jaded advertising and web publishing professionals
· Creative thinkers both on and off the job
· Appreciate products/services that help them get on with it

CAPTURE THEIR ATTENTION

· Global, fully integrated "Empowering Originals" campaign

GLOBAL PRINT CAMPAIGN

Renegade staged photo shoots with real DoubleClick clients and employees, showcasing them doing what they love doing outside the office, in the office environment. We then incorporated testimonial quotes about how DoubleClick professional tools save time, stress, and hassle at work, so that end users have room to pursue the passions that make them original people.

HIGH IMPACT DIRECT MAIL

For the launch of DART Motif, a rich media ad design tool, Renegade sent top agency creative directors fully functional light boxes with a clever collection of cutouts to piece together banners. A recent upgrade to the DART Search media management suite inspired Renegade to invent a "key word" board game called "Click To It" that we mailed to media buyers. The response rates for both of these programs are more than five times a typical DM (direct mail) piece.

GLOBAL TRADE SHOWS

Renegade created the "Originals Playground" booth for technology trade shows around Europe and the United States. The objective was to integrate people's playful, creative sides into the work setting. To that end, we loosened up invitees with a full bar designed to look like a light box, and invited them to play with assorted wigs and costumes stashed in office file cabinets. We photographed their shenanigans and gave them the goofy pictures with DoubleClick product information printed on the sleeve.
—Renegade, LLC

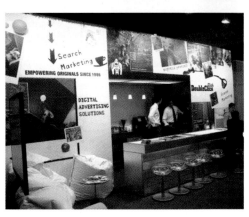

Within this category, the three biggest subcategories are *consumer ads*, which are directed toward the general public; *business to business (B2B)* (Figure 13-02), which is from one company to another; and *trade ads*, which are directed at specific professional or business groups.

Public service advertising is advertising that serves the public interest. According to The Advertising Council, an American public service advertising organization (www.adcouncil.org): "The objectives of these ads are education and awareness of significant social issues, in an effort to change the public's attitudes and behaviors and stimulate positive social change."

Commonly referred to as PSAs, public service advertisements are created by various advertising agencies around the world for a great variety of social causes and not-for-profit organizations. The following Case Study discusses a PSA, an anti-steroid campaign that was created by volunteer agency TBWA/Chiat/Day and produced by The Ad Council. (Also see Figure 1-14, a PSA to stop buzzed driving.)

In most countries, PSAs are considered a service to the community, and therefore there is no charge by the media to run these advertisements on television, on radio, or in print—although in order to have more control over the media and

CASE STUDY

ANTI-STEROIDS (DONTBEANASTERISK.COM)/THE AD COUNCIL/ TBWA/CHIAT/DAY

In 2007, the federal government seized 56 underground steroid labs in the United States, resulting in the confiscation of 11.4 million doses. The use of performance-enhancing substances is of primary concern in American sports. No segment of sports—from professional to youth—is immune to this problem. With increasing media coverage on steroid use in sports, teen usage has become a matter of greater consequence.

Not only are steroids a potential health hazard, they raise many ethical implications. In order to prevent teens from using steroids without increasing consideration, this campaign is designed to make steroids socially unacceptable. The PSAs will drive traffic to DontBeAnAsterisk.com to learn more about steroids, hear from professional athletes, and find healthy alternatives to excel in athletics.

—www.adcouncil.org

WEB BANNER, WEBSITE PSA: ANTI-STEROIDS

- SPONSOR ORGANIZATION: UNITED STATES OLYMPIC COMMITTEE
- CAMPAIGN WEBSITE: WWW.DONTBEAN ASTERISK.COM
- VOLUNTEER AGENCY: TBWA/CHIAT/DAY
- COURTESY OF THE AD COUNCIL (WWW.ADCOUNCIL.ORG)
- PRINT: PHOTOGRAPHER: TIM TADDER ©
- WEB BANNER & WEBSITE: ILLUSTRATION: COURTNEY REAGOR ©

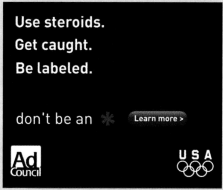

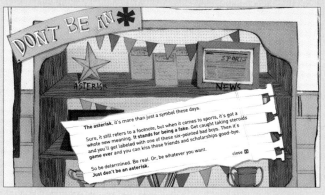

time placements, some nonprofit organizations and government agencies have begun to purchase advertising time and space, in addition to the donated time and space.

Cause advertising, *sponsored by corporations*, is used to raise funds for nonprofit organizations and is run in paid media. Cause advertising is affiliated with a corporation and used in part to promote a corporation's public persona or brand, unlike public service advertising where there is no commercial affiliation.

TYPES OF MEDIA

More and more, people are spending their time on their mobile phones or in front of computer screens. We are witnessing a convergence of media, where, for example, a mobile phone can become any person's media hub with an Internet connection, programmed content, music, GPS, and more. As technology rapidly evolves, it is most likely that our mobile phones will become one of the most important players in carrying ad messages.

In the past, television commercials and print ads were the main carriers of ad messages. Now, television is often used to drive people to the web where they can interact with a brand or group.

People also now do much of their "shopping research" on the Internet before stepping into brick and mortar stores. Out-of-home (outdoor, ambient, posters, and more) serves the same function, driving us to the web or our mobile phones. As we all spend more time on the web and mobile, seeking entertainment and information, connecting on social networking sites, tweeting, using RSS feeds, downloading widgets, using the web to connect with like-minded others and friends, building web communities, or blogging, advertising will evolve to best take advantage of technology, social networking applications, and emerging media.

WHO CREATES ADVERTISING?

In an advertising agency, a conventional creative team is a duo composed of an art director and a copywriter. A creative director or associate creative director, who makes the final creative decisions about the idea, approach, art direction, and copywriting, supervises the creative team before the work is presented to the client. Some agencies prefer unconventional creative teams or brand teams with several other members, which might include an account manager, IT expert, interactive designer (if appropriate), and marketing expert, among others. Together they work on conceptual development, generating "big ideas." After generating ideas, the art director is responsible for the art direction (overall look and feel, visual style, selection of photographer or illustrator) and design; and the copywriter is responsible for the writing. When a creative team works well, the division of labor might overlap. Any good art director should be able to write copy, and any good copywriter should be able to think visually.

Advertising is collaborative. Besides the traditional creative team of art director and copywriter, advertising depends upon other professionals, including strategic planners, marketing managers, programmers, and interactive designers or agencies when dealing with screen-based media, unconventional marketing agencies, media planners, commercial directors, producers, talent (actors, musicians, photographers, illustrators), casting directors, and location scouts, among others.

Traditionally, advertising agencies created advertising and controlled the brands. Now technology (iMovie, digital video cameras, Pro Tools, and other tools) makes it possible for regular people—customers, consumers, anyone—to economically and practically create in ways previously privy to advertising professionals. Brand companies and agencies are handing over the making of content to the public, ceding some control, trying to engage people as brand-makers. Technology has shifted much of a brand's power to people. The more people participate with a brand, the more those people will use as well as feel loyal to that brand. The Butler, Shine, Stern & Partners (BSSP) "Converse Brand Democracy" campaign (Figure 13-03) is one of the first examples of this new trend:

BSSP's Premise
Since the 1950s, Converse has had the best ad agency in the world working for them: Dean, Pollock, Ramone, Cobain, Pop, and Warhol. The brand had

FIG. **13** / **03**

POSTERS: *CONVERSE BRAND DEMOCRACY*

· BUTLER, SHINE, STERN & PARTNERS, SAUSALITO

Because we saw these as films, we created movie posters to promote them. They were sent to the artists and ran as wild postings in key markets.
 —© BSSP.COM

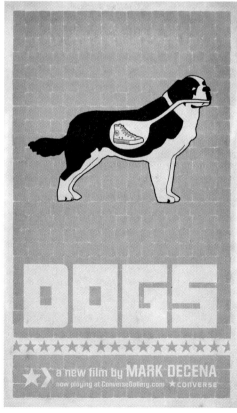

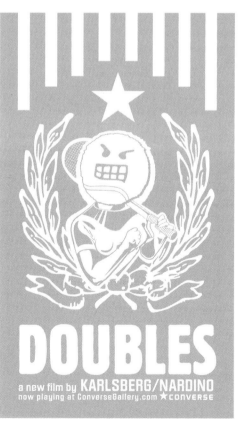

always been defined by the people who wore the shoes, not by its marketing. And the way we saw it, the worst thing any agency could do was mess up what these guys had done for decades. So we based our idea on the notion that we don't own the brand, the consumer does. We decided to let the legions of originals who own the brand create the communications for us. And maybe along the way we'd discover the next Ramone or Pollock.

Brand Democracy: Idea

From that thought, we created Brand Democracy: advertising created by the people. We solicited films from the Converse evangelists. Not commercials. Not scripted talking points. Just 24-second films. The only rule was that the films not be political or R-rated.

Solicitation

To jump-start the idea, we first went to film schools. Then we went everywhere else. We had over 400 films in the first three months. And the movement grew quickly from there.

Television

These films weren't just a couple of friends messing around in the backyard. (Well, a few were.) They were real works of art that reflected the range of the people who love the brand. At last count, we received over 2,000 films from 20 countries.

Web

In addition to select films airing on MTV, the best films were featured on the web at ConverseGallery.com. This forum gave the filmmakers a chance to share their inspiration and ambition, and allowed consumers to form a deeper relationship with the films and the brand. It was the epicenter of the democratic effort, and was an original and organic convergence of web and TV.

Print/Outdoor

We expanded this movement to painters and graphic designers to create outdoor and print ads. The outdoor was localized, so a board that ran in LA featured an emerging LA-based artist.

Product Democracy

We even created a new revenue stream for Converse by developing Product Democracy, a campaign in which consumers designed graphics on Chuck Taylors. The new styles were then sold around the world. We enlisted 35 artists to create unique designs.
—© BSSP

ADVERTISING DESIGN PROCESS

Five Phases of the Advertising Design Process:

Orientation ▶ Analysis ▶ Concepts ▶ Design ▶ Implementation

Clients are not saying, "Make us ads" or "Make us websites," they're saying, "Create interaction between our brand and our customers." That's our job now.
—ROBERT RASMUSSEN
Executive Creative Director
Nike Account at R/GA, as quoted in The New York Times Magazine

In advertising preliminary research (as well as post-design testing, for example, focus groups) can be quite extensive. Agencies receive a good deal of research and information from clients or utilize marketing research firms. Then they move to strategic planning, which involves many professionals and writing a creative brief.

ANALYSIS

Essentially, a creative brief is a strategic plan that both client and agency agree upon and from which the creative team works as a strategic springboard. The advertising strategy is the master plan, determined during analysis before the creative team goes to work on idea generation. It is outlined in the creative brief, and as creative director John Lyons puts it, "A strategy is a carefully designed plot to murder the competition." A thoughtful, clear brief offers the creative team a solid point of departure and sets them on the right path for ideation. Research, information about the brand or group, and the budget all play into forming the strategy. A brief is written by the client's marketing team, or collaboratively between client and ad agency, or by the advertising agency alone. (See The Design Brief in Chapter 4 for more information.)

SAMPLE CREATIVE BRIEF FROM THE RICHARDS GROUP, DALLAS, TX

REMEMBER. MEDICAL EXPERTS
RECOMMEND INCREASING YOUR HEARTRATE
AT LEAST THREE TIMES A WEEK.

TABU

ACTUALLY. THERE IS ONE
KNOWN CURE FOR SNORING.

TABU

JUST FOR THE RECORD, BASEBALL
ISN'T AMERICA'S FAVORITE PASTIME.

TABU

Warning: People don't like ads. People don't trust ads. People don't remember ads. How do we make sure this one will be different?

Why are we advertising?
To generate awareness for Tabu [Figure 13-04] by making customers feel more comfortable about buying sexy lingerie.

Who are we talking to?
Men who buy lingerie for a wife or girlfriend, and women who buy lingerie for themselves (to please the men in their lives).

What do they currently think?
"I'm a little uncomfortable about buying sexy lingerie; lingerie is very intimate and private."

What would we like them to think?
"This is a friendly, uninhibited store. I wouldn't be embarrassed to ask for anything."

What is the single, most persuasive idea we can convey?
Tabu makes buying lingerie fun.

Why should they believe it?
Because we're honest about why people buy it.

Are there any creative guidelines?
Sexy and intelligent; not sexist and crude.
 —The Richards Group

FIG. **13** /**04**

TABU LINGERIE

- THE RICHARDS GROUP, DALLAS
- ART DIRECTOR: JEFF HOPFER
- WRITER: TODD TILFORD
- PHOTOGRAPHER: RICHARD REENS
- CLIENT: TABU LINGERIE

CONCEPTUAL DESIGN

The creative team is briefed during orientation and during that phase does all that is necessary in preparation for concept generation (see Concept Generation Process in Chapter 4). An **advertising idea** is the creative conceptual solution to an advertising problem—a strategic formulated thought that communicates a message, calling people to action.

Functional versus Emotional Benefits

What's in it for me? Will this brand make me happier, healthier, richer, or more attractive; get me where I want to go; or make my life easier? Will I help if I give to this group or cause? *An ad has to offer a benefit.*

Functional benefits are the practical or useful characteristics of a product or service that aid in distinguishing a brand or group from its competition. For example, bath soap may have the advantage of extra moisturizer, or a credit card company may protect against identity theft. Figure 13-05, "The Practically-All-Screen TV" for REGZA HDTVs, focuses on a newly designed, slimmer frame. The functional benefit is that "you can fit more TV into the same space when you buy the 'practically-all-screen' TV," writes creative director Michael "Mac" McLaurin.

Emotional benefits are based on connecting a brand or group with people on an emotional level, *not* based on any functional characteristic of a product or service. Ads that touch us emotionally—promising greater self-esteem, a virtuous feeling, or any emotional benefit—can, perhaps, have even greater impact than those that promise functional benefits. For example, all hair-coloring covers gray, which is a functional benefit. But, if a hair-coloring brand promises improved self-esteem, that emotional benefit might connect with the target audience. A dark chocolate candy brand could tout the *functional benefit* of flavonoids or it could tout the *emotional benefit* of sensory delight or feelings of indulgence.

To drive more awareness for Oxyride (Figure 13-06), a new entry in the competitive battery category, Renegade partnered with the House Rabbit Society to "raise awareness about the health benefits of neutering your rabbit, and let the press and the consumer discover the competitive message for themselves." The campaign makes an emotional connection with the youthful target through the kind of off-beat humor they appreciate. Bunny owners appreciate the practical underlying message aimed at them.

Storytelling

Memorable advertising and branding involves good brand storytelling—the skill and act of presenting a brand or group as part of a greater narrative. To do this, storytelling must be part of the strategy—formulating the brand or group

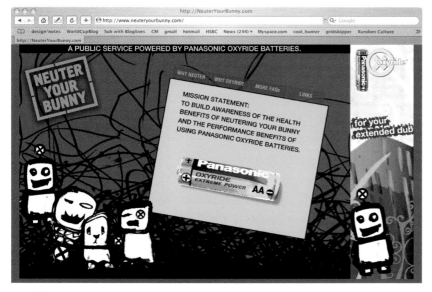

FIG. **13** / **06**

PANASONIC "NEUTER YOUR BUNNY"

· COURTESY RENEGADE, LLC, NEW YORK

THE CHALLENGE

· Drive awareness for a new entry in the competitive battery category

KNOW THY TARGET

· Skeptical, cynical, 16- to 24-year-old gadget enthusiasts

CAPTURE THEIR ATTENTION

· Partner with the House Rabbit Society to raise awareness about the health benefits of neutering your rabbit, and let the press and the consumer discover the competitive message for themselves.

MEASURABLY EFFECTIVE

Within two weeks of the launch of Neuter Your Bunny, two large national retailers called to discuss new distribution plans for Oxyride batteries.

EMOTIONAL CONNECTION

For the youthful target, the campaign's humor hits on just the kind of joke they most enjoy. For bunny owners, on the other hand, the connection is even easier. Neutering reduces health risks and aggressiveness in both female and male rabbits.

NEWSWORTHY

Without ever explicitly saying the competitor's name, everyone from The New York Times *to* Time Magazine *to blogs around the world told the story for us, explaining how Oxyride outperforms the competition. Other press mentions include* The New York Post, Newsday, Bergen County Record, Promo Online, CNET, *and engagenet.org, to name a few.*
 —© Renegade, LLC.

with a point of view, attributing a personality to it, imbuing it with an "inner life." For example, the Nike spirit certainly starts with the "Just Do It" tagline, becoming a point of view, a motivational call to action, with all the integrated advertising contributing to that broader story. (More about storytelling later in this chapter when we study campaigns.)

In advertising, storytelling has a cumulative effect when consistently told and/or reinforced across media in a campaign. *Each individual ad, regardless of media—whether it's a website or print ad—is a version of and contributor to the story.* Screen-based media with motion capabilities, especially television, web, and mobile, have the opportunities to tell "short stories" with sound and

FIG. **13**/**07**

MINI CLUBMAN

· BUTLER, SHINE, STERN & PARTNERS,
 SAUSALITO

**"ZIG, ZAG, ZUG" ADVERTISING
LAUNCH CAMPAIGN**

Coinciding with the MINI Clubman
on-sale date, the teaser ads were
filled in with ZIG, ZAG, and ZUG
graphics, images of the MINI
hardtop, MINI convertible, and the
new MINI Clubman, and the tagline,
"MINI Clubman. The Other MINI."

"THE OTHER NEIDERMEYER"

In addition was "The Other
Neidermeyer" featuring a series
of traditional family portraits
each with one family member
that stands out as a bit odd or
enigmatic in much the same way
the MINI Clubman does among
the members of the MINI clan.

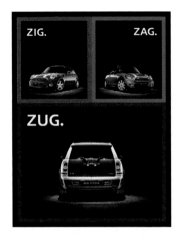
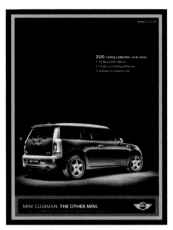
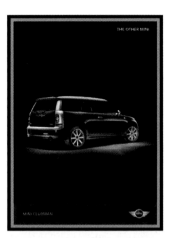

movement. If you compare this type of advertising to films or television programming, the skill for storytelling/narrative miniaturization is crucial.

MINI's *story* was different than other vehicles. When MINI launched in the United States, it "zigged." When MINI introduced its convertible, it "zagged." For the all-new MINI Clubman (Figure 13-07), Butler, Shine, Stern & Partners (BSSP) decided MINI would "Zug." Although the Clubman is a MINI, its five-door configuration and proportions distinguish it from the MINI family. Aimed at cultural trendsetters, to engage them in a brand story and conversation, BSSP's idea was based on the fact that "the world is filled with mass-produced sameness, even the copies are copies," and explained that's why "some of us 'zug.'" To tell this story, BSSP created teaser wallscape ads that simply read "ZIG" and "ZAG" placed in major U.S. transportation

hubs. Those were followed by print ads that began to explain the "ZIG ZAG ZUG" story, including the MINI Clubman tagline, "The Other MINI." This campaign story unfolded across media, including print, television, guerrilla marketing, out-of-home, online videos, ads embedded in video games, and a 24-page booklet magazine insert called "The Book of ZUG," which explained the philosophy behind the car. The ad defines the word *ZUG* as an "adjective, verb or noun" meaning "to be unlike others, to do something different, and a place in Switzerland." This integrated advertising launch campaign was bolstered by national cable television spots and a variety of other applications across media, including those mentioned earlier as well as online banner and video ads on Car Enthusiast, design-oriented, and social networking websites, and mobile telephone content.

APPROACHES TO CONCEPT GENERATION

Creative advertising is the goal—stretching beyond the ordinary, to be original, innovative. No one notices humdrum advertising. Illustrating points of departure for developing ideas might seem counterintuitive to being creative; however, these can serve as a *springboard*, as starters, to demonstrate how one could mine for creative avenues. Liken it to learning to paint by studying Paul Cézanne's methodology or any other exemplary painter's process.

> *Figure of speech/pun.* Using any type of rhetorical device can help jump-start an idea; although the poor pun is considered by some to be a low form of humor, many people find creative wordplay a rich source for entertainment. Other figures of speech include oxymoron, synecdoche, and metonymy.

> *Visual analogy, simile, or metaphor.* A visual analogy is a comparison based on some likeness or similarities. We assume that if two things are alike in one respect, they are alike in other or all respects. A visual metaphor uses a visual that ordinarily identifies one thing to signify another, thus making a meaningful comparison; for example, a rhinoceros to designate dry skin, a Shar-Pei dog to designate a wrinkled human face, a pretzel and the human back, or a white-washed fence as a metaphor for whitened teeth.

> *Symbolism.* In this ad, IBM declares its support for programs designed to strengthen women's skills in areas such as math and science by using colored baby booties, which symbolize gender (Figure 13-08).

> *Icons.* Icons can represent a corporation or brand in a very friendly way.

> *Life experience.* If people can relate to what you're saying, you're halfway home. "Yeah, that happens to me," should be someone's response to your ad. These ads behave as observational humorists, pointing out the humor in everyday occurrences.

> *The problem is the solution.* Often, the answer to an ad problem is looking at the problem itself. In the late 1950s, Volkswagen wanted to sell a good deal more VW Beetles in America. The problem was the Beetle was small and strange looking

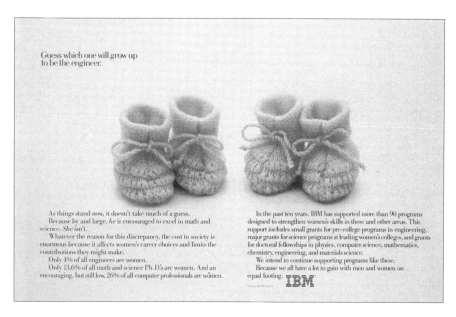

compared with large, streamlined American cars. Doyle Dane Bernbach's (DDB) solution was to emphasize the characteristics that set VW apart from the competition; for example, the care put into manufacturing and inspection, which resulted in the now famous "Lemon" ad (Figure 13-09). Other VW ads from DDB touted: "Think small" and "It's ugly, but it gets you there." In the late 1990s, the Leo Burnett agency

FIG. **13** / **08**

"GUESS WHICH ONE WILL GROW UP TO BE THE ENGINEER?"

· DENTSU

· CREATIVE DIRECTOR/WRITER: BOB MITCHELL

· ART DIRECTOR: SEYMON OSTILLY

· COURTESY OF IBM CORPORATION

FIG. **13** / **09**

"LEMON," 1959

· DOYLE DANE BERNBACH (DDB), NEW YORK

· CLIENT: VOLKSWAGEN

This gutsy ad winks at its audience, as did most of DDB's advertising. Doyle Dane Bernbach and its legendary founder, Bill Bernbach, are credited with the creative revolution in advertising.

FIG. 13 / 10

"FOOTBALL RESURRECTED"

- AIRING: WEB, PRINT, WILD POSTINGS, IN-STORES, CONCERT TOUR
- EVB SAN FRANCISCO, A DIGITAL CONTENT MARKETING FIRM (WWW.EVB.COM)
- EXECUTIVE CREATIVE DIRECTOR: JASON ZADA
- ASSOCIATE CREATIVE DIRECTORS: LAUREN HARWELL, JAIME ROBINSON
- ART DIRECTOR: SEAN O'BRIEN
- COPYWRITER: JEREMY DE FORGE
- DESIGN: SEAN O'BRIEN, JAMES SANSA-NGASAKUN
- EXECUTIVE PRODUCER: AMANDA COX
- PRODUCER: PETER ANTON
- TECHNOLOGY DIRECTOR: JEFFREY TITUS
- FLASH PROGRAMMERS: NICK MITROUSIS, JUSTIN PETERSON
- MOTION DESIGNER: SHAWN MYERS
- HTML LEAD: GENE KIM
- PRODUCT: ALL-PRO FOOTBALL 2K8
- CLIENT: 2K SPORTS
- URL: FOOTBALLRESURRECTED.COM

GOALS

- *To boldly unveil 2K Sports' return to the video game market after four years*
- *To captivate gamers and football fans with legendary music and football favorites*
- *To create brand preference for 2K Sports over competitors including EA*
- *To encourage on- and offline conversation around the game launch and ultimately drive consumers to play/purchase the new game*

CAMPAIGN RESULTS

- *The "Football Resurrected" campaign spurred over 380,000 blog conversations surrounding 2K's return to the video game market.*
- *Video episodes posted on YouTube were viewed by over 500,000 people.*
- *The campaign was officially announced through a features story in* The New York Times *and included a campaign image of hip-hop rapper Rakim.*

—EVB

used Altoids "curiously strong" peppermint flavor to their advantage.

> *Compare and contrast.* A comparison between brands can be boring or seem mean-spirited, like the old cola and fast-food wars. However, comparisons to things other than the competition can be very seductive, for example, comparing the sensation of eating a YORK Peppermint Pattie™ to skiing in crisp mountain air or standing under a refreshing waterfall, or contrasting rough and soft as in prickly cacti versus cotton socks.

> *Exaggeration.* Exaggeration can easily drive a point home. A classic example is an ad for Colombian coffee in which the pilot turns the plane around because they forgot the Colombian coffee. This brand is so good that. . . . These high heels are so high that. . . . Our vacuum cleaner is so powerful that. . . .

> *Endorsement.* An ad may feature a celebrity to endorse the brand or group (see Rakim and Jerry Rice in Figure 13-10; Ryan Sheckler in the Panasonic "Share the Air" Case Study; William Shatner in Figure 13-22); or, it may feature an endorsement from an everyday person with whom the potential consumer can identify.

> *Irony.* Since the advertising creative revolution of the early 1960s, ad professionals have found value in a self-conscious wink at the audience, with no pretense, no hard sell. The underlying approach is: "We know you know we're trying to sell you something, so let's just enjoy this transaction together."

Engaging Content

How can advertising connect with people? Storytelling is certainly one way. Entertainment is another way to connect with an audience.

"EVB developed a lifestyle marketing campaign titled 'Football Resurrected' that combined music, sports, and gaming cultures to mark 2K's return

to the football videogame arena with All-Pro Football 2K8." As shown in Figure 13-10, EVB's "campaign was designed to connect with next-generation gamers and football fans through engaging content carried across TV, print, online, wild postings, street teams, packaging, and logo design. At its core, EVB worked with six of hip-hop's most well-known legends to develop six 2-minute episodes, shot in a stadium tunnel, featuring each artist performing freestyle rap poetry about 2K's return to football gaming. The episodes were unveiled on a dedicated microsite, www.footballresurrected .com, XBOX, YouTube, and MTV2. Using the episodic content featuring hip-hop's Rakim, EVB developed 15- and 30-second spots [television commercials] to air on stations including ESPN, NFL, MTV, BET, and USA. Print ads ran in lifestyle, music, and gaming publications. Street teams and wild postings occurred during the 2K national music Bounce Tour featuring 2K-endorsed artists."

People enjoy being entertained; and entertaining humor disarms or endears. For example, a website for Burger King created by Crispin Porter

& Bogusky, Subservientchicken.com, received an enormous number of hits; people spent about seven minutes on average on the site because they found it entertaining.[1] Humorous ads—usually online ads or television ads—generate buzz or word of mouth. When people find an ad entertaining or outrageous, they tend to tell others about it, perhaps even e-mail it, which means that *people are talking about your brand or group.*

Kinetic, in Singapore, talks about Figure 13-11: "Nike is a strong advocate of playing by different rules. As part of Nike's global campaign to encourage the playing of football [soccer] anywhere and everywhere (rather than just on the field), we devised a special football vending machine just for the Singapore market. Given that all one needs is a ball to play football, this 'open 24 hours' vending machine basically made it easy for people to access a ball anytime. Inspired by the spirit of football improvisation, the vending machine was placed at high-traffic urban spots so that consumers can have easy access to a football whenever and wherever they feel like playing. A world's first, the vending machine

FIG. **13** / **11**

NIKE VENDING MACHINE

· KINETIC, SINGAPORE
· CREATIVE DIRECTORS: ROY POH, PANN LIM
· ART DIRECTOR: JONATHAN YUEN
· COPYWRITERS: ALEX GOH, EUGENE TAN
· PHOTOGRAPHER: JEREMY WONG
· CLIENT: NIKE

FIG. **13** / **12**

**TOSHIBA REGZA LCD HDTVS,
"FIND THE RIGHT TV.COM"**

· DELLA FEMINA/ROTHSCHILD/JEARY
& PARTNERS, NEW YORK
· CREATIVE DIRECTOR: MICHAEL "MAC"
MCLAURIN
· CLIENT: TOSHIBA

not only met the campaign objectives of bringing football to the streets, it also reinforced Nike's image as the leading sports brand—a supporter of the innovative, bold, and unprecedented. The first in the world, the vending machine was a massive hit, selling more footballs in one week than two months in stores. Through widespread media coverage—it was on every news channel the night it was launched—and word of mouth, the vending machine attracted huge crowds. Although the same footballs could be bought from stores, people were willing to queue for the novelty of buying a ball from the vending machine. Even Japanese tourists—hailing from the land of vending machines!—were witnessed taking photos of it. Initially meant as an outdoor advertising piece rather than a sales tool per se, the vending machine did so well that now, even the US and KL [Kuala Lumpur, Malaysia] markets have bought the idea."

As in Panasonic's "Share the Air," advertising can offer some type of valuable function or *utility* or online social center, whether it acts as a media platform and the hub for a sport (for example, "Visit NikePlus.com to track your runs, set goals, participate in challenges, and join the largest running club") or setting wellness lifestyle goals (for example, Kashi.com where you can use their "snack evaluator" or find family fitness activities). Here's the key: for advertising to capture people's

attention and time, *it should not be all about the brand, it has to be about people.*

Michael "Mac" McLaurin explains the challenge in creating a campaign for flat screen TVs: "The marketplace for flat screen televisions had become increasingly confusing for consumers. REGZA HDTVs from Toshiba now encompassed a full line of sizes, styles, and price points, but this assortment just contributed to the confusion." In Figure 13-12, "FIND THE RIGHT TV.COM" for TOSHIBA REGZA LCD HDTVs, McLaurin says, "Our idea was to 'match' consumers to the perfect TV, much like the popular match.com, which helps match people over the Internet. We created FIND THE RIGHT TV.COM to make matching you to the right TV fun and easy. By answering eight simple lifestyle questions, consumers were quickly matched to the perfect REGZA TV. Additionally, consumers were invited to upload a photo of their rooms, to see what their perfect TV match would look like in their life. Magazine, online banner ads, and point-of-purchase displays drove people to the site."

DESIGN DEVELOPMENT

Everything you learned about the fundamentals of design, visualization, and composition applies to designing an ad. Any effective ad is based on an idea—the creative team's primary reasoning. The idea sets the framework for all your design

CASE STUDY

PANASONIC "SHARE THE AIR" AND PANASONIC
SHARETHEAIR.NET/RENEGADE

Define the Challenge
- Position Panasonic products as the perfect accompaniment to the action sports lifestyle.

Know Thy Target
- Action sports fans are all about creative expression, social connectivity, and community experience.

Capture Their Attention
- Sponsor the Dew Action Sports Tour (AST) for the fifth consecutive year, offering activities like athlete autograph signings, an instant-win game, product demos, and camera loans.
- Launch sharetheair.net, a destination site for the action sports community with celebrity photo blogs, Action Sports Tour (AST) info, and a video submission contest.

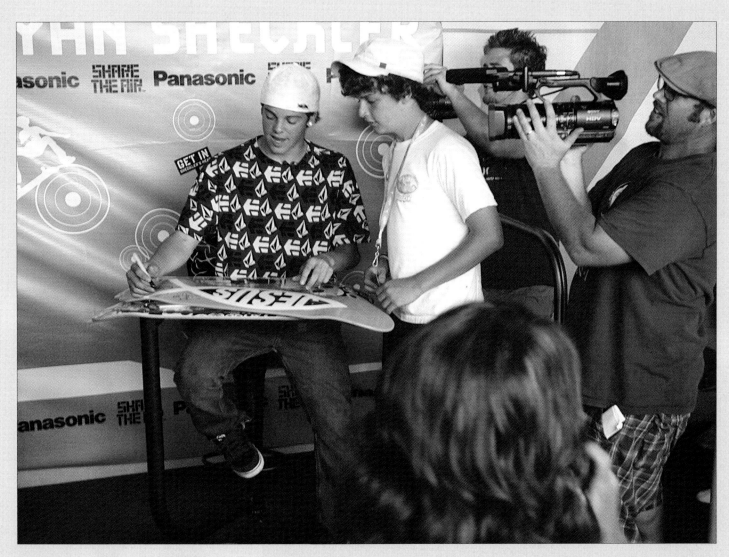

PANASONIC "SHARE THE AIR"

· COURTESY RENEGADE, LLC, NEW YORK

PANASONIC'S SHARE THE AIR FESTIVAL VILLAGE EXPERIENCE

A two-story tall, 40' × 50' build-out with aluminum truss work and sail cloth splashed with action sports graphics, jam-packed with Panasonic's latest products and super cool action sports-related experiences. The 103" Plasma Room lets you experience the eye-popping power of the world's largest plasma and state-of-the-art Blu-ray disc player, and every visitor gets a free pair of Panasonic-branded Googly-eye glasses. In the Instant Win Game, no one leaves empty-handed, whether it's with a great Panasonic product (like a portable DVD player) or a cool Panasonic branded item.

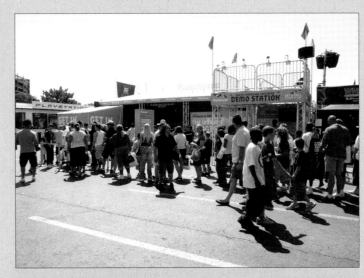

DIGITAL CAMERA/CAMCORDER LOANER PROGRAM

A huge hit at past Dew Tour stops, Panasonic once again provides free loans of the latest Lumix Digital Still Cameras and Panasonic Digital Camcorders. Putting the products straight into the hands of Tour attendees, Panasonic lets them capture the coolest tricks for themselves. This year, participants can even take their digital footage home on a free 128MB SD media card or DVD.

"GET IN RYAN'S HEAD" LISTENING AND AUTOGRAPH STATIONS

Already a legend at 17, Ryan Sheckler is now on board as Panasonic's featured action sports athlete. Ryan's room has three HD plasma monitors showcasing HD footage captured with Panasonic HD camcorders on Ryan's recent world tour. This is custom content you won't see anywhere else. You can also take the "Do you know Ryan?" interactive test to see just how much you really know about the two-time Dew Tour skate champion. Ryan will also be on hand signing autographs for his fans at each of the Dew Tour stops.
 —Renegade, LLC

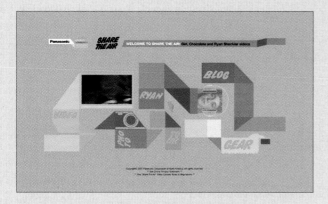

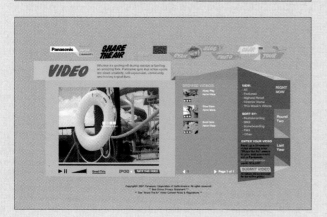

PHOTO BLOG

Designers, skaters, and photographers from the Girl Skateboard Team join forces to create five photo blogs featuring the latest behind-the-scenes news from the skate community, cool tricks caught on camera, the freshest designs for Girl Skateboards, and, of course, some good old-fashioned goofing around. Giving skate fans an inside look into the daily lives of their favorite athletes and artists, and letting the pros connect with their biggest fans—now that's sharing the air!

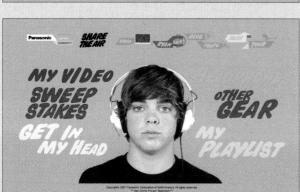

SHECKLER BANNERS

Panasonic Headphones sponsors Ryan Sheckler, the wildly popular 17-year-old skater who has won tons of prestigious skate awards and built a virtual army of enthusiastic fans. Media banners featured an actual avatar created in Ryan's likeness, and ran on websites targeted to hardcore skateboarding males as well as adoring teenage girls. Now they can all get into Ryan Sheckler's head by clicking on web banners featuring some of Ryan's favorite and not so favorite things.

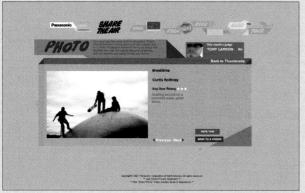

PHOTO AND VIDEO CONTEST

Aspiring photographers and videographers can share their photos and videos online for a chance to win some amazing prizes. Judges from the Girl Skateboards and Chocolate Skateboards teams unite to pick the best photos and videos. A new winning photo is selected each month to win a Panasonic digital camera, and top prize for the Share the Air video contest is an HD video package worth over $10,000! All photo and video submissions live on the sharetheair.net site for visitors to view and enjoy.

decisions—for how you create, select, crop, and arrange imagery; write copy; select colors; or choose a particular typeface.

An ad must:

> Grab attention (it has to be visually interesting).
> Communicate a message (it has to be clear).
> Call people to action (it has to motivate).

Elements of an Ad

Most ads consist of the following components: visual, headline (or line), body copy, tagline, and sign-off. The **visual** is the principal image, which may be a photograph, an illustration, graphics, or any other kind or combination of images. The **headline** is the principal verbal message. The **body copy** is the text that supplements and supports the message. The **tagline** conveys the brand benefit or positioning, generally acting as an umbrella theme or strategy for a campaign or a series of campaigns; also called a claim, endline, strap line, or slogan. A tagline helps complete the advertising communication, rounding out the meaning. The strategy behind a campaign is usually revealed in the tagline. The **sign-off** includes the brand or group's logo, web address, a photograph or illustration of the packaging or product, or both.

Visual/Verbal Synergy

Together, the image and copy (the visual and verbal components), how they are visualized, how they are designed, how they work off one another, express the advertising idea in a synergistic visual/verbal relationship. *Working cooperatively, the visual and verbal components should produce a greater effect than that of either part alone.* Visual/verbal synergy is established in this ad for Volkswagen (Figure 13-13). The line and visual depend upon one another for the total ad message. Here is a way to test for visual/verbal synergy: cover the visual and read the line. Do you get the meaning of the ad? Now reverse it; cover the line and look at the visual. Is the ad message communicated? Now look at the entire ad. The message should be clear because of the cooperative action of the visual and verbal components. When this type of synergistic action takes place, the communication becomes seamless.

Copy-Driven versus Visual-Driven

When the copy does the "heavy lifting" in an ad, that is, the message is primarily conveyed through the headline, then the ad is considered to be copy-driven (Figure 13-14).

FIG. **13** / **13**

VOLKSWAGEN POLO, 'COPS'

· ADVERTISER: VOLKSWAGEN
· PRODUCT: VW POLO
· ENTRANT COMPANY: DDB
· COUNTRY: UNITED KINGDOM
· YEAR: 2004
· MEDIA: PRESS LIONS
· AWARD: GRAND PRIX
· OTHER CREDITS:

CREATIVE DIRECTOR: JEREMY CRAIGEN/ EWAN PATERSON

COPYWRITER: FEARGAL BALLANCE/SIMON VEKSNER

ART DIRECTOR: NICK ALLSOP/DYLAN HARRISON

PHOTOGRAPHER: PAUL MURPHY

You get back from your honeymoon even more in love than the day you left. If that's possible.

He's your "husband" now. And you smile as you say the word silently in your head. So you make him his breakfast and you pour him his coffee, and you laughingly say that he shouldn't get used to this.

Then, as you share an amusing story from the morning paper, he looks at you and says, quite seriously, that his eggs are burned.

You laugh, which, to your surprise, angers him. And from out of nowhere, his fist flies toward your face. And the wedding band that you so lovingly placed on his finger just 2 weeks ago, slices your chin wide open.

It happens. Just like that.

There are more than 20,000 reports of domestic violence each year in St. Louis. You can help.
Please give to your United Way. It hits home.

Your father dies of a heart attack at the age of 54. You loved him. And you miss him. And you hate him for leaving your so suddenly.

But he's gone. So you grieve. And life goes on.

Then one day you're doing the dishes, and there's something about the way the soap suds look that makes you sob uncontrollably.

And even when the sobbing stops, it never stops in your head. So the dishes go undone. And the grass goes unmowed. And the kids go uncared-for. And the dog never gets let out.

Because you're spending all of your time in your room. In your bed. In the dark.

It happens. Just like that.

There are more than 200,000 cases of severe depression in St. Louis. You can help.
Please give to your United Way. It hits home.

You're packing your bags, and you're loading the car, and you're moving out of your house. The kids try to help, but they're just in the way. And the baby is crying, and needs to be changed. And it looks like that last bag won't fit in the car. And all you can think of is, "What will we do with the goldfish?" Because you can't take it with you where you're going. Because you don't know where you're going. Because you once had a husband, who had a job, that paid the mortgage, and fed the kids. And now, you don't.

It happens. Just like that.

There are more than 8,000 homeless people in the St. Louis area. You can help.
Please give to your United Way. It hits home.

FIG. 13 / 14

PRINT CAMPAIGN: "IT HITS HOME"

· DMB & B, ST. LOUIS, MO
· CREATIVE DIRECTOR/WRITER: STEVE FECHTOR
· ART DIRECTOR: VINCE COOK
· PHOTOGRAPHER: SCOTT FERGUSON
· CLIENT: THE UNITED WAY

We tried to make the posters poignant. We felt the copy had to be read and dwelled on, so we dropped the visuals behind the words. The effect was dreamlike, as if the images were reminiscences in the mind of the person who had suffered. It must have worked, because more than one person choked up when they read it.
—Vince Cook, Art Director, DMB & B

Using copy in an "under the radar" format in Figure 13-15, Kineti created a print campaign for Jubes Nata De Coco cubes, a healthy dessert that is zero in calories and high in fiber. "Perfect for the health-conscious, especially women," Kinetic describes. "To reach out and engage them, an effective and refreshing approach was needed. Romance novels are almost a must-have for many women. For some, it is a staple and not a page is missed. Since the idea mimics the content of romance novels where juicy tales abound, the idea fits perfectly in the romance section of bookstores. The flyers and posters, which are replicas of pages in books, are inserted in romance novels."

When the communication is mainly or only determined by the visual, the ad is visual-driven, for example, the Apple iPod™ dancer ads. And what is most surprising is that you can tell a story in a single image (see Figure 5-26). When aiming at a global audience where language translations might cause miscommunication, some feel the best route is no-copy advertising, where the visual communicates the entire message, with no copy except for perhaps a tagline.

DO'S AND DON'TS OF ADVERTISING

There are no rules in advertising because it is a creative business/field that needs to break rules to grab people's attention. However, the novice needs some useful guidelines.

Do's

- Design should grab someone's attention.
- Communicate one clear message per ad.
- Create visual/verbal synergy.
- Determine a functional or emotional benefit.
- Avoid clichéd visuals and copy.
- Visual and line should not repeat one another.
- Write in plain, conversational language. Avoid copy that sounds like a sales pitch.
- Break copy lines in logical places; line breaks should echo breaks in speech.
- Respect the audience.
- Reflect diversity.

Don'ts

- Don't use the brand's or group's logo as the headline.
- Don't use headlines, taglines, or body copy from existing ads.
- Don't employ negative stereotypes.

Since advertising is mass communication, even when directed toward a segment of a population, it is drawn in broad strokes. Those broad strokes, for many, translate to mean generalizing and stereotyping of cultures, groups, and genders. All of us—clients, account managers, executives, and creative professionals—need to be more vigilant, to interrogate all connotative cultural messages in the visual communications they commission and create.

THE AD CAMPAIGN

As previously noted, an advertising campaign is a series of coordinated ads—in one or more media—that while able to stand alone are based on a single, overarching strategy or theme. A campaign serves to get people's attention over a period of time and across media. Many believe a person needs to hear and see a brand's ads many times in order to absorb the message and *buy* the brand, or answer the call to action on behalf of a cause. The strategy and core idea for a campaign needs to be elastic enough to provide material for many individual ads, and may need to be flexible enough to work across media, in print as well as in screen-based media, out-of-home, and perhaps in unconventional formats. When a student has a portfolio composed of creative integrated ad campaigns, it demonstrates his or her ability to take a core idea and run with it.

Some print campaigns utilize the same compositional structure with designated positions for the components, as seen in Figure 13-16. The headline may vary and the visual will vary, but the composition/layout remains constant; for example, the famous original, long-running Absolut Vodka campaign where the iconic bottle is centered.

VARIETY IN AD CAMPAIGNS

An ad campaign should offer something new each time people see and read an individual ad from the campaign. Variety—that element of new-

It was her curiosity and the first innocent taste that proved to be her undoing. As she swept her tongue across the sweet moistness and tantalising smoothness, she was engulfed by a certain swooning, sinking into swirling depths which she never thought she would ever emerge. While her knees shook like willows in the wind, the dizzying onslaught of pleasure spun her head like a child's top. The sensations were titillating and intense, and far too overwhelming for her virgin senses, fueling her desire for more chewy strawberry-flavoured Nata De Coco cubes from *Jubes*. Ever so high in fibre. Ever so sweet and succulent a dessert that is always so juicy.

Her hazel eyes closed as she bit her flushed lips to mute her gasp of pleasure. Feverish desires blended with those rippling sensations were lapping in her mouth. It was a potent mix. So pleasing and intoxicating, she found her body writhing in anticipation. The tingling shivers unlocked a secret desire deep inside her, awakening emotions and sensations she never knew existed. They stirred from their slumber, stretching inside her, like ravenous tendrils reaching out for the warmth of the sun. They coaxed her to surrender to the moment, teasing and tempting her. Till she finally succumbed to the chewy grape-flavoured Nata De Coco cubes from *Jubes*. The low-calorie dessert that whets the appetite endlessly, and is always so juicy.

FIG. **13** / **15**

**PRINT CAMPAIGN: JUBES®
NATA DE COCO**

· KINETIC, SINGAPORE
· CREATIVE DIRECTORS: ROY POH, PANN LIM
· ART DIRECTORS: PANN LIM, ROY POH
· COPYWRITERS: ALEX GOH, EUGENE TAN
· PHOTOGRAPHER: JEREMY WONG
· CLIENT: WONG COCO PTE LTD.

The idea fits snugly in the books and never fails to catch the attention of the target audience.
—Kinetic

ness or surprise—helps generate interest in each successive ad. However, each individual ad needs to share enough similarities to ensure it is recognized as part of a unified campaign so that the strategic message becomes cumulative and affects people enough to call them to action. For unity with variety, some elements must remain the same, for example, the color palette or types of images. You vary the composition from ad to ad, yet the campaign remains unified despite a degree of variation.

Here are some pointers:

> Vary the composition: the visual and headline do not have to be in the same position in every ad.

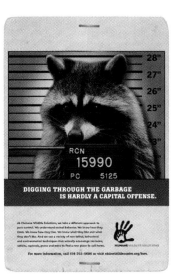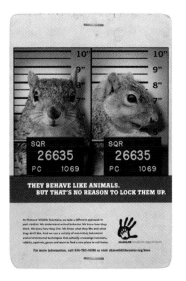

FIG. **13** / **16**

CAMPAIGN: "MUG SHOTS"

· FECHTOR ADVERTISING, COLUMBUS, OH
· CREATIVE DIRECTOR: STEPHEN FECHTOR
· COPYWRITERS: STEVE COX, STEPHEN FECHTOR
· ART DIRECTORS: OSCAR REZA, ROCCO VOLPE
· PHOTOGRAPHER: CARMON RINEHART
· CLIENT: HUMANE WILDLIFE SOLUTIONS
· COPYRIGHT © 2008 BY FECHTOR ADVERTISING

We approached the development of this campaign by asking the philosophical question, "Are they living on our turf or are we living on theirs?" Then the campaign just wrote itself.
—Stephen Fechtor

AD CHECKLIST

- Find an insight into the audience.
- Make sure the idea is strategic.
- Differentiate from the competition.
- Incorporate a functional or emotional benefit or both.
- Create a visual and composition that is interesting.
- Communicate a clear message.
- Call people to action.

› Create a limited yet flexible color palette.
› Determine two or three elements that will remain constant while others can change.
› Choose one extended font family, varying the way you use it.

THINKING CREATIVELY

Thinking creatively defies formulas. However, *to learn to think creatively* or tap into one's potential, it helps to learn by example. The following are very elastic ways of thinking. Of course, each of these must be based on an advertising idea. (See Chapter 4 for more on creative thinking.)

› *Visual surprise.* Create a visual that will make viewers do a double take. Look at something in a mirror. Turn a mouth upside down. Look at something through a wet lens (Figure 13-17).

› *Merge things.* Bring two different things—images or objects—together to make a new one. Merge a tennis ball and a croissant to denote the French Open tennis tournament..

› *Be literal and really push it.* Personify things—give inanimate objects human qualities. Really push your point as in Figure 13-18.

Creative professionals thrive on thinking creatively; however, there are various industry and government regulations that must be considered, as well as universal ethical considerations about what is appropriate and principled. Some advertising is closely regulated; for example, in the United States, the Food and Drug Administration (FDA) regulates pharmaceutical marketing. Figure 13-19 is an example of how required information must be included in pharmaceutical advertising.

A MAN WALKS INTO A BAR WITH A PENGUIN . . .

Although humor isn't a creative approach, it is a way to emotionally connect with people. And humor is entertaining. There are many types of humor and any audience should be scrutinized for how it will respond. If you think of the type of humor in films aimed at adolescent males as

FIG. **13** / **17**

PRINT CAMPAIGN: JUBES NATA DE COCO

- KINETIC, SINGAPORE
- CREATIVE DIRECTORS: ROY POH, PANN LIM
- ART DIRECTORS: PANN LIM, ROY POH
- COPYWRITERS: ALEX GOH, EUGENE TAN
- PHOTOGRAPHER: JEREMY WONG
- CLIENT: WONG COCO PTE LTD.

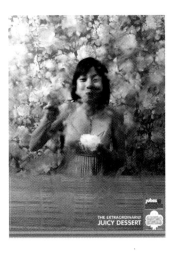
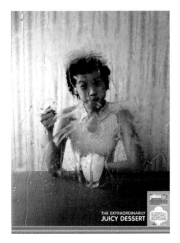

FIG. **13** / **18**

POSTER: *NATURE—LOVE IT WHILE IT LASTS*,
**"DIESEL SPRING/SUMMER 2004" ADVERTISING
CAMPAIGN**

· AGENCY: KESSELSKRAMER, AMSTERDAM
· ART DIRECTOR: KAREN HEUTER
· COPYWRITER: DAVE BELL
· PHOTOGRAPHY: HENRIK HALVARSSON
· POSTPRODUCTION: CABBE @ ARTISTA STUDIO
· CLIENT: DIESEL SPA

*Kiss it. Lick it, even. Go on . . . it feels good, doesn't
it? Feels . . . sexy. That's because you're not holding
paper. You're holding a small piece of tree. A piece
of nature (recycled, of course).*

*Nature is something we take for granted. The
only time we ever seem to run into it is when we're
buying food from the supermarket. Or watching the
National Geographic channel on TV. We've started
using nature for our own enjoyment and needs. In its
new advertising campaign for Spring/Summer 2004,
Diesel asks you to give something back to nature.*

*So if you think cows were made for meat . . .
and trees were put on this earth to be carved into
chairs . . . this campaign is for you. It's time to start
loving nature while it lasts. And you can start licking
this press release again.*

—KesselsKramer

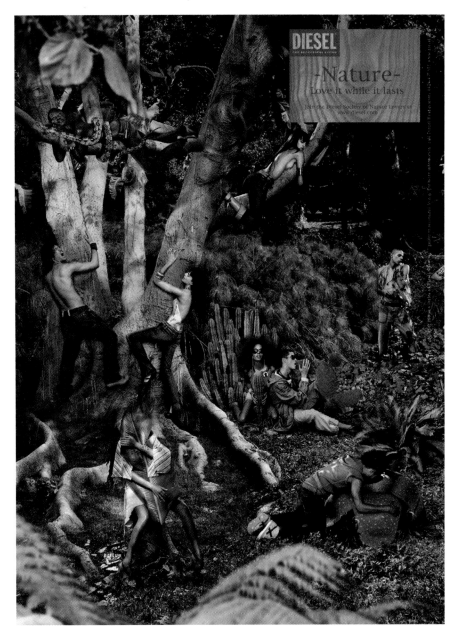

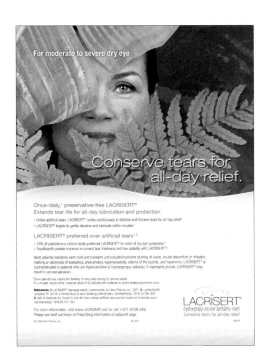

FIG. **13** / **19**

PRINT AD: LACRISERT

· CLIENT: ATON PHARMA, INC.
· © ATON PHARMA

Lacrisert is a preservative-free prescription treatment
for moderate to severe dry eye that lasts all day.

opposed to the humor aimed at baby boomer women, you start to get a sense that you must aim it wisely. True wit is exhibited in these classic ads from agencies in Figures 13-20 and 13-21.

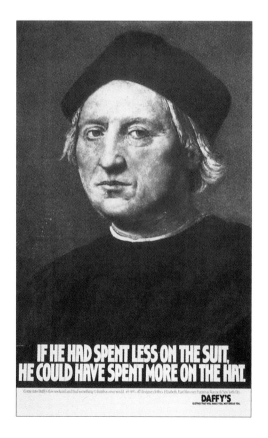

EFFICACY

Effective campaigns sell products or promote causes. When effective campaigns generate brand loyalty or brand endearment, storytelling is usually at their foundation. How do you tell an engaging and relevant story? A story, traditionally presented through action, dialogue, and narration, is told in advertising through various media though always supporting the larger story of "who and what" a brand or group is, as a living entity.

COMMERCIALS

As with all advertising, commercial spots for television, web, mobile, or any screen-based media that has motion capability start with orientation, analysis, and conceptual development. Often, commercials are part of an integrated campaign with print and out-of-home components.

Potentially, a commercial has several advantages over print or a static screen. Commercials allow for storytelling with sound (including music, voice, and special effects) and motion (action, dance, demonstration, and visual effects). Only specific lengths of time (15 seconds, 30 seconds, or 60 seconds) are given to explain the message. Great TV or online commercials are noticed, relevant, remembered, and compelling, like this campaign for Priceline starring spokesperson William Shatner (Figure 13-22). Butler, Shine, Stern & Partners (BSSP) identified an interesting consumer segment—treasure hunters—people who hunt for the lowest prices and then boast about their finds to others. They also learned that Priceline negotiates directly with each of their partners (airlines, car rental companies, hotels, etc.) to obtain the best deals for their clients. Then BSSP linked this consumer insight to both their celebrity spokesperson's repute and comedic talent and to Priceline's functional benefit, resulting in entertaining spots that tell a story while driving the functional benefit home.

With print, you have approximately two seconds to grab the viewer's attention. It's a little bit different with television. A television viewer may be attracted to a television commercial—also called a TV spot—and watch the entire ad, or he

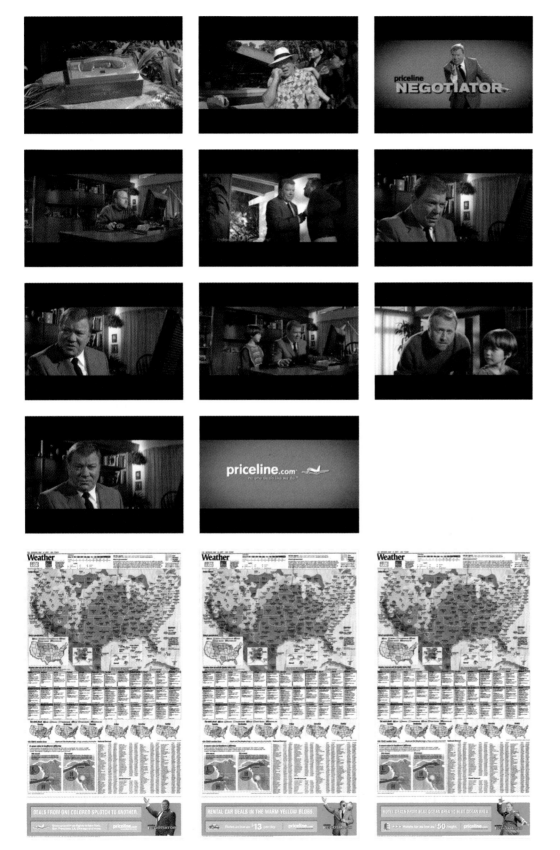

FIG. **13** / **22**

TV, PRINT: "THE NEGOTIATOR"

· BUTLER, SHINE, STERN & PARTNERS, SAUSALITO
· CLIENT: PRICELINE

Shatner's karate moves from *TJ Hooker*, the playfulness of his TV persona, the moxie of a super-cool spy à la the 1960s spy spoof *Our Man Flint*, coupled with a Priceline brand truth yields "The Negotiator."

CASE STUDY

An example of effective storytelling is the Dove Campaign for Real Beauty, which revitalized the 50-year-old brand by breaking with an industry tradition of presenting model perfect (thin, flawless) images of women. Ogilvy's online magazine *Viewpoint* said: "Dove recognized how out of sync the beauty industry was with women's attitudes, and set out to change it."

Unilever's website explains: "The intention of the campaign was to raise consciousness of the issues surrounding beauty and to challenge long-held stereotypes. It invited women's active participation and debate in broadening the definition of beauty.

"The Dove global Campaign for Real Beauty is a catalyst for activating Dove's beauty philosophy and to announce a wider, more refreshing view on beauty.

"The campaign is:
- An encompassing message and intrinsic to all of Dove's communications
- A personification of Dove's philosophy in front of consumers
- An invitation to women to join our endeavor."

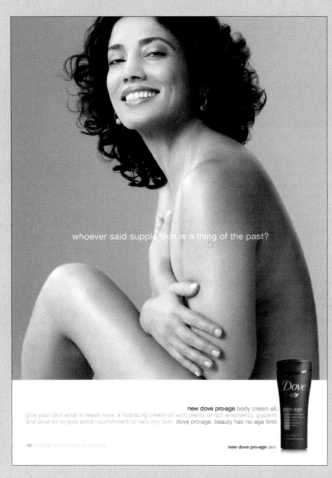

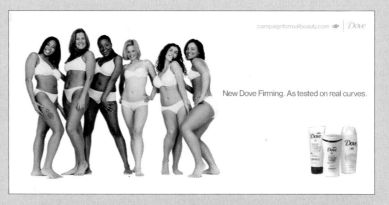

DOVE CAMPAIGN FOR REAL BEAUTY

or she may drift in and out. Thus, if the viewer stays in the room during the spot, there is an opportunity to regain attention if it has waned. That's where creative thinking comes in. If a TV spot is engaging, a person will watch. If it's pedestrian, most likely the viewer will tune it out, leave the room, text message, or check e-mail. The same holds true for online or mobile commercials.

Visualizing an ad for television begins with a storyboard. A storyboard illustrates and narrates the key frames of a television ad concept. The visuals are drawn inside small frames, in proportion to a screen; and the action, sound or special effects, and dialogue are written underneath or next to each frame.

GUERRILLA ADVERTISING

Print, television commercials, radio, and out-of-home are considered traditional advertising because of how and where they are seen and heard. Since the public recognizes traditional advertising as such—expects advertising to interrupt television programming or permeate magazine articles—many have learned to tune it out. With people watching less television, with more channels to watch splintering audiences while they hold remote controls, with digital video recorders allowing people to skip commercials, and with people spending more time gaming or online, television commercials are no longer the unfailing message carriers they once were.

Unconventional advertising "ambushes" the public; it appears in the public or private environments—places and surfaces where advertising doesn't usually live, such as on the sidewalk or at the bottom of golf holes; it's also called guerrilla advertising, stealth marketing, ambient marketing, and nontraditional marketing. It should be engaging, not intrusive.

AMBIENT ADVERTISING

Utilizing existing structures in public spaces, such as bus shelters, lampposts, fire hydrants, corners of buildings, or parking spaces as in Figure 13-23—ambient advertising gets under people's ad radar to surprise them.

FIG. **13** / **23**

INSTALLATION: "GO CUBIC"

· AGENCY: STRAWBERRYFROG, AMSTERDAM
· CLIENT: IKEA, NETHERLANDS

Our aim was to build excitement and demonstrate in a fun and unexpected way how people can "maximize their space at a minimal price."

Eighteen living room installations appeared overnight in twelve different IKEA cities across the Netherlands. Each installation was set in 8.5 square meters—the size of an average parking space—complete with a resident eating breakfast, reading the newspaper, and chatting to passersby. All of the furniture was free, and the public was encouraged to "steal" the furniture and take it home with them.

We deliberately chose colorful furniture to increase visibility and spread the buzz from the street into the office and people's homes.

—Strawberryfrog

SHOWcase

G.B.

Gui began his career as a graphic designer in Rio de Janeiro, Brazil, where he got his BFA in Design.

After working in Brazil, he moved to New York to work for R/GA. After joining the agency in 2003, he quickly grew into one of the agency's leading creatives. After four years of working on the award-winning Nike account, most recently as an associate creative director, Gui joined Mother New York in July 2007 to pursue new challenges in integrated advertising. As one of the senior creatives at the agency, he produced work for Mother's largest clients. In October 2008, Gui moved to Syrup New York, part of the LBi group, to lead global integrated account Puma Teamsport, with a strong focus on football (soccer), which has always been one of his dreams.

He has won more than two dozen awards including top honors at the industry's most prestigious competitions including Cannes Titanium Lion, Cannes Cyber Lion Grand Prix, D&AD Black Pencil, Best of Show in One Show Interactive, and the Grand Clio. In 2006 Gui was featured in Print magazine as one the twenty most talented designers under 30. His work has been shown in exhibits and published in numerous magazines and books in Brazil, the United States, Europe, and Asia. Gui often speaks at events and works with students in workshops and lectures, as he strongly believes that sharing knowledge contributes to a stronger and more integrated creative community.

Gui is a futebol (soccer) aficionado and always claims the number 10 jersey when he plays. He likes to believe that his skills live up to the mystical nature of that number. He also has a small part as a voice in Grand Theft Auto IV. He thinks that's cool.

—http://www.guiborchert.com/info .html

Q: Why did you choose a career in visual communication?

As a kid, I enjoyed drawing scenes. I entertained myself, in my own way, through telling stories with images. That's what I love to do. Later on, I thought I wanted to design cars so I started out as an industrial design major. In the middle of college, I realized I liked concepting, but the production part (building the model, for example) didn't engage me, so I changed my major to graphic design. Graphic design is more interesting to me, since it is about visual communication; for example, a logo is the smallest canvas for telling a story. A logo has to say a lot about a company. For me, that is a big challenge. More and more, my keen interest in ideas and storytelling moved me into advertising—I believe great advertising is about telling stories.

What is your day at the agency like?

Read the news in the morning and check the blogs with my morning coffee. Meetings. Work includes a variety of activities depending upon the project and which phase of the project we're in. A day could include: being briefed by the strategist, concepting with my writing partner, presenting work, shooting TV or print, a web shoot, talking to production companies, designing, or editing.

What is the relationship between being a graphic designer and being an art director?

Art directors should be great designers. If a good idea is not well designed it will die. And if a good design doesn't have a viable concept underpinning it, it's merely a pretty thing. Both graphic design and advertising involve cool ways of communicating things, coming up with an idea and finding the best way—and new ways—to communicate it.

How do you generate your ideas?

By understanding the problem, knowing the background, I am able to find an insight. The strategist will feed the creative team a lot of information. While reading that research, usually some insight pops up. (Often, the strategist will choose the key information—the points of inspiration. Collaboration happens with the strategist or planner, where we sit around a table and discuss the research.) To learn as much as I can, I'll ask questions or find answers myself. I find reading about related topics on wiki is a good method for me. Out of that cluster, some fact or info will pop out. Always pursue as much information as you need to find an insight. As soon as you immerse yourself in the research, good stuff happens. Going directly to work on the computer is the worst way to proceed; before you start concepting, you need enough to contemplate. Another avenue to avoid is looking at other people's work for inspiration. You look at other people's work for information, to see what's been done, but *not* for inspiration.

Any advice on idea generation?

Avoid your first thoughts. Of course, once in a while your first thought may be the best one, but most often the first natural place you go is usually the safest, not the most creative. If you keep generating ideas, you'll land in a more interesting place. Take advantage of the difficulties. Find ways to do it in ways that haven't been done before. Inspire the audience to think. With too much "see and say," you're assuming the audience is not smart. Don't compromise doing mind-numbing ads because you think people won't get it. Once someone thinks about something, they're more involved with the brand. If you're looking for good ideas, don't look where most people look. Go where no one has looked, but also it has to make sense.

How do you convince a client to go with an ad that's not "see and say," not blatant?

A lot of clients don't understand this, because they are understandably afraid that this type of "thinking person's" ad won't sell. If you're afraid, then you're not going to do or get the best work. Great work really does come from great clients. Pick your battles with clients. You don't want to fight over every little thing. You have to give in on some things, so, later you can push back on the important things. Gain their trust. At the end of the day, I am passionate about my work and

TV SPOT: "FACES"

· MOTHER, NEW YORK
· ART DIRECTOR/DESIGNER: GUI BORCHERT
· CLIENT: DELL

believe it will produce the best result for my client. The client needs to believe that I want what is best for the brand. It's baby steps; trust grows and you build your relationship with the client so that their trust allows for more creative work.

How do you deal with project constraints? Media and budget constraints?

Use the limitations of the project to your advantage; view constraints as a challenge and be inspired by the limitations. Take those limitations and be more creative. If your client says, "Here's ten million dollars, go create an ad," that's too easy. If the Brazilian national soccer team plays against ten-year-olds, they're not challenged; and it's not interesting. *I always look for a challenge.* For example, if you give me a blank page and pen, I'll spend ten days thinking of what I want to draw. On the other hand, if you tell me: "You can only use dots to communicate love," I would have an easier time.

Does media ever drive the idea?

Ideally, the idea drives the media. But sometimes, the budget influences media choices and sometimes the media might influence it. *Bottom line:* It's all about communication.

The reality is sometimes clients come with their marketing plan in hand; they have the media figured out and you have to deal with it. The way I deal with a predetermined media plan is I present how my idea would live in various types of media, to give them a sense of how it would play out if they were to use other media. I present a large deck with all sorts of applications, which might inspire them to change the original plan or at the very least plant a seed. In that case, when someone else does it and it works, they might think: maybe we could have done that and you will have earned their trust for next time. Or they'll come back and want to do it later on. The more integrated advertising is, the better. Think of how a film or video could live anywhere these days, for example.

How do you know if you've generated a good idea or a great idea?

If I am really excited about an idea, that's how I know I hit it. When I can't stop talking about an idea, and I can't wait to come into the agency

POSTER AND INTERACTIVE EXPERIENCE: NIKE RESTORATION

· R/GA, NEW YORK

· ART DIRECTOR/DESIGNER: GUI BORCHERT

· CLIENT: NIKE

to work on it, then I know I've hit on something powerful. A great idea generates alternatives, series, details—"We can do this with it or we can do that with it"—and it keeps going, non-stop.

What does storytelling mean in this business?

It's visual communication, whether it's a visual identity or an ad. A print ad or YouTube video has to tell a story. One logo has to tell that story. Brands have to communicate specific ideas, a feel in a certain tone, not literally, not overtly, but with hints at it. You ask yourself: What do I want people to think and feel when they see this logo? You are telling a story in one image.

What about the importance of typography?

Great type can save a design. A really good way to measure talent in a junior portfolio is by the person's typographic skills. If I see poor typography in a book, it is very likely I won't be interested in the rest of the work. But this is something that can be acquired. If you love type you can learn to master it. And it's easy to fall in love with it. And when you do, you will know it's forever.

How do you work with existing brand strategy?

Each client has their own brand positioning. There is an umbrella and if it's in place already

your work can live under there, make sense, and help build the equity they already have, and hopefully evolve it using what is there as a starting point.

Is each commercial its own story? Is there one bigger story?

One big story or its own story, it depends. It may be the kind of brand that requires that everything fits neatly. Others are looser. It varies from client to client, but always a story nevertheless.

What do you look for in a junior book?

I want to see the work they are most proud of. Only include work you're really proud of in your book. If you include nine great pieces and one weaker piece, chances are a reviewer will spend the time on the one poor piece. Don't ever put in work you're not proud of. (That goes with clients, too. Never show a just OK piece to a client, not one, because chances are that's the one the client will choose.) You can totally include work that hasn't been produced, as long as it is good and you are able to explain it well. For example, a website doesn't have to be live, you can include screen shots. Or even student work, or work you've created for fun or just to build your book. If it's good, add it; just be honest about where it came from.

Partner up with a copywriter and/or photographer to create some speculative work that excites you.

Present your work well. If your portfolio looks thrown together, then I will assume you will not be careful with the work you do for me.

Anybody can learn software, but not everybody can think well and has talent. Know design theory. It doesn't need to be the most professional work in the world, all I need to see is at least a spark of potential. That said, pay attention to detail and do your best to present it in a way that will elevate your ideas and craft. Refine the type. It makes a huge difference.

I once learned this important point from a teacher: Don't include the type of work that you don't want to do for a living. For example, if you

want to be an art director, then don't include a lot of illustration; include a favorite, so that they know you have the skill. A junior has to be able to explain his or her ideas to me. I prefer people who are genuinely passionate about their work. (You don't have to be a slick presenter; being genuinely enthusiastic is good enough.)

What qualities do you look for in junior talent?

I look for hints of talent, to see if this person can think conceptually and can be a great thinker one day or will if what I see indicates he or she will be an amazing designer at some point. I look for someone who will inspire me. I want to be surrounded by people who inspire me, to find people who possess characteristics or talents I don't have. If the person surprises me, because he or she is interesting, that makes me realize I will be able to learn from him or her, and in turn, that person will learn from me. Of course, there has to be chemistry, it has to be a good match. I want students to realize that every good designer I know has a story about how he or she got rejected, or rejected more than once. Not everyone matches with everyone, not everyone is nice. Don't second-guess yourself. Don't get discouraged, but use a rejection to improve. Try to understand why you got rejected and think, "Could I have done something better?"

What is the future of advertising?

Advertising is not going to change; it will always exist. The need to communicate something, to tell a story, will always exist. We have to sell a specific good or service to this audience. Where can we reach them? At home? On their TVs? On their mobile phones? You have an idea—and then you come up with how and where you're going to execute it. Come up with something that has never been done before—TV, web, out-of-home, mobile, and things that haven't been done yet. If you just look at what's been done before, then you need to say, let's do something different.

Know what to say and how to say it; everything else comes from that.

Technology will keep evolving and advertising will have to move with it. For example, technology changes things, as Skype is here and has changed the face of long distance calling. The technology will help us keep things fresh, to allow us to tell stories in new ways and formats.

As soon as wireless is ubiquitous, we will be able to watch programming live from anywhere in the world on our mobile phones. More than ever, we have to create things people want to watch.

Integrated work is better because you'll be inspired to see more of it in other places. At the end of the day, there will always be a place for brands to tell a story.

PRINT AD: NIKE VAPOR

- R/GA, NEW YORK; WIEDEN + KENNEDY, PORTLAND
- ART DIRECTOR/DESIGNER: GUI BORCHERT
- CLIENT: NIKE

"OUR STORY"

From the start, we felt that the greatest untapped strengths of MINI were the passion and devotion of its owners. So we decided to do something a little different. We decided to advertise to the people who had already purchased a MINI. Sound strange? Here's why it worked.

Since its U.S. launch in 2002, MINI has exceeded sales goals, but by 2006 it had gone from having no direct competitors to having over a dozen. This development made the early adopting owners of the vehicle more important than ever.

MINI owners are passionate. They're borderline evangelical. In that way, they're more effective than any print ad could be at converting others who haven't quite bought in.

With that in mind, we created a super-secret, integrated campaign with messages only MINI owners could see. We called it the MINI Covert campaign.

Book

First, we sent a book to 150,000 MINI owners called "A Dizzying Look at the Awesomeness of Small." This book included an introduction with a secret compartment that housed the Covert Kit. This kit included instructions and three decoder tools that would help owners decipher the rest of the campaign.

The blogosphere responded with that much-desired thing people refer to as "buzz," not only on dozens of independent blogs but also on many automotive sites and general mass sites such as Flickr and YouTube.

Decoder

After the book was sent, three print ads in targeted pubs let MINI owners know how to use their tools to decipher the secret messages. And, for the uninitiated, we even had an "overt" message in the ads. For example, "Non MINI Owners: Get your complimentary decoder with the purchase of any MINI."

In the first print execution, owners were asked to use their decoder. The message led them to a super-secret website, and the adventure was on.

Decryptor

This ad used the sophisticated spy language known as Pig Latin to throw the curious off the scent. Again, owners were directed to a site and non-owners grew more intrigued.

Glasses

What's a good espionage operation without some cool spy glasses? OK, maybe ours weren't really that cool, but the results were.

c-Fit

The mysterious print ads led curious readers to corresponding websites. The sites required a little

MINI COVERT

· BUTLER, SHINE, STERN & PARTNERS, SAUSALITO

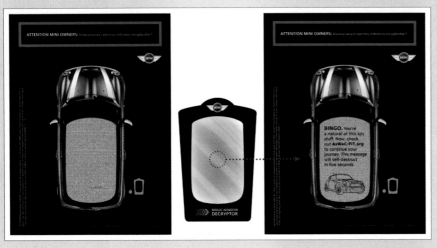

more investigation in case "outsiders" happened to find them.

The first was dedicated to the protection of insects. It included short videos promoting that cause. (One featured an attack by an enormous killer bee that bore a strange resemblance to one of our office canines.) But more importantly, it led MINI owners to an invitation to participate in a cross-country road rally called MINI Takes the States.

MINI Takes the States

Not only did tens of thousands of people find the reward from the c-Fit site, but thousands followed through and participated in the cross-country driving extravaganza that stretched from Monterey, California, to beautiful Jersey City. Three thousand MINIs cruising down the highway is not a bad way to spread the love.

Spy Gear

Every good sleuth needs good spy equipment. So on this site, we presented cover for the next reward with some gag spy stuff. Of course, there were more videos, including the musical stylings of a paleontologist turned singer. But again, the true payoff was another reward for MINI owners.

Adventure Toggle Switches

This reward let MINI owners further customize their vehicles by adding a little intrigue to their control panels. What car couldn't use an ejector switch or cloaking device?

Awesomeness of Small

The final site was a look at the benefits of being small. It featured another informative video showing the adventures of a butterfly with a bad attitude and a black belt. It also featured the final reward.

Medallion

For completing the final leg of the Covert print campaign, MINI owners could order proof of their participation and incredible investigative

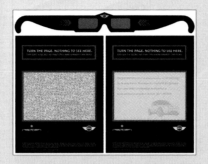

abilities. This reward came in the form of a medallion to be hung from the rearview mirror or to be worn around the neck while wearing a tuxedo at Monte Carlo casinos.

Motorby

In addition to creating a new way to talk to MINI owners, we created an entirely new way to directly communicate with drivers on the road. Using RFID technology embedded into a key fob, outdoor boards literally talked to MINI owners on the road.

Results

We preached to the choir. And the choir sang. Loudly.

—© BSSP

FIG. **13** / **24**

AMBIENT CAMPAIGN: NOBLE EDUCATION

· KINETIC, SINGAPORE
· CREATIVE DIRECTORS: ROY POH, PANN LIM
· ART DIRECTORS: PANN LIM, ROY POH
· COPYWRITERS: ALEX GOH, EUGENE TAN
· PHOTOGRAPHER: JEREMY WONG
· CLIENT: NOBLE EDUCATION

Regular objects found within the shop vicinity were used to simulate the effect of a pop-up book.
—Kinetic

FIG. **13** / **25**

AMBIENT: "MARYLAND COOKIES INVASION"

· DIABOLICAL LIBERTIES, UK
· PHOTOGRAPHY: DIABOLICAL LIBERTIES, UK
· CLIENT: MARYLAND COOKIES
· CREDIT: IMAGES REPRODUCED FROM "YOUR SPACE OR MINE," PUBLISHED IN THE U.K. BY AMBIENT MEDIA AGENCY DIABOLICAL LIBERTIES, 2003.

Instead of a traditional, nationwide billboard campaign, giant cookies from outer space crash-landed onto prominent buildings in twenty cities simultaneously. This was followed up by "meteor shower" street displays consisting of two-foot-tall cookies landing in busy retail areas throughout the country over a period of three days.

A large-scale street media campaign was also executed simultaneously in all of the cities where activity was taking place. Locations included London Waterloo Bridge, Blackfriars Bridge, Old Street, Shepherd's Bush Roundabout, Centrepoint, Olympia, and Tottenham Court Road.
—Diabolical Liberties

Figure 13-24 is an ambient campaign to promote a bookstore that specializes in children's pop-up books. Ambient can take many forms. Instead of a traditional, nationwide billboard campaign, why not have giant cookies from outer space crash land onto prominent buildings in twenty cities simultaneously (Figure 13-25)? One could think of unconventional advertising as promotional design, public relations events, or a mix of both.

Certainly, effective unconventional solutions have been shown to successfully promote brands or groups in break-through ways that live beyond their media space, such as the limited edition mailer for Onitsuka Tiger running shoes by Asics, Tokyo '64 Collection that became an eBay collectible (Figure 13-26).

A FINAL WORD

Since the creative revolution of the 1960s, creative advertising has made great strides to distance itself from hucksterism. More than ever before,

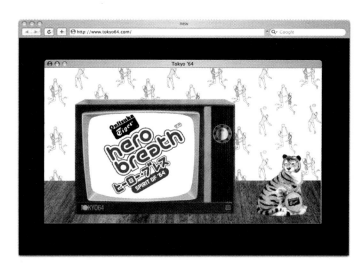

FIG. **13** / **26**

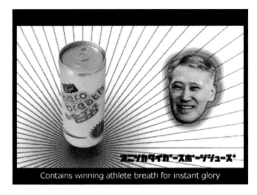
Contains winning athlete breath for instant glory

CREATIVE BRIEF AND CAMPAIGN: "HERO BREATH"

· STRAWBERRYFROG, AMSTERDAM
· ONITSUKA TIGER RUNNING SHOES BY ASICS, TOKYO '64 COLLECTION

THE BRIEF

· *Celebrate the reissue of Onitsuka Tigers Tokyo '64 Collection in the run-up to the Athens Olympic Games.*
· *Cut through the massive brand spends of Nike and Adidas, while maintaining the innovative spirit of the Tiger brand.*
· *Focus on authenticity instead of sports clichés.*

THE SOLUTION

· *A limited edition mailer for instant glory!*
· *We broke through to trendsetters globally with an integrated campaign, pushing the only legal performance-enhancing drug at this year's Olympics.*

INSIGHT

· *Onitsuka Tiger swept the board in the '64 Olympics, winning 19 Gold medals for Japan.*
· *We recognized that something special was going on that year—so we captured it!*
· *Hero Breath—authentic breath, direct from the mouths of the Japanese 1964 Olympians, captured in commemorative cans.*
· *Hero Breath was sent out to influencers in major world cities. The shoe collection and film of the capture of the breath were featured on the accompanying website: www.tokyo64.com.*

THE RESULTS

· *Hero Breath has generated significant worldwide press, commentary, and buzz. Editorials alone in opinion-forming magazines range from Italian* Vogue *to* Sportswear International, *covering an estimated audience of 16 million readers.*
· *This tactically targeted campaign ensured that the Tokyo '64 collection completely sold out.*
· *The controversial can of "legal dope" has now become an eBay collectible.*

Hero Breath reflects our pioneering spirit and gives us presence in a very competitive market. We're delighted.
—Carsten Unbehaun, Marketing Director, Asics, Europe

CASE STUDY

With the focus on a more unconventional means of promotion, Hornall Anderson convinced CitationShares to think beyond the 30-second spot and talk about viral advertising as a medium. The result was an innovative solution in the form of a series of three viral videos, featuring Michael Phelps—world-champion swimmer and winner of 8 gold medals in the 2008 Olympics. The 15- to 20-second film clips focus on "luxury meets levity" and were created for distribution to a wide audience via Internet channels—an audience typically comprised of 35- to 65-year-olds.

With humor in the foreground, setting the scenes in and around CitationShares jets highlights the luxury, comfort, and service inherent in the CitationShares experience, all the while subtly driving traffic back to the client's branded site. As a result of building brand equity from street level up, CitationShares is able to glean attention and interest from an audience that may otherwise never have been exposed to their company.

Through such themes as "Michael Phelps Flies," "Michael Phelps Sings," and "Michael Phelps Prank," Hornall Anderson has effectively marketed a premium, niche brand to a broad and increasingly media savvy audience. And by leading with the content, not the product, the videos provide a subtle, accessible introduction to the luxury and service that the CitationShares brand embodies.

—Hornall Anderson

CITATIONSHARES "PRIVATE MOMENTS WITH MICHAEL PHELPS" SKETCHES & VIRAL VIDEOS (SERIES OF 3)

- HORNALL ANDERSON, SEATTLE
- CREATIVE DIRECTOR: JAMIE MONBERG
- ART DIRECTOR: JOSEPH KING
- AGENCY PRODUCER: DANA KRUSE
- ACCOUNT MANAGEMENT: CHRIS MONBERG
- CONTENT PRODUCER: ZAK MENKEL
- DIRECTOR: DAVE LADEN
- PRODUCTION COMPANY: ÜBER CONTENT
- EDITORIAL: FILMCORE
- STORYBOARD ARTIST: TOM PRICE
- CLIENT: CITATIONSHARES

the self-conscious tone of much celebrated advertising winks at the viewer. To keep moving forward, all advertising professionals, not just a small number, need to find responsible voices.

Almost every country regulates advertising to some extent, especially advertising to children. Some advocacy and watchdog groups are Adbusters, Action for Children's Television, mediawatch-uk, Commercial Alert, the Advertising Standards Authority, Media Task Force of the National Organization for Women, and Guerrilla Girls, as well as individual critics such as Jean Kilbourne and collectives such as Men Organized Against Sexism and Institutionalized Stereotypes (OASIS).

EXERCISE 13-1

PRODUCT RESEARCH

❶ Choose a product or service.

❷ Research it.

❸ Find an insight into the audience. Find an insight into the product or service.

❹ Brainstorm strategies for selling it.

PROJECT 13-1

PUBLIC SERVICE ANNOUNCEMENT (PSA)

Step 1

a. Choose a nonprofit organization or a charity.

b. Gather information about it.

c. Find an insight into the audience. Find an insight into the organization. Determine the emotional benefit.

d. Write a creative brief.

e. Generate a few ideas based on the emotional benefit. Refine one.

f. Write a tagline.

Step 2

a. Create a PSA for any media: print, TV, video sharing, mobile, web, or guerrilla.

b. Produce ten sketches.

Step 3

Refine the sketches. Create two roughs.

Remember: Always establish a visual hierarchy.

Step 4

Create a comp.

Comments: Here is an opportunity to create an emotional connection with the viewer. Go for the gut or heart. And avoid clichéd images and statements.

Go to our website **GD/s** for *many* more Exercises and Projects, and presentation guidelines, as well as other study resources including the chapter summary.

NOTE

1. Rob Walker. "Consumed: Poultry-Geist," *New York Times*, May 23, 2004, late edition, sec. 6, p. 18, col. 1.

14/

WEB DESIGN

<<< / *facing page*

**WEBSITE: WWW
.PAULELLEDGE.COM**

· LOWERCASE |
LOWERCASEINC.COM

· ART DIRECTOR/DESIGNER:
TIM BRUCE

· PHOTOGRAPHY: PAUL
ELLEDGE

· FLASH ANIMATION,
PROGRAMMING: KURT
SABERI

PEOPLE

HAVE ALWAYS BEEN ENGAGED BY

ATTENTION-GRABBING GRAPHIC DESIGN—CONTEMPLATING A CD COVER WHILE LISTENING TO THE MUSIC, STUDYING AN INTERESTING BOOK COVER, OR LAUGHING AT A FUNNY TV COMMERCIAL, FOR EXAMPLE. WEB DESIGN, HOWEVER, TAKES IT A STEP FURTHER BY OFFERING AN *INTERACTIVE* EXPERIENCE.

INTRODUCTION: WHAT DO PEOPLE WANT FROM THE WEB?

Web design can secure a visitor's involvement with an engaging interactive experience, providing the interactive experience is well designed. Through a collaborative effort, EVB San Francisco and Toy New York created the "Elf Yourself" campaign for OfficeMax (Figure 14-01). EVB comments: "For the holidays, Elf Yourself allowed visitors to upload up to four photos and record a personal voice message through a toll-free number. The face or faces were then attached to an animated Elf body, the voice processed to sound elf-like, and the result was a dancing and talking Elf that could be forwarded to friends or posted on a personal website or blog. In six weeks, ElfYourself.com attracted a booming number of visitors and hit the bull's-eye of viral success—it seeped into popular culture. Its popularity began on personal and industry blogs, spread to social networks, *Flickr, Digg,* and *Facebook,* and soon to mainstream media, *USA Today* and *New York Times.* Then, broadcasters at several stations, *TODAY Show, Good Morning America, CNN American Morning,* and *ABC World News Now,* created custom greeting for their viewers."

What makes an online experience engaging? It should be entertaining, educational, exciting, intriguing, or rich. "In this seductive online experiment," explains Big Spaceship (Figure 14-02), "HBO invites you to experience the perverse pleasure of voyeurism. Our challenge? Substitute a window and binoculars for a monitor and mouse, and bring the vicarious thrill to life by creating detailed architectural facades and a living, breathing Manhattan setting for the stories. Find out what people do when they think no one is watching.

"*What Makes It Different or Better?* The HBO Voyeur Project brings twelve of the hidden stories of New Yorkers into view. Each of these stories takes place in a different apartment in five locations throughout the city, with the main action unfolding in the eight apartments of a tenement building in the Lower East Side. We wanted to get users close to the sights, sounds, and emotions of the drama without ever violating the personal space of the characters. All of the storylines are interconnected. So the more you watch, the more questions you have."

A website visitor can become an active participant (user) by making choices: visit a site; move through a site; enter information, reviews, or comments; and generally interact with content at various points. A visitor can search for and download information or programs, purchase products, play games, enter contests, watch movies or TV programs, comment on message boards, IM, blog, view animations and videos, and—let's not forget—read information and fiction, obtain news, and take academic courses all online. Since more and more people spend more and more time online for entertainment, creating any "fun" digital opportunity could potentially help build a brand or organization. What would young men find

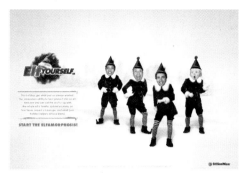

FIG. **14** /**01**

THEME: "ELF YOURSELF"

· LAUNCH: NOVEMBER 20, 2007
· URL: ELFYOURSELF.COM
· AIRING: WEB, PRINT, IN-STORES
· CLIENT: OFFICEMAX

CAMPAIGN CREDITS

· EVB SAN FRANCISCO, A DIGITAL CONTENT MARKETING FIRM (WWW.EVB.COM)
· EXECUTIVE CREATIVE DIRECTOR: JASON ZADA
· DIRECTOR: JASON ZADA
· ART DIRECTOR: MAX MENATH
· COPYWRITER: CHELSEA TUCKER
· DESIGNER: FRANCISCO TAVARES
· PRODUCER: MAGGIE O'BRIEN
· TECHNICAL LEAD: NICK MITROUSIS
· MOTION DESIGNER: SHAWN MYERS
· MOTION DESIGNER: JASON JOBE
· TOY NEW YORK
· CHIEF CREATIVE OFFICER: ARI MERKIN
· ART DIRECTORS: TIFFANY MCKEE, JASON STEFANIK
· COPYWRITER: ALEX TAYLOR
· ACCOUNT DIRECTOR: JAMIE ROSEN
· ACCOUNT EXECUTIVE: KELLAN ANDERSON

GOALS:

1. To elevate brand perception of OfficeMax and distinguish the office supply retailer from major competitors utilizing humor, entertainment, and humanization;
2. To establish OfficeMax as a holiday shopping destination.

CAMPAIGN RESULTS:

· *ElfYourself.com became a holiday destination in 2007, and from 11/20/07 to 1/2/08:*
 · *More than 193 million site visits with 123 million elves created;*
 · *More than 210 million elf dances were viewed;*
 · *60 elves created per second;*
 · *Users spent a combined 2,600 years on the site;*
 · *Site ranked No. 51 most-visited on the web (Hitwise, 12/07);*
 · *Ranked No. 1 on "Movers & Shakers" list (Alexa Rankings, 12/07);*
 · *Ranked among top 1,000 sites in 50 countries (Alexa Rankings, 12/07);*
 · *One in ten Americans visited ElfYourself.com (Nielsen).*
· *As a result of Elf Yourself, OfficeMax.com attracted 15.3 million visitors in December, up 170 percent from November, making it the top gaining Internet property (comScore).*
· *From a follow-up survey, we learned 1/3 of people aware of ElfYourself.com claimed it improved their perception of OfficeMax, and 1/3 of those who visited ElfYourself.com claimed it influenced their decision to visit OfficeMax.*

—EVB

FIG. **14** /**02**

HBO VOYEUR

· HTTP://WWW.HBOVOYEUR.COM
· DIGITAL AGENCY: BIG SPACESHIP
· AGENCY: BBDO NEW YORK
· CLIENT: HBO

FIG. **14**/**03**

GRUPO W, MEXICO

- THE STUNTMAN (HTTP://WWW
 .THESTUNTMAN.LA/)
- GRUPO W, COAHUILA, MEXICO
- CREATIVE DIRECTORS: ULISES VALENCIA,
 MIGUEL CALDERÓN
- ART DIRECTOR: MIGUEL CALDERÓN
- DESIGNER: JEZREEL GUTIERREZ
- COPYWRITER: IVAN GONZALEZ
- MULTIMEDIA PRODUCER: ULISES VALENCIA
- MULTIMEDIA PRODUCTION: SEBASTIAN
 MARISCAL, N-RENDER, SUBSUELO AUDIO
- PROGRAMMER: RAUL URANGA, EDGAR
 ORTIZ, DANIEL GRANATTA
- PHOTOGRAPHY: LA CENTRAL
- CLIENT: REXONA FOR MEN, UNILEVER

Stuntman is your new unbreakable toy. With this completely articulated action figure, you can release all your accumulated adrenaline after hours at the office. This application allows the user to beat and throw the main character without doing any harm or breaking a sweat. Stuntman is a highly addictive viral game designed to promote the campaign of Rexona for men: Action City.

Objective/Target: *The main objective of The Stuntman and the whole Rexona for Men campaign was to position the brand in its target audience in Latinamerica. The main concept for the interactive Campaign and for the TV campaign: StuntCity, consisted of establishing Rexona as the deodorant for the modern man who loves taking risks and needs superior protection.*

Solution: *To achieve this objective, we created Stuntman, the viral game from the Rexona for Men campaign developed in flash technology. There, the user can live the experience of beating the stuntman character, throwing him against different places in the interface without harming him, because he is an action double.*

The production of the site required a team of movie professionals to make the movements of the action double more realistic.
 —Grupo W

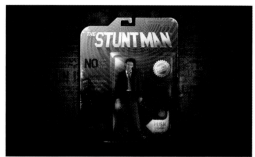

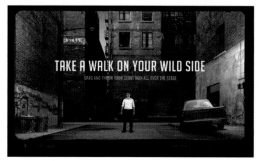

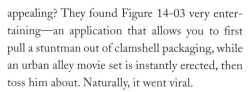

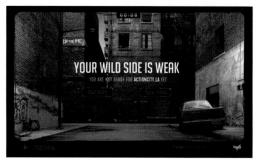

appealing? They found Figure 14-03 very entertaining—an application that allows you to first pull a stuntman out of clamshell packaging, while an urban alley movie set is instantly erected, then toss him about. Naturally, it went viral.

The Hear and Be Heard Fund needed a website to promote awareness for hearing impaired children (see "Case Study: What Noise?/Kinetic").

WEB DESIGN— THE BIG PICTURE

Technology evolves daily and we can predict that digital media presentations, applications, and uses for visual communication will significantly evolve over the next decade. Since the 1990s, the Internet has played an important part in advancing technological changes, and its impact on daily life will continue to be felt in innumerable ways.

Along with technology, environmental issues make regular headlines. As we find opportunities to go green, more information that was formerly available in print can go digital. For example, in Figure 14-04, "by designing the website in a way that it becomes The Green Building Institute's primary marketing tool," Ida Cheinman and Rick Salzman of Substance151 "eliminated the need for a number of paper-based materials."

Designing for interactive media is collaborative—involving a team of experts who develop and execute web design applications, usually including a lead creative team (a creative director, art director, designers, writers, and producer) and technology professionals, as well as animators, motion designers, programmers, testers, the client, and

perhaps even a cognitive psychologist or social anthropologist (who might provide insight into or predict visitor behavior). Designing for digital media is an iterative process, requiring prototyping and testing, maintenance, publicity, site seeding (where websites are indexed into database search engines), and updates or redesign.

Web designers must work cooperatively with information technology (IT) programmers. These professionals depend upon one another's expertise and contribution to the development of a functional online design application. One of their goals is to respect the user—making the website clear, useful, and frustration-free, alleviating any

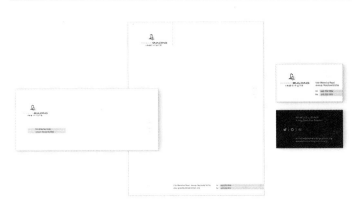

FIG. **14** / **04**

THE GREEN BUILDING INSTITUTE

- SUBSTANCE151, BALTIMORE
- CREATIVE DIRECTOR: IDA CHEINMAN
- DESIGNERS: IDA CHEINMAN, RICK SALZMAN
- CLIENT: *THE GREEN BUILDING INSTITUTE*, JESSUP, MD

Project Objective: *The Green Building Institute (GBI) is an emerging nonprofit organization working to advance environmentally sustainable building practices through education and example. Substance151 was approached by GBI to create a new brand identity and a web presence that allows for growth and scalability.*

Project: *Substance151 developed a brand image that reflects GBI's vision of the world where natural and built environments co-exist. This fusion of geometric and organic, manmade and natural is the main visual concept of the new brand identity and its applications. The choice of evocative contrasts achieved through carefully selected photography and icons used in both online and offline materials continue to communicate the fusion between built and natural environments.*

PRODUCTION NOTES:

- *Paper: Mohawk Options, White Smooth—100% PCW and FSC-certified; manufactured with renewable, nonpolluting wind-generated electricity.*
- *Printing: Rainbow Printing of Maryland—uses soy-based inks.*
- *By choosing a local printer, we (1) minimized energy use associated with long-distance deliveries; (2) contributed to building a sustainable local economy.*
- *By designing the website in a way that it becomes The Green Building Institute's primary marketing tool, we eliminated the need for a number of paper-based materials.*

LESSONS LEARNED:

- *Using environmentally conscious paper/inks and a local printer is cost-effective, sustainable, and rewarding.*
- *By conducting all presentations over the Internet/via PDFs, we saved paper otherwise needed for multiple color proofs; once the design was finalized, we gave the client Pantone chips for color approval.*
- *Using web-based marketing communications reduces paper waste and printing-related energy use.*
 —Substance151

CASE STUDY

WHAT NOISE?/KINETIC

The client needed the site to be informative and as such, provided us with facts and figures relating to the topic. We found it to be a real challenge because initially, it seemed like the site was to be primarily based on the information provided as the client believed that it was the best way to reach out to the people. After giving it some careful consideration, we felt that the approach was too safe and predictable; hence it may not be very successful in the current online environment. So we went on to persuade the client to go about it in another fashion, one that captures a person's attention by means of placing the user in the perspective of a hearing impaired child through interactive means.

We felt that in order for the site to work, it would have to be very stealthy. We needed to draw people in by playing up on their curiosity in order to sell them a very serious message. One that on its own, though important, is too easily ignored in this day and age, if done using a traditional method. With this in mind, we came up with a rather vague sounding, yet somewhat relevant URL "whatnoise.org" as a working title. Then we set about finding a way to relate the experience of a hearing impaired child to the user.

After several brainstorm sessions, we decided that the best way to go about it would be to use very simple games to engage the user. However, it was no easy task as the game ideas needed to be relevant and at the same time, not come across as too forced. Eventually, we managed to craft three micro games to represent three key issues faced by these children, each one specifically relating to a symptom. All three games have different interactivity, but they all work in the same manner in that the first levels are all relatively easy to complete. When it comes to the second level, the user will feel handicapped in a certain way and will find it almost impossible to complete the task. That's when they will feel the frustration and the plight of these children, and it is here that the relevant information is revealed to them. It's only after playing a game that the user, on returning to the home page, will then find that it's actually a website for a charity as the logo and a menu bar with more information will then appear. Since its launch, the site has been receiving a lot of attention not just from the local community, but also from around the world. It's a very good result, especially for a site that is aimed at creating awareness.

—Kinetic

WEBSITE: WHAT NOISE?

· KINETIC, SINGAPORE
· CREATIVE DIRECTOR: SEAN LAM
· ART DIRECTORS: FRANCIS TAN, SEAN LAM
· DESIGNER/DIGITAL EXPERT: FRANCIS TAN

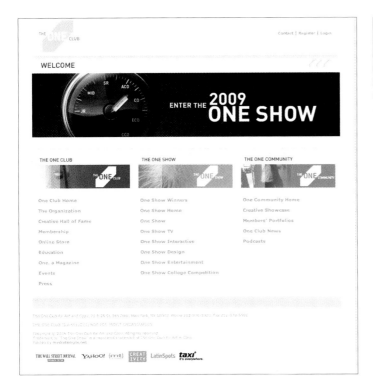

FIG. **14** / **05**

WEBSITE: THE ONE CLUB

· ART DIRECTOR: KEVIN SWANEPOEL

· DESIGNER: MICHELE SANDERS

· PROGRAMMING AND BACKEND
 DEVELOPMENT: WAYNE POSTHUMUS,
 WALDO ZEVENSTER

The site is divided into four sections. The First is The One Club Organization. This section has details about the organization, the Creative Hall of Fame, the Board of Directors, et cetera. The Second section deals with the award shows: The One Show, One Show Design, and One Show Interactive, which have searchable advertising and design archives (over 12,000 ads). The Third section is a community-driven Creative Showcase where creatives can share their most recent works with no charge. The Fourth section is the Entry system that allows agencies and creatives to enter and manage their awards submissions.

—Kevin Swanepoel

performance problems in the design, and offering the user a media-rich experience. A collection of "pages" or files linked together and made available on the World Wide Web, **websites** are authored and owned by companies, organizations, and individuals. The selection and coordination of available components to create the layout and structure of a website requires a specialized knowledge base that spans a broad range of disciplines. Web design involves strategy, collaboration, creativity, planning, design, development, and implementation.

PURPOSES OF WEBSITES

Compared with print, interactive media is in its infancy; however, younger generations have grown up with the web and many spend most of their leisure time with interactive media. Website purposes include:

› Public service, nonprofit groups
› Organizations (see Figure 14-05)
› Government
› Commercial
› Educational
› Editorial
› Reference
› Institutional promotion
› Transactional
› Self-promotion
› Hybrid/experimental
› Gaming
› Entertainment
› Video sharing
› Photo sharing
› Blogs
› Communities
› Social networking
› Professional networking
› Intranet

Kinds of Website Projects

Agencies and studios that design websites receive a variety of assignments, including:

› New website design and launch
› Website redesign
› Website re-architecting
› Global site design and redesign with room for local marketing differences
› Integrated campaign design
› Microsite (sub-site) design

FIG. **14**/06

OLPC SUGAR INTERFACE

· LISA STRAUSFELD/PENTAGRAM
· DESIGN: LISA STRAUSFELD/PENTAGRAM
 WITH RED HAT AND ONE LAPTOP PER
 CHILD FOUNDATION
· CLIENT: ONE LAPTOP PER CHILD
 FOUNDATION

Part of OLPC Mission: *To create
educational opportunities for
the world's poorest children by
providing each child with a rugged,
low-cost, low-power, connected
laptop with content and software
designed for collaborative, joyful,
self-empowered learning.*

*While traditional computer
interfaces are modeled on the
desktop metaphor, Sugar places
the individual user at the center of
the interface, which is icon-based
and has four levels of view: Home,
Friends, Neighborhood, and Activity.
Users can move outward from the
Home view, where they can set
preferences like color, to the Friends
view, where they can chat with their
friends, to the larger Neighborhood
view, where they can locate other
users and gather around an activity.
The Activity view looks inward:
children, alone or together, can
focus on a project at hand. In
each view, a toolbar-like frame is
available that organizes navigation,
people, activities, and files around
the four sides of the view.*
 —http://blog.pentagram.com/
2006/12/new-work-one-laptop-per-
child.php#more

› Blog design
› Entertainment and game design
› Online education design
› Interface design (see Figure 14-06)

WEBSITE DEVELOPMENT

As with solving any graphic design problem, there are various stages in the design and implementation process of a website design. Besides the usual stages of creating proposals and creative briefs, the web design application process requires thorough prototyping, where the site is created and tested for usability. There are ten key steps in this part of the website development process:

1/ Project plan: orientation and analysis to set and guide the goals and form the team of experts

2/ Creative brief: to outline creative strategy as it relates to the broader brand or visual identity, positioning and target audience, and all the other objectives of a brief

3/ Site structure: plan, map, and prepare content and information architecture (functional specifications) and address technological challenges

4/ Content outline

5/ Conceptual design: generate design concept based on brand identity strategy and brief

6/ Visual design development: design grid/ template and element placement, determine visualization method, set color palette, web type styles, style of navigational cues/graphic interface (link buttons), style of photos, illustrations, and other graphic elements, determine how to integrate media; lay out main screens to determine geography, almost like a storyboard

7/ Technical specs

8/ Prototype

9/ Technology: technical solutions; alpha; beta I and II

10/ Implementation: launch, promotion, updating, ongoing testing for usability

DEFINING WEB-RELATED TERMS

Content is the body of information that is available to visitors on a website. It is the subject and substance of the text and graphics. Content can

include general information, data, news, stories, poetry, and entertainment, as well as music, photos, and videos; information that enhances knowledge and interest in the brand, institution, or social cause; downloadable or printable material; and interactive "goodies" such as contests, giveaway items, screen savers, and games. Content should be well organized and easy to understand and access.

When providing content, *good writing* should always be a priority. Rules of writing apply to the web and other new and emerging media, the same as to any print media. How well headlines and copy or text is written greatly affects communication. Unity, coherence, and emphasis are always main goals, according to Homer E. Woodbridge in his classic book on writing, *Essentials of English Composition*. Make messages clear, weaving them into the concept or theme and user experience. Editing for clarity and pith also applies.

Information architecture is the careful organization of website content into hierarchical order. For a user to be able to easily move through—or *navigate*—a website, the content must be organized and structured in a logical way, from general to specific. However, web architecture is nonlinear; it must allow for nonlinear, nonsequential navigation. A visitor must easily be able to get where he or she wants to go from any point in the website. Clearly organized information architecture is crucial to giving the user a positive and frustration-free experience, especially for text-heavy websites, such as editorial sites (online magazines and newspapers), archives, museums, and government sites. The information architecture is the designer's guide to the overall composition of the website and hierarchy of individual graphic elements.

Once clear and user-intuitive information architecture has been established, a designer creates a corresponding "push-button" system, or a graphic interface, for accessing the information. The visual design of information architecture is the **navigation system**. A consistent visual structure is equally critical to ease of use and a frustration-free user experience. Many websites have several levels of navigation, including:

› Portal navigation that leads to many other websites

› Primary global or meta navigation within one website

› Secondary or sub-navigation (for second-tier information)

› Single web page navigation

A well-designed website will have a streamlined visual layout that provides an immediate sense of location at all times, one that offers consistent elements from page to page. Whether the website is three screen pages or a hundred screen pages in scope, a plan is necessary for leading the viewer through the site.

The first screen the visitor sees is a **splash page**, which serves as an introduction to a website, usually featuring animation or an engaging visual, though not all sites have splash pages. (A splash page offering visitors a "Skip Intro" option is best practice.) The splash page does not have navigation or important content, and when any animation is over, the home page comes up.

The **home page** is the primary entrance to a website and contains the central navigation system. A visitor can also sometimes enter via a link to a page other than the home page. The home screen is more than a title page—along with a central navigation system, it gives the visitor contact information and establishes the "look and feel" of the site. If a visitor finds a home page engaging, he or she is more likely to be drawn further into the site. The home page can set the tone for the entire website experience. It should have the most important information visible without scrolling; some refer to this as "above the fold," from newspaper industry jargon.

The colors, graphics, textures, and spatial illusions set up an emotional level of expressiveness. If the home page displays moving graphics that twist, turn, and flip, the visitor will expect playful activity throughout the site; a home page with clean, still imagery will cause visitors to expect this same simplicity everywhere else.

All navigation systems consist of visual and digital **links** that connect one location on a web page to another location, at either the same website or a different one.

The visual areas of links are referred to as tabs and buttons. Tabs are simply graphic interface metaphors based on the function of tabs on file

FIG. **14** / **07**

WEBSITE: WWW.PAULELLEDGE.COM

· LOWERCASE | LOWERCASEINC.COM
· ART DIRECTOR/DESIGNER: TIM BRUCE
· PHOTOGRAPHY: PAUL ELLEDGE
· FLASH ANIMATION, PROGRAMMING: KURT SABERI

Crawling with enchanting little drawings, this site might be one of Kandinsky's notebooks, but it's not. It's the online portfolio of photographer Paul Elledge.

"We drew inspiration from Paul's photography," Tim Bruce says of the highly creative site, but much of its style comes from a particular habit. "Travel with him," says Bruce, "and you notice he's a doodler." Elledge doodles wherever he has a pen and a surface—on paper and all over his photography cases. "Stop by his studio," Bruce goes on, "and you'll notice that the drawing goes beyond the travel gear to light switches and walls. We looked to extend this experience onto the web." As for Elledge, he wanted to update his site functionally, but he also wanted it to reflect his diverse photographic range. He wanted to be able to go in and easily tweak his galleries. And he wanted, of course, to doodle all over it. "The closer we got to communicating Paul's point of view," says Bruce, "the more original it is. Paul chose this direction by instinct, and the final site is hardly distinguishable from the initial sketches."

—Romy Ashby, http://www.stepinsidedesign.com/STEP/Article/28804/0/page/9

folders. Both tabs and buttons are interactive links. It is critical that tabs and buttons are clear, simple, and consistent in style, shape, and color so the visitor can recognize clickable links and move quickly and efficiently through the site. Color in particular is a strong visual "flag" or "cue" that the visitor can immediately recognize. Our mind tends to see and register color before it does shape; therefore it is most important to use color clearly, effectively, and consistently. Best practice dictates that if red is chosen for a button on the home page or global navigation of the site, then that color red should be used exclusively for this purpose throughout the site and for no other nonclickable graphics or information.

A button is used to make selections; however, buttons do not necessarily have to look like little round disks. They can be graphic forms of any shape or they may be imagery that creates a visual metaphor. For inspiration, researching well-designed, award-winning websites is the best way to see what is possible in designing navigation buttons. Almost all the visual communication trade magazines, such as *One Club Interactive, Print,* and *Communication Arts,* publish interactive annuals of award-winning new media design.

If the information architecture and navigation system graphics are well designed during the initial phase of website development, any subsequent phases or developments in the design will be easily facilitated. A plan of how the pages will "flow" will ensure easy navigation and give a sense of where a visitor is—a sense of location/geography—anywhere throughout a website. Some designers use a storyboard or flow chart technique to determine the flow of the site plan.

CONCEPTUAL DEVELOPMENT AND VISUALIZATION

A design concept is the driving idea—the backbone—of the planning for any interactive solution, based on the content, strategy, goals, and the brief, which should address the specifics of the goals for the website. For a concept, visualization, and design development for photographer Paul Elledge, Tim

Bruce of Lowercase not only drew inspiration from Elledge's photography, he based it on Elledge's creative habits (Figure 14-07). Bruce sought to extend Elledge's penchant for extreme doodling (on any surface—on paper and all over his photography cases) to the website. Thus the visualization of the site became "a little look into a creative mind," explains its designer, Tim Bruce. "We think one should look at brands as the sum total of the experience. Our work is about extending the brand of a person or organization out to people who haven't gotten to know the person or organization directly. Paul Elledge photography fits this bill."

Related to design concept development is that of formulating a theme. Interactive designer Hillman Curtis often utilizes a thematic approach, which he discusses in his book, *MTIV: Process, Inspiration, and Practice for the New Media Designer.* If you can identify a theme that best tells your group or brand's story, that theme can be used as a consistent design element (images, color palette, and typography) throughout to drive the flow of the design.

The brand image, conveyed through concepts and visual design, should be consistent across all media in order to sustain a brand. Usually, there is a lead agency or studio that establishes the strategy/concept-base for a marketing effort or integrated campaign.

For visualization, there must be a consistent "look and feel" with the existing or concurrent design of the brand identity, as in Figure 14-08 for

FIG. **14** /**08**

CLIENT: CHICAGO PARTNERS, LLC

· CROSBY ASSOCIATES, CHICAGO
SIGNATURE AND SYMBOL
· CREATIVE DIRECTOR/ART DIRECTOR:
 BART CROSBY
· DESIGNERS: BART CROSBY, JOANNA
 VODOPIVEC

*WEBSITE, STATIONERY, PRACTICE
 BROCHURES, COFFEE MUGS*
· CREATIVE DIRECTOR/ART DIRECTOR:
 BART CROSBY
· DESIGNER: JOANNA VODOPIVEC

FIG. **14** / **09**

ELEMENTS

· REGINA RUBINO/IMAGE: GLOBAL VISION, SANTA MONICA
· CREATIVE DIRECTOR: REGINA RUBINO
· DESIGN DIRECTORS: REGINA RUBINO, ROBERT LOUEY
· DESIGNERS: ROBERT LOUEY, REGINA RUBINO, CHRISTINA BLACKENSHIP

Chicago Partners and Figure 14-09 for Elements. If there are print or offline graphic design applications for this same brand or group, then there should be online and offline campaign integration; one design should be informed by the other, and the entire branding program should be consistent.

For example, a website design for a retailer may want to reflect the same type of shopping experience that the visitor has in the actual store, or the design may duplicate online the layout and look of the store itself.

VISUAL DESIGN

Visual design is not just about visual impact or aesthetics—it should be a marriage of form and function to ensure an effortless and worthwhile user experience. For example, in Figure 14-10, Visual Dialogue developed a website for Incounsel that gave "them a presence that stands out in the conservative world of law firm websites. Text and images are concealed and revealed through the use of overlays. As the user scrolls though the copy, the relevant section moves to the foreground, while metaphoric photos are progressively brought into focus in the top band."

Visual hierarchy ranks visuals and text in order of importance, which should be a natural outgrowth of content, emphasizing and ordering content from the most important to the least important. Most commercial, editorial, or govern-

mental websites have a great deal of content, with layers of relational information arranged in ranking order, creating multiple hierarchies. For example, if you want to read about advertising on *The New York Times* website, that content is a subcategory of the business section. Or if you want to explore relationships among photographs on the National Archives Experience, Digital Vaults, you would go to "Pathways," then select a pathway or create a new pathway. On websites with real-time and collaborative content, data is retrieved and displayed in dynamic hierarchies, where content is ranked according to community participation, for example, digg.com.

Michael O'Keefe, information systems designer, implores, "Guide someone through a site, so it's not random, almost like a guided tour." A strong grid creates a visual identity *and* maintains order, creating a sense of "geography and location," making it easy for the visitor to quickly locate various options and have a smooth passage through a formidable amount of information. Establish the flow of information from the broad message to the specific.

A grid is most often used as the central ordering structure for a website, a framework, used to create a uniform layout from page to page, while allowing for some variation. Jeffrey Zeldman compares web design to architecture, in how the planes and grids of a structure facilitate its use.

The grid splits the page into columns with defined widths, spacing, and margins, to establish positions for the standard elements on the page and alignment of text and pictures. Often, there is more than one grid per online design to allow for the different types of content and applications; when that is the case, the grids are designed with unity in mind.

The visual design of a website grid has a master layout, used to guide the composition and placement of every element—text, headers, and graphics—from screen to screen. By maintaining a visual grid, the visitor will have an easy time locating titles, information, and navigation graphics, thus enabling a smooth passage around the site. (Software layout programs refer to a stock layout as a template. And non-designers utilize stock templates in lieu of designing a grid.)

A grid is used so that the design is consistent and content can be easily loaded and updated, affording a visitor a sense of location—so that he or she has a sense of the geography of the site. Toni Toland, professor at Syracuse University, refers to this as the blueprint. For example, as an

FIG. **14** / **10**

WEBSITE: INCOUNSEL (WWW .INCOUNSEL.COM)

· VISUAL DIALOGUE, BOSTON
· DESIGN DIRECTOR: FRITZ KLAETKE
· DESIGNERS: FRITZ KLAETKE, IAN VARRASSI
· COPYWRITERS: SAM AND FRAN DI SAVINO
· PHOTOGRAPHERS: STOCK, KENT DAYTON
· FLASH PROGRAMMING: IAN VARRASSI

Problem: *Incounsel is a consulting firm providing onsite legal management to growing technology companies. The principals of Incounsel wanted their website to differentiate the firm from the tradition-bound look typical of the legal industry. They also wanted to suggest focus, growth, and a collaborative process to a web-savvy, high-tech audience.*

Solution: *The dynamic website we developed gave them a presence that stands out in the conservative world of law firm websites. . . . According to the principals of the firm, "Visual Dialogue's work has provided a strong ROI for Incounsel by allowing us to put forward a clear marketing message to attract clients and increase revenue."*
—Visual Dialogue

FIG. **14** / **11**

GLACEAU

- HTTP://WWW.VITAMINWATER.COM/
- DIGITAL AGENCY: BIG SPACESHIP, NEW YORK
- CLIENT: GLACEAU

Our good friends over at Glaceau have one-upped Mother Nature by infusing plain ole water with vitamins and electrolytes. Unfortunately, users can't take a sip of their favorite Vitamin Water flavor or try out the new Vitamin Energy drink straight from their computers. So Glaceau challenged us to present their brand and full line of products as if the user could pick up the bottles and take a sip. The even greater challenge was to include massive amounts of content without overloading the user—from witty, personality-filled copy to celebrity endorsements to the scientific benefit of vitamins.

WHAT MAKES IT DIFFERENT OR BETTER?

We created a Glaceau ecosystem that captures the personality and fun of each product as well as the art and science of water. The fact that Glaceau's identity is so well-established forced us to broaden the message from witty copy and clean graphic design to bringing to life the scientific makeup of each product and still be irreverent. Users can explore each and every bottle, flavor, vitamin, and boost of energy to their hearts' content. With swirling particles and spinning bottles, each drink nearly pours out of the monitor. With a few howler monkeys getting bikini waxed and poison dart frogs to kiss, people get to enjoy the wild and wooly Glaceau microclimate.
—© Big Spaceship LLC

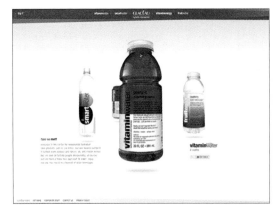

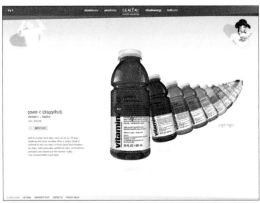

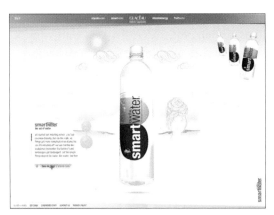

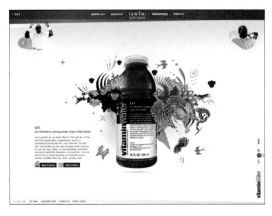

analogy, houses in a development might all use the same blueprint, however, each house is "personalized." Within a site, each page may have differences, yet there is still a visual unity throughout, as in Figure 14-11, which has a very clear visual hierarchy and makes finding information easy, enhancing the intense energy of Big Spaceship's concept and visual design for Glaceau.

Unity refers to the level of consistency and correspondence throughout a site. Creating visual correspondence among the pages—unity throughout the entire work, rhythm from page to page, and a flow from page to page—is crucial. Providing a sense of location for the visitor is equally important. For instance, the home page link should be visually consistent (the same shape and in the same spot on every screen page) throughout the site. In addition, each screen should have a title in the same spot so the visitor knows exactly where to look to determine his or her "location" within the site. The visitor should never think, "Where am I?" without knowing where to look for the answer.

The problem of unity in a website design is similar to establishing unity in a song; they are both experienced in "chunks" or sections. "There are many ways to create unity in music," notes Professor Matthew Halper of the music department at Kean University of New Jersey. "One of the most prevalent might be generally called 'thematic processes,' for example, the repetition of some recognizable musical chunk, let's say a melody, in a slightly altered form at various points in the piece. Notice that such a strategy assumes that some aspect of the 'chunk' changes while something else stays the same."

Color

A web page designer does have special considerations regarding color. When you design for print and see your design through production onsite at the printing facility, you have a good amount of control over the final color. Not so with web design. You can't control the color on the monitor of every web user, especially considering that Macintosh systems display color at a lighter value than non-Mac systems. It's best to view your design on all types of systems and browsers to ensure your color

is balanced. Consult a technology-based manual on web color for limitations and cross-platform use, and functionality, which refers to how the site design works on all platforms, web browsers/versions, and modem/line speeds. The rich color palette and textures of Velvet Moon Chronicles (Figure 14-12) reflects the intensity of the content of Shannon Denise Evans's multimedia project. What the visitor immediately sees is an indicator of the journey to come.

Style

The style of a website can be as varied as that of a print ad. It can utilize photography or illustrations or a combination of both. It can be classic in composition or edgy or experimental. For example, in Figure 14-13 for Ekens® ["The Oak"], a Swedish high-end bed manufacturer, art director Charisse Gibilisco comments: "The Ekens brand was to be revitalized and repositioned after several years of a slightly conservative position to a younger, urban, up market brand. The design creates an atmosphere of exclusivity and subtlety

in which the visitor is inspired and intrigued. To obtain this, elegant and stylish interior photography was combined with vivid, organic illustrations in a clean, sophisticated design structure to create interesting contrast and balance."

The tone may be irreverent, humorous, formal, conservative, or provocative. Certainly, the tone should work cooperatively with the style. For nonexperimental sites, keep in mind this advice from Landor Associates, Branding Consultants and Designers Worldwide: "Keep it clean and simple."

FIG. **14**/**12**

WEBSITE: VELVET MOON CHRONICLES

· DESIGN AND PROGRAMMING: LAVA DOME CREATIVE, BOUNDBROOK, NJ
· DESIGN DIRECTOR: MIKE SICKINGER
· VELVET MOON CHRONICLES/SHANNON DENISE EVANS

Velvet Moon Chronicles is an edgy and sexy multimedia project (novel, webisodes, live theater) that follows the life of Zoë, a celebrated, wealthy, and accomplished "companion" to Manhattan's elite, whose reality gives way to a mysterious world revealing itself to her as she sleeps.
—Shannon Denise Evans

FIG. **14**/**13**

WEBSITE: EKENS.SE

· SIGNALERA, SWEDEN
· PROJECT LEADER: HENRIK MALMQVIST
· ART DIRECTORS: JENS MARTIN, CHARISSE GIBILISCO
· PRODUCTION MANAGER: DAVID KINNBERG
· COPYWRITERS: STAFFAN HASSBY; KUNDE & CO., COPENHAGEN
· FLASH PROGRAMMING: DAVID DAHLSTRÖM
· PHOTOGRAPHER: MADS ARMGAARD/ GAB.DK
· ILLUSTRATOR: LOTIE, REPRESENTED BY DUTCHUNCLE, LONDON
· CLIENT: EKENS®
· © EKENS 2007

Ekens.se utilizes illustration, photography, and a design language established in the Ekens catalog, which was created by Kunde & Co., a Danish agency. The sources of inspiration for all materials are the brand's three main features: individuality, comfort, and innovation.
—Charisse Gibilisco

FIG. **14**/**14**

WEBSITE: NIKE LAB, SPRING 2004

· WWW.NIKELAB.COM
· R/GA, NEW YORK
· PRODUCER: JENNIFER ALLEN
· ART DIRECTOR: JEROME AUSTRIA
· VISUAL DESIGNERS: GUI BORCHERT, MIKHAIL GERVITS, HIROKO ISHIMURA
· FLASH DEVELOPERS: LUCAS SHUMAN, VERONIQUE BROSSIER
· INTERACTION DESIGN: CARLOS GOMEZ DE LLARENA
· COPYWRITING: JASON MARKS
· QUALITY ASSURANCE: AUGUST YANG

NIKELAB.com is Nike's showcase of performance innovation—a completely interactive experience that lets customers learn about Nike's innovative products through cutting-edge graphics and original episodic content. The theme for Spring 2004 was Vapor Station. The concept is based on a futuristic Nike research center where the secrets of speed are studied and unlocked. Each chamber inside Vapor Station houses a facet of Nike's obsession with speed, from interactive product stories to curated video compilations to speed experiences created through collaborations with digital artists.
　—R/GA

FIG. **14**/**15**

30 DAYS OF NIGHT

· HTTP://WWW.SONYPICTURES.COM/30DAYSOFNIGHT/
· DIGITAL AGENCY: BIG SPACESHIP, NEW YORK
· CLIENT: SONY PICTURES DIGITAL ENTERTAINMENT/COLUMBIA–TRISTAR

Sony Pictures wanted to issue a stern warning against going up to Barrow, Alaska—especially for the month when the sun never rises, like in their newest vampire flick, 30 Days of Night. So how do you make a cool subject like vampires even cooler?

WHAT MAKES IT DIFFERENT OR BETTER?

We built an online Barrow where people can wander the streets and wait anxiously as the sun dips below the horizon and the vampires creep out of the shadows.

*　We put people into the thick of it. Let them explore the sleepy town at dusk. Made sure to equip them with a shotgun, just in case they stumble upon one of those pesky vampires. Because Barrow is lousy with vampires. The sun sets fast and pretty soon people are glancing over their shoulders at whatever that was in the corner in their eye.*
　—© Big Spaceship LLC

ENGAGING CONTENT

A rich user experience is where the website actually performs or offers value, one where the visitor is not just passively looking through it, according to Michael O'Keefe. A shopping site offering rich media (audio, video, Flash animation), where one can transact with another entity and make selections, such as Nike Lab, is a rich user experience (Figure 14-14).

Sony Pictures' *30 Days of Night*—a film about an Alaskan town that is plunged into night for 30 days and plagued by vampires—engages visitors at their site shown in Figure 14-15. Big Spaceship describes the pleasure of working on this assignment:

Even with all the wandering to and fro, people never lose sight of the central navigation that tells them about the cast and crew, lets them download cool stuff and links them to the online multiplayer game we created (yes, we got to make a multiplayer game too). . . . Our design team tapped a vampire-ish coworker to stand in as the fast-approaching blood sucker in the mini-game. Our development team figured out the best way to have snow fall without creating a total white out. Oh yeah, and our sound designer really, really liked making spooky vampire music. We're going to miss working on this project.

As both web and mobile applications proliferate, tools and features will become ever more important for creating engaging content. The Poetry Foundation website designed by Winterhouse (Figure 14-16) is a rich poetry resource featuring the "Poetry Tool," which allows users to search and find poems by occasion, title, category, or terms, such as haiku or free verse.

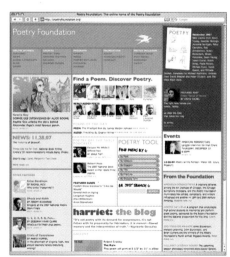

FIG. **14** / **16**

PRELIMINARY SKETCH, WEBSITE REDESIGN

· WINTERHOUSE, FALLS VILLAGE, CT
· CREATIVE DIRECTION: WILLIAM DRENTTEL, JESSICA HELFAND
· DESIGN AND DEVELOPMENT: BETSY VARDELL
· COPYRIGHT FOR ALL SCREEN IMAGES: © POETRY FOUNDATION, 2005–2007

The online face of The Poetry Foundation, publisher of Poetry *magazine, took home the Webby in the associations category. The site is a rich resource on the subject of poetry, with feature articles, cartoons, news, and audio podcasts of renowned poets reading and discussing their work.*

But another feature that no doubt helped push the site to its Webby glory is the Poetry Tool, which allows users to find poems by category, occasion, title, first line, or glossary term, such as free verse, haiku, or limerick. The tool lists 18 poems appropriate for Mother's Day, for instance, and 185 poems that begin with the letter "O." (It includes poems from the oft-recited "O Captain! My Captain!" to more modern pieces.) Users can also find poets by first name, last name, or even year of birth.

http://news.cnet.com/2300-1026_3-6180902-2.html

ESsay

D.S.

DANIEL STEIN, CEO & FOUNDER OF EVOLUTION BUREAU

A veteran of the interactive revolution, Daniel has spent 16-years contributing to the industry's evolution. Staying true to his vision, he helped transform the internet from a dot-com punch line to one of the most powerful forms of media today. In 2000, Daniel founded Evolution Bureau, a progressive, unconventional advertising agency that develops cross-platform engagement and communication programs for today's media-agnostic consumer. He is the driving force behind the agency's strategic vision and growth, supporting clients such as Alberto Culver, adidas, Wrigley and Levi's. His diehard passion and "never get too comfortable" attitude keeps the agency at the forefront. Recognized for pushing industry boundaries, Daniel is frequently quoted by the media and travels worldwide advising clients and experimenting with new forms of marketing.

THE MOST SUCCESSFUL INTERACTIVE CAMPAIGNS HAVE THESE FIVE PRINCIPLES IN COMMON[1]

Reading Twitter recently, I came across a great quote by Tom Ajello (Meat99), who said Twitter is like "an army of deaf people shouting into a canyon." This also describes the current state of traditional marketing.

If ads are losing effectiveness, is the best solution to create more ads, increase frequency, and heighten disruptiveness? Should you continue using the same words but louder? The problem is consumers no longer speak the language of traditional marketers. Instead, they speak digital. They control the messages they consume and filter and navigate the media landscape with a new kind of freedom. Instead of screaming to get attention, advertisers need to create a positive experience that consumers will freely seek out and enjoy in their own time.

At EVB, we've experimented with new media, failed a few times, learned a lot, and enjoyed some achievements. Looking back, each successful initiative shared specific tactics. These commonalities have become our core principles.

1. Practice participation marketing. The key to engagement is participation. Consumers are empowered to engage in the content they choose; if they don't "care" about a campaign, they'll avoid it. When executed in a welcoming, non-disruptive manner, digital content invites consumers to engage on their terms.

Before digital content is developed and released, it's integral to ask why the consumer should care. A simple question, but not one marketers have historically considered. In today's marketplace, marketers don't build brands—consumers do. Our job becomes providing consumers with the content, message, and tools that enable them to create a personalized experience to share with others.

A great example of participation marketing is the "Freak your mind" campaign created for the third-season premiere of A&E's *Criss Angel Mindfreak*. Users provided a friend's name, phone, and e-mail, and a video featuring Angel performing a personalized magic trick was sent to the friend, taking them from e-mail to video to mobile, ending in a mind-boggling scare. Once someone was "freaked," he or she passed it on tenfold. In weeks, the campaign garnered millions of visitors and resulted in the show's highest ratings to date.

2. Think "working production." The terms "working dollars," to define media, and "non-working dollars," to define creative and production, have never made sense to me. For engagement marketing, such terms are irrelevant. Instead, emphasis must be put on the "experience" created to draw consumers and retain their attention. By elevating the importance of creative and production, unique consumer experiences are born, and consumers become brand ambassadors willing to share your content with their digital networks.

I'm often asked for seeding strategies "to make something viral." The truth is, if the content doesn't strike a chord, no amount of seeding or advertising will make it viral. Campaigns like "Elf yourself" [see Figure 14-1] and "Freak your mind" each started with an e-mail to a select group of "influencers," who took it upon themselves to contribute to its success. Next are the blogs; they are the tipping point. If the blogs ignore your content, it has little chance. After blogs comes the digital press. From there, the traditional press furthers the spread of content.

3. Create liquid content. At this point, all marketing is digital. Why should a great idea be constrained by the boundaries of the Web? To create "liquid" content capable of moving freely among platforms, start with an overarching idea and then find the best way to distribute it. No message should live and die in a single medium.

The recent 2K Sports campaign was built around the core idea of "football resurrected" [see Figure 13-10], marking 2K's return to the gridiron video game arena with All-Pro Football 2K8. The campaign launched with a dynamic digital component and expanded to TV, print, street teams, and a national concert tour that together celebrated the return of "real" football gaming.

4. Simplicity is key. Digital consumers are "snackers" and choose to be reached on their terms with quick and satisfying content. They lead fast-paced, multitasking lives with only enough time for content that serves a useful or entertaining purpose. It should allow them to briefly engage and move on. A campaign should give more to the consumer than it takes in return. Many assume that "digital marketing" must use a lot of high-tech bells and whistles. In fact, simple, useful content is more effective and more welcome.

5. Integration is never an afterthought. Forcing together disparate parts and shoehorning creative doesn't make a campaign "integrated." Instead, strive for ideas that are integrated at the core and work gracefully together between platforms.

The Adidas soccer campaign around the 2006 and 2007 Major League Soccer seasons utilized an integrated idea with powerful results. In 2007, the campaign, called "MLS Represent," commissioned 13 rising bands to write and record original anthem tracks for each MLS team. The tracks were made available for free download. Concert posters were created for local postings and used in print media. User-generated videos were created online. CDs were distributed at Adidas retail locations and events. Anthems were played in stadiums, some live. Music videos were filmed and later used for TV and online advertising.

The days of one-way communication are behind us. Speaking louder will only further separate you from your audience. In fact, they aren't your "audience" anymore; they are an "active participant" in the content you create.

EVB AND "FREAK YOUR MIND"

In support of A&E's hit show *Criss Angel Mindfreak*, EVB produced an experiential, interactive site at FreakYourMind.com. The campaign titled "Freak Your Mind" seamlessly transfers the entertainment experience of television to an online platform that appeals to a virtual audience. It's a cyber magic trick you can virtually play on your friends, taking them on a multiplatform roller coaster ride that ends in a freakish scare. With the

help of *Mindfreak* host Criss Angel, users create and send a personalized video e-mail sure to freak their friend's mind. Opening the video e-mail in a YouTube-like site, viewers are greeted by a magic trick performed by Criss, who surprisingly reveals the viewer's name and phone number. The video self-destructs, and seconds later the person's phone rings with Criss on the line addressing them by name and reminding them to watch his June 5 season premiere.

SHOW: CRISS ANGEL MINDFREAK

· THEME: "FREAK YOUR MIND"
· URL: FREAKYOURMIND.COM
· AIRING: WEB, MOBILE
· EVB SAN FRANCISCO, A DIGITAL CONTENT MARKETING FIRM (WWW.EVB.COM)
· EXECUTIVE CREATIVE DIRECTOR: JASON ZADA
· COPYWRITER: BOB GOELDNER
· ART DIRECTOR: RYAN CARVER
· TECHNOLOGY DIRECTOR: JEFF TITUS
· PROGRAMMERS: JUSTIN PETERSON, LUCAS SHUMAN
· MOTION GRAPHIC ARTIST: SHAWN MEYERS
· ACCOUNT SUPERVISOR: RYAN TOLAND
· EXECUTIVE PRODUCER: AMANDA COX
· CLIENT: A&E NETWORK

GOALS:

· *To generate excitement and anticipation leading up to the season premiere of* Mindfreak*;*
· *To transfer the* Mindfreak *television experience to the web and enable consumers to virally spread the virtual magic experience across the Internet;*
· *To spread awareness and garner new viewers to watch* Mindfreak *on June 5.*

RESULTS:

· *"Freak Your Mind" spread virally across the web with over two million visits after 60 days of being live;*
· *Users played over one million magic tricks on friends after 30 days of being live;*
· *A&E's season premiere of* Mindfreak *yielded the network's highest ratings to date with over 1.7 million viewers;*
· Mindfreak *was the No.1 watched show for adults 18–49 years old during the 10 p.m. to 11 p.m. timeslot.*

—EVB

EVB AND "MLS REPRESENT"

A website experience can include the additional sensory experience of sound—music, voice, special effects, found sounds—which should never be underestimated in its emotional appeal, as well as functional benefit. For Adidas Soccer, EVB created the Adidas Major League Soccer (MLS) campaign. Titled "MLS Represent," one of their five main goals was "to connect with soccer fans and soccer players through music." EVB brought together MLS teams and local music talent to create original anthems for each team and host city. EVB describes the campaign: "Anthems were featured on fan and team sites and on the Adidas 'MLS Represent' website (www.adidas .com/MLS), where fans could download complimentary songs and learn about each team, its players, and respective hometown band. Additionally, fans could *represent* their team by creating mash-up music videos that combine a team anthem with MLS game footage that could be sent to friends or rivals."

—EVB

"MLS REPRESENT" WEBSITE (WWW.ADIDAS.COM/MLS)

· EVB SAN FRANCISCO, A DIGITAL CONTENT MARKETING FIRM (WWW.EVB.COM)
· THEME: "MLS REPRESENT"
· LAUNCH: AUGUST 2007
· URL: ADIDAS.COM/SOCCER
· AIRING: WEB (ADIDAS MICROSITE/FAN SITES/MLS TEAM SITES), RADIO, IN-STADIUMS
· CLIENT: ADIDAS SOCCER

CAMPAIGN CREDITS

· EXECUTIVE CREATIVE DIRECTOR: JASON ZADA
· ASSOCIATE CREATIVE DIRECTORS: LAUREN HARWELL, JAIME ROBINSON
· ART DIRECTOR: SEAN O'BRIEN
· COPYWRITER: JEREMY DE FORGE
· DESIGN: SEAN O'BRIEN, JAMES SANSA-NGASAKUN
· EXECUTIVE PRODUCER: AMANDA COX

· PRODUCER: PETER ANTON
· TECHNOLOGY DIRECTOR: JEFFREY TITUS
· FLASH PROGRAMMERS: NICK MITROUSIS, JUSTIN PETERSON
· MOTION DESIGNER: SHAWN MYERS
· HTML LEAD: GENE KIM
· MUSIC COMPANY: ROCK RIVER MUSIC

GOALS:

· *To connect with soccer fans and soccer players through music;*
· *To resurrect the age-old tradition of team anthems for U.S. Major League Soccer;*
· *To foster camaraderie, friendly rivalry, and on- and offline conversations around the 2007 MLS Playoffs;*
· *To develop brand association of Adidas with Major League Soccer;*
· *To elevate the brand perception of Adidas with soccer fans and players.*

Campaign Caption: *For the second year, EVB created the Adidas Major League Soccer (MLS) campaign. Titled "MLS Represent," EVB paired 13 MLS teams with local artists or bands from rock, pop, hip-hop, Latin, and punk genres to write and record an original anthem song that symbolized each MLS team and home city.*

"MLS Represent" was designed to encourage camaraderie and rivalry around the sport. Participating bands included OK GO, Mike Jones, and Barenaked Ladies. The campaign launched in August and continued through the 2007 MLS Playoffs in November 2007.

CAMPAIGN RESULTS:

· *MLS teams and fans embraced "MLS Represent" using team anthems during half-time shows, tailgate parties, at home, online, etc., in celebration of their favorite team;*
· *Over 80,000 blogs wrote specifically about the Adidas "MLS Represent" campaign.*

—EVB

FIG. **14** / **17**

MY FAMILY "CENSUS" MICRO SITE

· HORNALL ANDERSON, SEATTLE
· INTERACTIVE DIRECTOR: JAMIE MONBERG
· INTERACTIIVE DESIGNERS: HANS KREBS, JOSEPH KING
· DEVELOPERS: JASON HICKNER, ADRIEN LO
· PRODUCER: ERICA GOLDSMITH
· COPYWRITER: SARAH TYLER

When Ancestry.com finished making 140 years, worth of U.S. Census data available online, they wanted to celebrate. For them, Hornall Anderson "built a microsite to mark their achievement and draw attention to the incredible opportunities this resource provides" (Figure 14-17). Hornall Anderson explains: "The rich, interactive site acts as the tip of the iceberg, giving visitors a glimpse of how they can use this massive repository both to explore their own family's story and to learn more about the larger population and immigration trends of the last century and a half. The design incorporates authentic photos and documents to show that census records are more than lists of names: they are artifacts, snapshots of our collective and personal history."

A website cannot offer a rich user experience without knowing something about the viewer. Never underestimate the need for detailed research about audiences. For Figure 14-18, www.Three Degrees.com, Aaron Marcus and Associates, Inc. (AM+A) "experimented with many sketches specifically designed for teenagers, which were based on detailed research that analyzed teenagers' preferences, on a weekly basis, concerning such matters as color, shape, texture, personalities, and other

FIG. **14** / **18**

WWW.THREEDEGREES.COM: WEB-BASED/MESSAGING, FILE-SHARING FOR TEENS

· AARON MARCUS AND ASSOCIATES, INC., BERKELEY
· ART DIRECTOR/PRINCIPAL DESIGNER: AARON MARCUS
· DESIGNER/ANALYSTS: CLAUDIA DALLENDOERFER, LARRY GUAN
· DESIGN DIRECTOR: EUGENE CHEN

Aaron Marcus and Associates, Inc. designed these sketches of prototype screen components for a messaging and file sharing Web application being developed by Microsoft that was specifically targeted for teenagers. The application was called ThreeDegree.com and went live for a period of time about 2001–2002 before it was absorbed into other software developments.
—Aaron Marcus and Associates, Inc.

characteristics. AM+A designed many kinds of visual imagery and three-dimensional imagery to convey excitement and unique user experience. This effort was one of Microsoft's earliest user-centered design efforts, which included housing teenagers in a house for a period of time in which their socializing and communication habits could be studied. AM+A's prototype was shown to Bill Gates, who reacted favorably and gave the project a green-light to go forward with product development."

IMPORTANT POINTS FOR WEBSITE DESIGN

What are the most essential considerations for web design?

› Respect the user.

› Engage the visitor through visual interest and clarity.

› Integrate design of website with brand identity: color palette, graphic elements, tone, visualization method, imagery.

› Prototype and test, test, test!

› Ensure logical web hierarchy.

› Content should be easy to find, read, and print or download. (Most content should be brought to the immediate attention of the visitor; however, it is acceptable to allow some content to be "found.")

› Offer or do something that traditional graphic media can't.

› Offer a media-rich experience.

› Provide an interactive experience that will allow a relationship to form between brand or group and visitor.

› Get the visitor to interact.

› Follow the ADA Standards for Accessible Design guidelines for web design (www.ada.gov).

MAXIMIZING POTENTIAL: TECHNOLOGY AND INTEGRATING MEDIA

At any point, learning to embrace the strength and potential of available technology is a good rule of thumb. Knowing what newer media, emerging media, and media platforms and outlets are capable of will allow you to execute concepts in fuller ways. For example, Second Story's design for the National Archives Experience, Digital Vaults, embraces Web 2.0 technology (see "Case Study: National Archives Experience, Digital Vaults/Second Story").

In the past, television commercials and print ads were the main carriers of ad messages. Now television, as well as print, is often used to drive people to the web where they can interact with a brand or group. More and more we see a convergence of media; for example, a mobile phone can become any person's media hub with an Internet connection, camera, programmed content, GPS, and more. As technology rapidly evolves, it is most likely that our mobile phones will become one of the most important players in carrying content and messages. Mobile, widgets, and emerging digital platforms have sister solutions or companion solutions related to website content. An informed designer or team should understand how to link strategy, core concepts, and visual design across platforms, as did R/GA for Nokia Urbanista Diaries (see "Case Study: Nokia Urbanista Diaries/R/GA").

POINTS TO CONSIDER

When designing an interactive experience, always keep the visitor's point of view in mind:

• Does content download and stream as fast as possible (in less than 15 seconds)?

• Does it enable communication? Is it easy to navigate? Can someone easily find information?

• Is it frustration-free?

• Is it relevant to the audience? Would someone want to return? Does it create worthwhile dialogue with the visitor? Is the online experience worth someone's time?

• Is the visitor getting something he or she can't get elsewhere (a media-rich experience)?

MOTION

Screen-based media can support graphics that move over a period of time; also called four-dimensional design. In order to create moving graphics, one must be well acquainted with the necessary technical issues, production techniques, and software such as Adobe Photoshop, Adobe Illustrator, Adobe Flash, Apple Final Cut Pro, Adobe Dreamweaver, Adobe Fireworks, and Adobe After Effects. However, one must also apply two-dimensional design principles to screen-based visual communications. Like any other visual communications application, screen-based media can communicate a message and be expressive. The audience may not know how to critique successful motion design but the viewer will be aware if your motion solution is *not* fluid, forceful, or aligned in makeup with the other visual components of the piece.

As always, a designer working with motion must consider concept generation, function, form, aesthetics, meaning, and ultimately, communication. Whether screen-based media is incorporated into other media or stands alone, one must be conversant with the following considerations:

> Concept generation based on strategy and brief
> Theories fundamental to motion or animation
> Narrative forms or storytelling (linear and nonlinear narrative forms)
> Planning of action
> Sequencing of images for maximum impact and communication
> Integration of different media (if relevant)

As with creating concepts and visuals for television commercials, screen-based media can involve narrative forms (storytelling for linear, nonlinear, realism, abstraction, and experimental), sequencing of images and events, composition, and visual and motion variables (characteristics, attributes, or qualities). As always, the underlying concept drives the execution, as it does in Figure 14-19: "Smarterer. Connecteder. Funnerer. Not the typical descriptors used to explain mobile technology. But the T-Mobile G1—manufactured by HTC—isn't your typical phone. As Google's first foray into the wireless market, the G1 is the first phone running Google's Android platform and is already generating excitement."

Hornall Anderson continues: "We developed the whimsical launch theme and a range of support materials for a fourteen-city tour designed to build momentum in the T-Mobile retail channel and train the sales force to be G1 experts in anticipation of a surge of demand for the new phone. The theme employed a tongue-in-cheek misuse of grammar inspired by the Google name itself—technically a misspelling of 'googol'—and communicates the populist positioning of the device and the idea of not taking itself too seriously. The result: an energized and prepared sales force, and a solid launch pad for this historic device."

MOTION AESTHETICS

Motion aesthetics refers to the process and consideration of how form creates impact over time in a design. Fundamental to screen-based media is an individual **frame**—single static image, one

FIG. **14** / **19**

PROJECT: HTC G1 LAUNCH
SIZZLE REEL

· HORNALL ANDERSON, SEATTLE
· CREATIVE DIRECTOR: MARK POPICH
· ART DIRECTOR: JOSEPH KING
· INTERACTIVE DESIGNERS: OWEN IRIANTO, HAYDEN SCHOEN
· PRODUCTION HOUSE: OH HELLO
· MUSIC: OH HELLO
· PRODUCER: DANA KRUSE
· ACCOUNT DIRECTOR: TRACI FINATTI
· STRATEGY: SUNITA RICHARDSON
· COPYWRITER: MATT FONTAINE
· CLIENT: HTC

CASE STUDY

NATIONAL ARCHIVES EXPERIENCE, DIGITAL VAULTS/ SECOND STORY

"With a database of some 1,200 documents, photographs, drawings, maps, and other materials and a keywording system that visually links records, the Digital Vaults website enables visitors to customize their exhibit experience and to create posters, movies, and games that can be shared by e-mail. Each record in Digital Vaults is also linked to the National Archives research database, so visitors who want to know more can take the first steps toward a research journey into the National Archives."[2]

This case study features Second Story's "Visual Explorations" for this project. The site (http://www.digitalvaults.org/) showcases the records in the National Archives. The concept puts images at the forefront, emphasizing how records are related and how, when put together, they tell a surprising, informative, and important story.

WEBSITE AND VISUAL EXPLORATIONS: "DIGITAL VAULTS"

· SECOND STORY INTERACTIVE STUDIOS FOR THE NATIONAL ARCHIVES EXPERIENCE, "DIGITAL VAULTS," WASHINGTON, DC
· CLIENT: FOUNDATION FOR THE NATIONAL ARCHIVES

Digital Vaults embraces "Web 2.0" technology in a way that has already garnered attention. Archivist of the United States Allen Weinstein said, "The National Archives Public Vaults exhibit in Washington allows visitors to interact with some of our vast holdings. The Digital Vaults takes this interactivity a step further on the Internet. It gives visitors the ability to choose what historical subjects they wish to explore so they can browse records in an entirely new way. Through this website, online visitors of all ages can enjoy exploring the Digital Vaults and learning about the essential holdings of the National Archives.

The online visitor to Digital Vaults decides what subjects to explore, from the atomic bomb to prohibition, from World War II to suffrage rights. The website displays records and their relationship to the chosen subject and to other records. The visitor is free to follow pathways between records and explore where the free association leads.
—http://www.archives.gov/press/press-releases/2008/nr08-108.html

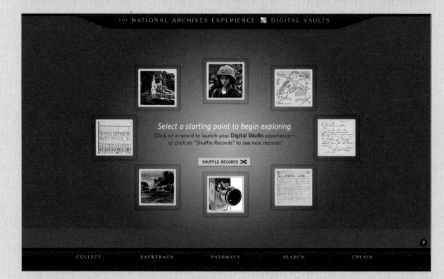
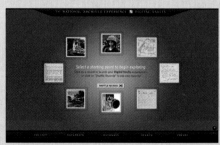
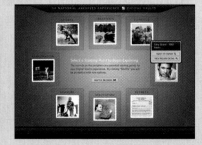

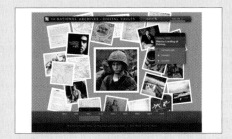
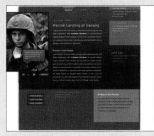
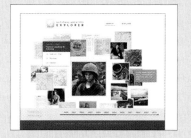

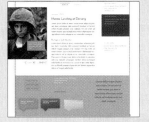

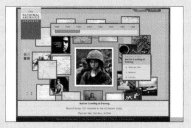

Visual Explorations:
The visual explorations represented options for the site's look and feel. The hope was that the different approaches taken would spark conversations on colors, fonts, and interface elements that would result in a defined visual approach for the site.
—Second Story Interactive Studios

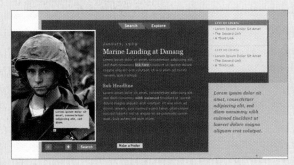
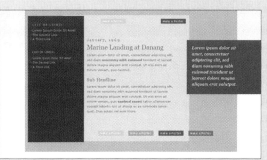

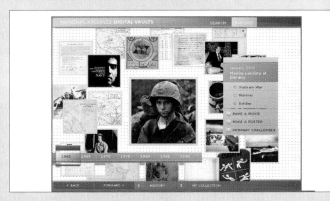
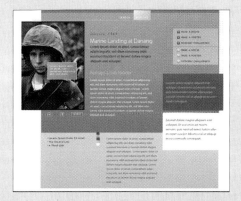

CASE STUDY

NOKIA URBANISTA DIARIES/R/GA

NOKIA URBANISTA DIARIES

NOKIA CLIENT SUPERVISORS

- E-MARKETING DIRECTOR: ARTO JOENSUU
- SENIOR E-MARKETING MANAGER: JUUSO MYLLYRINNE
- E-MARKETING MANAGER: NINA VENÄLÄINEN
- R/GA
- EXECUTIVE CREATIVE DIRECTOR: JAMES TEMPLE
- ASSOCIATE CREATIVE DIRECTOR: NATHALIE HUNI
- ART DIRECTOR: ATHILA ARMSTRONG
- VISUAL DESIGNER: ENNIO FRANCO
- INTERACTION DESIGNER: KATHRIN HOFFMANN
- COPYWRITER: NEIL STARR
- TECHNICAL DIRECTOR: DARREN RICHARDSON
- SENIOR FLASH DEVELOPER: NICOLAS LE PALLEC
- FLASH DEVELOPERS: TOMAS VOROBJOV, STUART LEES
- QUALITY ASSURANCE: NEIL DUGGAN
- GROUP ACCOUNT DIRECTOR: ANTHONY WICKHAM
- SENIOR PRODUCER: DYLAN CONNERTON

Urbanista Diaries is a digital platform that utilizes a website, a mobile application, and personal widgets to allow people to capture and share their lives in real-time through the Nokia N82. The powerful Nokia N82 is enabled with GPS-technology and a five-megapixel camera that allows users to tag each photo to a specific location and instantaneously share their experiences with anyone via widgets posted on blogs or social networking sites, like Facebook.

Urbanista Diaries was rolled out in an extensive three-phase campaign that engaged bloggers, journalists, and everyday people to take photos of their life adventures. For the first phase, four influential bloggers were sent across the globe with a Nokia N82 to record their journeys and share it with guests on the Urbanista Diaries site. For phase two, Nokia partnered with several top media sites such as Wallpaper, Lonely Planet, National Geographic, and CNN to document major world events in real time via journalists, artists, and scientists. People could follow the unfolding events both on the site and via widgets. Phase three opens up the experience to everyone with a GPS-enabled Nokia device. Now anyone can upload their personal photos from their journeys to the site or their personal widget for all their friends and family to track. Urbanista Diaries is another example of how Nokia is changing the way people share the stories of their lives.

The driving insight behind Urbanista Diaries was that merely informing people that the new Nokia N82 came equipped with a GPS and a five-megapixel camera was not enough to cut through a crowded market dominated by highly competitive communications. Instead, demonstrating the Nokia N82's capabilities and its benefits would provide a more compelling case.

—Nokia

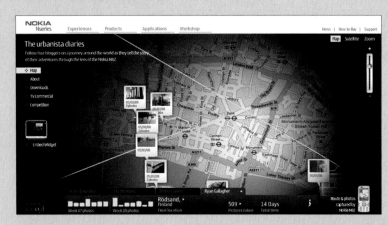

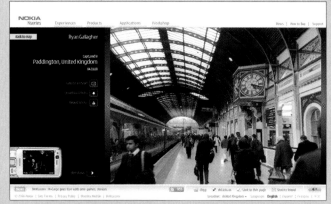

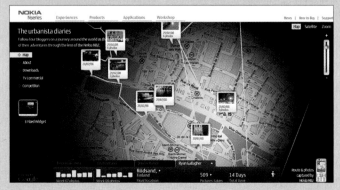

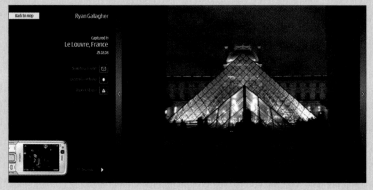

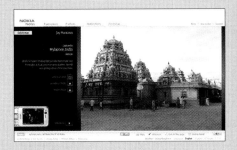

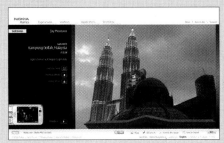

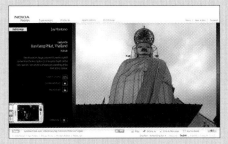

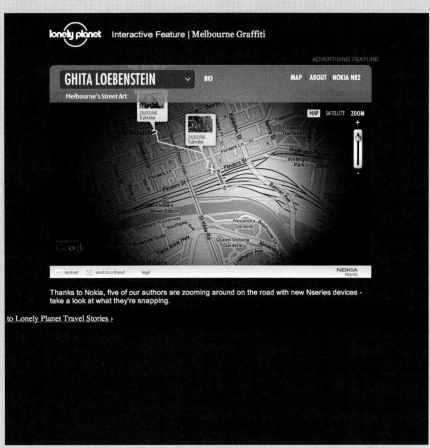

Thanks to Nokia, five of our authors are zooming around on the road with new Nseries devices – take a look at what they're snapping.

to Lonely Planet Travel Stories ›

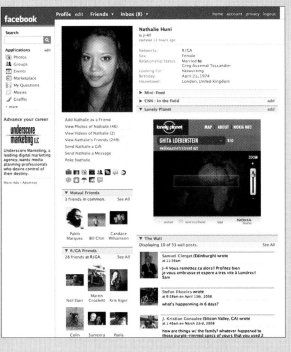

FIG. 14 / 20

**ANIMATED LOGO FOR FILM
COMPANY: MTV**

· NUMBER SEVENTEEN, NEW YORK
· ART DIRECTION: EMILY OBERMAN,
 BONNIE SIEGLER
· DESIGNER: KEIRA ALEXANDRA
· CLIENT: MTV PRODUCTIONS

*An astronaut planted the flag on the
moon to declare the start of music
television (MTV). So we decided
that MTV Productions (their film
company) should be represented by
the moon man leaving the moon to
search for new frontiers (film).*
 —Number Seventeen

FIG. 14 / 21

**TV OPENING SEQUENCE:
*SATURDAY NIGHT LIVE***

· NUMBER SEVENTEEN, NEW YORK
· ART DIRECTION: EMILY OBERMAN,
 BONNIE SIEGLER

*We represented the dynamic energy
of New York City at night using an
abstract animation of colored bars.*
 —Number Seventeen

of many strung together to create motion graphics. Frames are created but connected and used in multiples over time. A **temporal relationship** exists in screen-based media—the relationship or interplay between two separate events or images; this involves **chronology**—the order of events. A screen-based design solution is composed of a number of media items (events, frames, images, and sound), each of which has its own duration. These can be combined into a whole by specifying the temporal relationships among the different items. Temporal relationships also refer to the relationships among frames.

As in all graphic design, one must consider **spatial relationships**—the distance between the thing seen in relation to the viewer, how far/how close, and the shifts between near and far. Visuals or images can be seen from **close-up** (a shot that is zoomed in), a **medium shot** (seen from a medium distance), or a **long shot** (seen from far away). For example in Figure 14-20, an animated logo for MTV Productions, we see a variety of shots, starting with a long shot moving toward a close-up.

How a designer interposes different types of shots, each frame forming spatial relationships to the other, creates rhythm and contrast. **Rhythmic relationships** in screen-based media also can be created by the duration of each shot, and the same way one does in print, by the interaction of visuals, with contrast, and variation. For example, in Figure 14-21, the use of an abstract animation of colored bars creates rhythmic interplays between frames of this television opening sequence for *Saturday Night Live*.

VISUAL BASICS FOR SCREEN-BASED MEDIA

Thus far in this book we have learned that, when designing, one must consider all the formal elements and apply all principles of composition. What applies to print also applies to creating visual communications that move over a period of time. *Each "frame" must be considered, as well as how each frame flows into the next frame and the overall impact of the total frames as a group. Equally, each web page must be considered, as well as how each*

MOTION AESTHETICS—DEFINING TERMS

Motion aesthetics, planning, and basic production techniques are involved in any motion project. One must also become familiar with screen-based terms and take into account screen-based matters.

- **The Narrative/Storyline:** The process of telling a story or giving an account of something, including the chronology, the order in which things happen, with the inclusion of a beginning, middle, and end, though not necessarily in that order.

- **Sequence:** The particular order in which frames are arranged or connected; also, it is the order of actions or events in the narrative (linear or nonlinear); or a chunk of visual information, like an image sequence that transitions in and out.

- **Duration:** The period of time that the motion exists.

- **Pacing/Tempo:** The speed and/or rhythm at which the screen-based application unfolds and moves.

- **Montage:** The use of visuals composed by assembling, overlaying different visuals or materials collected from different sources.

page flows into the next page and the overall impact of the entire website. When considering the overall screen-based piece, the following elements are critical to create impact.

PROXIMITY
Grouping elements should enhance content and communication. All visual elements must seem related, but some visual elements will create groupings due to proximity. The negative space around each visual element and between visual elements reveals how they are related by meaning and function.

CONTRAST
Without contrast all visual elements would look the same, yielding monotony. Establishing contrast produces impact because it helps create distinction and visual diversity, and most importantly, makes a distinction among visual elements, helping set up the hierarchy of information in the screen-based application. As with any visual

FIG. **14** / **22**

**TV OPENING SEQUENCE: *WILL
& GRACE***

· NUMBER SEVENTEEN, NEW YORK
· ART DIRECTION: EMILY OBERMAN,
BONNIE SIEGLER

*The big type moving across the
screen represents Will and Grace
and how their lives overlap, and
the footage shows the characters'
personalities.*
—Number Seventeen

communications application, one must build clear levels of information on a page or in motion to help the viewer to glean information, enhancing readability and comprehension.

REPETITION AND ALIGNMENT

Repetition inculcates the audience. Just as a "hook" in music, that is, a repeated series of notes or phrase, works its way into the subconscious of the listener, so too does visual repetition in the viewer's mind. Beats and rhythms can be established as an underpinning with other information overlaid. Indeed, with motion graphics, percussive or musical beats can be combined with rhythmic animation to enhance the effect.

As in music, the viewer will recall alignment seen before. When the viewer sees an alignment held throughout or changed in a meaningful way, that creates a remembered master layout to anchor the piece in his or her mind. The motion design solutions may feel and appear more ordered.

USE OF TYPOGRAPHY
AND GRAPHICS IN
SCREEN-BASED MEDIA

Determine headings and subheadings in terms of color, size, and weight to distinguish the hierarchy of type from one another as well as from visuals. Letterforms or words may stand out by using weight for contrast. The interplay of positive and negative shape relationships will have enormous effect on establishing flow from one frame to another.

The conceptual interplay between type and visuals in print is much the same as in screen-based applications, except the bonus of motion adds potential for heightened dramatic or comedic effect. How type interfaces with visuals in screen-based media, as in print, can effectively communicate meaning, both literally and symbolically, as in Figure 14-22, the television opening sequence for *Will & Grace*.

Motion is an experience. It can also be part of an environmental encounter as in Figure 14-23, the 118-foot-long IAC Video Wall by Trollbäck + Company, which dominates the back wall of the lobby of the IAC headquarters in Manhattan designed by architect Frank Gehry. "It's an

FIG. **14** / **23**

IAC VIDEO WALL

· TROLLBÄCK + COMPANY, NEW YORK
· CREATIVE DIRECTORS: JAKOB TROLLBÄCK, JOE WRIGHT
· DESIGNERS: TOLGA YILDIZ, LLOYD ALVAREZ
· CLIENT: IAC

FIG. **14** / **24**

MEDIEVAL SEASON, BBC FOUR.
RKCR/TRANSISTOR/RED BEE
MEDIA

- RKCR/Y&R
- AGENCY CREATIVES: NICK SIMONS, JULES CHALKLEY
- AGENCY CREATIVE DIRECTOR: DAMON COLLINS
- PRODUCER: SARAH CADDY @ RED BEE MEDIA
- ANIMATION PRODUCTION COMPANY: STRANGE BEAST
- ANIMATION CREATIVE DIRECTOR: JAMES PRICE/TRANSISTOR STUDIOS
- ANIMATION DIRECTOR: JAMIE ROCKAWAY
- ANIMATION PRODUCERS: GABRIEL MARQUEZ, KAYT HALL
- POST PRODUCTION: THE MILL
- CLIENT: BBC FOUR MARKETING
- MUSIC: ORIGINAL "PURPLE HAZE" TRACK WAS COMPOSED BY JIMI HENDRIX. THE ORIGINAL SINGLE WAS RELEASED IN 1967 BY TRACK RECORDS UK (REF. TRACK 604001).

Our arrangement was done by Tam Nightingale of Nightingale Music Ltd., and recorded by four musicians, Jon Banks, Keith Piper, Sharon Lindo, and Lynda Sayce, with a total of twelve instruments on Monday 17th, Tuesday 18th, and Wednesday 19th March 2008. Music copyright is owned by BBC.
—Sarah Caddy @ Red Bee Media

Professor Robert Bartlett, one of the world's leading medievalists, is the host of this series investigating the medieval period.

installation piece that people see every day, so we wanted it to be inspiring and stimulating, an art installation rather than a loud billboard," said Jakob Trollbäck, founder of Trollbäck + Company, in *Contagious* Magazine. "It is an exciting and artistic visual experience that enhances understanding of how the company interfaces with our lives."[3]

MUSIC AND SOUND IN SCREEN-BASED MEDIA

We've all heard advertising jingles that stay with us, provoking endearment to brands or nostalgic feelings as we hum them. Audio provides a strong component in screen-based media, lending to audience enthusiasm and engagement and to making the piece memorable. For Figure 14-24, BBC's "Inside the Medieval Mind," an arrangement of Jimi Hendrix's "Purple Haze" plays a key role. "We animated to Jimi Hendrix's recording, then we changed the track out and did minor tweaking," explains Price. "It was good for us to animate to a music track because it really helps with timing. When you can marry two things together like sound and vision, it's a much stronger project. So it was really great to have the

opportunity to actually do that and then point to people and say, 'This is why we should have the music at the start.'"[4]

Random House Films appointed Hush Studios to create an animated identity for their new production company. The animation would play before all of their feature films and trailers in theaters as well as on future broadcast and DVD releases. Partnered with Focus Features, Random House is poised to become a major player in Hollywood. As a result, "they were looking to develop a visual signature as recognizable as the DreamWorks moon or the MGM lion," according to Hush.

"You want beveled and chromed 3D typography? Some klieg lights shining in your eyes? A monumental, orchestral sound track, perhaps? Nope, not this time," explains Hush. "Instead, we took Random House's brand—defined by the world of print publications—and catapulted it into the world of cinema for the launch of Random House Films. In the end, the piece moves us from the most intimate moments of a writer's initial conception—when the first letter is typed and the ink is dried—to an expansive cinematic world of light, color, and sound" (Figure 14-25).

FIG. **14** / **25**

ANIMATED IDENTITY: RANDOM HOUSE FILMS

- HUSH STUDIOS, NY
- CREATIVE DIRECTORS: ERIK KARASYK, DAVID SCHWARZ
- DESIGNERS: JONATHAN CANNON, DOUG LEE, DAVID SCHWARZ, ERIK KARASYK
- ANIMATOR/COMPOSITOR: JONATHAN CANNON
- 3D: ERIK KARASYK
- SOUND DESIGNER: JASON TRAMMELL.
- SOUND MIX: TONY VOLANTE, SOUNDLOUNGE
- CLIENT: RANDOM HOUSE FILMS
- RANDOM HOUSE: PETER GETHERS, VALERIE CATES, CLAUDIA HERR, SHILPA NADHAN
- FOCUS FEATURES: JEB COLEMAN

Sound plays in very subtly, yet is completely synergistic with the motion.

ESsay

N.L

NICK LAW, EVP, CHIEF CREATIVE
OFFICER, NORTH AMERICA, R/GA

*Nick Law joined R/GA with a
breadth of experience spanning
many disciplines and continents. He
has overseen creative executions
at the most senior levels on print,
advertising, branding, packaging,
and interactive design projects,
and is responsible for defining and
delivering creative projects for design
engagements, especially focusing on
new business initiatives and R/GA
marketing efforts. Prior to joining
R/GA, Nick was creative director at
FGI; a senior designer at Deifenbach
Elkins (now FutureBrand) in New
York; a senior designer for DMB&B
(D'Arcy Masius Benton & Bowles) in
London; and the founder and owner
of Studio Dot, an Australian-based
creative firm. Nick began his career at
Pentagram in London. He has earned
many international awards and has
been published in the United States,
Australia, and Great Britain.*

*Whatever your
design aptitude,
your willingness
to collaborate
is central to
becoming a
successful
interactive
designer.*

There is a quaint belief among the design community that design is an international language. As anyone who is mystified by the Beijing Opera or thrash metal music can testify, it is a claim not even music can make. Design is many languages. With the disintegration of the mass market, these languages are multiplying to reach ever more specific audiences. Propelling this fragmentation is the Web—a channel that connects and atomizes the world simultaneously. For those of us in visual professions, the Web has become a dynamic, democratic, and idiosyncratic design bazaar.

Thanks to its ever-broadening band, the Web has also become a medium where film, music, art, culture, and commerce meet. It is the only channel where all the creative disciplines come together to entertain, inform, and transact—all at once, all the time, everywhere, and for everyone. Art directors, designers, typographers, photographers, animators, filmmakers, and information architects all contribute and collaborate. Embracing the breadth and depth of the interactive canvas is the first step to designing for the Web.

It's easy to forget that this new interactive medium is so young. During the first years of the Internet, everything (including its impoverished aesthetic) was shaped by bold young techno fetishists. Only recently have well-rounded designers stepped forward to push pixels. For those trained in disciplines like advertising, identity, and print design, the hardest part of designing a website is dealing with its additive process. For designers who have been trained to subtract elements and distill meaning, this can be counterintuitive. While the success of an ad, logo, or billboard is judged by its ability to convey a simple powerful idea, the value of a website is often based on its ability to provide multiple experiences—not only to attract, but also to remain attractive. In most cases, designing a website is an ongoing process of bringing clarity and appeal to this depth and complexity.

Any medium can be hamstrung by trite design doctrines, but to impose such a thing on interactive [media] is a tragic denial of its kaleidoscopic nature. That's not to say there aren't budding design principles and standards emerging from the chaos. Designing for the Web often requires using standard conventions such as left-hand navigation, search boxes, and underlined links. The trick is to do so without sacrificing a dramatic branded experience; slavish adherence to standards does not make a Nike site Nike.

Most of us in the graphic design profession are accustomed to dividing our colleagues into stylists and conceptualists. While these sensibilities are found in visual designers on the Web, there is an even more profound division between what we at R/GA call systematic designers and experiential designers.

A systematic designer's strength is in making information-rich websites coherent. Using the classic design elements of color, shape, and composition, together with typographic and iconic systems, they create a sensible hierarchy of entry points into a page. They emphasize and enhance the information architect's functional intent. At a time when more and more people are using the Web as not only a source of information, but also of entertainment, there is a great need for experiential designers—designers who understand how to weave multiple narratives and bring drama to interaction.

Whatever your design aptitude, your willingness to collaborate is central to becoming a successful interactive designer. In the interactive medium—just as the name suggests—there are no solitary practitioners.

—Nick Law

EXERCISE 14-1

OPENING TITLES

Design opening titles for either a film or a television program that combine typography and visuals with an emphasis on polar contrasts (see Chapter 6 on Johannes Itten's "polar contrasts").

Storyboard your opening sequence in five frames. The skills utilized in this exercise prepare one for dealing with motion and also communicating the intent of an animation or video.

PROJECT 14-1

DEVELOPING A MICROSITE

Step 1

a. Select an existing brand or organization or a state or city tourist board.

b. Develop a concept for a microsite. For example, if you select a chocolate brand, the microsite could focus on the health benefits of consuming dark chocolate. If you select a child advocacy organization, the microsite could be about recognizing signs of abuse. If you select tourism, the microsite could be about the history of the city or state.

c. Write a title or headline for the microsite.

Step 2

a. Create or collect visuals to support your theme. Experiment with methods of visualization.

b. Visualize typeface and image relationships.

Step 3

a. Compose a home or landing page.

b. Compose a second page.

Go to our website **GD/6** for *many* more Exercises and Projects, and presentation guidelines, as well as other study resources including the chapter summary.

NOTES

1. Daniel Stein. "The Digital Rules of Engagement," *Adweek*, May 5, 2008. http://www.adweek.com/aw/content_display/community/columns/other-columns/e3i26f1bfd408799a2069ad1546ccdefb3f.

2. National Archives. "You Are One Click Away from a Great Online Field Trip!" Press Release, May 27, 2008. National Archives: Washington, DC. http://www.archives.gov/press/press-releases/2008/nr08-108.html.

3. "Window Shopping," *Contagious*, September 14, 2007. http://www.contagiousmagazine.com/News%20Article.aspx?REF=606&IsArchive=false.

4. Christine Clark. "'Scuse Me While I Kiss the Sky: Hendrix Goes Medieval on BBC Four," Boardsmag.com, June 1, 2008. http://www.boardsmag.com/articles/magazine/20080601/hendrixbbc.html.

Glossary

abstraction: a simple or complex rearrangement, alteration, or distortion of the representation of natural appearance, used for stylistic distinction and/or communication purposes.

additive colors: digital colors seen in screen-based media; also known as mixtures of light.

advertisement (ad): a specific message constructed to inform, persuade, promote, provoke, or motivate people on behalf of a brand or group.

advertising: the generation and creation of specific visual and verbal messages constructed to inform, persuade, promote, provoke, or motivate people on behalf of a brand or group.

advertising campaign: series of coordinated ads—in one or more media—that are based on a single, overarching strategy or theme, and each individual ad in the campaign can stand on its own.

advertising idea: the creative conceptual solution to an advertising problem—a strategic formulated thought that communicates a message, calling people to action.

alignment: the positioning of visual elements relative to one another so that their edges or axes line up.

analysis phase in the design process: examining all information unearthed in the orientation phase to best understand, assess, strategize, and move forward with the assignment.

art director: the creative professional in an advertising agency responsible for ideation, art direction (overall look and feel, visual style, selection of photographer or illustrator), and design.

asymmetry: an equal distribution of visual weights achieved through weight and counterweight, by balancing one element with the weight of a counterpointing element, *without mirroring* elements on either side of a central axis.

attribute listing: a method for analyzing and separating data through observing and identifying various qualities that might have otherwise been overlooked; it is a diagrammed list of attributes.

audience: any individual or group on the receiving end of a graphic design or advertising solution; the target audience is a specific targeted group of people.

balance: stability or equilibrium created by an even distribution of visual weight on each side of a central axis, as well as by an even distribution of weight among all the elements of the composition.

baseline: defines the bottom of capital letters and of lowercase letters, excluding descenders.

bleed or **full bleed:** a printing term referring to type or a visual that extends off the edges of the page, filling the page with an image.

body copy: narrative text that further explains, supplements, and supports the main advertising concept and message; type that is 14 points and less is used for setting text, also called **text type**.

borders: a graphic band that runs along the edge of an image, acting to separate the image from the background, like a frame, by something as simple as a thin rule or as ornate as a Baroque frame.

brand: the sum total of all functional (tangible) and emotional (intangible) assets that differentiate it among the competition.

brand architecture: the structuring of brands within the company's offerings (product portfolio).

brand name: the main verbal differentiator for a product, service, or group.

brand strategy: the core tactical underpinning of branding, uniting all planning for every visual and verbal application.

branding: the entire development process of creating a brand, brand name, and visual identity, among other applications.

broadside: a large sheet of paper, typically printed on one side, used to communicate information; also called *broadsheet*.

calligraphy: letters drawn by hand, the strokes made with a drawing instrument—literally, "beautiful writing."

capitals: the larger set of letters, also called **uppercase**.

cause advertising: sponsored by corporations, used to raise funds for nonprofit organizations, and run in paid media.

character: a letterform, number, punctuation mark, or any single unit in a font.

chart: a specific type of diagrammatic representation of facts or data.

chronology: the order of events.

chunking: related to modularity in graphic design, content is split or information is grouped into chunks by combining units or capsules of content or information into a limited number of units or chunks.

closed: a composition where the internal elements echo a page's edges to a great extent *and* the viewer's focus is kept tightly within the format.

closure: the mind's tendency to connect individual elements to produce a completed form, unit, or pattern.

collage: a visual created by cutting and pasting bits or pieces of paper, photographs, cloth, or any material to a two-dimensional surface, which can be combined with handmade visuals and colors.

column intervals: spaces between columns.

columns: vertical alignments or arrangements used to accommodate text and images.

combination mark: a logo that is a combination of words and symbols.

commercial advertising: promotes brands and commodities by informing consumers; it is also used to promote individuals, such as political candidates, and groups, including corporations and manufacturers.

common fate: elements are likely to be perceived as a unit if they move in the same direction.

comp or **comprehensive:** a detailed representation of a design concept thoughtfully visualized and composed.

composition: the form, the *whole spatial property and structure* resulting from the intentional visualization and arrangement of graphic elements—type and visuals—in relation to one another and to the format, meant to visually communicate and to be compelling and expressive.

construct: a quality or position a brand "owns" against the composition.

containment: separate elements are most easily perceived as a unit when placed in an enclosed area.

content: the body of information that is available to visitors on a website.

continuing line: lines are always perceived as following the simplest path. If two lines break, the viewer perceives the overall movement rather than the break; also called *implied line.*

continuity in Laws of Perceptual Organization: perceived visual paths or connections (actual or implied) among parts; elements that appear to be a continuation of previous elements are perceived as linked, creating an impression of movement.

continuity: the handling of design elements, like line, shape, texture, and color, to create similarities of form; it is used to create family resemblance.

copywriter: the creative professional in an advertising agency responsible for ideation and writing.

corporate communication design: involves any visual communication applications to communicate internally with employees, create materials for a sales force or other

employees, as well as applications used by a corporation or organization to communicate externally with other businesses, the public, stockholders, and customers.

correspondence: a visual connection established when an element, such as color, direction, value, shape or texture, is repeated, or when style is utilized as a method of connecting visual elements, for example, a linear style.

counter: the space enclosed by the strokes of a letter.

counterform: includes counters, the shapes defined within the forms, as well as the negative forms created *between* adjacent letterforms.

craftsmanship: the level of skill, proficiency, adeptness, and/or dexterity of the execution.

creative brief: a written document outlining and strategizing a design project; also called a **design brief.**

creative director: the top-level creative professional in an advertising agency (or design studio) with ultimate creative control over art direction and copy; usually the supervisor of the creative team who makes the final decisions about the idea, creative approach, art direction, and copywriting before the work is presented to the client.

creative team: in an advertising agency, a conventional creative team includes an art director and a copywriter. Unconventional creative teams may include an account manager, IT expert, interactive designer (if appropriate), and a marketing expert.

critique: an assessment or evaluation of work.

cropping: the act of cutting a visual, a photograph, or illustration in order to use only part of it.

demographic: selected population characteristics.

design brief: a written document outlining and strategizing a design project; also called a **creative brief**.

design concept: the creative thinking underpinning the design solution. The concept is expressed through the integration and manipulation of visual and verbal elements.

diagram: a graphic representation of information, statistical data, a structure, environment, or process (the workings of something).

diffusion: characterized by blurred forms and boundaries, transparencies, muted color palettes, layering, open compositions, and painterliness.

display type: type that is used primarily for headlines and titles and more difficult to read as text type.

economy: stripping down visuals to fundamental forms, using as little description and few details as possible for denotation.

editorial design: involves the design of editorial content; also called **publication design**.

emotional benefit: an asset based on feelings and responses, not on a functional characteristic of a product or service.

emphasis: the arrangement of visual elements, stressing or giving importance to some visual elements, thereby allowing two actions: information to be easily gleaned and the graphic design to be easily received.

environmental design: promotion, information, or identity design in constructed or natural environments, defining and marking interior and exterior commercial, cultural, residential, and natural environments.

equivocal space: when interchangeable shapes (such as a checkerboard pattern) or an ambiguous figure/ground relationship is created making the background and foreground difficult to distinguish; similar to figure/ground reversal.

execution: the fulfillment of the concept through physical processes that include the selection and manipulation of materials and/or software.

expressionistic: a visualization characterized by a highly stylized or subjective interpretation, with an emphasis on the psychological or spiritual meaning; there is no strict adherence to things as they appear in nature, as opposed to naturalism.

figure: a definite shape; also called a *positive shape*.

figure/ground: a basic principle of visual perception that refers to the relationship of shapes, of figure to ground, on a two-dimensional surface: also called **positive and negative** space.

flow: elements arranged in a design so that the viewer's eyes are led from one element to another, through the design; also called *movement*.

flowlines: horizontal alignments in a grid that aid visual flow.

focal point: the part of a design that is most emphasized.

formal elements: fundamental elements of two-dimensional design: line, shape, color, value, and texture.

format: the defined perimeter as well as the field it encloses—the outer edges or boundaries of a design; in actuality, it is the field or substrate (piece of paper, mobile phone screen, outdoor board, etc.) for the graphic design.

fractured space: multiple viewpoints seen simultaneously, as in Cubist style of fine art.

frame: single static image, one of many composed together to create motion graphics; the illusion of motion is created when we see a series of frames in rapid succession.

functional benefit: the practical or useful characteristic of a product or service that aids in distinguishing a brand from its competition.

gothic: typefaces based upon the thirteenth to fifteenth century medieval manuscript letterform; also called *blackletter*.

graph: a specific type of diagram used to indicate relationships between two (or more) variables, often represented on vertical and horizontal axes.

graphic design: a form of visual communication used to convey a message or information to an audience; a visual representation of an idea relying on the creation, selection, and organization of visual elements.

graphic design solution: a design that can persuade, inform, identify, motivate, enhance, organize, brand, rouse, locate, engage, and carry or convey many levels of meaning.

graphic interpretation: an elemental visualization of an object or subject, almost resembling a sign, pictogram, or symbol in its reductive representation.

graphic standards manual: guidelines for how the logo (and/or visual identity) is to be applied to numerous applications, from business cards to point-of-purchase materials to vehicles to websites; also called an **identity standards manual**.

grid: a guide—a modular compositional structure made up of verticals and horizontals that divide a format into columns and margins. It may be used for single-page formats or multipage formats.

ground: shapes or areas created between and among figures; also called *negative space*.

grouping: perceiving visual units by location, orientation, likeness, shape, and color.

gutter: the blank space formed by the inner margins of two facing pages in a publication.

harmony: agreement within a composition, where elements are constructed, arranged, and function in relation to one another to an agreeable effect.

headline: the main verbal message in an advertisement (although it literally refers to the main line of copy that appears at the head of the page); also called the **line**.

high contrast: a wide range of values.

home page: the primary entrance to a website that contains the central navigation system.

hue: the name of a color; that is, red or green, blue or yellow.

icon: a generally accepted (pictorial or symbolic) visual to represent objects, actions, and concepts; an icon resembles the thing it represents or at minimum shares a quality with it—it can be a photograph, a pictorial representation, an elemental visual (think magnifying glass desktop icon), or arbitrary (think radioactive sign), or symbolic (think lightning bolt to represent electricity).

identity design: involves the creation of a systematic visual and verbal program intended to establish a consistent visual appearance and personality—a coordinated overarching identity—for a brand or group; also called *brand identity*.

identity standards manual: guidelines for how the logo (and/or visual identity) is to be applied to numerous applications, from business cards to point-of-purchase materials to vehicles to websites; also called a **graphic standards manual**.

illusion of spatial depth: the appearance of three-dimensional space on a two-dimensional surface.

illustration: a visual rendering that accompanies or complements printed, digital, or spoken text to clarify, enhance, illuminate, or demonstrate the message of the text.

index: a visual that directs the attention of the interpreter (viewer), without describing or resembling the thing signified, due to its neighboring relationship to it.

information architecture: the careful organization of website content into hierarchical (or sequential) order.

information design: a highly specialized area of design that involves making large amounts of complex information clear and accessible to audiences.

integrated branding program: a comprehensive, strategic, unified, integrated, and unique program for a brand, with an eye and mind toward how people experience—interact and use—the brand or group.

interactive: graphic design and advertising for screen-based media; also called *experience design*.

intricacy: based on complexity, on the use of many component parts and/or details to describe and visually communicate.

kerning: adjustment of the letterspacing.

layout: the visual organization of type and visuals on a printed or digital page; also called *spatial arrangement*.

leading: in metal type, strips of lead of varying thickness (measured in points) used to increase the space between lines of type; also known as **line spacing**.

letterform: the particular style and form of each individual letter of an alphabet.

lettering: the drawing of letterforms by hand (as opposed to type generated on a computer).

lettermark: a logo created using the initials of the brand or group name.

letterspacing: spatial interval between letters.

light and shadow: employed to describe form; most closely simulates how we perceive forms in nature.

line: an elongated point, considered the path of a moving point; it also is a mark made by a visualizing tool as it is drawn across a surface.

line spacing or **leading**: spatial interval between two lines of type.

line type: (line attributes) refers to the way a line moves from its beginning to its end.

linear: line as the predominant element used to unify a composition or to describe shapes or forms in a design.

link: on a web page, a connection from one location to another location, or from one website to another website; also called *hyperlink*.

logo: a unique identifying symbol that represents and embodies everything a brand

or group signifies. It provides immediate recognition; also called a *brandmark*, *mark*, *identifier*, **logotype**, or *trademark*.

logotype: a logo that is an identifying mark where the name is spelled out in unique typography; also called **wordmark**.

low contrast: a narrow range of values.

lowercase: the smaller set of letters. The name is derived from the days of metal typesetting when these letters were stored in the lower case.

map: a specific type of diagrammatical representation used to depict a route or geographical area—to show location.

margins: the blank space on the left, right, top, or bottom edge of any printed or digital page.

mind map: a visual representation, diagram, or presentation of the various ways words, terms, images, thoughts, or ideas can be related to one another.

mini-portfolio: a bound collection of copies of work, including anywhere from three to all of the pieces in the portfolio. It can be to size or at a reduced size.

mixed media: a visual resulting from the use of different media, for example, photography combined with illustration.

mock-up: a facsimile of a printed three-dimensional design piece; also called a *dummy*.

modern typeface: serif typeface, developed in the late eighteenth and early nineteenth centuries, whose form is more geometric in construction, as opposed to the Old Style typefaces, which stayed close to forms created by the chisel-edged pen.

modularity: a structural principle used to manage content using modules.

module: any single fixed element within a bigger system or structure, for example, a unit on graph paper, a pixel in a digital image, a rectangular unit in a grid system, or a fixed encapsulated chunk of a composition.

motion aesthetics: the process and consideration of how form creates impact over time in a design.

motion graphics: time-based visual communication that integrates visuals, typography, and audio; created using film, video, and computer software; including animation, television commercials, film titles, promotional, and informational applications for broadcast media and new media.

naturalistic: a visual created by full-color or tone using light and shadow that attempts to replicate an object or subject as it is perceived in nature; also called *realistic*.

navigation system: the visual design of information architecture on a website.

nonobjective: a purely invented visual, not derived from anything visually perceived; it does not relate to any object in nature and does not literally represent a person, place, or thing; also called *nonrepresentational*.

notation: a linear, reductive visual that captures the essence of its subject, characterized by its minimalism.

objectives statement: a clear, succinct description of design objectives, which summarizes the key messages that will be expressed in the design; for example, facts or information, desired personality or image, and position in the market.

Old Style: Roman typeface, introduced in the late fifteenth century, most directly descended in form from letters drawn with a broad-edged pen.

opaque: dense, solid seeming, not see-through.

open: a composition where the major movements within the composition oppose the edges (think diagonals) or direct our eyes past the boundaries of the format.

orientation phase in the design process: the process of becoming familiar with an assignment, the graphic design problem, and the client's business or organization, product, service, or group.

package design: the complete strategic planning and designing of the form, structure, and appearance of a product's package, which functions as casing, promotes a brand, presents information, and becomes a brand experience.

parity products: products that are equivalent in value.

pattern: a consistent repetition of a single visual unit or element within a given area.

perspective: a schematic way of translating three-dimensional space onto the two-dimensional surface. This is based on the idea that diagonals moving toward a point on the horizon, called the vanishing point, will imitate the recession of space into the distance and create the **illusion of spatial depth**.

photography: a visual created using a camera to capture or record an image.

photomontage: a composite visual made up of a number of photographs or parts of photographs to form a unique image.

pictograph: an elemental, universal picture denoting an object, activity, place, or person, captured through shape; for example,

the images denoting gender on bathroom doors.

picture plane: the blank, flat surface of a page.

plane: a two-dimensional surface bound by lines that defines the outside of a form; it has length and breadth, position and direction, but no thickness.

point: the smallest unit of a line and one that is usually recognized as being circular; also called a *dot*.

portfolio: a body of work used by the visual communication profession as the measure of one's professional ability.

positive and negative: a basic principle of visual perception and refers to the relationship of shapes, of figure to ground, on a two-dimensional surface; also called **figure/ground**.

poster: a two-dimensional, single-page format used to inform (display information, data, schedules, or offerings) and to persuade (promote people, causes, places, events, products, companies, services, groups, or organizations).

presentation: the manner in which comps are presented to a client or in a portfolio.

problem-finding: the process of sketching or making marks that allows visual thinking, allows for discovery, for staying open to possibilities during the visual-making process; also called *problem-seeking*.

production: usually defined as preparing the electronic file, collecting and scanning all needed photographs and/or illustrations, then proofreading (with or without the client) and working with the printer.

promotional design: intended to introduce, promote, or sell brands (products and services), ideas, or events and to introduce or promote groups, not-for-profit organizations, and social causes.

proportion: the comparative size relationships of parts to one another and to the whole.

proximity: elements near each other, in spatial proximity, are perceived as belonging together.

public service advertising (PSA): advertising that serves the public interest.

publication design: involves the design of editorial content for print or screen; also called **editorial design** and **book design**.

reflected color: colors that can be seen on the surfaces or objects in the environment; also known as *reflected light* or *subtractive color*.

repetition: occurs when one or a few visual elements are repeated a number times or with great or total consistency.

rhythm: a pattern that is created by repeating or varying elements, with consideration to the space between them, and by establishing a sense of movement from one element to another.

rhythmic relationships: can be created in screen-based media by the duration of each shot, and in print or screen-based media by the interaction of visuals with contrast and variation.

roughs: sketches that are larger and more refined than thumbnail sketches and show the basic elements in a design.

rules: thin stripe(s) or line(s) used for borders or for separating text, columns of text, or visuals.

sans serif: typefaces characterized by the absence of serifs.

saturation: the brightness or dullness of a color; also called *intensity* or *chroma*.

scale: the size of an element or form seen in relation to other elements or forms within the format.

script: typeface that most resembles handwriting. Letters usually slant and often are joined.

semiotics: the theory of signs and symbols that deals with their constructed function and meaning.

serifs: the ending strokes of characters.

shape: the general outline of something.

sharpness: characterized by clarity of form, detail, clean and clear edges and boundaries, saturated color, readable and legible typography, proximate vision, hyperrealism, photorealism, closed compositions, and limited type alignment.

sign: a visual mark or a part of language that denotes another thing.

sign-off: includes the brand's or group's logo, a photograph or illustration of the brand, or both.

silhouette: the articulated shape of an object or subject taking its specificity into account (as opposed to the universal visual language of a pictograph).

similarity: like elements—those that share characteristics—perceived as belonging together. Elements can share likeness in shape, texture, color, and direction. Dissimilar elements tend to separate from like elements.

slab serif: serif typeface characterized by heavy, slab-like serifs.

spatial relationships: the distance between the thing seen in relation to the viewer, how far/how close, and the shifts between near and far.

spatial zones: formed by grouping several grid modules, in order to organize the placement of various graphic components.

splash page: the first screen a visitor sees on a website; it serves as an introduction to the site, and usually features animation or an engaging visual.

storyboard: illustrates and narrates key frames of the television advertising concept.

strategy: the core tactical underpinning of any visual communication, unifying all planning for every visual and verbal application within a program of applications.

style: the quality that makes something distinctive.

symbol: a visual having an arbitrary or conventional relationship between the signifier and the thing signified.

symbol mark: a logo that is an abstract or non-representational visual or a pictorial visual.

symmetry: mirroring of equivalent elements, an equal distribution of visual weights, on either side of a central axis; also called *reflection symmetry*.

tactile texture: a quality that can be physically touched and felt; also called *actual texture*.

tagline: catchphrase that conveys the brand benefit or spirit and generally acts as an umbrella theme or strategy for a campaign or a series of campaigns; also called a *claim*, *endline*, *strap line*, or *slogan*.

temperature: the perception of a hue as warm or cool.

template: a compositional structure with designated positions for the visual elements.

temporal relationship: in screen-based media, the relationship or interplay between two separate events or images.

text type: type that is 14 points and less is used for setting text; also called **body copy**.

texture: the tactile quality of a surface or the representation of such a surface quality.

thumbnail sketches: preliminary, small, quick, unrefined drawings of ideas, in black and white or color.

transparent: see-through from one image to another, from one letterform to another, from one texture to another.

transitional: a serif typeface, originating in the eighteenth century, that represents a transition from Old Style to Modern, exhibiting design characteristics of both.

trompe l'oeil: literally, "to fool the eye"; a visual effect on a two-dimensional surface where the viewer is in doubt as to whether the object depicted is real or a representation.

type alignment: the style or arrangement of setting text type.

type design and lettering: a highly specialized area of graphic design focusing on the creation and design of fonts, type treatments, and the drawing of letterforms by hand (as opposed to type generated on a computer).

type family: several font designs contributing a range of style variations based upon a single typeface design.

type font: a complete set of letterforms, numerals, and signs, in a particular face, size, and style, that is required for written communication.

type style: the modifications in a typeface that create design variety while retaining the essential visual character of the face. These include variations in weight (light, medium, bold), width (condensed, regular, extended), and angle (Roman or upright, and italic), as well as elaborations on the basic form (outline, shaded, decorated).

typeface: the design of a single set of letterforms, numerals, and signs unified by consistent visual properties. These properties create the essential character, which remains recognizable even if the face is modified by design.

typographic color: the overall density or tonal quality of a mass of type on a field— page or screen—usually referring to the mass of text type; also called *typographic texture.*

typographic design: a highly specialized area of graphic design focusing on the creation and design of letterforms, typefaces, and type treatments.

typography: the design and arrangement of letterforms in two-dimensional space (for print and screen-based media) and in space and time (for motion and interactive media).

unconventional advertising: advertising that "ambushes" the viewer; often it appears or is placed in unpaid media in the public environment—places and surfaces where advertising doesn't belong, such as the sidewalk or on wooden construction site walls; also called *guerrilla advertising*, *stealth marketing*, and *nontraditional marketing*.

unity: when all the graphic elements in a design are so interrelated that they form a

greater whole; all the graphic elements look as though they belong together.

uppercase: the larger set of letters, also called **capitals**. The name is derived from the days of metal typesetting when these letters were stored in the upper case.

value: refers to the level of luminosity—lightness or darkness—of a color.

value contrast: the relationship of one element (part or detail) to another, in respect to lightness and darkness.

variation: established by a break or modification in the pattern or by changing elements, such as the color, size, shape, spacing, position, and visual weight.

viral marketing: the use of a self-perpetuation mechanism, such as a website, to grow a user base in a manner similar to the spread of a virus; it also means a marketing phenomenon that facilitates and encourages people to pass along a marketing message.

visual: a broad term encompassing many kinds of representational, abstract, or non-objective depictions—photographs, illustrations, drawings, paintings, prints, graphic elements and marks, elemental images such as pictograms, signs, or symbols; also called *images*.

visual hierarchy: arranging graphic elements according to emphasis.

visual identity: the visual and verbal articulation of a brand or group, including all pertinent design applications, such as letterhead, business cards, and packaging, among many other possible applications; also called *brand identity* and *corporate identity*.

visual texture: the illusion of texture or the impression of texture created with line, value, and/or color.

visual weight: the illusion of physical weight on a two-dimensional surface.

volume: the representation of mass on a two-dimensional surface.

wayfinding system: visual system that incorporates signs, pictograms, and symbols to assist and guide visitors and tourists to find what they are looking for in museums, airports, zoos, and city centers.

webisode: in advertising, a short audio or video presentation on the web, used to promote a brand or group, preview music, and present any type of information.

word spacing: the space between words.

wordmark: a logo that is the name spelled out in unique typography or lettering; also called **logotype**.

x-height: the height of a lowercase letter, excluding ascenders and descenders.

Selected Bibliography

Advertising

Aitchison, Jim. *Cutting Edge Advertising II.* Singapore: Prentice Hall, 2003.

Berger, Warren. *Advertising Today.* New York: Phaidon Press, 2001.

Goodrum, Charles, and Helen Dalrymple. *Advertising in America.* New York: Harry N. Abrams, 1990.

Landa, Robin. *Advertising by Design, 2e.* Hoboken: John Wiley & Sons, 2010.

McDonough, John, and Karen Egolf, eds. *The Advertising Age Encyclopedia of Advertising.* 3 vols. New York: Fitzroy Dearborn, 2003.

Ogilvy, David. *Ogilvy on Advertising.* New York: Vintage, 1985.

Pincas, Stéphane, and Marc Loiseau. *A History of Advertising.* Köln: Taschen, 2008.

Robbs, Brett, and Deborah Morrison. *Idea Industry: How to Crack the Advertising Career Code.* Beverly, MA: Rockport Publishing, 2008.

Young, James. *A Technique for Producing Ideas.* Advertising Age Classics Library. New York: McGraw Hill, 2003.

Branding

Atkin, Douglas. *The Culting of Brands: When Customers Become True Believers.* New York: Penguin Group, 2004.

Duffy, Joe. *Brand Apart.* New York: One Club Publishing, 2005.

Fisher, Jeff. *Identity Crisis: 50 Redesigns That Transformed Stale Identities into Successful Brands.* Cincinnati: HOW Books, 2007.

Gobé, Marc. *Emotional Branding: The New Paradigm for Connecting Brands to People.* New York: Allworth Press, 2001.

Landa, Robin. *Designing Brand Experiences.* Stamford: Cengage Learning, 2006.

Neumeier, Marty. *The Brand Gap: How to Bridge the Distance Between Business Strategy and Design.* Berkeley: Peachpit Press, 2003.

———. *The Dictionary of Brand.* New York: AIGA Center for Brand Experience, 2004.

Roberts, Kevin. *Lovemarks: The Future Beyond Brands.* New York: PowerHouse Books, 2004.

Wheeler, Alina. *Designing Brand Identity: An Essential Guide for the Whole Branding Team.* 3rd ed. Hoboken: John Wiley & Sons, 2009.

Business of Graphic Design

Benun, Ilise, and Peleg Top. *The Designer's Guide to Marketing and Pricing.* Cincinnati: HOW Books, 2008.

Foote, Cameron. *The Creative Business Guide to Running a Graphic Design Business.* New York: W.W. Norton & Co., 2004.

Graphic Artists Guild. *Graphic Artists Guild Handbook: Pricing & Ethical Guidelines.* 12th ed. New York: Graphic Artists Guild, 2007.

Heller, Steven, and Teresa Fernandes. *Becoming a Graphic Designer: A Guide to Careers in Design.* Hoboken: John Wiley & Sons, 2005.

Color

Albers, Josef, and Nicolas Fox Weber. *Interaction of Color: Revised and Expanded Edition.* New Haven: Yale University Press, 2006.

Birren, Faber. *Principles of Color: A Review of Past Traditions and Modern Theories of Color Harmony.* Rev. ed. Atglen, PA: Schiffer Publishing, 1987.

Chevreul, M. E., and Faber Birren. *The Principles of Harmony and Contrast of Colors and Their Applications to the Arts.* Rev. ed. Atglen, PA: Schiffer Publishing, 1987.

Itten, Johannes. *The Art of Color: The Subjective Experience and Objective Rationale of Color.* New York: Van Nostrand Reinhold, 1974.

Munsell, Albert. *A Color Notation: An Illustrated System Defining All Colors and Their Relations 1941.* 9th ed. Whitefish, MT: Kessinger Publishing, 2004.

Composition

Elam, Kimberly. *Grid Systems: Principles of Organizing Type.* New York: Princeton Architectural Press, 2004.

Hurlburt, Allen. *The Grid: A Modular System for the Design and Production of Newspapers, Magazines, and Books.* New York: Van Nostrand Reinhold, 1978.

Landa, Robin, Rose Gonnella, and Steven Brower. *2D: Visual Basics for Designers.* Clifton Park, NY: Cengage Learning, 2007.

Müller-Brockmann, Josef. *Grid Systems in Graphic Design.* 3rd ed. Stuttgart: Verlag Gerd Hatje, 1988.

———. *A History of Graphic Communication.* Sulgen, Switzerland: Arthur Niggli, 1971.

Roberts, Lucienne, and Julia Shrift. *The Designer and the Grid.* East Sussex, UK: RotoVision, 2002.

Samara, Timothy. *Making and Breaking the Grid: A Graphic Design Layout Workshop.* Gloucester, MA: Rockport Publishers, 2002.

Composition and Design Principles

Arnheim, Rudolf. *Art and Visual Perception: A Psychology of the Creative Eye.* Berkeley: University of California Press, 2004.

Dondis, Donis A. *Primer of Visual Literacy.* Cambridge: MIT Press, 1973.

Hofmann, Armin. *Graphic Design Manual: Principles and Practice/Methodik Der Form—Und Bildgestaltung: Aufbau Synthese Anwendung/Manuel de Création Graphique: Forme Synthèse Application.* Sulgen, Switzerland: Arthur Niggli, 1965.

Kandinsky, Wassily. *Point, Line, and Plane.* 2nd ed. New York: Dover Publications, 1979.

Kepes, Gyorgy. *Language of Vision.* Chicago: Paul Theobald, 1961.

Lidwell, William, Kritina Holden, and Jill Butler. *Universal Principles of Design.* Beverly, MA: Rockport Publishers, 2003.

Wong, Wucius. *Principles of Form and Design.* Hoboken: John Wiley & Sons, 1993.

History

Crowley, David, and Jane Pavitt, eds. *Cold War Modern: Design 1945–1970.* London: Victoria & Albert Museum, 2008.

Drew, Ned, and Paul Sternberger. *By Its Cover: Modern American Book Cover Design.* New York: Princeton Architectural Press, 2005.

Drucker, Johanna, and Emily McVarish. *Graphic Design History: A Critical Guide.* Englewood Cliffs, NJ: Prentice Hall, 2008.

Eskilson, Stephen J. *Graphic Design: A New History.* New Haven: Yale University Press, 2007.

Fiell, Charlotte, and Peter Fiell. *Graphic Design for the 21st Century.* Köln: Taschen, 2003.

"Graphic Design and Advertising Timeline." *Communication Arts* 41, no. 1 (1999): 80–95.

Heller, Steven, and Seymour Chwast. *Graphic Style: From Victorian to Digital.* New York: Harry N. Abrams, 2001.

———. *Illustration: A Visual History.* New York: Harry N. Abrams, 2008.

Heller, Steven, and Mirko Ilić. *Icons of Graphic Design.* 2nd ed. London: Thames & Hudson, 2008.

Heller, Steven, and Elinor Pettit. *Graphic Design Time Line: A Century of Design Milestones.* New York: Allworth Press, 2000.

Hollis, Richard. *Graphic Design: A Concise History.* London: Thames & Hudson, 2001.

———. *Swiss Graphic Design: The Origins and Growth of an International Style, 1920–1965.* New Haven: Yale University Press, 2006.

Johnson, J. Stewart. *The Modern American Poster.* New York: The National Museum of Modern Art, Kyoto, and The Museum of Modern Art, New York, 1983.

Livingston, Alan, and Isabella Livingston. *Graphic Design and Designers.* New York: Thames & Hudson, 1992.

McDermott, Catherine. *Design Museum Book of 20th Century Design.* Woodstock, NY: Overlook Press, 1999.

Meggs, Philip B., and Alston W. Purvis. *Meggs' History of Graphic Design.* 4th ed. Hoboken: John Wiley & Sons, 2005.

Müller-Brockmann, Josef, and Shizuko Müller-Brockmann. *History of the Poster.* London: Phaidon Press, 2004.

Poynor, Rick. *No More Rules: Graphic Design and Postmodernism.* New Haven: Yale University Press, 2003.

Remington, Roger, and Barbara J. Hodik. *Nine Pioneers in American Graphic Design.* Cambridge: MIT Press, 1989.

Rothschild, Deborah, Ellen Lupton, and Darra Goldstein. *Graphic Design in the Mechanical Age: Selections from the Merrill C. Berman Collection.* New Haven: Yale University Press, 1999.

Vit, Armin, and Bryony Gomez-Palacio. *Women of Design: Influence and Inspiration from the Original Trailblazers to the New Groundbreakers.* Cincinnati: HOW Books, 2008.

———.*Graphic Design, Referenced: A Visual Guide to the Language, Applications, and History of Graphic Design.* Beverly, MA: Rockport Publishers, 2009.

Weill, Alain. *Graphic Design: A History.* New York: Harry N. Abrams, 2004.

Monographs

Chwast, Seymour. *The Push Pin Graphic: A Quarter Century of Innovative Design and Illustration.* San Francisco: Chronicle Books, 2004.

Glaser, Milton. *Milton Glaser: Graphic Design.* New York: Overlook Press, 2009.

Lukova, Luba. *Social Justice 2008, 12 Posters.* New York: Clay and Gold, 2008.

Rand, Paul. *Paul Rand: A Designer's Art.* New Haven: Yale University Press, 1985.

Sagmeister, Stefan. *Things I Have Learned in My Life So Far.* New York: Abrams, 2008.

Scher, Paula. *Make It Bigger.* New York: Princeton Architectural Press, 2002.

Strassburger, Michael, and Robynne Raye. *Modern Dog: 20 Years of Poster Art.* San Francisco: Chronicle Books, 2008.

Theory, Criticism, and Individual Points of View

Bierut, Michael. *79 Short Essays on Design.* New York: Princeton Architectural Press, 2007.

Bierut, Michael, William Drenttel, and Steven Heller, eds. *Looking Closer 5: Critical Writings on Graphic Design.* New York: Allworth Press, 2007.

Coles, Alex. *Design and Art.* Cambridge: MIT Press, 2007.

Csikszentmihalyi, Mihaly. *Creativity: Flow and the Psychology of Discovery and Invention.* 4th ed. New York: Harper Perennial, 1997.

Curtis, Hillman. *MTIV: Process, Inspiration, and Practice for the New Media Designer.* New York: New Riders Press, 2002.

Erlhoff, Michael, and Timothy Marshall, eds. *Design Dictionary: Perspectives on Design Terminology.* Board of International Research in Design. Basel: Birkhäuser Basel, 2008.

Glaser, Milton. *Art Is Work.* New York: Overlook Press: 2008.

———. *Drawing Is Thinking.* New York: Overlook Press, 2008.

Glaser, Milton, and Mirko Ilić, *The Design of Dissent: Socially and Politically Driven Graphics.* Beverly, MA: Rockport Publishers, 2006.

Heller, Steven, and Mirko Ilić. *The Anatomy of Design: Uncovering the Influences and Inspirations in Modern Graphic Design.* Beverly, MA: Rockport Publishers, 2007.

Heller, Steven, and Veronique Vienne. *Citizen Designer: Perspectives on Design Responsibility.* New York: Allworth Press, 2003.

Klee, Paul. *Pedagogical Sketchbook.* England: Faber and Faber, 1953.

Lupton, Ellen. *Design Writing Research.* New York: Phaidon Press, 1999.

Lupton, Ellen, and Miller Abbott. *The ABCs of the Bauhaus and Design Theory from Preschool to Post-Modernism.* New York: Princeton Architectural Press, 1993.

Maeda, John. *The Laws of Simplicity (Simplicity: Design, Technology, Business, Life).* Cambridge: MIT Press, 2006.

Margolin, Victor. *Design Discourse: History, Theory, Criticism.* Chicago: University of Chicago Press, 1989.

Moholy-Nagy, Lazlo. *Vision in Motion.* Chicago: Paul Theobald, 1947.

Müller-Brockmann, Josef. *The Graphic Artist and His Design Problems.* Sulgen, Switzerland: Arthur Niggli, 1961.

Poynor, Rick. *Obey the Giant: Life in the Image World.* 2nd ed. Basel: Birkhäuser Basel, 2007.

Rand, Paul. *Conversations with Students.* New York: Princeton Architectural Press, 2008.

———. *Design, Form, and Chaos.* New Haven: Yale University Press, 1993.

———. *Thoughts on Design.* New York: Van Nostrand Reinhold, 1970.

Smoke, Trudy, and Alan Robbins. *World of the Image.* White Plains, NY: Longman, 2006.

Tufte, Edward R. *The Cognitive Style of PowerPoint.* Cheshire, CT: Graphics Press, 2003.

———. *Envisioning Information.* Cheshire, CT: Graphics Press, 1990.

Typography

Bringhurst, Robert. *The Elements of Typographic Style*. Version 3.2. Point Roberts, WA: Hartley & Marks Publishers, 2008.

Burke, Christopher. *Active Literature: Jan Tschichold and New Typography*. London: Hyphen Press, 2008.

Carter, Rob. *American Typography Today*. New York: Van Nostrand Reinhold, 1989.

Carter, Rob, Ben Day, and Philip B. Meggs. *Typographic Design: Form and Communication*. 3rd ed. New York: Van Nostrand Reinhold, 2002.

Craig, James. *Basic Typography: A Design Manual*. New York: Watson-Guptill Publications, 1990.

———. *Designing with Type*. New York: Watson-Guptill Publications, 1992.

Dodd, Robin. *From Gutenberg to OpenType: An Illustrated History of Type from the Earliest Letterforms to the Latest Digital Fonts*. Dublin: Hartley and Marks Publishers, 2006.

Lupton, Ellen. *Thinking with Type: A Critical Guide for Designers, Writers, Editors, and Students*. New York: Princeton Architectural Press, 2004.

Müller, Lars. *Helvetica: Homage to a Typeface*. Baden: Lars Müller, 2002.

Perry, Michael. *Hand Job: A Catalog of Type*. New York: Princeton Architectural Press, 2007.

Ruder, Emil. *Typography*. Sulgen, Switzerland: Arthur Niggli, and New York: Hastings House, 1981. First published in 1967.

Rüegg, Ruedi. *Basic Typography: Design with Letters*. New York: Van Nostrand Reinhold, 1989.

Solomon, Martin. *The Art of Typography: An Introduction to Typo.Icon.Ography*. New York: Watson-Guptill, 1986.

Spencer, Herbert. *Pioneers of Modern Typography*. Rev. ed. Cambridge: MIT Press, 2004.

Spencer, Herbert, ed. *The Liberated Page: An Anthology of Major Typographic Experiments of This Century as Recorded in "Typographica" Magazine*. London: Lund Humphries, 1987.

Spiekermann, Erik, and E. M. Ginger. *Stop Stealing Sheep and Find Out How Type Works*. 2nd ed. Berkeley: Adobe Press, 2002.

Tschichold, Jan. *The New Typography: A Handbook for Modern Designers*. Translation by Ruari McLean. Berkeley: University of California Press, 1995.

Weingart, Wolfgang. *Wolfgang Weingart: My Way to Typography*. Baden: Lars Müller, 2000.

Zapf, Hermann. *Hermann Zapf and His Design Philosophy*. Chicago: Society of Typographic Arts Chicago, 1997.

Visualization

Chen Design Associates. *Fingerprint: The Art of Using Hand-Made Elements in Graphic Design*. Cincinnati: HOW Books, 2006.

Dougherty, Brian, and Celery Design Collaborative. *Green Graphic Design*. New York: Allworth Press, 2009.

Evans, Poppy, and Aaris Sherin. *Forms, Folds, and Sizes: All the Details Graphic Designers Need to Know But Can Never Find*. 2nd ed. Beverly, MA: Rockport Publishers, 2009.

Gonnella, Rose, and Christopher Navetta. *Comp It Up*. Clifton Park, NY: Delmar Cengage Learning, 2010.

Krug, Steve. *Don't Make Me Think! A Common Sense Approach to Web Usability*. 2nd ed. Berkeley: New Riders, 2006.

Landa, Robin, and Rose Gonnella. *Visual Workout: A Creativity Workbook*. Clifton Park, NY: Delmar Cengage Learning, 2004.

Perry, Michael. *Over and Over: A Catalog of Hand-Drawn Patterns*. New York: Princeton Architectural Press, 2008.

Reas, Casey, and Ben Fry. *Processing: A Programming Handbook for Visual Designers and Artists*. Cambridge: MIT Press, 2007.

Sherin, Aaris. *SustainAble: A Handbook of Materials and Applications for Graphic Designers and Their Clients*. Beverly, MA: Rockport, 2008.

Victionary. *Print Work: An Exploration of Printing Techniques*. Hong Kong: Victionary, 2008.

Zeldman, Jeffrey. *Designing with Web Standards*. 2nd ed. Berkeley: New Riders, 2007.

Recommended Reading

Arnheim, Rudolf. *Visual Thinking*. Berkeley: University of California Press, 2004.

Dondis, Donis A. *Primer of Visual Literacy.* Cambridge: MIT Press, 1973.

Frederick, Matthew. *101 Things I Learned in Architecture School.* Cambridge: MIT Press, 2007.

Gombrich, E. H. *Art and Illusion.* Princeton: Princeton University Press, 2000.

Gonnella, Rose, and Christopher Navetta. *Comp It Up.* Clifton Park, NY: Delmar Cengage Learning, 2010.

Kubler, George. *The Shape of Time: Remarks on the History of Things.* Rev. ed. New Haven: Yale University Press, 2008.

Landa, Robin. *Thinking Creatively.* Cincinnati: HOW books, 2002.

Lois, George. *George Lois: On Creating the Big Idea.* New York: Assouline, 2008.

Meggs, Philip B. *Type and Image: The Language of Graphic Design.* New York: Van Nostrand Reinhold, 1989.

Meggs, Philip B., and Alston W. Purvis. *Meggs' History of Graphic Design.* 4th ed. Hoboken: John Wiley & Sons, 2005.

Ortega y Gasset, José. *Dehumanization of Art and Other Essays on Art, Culture, and Literature.* Princeton: Princeton University Press, 1968.

Panofsky, Erwin. *Meaning in the Visual Arts.* Chicago: University of Chicago Press, 1983.

Rapaille, Clotaire. *The Culture Code: An Ingenious Way to Understand Why People Around the World Live and Buy as They Do.* New York: Broadway Books, 2007.

Wolfflin, Heinrich. *Principles of Art History.* New York: Dover Publications, 1950.

Woodbridge, Homer E. *Essentials of English Composition.* New York: Harcourt, Brace, and Howe, 1920.

Online Sources

Professional Organizations

The Advertising Council
www.adcouncil.org

American Institute of Graphic Arts (AIGA)
www.aiga.org

AIGA Design Archives
http://designarchives.aiga.org

Art Directors Club
www.adcglobal.org

D&AD
www.dandad.org

International Association of Business Communicators
www.iabc.com

Icograda
www.icograda.org

International Typographic Organization
www.atypi.org

The One Club
www.oneclub.org

Society of Illustrators
www.societyillustrators.org

The Type Directors Club
www.tdc.org

Publications

The Advertising Century
www.adage.com/century

Adweek
www.adweek.com

Brandweek
www.brandweek.com

CMYK Magazine
www.cmykmag.com

Communication Arts
www.commarts.com

Creativity Magazine
www.creativity-online.com

HOW Magazine
www.howdesign.com

Lürzer's Archive
www.luerzersarchive.com

Print Magazine
www.printmag.com

Step Inside Design
www.stepinsidedesign.com

Blogs

Design Blog, Cooper-Hewitt
blog.cooperhewitt.org

Design Observer
www.designobserver.com

Brand New
www.underconsideration.com/brandnew/

Museums

Ad Museum
www.admuseum.org

Cooper-Hewitt, National Design Museum
www.cooperhewitt.org

Design Museum London
www.designmuseum.org

The Eisner American Museum of Advertising and Design
www.eisnermuseum.org

Graphic Design Archive | RIT Libraries
http://library.rit.edu/collections/rit-special-collections/
design-archives.html

The Herb Lubalin Center for Design and Typography
http://lubalincenter.cooper.edu/

Museum of Modern Art
www.moma.org

Museum for Modern International Book Art, Typography and Calligraphy
www.klingspor-museum.de/EUeberdasMuseum.html

Smithsonian Institution
www.si.edu

Subject Index

Agencies, Clients, Creative Professionals, Studios, and Names Index